節慶
Festivities

中國少數民族大型節日活動

Major Events and Festivals of Ethnic Minorities in China

李秀恒 著
Eddy Li

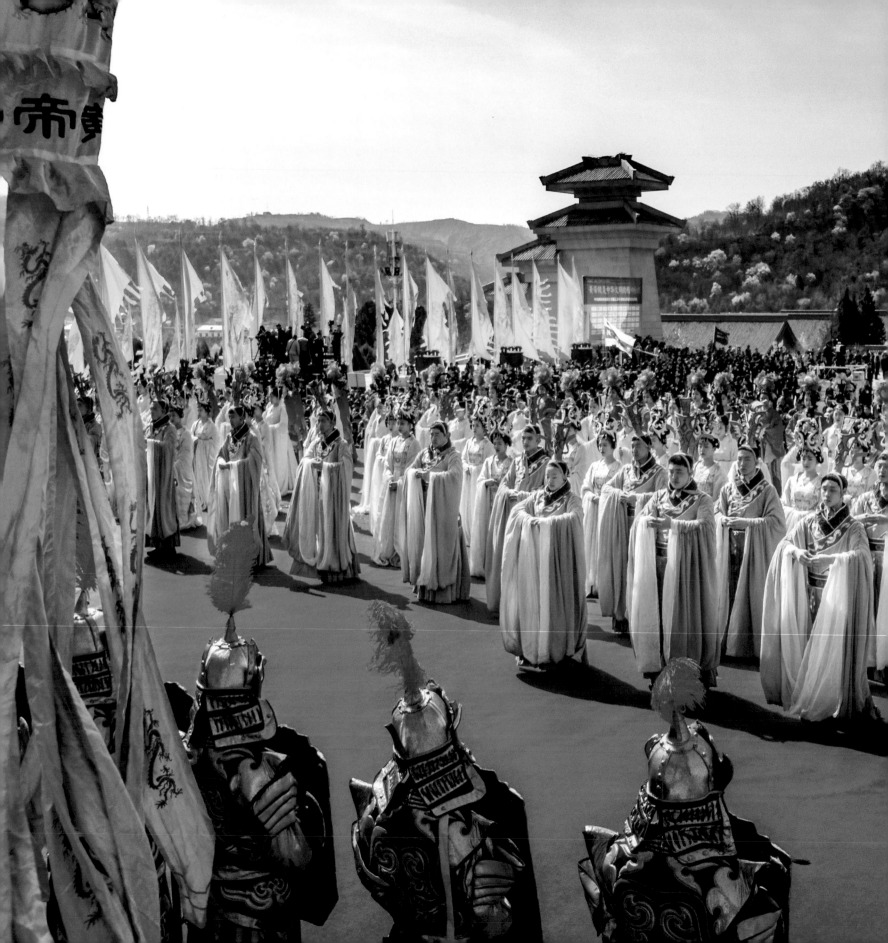

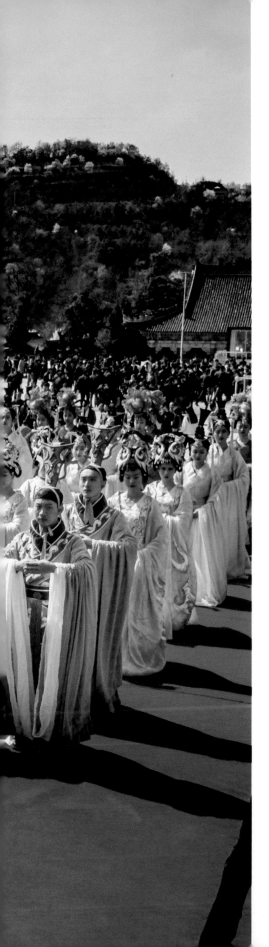

節慶 Festivities

中國少數民族大型節日活動
Major Events and Festivals of Ethnic Minorities in China

作者 Author	李秀恒 Eddy Li
翻譯 Translation	李佳燁 Natalie Li
	梁皓明 Kristie Leung
	馬健威 Victor Ma
責任編輯 Managing Editor	吳家駿 Alvis Ng
文字編輯 Text Writer	李佳燁 Natalie Li
	彭少良 Pang Siu Leung
	陳曉 Chan Hiu
美術主任 Art Director	駿二 Zimman Shunji
美術編輯 Designer	莫偉賢 Ryan Mok
	吳燊玉 Kola Ng
發行人 Publisher	熊曉鴿 Hugo Shong
總編輯 Editor in Chief	李永適 Yungshih Lee
策　劃 Acquisitions Editor	蔡耀明 Ivan Tsoi
出版社 Publishing House	大石國際文化有限公司
	Boulder Media Inc
地址 Address	台北市內湖區堤頂大道二段 181 號 3 樓
	3F, No.181, Sec 2, Tiding Blvd.,
	Neihu Dist., Taipei City, Taiwan
電話 Tel	+886 (02) 8797-1758
傳真 Fax	+886 (02) 8797-1756
台灣總代理	大和書報圖書股份有限公司
港澳總代理	泛華發行代理有限公司

2019 年 7 月初版
定價 Price：NT$1200 / HK$400
ISBN：978-957-8722-25-5（精裝）

國家圖書館出版品預行編目（CIP）資料

節慶：中國少數 民族大型 節日 活動 ／
李秀 恆著；
-- 初版 -- 臺北市：大石國際文化，2019.07
500 頁；25×25 公分
中英對照
ISBN 978-957-8722-25-5（精裝）
1. 攝影集
957.6　　　　　　　　108008456

節 慶 Festivities

目錄 Index

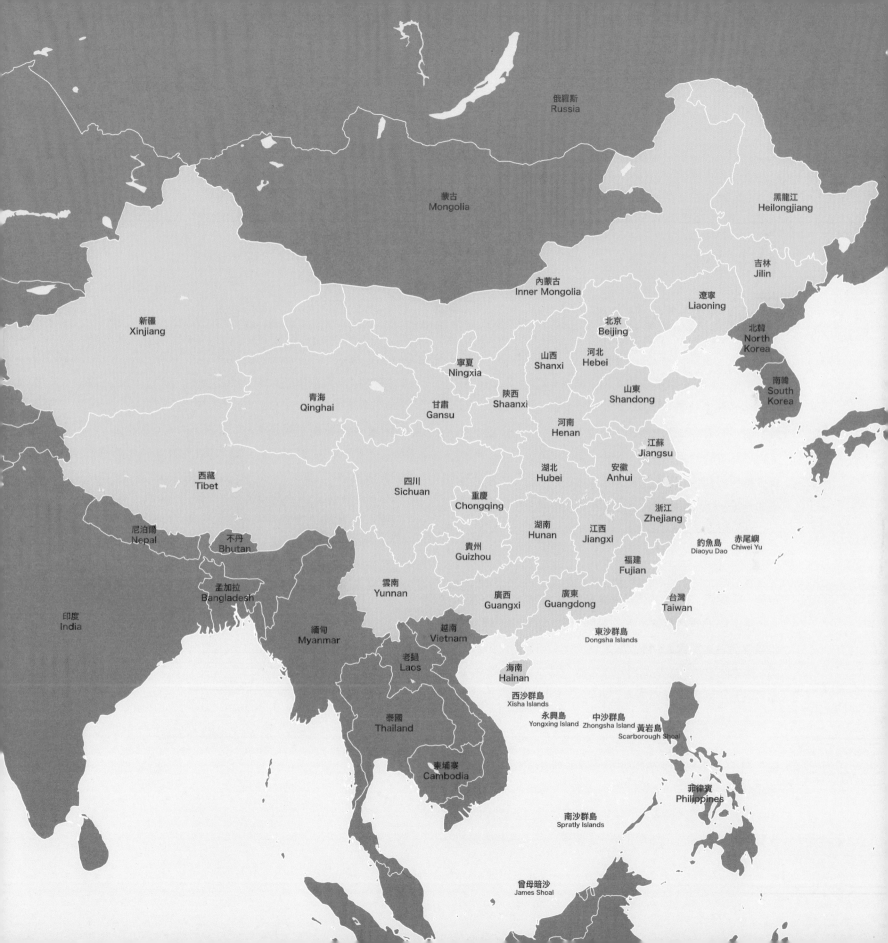

俄羅斯
Russia

蒙古
Mongolia

黑龍江
Heilongjiang

內蒙古
Inner Mongolia

吉林
Jilin

新疆
Xinjiang

遼寧
Liaoning

北韓
North Korea

北京
Beijing

寧夏
Ningxia

山西
Shanxi

河北
Hebei

南韓
South Korea

青海
Qinghai

甘肅
Gansu

陝西
Shaanxi

山東
Shandong

河南
Henan

江蘇
Jiangsu

西藏
Tibet

四川
Sichuan

湖北
Hubei

安徽
Anhui

尼泊爾
Nepal

不丹
Bhutan

重慶
Chongqing

浙江
Zhejiang

湖南
Hunan

江西
Jiangxi

釣魚島
Diaoyu Dao

赤尾嶼
Chiwei Yu

貴州
Guizhou

福建
Fujian

孟加拉
Bangladesh

雲南
Yunnan

廣西
Guangxi

廣東
Guangdong

台灣
Taiwan

印度
India

緬甸
Myanmar

越南
Vietnam

東沙群島
Dongsha Islands

老撾
Laos

海南
Hainan

西沙群島
Xisha Islands

泰國
Thailand

永興島
Yongxing Island

中沙群島
Zhongsha Island

黃岩島
Scarborough Shoal

東埔寨
Cambodia

菲律賓
Philippines

南沙群島
Spratly Islands

曾母暗沙
James Shoal

前言
Foreword

中國是由56個民族組成的多民族國家。不同的民族，都有獨特的歷史起源、宗教信仰、語言文化、傳統習俗或衣飾打扮，不僅為源遠流長的中華文化增色添彩，也是中華文化不可或缺的組成部分，是我們寶貴的文化財富。要領會少數民族特色，最佳方法是參與他們的節慶，因為那些慶典活動，往往最能反映出民族風格和傳統文化。

正因如此，本人花了幾年時間，走遍中國大江南北多個少數民族地區，拍攝他們大型節慶活動的精采畫面，例如西藏的「雪頓節」；內蒙古的「那達慕節」；廣東的「盤王節」……用鏡頭把他們豐富多彩的節慶活動「定格」下來，錄入這本名為《節慶：中國少數民族大型節日活動》的攝影集。書中的照片，都是經過數年累積的精選作品。這些作品不僅是少數民族大型節慶活動的一個印記，相信亦起到一種傳承作用。

這本攝影集是本人繼2018年與國家地理合作出版《帶路：通過鏡頭探索一帶一路的商機、風貌、人情》後，再合作出版的第二本個人攝影集，希望讀者可以透過此書對中國少數民族的風俗文化加深了解，並讓更多人認識中華文化的多元化。

在拍攝過程中深刻體會到，無論哪個少數民族的族群，都有一個共同點，就是不管身在何方，一到民族傳統的大時大節，都會想方設法返回家鄉，爭取與家人共度節慶。這種凝聚力，也許就是中華民族和中華文化能夠延續數千年而不衰的根源。

《節慶》得以面世，全靠得到多方面的支持和配合，特別是中國民族貿易促進會、國家民族事務委員會，以及中央和多個省市的海聯會、統戰部、宣傳部和攝影家協會等機構和團體的幫助，為拍攝工作提供了很大的支援，在此深表致謝。

China is a multi-national country, consisting of 56 ethnic groups. These groups are distinct in history, languages, culture, habitats, customs or costumes. These elements are indispensable and precious treasure, adding luster to the Chinese culture. The best way to understand ethnic minorities is to participate in their festivities. These festive activities are the direct embodiments of their folk style and traditional culture.

This is why I have spent years travelling around the country, seizing the most memorable moments in different festivals of various ethnic groups, such as the Sho Dun Festival in Tibet, the Naadam in Inner Mongolia, Panwang Festival in Qingyuan, and etc. The wonderful festive scenes are captured and "framed" through the lens and later assembled in this album - "Festivities: Major Events and Festivals of Ethnic Minorities in China", in which every photo has been meticulously selected from several years of accumulation. These photos bear the trace of the festivals and ceremonies of ethnic minorities and will hopefully become a record to be passed down and preserved.

This is my second collaboration with National Geographic after the "Belt and Road: Exploring the market, sceneries and people along the belt and road through lenses"

published in 2018. Hopefully, through this project, we are able to deliver a better understanding of the folk culture of ethnic minorities in China as well as the diversification of Chinese culture.

Throughout the journey, it occurred to me that there's one thing these ethnic groups share in common - no matter where they are, they would try to gather in their hometown for big festivals or ceremonies and unite with their families. This sense of belonging and cohesiveness is probably why the Chinese and their culture are able to thrive for thousands of years.

Upon completion of Festivities, I want to take this opportunity and express my utmost gratitude to many organizations for their kind support and assistance in this project, including the China Council for the Promotion of National Trade, National Ethnic Affairs Commission, Overseas Friendship Associations, United Front Work Departments and Publicity Departments of central and local administrative levels, various photographers' associations, and etc.

民族起源

「民族」一詞難有統一定義，有人認為民族是血緣共同體，亦有人認為這其實是一個政治概念，可是無論哪一個方面來定義，「民族」都代表著某一群人因某些方面的共同性或特徵而聚合，這些特徵又能使他們與其他擁有不同特徵的人群相區別。

上個世紀 50 年代，中國官方按照語言、地域、文化等標誌性特徵，劃分出了 56 個民族。其實自古以來，中國就是一個多民族聚居的國家，要探究民族起源，可謂千頭萬緒。

現在中國人普遍自稱為「炎黃子孫」，這與華夏民族的起源有關。距今 5,000 多年前，中國仍處於被稱為神話時代的「三皇五帝」時期，當時尚未有文字實物資料流傳，歷史事件主要靠傳說流傳至今。《史記・秦始皇本紀》中有「古有天皇，有地皇，有泰皇，泰皇最貴。」的記錄，《呂氏春秋》中則有「太昊、炎帝、黃帝、少昊、顓頊」五帝的記載，這些「三皇五帝」都是當時各個部落的領袖，並非現在所指的帝王。

如今中國人普遍相信的傳說版本是：炎帝為神農氏部族的首領，與北方部落的首領軒轅氏黃帝結為聯盟，合力擊敗蚩尤，並率領各自族人統一中原，也就是如今的河南、陝西、河北、山西、山東和安徽一帶。在黃帝的領導下，各部族融合而形成「華夏民族」。其後經歷堯、舜、禹等的領導，並再與其他民族融合，逐漸形成了一個強大的民族──漢族。

相對漢族而言人口相對較少的民族被稱為少數民族，他們當中，一部分是從「土生土長」的古代部族演變而成，例如羌族；有些因部族分化形成了幾個不同的民族，如五溪蠻分化出了苗族、瑤族等；有些是歷史上獨立的地方民族政權，如藏族、蒙古族、滿族等；朝鮮族、俄羅斯族、哈薩克族等則是國外移民所形成。這些族群與漢族一起居於中國這片廣袤的土地之上，共同形成了中華民族。

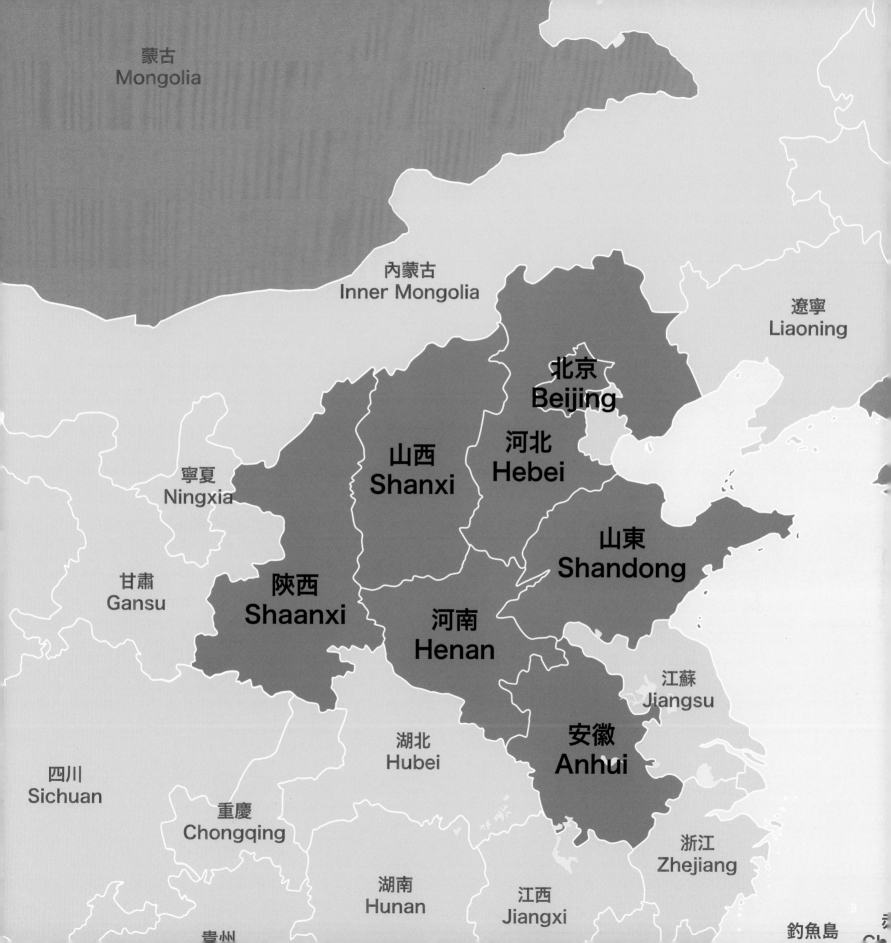

The Origin of Ethnic Groups in China

It's difficult to find a solid definition of ethnic groups commonly used. Some reckon it represents the bonding of blood, while some think it's simply a political concept. From whatever perspectives of view, an ethnic group is the aggregation of a certain type of people who share something in common which differentiate them from other groups.

In the 1950s, Chinese authorities had classified its population as 56 ethnic groups by their iconic traits such as languages, regions and culture. In fact, China has always been a multi-national state, and the origin of ethnic groups in China is complicated to explore.

Modern Chinese tend to label themselves as the descendants of Yan and Huang Emperors, which is related to the origin of Huaxia People. More than 5,000 years ago, China was still in the mythological period of Three Sovereigns and Five Emperors. Without written documentations from that time, the stories from this period were passed down only as legends. In Shiji (Records of the Grand Historian), the record of "Three Sovereigns" can be found as Tianhuang (Heavenly Sovereign), Dihuang (Earthly Sovereign) and Taihuang (Tai Sovereign). In Lüshi Chunqiu (Master Lü's Spring and Autumn Annals), the "Five Emperors" were documented, including Taihao, Yan Emperor, Huang Emperor, Shaohao and Zhuanxu. They were tribal leaders at the time rather than what we now know as emperors.

What most Chinese commonly believe nowadays is that Yan Emperor, the leader of Shennong, joined hands with Huang Emperor, the leader of Xuanyuan and defeated Chiyou. They led their people and united the tribes in Zhongyuan (Central

Plain), the area covering Henan, Shaanxi, Hebei, Shanxi, Shandong and Anhui provinces. Under the leadership of Huang Emperor, these tribes had formed the Huaxia People. Since then, Huaxia had been ruled by Yao, Shun and Yu, and gradually evolved into Han People after generations of integration with other ethnicities.

Ethnic minorities are ethnic groups that are comparatively less populated than Han. Among them, some are indigenous ethnic groups in the country, such as Qiang, which was originally an ancient tribe; while some minorities developed from the division of tribes, for instance, Miao and Yao ethnic groups both derived from the Man of the Five Creeks; some ethnic groups like Tibetan, Mongolia and Manchu came into being as the establishment of independent local authorities in history; Koreans, Russians, Kazakhs and other minorities were immigrants from their original countries. These groups, together with Han, are living harmonious together on the vast land of China and are all indispensable parts of the Chinese nation.

現存於世的黃帝陵及炎帝陵都在陝西省境內。每逢清明時節，不少華人都會來到他們的陵墓祭拜中華民族的祖先。

The existing mausoleums of Huang and Yan Emperors are both located in Shaanxi Province. Every year around the Tomb Sweeping Festival, a large number of Chinese people would come for fete activities to show respect to their ancestors.

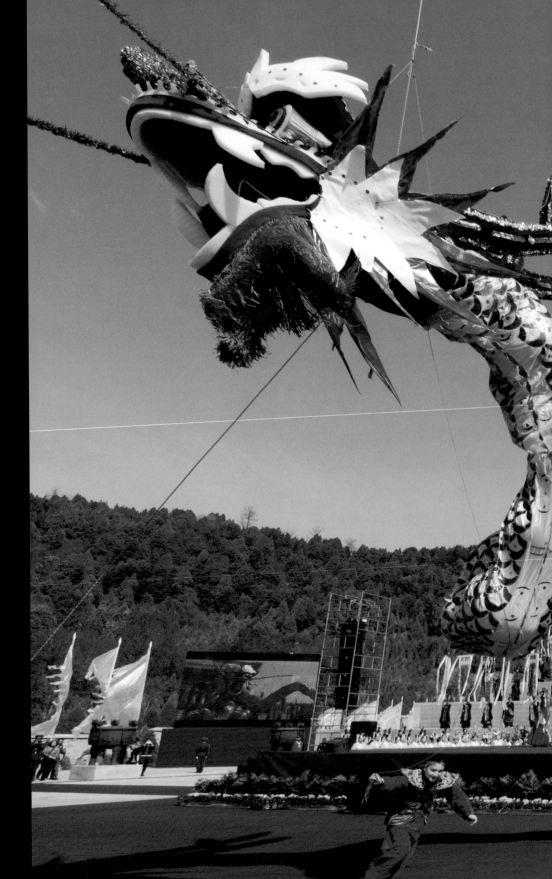

相傳黃帝部落採用龍圖騰，因此中國
人亦被稱為「龍的傳人」。

It is said that the tribe of the Yellow Em-
pire used a symbolic totem of dragon,
and Chinese are therefore also called
"the descendants of the dragons".

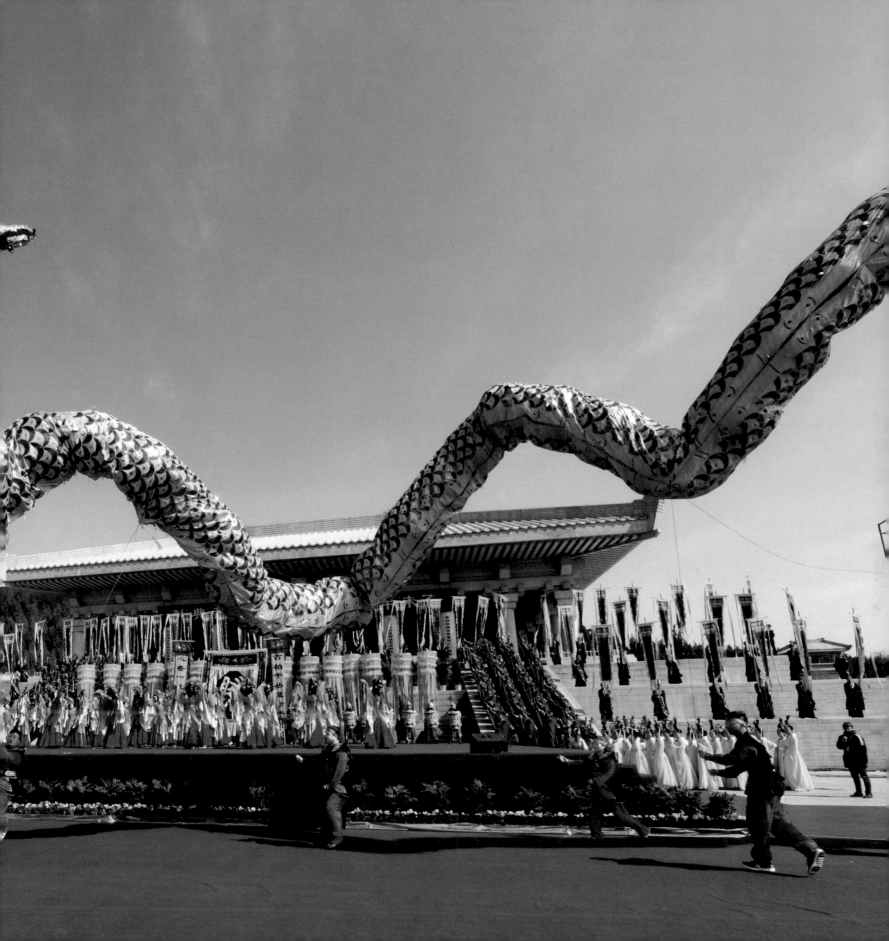

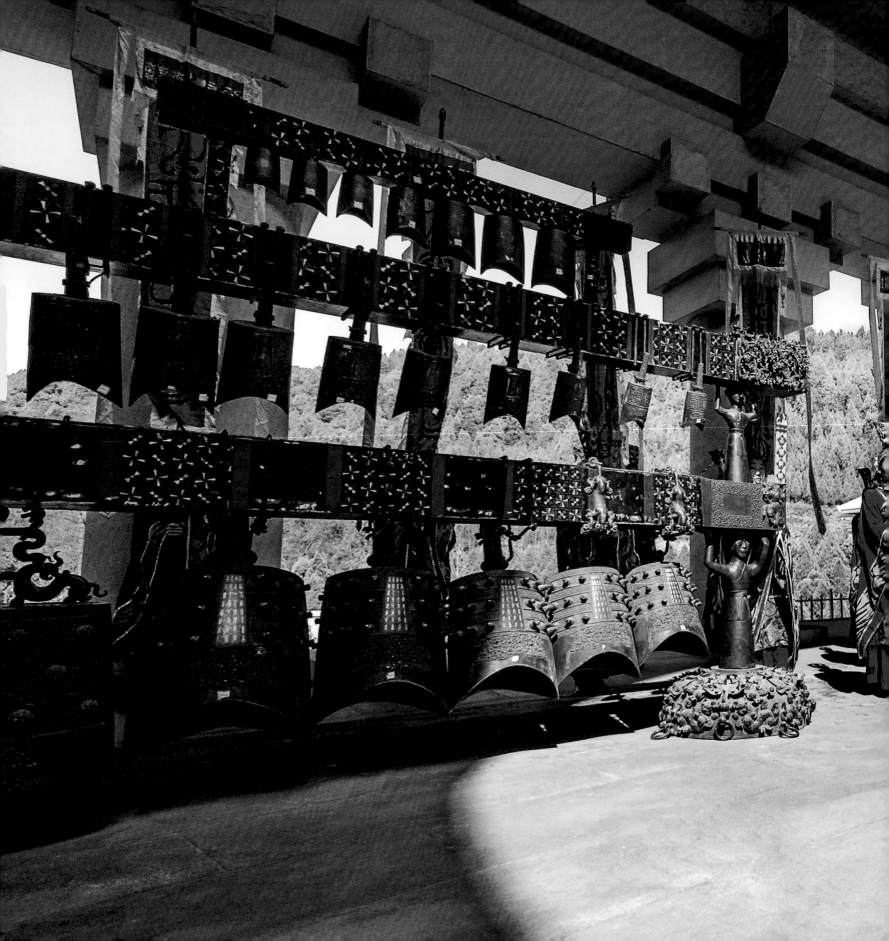

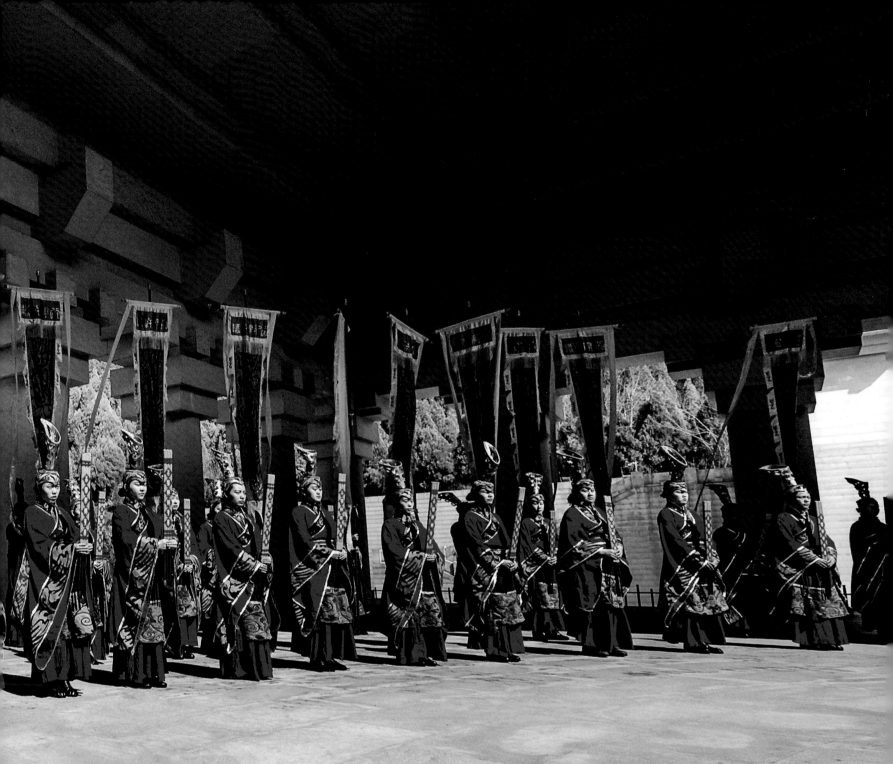

古代中國，編鐘是大型活動中必不可少的敲擊樂器，大小各異的編鐘整齊排列，營造出莊嚴的氣氛。

Chime-bell is one of the percussion instruments in ancient China, which is generally seen in major events. The marshalling arrangement of chime-bells in different sizes is adding to the solemnity of the occasion.

漢族

「漢族」一稱如今普遍認為緣自漢朝（公元前 202 年—220 年）。漢朝以前，中國雖然有夏、商、周三朝（約公元前 2100 年—公元前 771 年），但因國家體系還僅有雛形、民族概念亦不明顯，夏商周都不能被稱為是真正意義上的「民族國家」。

直到春秋時期（公元前 770 年—公元前 403 年）出現了「華夷之辨」，才有了「華夏」與「蠻夷」（四夷，即東夷、南蠻、西戎、北狄）之別，華夏民族的概念才逐漸形和強化，到春秋戰國時代（公元前 402—公元前 221）始出現「尊王攘夷」、「尊周室，攘夷狄」這樣有華夏民族意識形態的主張。

其後，秦滅六國建立了中國歷史上第一個統一的國家——秦朝（公元前 221—公元前 207），並完善了國家管理體系。不過，秦朝僅統一中國 14 年便亡朝，尚未能實現「民族同心」，便被劉邦所建立的漢朝所取代。

漢朝令中國真正長期統一，在此期間，軍事力量強大的漢帝國大肆開疆拓土，伐匈奴、通西域、平百越、定南夷，建立了可與羅馬帝國相媲美的強大帝國，民族認同感空前提升。四處征戰的漢軍也常自稱「漢人」，

作為一個文化共同體的民族——漢族，亦由此而生。

自此之後，漢人對民族的認同感不斷強化，漢語、漢字和漢文化更是影響了數以億計的漢人，而漢族亦發展成為目前世界上人口最多的民族。

漢朝的首都為長安，即現在陝西省省會西安，這裡也是中國歷史上十三朝（西周、秦、西漢、新朝、東漢、西晉、前趙、前秦、後秦、西魏、北周、隋、唐等等）的首都，共計 900 餘年，對漢文化意義重大。同時在不同朝代更迭的過程中，西安也見證了漢文化與其他不同民族文化融合的歷史。

Han People

The name of Han is generally considered to have been originated in the Han Dynasty (206 BC-220 AD). Before that, due to immature state system and ambiguous concept of nation, the three dynasties, Xia, Shang and Zhou (2100-771 BC), were not nation-states in a real sense.

It was not until the Spring and Autumn period (770-403 BC) did people start to differentiate Huaxia from Manyi (the Four Barbarians: Dongyi, Nanman, Xirong and Beidi). The identification of Huaxia was gradually formed and strengthened. Later in the Warring States period (402-221 BC) there were even advocates to support Han and resist Manyi.

Qin (221-207 BC) had then eliminated the other six of the Seven Warring States to become the first united country in Chinese history. Although the administration system was much improved, lacking the affectionate bonding of ethnicity, it only took 14 years for the dynasty to be replaced by Han.

Han Dynasty created a long-term prosperous period, during which the strong army of Han had conquered Xiongnu, Western Regions, Baiyue and Nanyi. The unprecedentedly powerful country had fortified the identification of the ethnicity. At that time, the Han army also began to address themselves as Han people. This marked the birth of a new cultural community - Han.

Since then, the sense of Han identity was continuously intensified. Its language, character and culture had influenced hundreds of millions of people, and the ethnic group itself has become the most populated ethnicity in the world.

The Han Dynasty set Xi'an, the current provincial capital of Shaanxi, as its capital. Known as Chang'an in ancient China, Xi'an was the capital of 13 ancient dynasties for more than 900 years – Western Zhou, Qin, Western Han, Xin, Eastern Han, Western Jin, Former Zhao, Former Qin, Later Qin, Western Wei, Northern Zhou, Sui, and Tang. The city has witnessed the integration of Han and other ethnic groups along the alternation of dynasties.

歷史悠久的西安，如今已是多民族文化共融的千萬人口城市，其中漢族人口佔 99.1%，少數民族人口又以回族為最大族群，約有 5 萬人。西安市的市中心矗立著建於明代的鐘樓，東西南北四條大街在此交匯。

Cultures of multiple ethnicities converge and integrate in the historical city of Xi'an. Now it is a modern city with a population of more than 10 million – 99.1 percent are Hans, and Hui, with 50,000 people, is the largest group in the city's remaining ethnic minorities. The Bell Tower of Xi'an has been standing at the center of the city since Ming Dynasty, at which four major thoroughfares from all directions converge.

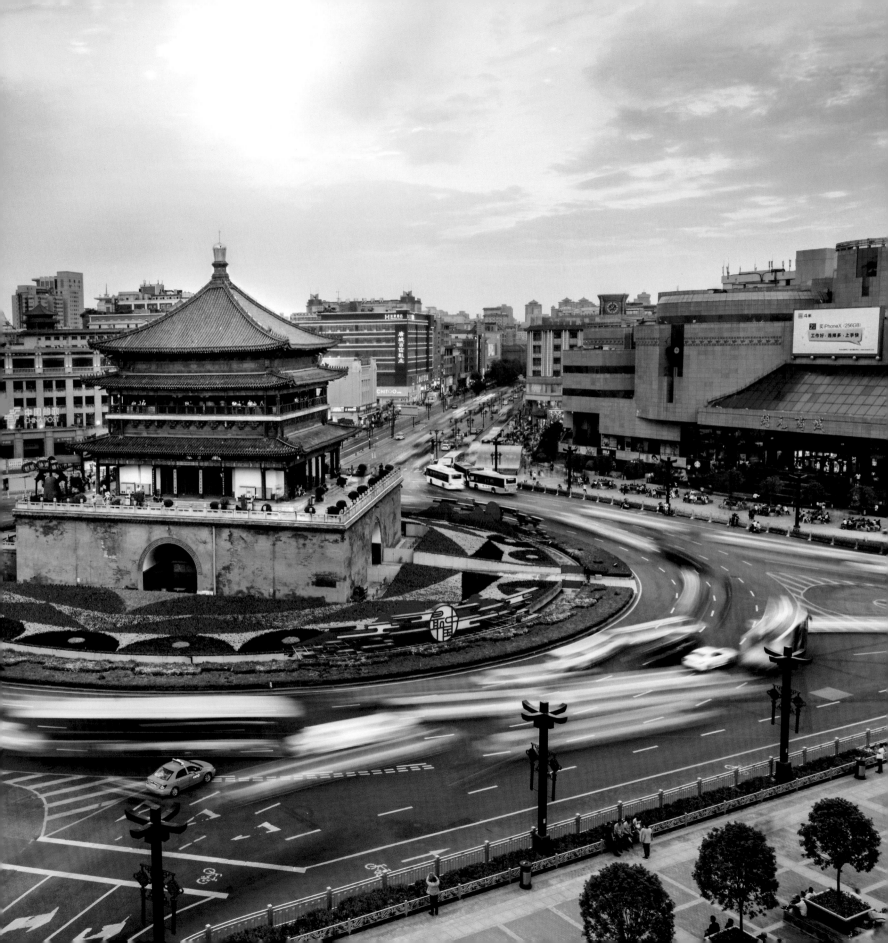

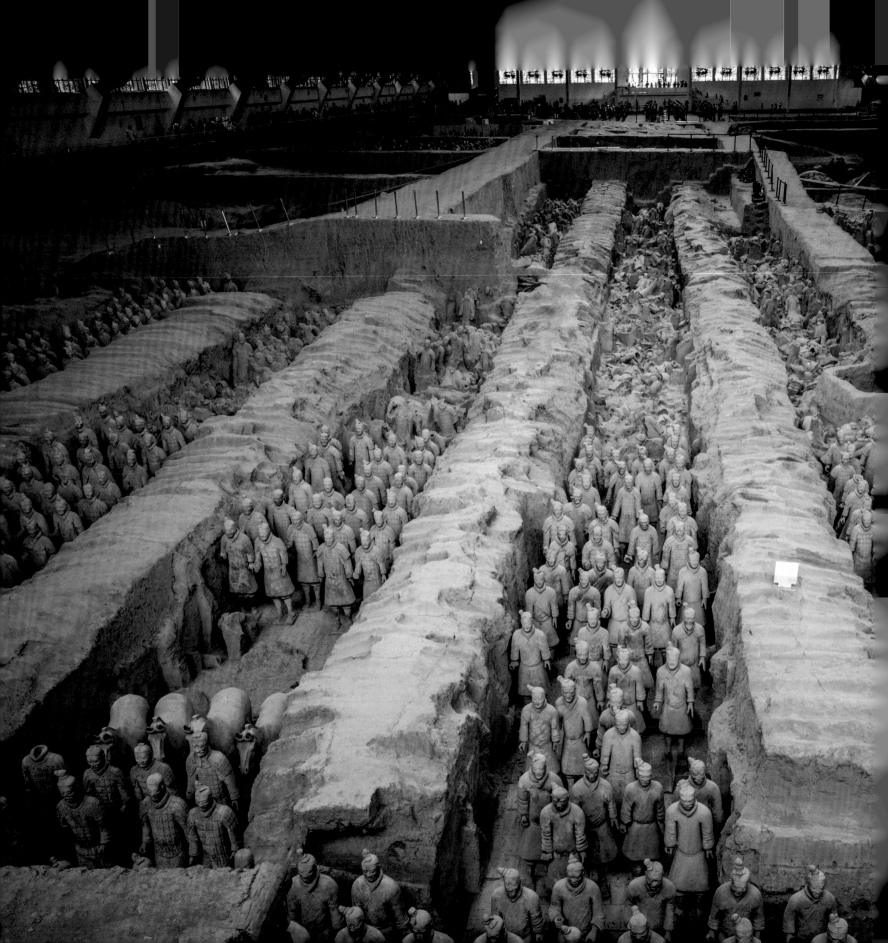

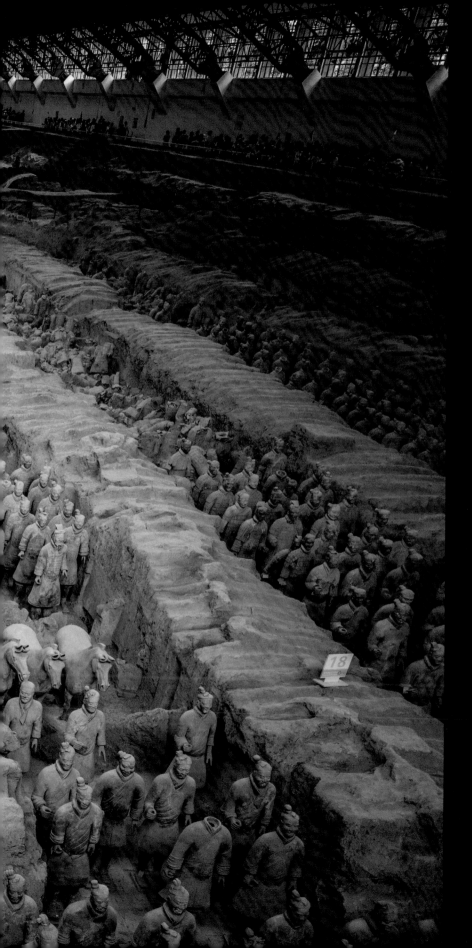

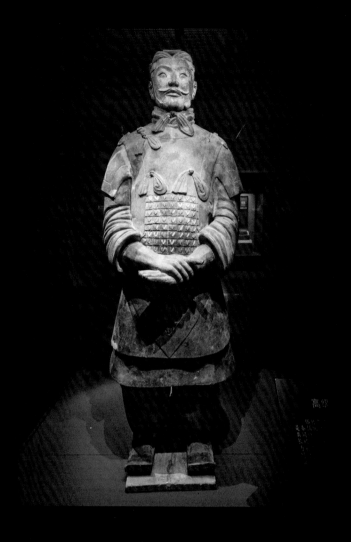

一望無際的秦朝兵馬俑，為觀者帶來了視覺及心靈上的震撼。而這幅場景僅僅是秦始皇帝陵博物院的冰山一角。（左）身著盔甲的秦高級軍吏俑雙手交疊於身前，呈拄劍姿勢。（右）

The boundless view of the Terracotta Army is impactful, both visually and mentally. But what we see is simply a tip of an iceberg in the Emperor Qinshihuang's Mausoleum Site Museum. (Left) The terracotta senior military officer in armor is presenting the gesture of leaning on a sword, with one hand overlapping on the other. (Right)

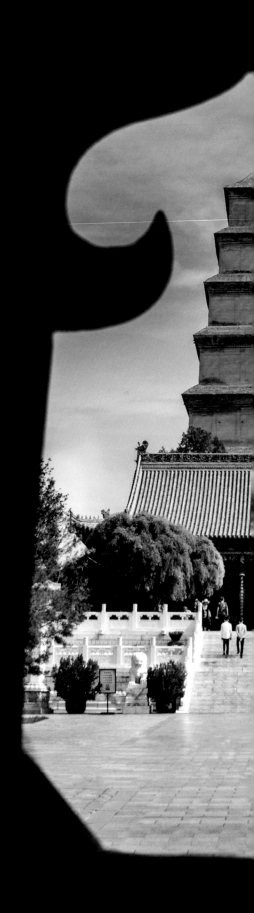

公元 652 年，唐高宗時期，為了珍藏遠從印度帶回的梵本佛經，玄奘法師主持修建了大雁塔，地點就在大慈恩寺之內。藏經塔外形具西域風格，初為五層塔，塔身方形，而後改建為如今所見的七層。在 2013 年，大雁塔作為「絲綢之路：長安—天山廊道的路網」的組成部分，被列入世界文化遺產中。

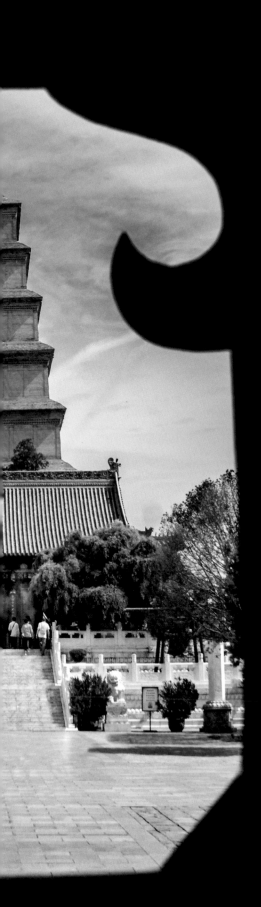

In 652 AD during the reign of Emperor Gaozong of Tang, in order to treasure the sutras and figurines of the Buddha that were brought to China from India, monk Xuanzang took charge of the construction of the Giant Wild Goose Pagoda at a location within the Daci'en Temple. The pagoda in the style of western region was originally a five-story square building, and was reconstructed into seven stories later. In 2013, as a part of the "Silk Roads: The Routes Network of Chang'an-Tianshan Corridor", the Pagoda was listed as a UNESCO world heritage.

建於唐代的小雁塔，是西安博物院建築群的中心，2014年連同「絲綢之路：長安—天山廊道路網」被列入世界遺產。

Built in the Tang Dynasty, the Small Wild Goose Pagoda is at the center of the Xi'an Museum complex. It was included into the "Silk Roads: The Routes Network of Chang'an-Tianshan Corridor", which was listed as a UN-ESCO world heritage in 2014.

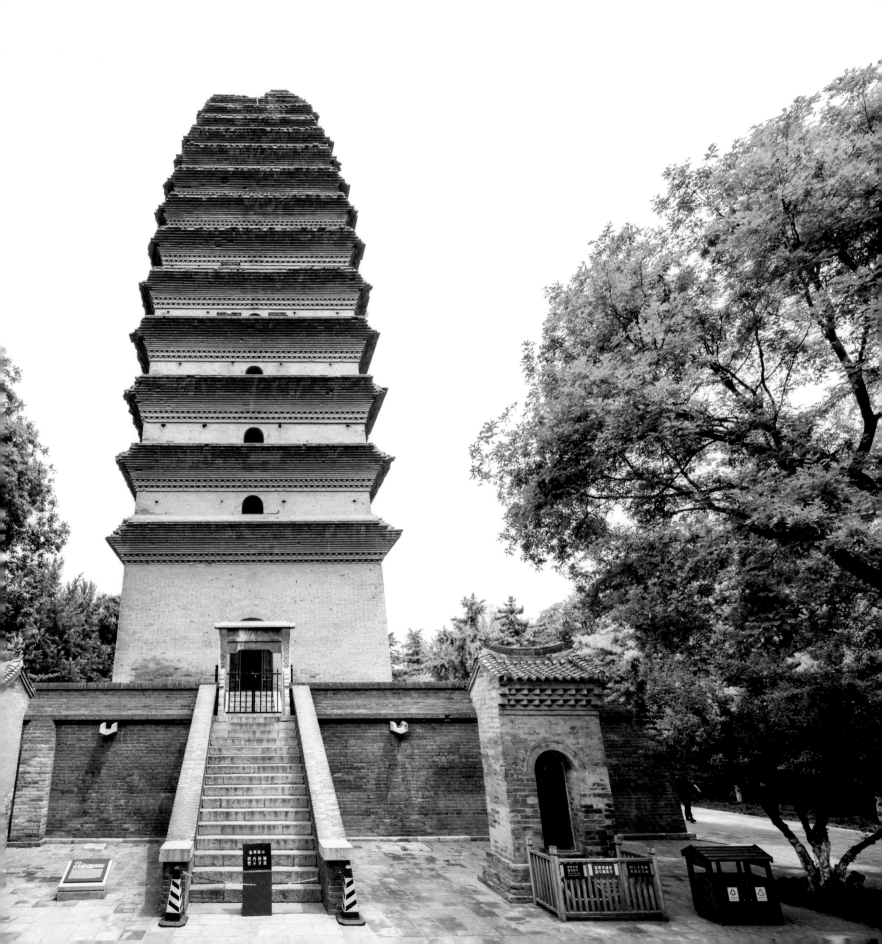

民族融合

古今中外民族的形成、變化、發展，都與不同民族之間的關係密切相關，特別是在像中國這種多民族國家，民族融合是歷史發展的必然趨勢。現代專家一般認為，在中國歷史有四次大規模民族融合。

中國歷史上第一次民族大融合是春秋、戰國時期（公元前 770 年－公元前 221 年）。大規模的戰亂使華夏族人與其他黃河中下游周邊地區的民族融合，形成以華夏族為主體的華夏文明。

第二次民族大融合發生在魏晉南北朝時期（公元 220 年－公元 589 年）。當時社會環境極為動盪，政權更迭頻密，整個中國處於民族大遷徙和民族大雜居的狀態。五胡十六國時期，匈奴、鮮卑、羯、氐、羌等少數民族先後進入黃河流域中下游建立政權。這些少數民族政權為了鞏固統治，模仿漢朝的制度，並推行「胡姓改漢姓」、「胡服易漢服」和「胡漢聯姻」等政策，加速漢族與其他少數民族的融合，也豐富了中原地區的少數民族族群。

第三次民族大融合是在宋、遼、金、元時期（公元 916 年－公元 1388 年）。這一時期邊疆地區戰事頻繁，國家邊界時常出現改變，邊疆成為漢族與遼、金、夏等民族融合的熱點。其後，蒙古族在中國建立元朝，推行階級制度，確保不同民族都能共同生存發展。

第四次民族大融合發生在清代，也最終奠定了現在中國的民族分佈基礎。滿族人入關建立政權之後，除強迫漢族人「剃髮易服」試圖保持本民族特色外，還提出「滿漢一家親」和「大民族」的民族懷柔政策，認為相對於外國人來說，中國各個民族如滿、漢、回、蒙等，同屬中華這個更大的民族。到了清朝末期，內憂外患交逼，掀起列強瓜分中國的浪潮，促進了中國民族觀念的覺醒，加強了各民族的凝聚與融合。新中國成立後，實行民族區域自治政策，並鼓勵全國 56 個民族和諧共融。

The Integration of All Ethnic Groups

The formation, alternation and development of ethnic groups all over the world are closely related to the relationship among different groups. In a multinational country like China, the unification of all ethnic group seems an inevitable historical trend. Modern-day experts generally consider there to be four major integrations in Chinese history.

The first took place during the Spring and Autumn Period to the Warring States Period (770-221 BC). Large scale of chaos caused by war had forced the Huaxia people to integrate with other group at the downstream areas of the Yellow River, creating a perfect breeding ground for Huaxia civilization.

The second integration was in the Wei, Jin, and Southern & Northern Dynasties (220-589 AD). Turbulent social status and ever-changing regimes had urged different groups to migrate and intermingle with others. During the Sixteen Kingdoms, Xiongnu, Xianbei, Di, Jie, Qiang, and other ethnic minorities established their own administration at the lower reaches of the Yellow River. In order to consolidate their ruling, they have copied the system of Han Dynasty and advocated their people to rename, dress and marry like a Han. This had accelerated the integration of Han and other ethnicities as well as enriched the ethnic groups in Central Plain.

From Song to Yuan Dynasties (916-1388 AD), the third integration took place. The border lines were frequently changed by battles, and these areas had witnessed the integration of Han, Liao, Jin, Xia and other peoples. In Yuan Dynasty, the Mongols came up with a hierarchy system of citizens to guarantee different groups of people were able to develop while living together.

The last integration was in Qing, which laid foundation for the current distribution of population in China. After taking control of the country, the Qing government commanded all nationals to shave hair and dress like Manchu people, so as to maintain their ethnic features. They further proposed policies like "Manchu and Han people are a family" and "dominant nation", suggesting that all nationals, whether being Manchu, Han, Hui or Mongols, belong to the same dominant nation, as opposed to foreigners. In the late Qing period, domestic unrest and foreign invasion were trying to split the whole country apart, which had awakened the concept of Chinese nation and facilitated the unification of all ethnicities in the country. After the establishment of the People's Republic of China, policy of autonomy was introduced, and the 56 ethnic groups have reached an unparalleled relationship of harmony.

成吉思汗紀念館位於蒙古國首都烏蘭巴托近郊。成吉思汗帶領蒙古族征戰四方，為蒙古帝國打下了遼闊的疆域。在中國，元朝結束了當時南宋與金朝的對峙，實現了統一。

Genghis Khan Statue Complex is located in suburban Ulaanbaatar, capital of Mongolia. Under the lead of Genghis Khan, the Mongolian Empire expanded to an unprecedented territory. In China, the Yuan Dynasty has unified the country, ending the confrontation between South Song and Great Jin.

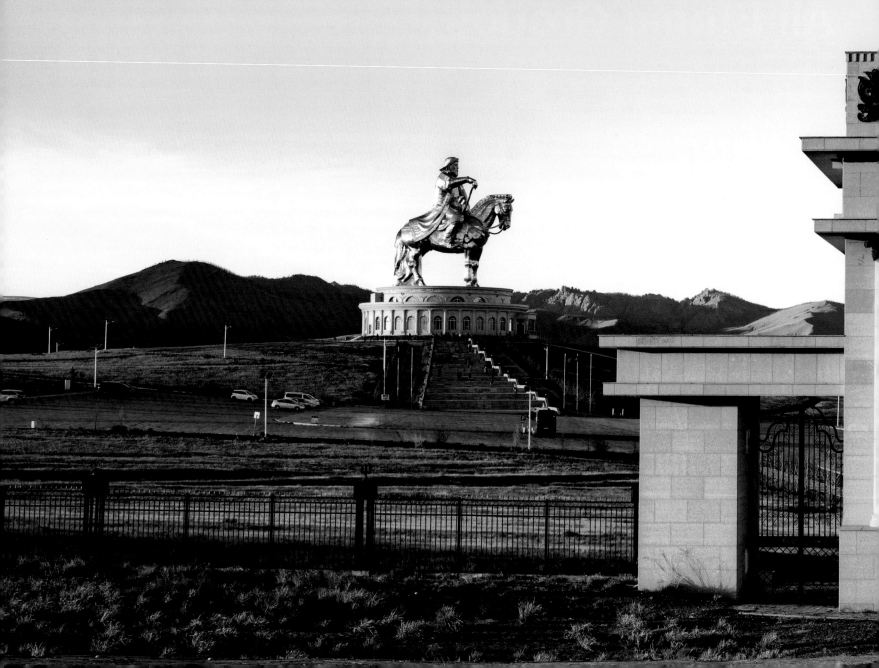

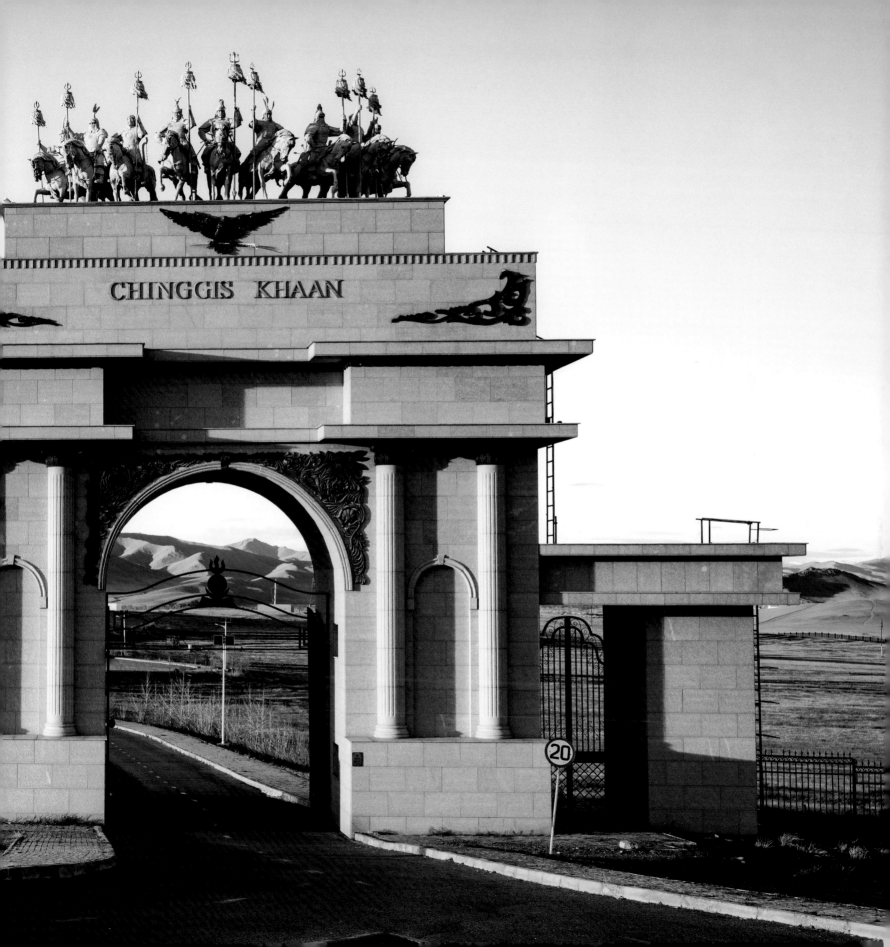

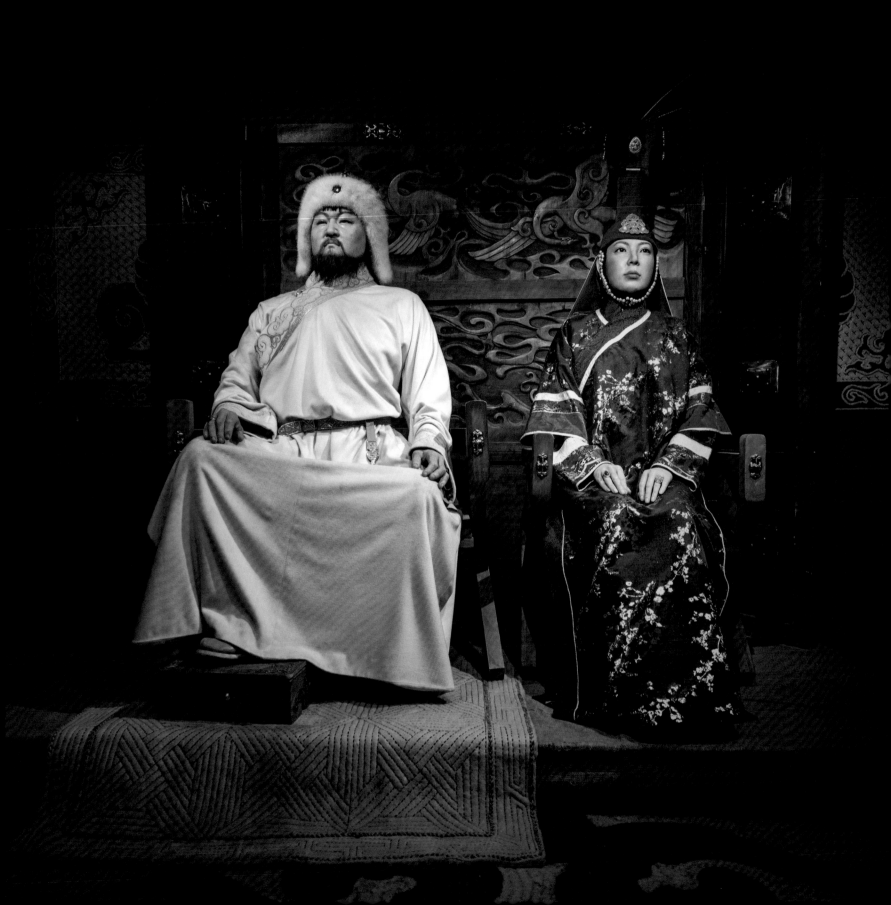

元朝時期，蒙古族作為統治階級，大量任用了其他少數民族擔任朝廷要職，促進多民族發展的局面。成吉思汗紀念館內設有他和妻子的蠟像。

In Yuan Dynasty, the ruling Mongols assigned many ethnic minorities to different positions, pushing forward the multinational development in China. There are wax-works of Genghis Khan and his wife in the Genghis Khan Statue Complex.

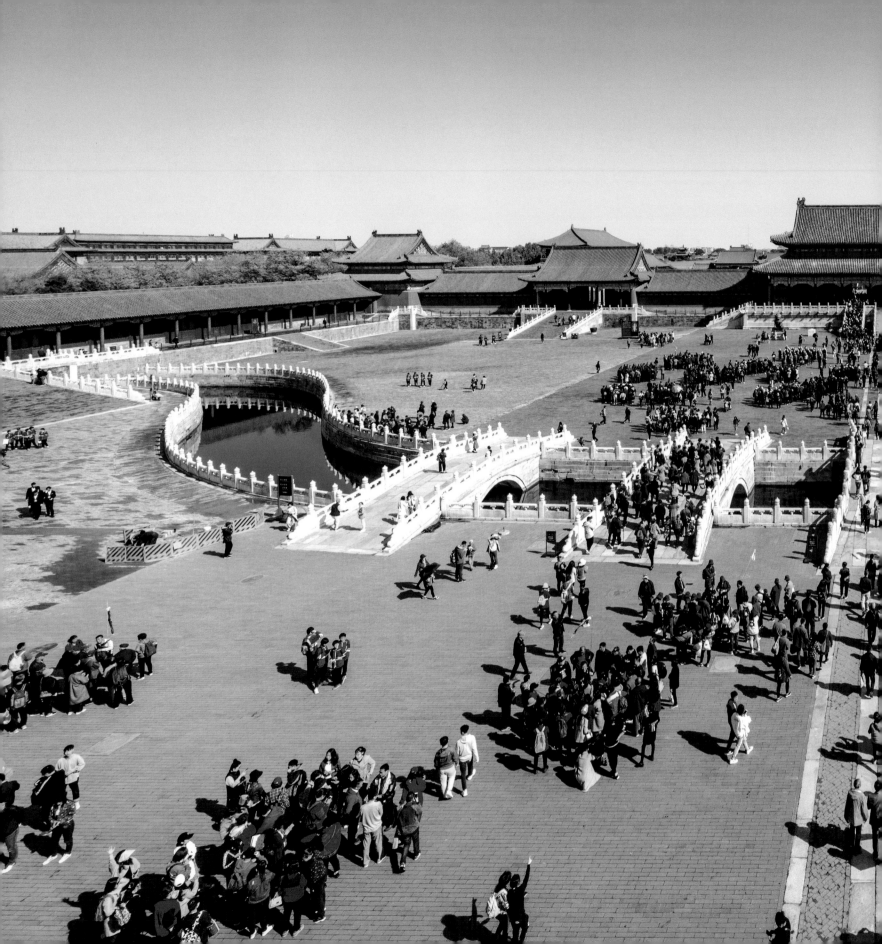

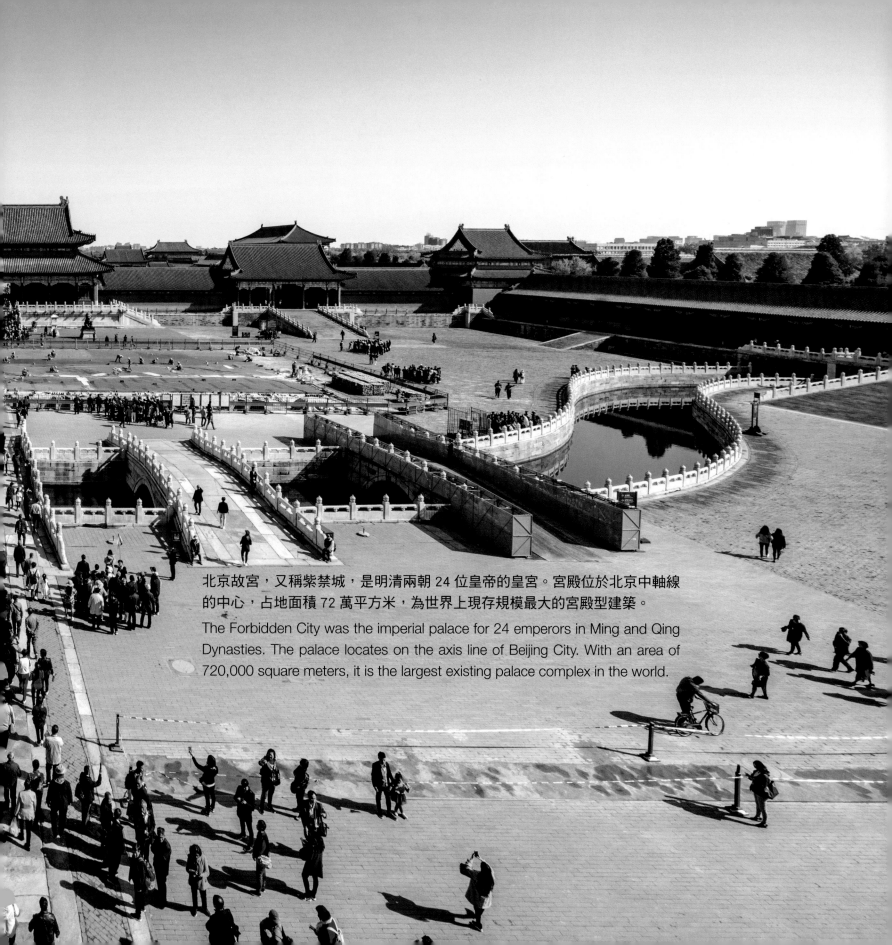

北京故宮，又稱紫禁城，是明清兩朝 24 位皇帝的皇宮。宮殿位於北京中軸線的中心，占地面積 72 萬平方米，為世界上現存規模最大的宮殿型建築。

The Forbidden City was the imperial palace for 24 emperors in Ming and Qing Dynasties. The palace locates on the axis line of Beijing City. With an area of 720,000 square meters, it is the largest existing palace complex in the world.

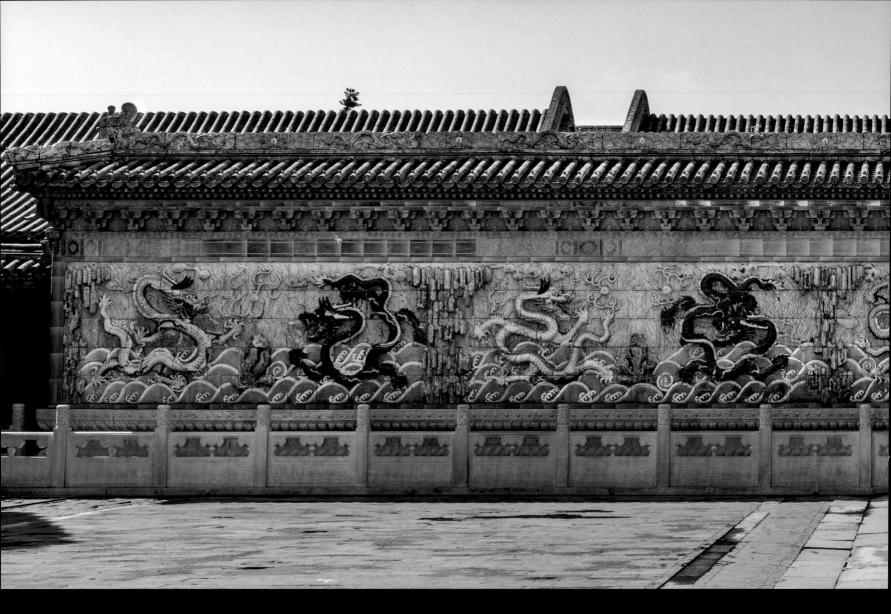

北京故宮內的「九龍壁」始建於清朝乾隆三十七年（1772 年），總長 29.4 公尺。壁身坐南朝北，正對皇極門，是為遮擋對寧壽宮視線而建。

The Nine Dragon Wall in the Forbidden City was first built in the 37th year of Qianlong (1772). At 29.4 meters long, it faces north, towards the Gate of Imperial Supremacy (Huangji men). The construction was designed to block the view through the Gate into the Palace of Tranquil Longevity (Ningshou gong).

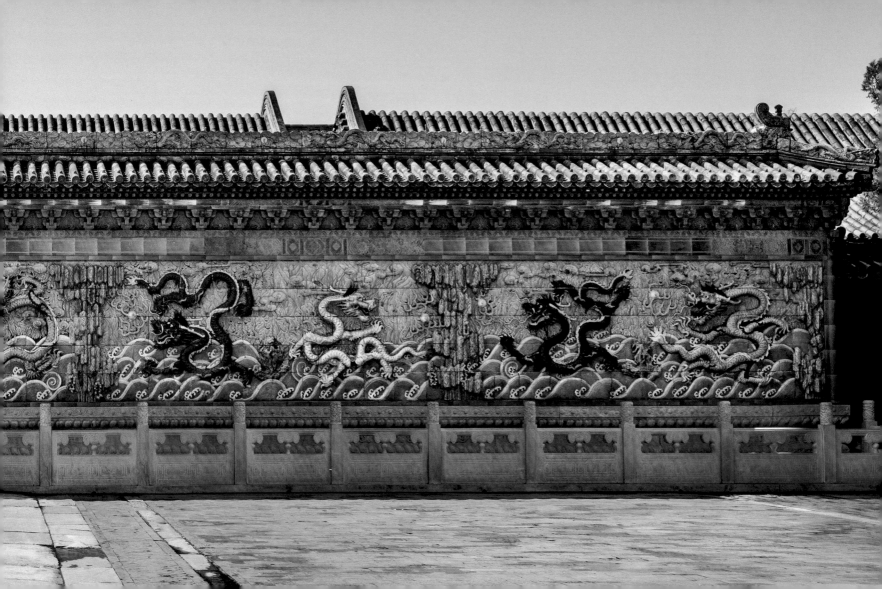

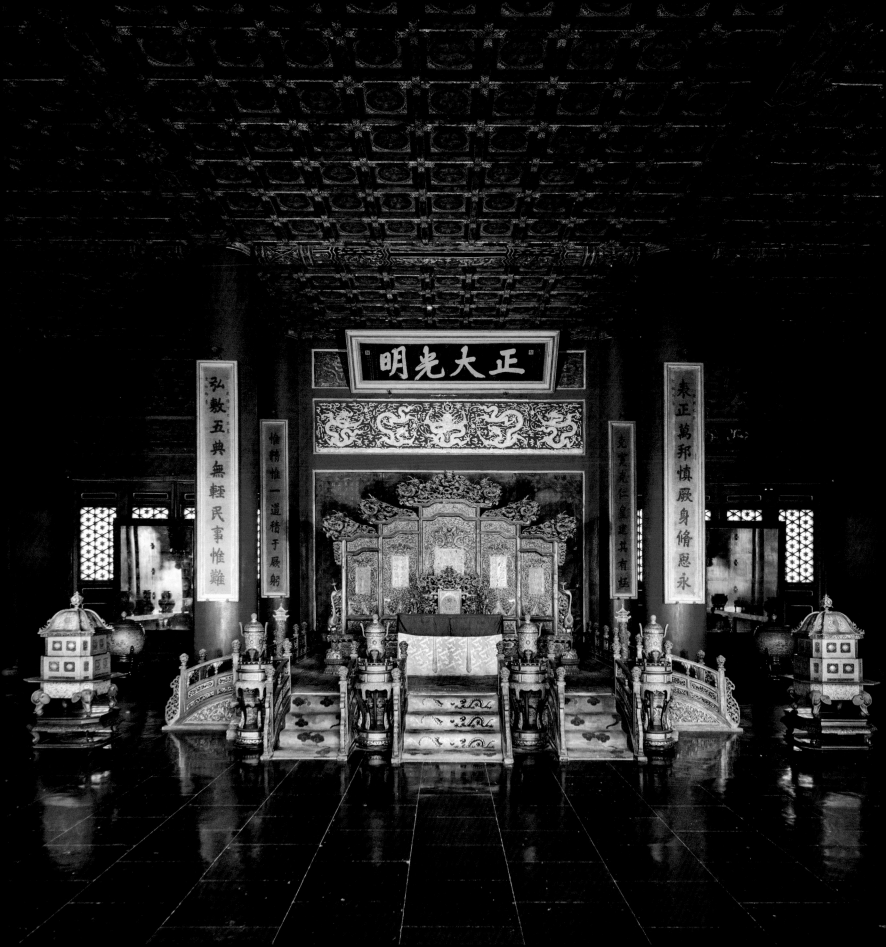

太和殿是故宮最宏偉、最重要的宮殿，皇帝登記、冊封皇后的大典都在此舉行。其內高懸的「正大光明」四字，是順治帝對自己及皇位繼承人能夠保持坦蕩正直的勉勵之語。出處為宋代大家朱熹。

Hall of Supreme Harmony (Taihe Hall) is the largest and most important hall in the Forbidden City. It was the venue for enthronement of emperors and coronation of queens. Hung in the hall, "Zheng Da Guang Ming" (literally translated as "honest, generosity, upright and reasonable") are words of encouragement from Shunzhi Emperor to himself and his successors. These words came originally from Zhu Xi, a philosopher in Song Dynasty.

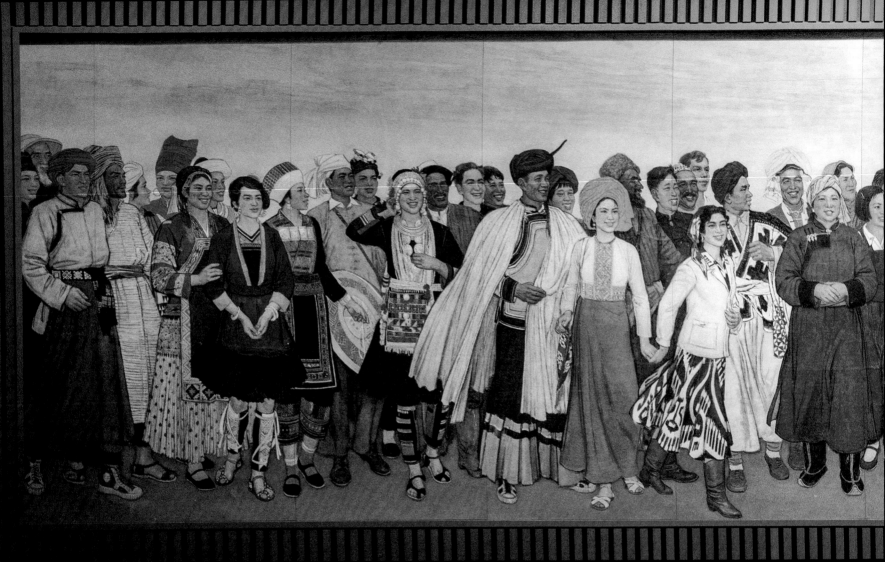

位於湖南省韶山市的韶山毛澤東同志紀念館中的畫作，體現了毛澤東的民族
共融政策──中國國內各民族一律平等，民族之間要平等團結互助，各民族
要團結在一起，共同為建設中華民族而努力。自 1949 年確立了 55 個法定
少數民族以來，全國 56 個民族和諧共處。

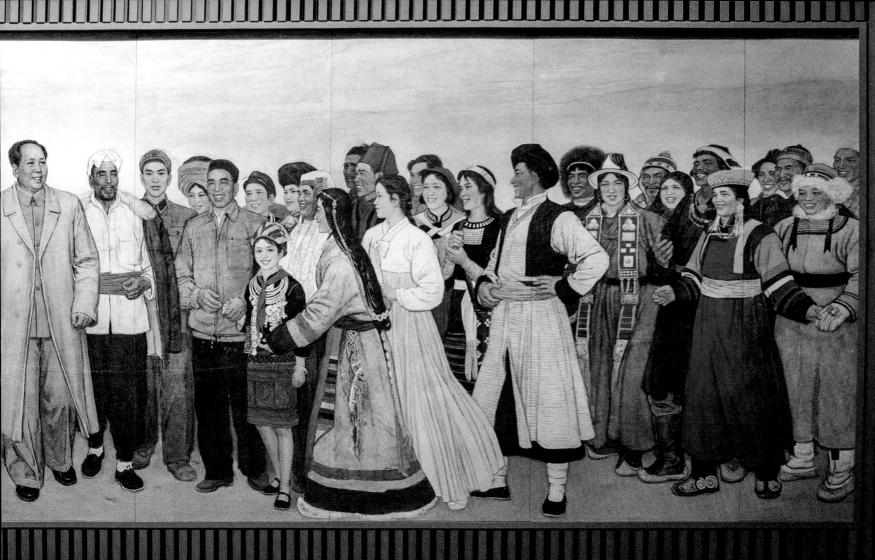

The painting in Shaoshan Mao Zedong Memorial Museum in Shaoshan City, Hunan Province reflects the ethnic policy of Mao Zedong - all ethnic groups in China are equal, they must be united and support each other, and must work together for the prosperity of China. The 56 nationalities have been living harmoniously together since the 55 ethnic minorities were officially recognized in 1949.

世界屋脊

全世界共有 14 座海拔超過 8000 公尺的山峰，當中有 10 座位於青藏高原之上。廣袤的青藏高原平均海拔在 4000 公尺以上，素有「世界屋脊」之稱，在中國境內的範圍主要集中在西藏和青海兩省。

儘管生活條件嚴峻，但有研究指出，早在 4 萬年前，青海高原上就已經有舊石器文化的人類居住蹤跡。

在歷史上，高原上居住著遊牧民族西羌的各部族。到了公元 4 世紀，鮮卑族遷徙至甘肅、青海等地區，與青藏高原之上的西羌族有了直接交往。唐宋時期，吐蕃部落的領袖松贊干布領兵平息內亂，統一各個部落，建立了青藏高原歷史上第一個政權——吐蕃王朝（公元 618 年 -842 年）。

自吐蕃王朝開始，西藏就以拉薩為首府，亦是全區政治、經濟及文化中心。西藏自治區的人口組成較為單一，常住人口以藏族人為主，佔總人口的 90.5%；漢族人口佔 8.1%，其他少數民族人口則佔 1.4%。

青海省位居青藏高原的 東北部，與西藏、新疆、四川、甘肅相鄰，是長江、黃河、湄公河（中國境內部分稱為「瀾滄江」）三大水系發源地，因此有「三江源」及「中華水塔」的稱譽。

青海是一個多民族聚居的省份，首府為西寧，少數民族人口佔青海總人口近一半，約 47%，主要有藏族、回族、土族、撒拉族和蒙古族，其中藏族人口約佔總人口的 25%，回族人口約 15%，土族則佔 3.6% 左右。此外，土族和撒拉族為青海所獨有的少數民族。

The Roof of the World

Among the world's 14 eight-thousanders, ten of them are located on the Tibetan Plateau. With an average altitude of more than 4,000 meters, it is also called "the roof of the world". Its main area within the Chinese territory is in Tibet and Qinghai.

Despite the atrocious environments, some researches indicate that dating back to over 40,000 years ago, prehistoric people from the Old Stone Age had lived on the Tibetan Plateau.

According to history, there lived different tribes of the western Qiang - a group of nomads. During the 4th century, the Xianbei people migrated to Gansu and Qinghai areas, which enabled their communications with the western Qiang. During the time of Tang Dynasty, the first ever regime on the Plateau - the Tibetan Empire (618-842 AD) - was established by Songtsen Gampo who led army of his tribe to conquer all tribes in Tibet.

Since then, Lhasa has always been the capital city of Tibet, as well as the political, economic and cultural center of the province. The composition of population in Tibet Autonomous Region is relatively undiversified, with around 90.5 percent of its residents being Tibetan people, 8.1 percent being Han people, and the rest taking up only 1.4 percent.

Qinghai Province is neighbor to Tibet, located on the northeastern part of the Plateau. Being the sources of three main rivers – the Yangtze, the Yellow River, and the Mekong (its part in the territory of China is the Lancang River) – the province is therefore called "the origins of three rivers" and "the water tower of China". Xining is its capital. Qinghai is a multi-ethnicity province - almost half of its population is ethnic minorities (47%), with Tibetan taking up a quarter, Hui people 15%, and Tu people 3.6% of the population.

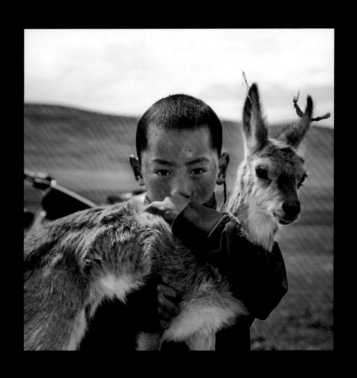

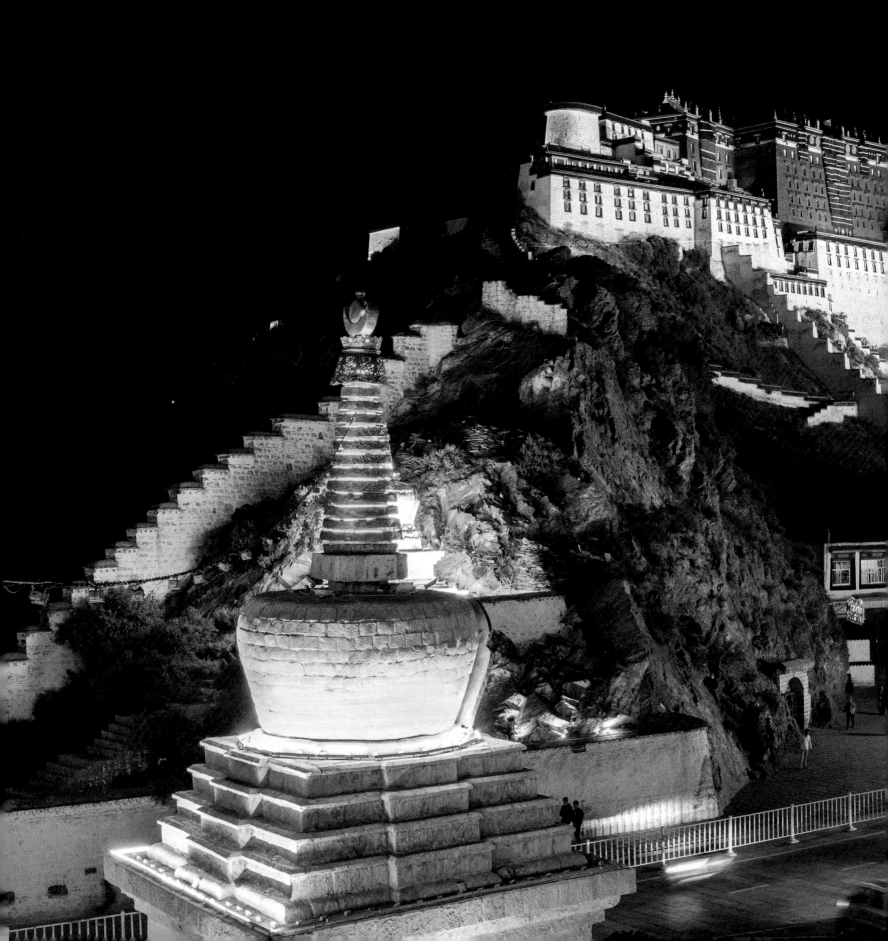

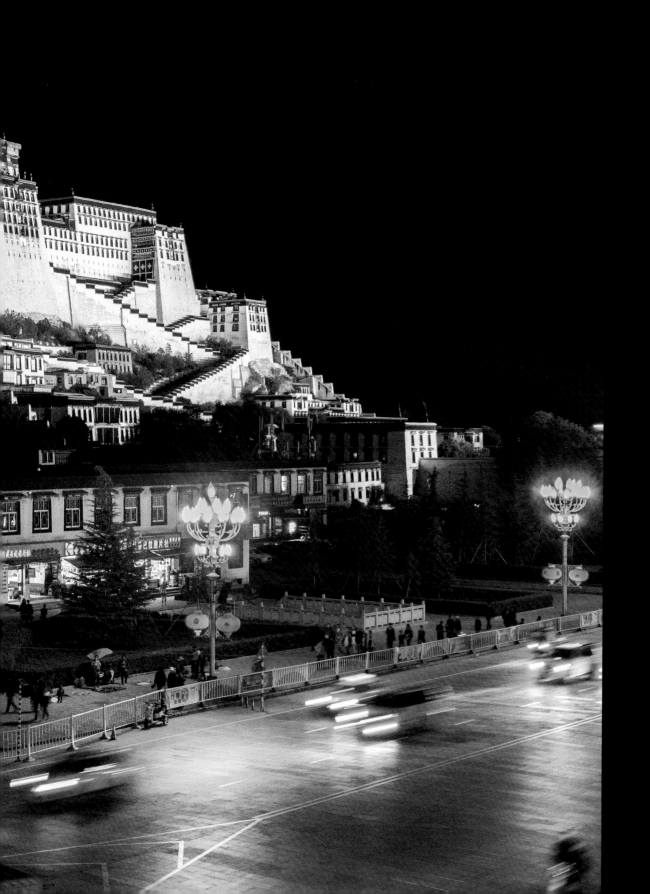

布達拉宮是拉薩的地標，
為藏傳佛教地位最高的
寺廟。

The Potala Palace is the
landmark in Lhasa and
the temple with utmost
importance in Tibetan
Buddhism.

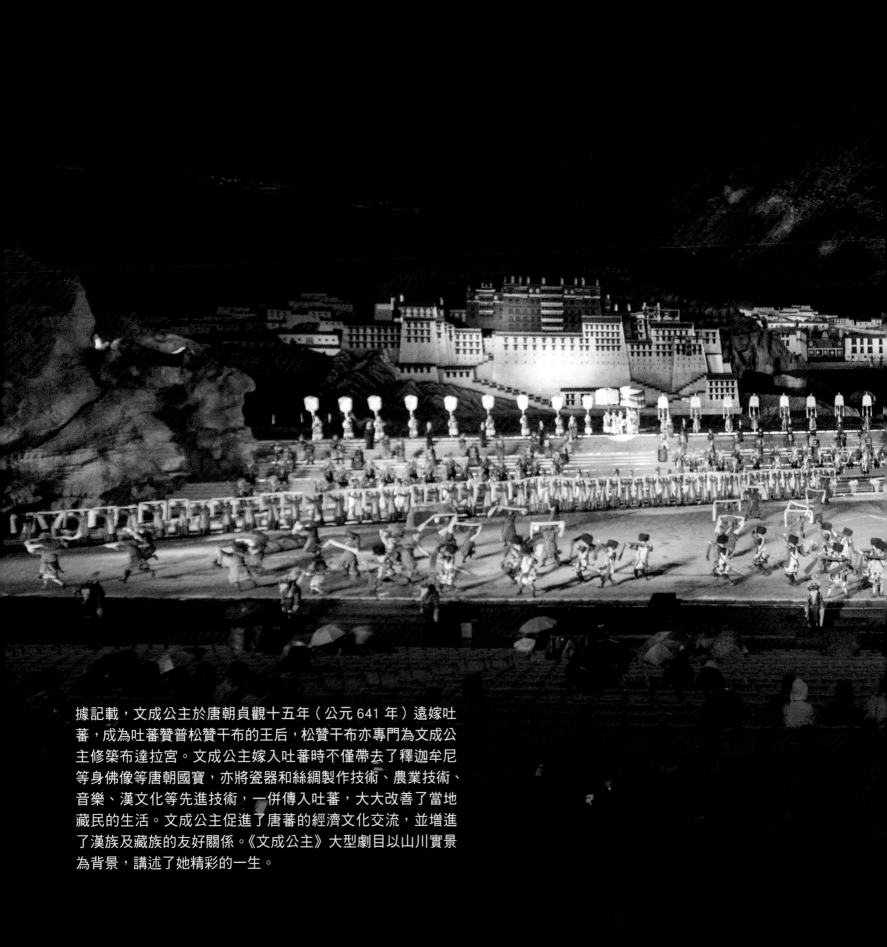

據記載，文成公主於唐朝貞觀十五年（公元 641 年）遠嫁吐蕃，成為吐蕃贊普松贊干布的王后，松贊干布亦專門為文成公主修築布達拉宮。文成公主嫁入吐蕃時不僅帶去了釋迦牟尼等身佛像等唐朝國寶，亦將瓷器和絲綢製作技術、農業技術、音樂、漢文化等先進技術，一併傳入吐蕃，大大改善了當地藏民的生活。文成公主促進了唐蕃的經濟文化交流，並增進了漢族及藏族的友好關係。《文成公主》大型劇目以山川實景為背景，講述了她精彩的一生。

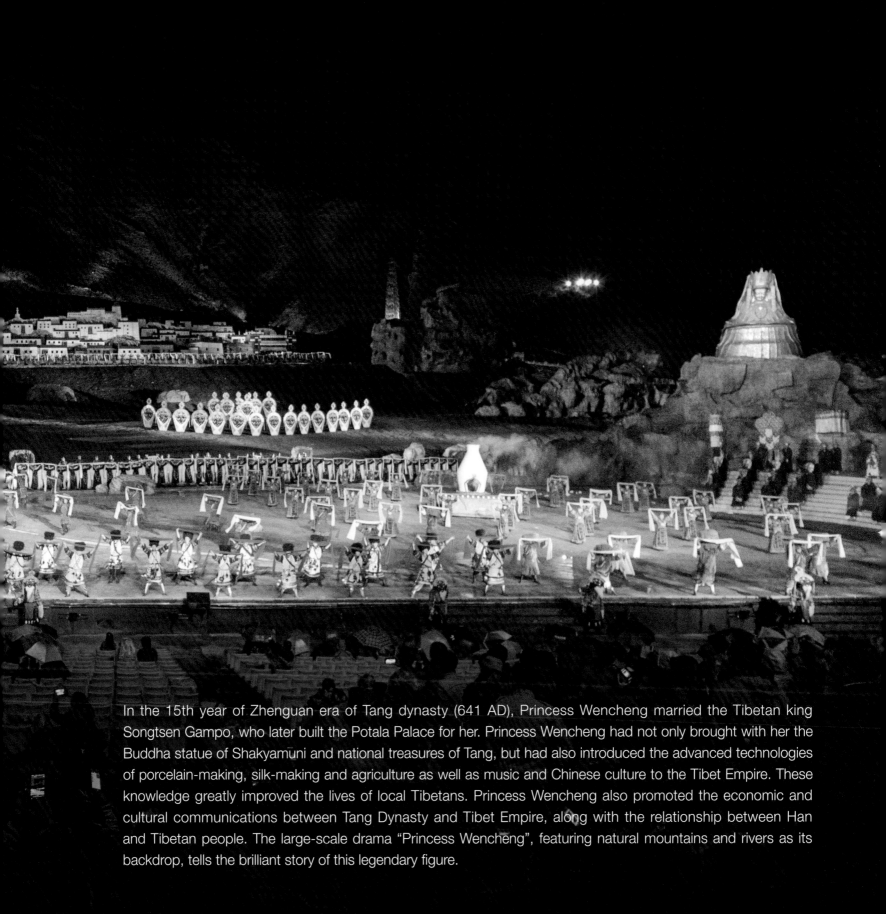

In the 15th year of Zhenguan era of Tang dynasty (641 AD), Princess Wencheng married the Tibetan king Songtsen Gampo, who later built the Potala Palace for her. Princess Wencheng had not only brought with her the Buddha statue of Shakyamuni and national treasures of Tang, but had also introduced the advanced technologies of porcelain-making, silk-making and agriculture as well as music and Chinese culture to the Tibet Empire. These knowledge greatly improved the lives of local Tibetans. Princess Wencheng also promoted the economic and cultural communications between Tang Dynasty and Tibet Empire, along with the relationship between Han and Tibetan people. The large-scale drama "Princess Wencheng", featuring natural mountains and rivers as its backdrop, tells the brilliant story of this legendary figure.

藏族 Tibetan People

自遠古時期開始，藏族的先民就居住在雅魯藏布江中游兩岸。及至公元 4 世紀，高原上的羌族與遷至甘青地區的鮮卑族互通，逐漸形成了以遊牧維生，零散分佈的各個部落。

公元七世紀之時，松贊干布統一了這些部落，建立了吐蕃帝國。這位藏族英雄積極向四鄰的先進文明學習，並與唐朝的文成公主及尼波羅國的尺尊公主聯姻，命臣下參照梵文創立藏文書寫系統，讓藏語得以書面化。他在位期間更制定了藏曆，佛教亦在這個時期傳入藏區。

在語言、文字乃至宗教信仰逐漸統一的前提下，到了公元 11、12 世紀，藏族作為一個民族才開始逐漸形成。

如今藏族主要分佈在中國的西藏、青海、四川、甘肅和雲南五省，總人口約 630 萬。絕大多數藏族人篤信佛教，藏傳佛教對藏民的影響，深入到日常生活中的方方面面，即便是普通信眾，亦普遍以喇嘛（藏傳佛教僧侶）的行為準則自律。

Since ancient times, the ancestors of Tibetan people had been living along the midstream of Yarlung Tsangpo. In the 4th century, the Qiang people living on the Plateau and the Xianbei people who migrated to the Gansu and Qinghai areas began to intercommunicate. Gradually, the nomads became scattering tribes.

During the 7th century, Songtsen Gampo unified these tribes and established the Tibetan Empire. The national hero learned vigorously from advanced civilizations, and married the Tang Princess Wencheng and the Licchavi Princess Bhrikuti. He commanded the creation of Tibetan script, endowing the language a written form. During his in-position times, Tibetan calendar was formulated and Buddhism was introduced into the area.

It was not until the 11th to 12th century, when the languages, scripts and even religions were integrated little by little, did the Tibetan people, as an ethnic group, start to take shape.

Today the Tibetan people are living mainly in five provinces - including Tibet, Qinghai, Sichuan, Gansu and Yunnan. In China, there are approximately 6.5 million Tibetan people. Most of them are devout believers of Tibetan Buddhism, which has impacted on almost every aspect of their daily life. Even the most prevailing believers are as disciplined as lamas.

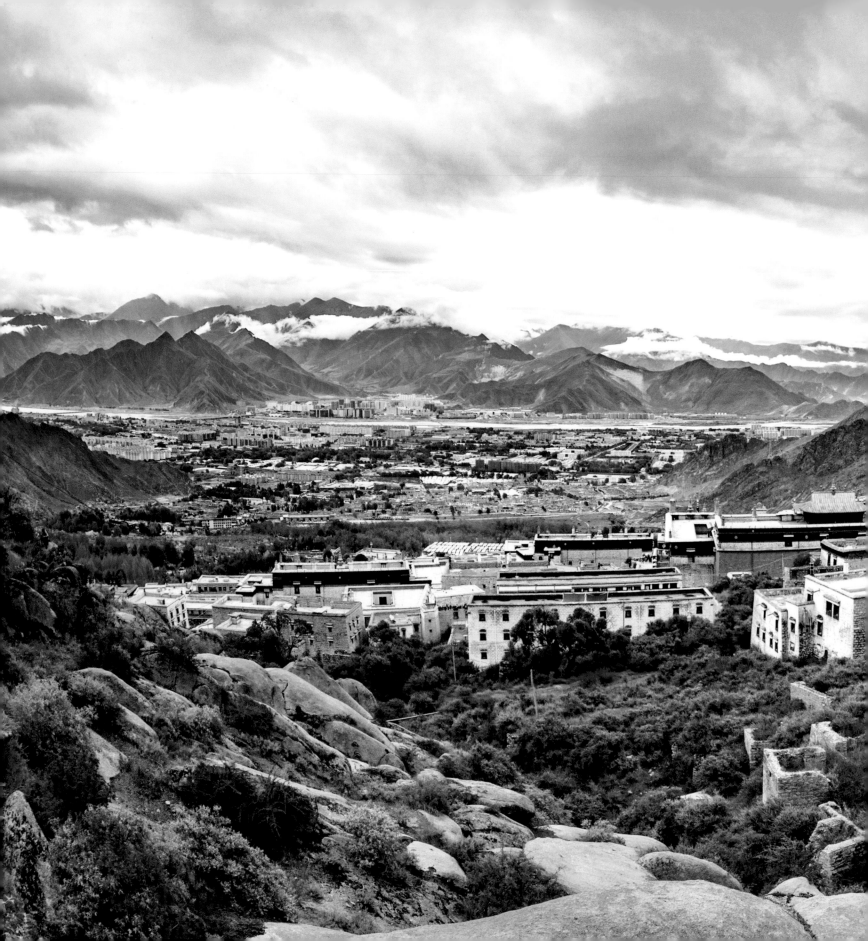

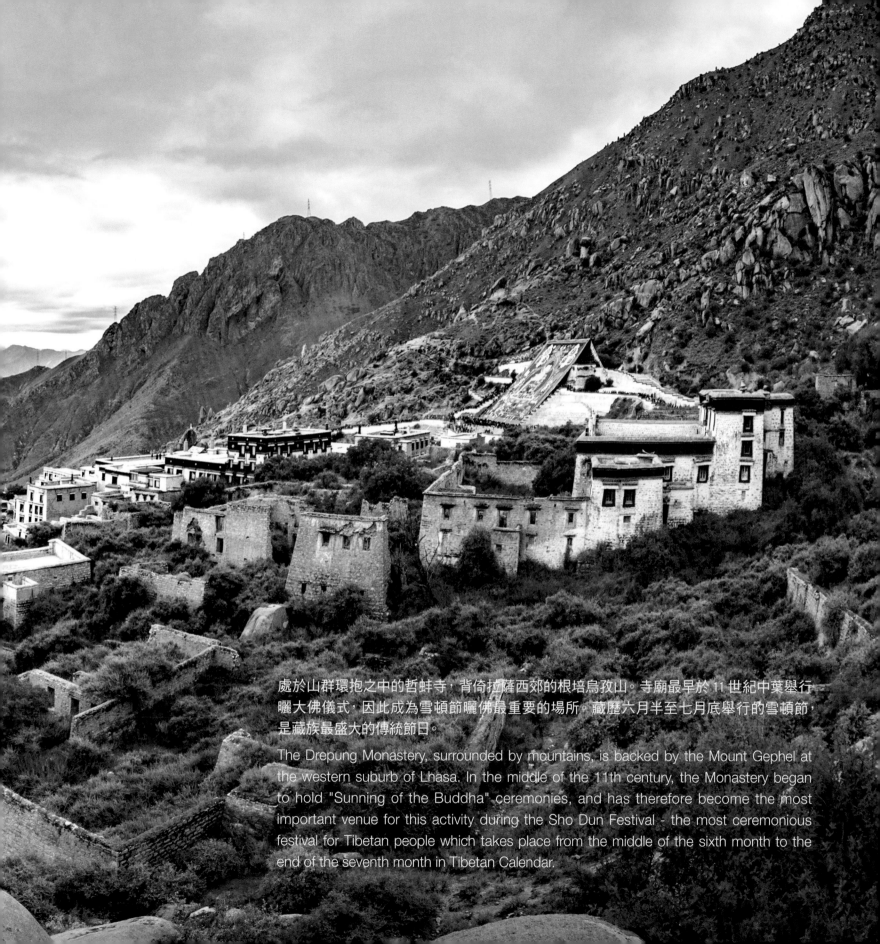

處於山群環抱之中的哲蚌寺，背倚拉薩西郊的根培烏孜山。寺廟最早於 11 世紀中葉舉行曬大佛儀式，因此成為雪頓節曬佛最重要的場所。藏曆六月半至七月底舉行的雪頓節，是藏族最盛大的傳統節日。

The Drepung Monastery, surrounded by mountains, is backed by the Mount Gephel at the western suburb of Lhasa. In the middle of the 11th century, the Monastery began to hold "Sunning of the Buddha" ceremonies, and has therefore become the most important venue for this activity during the Sho Dun Festival - the most ceremonious festival for Tibetan people which takes place from the middle of the sixth month to the end of the seventh month in Tibetan Calendar.

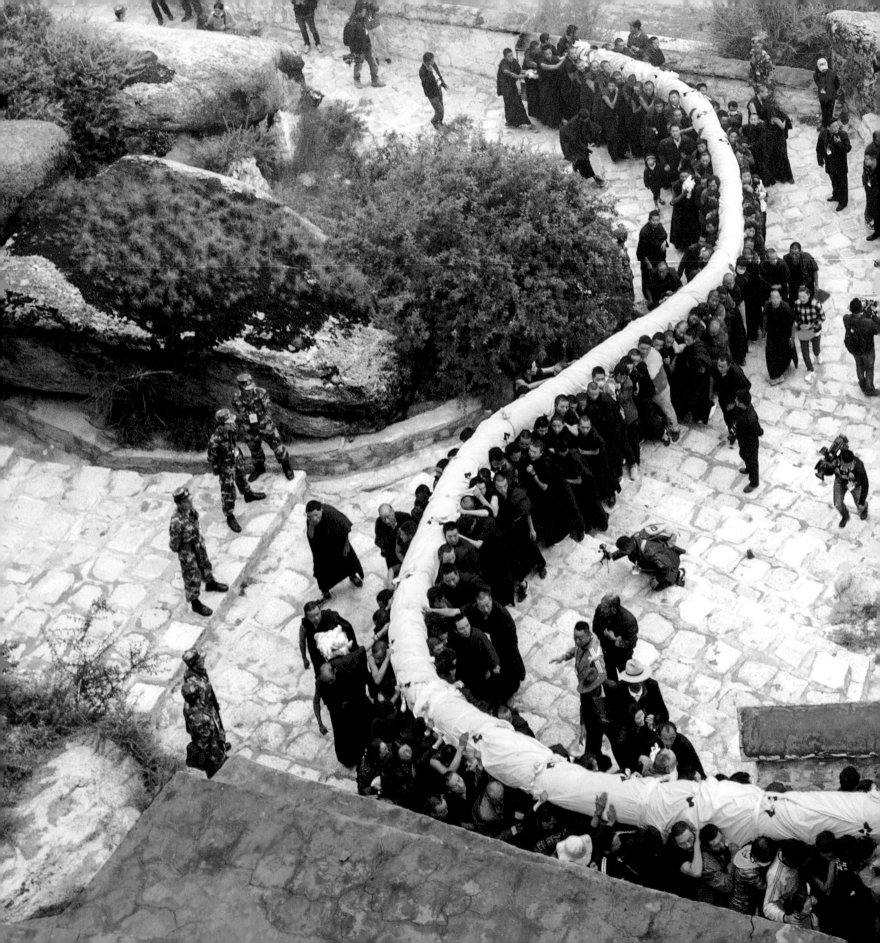

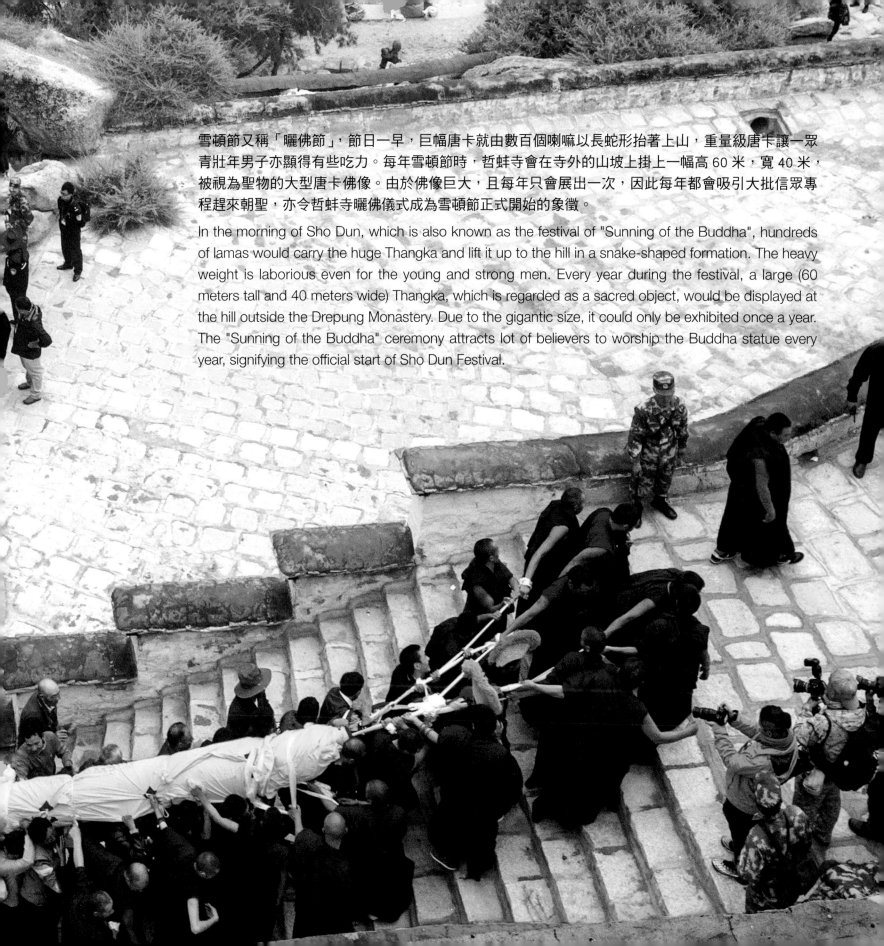

雪頓節又稱「曬佛節」，節日一早，巨幅唐卡就由數百個喇嘛以長蛇形抬著上山，重量級唐卡讓一眾青壯年男子亦顯得有些吃力。每年雪頓節時，哲蚌寺會在寺外的山坡上掛上一幅高 60 米，寬 40 米，被視為聖物的大型唐卡佛像。由於佛像巨大，且每年只會展出一次，因此每年都會吸引大批信眾專程趕來朝聖，亦令哲蚌寺曬佛儀式成為雪頓節正式開始的象徵。

In the morning of Sho Dun, which is also known as the festival of "Sunning of the Buddha", hundreds of lamas would carry the huge Thangka and lift it up to the hill in a snake-shaped formation. The heavy weight is laborious even for the young and strong men. Every year during the festival, a large (60 meters tall and 40 meters wide) Thangka, which is regarded as a sacred object, would be displayed at the hill outside the Drepung Monastery. Due to the gigantic size, it could only be exhibited once a year. The "Sunning of the Buddha" ceremony attracts lot of believers to worship the Buddha statue every year, signifying the official start of Sho Dun Festival.

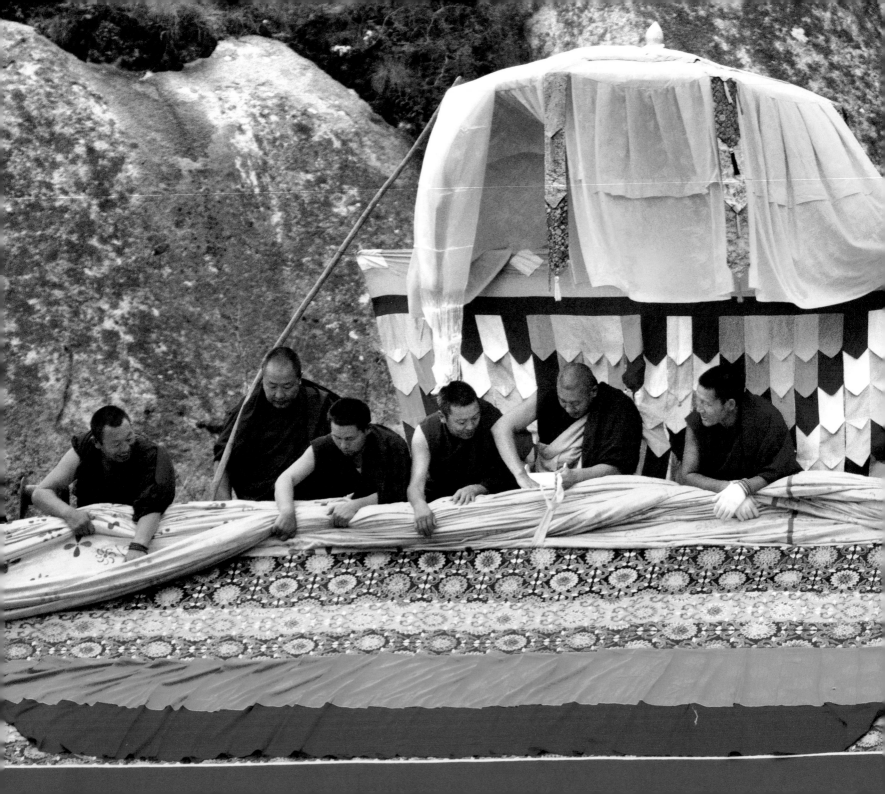

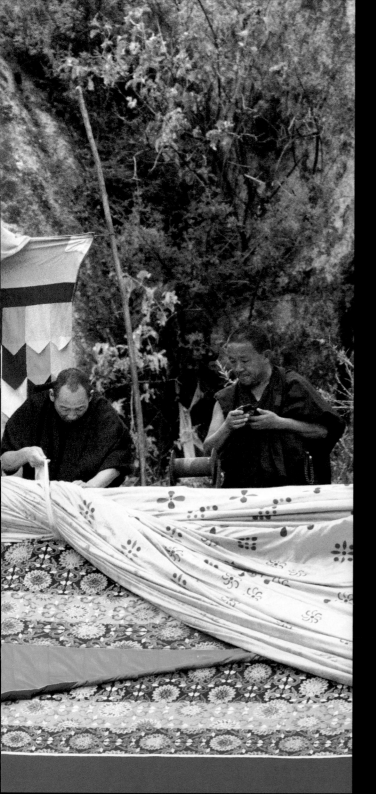

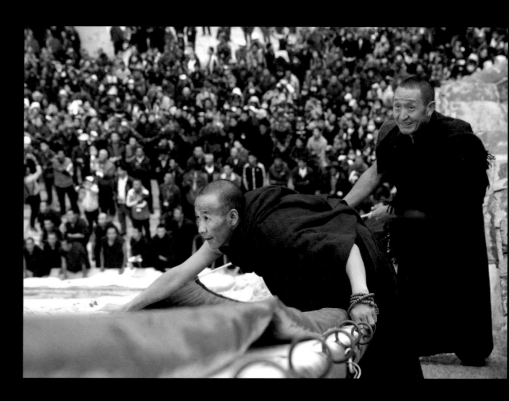

曬佛台上方的喇嘛負責固定唐卡頂部。（左）而兩邊的喇嘛則會把捲軸整理平坦，讓人們更易觀賞。（右）

Lamas above the displaying location are in charge of fastening the upper part of the Thangka. (Left) Those at sideways would smooth the scroll for easier admiration. (Right)

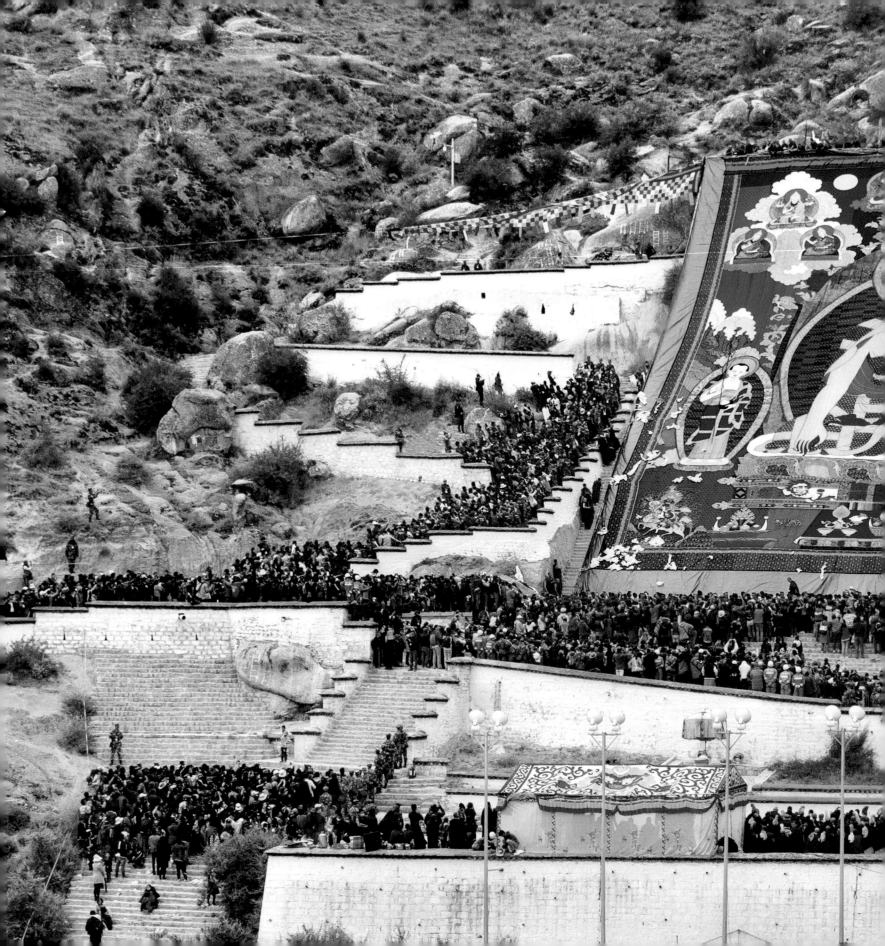

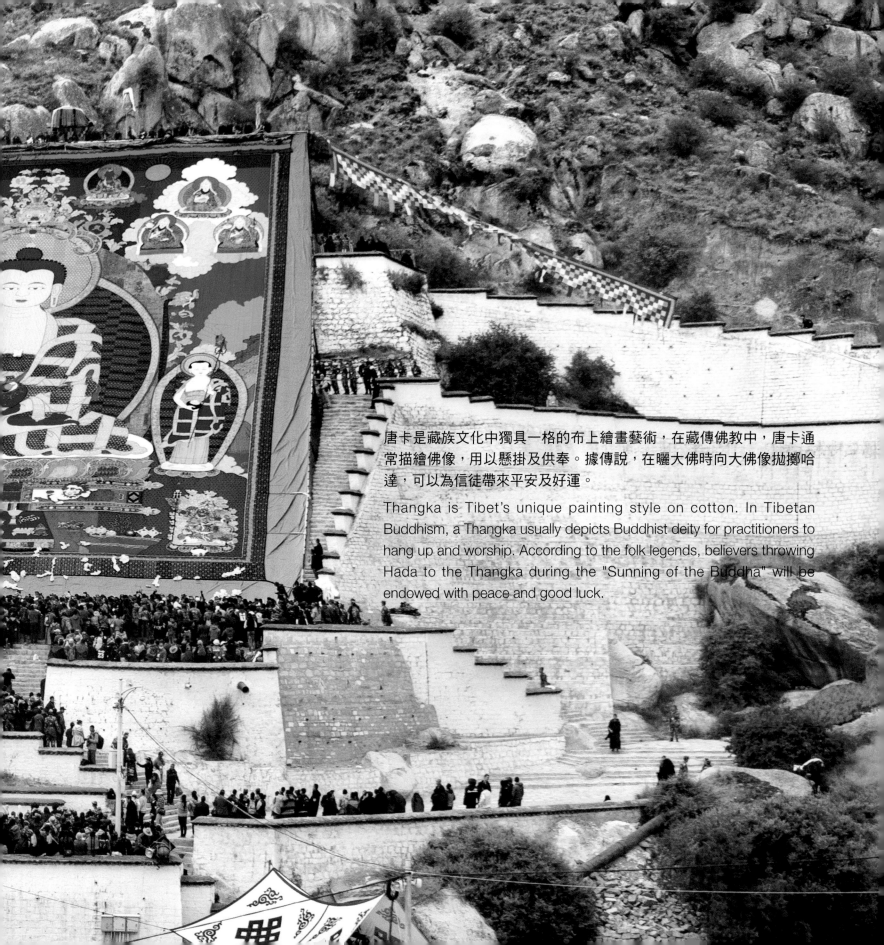

唐卡是藏族文化中獨具一格的布上繪畫藝術，在藏傳佛教中，唐卡通常描繪佛像，用以懸掛及供奉。據傳說，在曬大佛時向大佛像拋擲哈達，可以為信徒帶來平安及好運。

Thangka is Tibet's unique painting style on cotton. In Tibetan Buddhism, a Thangka usually depicts Buddhist deity for practitioners to hang up and worship. According to the folk legends, believers throwing Hada to the Thangka during the "Sunning of the Buddha" will be endowed with peace and good luck.

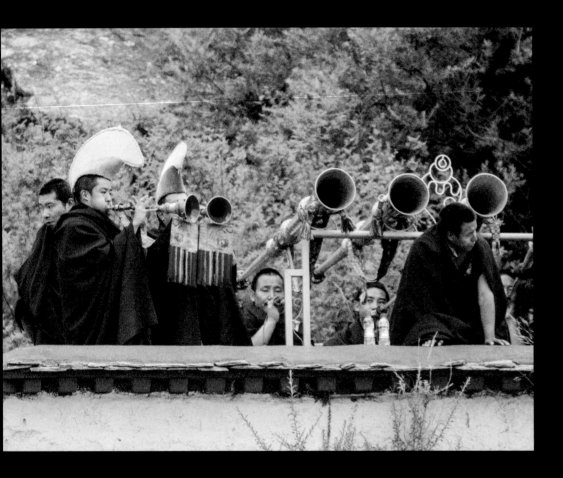

法號是藏族大型儀式中的重要樂器，又稱作「筒欽」。（左）唐卡下方人山人海，皆震撼於佛像的巨大以及精美。（右）

The Tibetan horn, also known as "tongqin", is often seen in major ceremonial events in Tibet. (Left) Numerous people have gathered beneath the Thangka, astonished by the greatness and refinedness of the Buddha image. (Right)

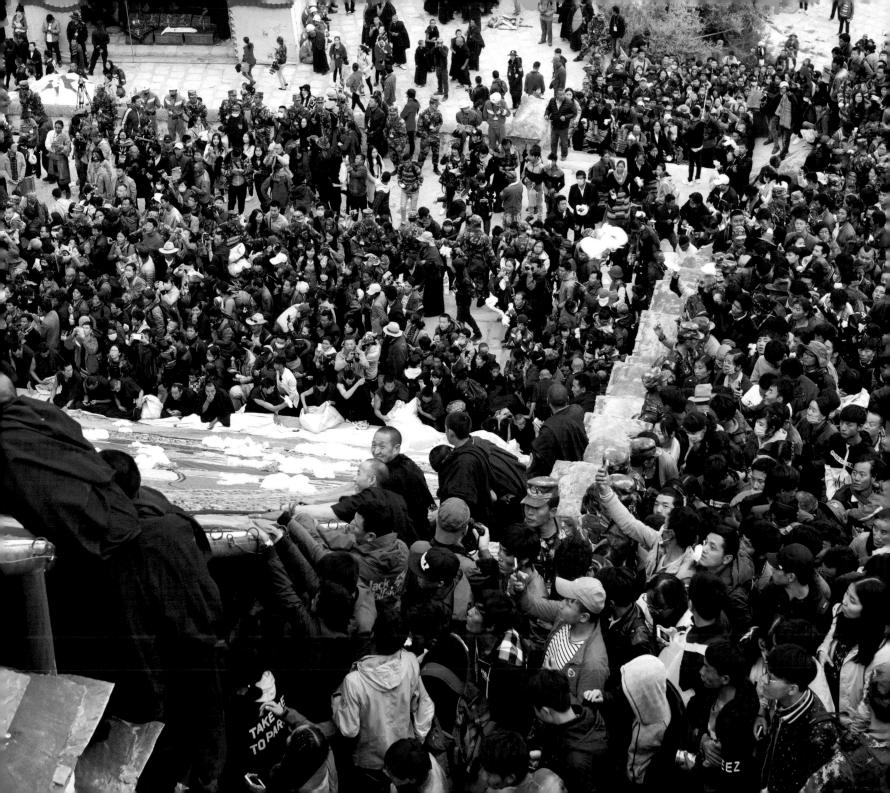

一年一度的大型曬佛儀式之後，僧人們依舊不忘每日必行的修行活動。齊坐誦經結束之後，喇嘛們稍事休息，為即將到來的激烈辯經做好準備。一名小僧正轉頭與同伴小聲議論。

After the annual "Sunning of the Buddha", lamas still have to maintain their daily practice. They sit and chant sutras together, then take a rest to prepare for the intense debate of Scriptures later on. A young lama is turning his head to his friend and secretly having a discussion.

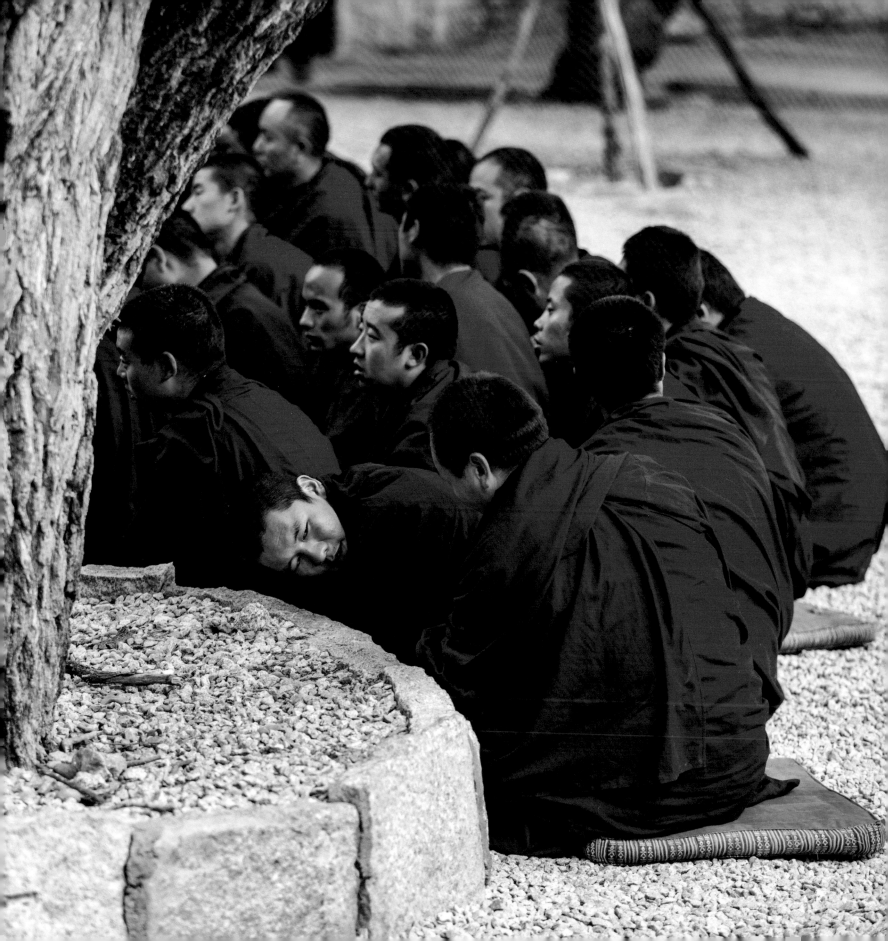

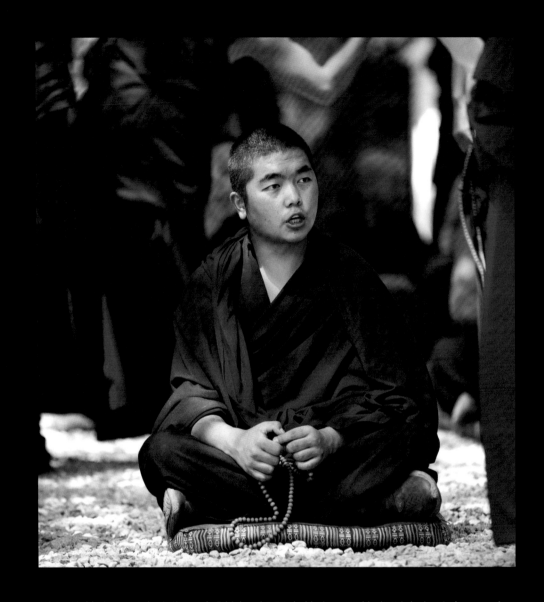

辯經的其中一種方式為兩人對辯，提問者站立，回答者則坐在地上。（左）提問者把右手高高舉起，拍向左手，這聲清脆的拍掌代表著敲醒人們心中的慈悲和智慧。（右）

One of the debate mode is one-on-one debate, with the question proposer standing and the answerer sitting. (Left) The questioning person lifts his right hand high and clap his left hand. This ringing sound is to awaken the benevolence and wisdom in people's minds. (Right)

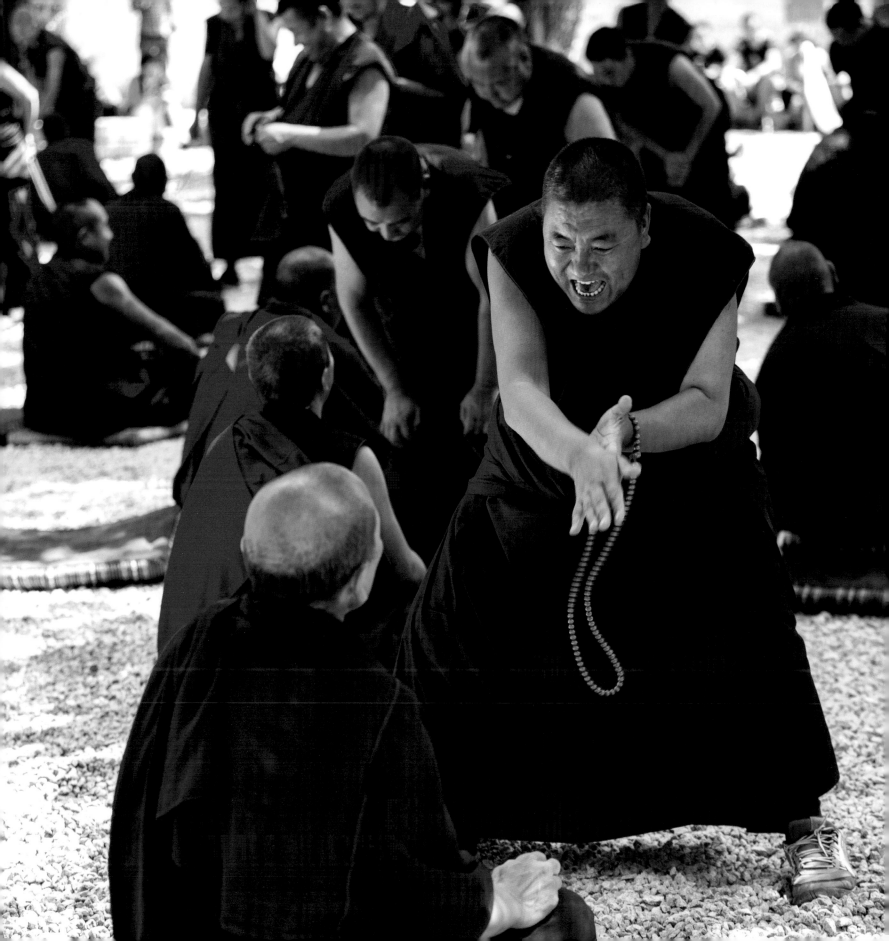

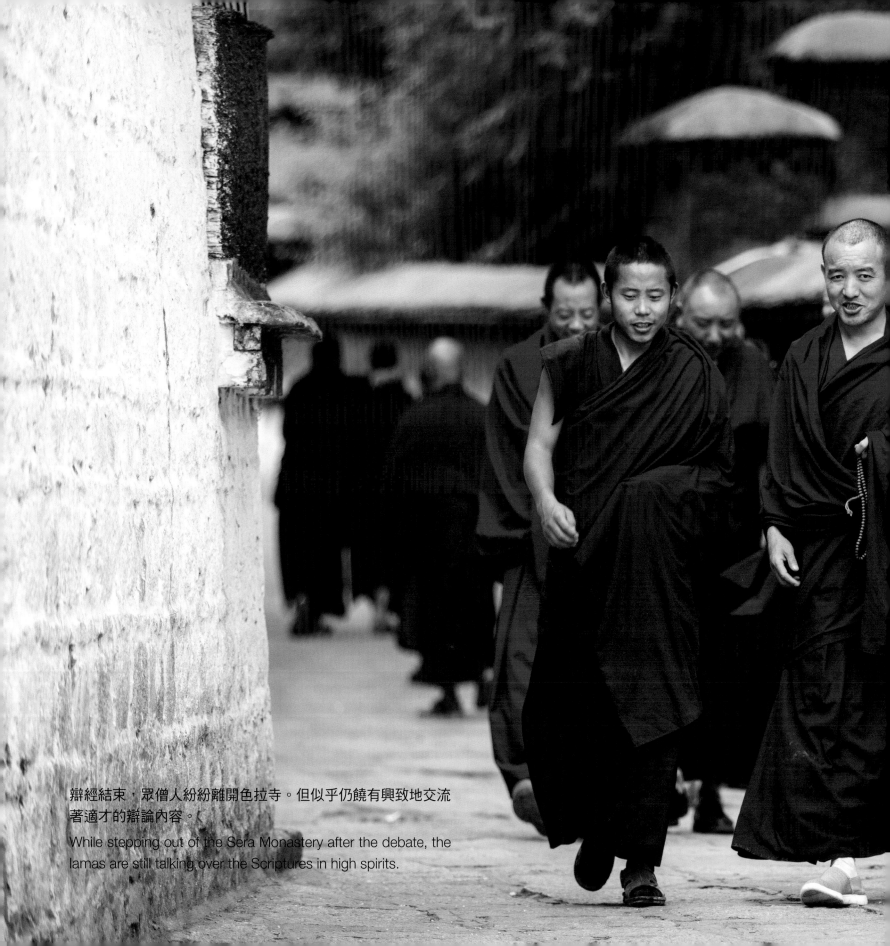

辯經結束，眾僧人紛紛離開色拉寺。但似乎仍饒有興致地交流
著適才的辯論內容。

While stepping out of the Sera Monastery after the debate, the
lamas are still talking over the Scriptures in high spirits.

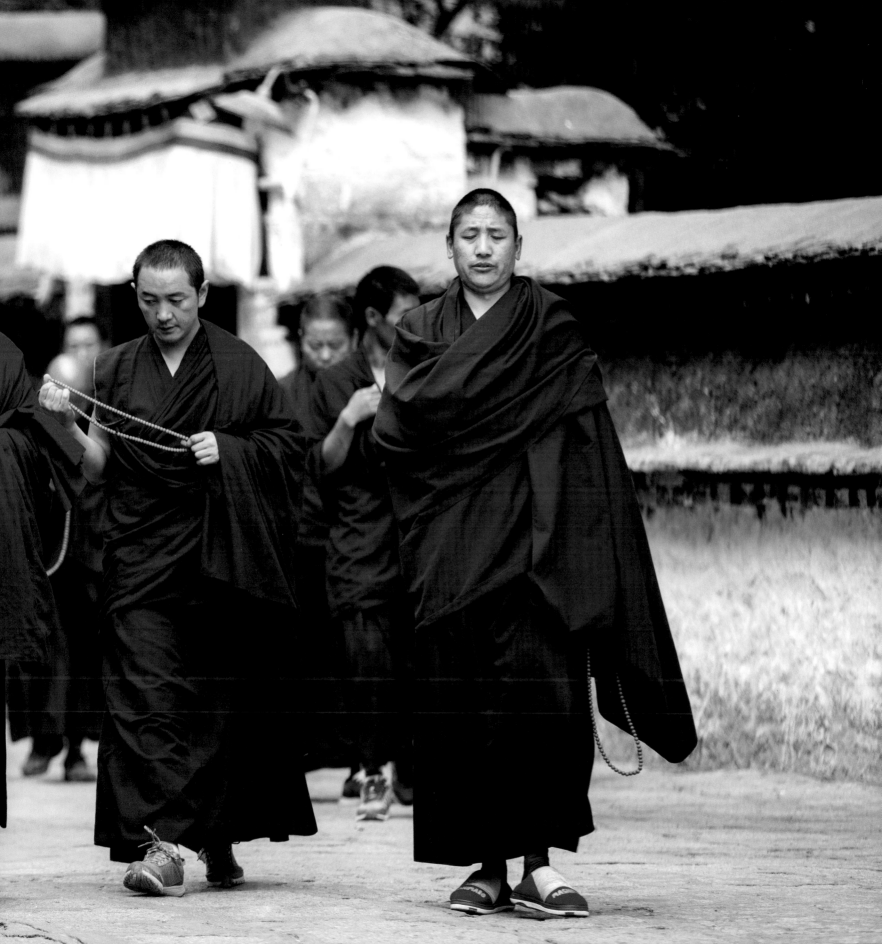

「雪」在藏語中表示「酸奶」，而「頓」則有「宴會」之意，
因此雪頓節按字面上理解是吃酸奶的日子。（左）當天
藏族人民三五成群來到羅布林卡之內，在樹蔭之下鋪
上地毯，共度節日。（右）

In Tibetan, "Sho" means yogurt and "Dun" implies
banquet, thus Sho Dun Festival is literally the day to
have yogurts. (Left) People come to the Norbulingka
in groups, sitting on blankets under the trees and
celebrating the festival together. (Right)

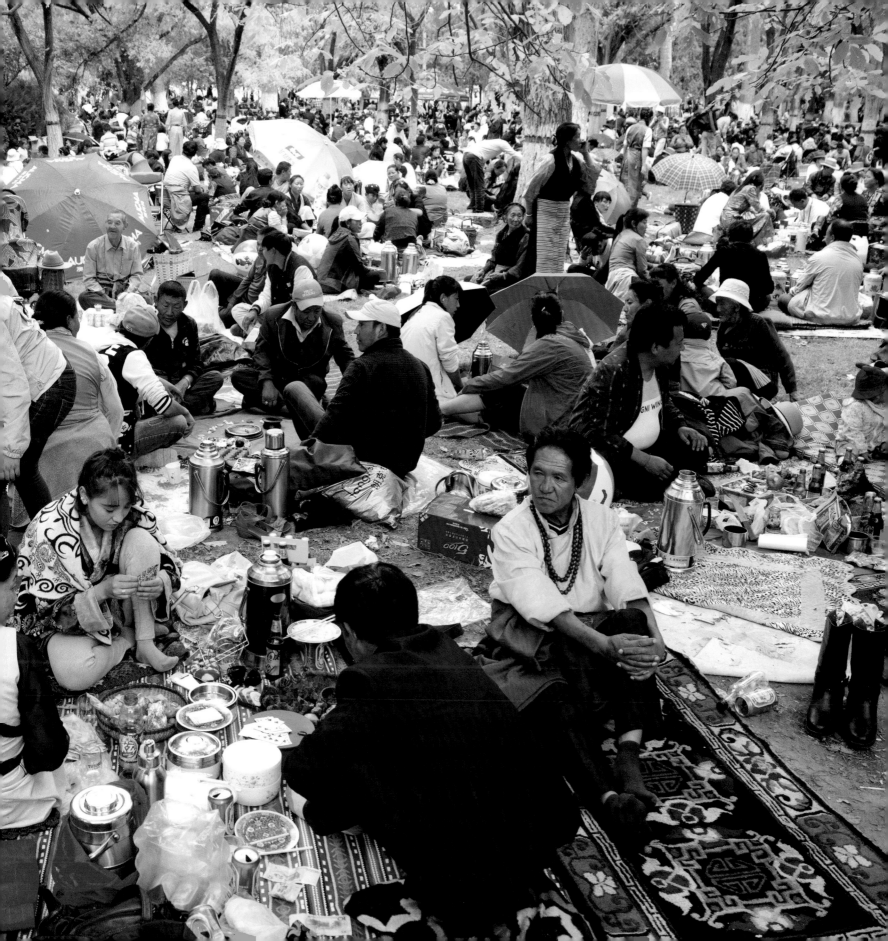

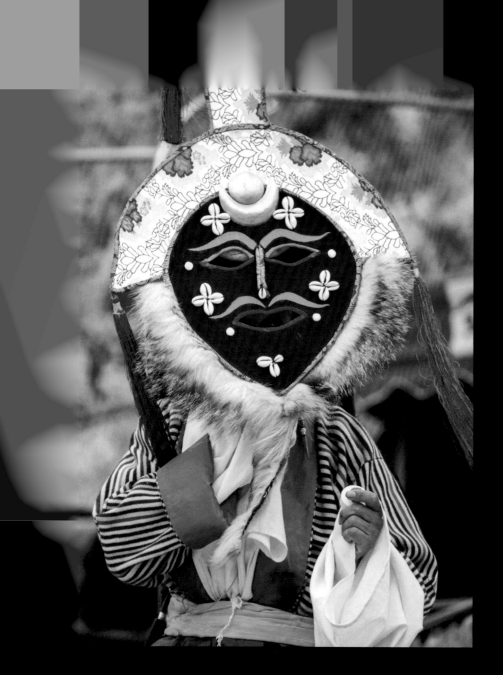

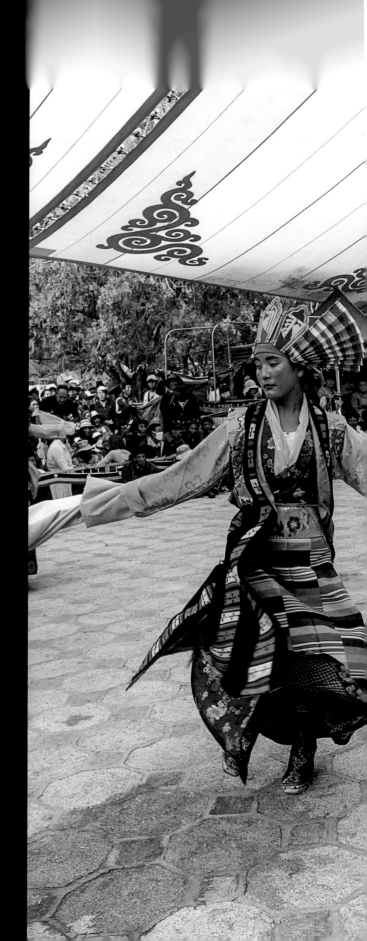

藏戲中，黑色面具多為妖魔鬼怪，象徵著兇殘和恐怖。（左）
1959 年之前的雪頓節，只有男性演員被允許進入羅布林卡內表
演，但現已可見到不少女演員的身影。（右）

n Lhamo performance, monsters usually wear black masks
which symbolizes ferocity and terror. (Left) Before 1959, only
male actors were allowed to put on a show in Norbulingka on the
Festival. In nowadays, however, actresses are commonly seen in
the performances. (Right)

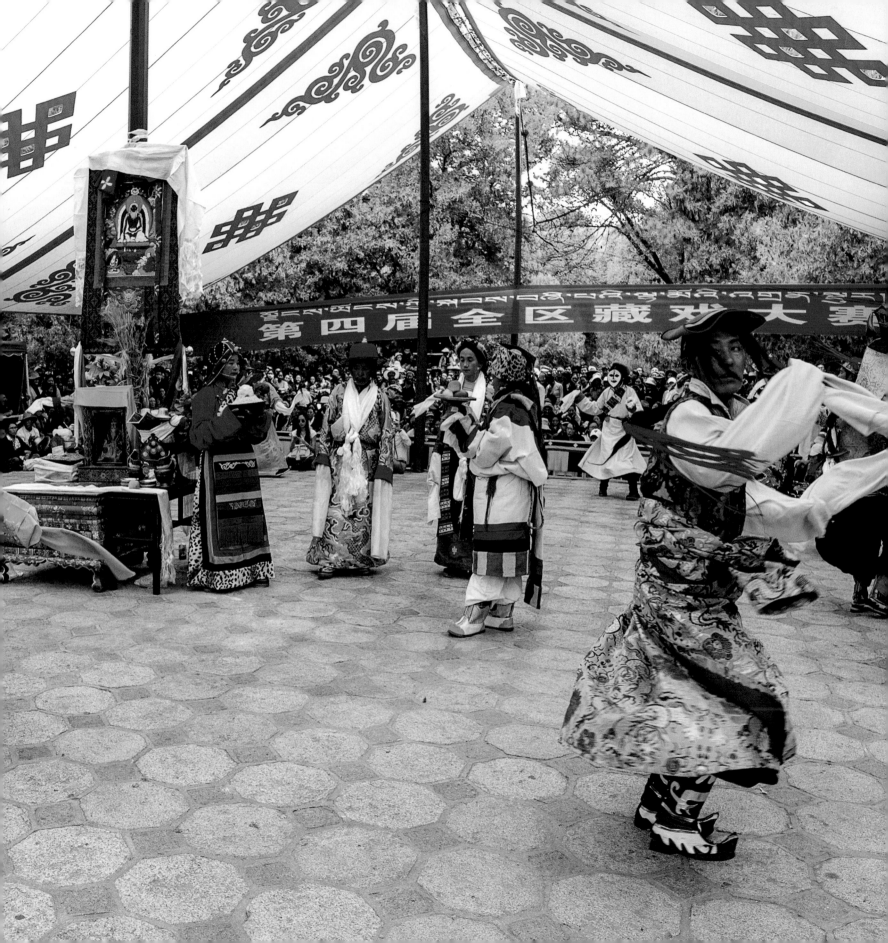

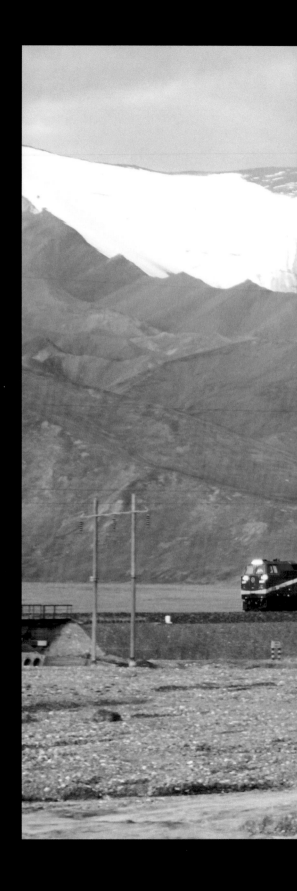

青藏鐵路，從西寧至拉薩穿越高原上的 1,956 公里，是全世界海拔最高的一條鐵路幹線，被譽為「天路」。（右）鐵路的其中一段與 315 國道並行，沿途可見延綿的昆崙山脈。（左）

The Qinghai–Tibet railway runs from Xining to Lhasa on the plateau with distance of 1,956 kilometers. It is a railway with the highest altitude in the world, and is referred as the "railway to heaven". (Right) A part of the railway is parallel to the G315 National Highway, with the Kunlun Mountains stretches endlessly along the way. (Left)

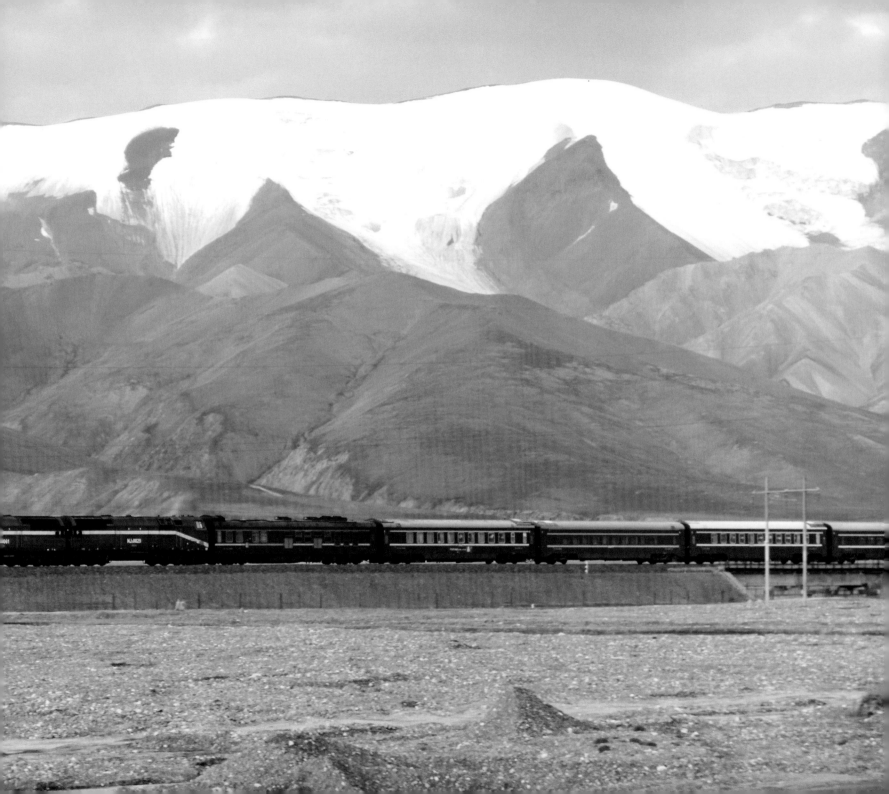

青海的阿尼瑪卿山是崑崙山系支脈阿尼瑪卿山脈的最高峰，被藏族譽為四大神山之一。
雪山之上遍佈著五彩的經幡，由此可見藏民對信仰的高度虔誠。

Qinghai's Amne Machin range is an extension of the Kunlun Mountains. Its highest peak Amne Machin is regarded as one of the four sacred mountains by Tibetan people. On the snow-covered mountain, countless colorful prayer flags are spread all over, indicating the high degree of devotion Tibetan people have towards their religion.

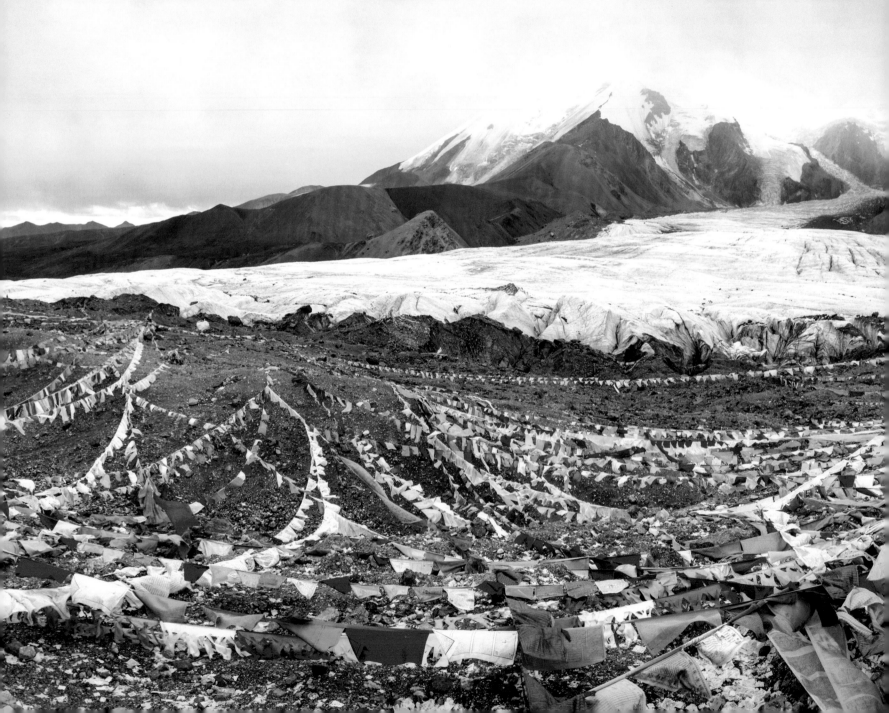

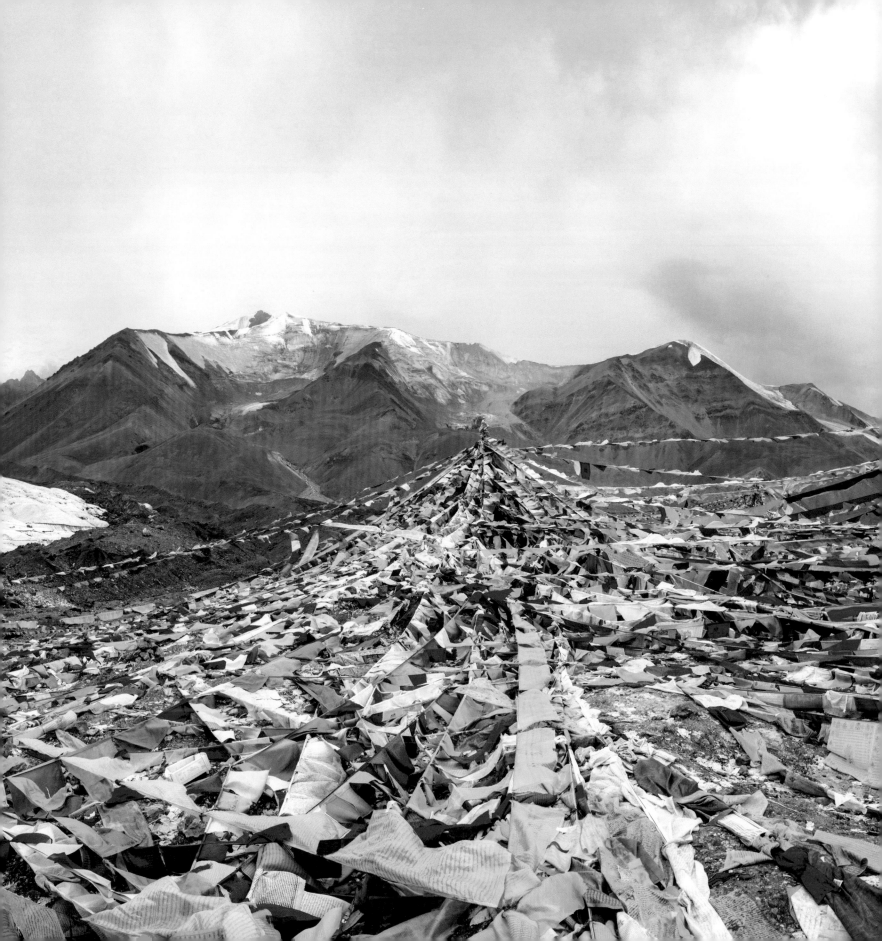

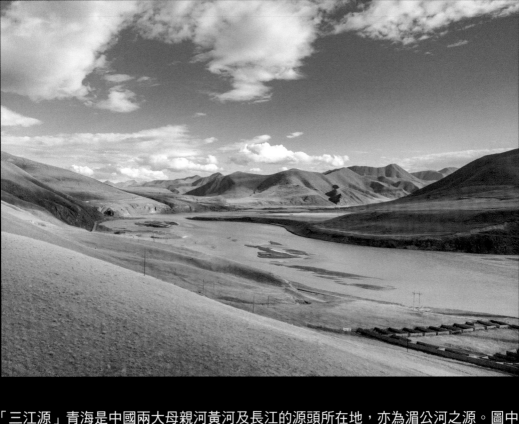

「三江源」青海是中國兩大母親河黃河及長江的源頭所在地，亦為湄公河之源。圖中通天河為長江上游玉樹河段，據傳古代名著《西遊記》中曬經情節便發生於此。（左）青藏高原之上有大大小小數百個鹽湖，它們是青海最大的資源。（右）

The "three-river source" Qinghai is the source region of two mother rivers of China - the Yellow River and the Yangtze - as well as the Mekong. Tongtian River here is a part of the Yangtze in Yushu area. It is said that this is where the sutras were exposed under the sun in the famous book "The Journey to the West" in ancient China. (Left) There are hundreds of salt lakes on the Tibetan Plateau. They are the largest resource in Qinghai. (Right)

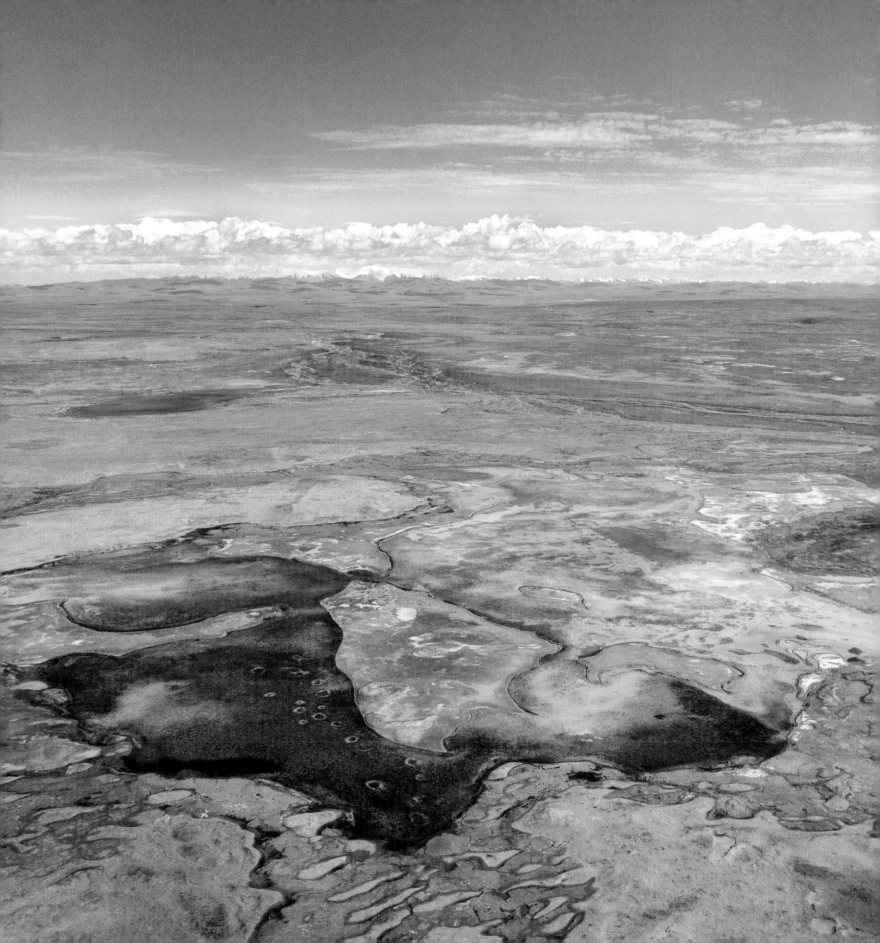

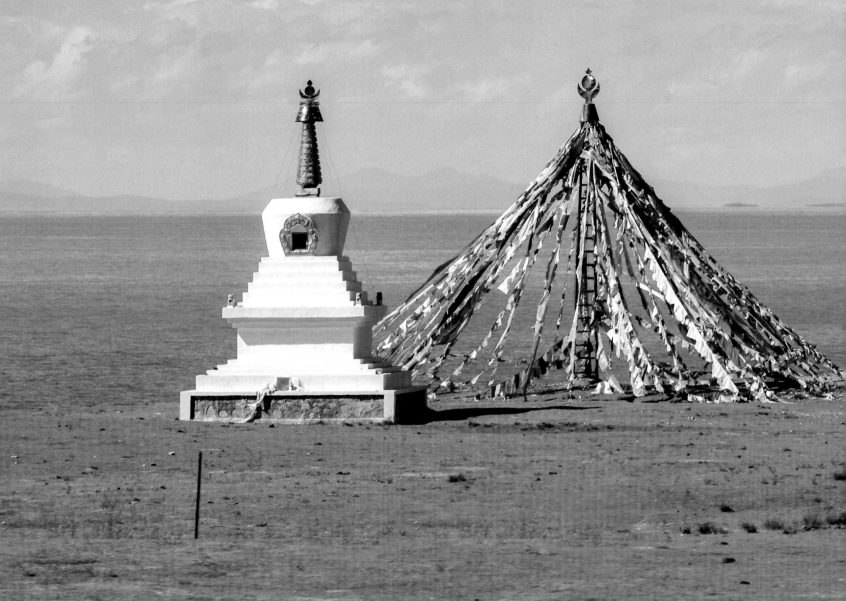

青海湖景區內豎立著外形類似蒙古包的經幡，以藍白紅綠黃的五色幡結成，
分別象徵著天空、白雲、火焰、綠水及土地。

Within the tourist attraction of the Qinghai Lake, prayer flags in the shape
of a Mongolian yurt consist of blue, white, red, green and yellow flags,
indicating the sky, clouds, fire, water and land, respectively.

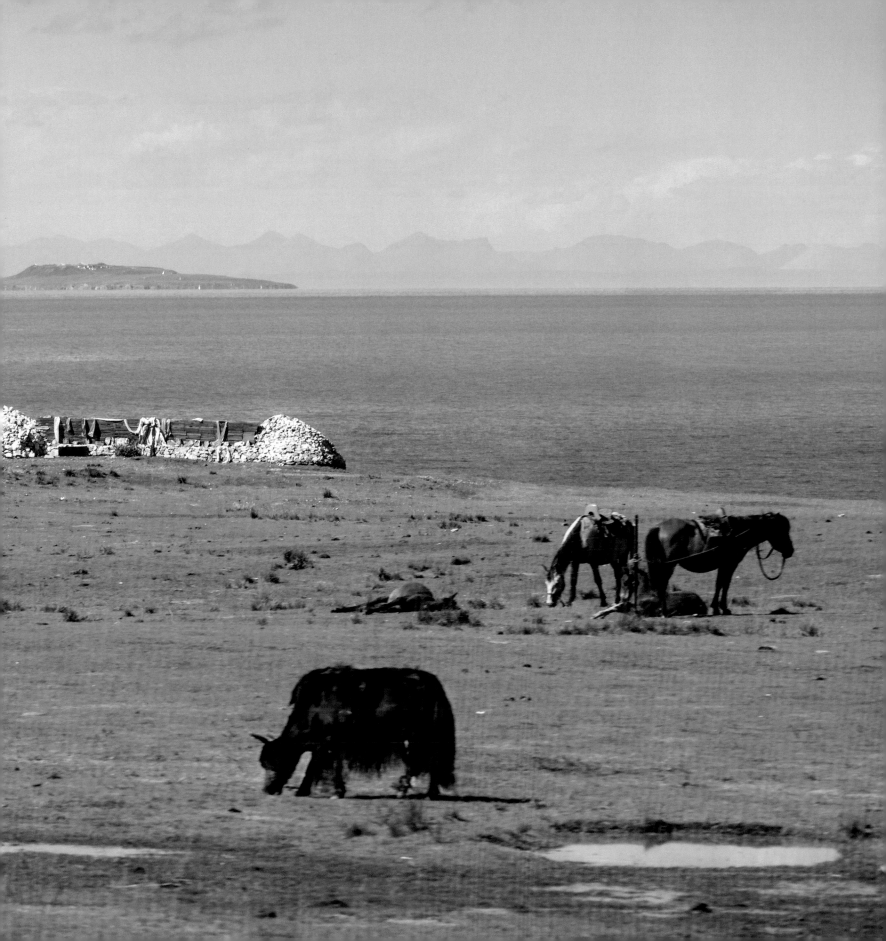

青海湖，在藏語中稱作「措溫布」，意為青色的海，位於青藏高原的東北部，是中國最大的內陸湖。

Qinghai Lake is called Co Ngoinbo in Tibetan, meaning "the cyan sea". Located at the northeastern part of the Tibetan Plateau, it is the largest open and closed lake in China.

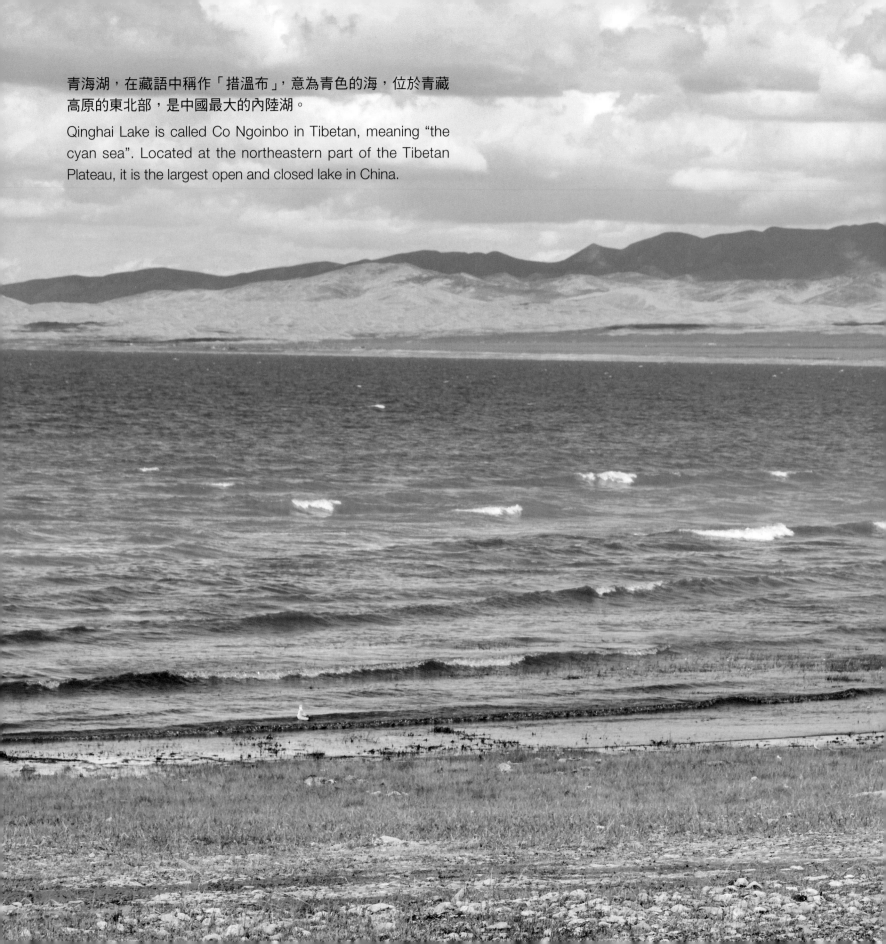

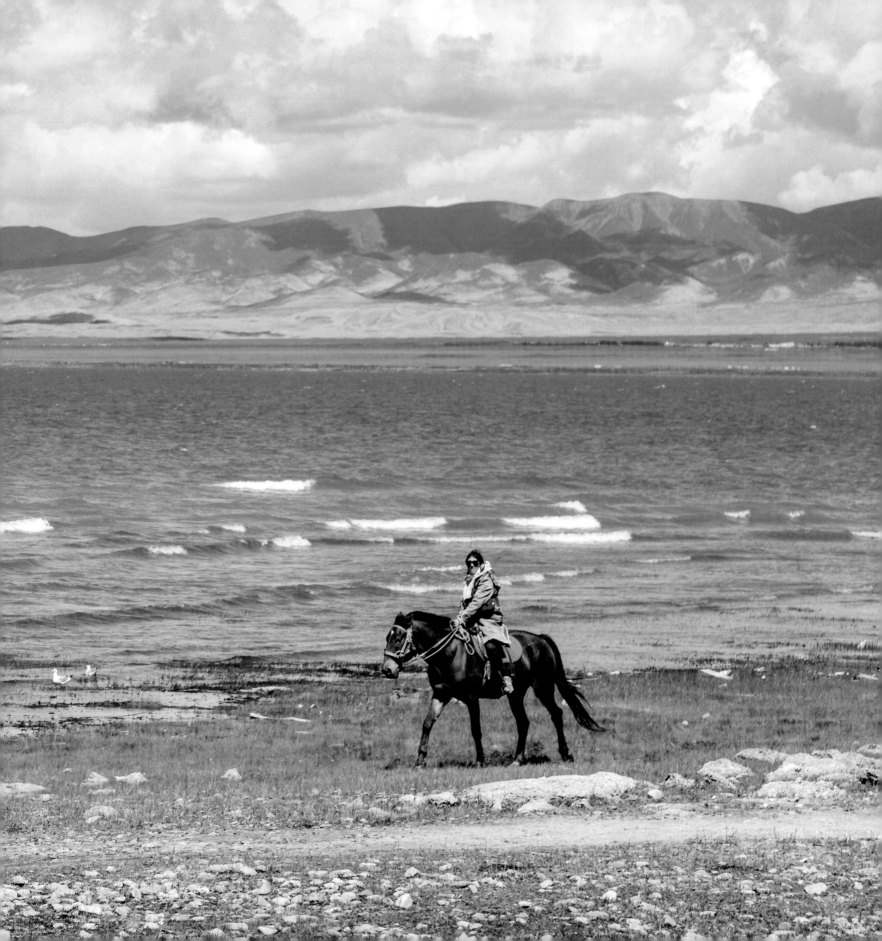

每年夏季青海湖邊盛開大片油菜花。

Every year in summer, acres of canola flowers look extraordinarily fascinating by the Qinghai Lake.

禪古寺建於 12 世紀，不但為藏傳佛教聖地，更因修建和管護文成公主廟
而享有聲譽。圖為震後重建的新址。

The Thrangu Monastery was originally built in the 12th century. It is not only
a sacred place in Tibetan Buddhism, but is also famous for its contribution
in preserving the Temple of Princess Wencheng. It was rebuilt again after
the devastating earthquake.

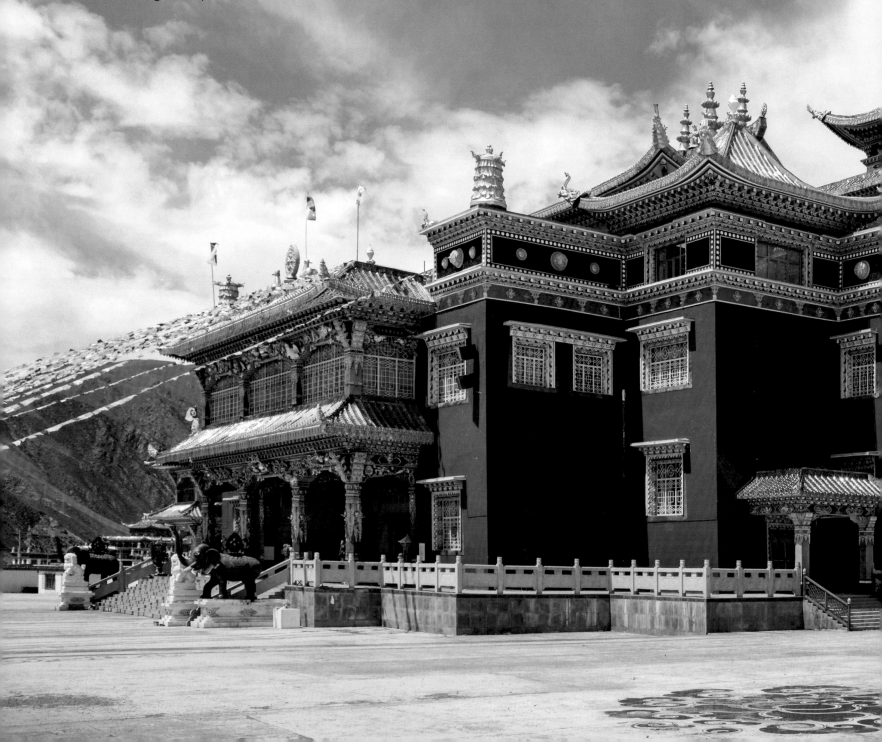

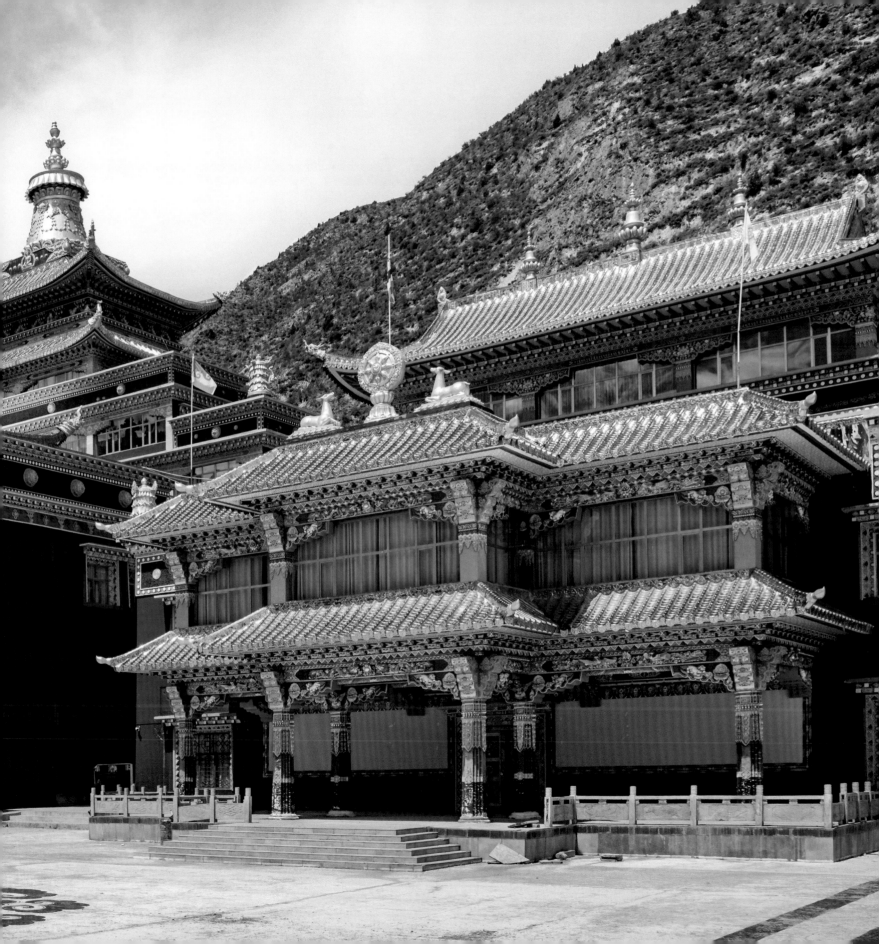

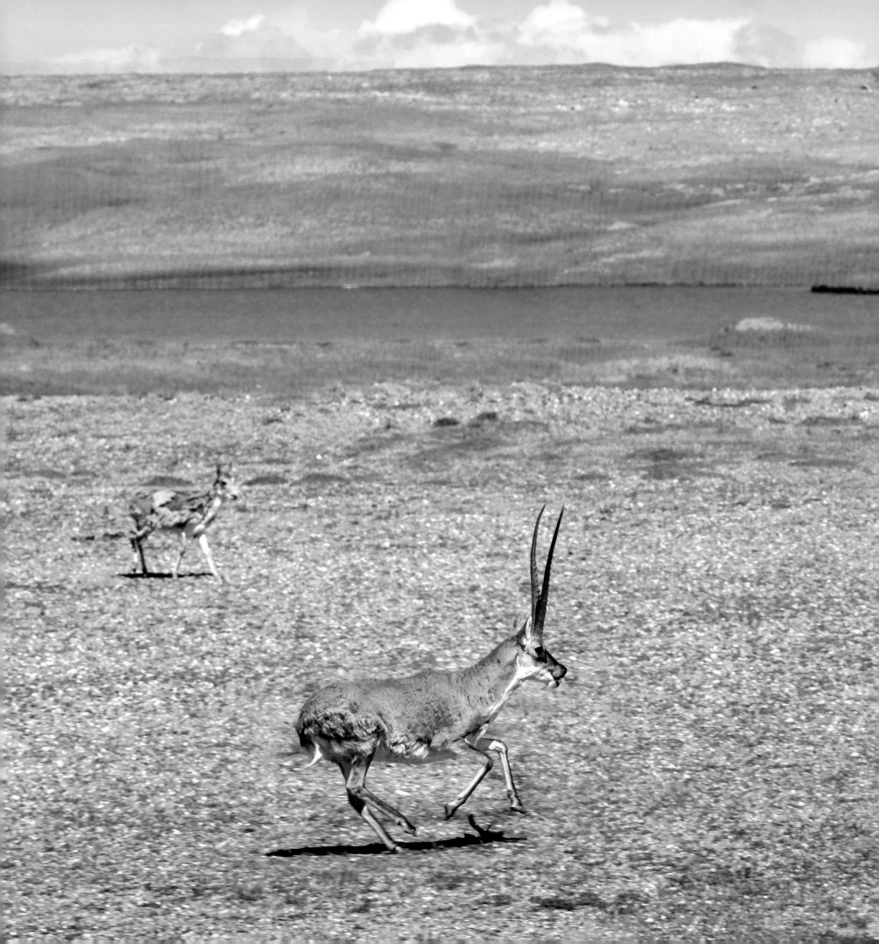

可可西里國家級自然保護區，是一片面積 45,000 平方公里的廣袤地域，位於青海省西北部，與新疆、西藏接壤。在這片土地上，原始生態環境基本未受到任何人為破壞，是目前中國面積最大、海拔最高、野生動物資源最為豐富的自然保護區之一。（右）可可西里氣候極度嚴酷，被稱為「世界第三極」、「生命的禁區」，人類無法長期居住，藏羚羊等高原野生動物在此卻有著得天獨厚的生存條件，得以繁殖。藏羚羊是可可西里最具代表性的物種，被稱為「可可西里的驕傲」。（左）

Hoh Xil National Nature Reserve is a large piece of land with an area of 45,000 square

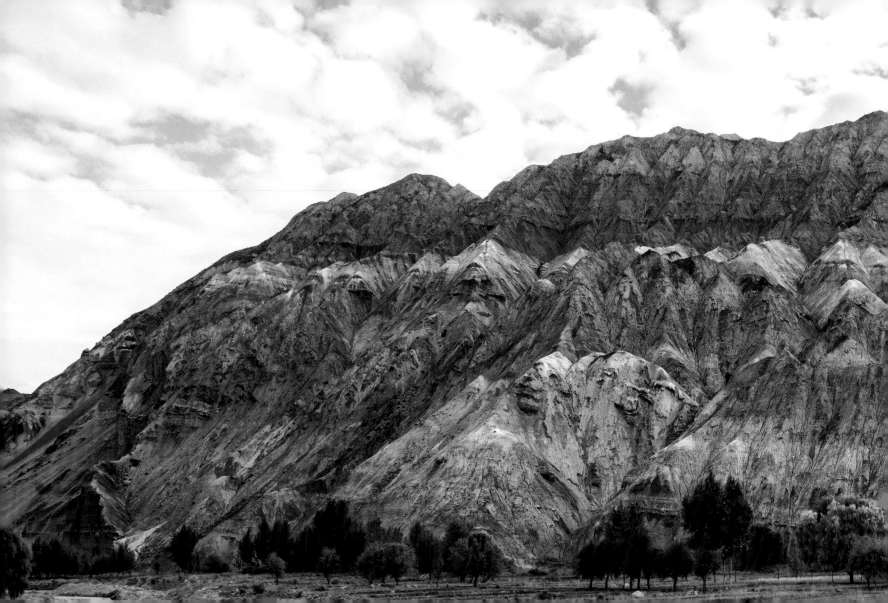

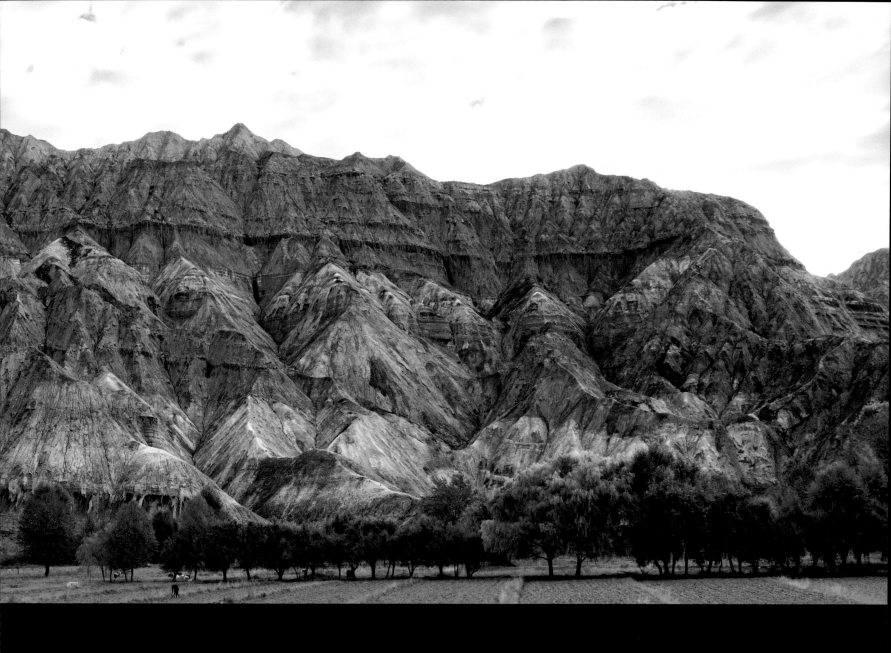

貴德國家地質公園距離西寧約 70 公里，其內可以觀賞到奇特的丹霞地貌。

Seventy kilometers away from Xining, the peculiar Danxia landscape can be seen in the Guide National Geopark.

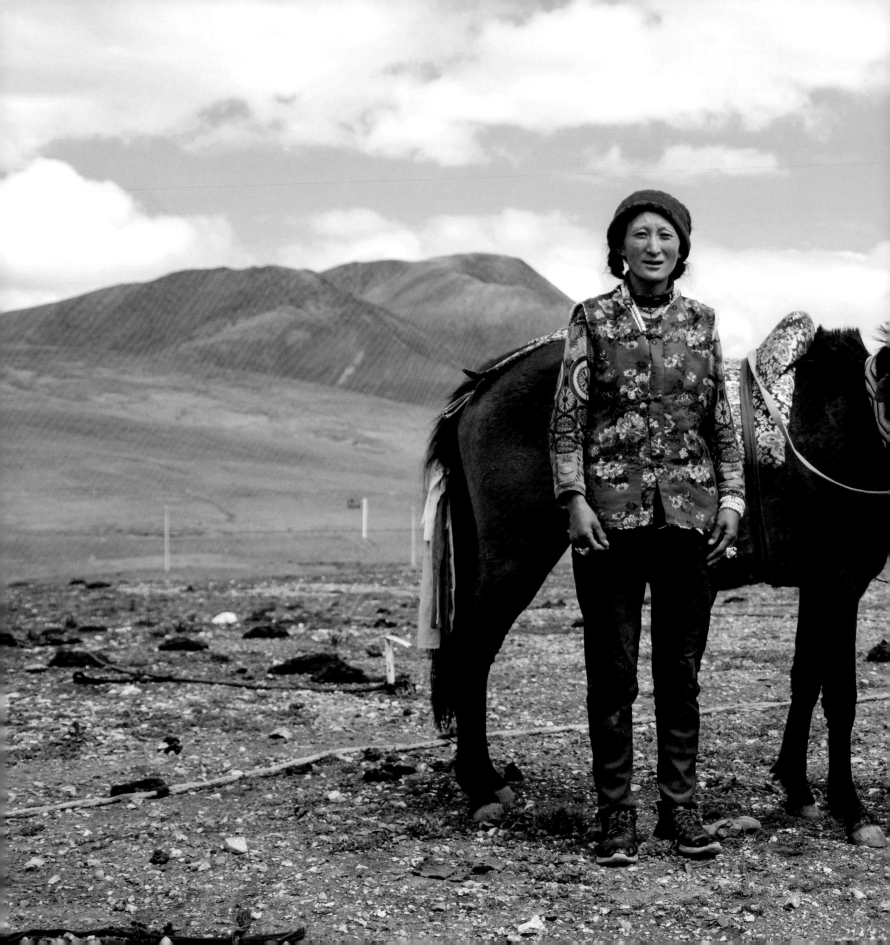

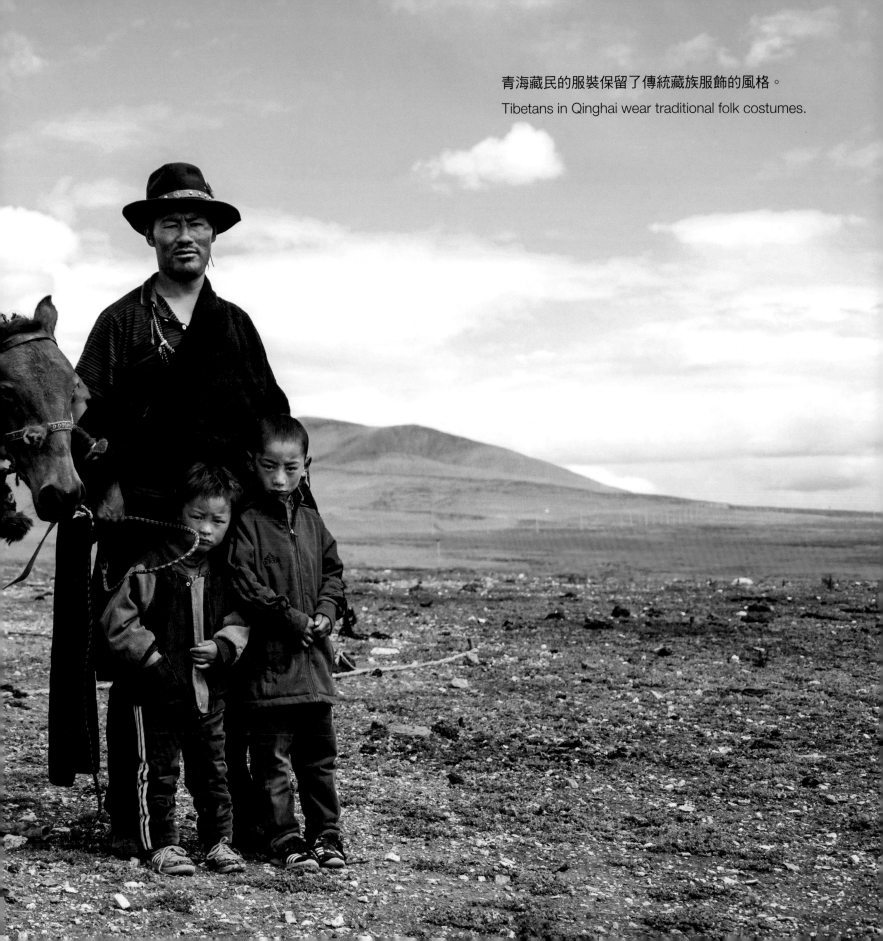

青海藏民的服裝保留了傳統藏族服飾的風格。
Tibetans in Qinghai wear traditional folk costumes.

在青海湖畔，仍有牧民居住在藏式帳篷之內。如今，隨著政府的安置計劃，
這些傳統的帳篷越來越罕見。圖中的藏民家庭，儘管生活條件並不優越，
一家七口仍和樂融融地生活在一起。

By the Qinghai Lake, some herdsmen are still living in the Tibetan-style
tents. Today, these traditional tents are becoming increasingly rare as the
government is helping more and more families to settle in modern houses.
This 7-people Tibetan family live happily together despite underprivileged
living conditions.

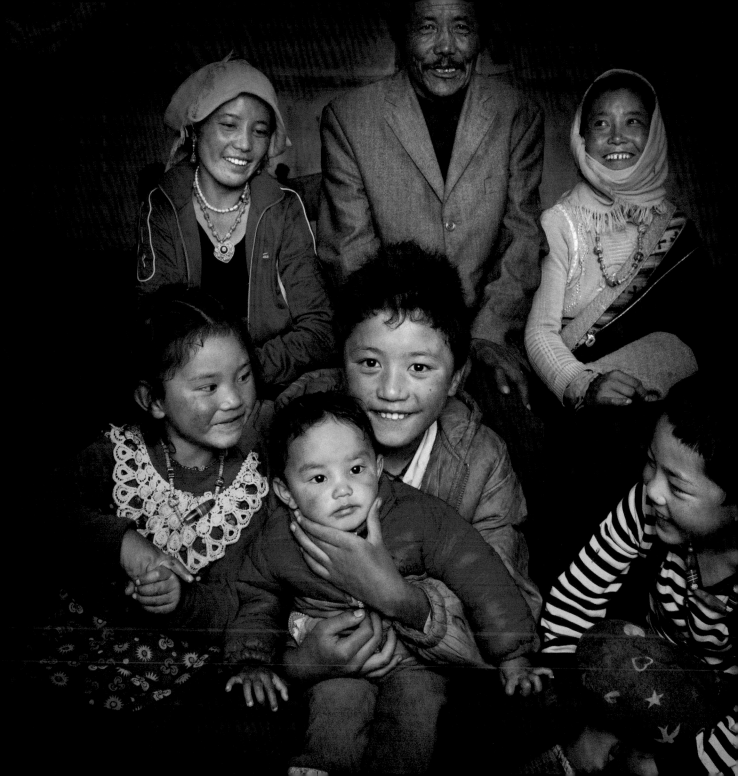

「醍醐灌頂」這一成語，就是來源於藏傳佛教之中的灌頂儀式，比喻以智慧灌輸於人，讓人大徹大悟。

A Chinese idiom "pouring rich liquor over one's head" comes exactly from this ritual of Abhisheka in Tibetan Buddhism, implying the receiver's being enlightened.

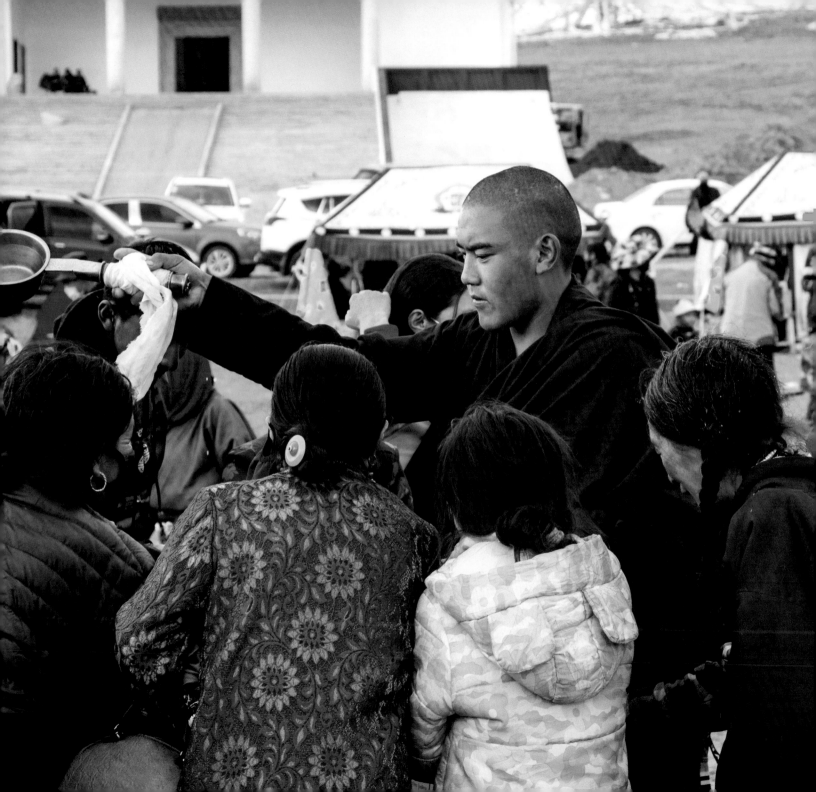

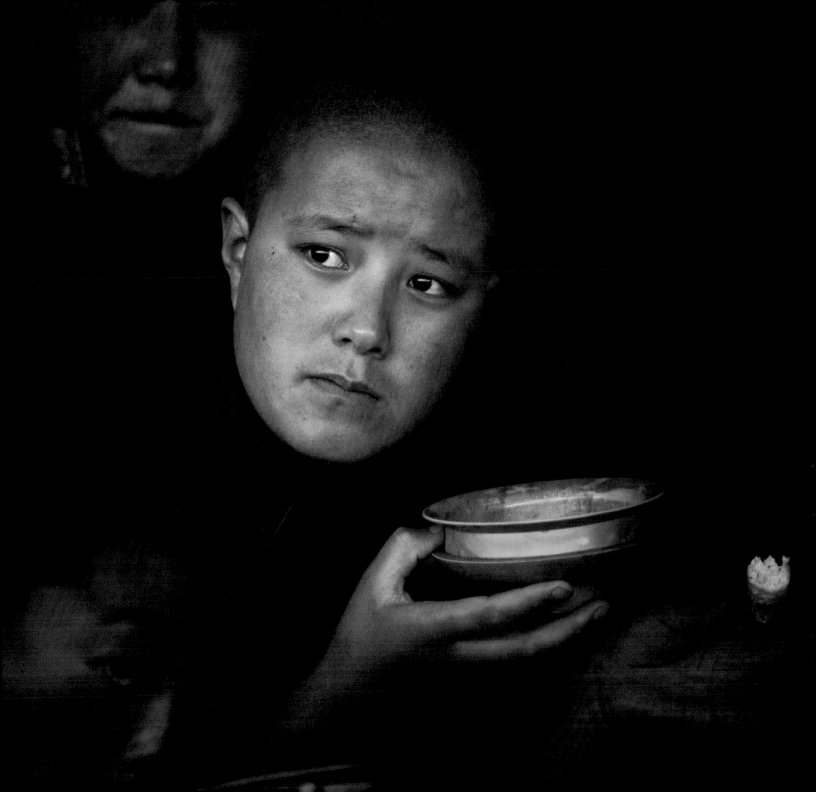

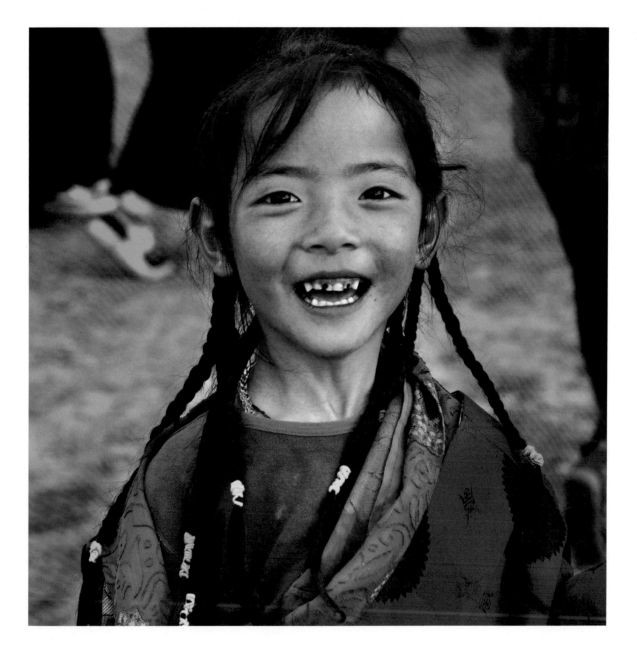

這次的法會中所有的法師皆為女性，藏傳佛教將出家的女性稱為「阿尼」。（左）藏族小女孩
在接受灌頂之禮之後，面上露出了燦爛的笑容。（右）

All priests in this ceremony are female. They are called Ani in Tibetan Buddhism. (Left)
After being poured on the head, the Tibetan girl is showing a dazzling smile. (Right)

經幡之上，通常印有經文、佛像、吉祥圖案等。（左）轉經筒之前，一名藏族孩童正端坐在地，認真地研讀經文。（右）

Sutras, the images of Buddha and symbols representing fortune are often seen on prayer flags. (Left) In front of a prayer wheel, a Tibetan boy is sitting still while studying sutras. (Right)

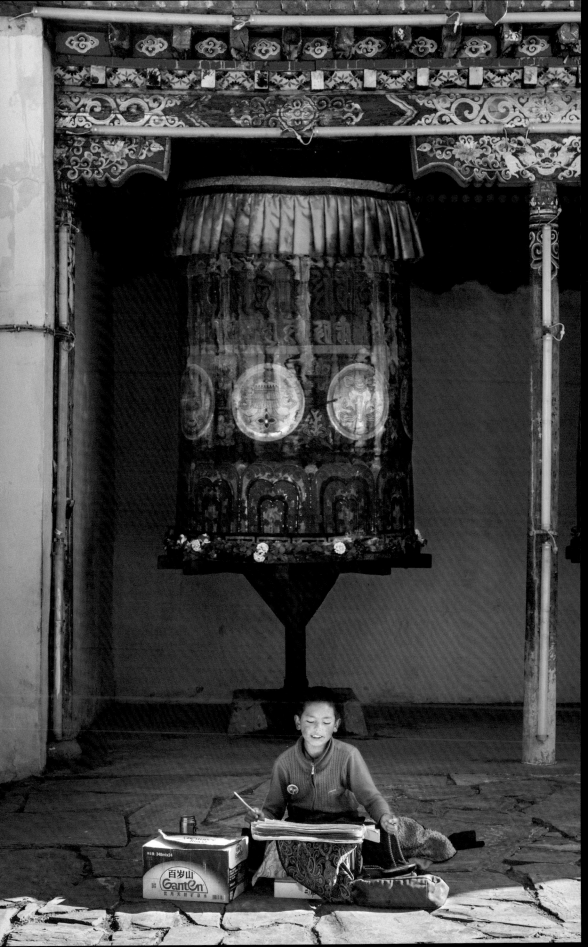

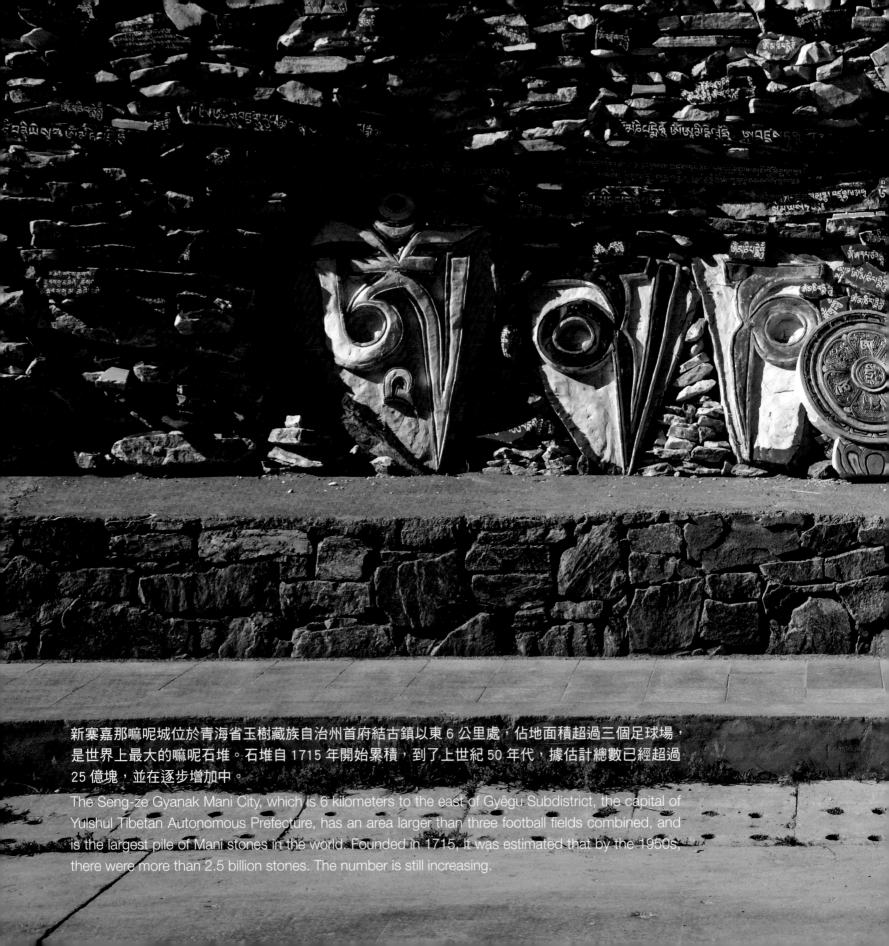

新寨嘉那嘛呢城位於青海省玉樹藏族自治州首府結古鎮以東 6 公里處，佔地面積超過三個足球場，是世界上最大的嘛呢石堆。石堆自 1715 年開始累積，到了上世紀 50 年代，據估計總數已經超過 25 億塊，並在逐步增加中。

The Seng-ze Gyanak Mani City, which is 6 kilometers to the east of Gyêgu Subdistrict, the capital of Yulshul Tibetan Autonomous Prefecture, has an area larger than three football fields combined, and is the largest pile of Mani stones in the world. Founded in 1715, it was estimated that by the 1950s, there were more than 2.5 billion stones. The number is still increasing.

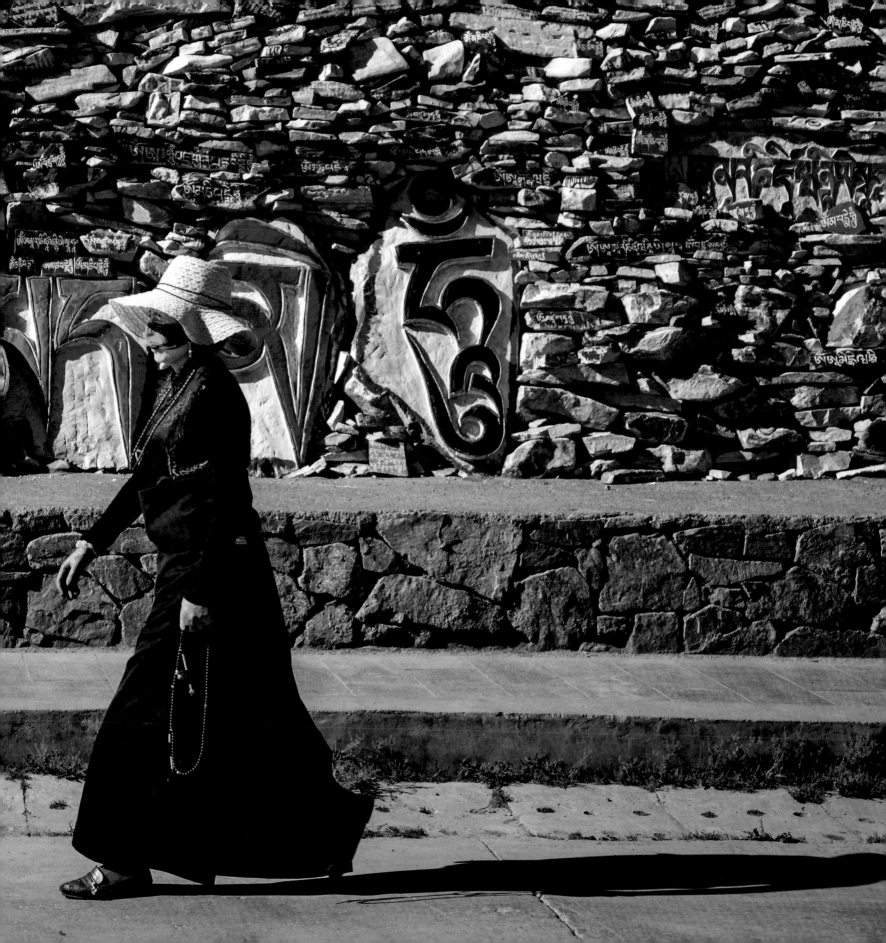

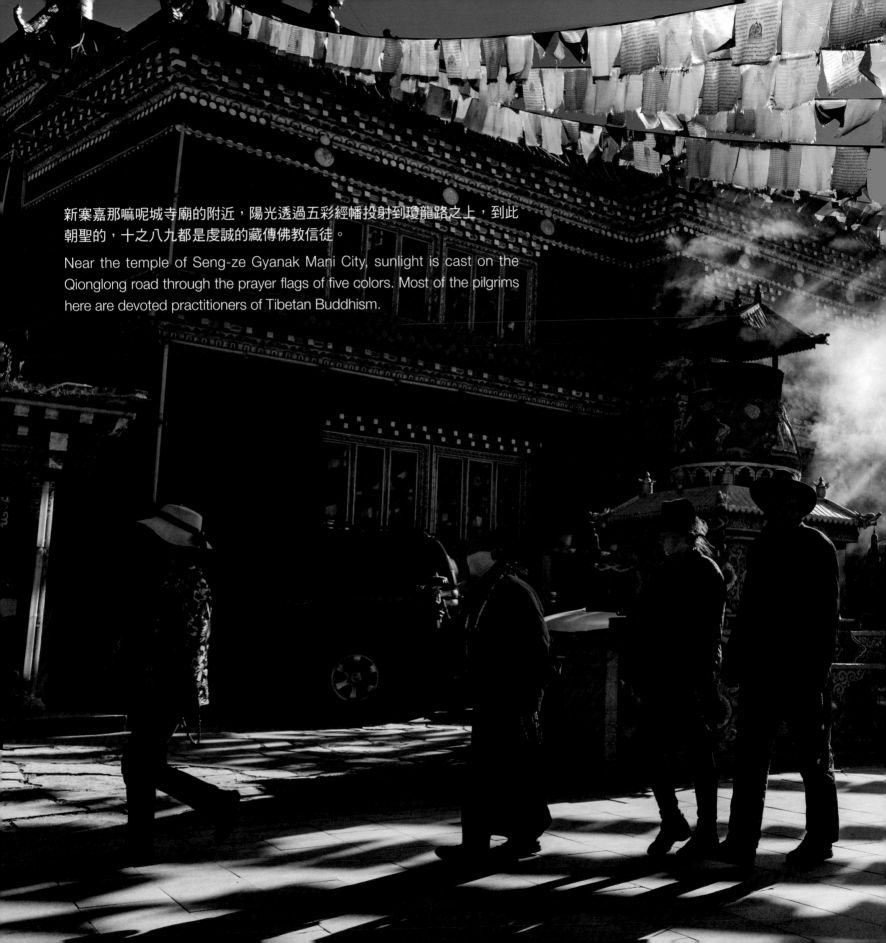

新寨嘉那嘛呢城寺廟的附近，陽光透過五彩經幡投射到瓊龍路之上，到此朝聖的，十之八九都是虔誠的藏傳佛教信徒。

Near the temple of Seng-ze Gyanak Mani City, sunlight is cast on the Qionglong road through the prayer flags of five colors. Most of the pilgrims here are devoted practitioners of Tibetan Buddhism.

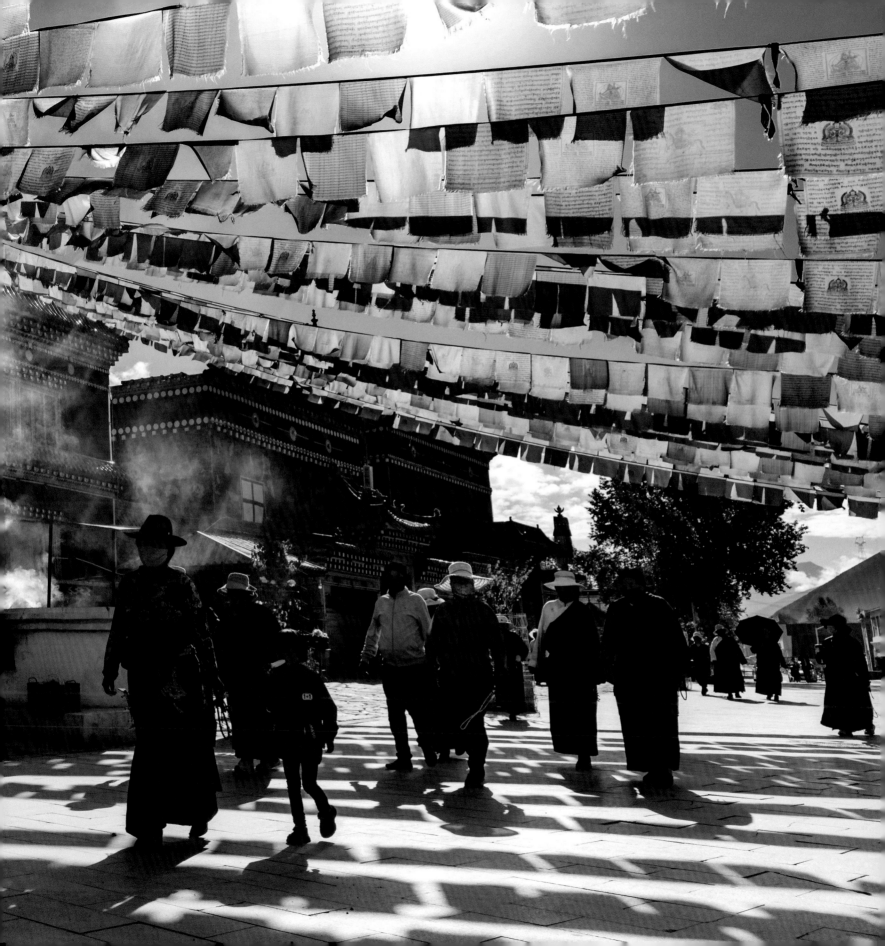

塔爾寺藏語稱為「貢本噶丹賢巴林」，坐落於蓮花山之中。寺廟建於明代，是藏傳佛教格魯派六大寺院之一。

The Ta'er Temple is called "Kumbum Jampa Ling" in Tibetan. It is constructed in the Lianhua Mountain (or Mount Lotus). Built in the Ming Dynasty, it is one of the six major temples of the Gelug school of Tibetan Buddhism.

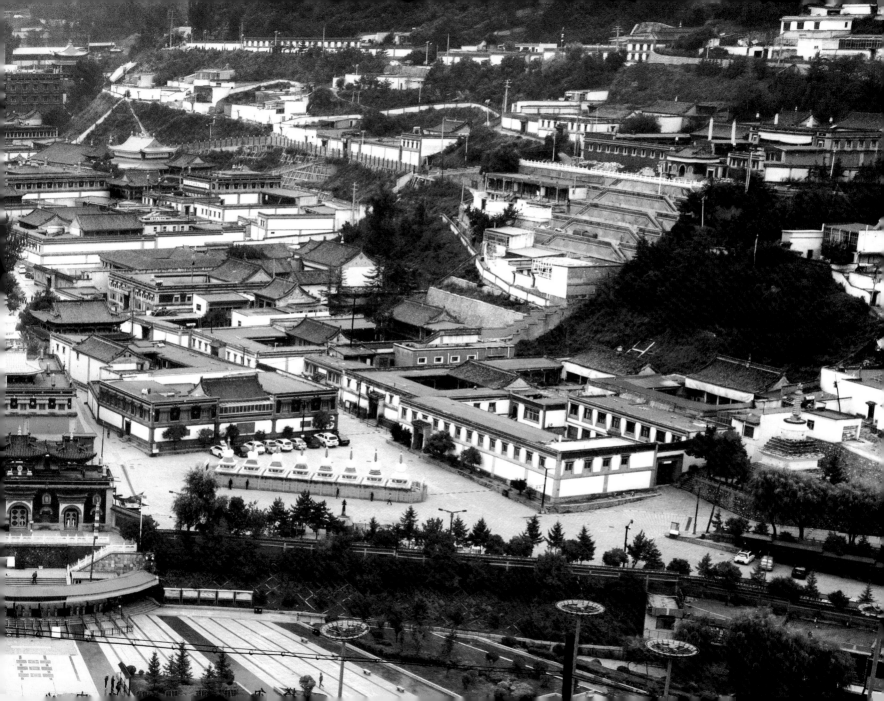

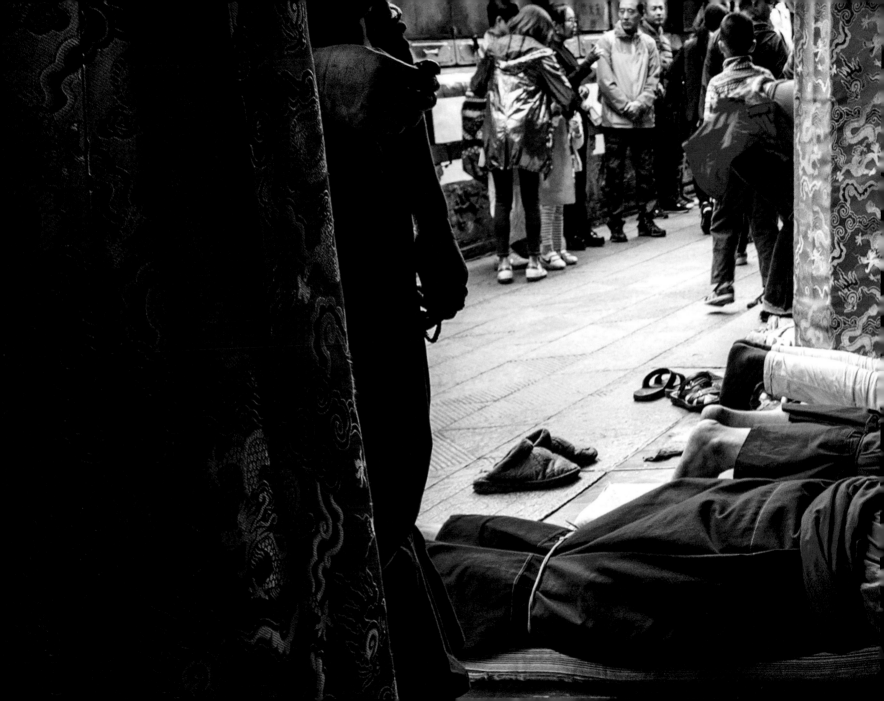

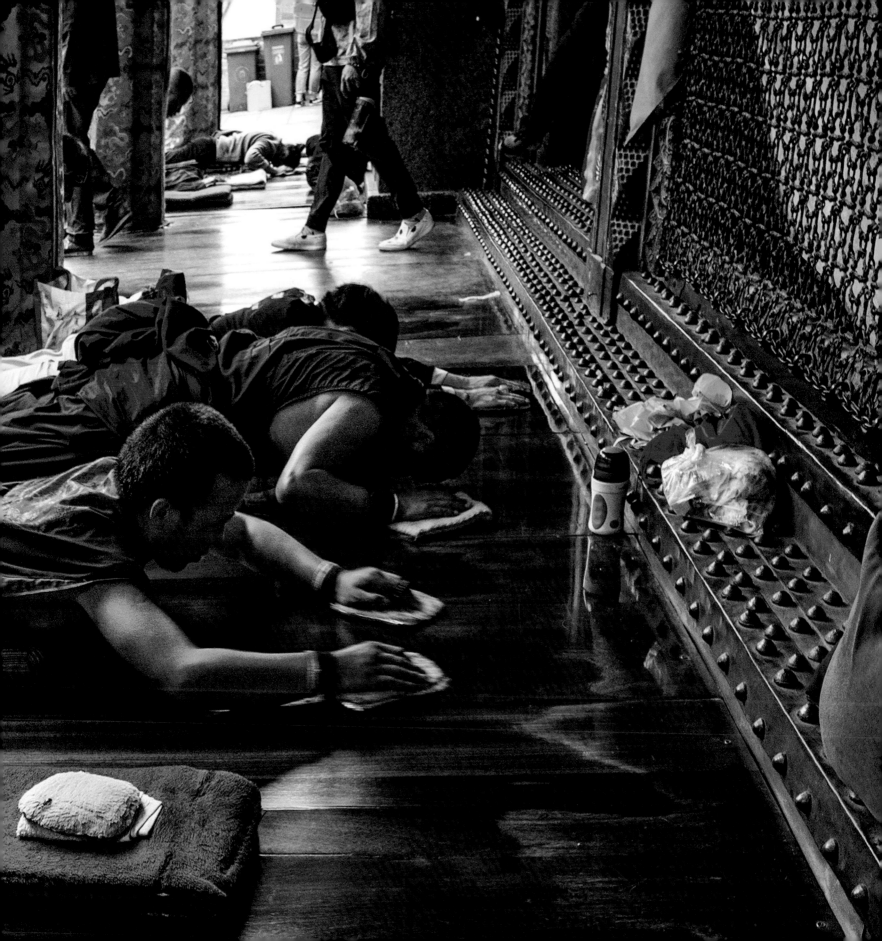

青海省西寧市塔爾寺建於明洪武十年（1377 年），因修建了藏傳佛教格魯派的創始人喀巴大師的紀念塔，之後才擴大建成寺院，形成了「先有塔，後有寺」的情況，故被稱為塔爾寺。同時，塔爾寺內的酥油花、壁畫和堆繡因製作精美，被譽為「塔爾寺藝術三絕」，每年都吸引成千上萬的遊客入寺參觀。

Ta'er temple, located in Xining, Qinghai Province, was built in the 10th year of Hongwu Emperor in Ming dynasty (1377 AD). The memorial tower of the master of Kabbah (the founder of the Gelug school of Tibetan Buddhism) was constructed before the temple was built. Therefore, local people referred the temple as Ta'er (tower). Exquisite butter sculptures, murals, and barbolas are the three extraordinary artwork styles of Ta'er, attracting hundreds of thousands of tourists to the temple every year.

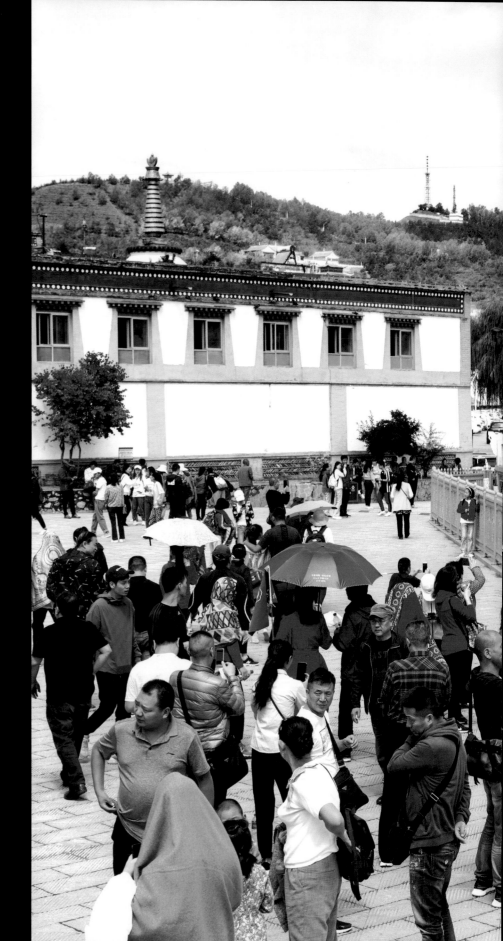

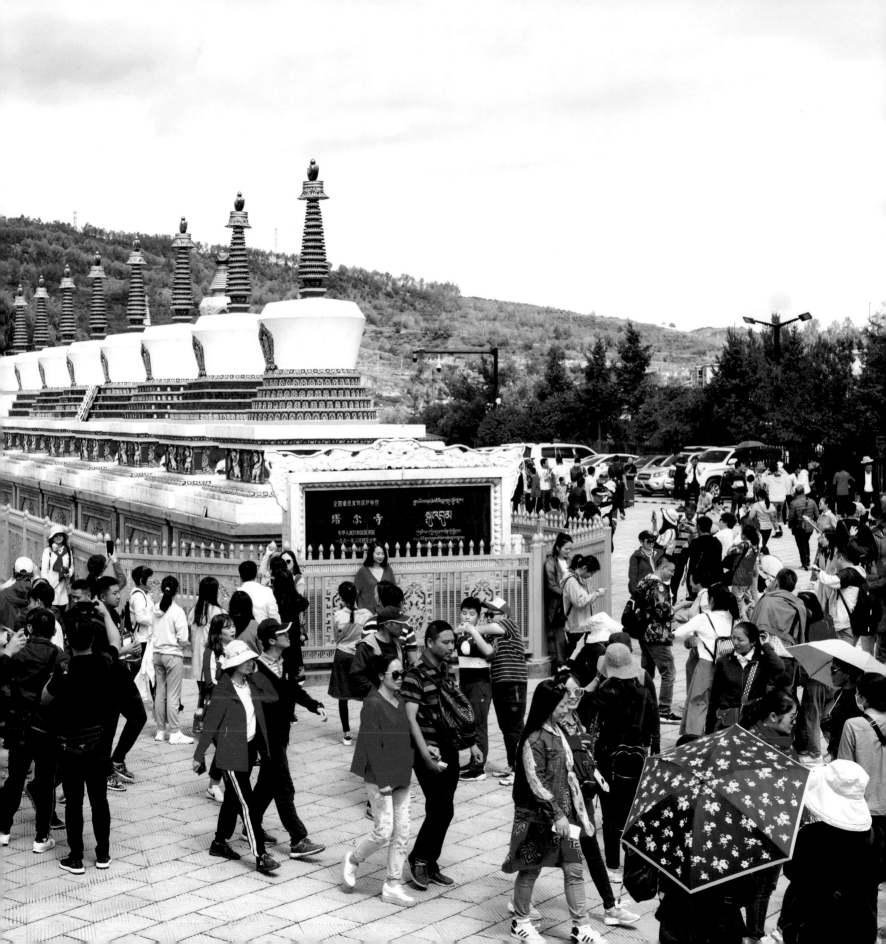

酥油花的最初來源，是以酥油捏成各種形狀，來代替用以祭祀的動物，減少了殺戮。後來，酥油花被藏傳佛教廣泛採用以作供品，逐漸成為藏傳佛教的一大特色。塔爾寺中，擺設著精美絕倫的雕塑藝術酥油花，每年的正月十五，此處都會舉行一年一度的酥油花展。

The original function of Tibetan butter sculptures was to avoid slaughtering by using different butter figures to make substitutes of the sacrificed animals in fete ceremonies. Later, the butter sculptures are extensively adopted by Tibetan Buddhism as offerings, and have become a unique feature of this religion. Exquisite Tibetan butter sculptures are displayed in the Ta'er monastery. Every year at the Lantern Festival, an annual exhibition of butter sculptures is held in the temple.

土族

Monguor People

土族的先民乃古代鮮卑族的支系，在隋朝時期（公元 581 年－ 618 年），曾一度在青海一帶建立吐谷渾政權。唐朝時期（公元 618 年－ 907 年），這個國家被吐蕃征服，不復存在。

經過多個朝代的更迭，吐谷渾人逐漸與其他民族融合。到了公元 17 至 19 世紀，由於清政府大力推崇藏傳佛教，導致土族人口減少至不足兩萬人。直至中華人民共和國成立之後，實行鼓勵少數民族文化的政策，土族人口才逐漸增加。

土族主要聚居於青海東部的自治縣內。

The ancestors of Monguor People were originally a branch of the ancient Xianbei, who had once built a kingdom called Tuyuhun in the Qinghai area during the Sui Dynasty (581-618 AD). Later in Tang (618-907 AD), the regime collapsed as the Tibetan Empire occupied the area.

The altering dynasties had witnessed the merging of Tuyuhun people and other nationalities. Between 17th and 19th centuries, since the Qing government held Tibetan Buddhism in esteem, the population of Tuyuhun therefore decreased to less than 20,000. It was not until the promotion of culture of ethnic minorities by the People's Republic of China did the Monguor population started to increase little by little.

The autonomous counties in eastern Qinghai are their main inhabiting region.

土族婦女的服飾稱為「七彩袖」，兩袖由七種顏色的布圈組成。（左）青海東北部的互助土族自治縣內，建有展示土族民俗文化的「土族園」。（右）

Tu women wear a type of folk costume called "seven-colored sleeves", which are made of cloth in seven different colors. (Left) There is a "Tu People Park" in the Huzhu Tu Autonomous County in northeast Qinghai, to display ethnic culture of them. (Right)

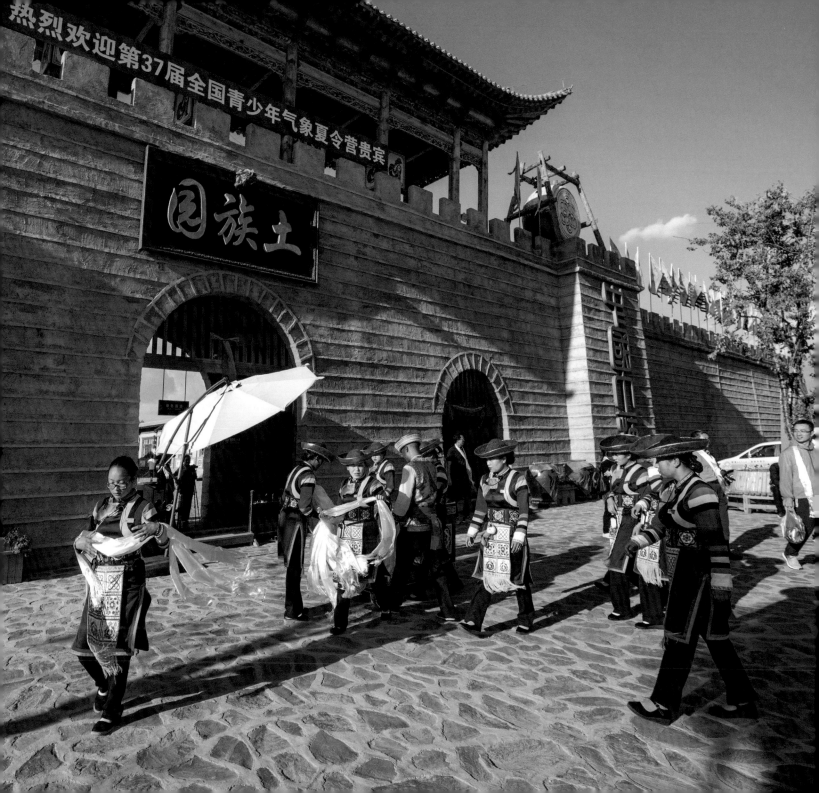

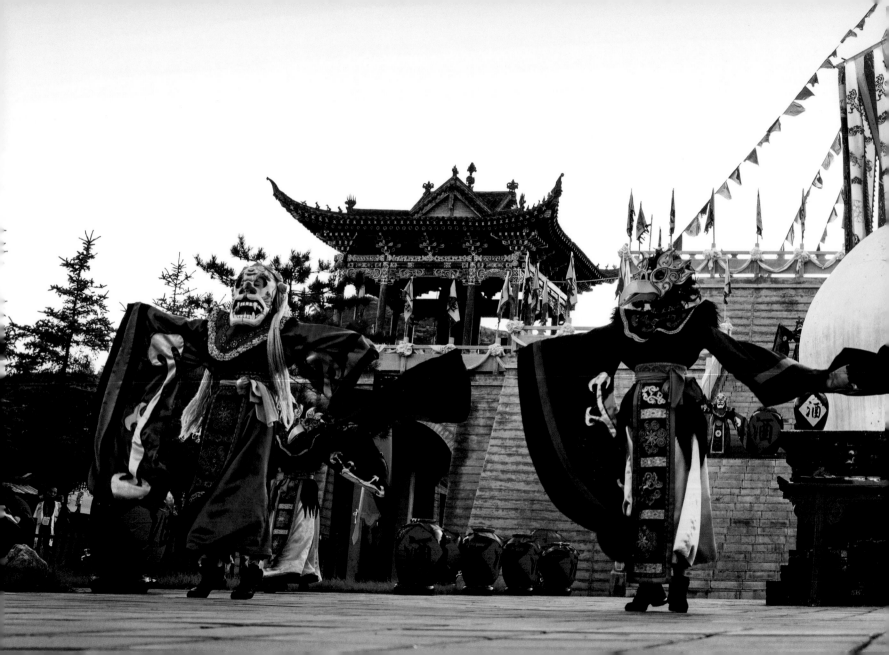

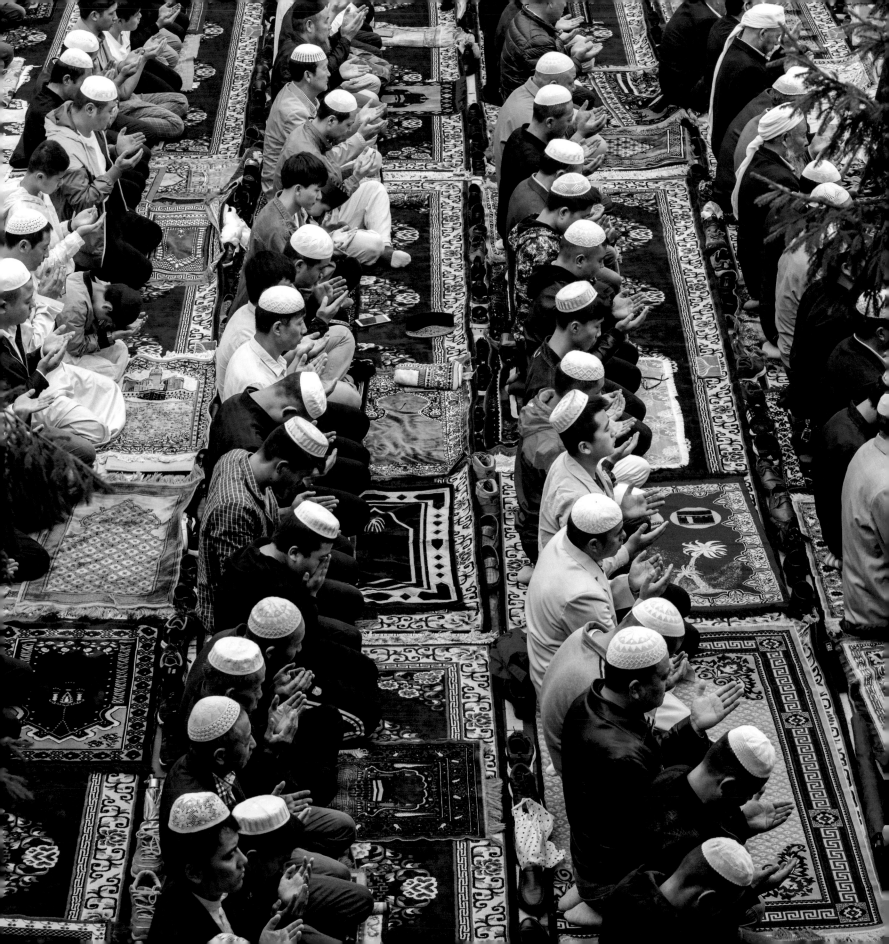

回族

Hui People

回族，是「回回民族」的簡稱。在清代，「回回」是對不食豬肉宗教信仰者的統稱。

歷史上，回民主要是在元代（公元 1271 年－1368 年）由中亞、西亞等地區大量遷至中國，他們因當時政府駐軍或行政之需而分佈在全國各地。到了明代民族同化政策讓留居中國的中西亞人與其他民族通婚並逐漸漢化，卻仍然保留了本身的伊斯蘭宗教信仰及生活習慣。

在這樣的歷史前提之下，回族成為了中國分佈最廣的少數民族，散處於全國大部分省份，總人口超過一千萬，為 56 個民族中的第三位。

在 1949 年之後的民族認定中，回回民族被識別為一個受到官方承認的少數民族，並建立了寧夏回族自治區。

Hui is short for "Hui Hui", which term, in Qing Dynasty, was used to address religious group abstaining from pork.

In history, Hui people were those who migrated from Central and Western Asia to China out of the need of the Yuan (1271-1368 AD) government for garrison or administration. The succeeding Ming allowed these people to stay in the country and intermarry with others. The foreigner had gradually assimilated into local society while retaining their Islamic religion, habits and customs.

Under the given historical background, the Hui has become the most widespread ethnic minority in China, who can be found in almost every province. Their total population exceeds 10 million, ranking the third in all 56 ethnicities.

After 1949, the authorities officially recognized Hui as one of the ethnic minorities. Ningxia Hui Autonomous Region was then established.

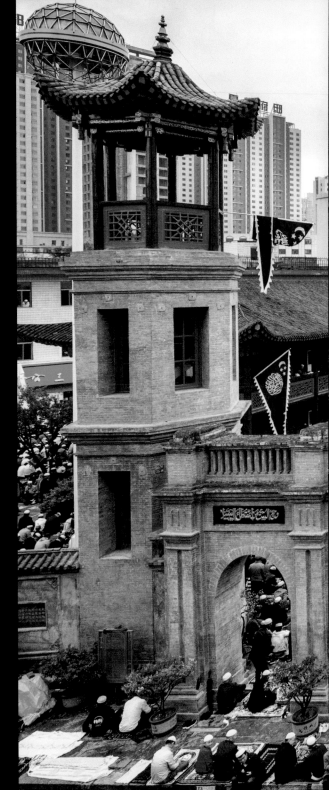

青海省西寧市東關清真大寺擁有超過 900 年歷史，每至重要節日，這是西寧市超過 15 萬穆斯林的重要聚集地。伊斯蘭曆每年 12 月 10 日為古爾邦節，是為了紀念先知易卜拉欣忠實執行真主命令向阿拉獻祭自己的兒子，而後又用羊羔代替的故事，因此又被稱為「宰牲節」。

With a history more than 900 years, the Xining Dongguan Mosque in Qinghai is an important place of gathering for more than 150,000 Muslims in the city on import religious occasions. Eid al-Adha falls on the 10th day of Dhu al-Hijjah (the 12th month in Islamic calendar), honoring the obedience to God's command of Ibrahim, who is willing to sacrifice his son. The God then provided a lamb to sacrifice instead, so the festival is also called "Feast of the Sacrifice".

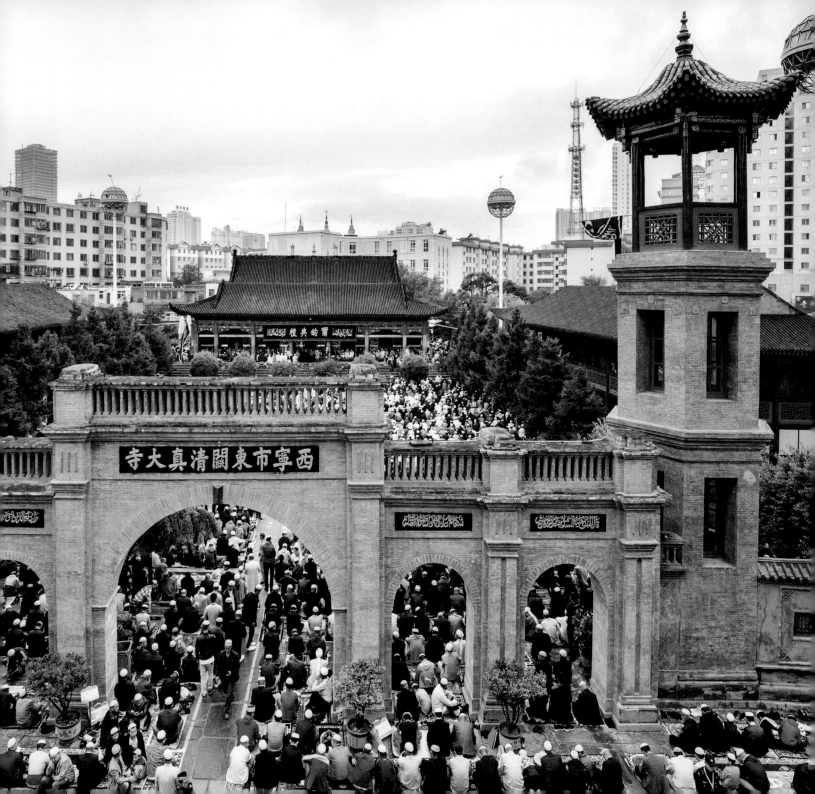

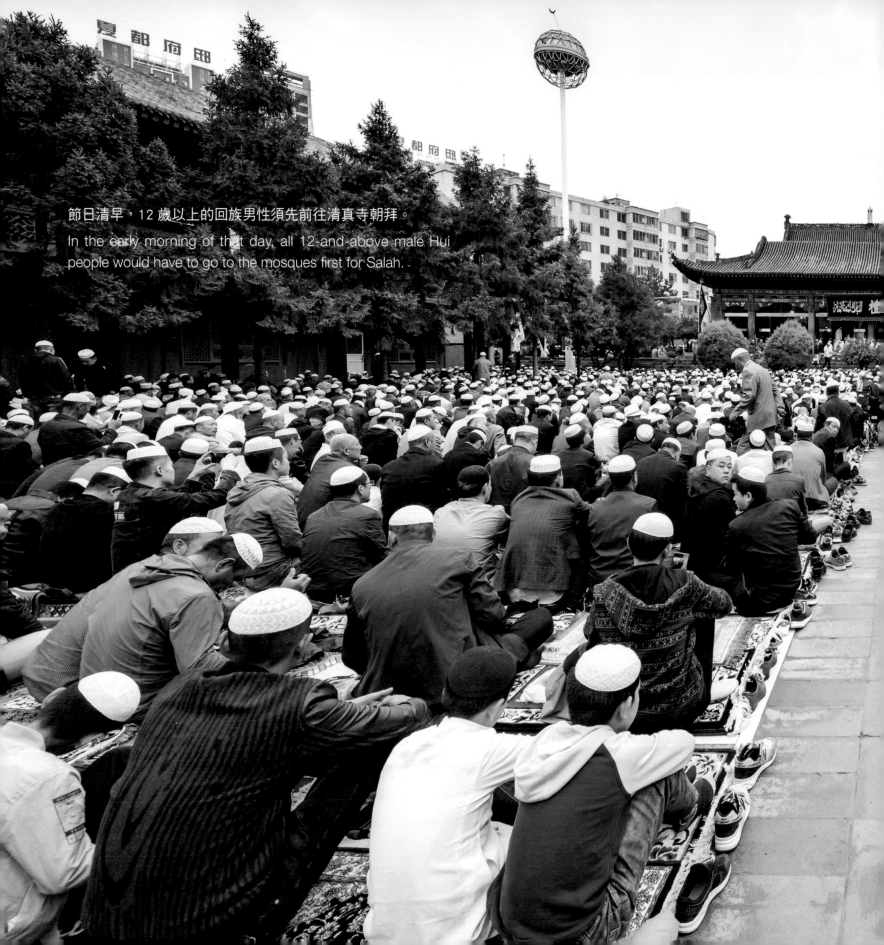

節日清早，12 歲以上的回族男性須先前往清真寺朝拜。

In the early morning of that day, all 12-and-above male Hui people would have to go to the mosques first for Salah.

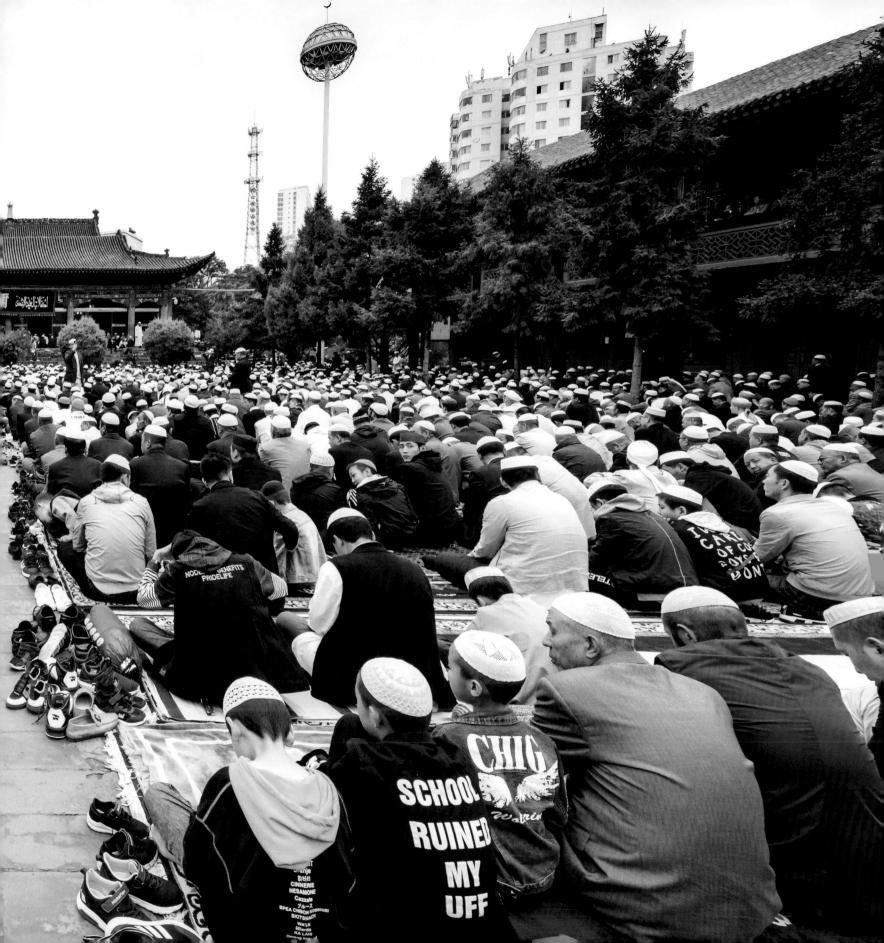

「阿訇」是在古波斯語中意為老師、學者，如今是回族對宗教場所首領的尊稱。重大節日中，阿訇會在清真寺內講述穆罕默德的歷史和創建伊斯蘭教的功績。

"Akhoond" means teacher or scholar in Old Persian, and is referred by Hui to be the head of a religious venue. On important occasions, Akhoond would tell about the story of Muhammad and how he founded Islam.

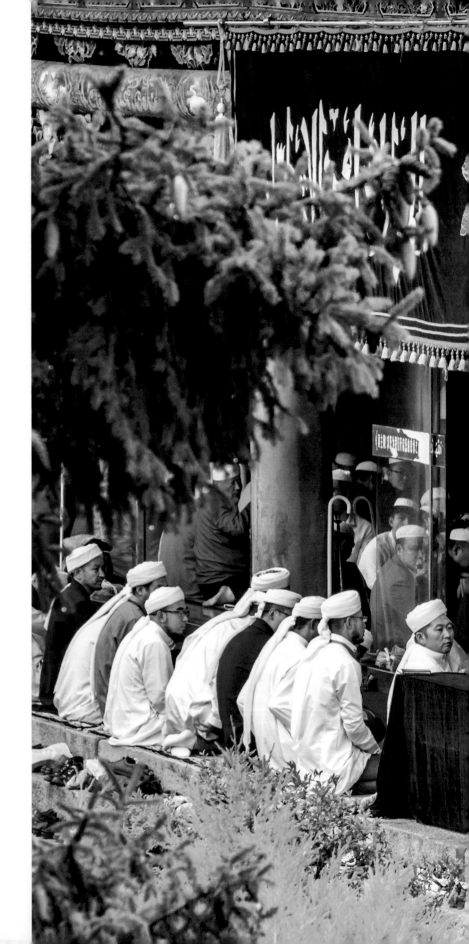

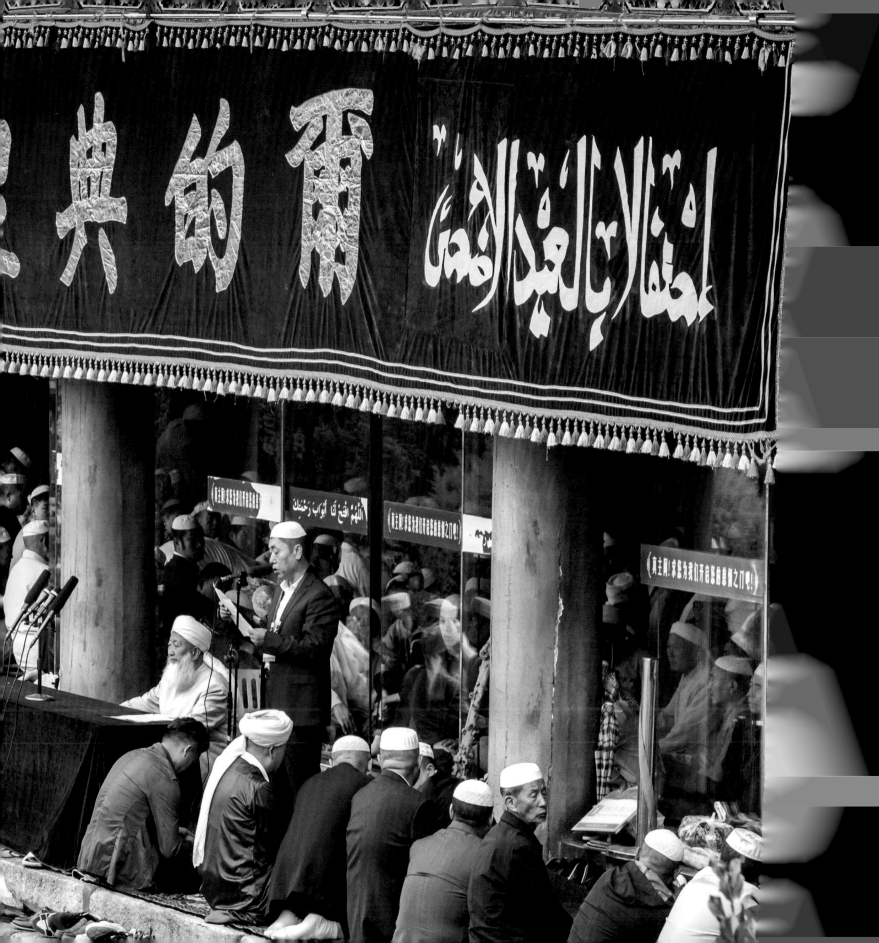

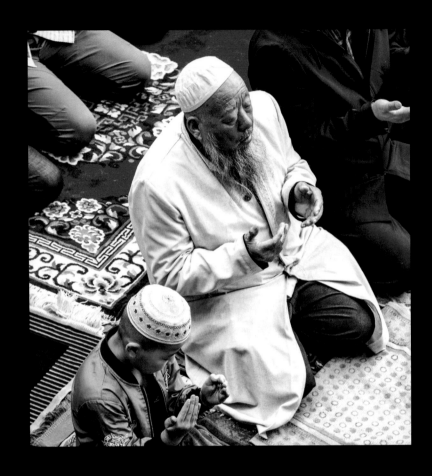

回族崇尚的是伊斯蘭遜尼派，包括禮拜在內的五大支柱「五功」被認為是這個教派的基本原則，其他四項為證信、齋戒、天課和朝覲。（左）大多數男性回民佩白色的戴塔基亞帽子，而小部分亦會使用戴斯他勒頭巾纏裹頭部。（右）

Hui worships Sunni Islam, which regards the Five Pillars as its fundamental principles, including Prayer. The other four are Faith, Charity, Fasting and pilgrimage to Mecca. (Left) Most Hui men wear white Taqiyah, while some would use Dastar to wind around their heads. (Right)

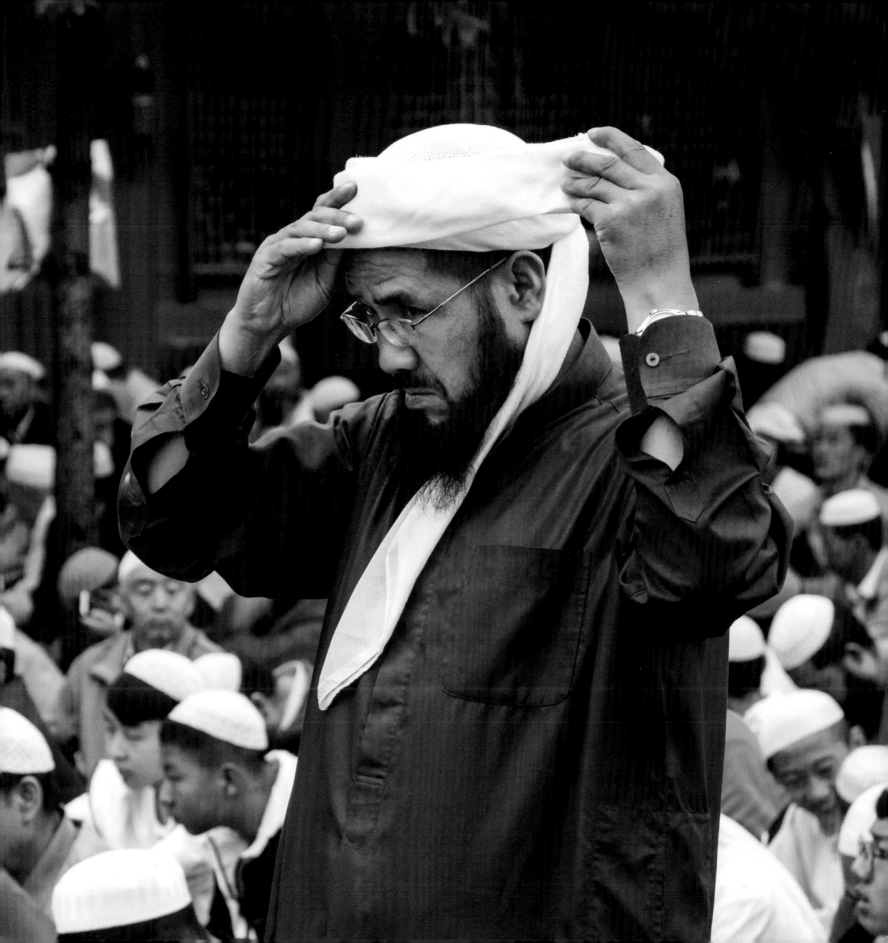

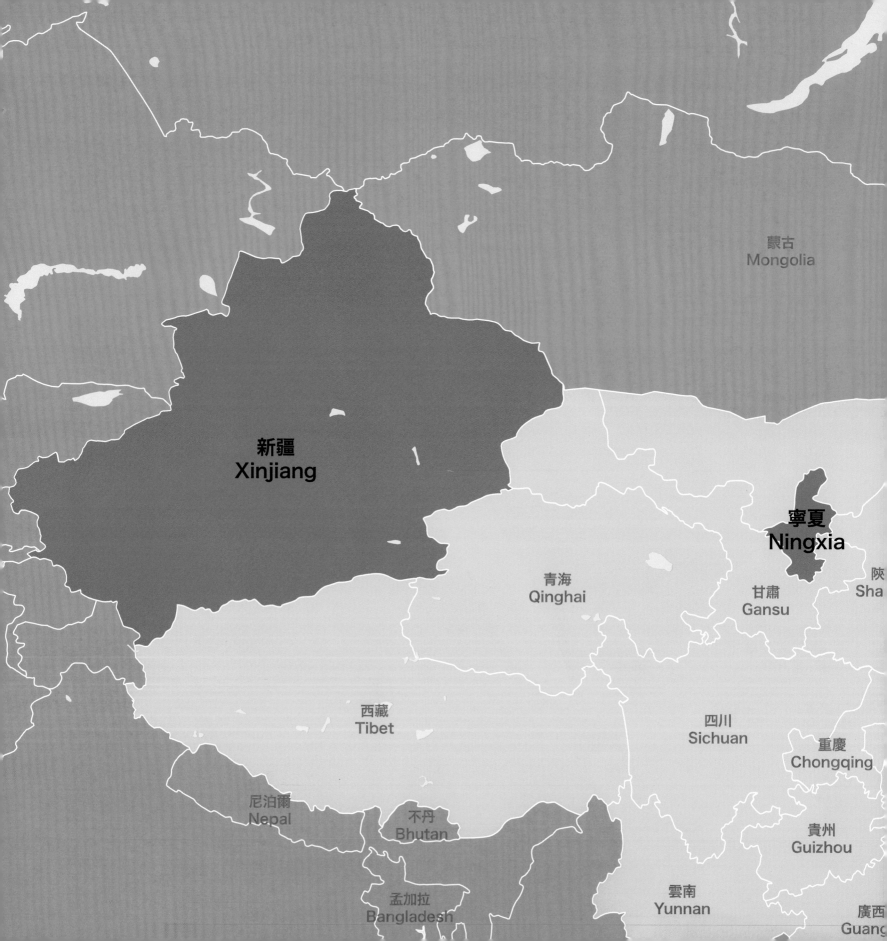

西北風貌

西北地區，從行政區域劃分，包括了陝西、甘肅、青海、寧夏回族自治區及新疆維吾爾自治區五個省區。若依據自然環境和人文特徵加以劃分，則更可囊括內蒙古自治區的中西部，而不包含陝西省的大部及青海省。

在經濟方面，雖然本區礦產資源豐富，開發難度卻相對較大。自 2000 年始，國家正式開始實施「西部大開發」政策，旨在「把東部沿海地區的剩餘經濟發展能力，用於提高西部地區的經濟和社會發展水平、鞏固國防」。政策的主要項目包括西電東送、南水北調工程、西氣東輸及青藏鐵路。近年力推的「一帶一路」計劃中，西部地區作為古代絲綢之路的重要通道，亦受到了重視。

地廣人稀的西北地區，佔據全國面積的 30%，由於位於內陸，受高原、山地阻隔，氣候乾旱，形成廣袤的荒漠及戈壁沙灘。因此，這裡的總人口只佔全國人口的 7.3%，其中約三分之一為少數民族人口，主要的少數民族有回族、維吾爾族、哈薩克族、藏族、蒙古族、俄羅斯族等。

全國五大省級少數民族自治區，其中就包括了寧夏和新疆，分別以銀川及烏魯木齊為首府，前者為回族自治區，後者則是維吾爾族自治區。

The Splendid Northwest

Administratively speaking, Northwest China covers five provincial districts, including Shanxi, Gansu, Qinghai, Ningxia Hui Autonomous Region and Xinjiang Uyghur Autonomous Region. But if categorizing according to natural environment and cultural features, Northwest should also include the middle and western part of the Inner Mongolia Autonomous Region, yet excluding most parts of Shanxi and Qinghai.

On the economic front, although the Northwest is abundant in mineral resources, the exploitation is by no means easy. Since the year of 2000, the government kicked off the policy of "Western Development", with a purpose to "take advantage of the surplus value of economic development in the eastern coastal area to elevate the level of economy and social life in the Northwest and strengthen national defense". West-East Electricity Transfer Project, South–North Water Transfer Project, West-East Gas Pipeline and Qinghai-Tibet railway are its main projects. In recent years, the Belt and Road Initiative has also attached great importance to this district for it covers a main route along the ancient Silk Road.

The vast and sparsely populated area has taken up 30 percent of China's gross area. Located in the inland and obstructed by highlands and mountains, the Northwest is a dry area covered by immense wilderness and Gobi deserts. Therefore, its population accounts for only 7.3 percent, among which one third of them are ethnic minorities, including mainly Hui, Uygur, Tibetan, Mongolian, Russian Peoples, etc.

Of the five provincial autonomous region by minority groups, Ningxia and Xinjiang are self-governed by Hui and Uygur respectively. Yinchuan is the capital of Ningxia and Urumqi is that of Xinjiang.

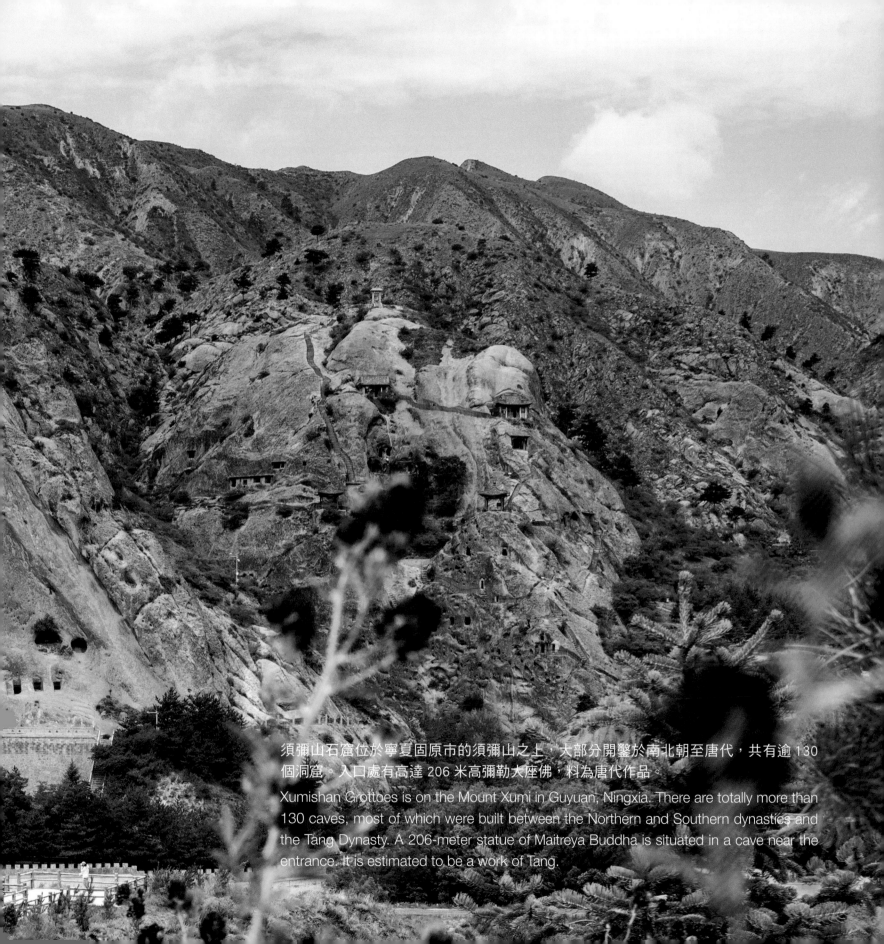

須彌山石窟位於寧夏固原市的須彌山之上，大部分開鑿於南北朝至唐代，共有逾 130 個洞窟。入口處有高達 206 米高彌勒大座佛，料為唐代作品。

Xumishan Grottoes is on the Mount Xumi in Guyuan, Ningxia. There are totally more than 130 caves, most of which were built between the Northern and Southern dynasties and the Tang Dynasty. A 206-meter statue of Maitreya Buddha is situated in a cave near the entrance. It is estimated to be a work of Tang.

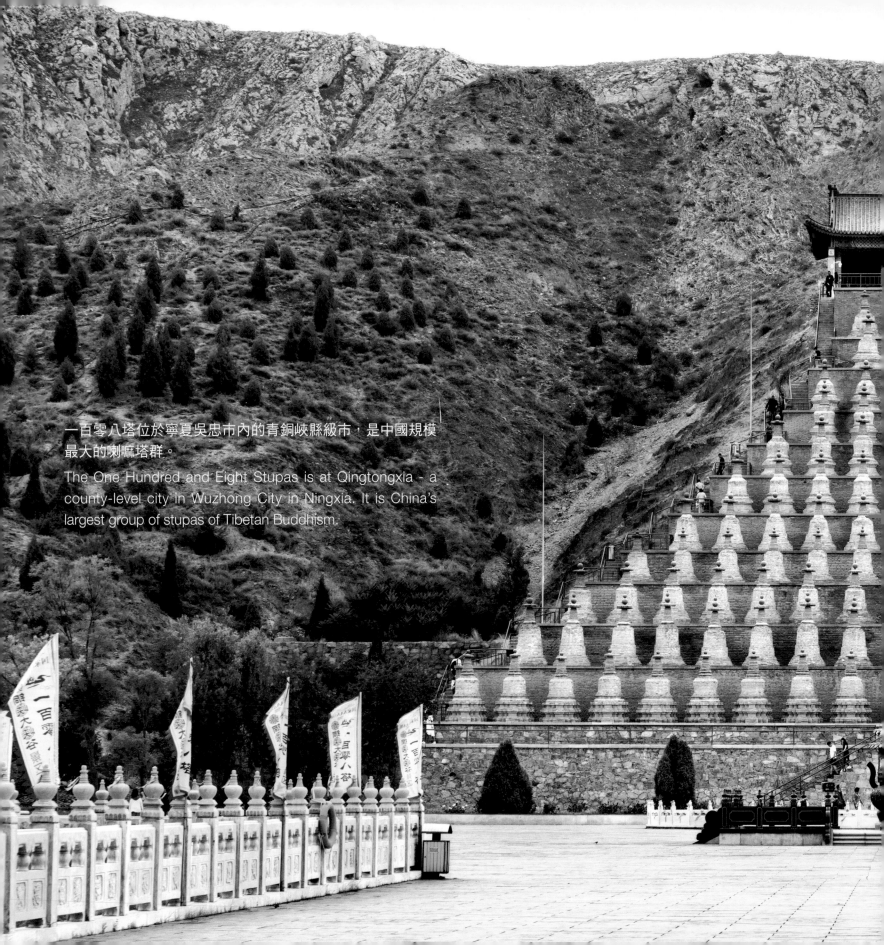

一百零八塔位於寧夏吳忠市內的青銅峽縣級市，是中國規模最大的喇嘛塔群。

The One Hundred and Eight Stupas is at Qingtongxia - a county-level city in Wuzhong City in Ningxia. It is China's largest group of stupas of Tibetan Buddhism.

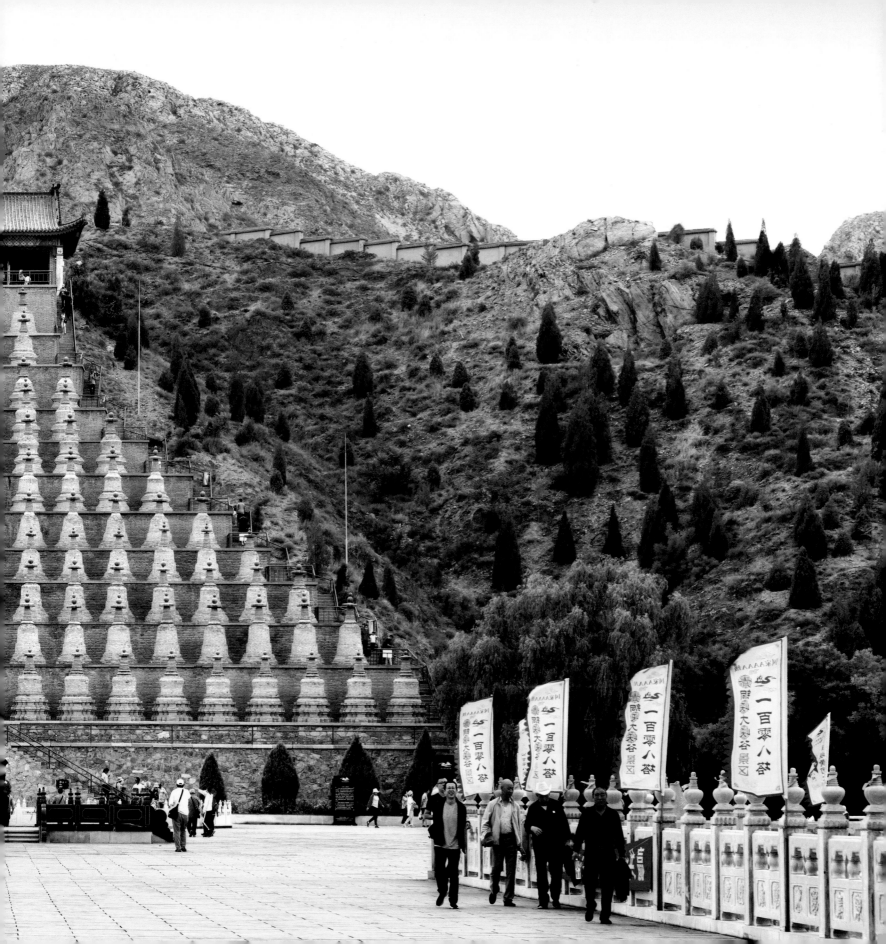

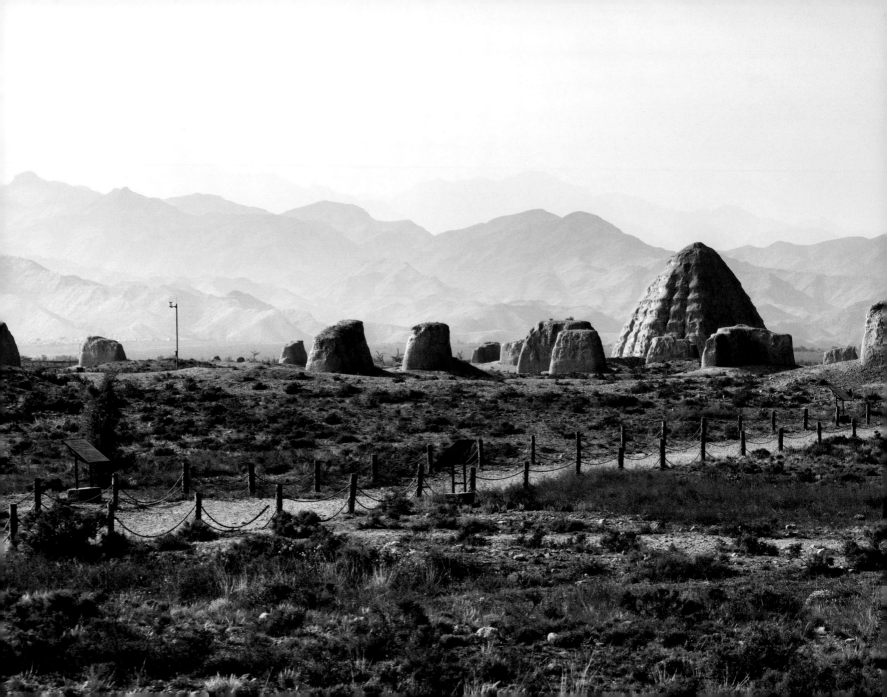

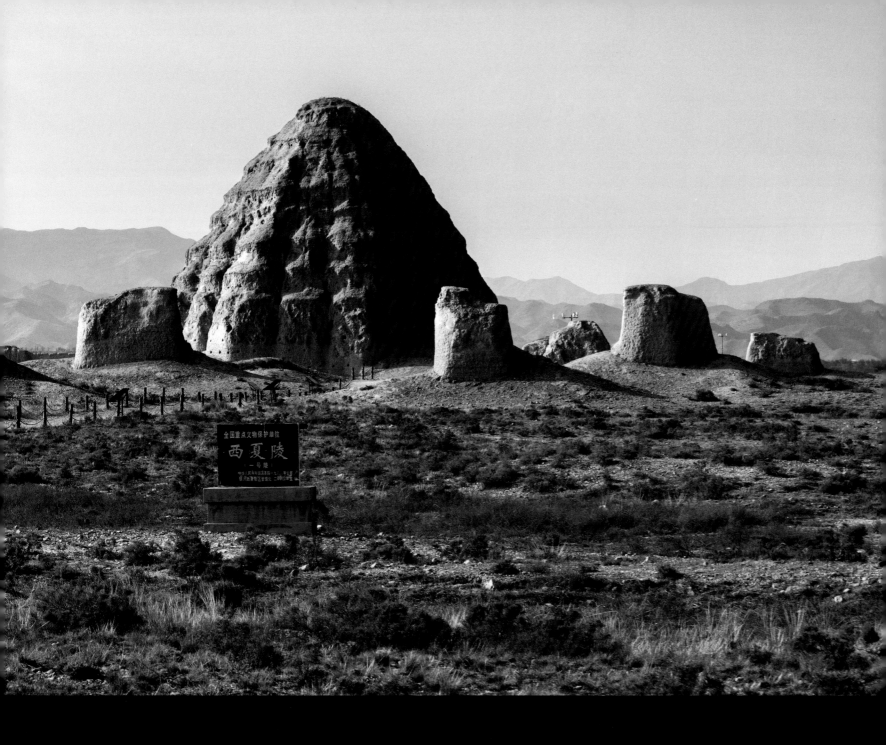

在銀川市西夏區的賀蘭山腳，佔地 50 平方公里的西夏王陵有「東方金字塔」之稱。截至 2014 年，考古學家共確認出西夏帝陵 9 座。

Located at the foot of Helan Mountains, the Western Xia mausoleums covers an area of 50 square kilometers. It is dubbed as the "Pyramids of China". Until the year of 2014, archaeologists had been able to confirm 9 imperial mausoleums in total.

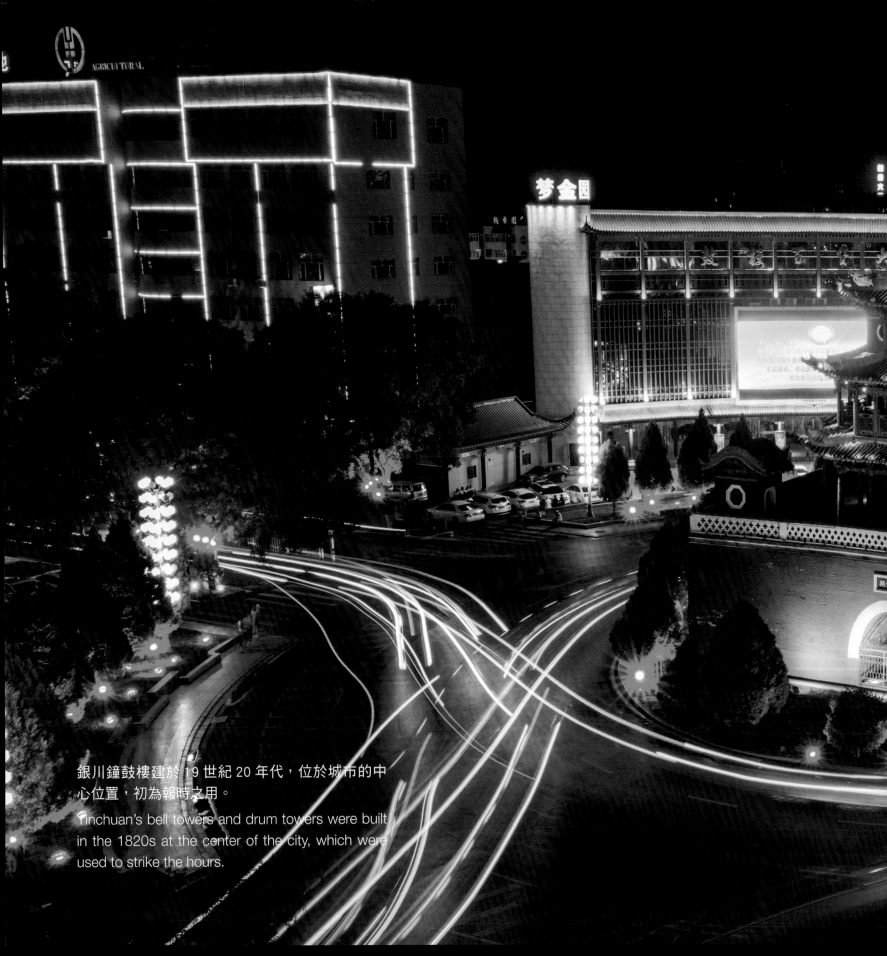

銀川鐘鼓樓建於 19 世紀 20 年代，位於城市的中心位置，初為報時之用。

Yinchuan's bell towers and drum towers were built in the 1820s at the center of the city, which were used to strike the hours.

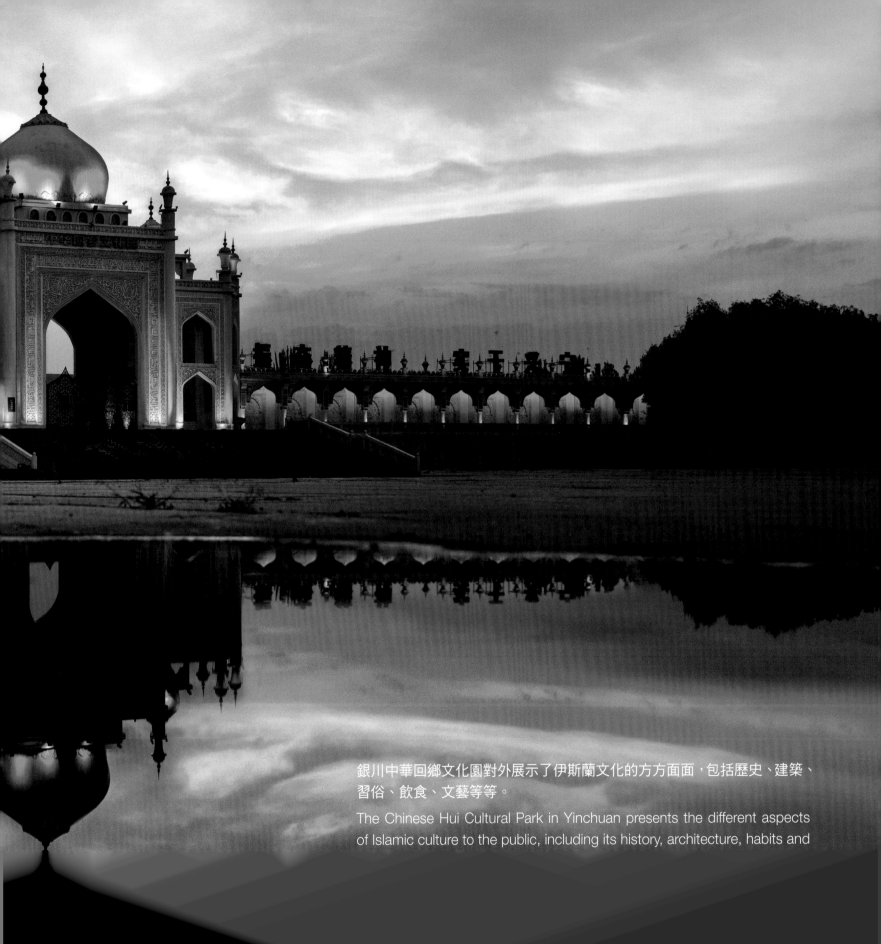

銀川中華回鄉文化園對外展示了伊斯蘭文化的方方面面，包括歷史、建築、習俗、飲食、文藝等等。

The Chinese Hui Cultural Park in Yinchuan presents the different aspects of Islamic culture to the public, including its history, architecture, habits and

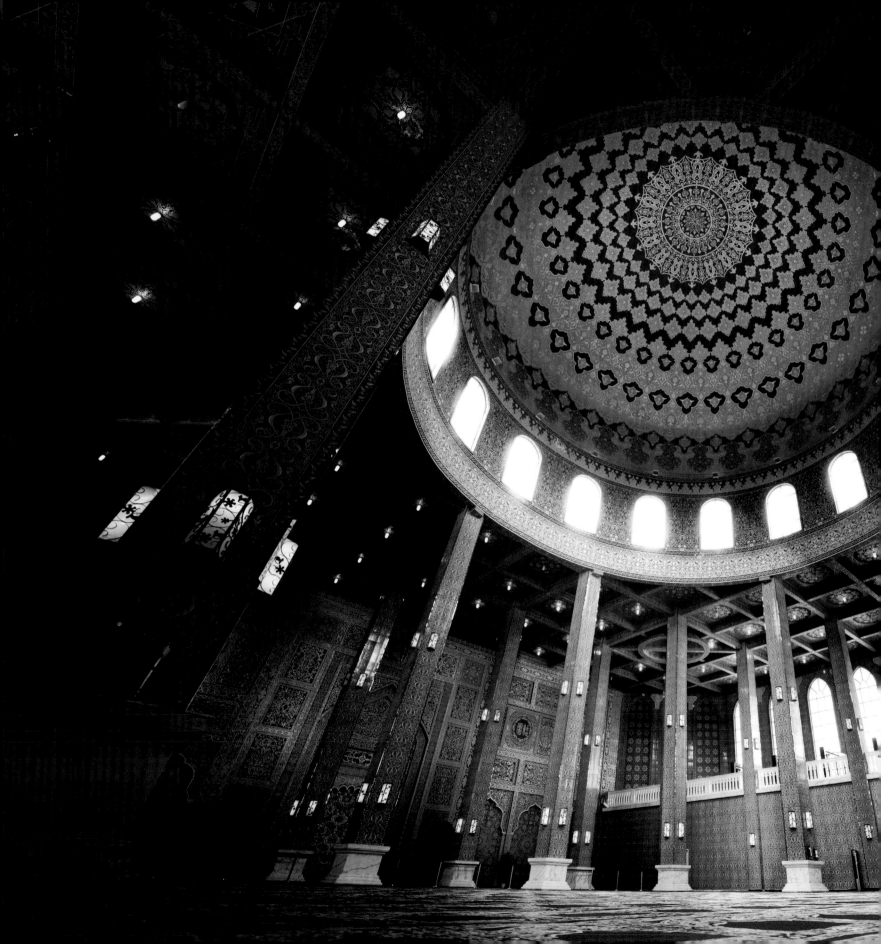

文化園展示了伊斯蘭傳統建築。伊斯蘭建築大量採用拱形和圓頂，其中一個原因，是為大型宗教儀式營造良好的視聽效果和空間感。

Traditional Islamic constructions can be seen in the Cultural Park. Arches and domes are commonly used in Islamic architecture. One of the reasons is to create satisfactory visual and aural effect and special environment for major religious events.

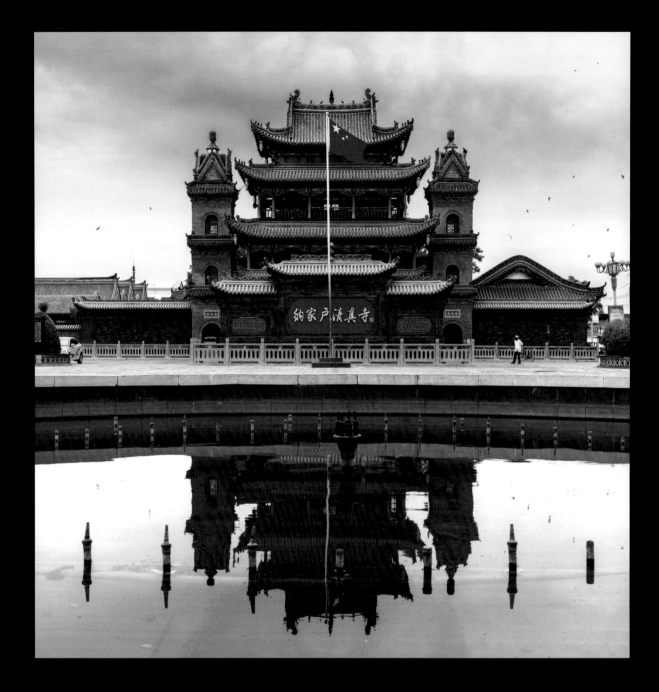

銀川的納家戶清真寺始建於明代，建築為傳統中式古代寺廟風格。（左）每天，都有超過 200 名回民來到這座擁有 500 年歷史的寺廟參拜，每逢重大節日更有多達 3,000 人。（右）

The Najiahu Mosque in Yinchuan is a traditional temple-style construction of ancient China built in the Ming Dynasty. (Left) Every day, more than 200 Hui people come and visit this 500-year-old mosque for Salah. On important festivals, around 3,000 people would gather here. (Right)

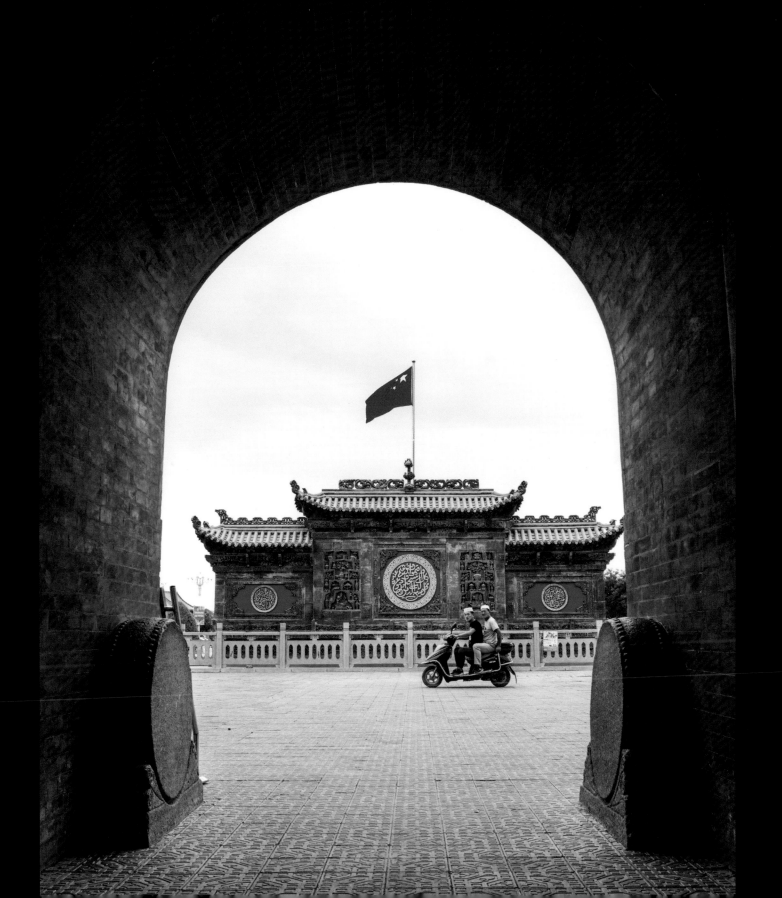

寧夏回族　　Hui in Ningxia

寧夏是中國回族先民最早的聚居地區。在元代（公元 1271 年 - 公元 1368 年），寧夏作為當時重要的屯墾區，大量來自中亞及西亞的穆斯林軍士和他們的家屬被安置至此。據估計，當時的回族先民人數約有 10 萬左右。

1958 年，寧夏回族自治區正式成立。目前，寧夏是全國最大的回族聚居區域，超過 240 萬回民居住於此，佔全區人口的 36%。

每逢伊斯蘭節日，寧夏的主要清真寺都會門庭若市，其中，又以伊斯蘭曆 10 月 1 日開齋節的場面最為震撼。開齋節是穆斯林慶祝齋戒月結束而舉行盛典。

Ningxia was one of the first places in China to be an inhabiting region for the forefathers of Hui. In Yuan Dynasty, Ningxia, as a then major wasteland to be opened up by station troops, had housed a large number of Muslim soldiers and their families from the middle and western Asia. The population of them combined was estimated to be around 100 thousand.

In 1958, Ningxia Hui Autonomous Region was officially founded. At the moment, it is the largest Hui community, with more than 2.4 million of them accounted for 36 percent of the regional population.

Whenever there's an Islamic festival, main mosques in Ningxia would be swarmed with Muslims. Especially on Eid al-Fitr - the first day of Shawwal (the 10th month in Islamic Calendar) to celebrate the end of Ramadan - the scene is astounding for viewers.

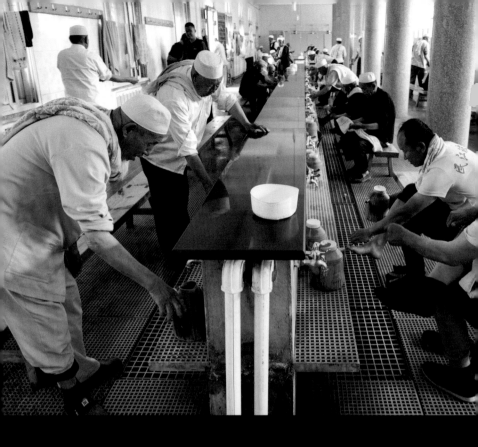

每逢重要活動前，穆斯林都必須「小淨」，以水清洗手、口、鼻孔、胳膊、頭、足等部位，以潔淨的身心進行宗教活動。（左）經過 1400 多年的發展，開齋節已是全球穆斯林重大節日之一，也是穆斯林在長達一個月的齋戒後，為自己能戰勝慾望而歡慶的節日。據專家解釋，齋戒一個月是為了讓富人品嚐飢渴滋味，以戒窮奢極欲、揮霍無度；而要節衣縮食，省錢救濟窮人。（右）

Muslims have to go through "Wudu" right before they attend major religious events, cleaning their hands, mouths, nostrils, shoulders, heads and feet with water to achieve a pure status both physically and mentally. (Left) With a history more than 1,400 years, Eid al-Fitr has become one of the major festivals of Muslims around the world. Muslims celebrate the festival after they have been fasting for a month. According to experts, the month-long fasting is a chance for the rich to experience hunger and thirst, so as to avoid extravagance and profligacy, and save money to help the poor. (Right)

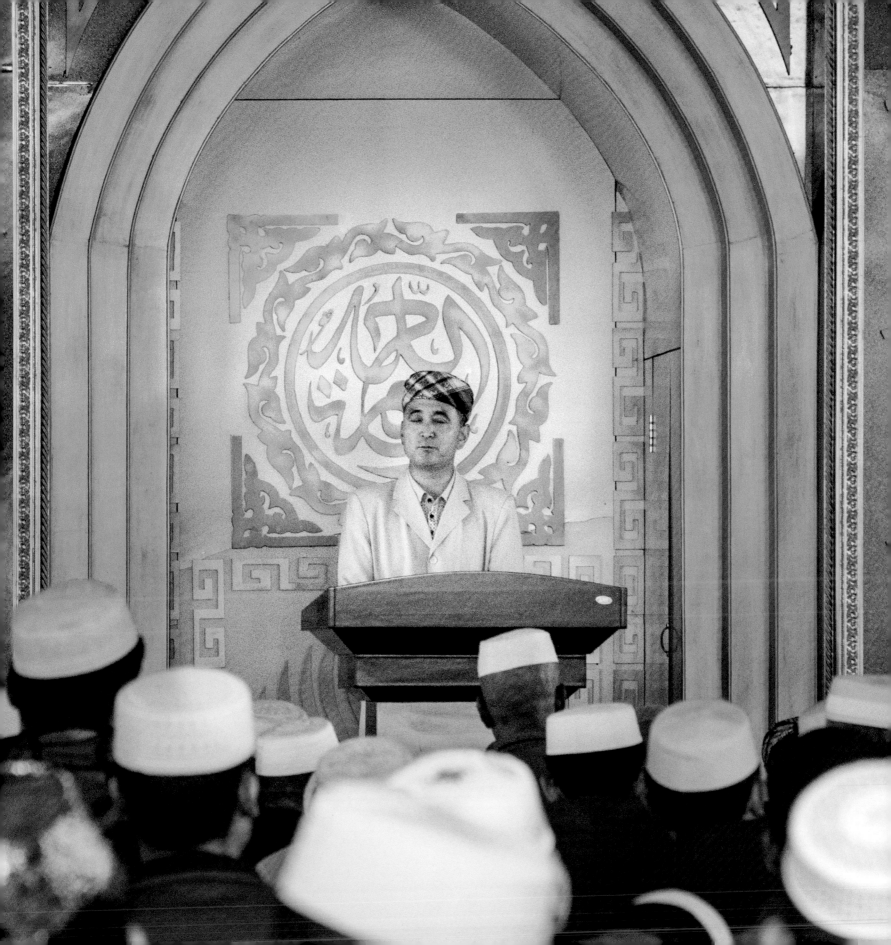

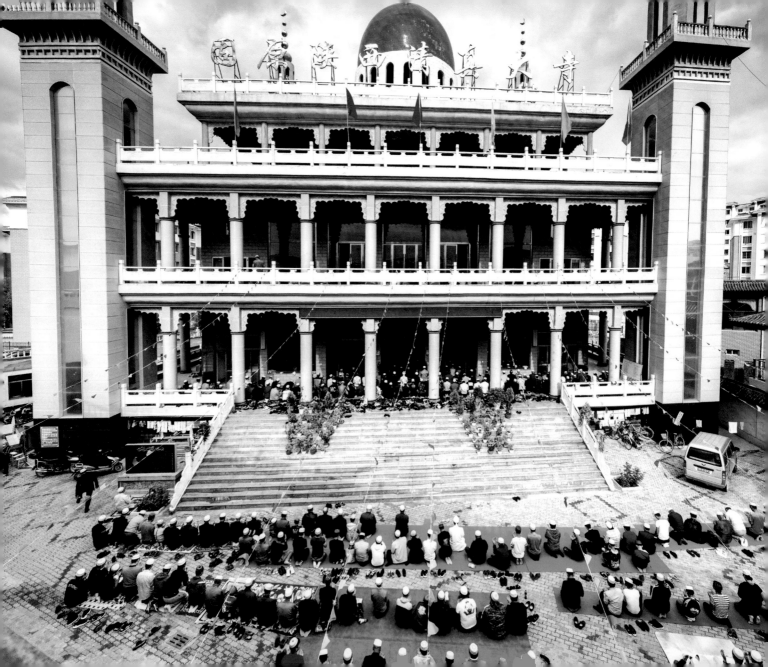

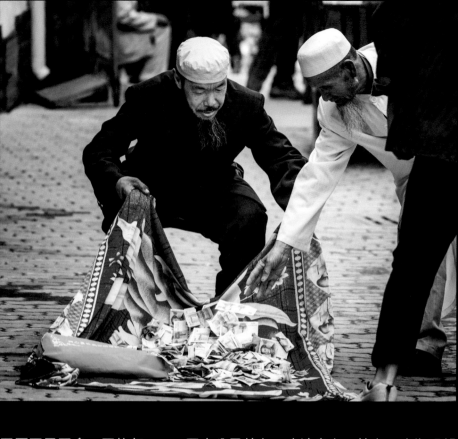

固原回民眾多，平均每 11.46 平方公里就有一座清真寺，其中 6 座為明朝遺跡，428 座建於清代，615 座建於民國。（左）在進行節日的禮拜之前，必須進行開齋捐，資助其他窮困的穆斯林。（右）

A large population of Hui live in Guyuan city, in which there's a mosque in every 11.46 square kilometer on average. Six of them were Ming's remains, 428 were built in Qing, and 615 of them were built before 1949. (Left) Before the Eid prayer, Zakat al-Fitr must be made to help the Muslims in poverty financially. (Right)

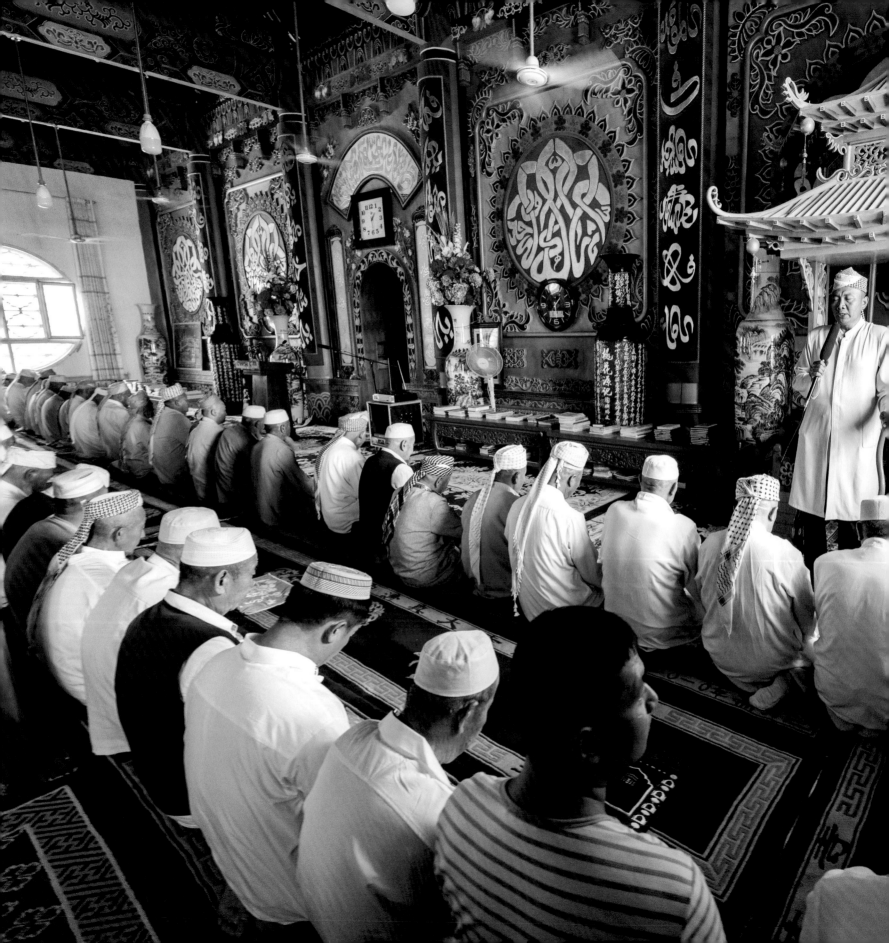

前文曾提及的「阿訇」這個稱謂，如今已逐漸演變成回族對伊斯蘭教中宗教學識較高者的尊稱。由於回族穆斯林大多不懂阿拉伯文，無法對《古蘭經》進行念誦，這時候就需要倚賴阿訇加以講解、引導，許多伊斯蘭宗教活動都在他們的率領之下進行。

The before-mentioned title of "Akhoond" has gradually become what Hui refers to the honorable Islamic people who is erudite in this religion. Most of Hui people cannot read Arabic, causing their difficulty in chanting the Koran. An akhoond is, therefore, responsible for leading them to go through religious events by explaining and guiding.

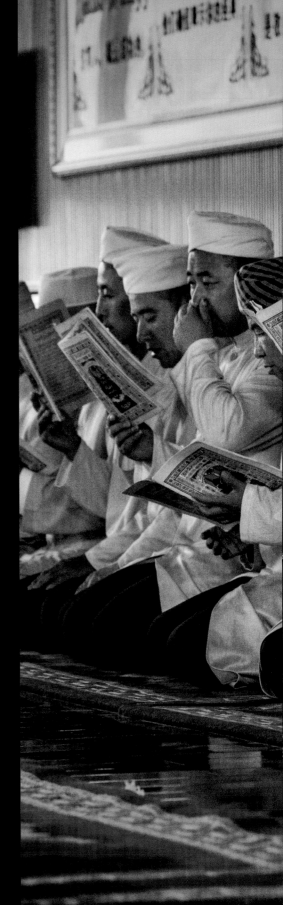

雖然《古蘭經》現已有不同的譯本，但在禮拜期間，穆斯林仍被要求以阿拉伯語誦讀。（左）參加者每人手握一本古蘭經，跟著阿訇誦讀。（右）

Although there are existing translations of the Koran, during the Salah, Muslims are still required to read in Arabic. (Left) Every participant is holding a copy of Koran and read after the Akhoond. (Right)

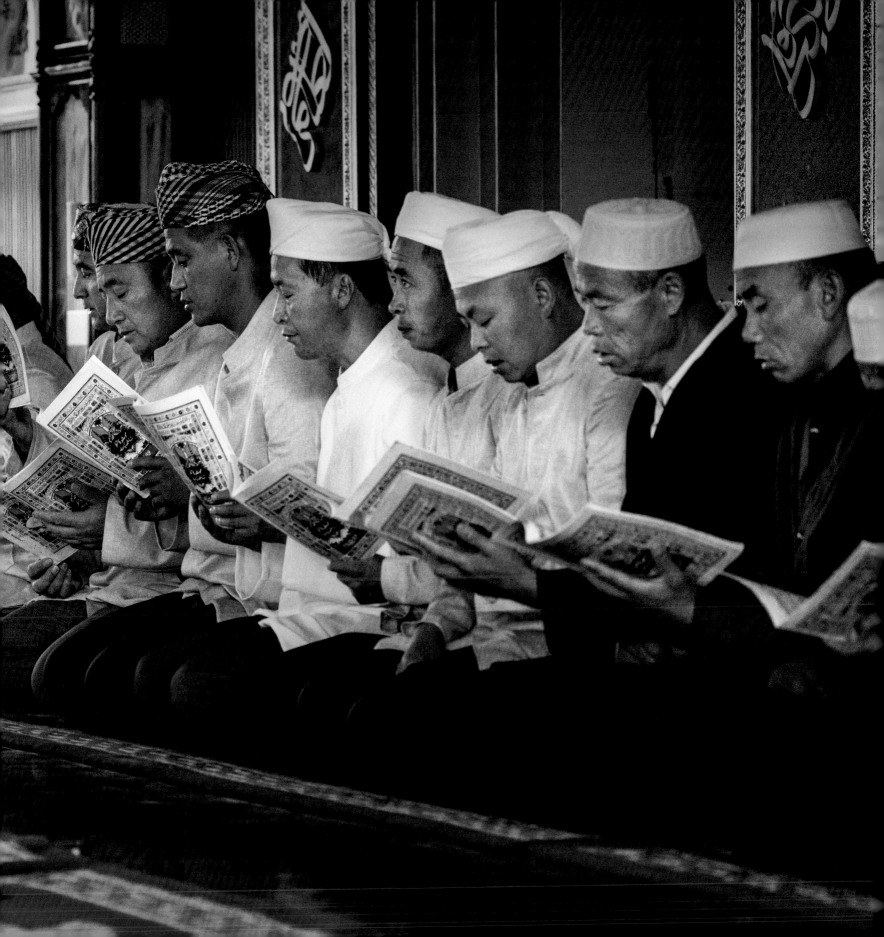

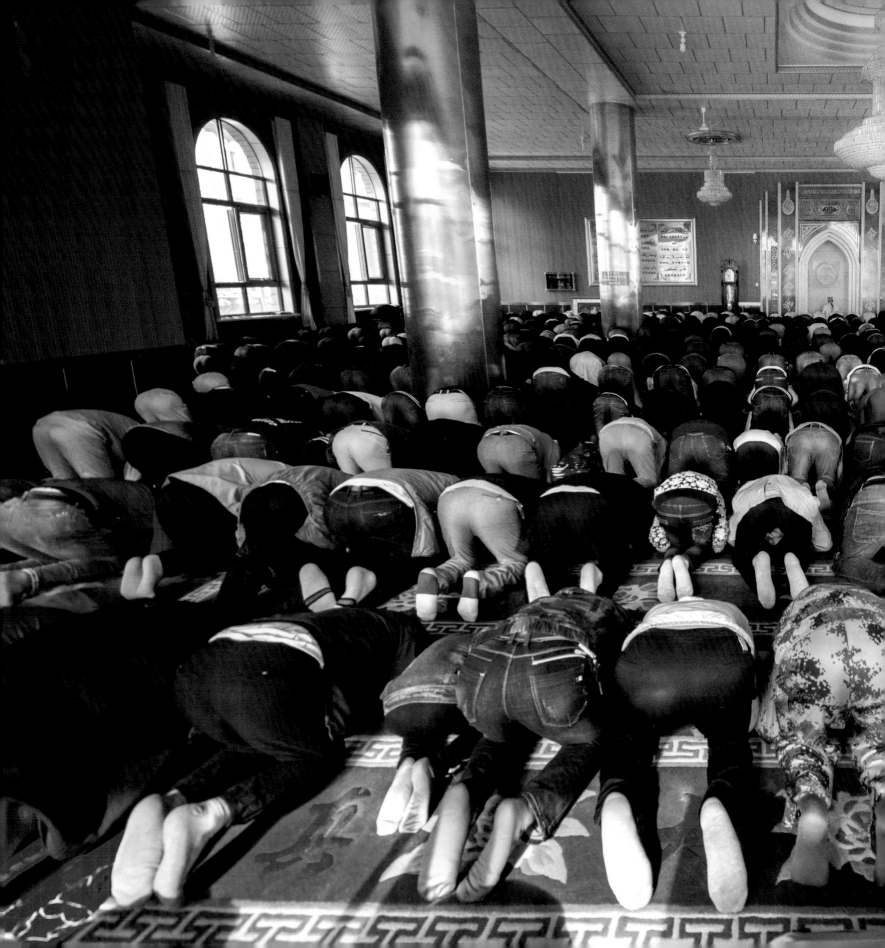

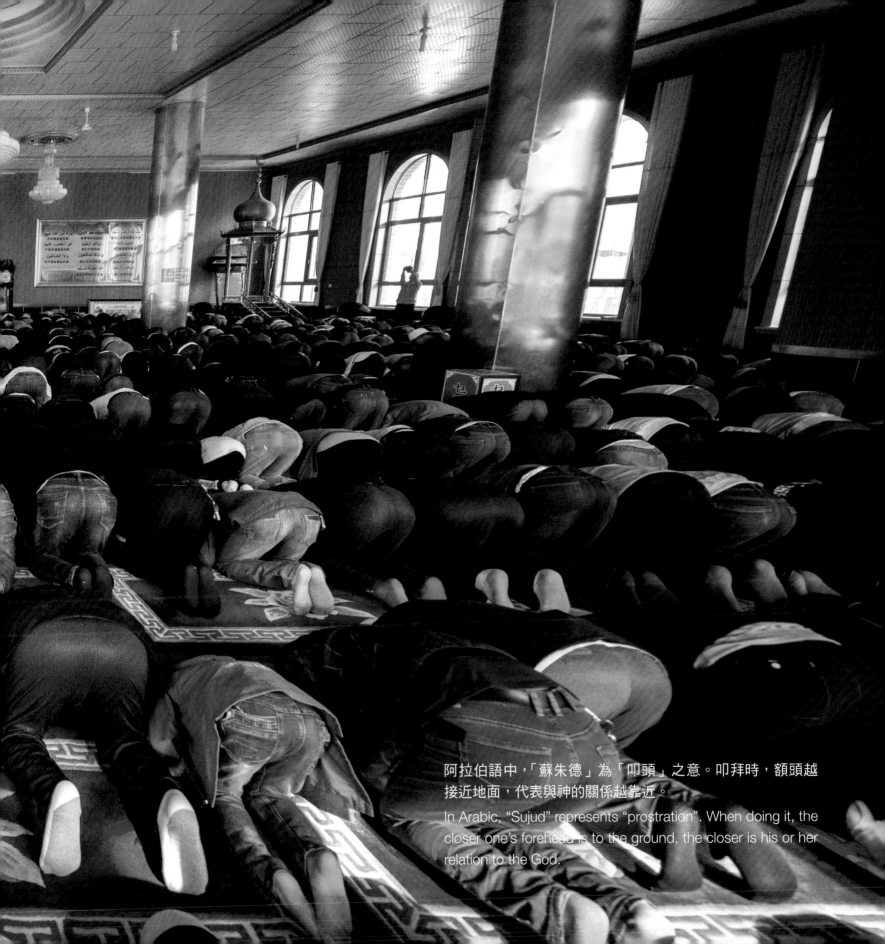

阿拉伯語中，「蘇朱德」為「叩頭」之意。叩拜時，額頭越接近地面，代表與神的關係越靠近。

In Arabic, "Sujud" represents "prostration". When doing it, the closer one's forehead is to the ground, the closer is his or her relation to the God.

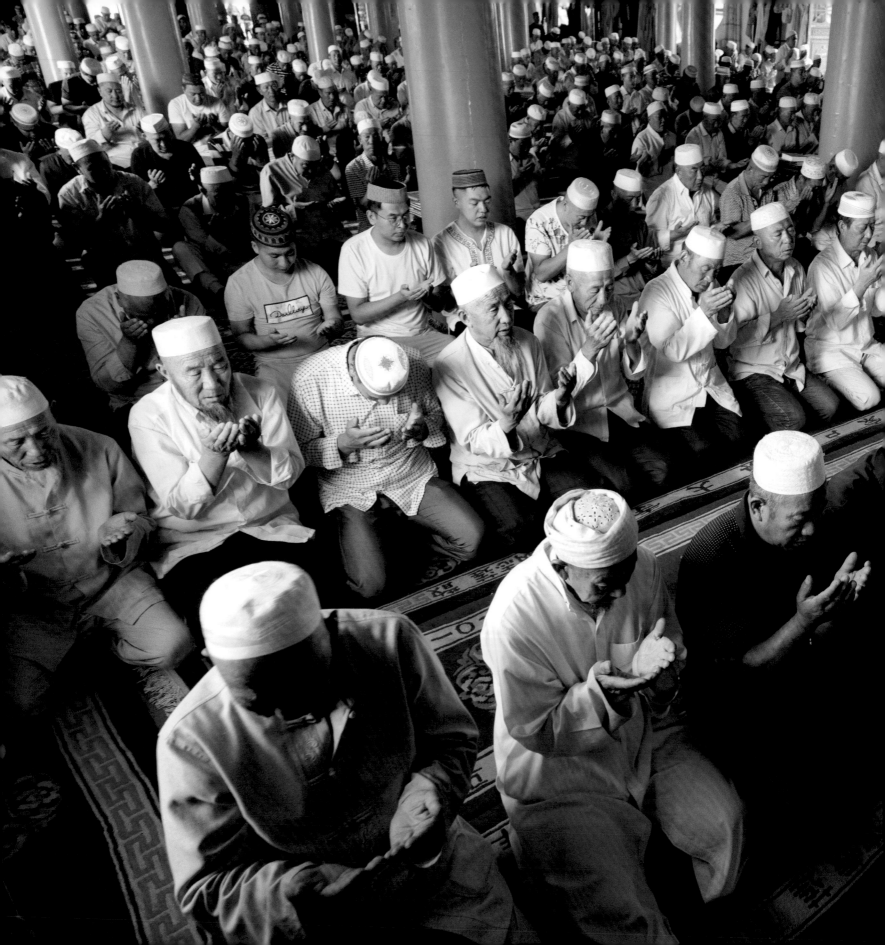

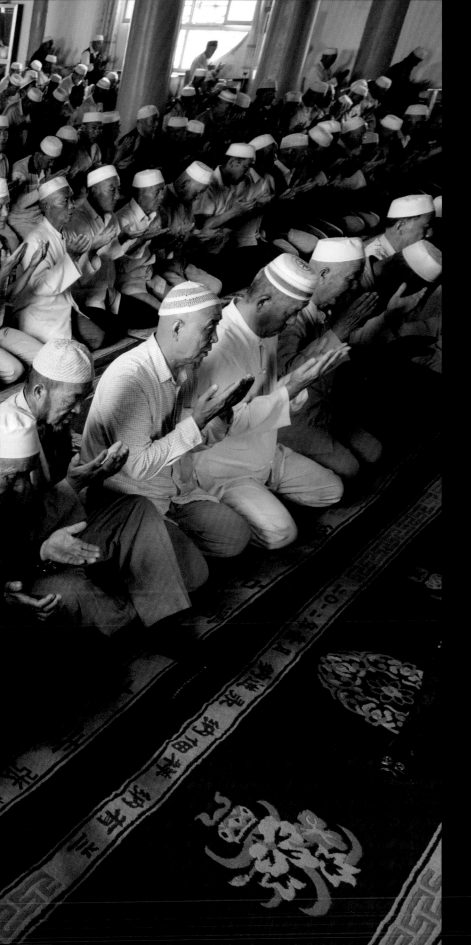

禮拜將要結束之時，回族穆斯林集體做出手心向上的姿勢，最後一次向主祈求自己的心願。

Coming to the end of Salah, Hui Muslims hold their palms upward to make the last prayer to their God.

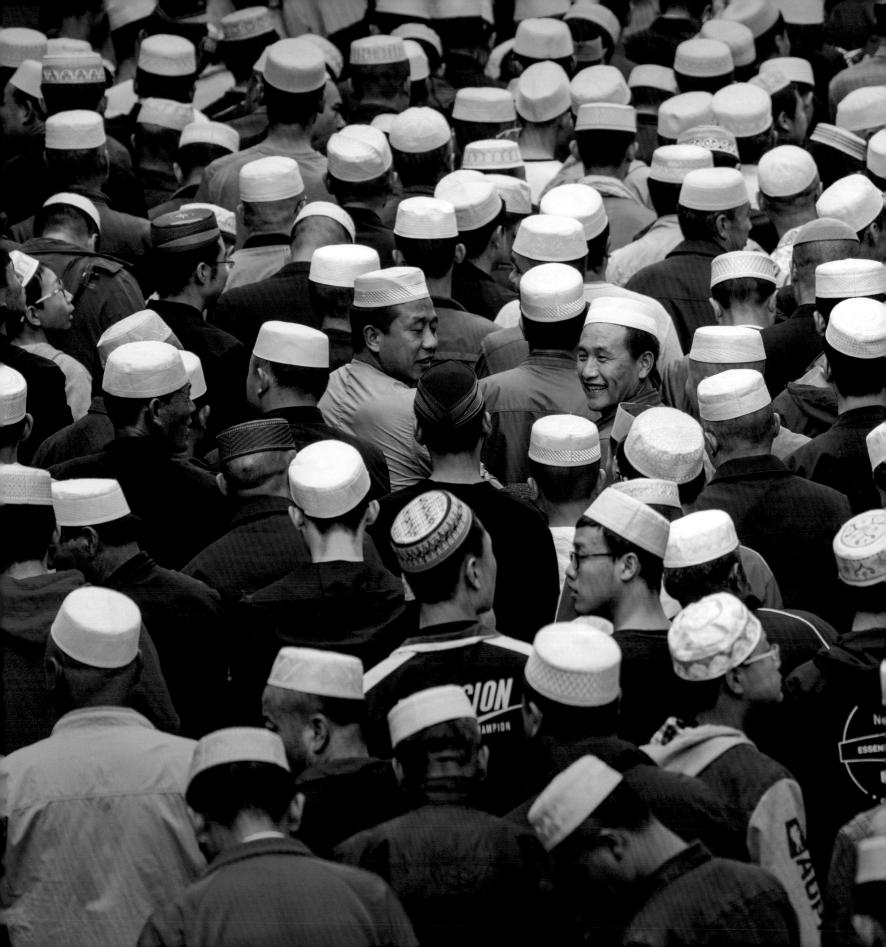

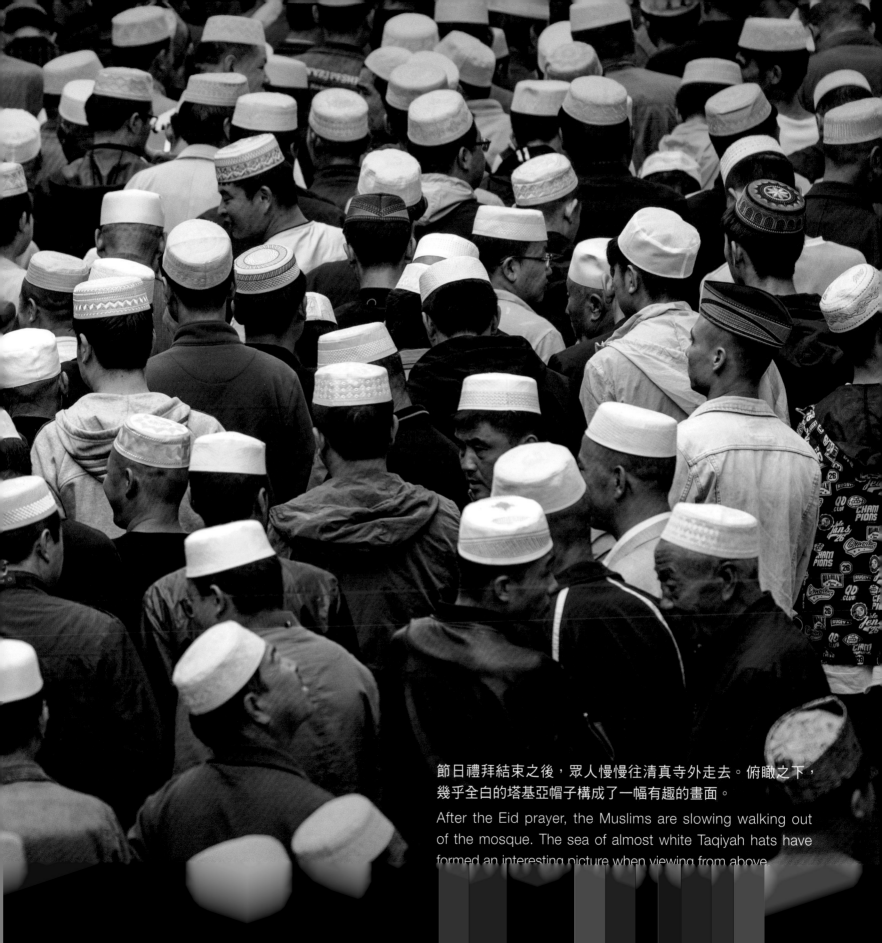

節日禮拜結束之後，眾人慢慢往清真寺外走去。俯瞰之下，
幾乎全白的塔基亞帽子構成了一幅有趣的畫面。

After the Eid prayer, the Muslims are slowing walking out
of the mosque. The sea of almost white Taqiyah hats have
formed an interesting picture when viewing from above.

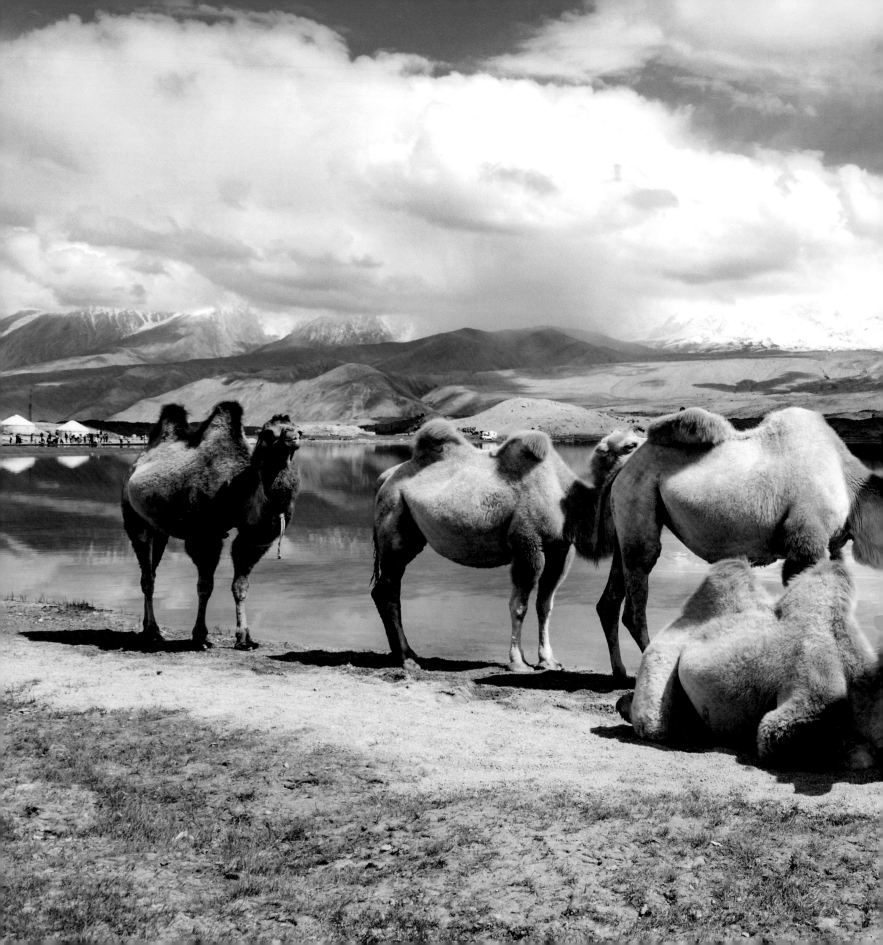

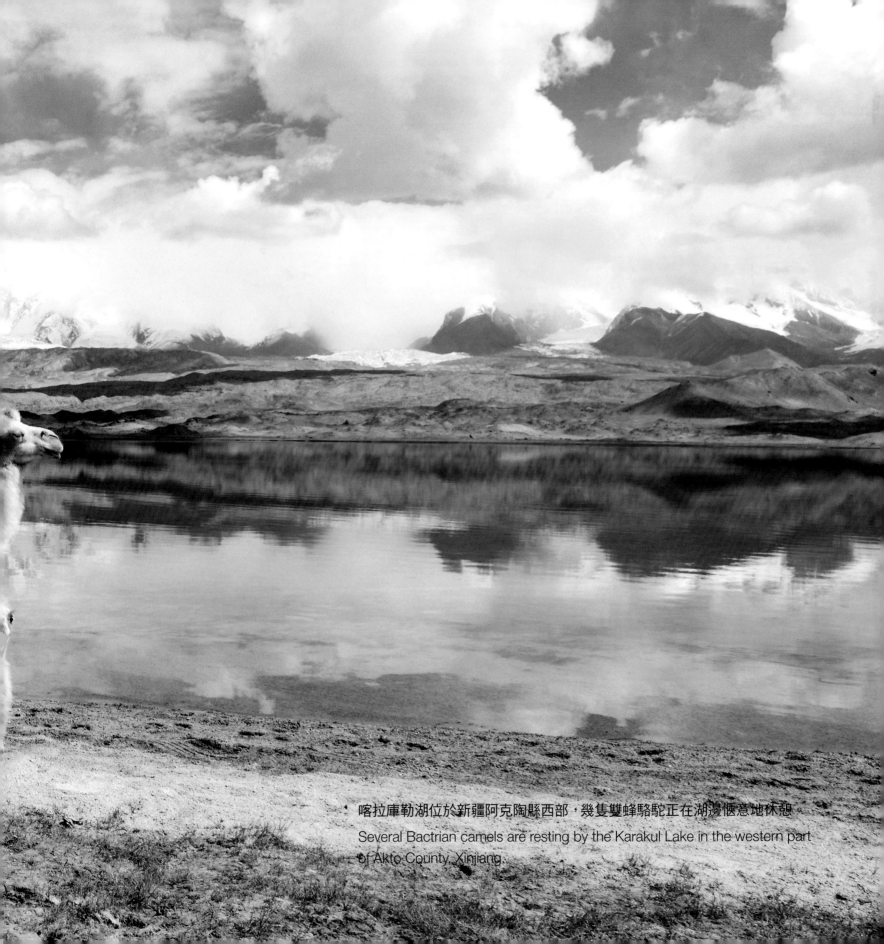

喀拉庫勒湖位於新疆阿克陶縣西部，幾隻雙蜂駱駝正在湖邊愜意地休憩。
Several Bactrian camels are resting by the Karakul Lake in the western part of Akto County, Xinjiang.

維吾爾族　Uyghurs

維吾爾族和回族，是中國兩大信奉伊斯蘭教的少數民族，也因此，兩個民族在節日、飲食、信仰等方面都有一定的共同之處。

然而，他們的區分還是十分明顯。從外貌上，維吾爾族中高鼻樑、大眼睛的樣貌不在少數，符合歐羅巴人種的特徵；從聚居地區來看，維吾爾族主要聚居在新疆及湖南省桃源縣地區；從語言文字方面來看，他們主要使用維吾爾語及以阿拉伯字母為基礎的文字體系；而從歷史起源上來看，維族在中國可追溯的歷史更為久遠，最早可在漢代（公元前 202 年—公元 220 年）的史冊中發現這個民族的音譯名。

1955 年，新疆維吾爾自治區正式成立。

Uyghurs and the Hui are two main ethnic minorities who practice Islam. Therefore, it is common for these two ethnicities to share in common some festivities, cooking culture, religion, and so on.

Their differences, however, are not to be missed. From their facial appearances, many Uyghurs have narrow noses and big eyes, complying with the features of the Caucasian race. Judging from the inhabiting region, the Uyghurs live mainly in Xinjiang and Taoyuan County in Hunan Province. Linguistically speaking, they speak Uyghur language and the writing system is based on Arabic alphabets. And from the historical point of view, Uyghurs have a longer traceable history for some similar transliteration has be found in records from the Han Dynasty (202 BC-220 AD).

In the year of 1955, the Xinjiang Uyghur Autonomous Region was officially established.

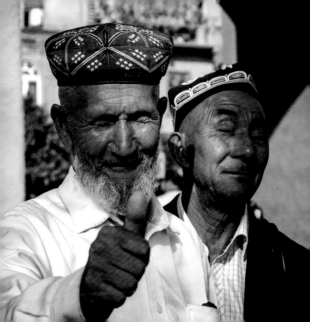

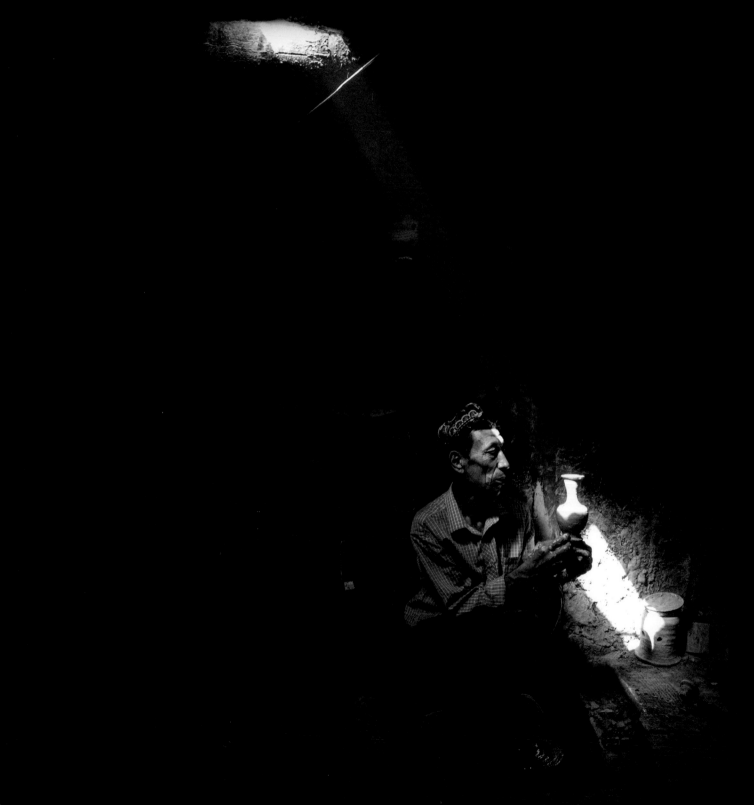

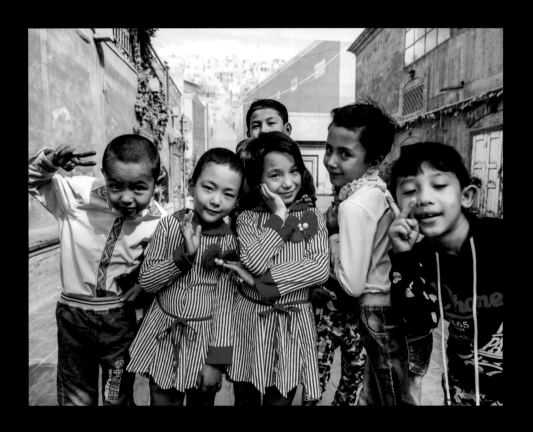

新疆土陶燒製技藝已經流傳多年，但如今卻越來越少手藝人熟悉這個技術。也許只有在古城中能找到他們堅持的工匠精神。（左）喀什卡爾古城內的孩童天真活潑。（右）

The technique of firing potteries is a legacy in Xinjiang, yet today, less and less workman are familiar with it. Maybe the persistent craftsmanship can now only be found in the old town. (Left) Children in Kashgar Old City are unsophisticated and lively. (Right)

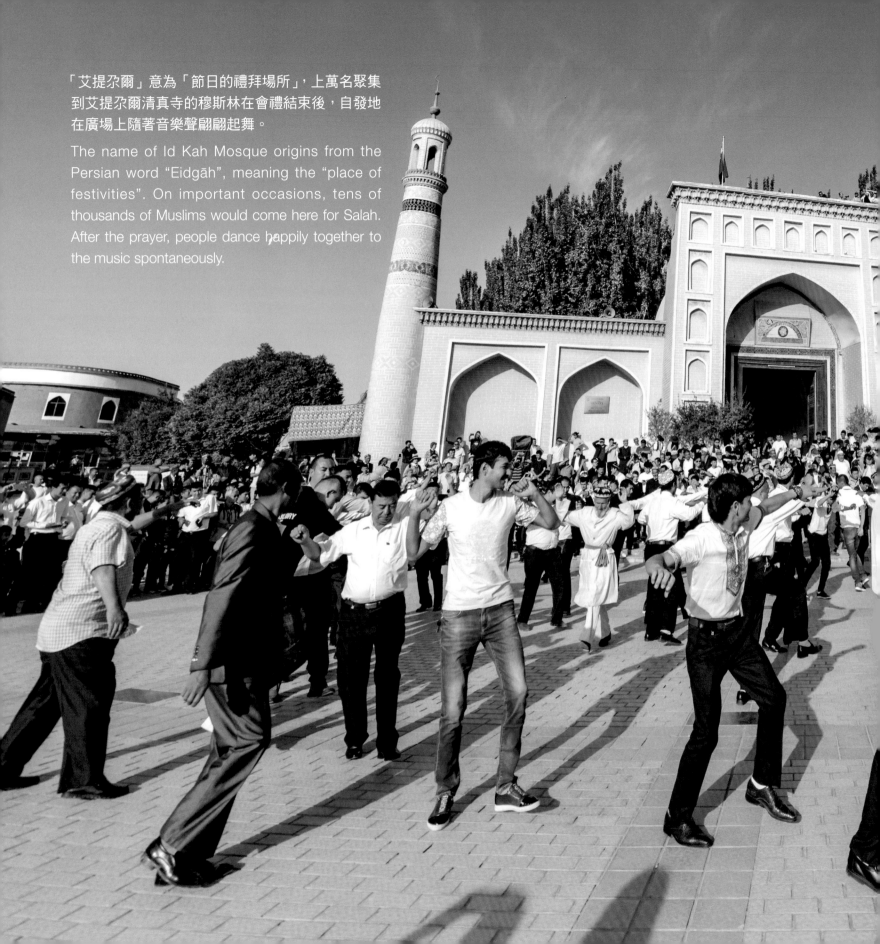

「艾提尕爾」意為「節日的禮拜場所」，上萬名聚集
到艾提尕爾清真寺的穆斯林在會禮結束後，自發地
在廣場上隨著音樂聲翩翩起舞。

The name of Id Kah Mosque origins from the
Persian word "Eidgāh", meaning the "place of
festivities". On important occasions, tens of
thousands of Muslims would come here for Salah.
After the prayer, people dance happily together to
the music spontaneously.

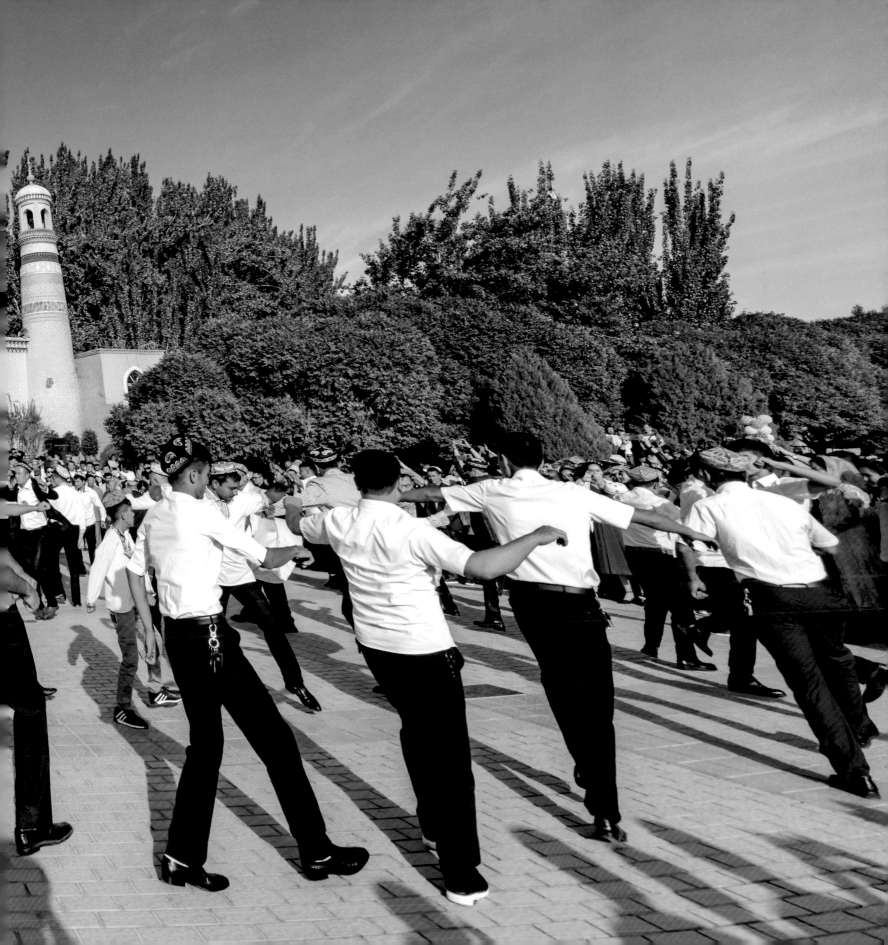

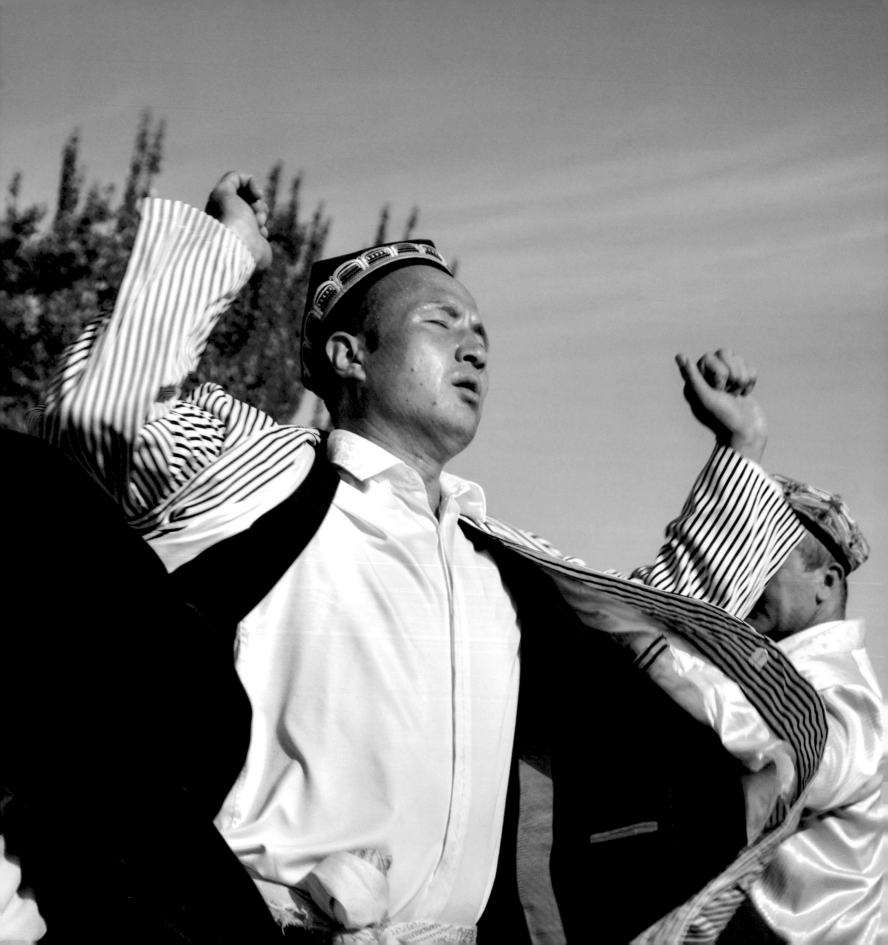

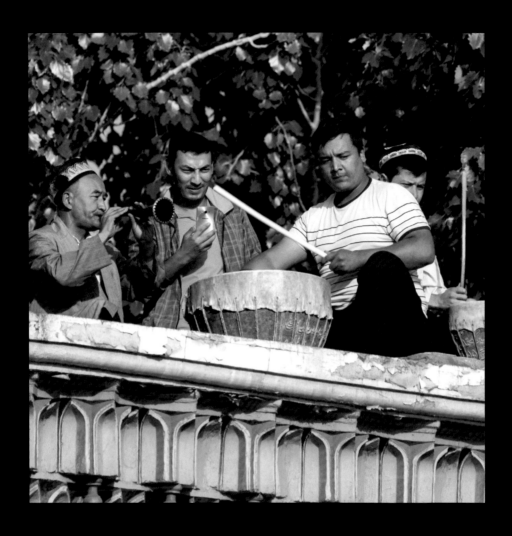

一名男子邊跳舞邊忘我地閉上了雙眼，享受節日的歡樂氣氛。（左）清真寺屋頂之上，一個小型樂隊正奏著歡快的樂聲。（右）

Immersing himself in the joyous festive atmosphere, a man is dancing while closing his eyes. (Left) At the rooftop of the mosque, a band is playing pieces of lively music. (Right)

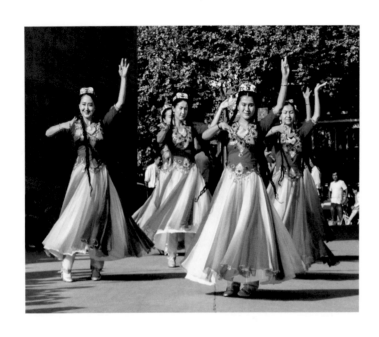

維吾爾的民族舞蹈以活潑靈巧著稱，賦有濃郁的波斯風格。（左）在古城入口處，每天都有舞蹈表演。（右）

Uyghur folk dance is famous for its liveliness and dexterousness, which is similar to the style of Persian dance. (Left) Uyghur dancers put on performances every day at the entrance of the Old City. (Right)

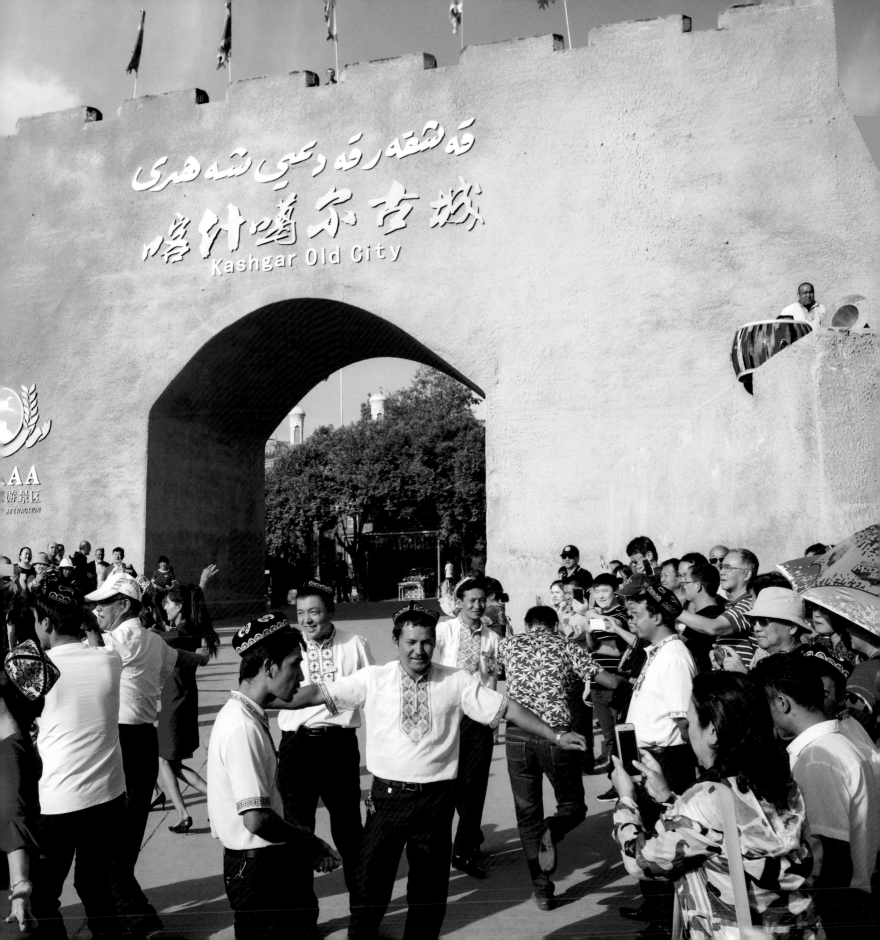

露天市集之上,為迎接宰牲節的到來,不少維吾爾族人正在買賣牲口。

In preparation for the "Festival of Sacrifice", Uyghur people are trading livestock at the open-air market.

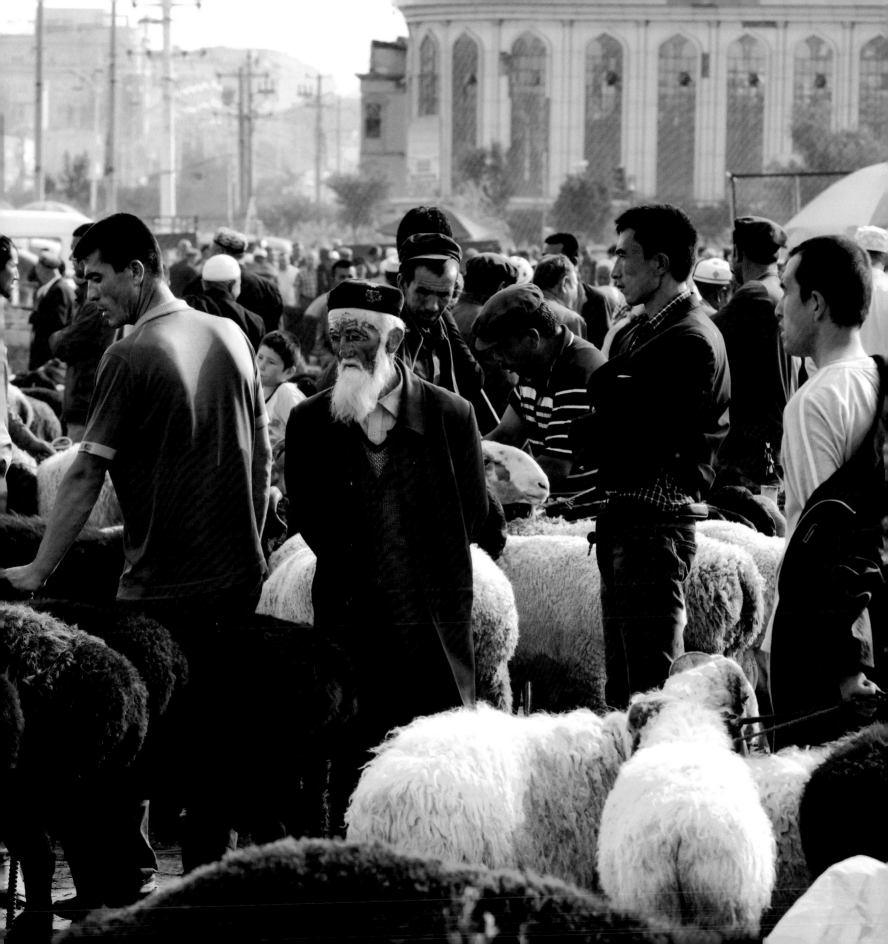

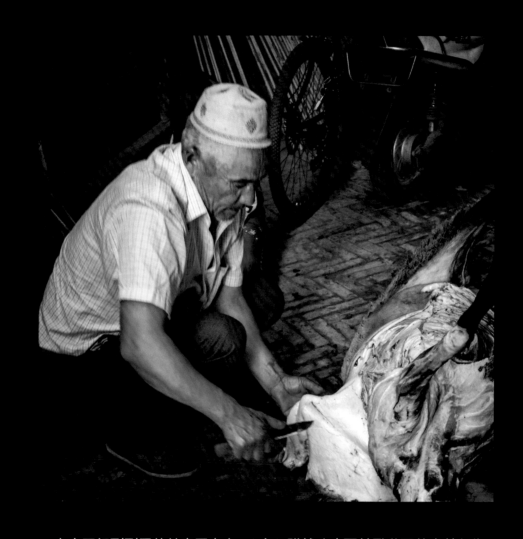

一家人正把剛剛買的羊牽回家中。（右）雖然政府不鼓勵私下的宰牲行為，但部分傳統的穆斯林仍會偷偷在家中進行。（左）

A family is bringing home the sheep they just bought. (Right) Although slaughtering a sheep in private is not encouraged by the government, some traditional Muslims would still do it secretly. (Left)

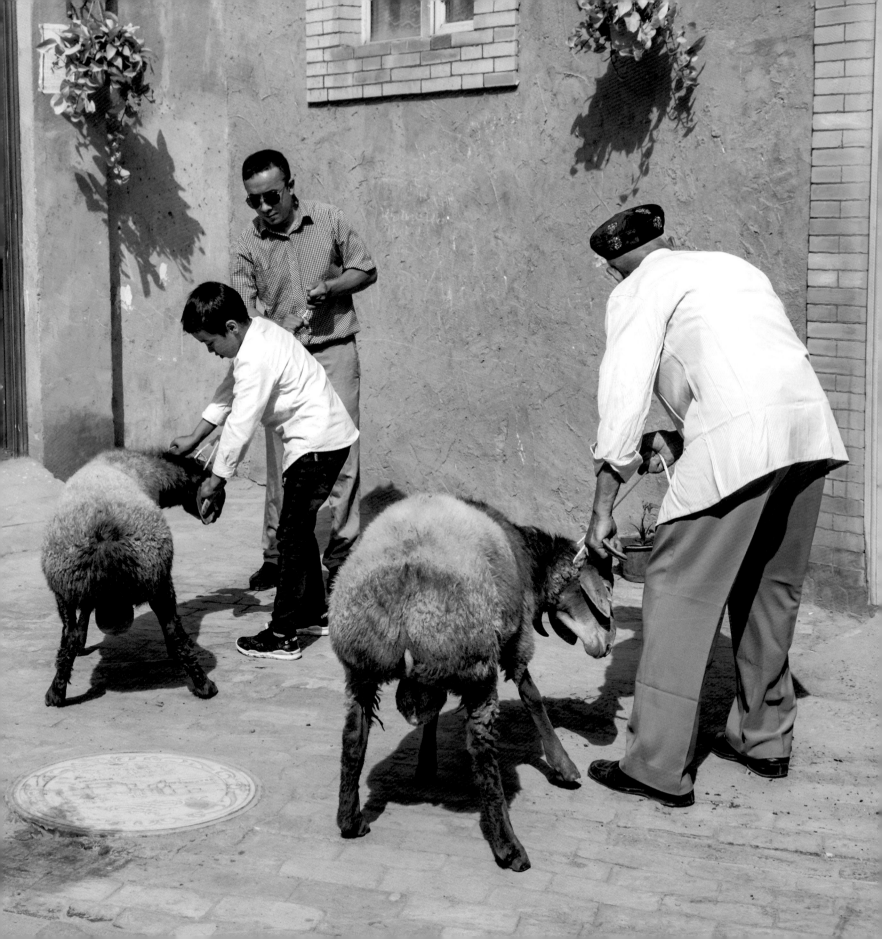

古爾邦所宰殺的牲口，其肉通常要被分為三份，
分別留作自用、送給親友及贈予窮人及有需要
者。

The meat from the sacrificed animal at Eid al-Adha shall be divided into three parts. The family retains the first share; another share is given to relatives and friends; and the remaining is donated to people in poverty or with needs.

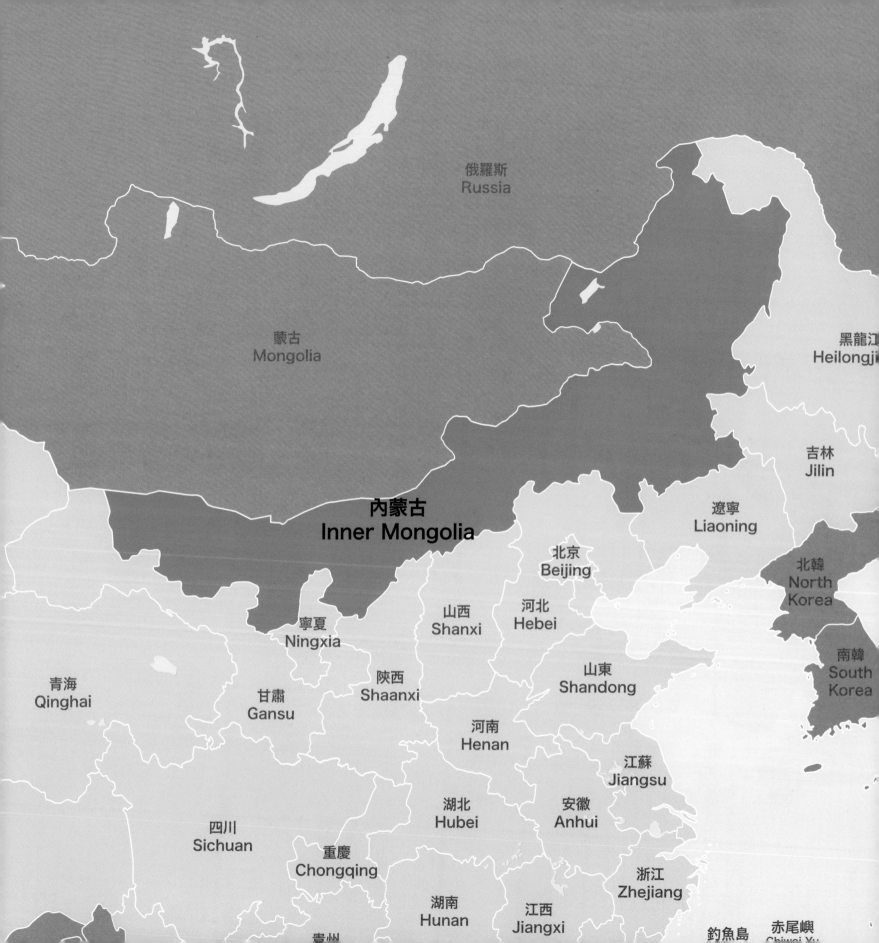

草原風情
The Majestic Grassland

內蒙古自治區位於中國的北部，對外與俄羅斯及蒙古國接壤，對內毗鄰八個省份，橫跨東北、華北和西北三大區域，是東西跨度最大的省區。首府是「呼和浩特」，而最大城市是「包頭」。

內蒙古是多民族的聚居地，主要人口是漢族，約佔八成，最主要的少數民族自然是蒙古族，人數超過四百萬，約佔全區人口的 17%。

這片佔中國國土總面積 12% 的土地，海拔由 600 至 1,400 米不等，擁有森林、草原、沙漠、湖泊、溫泉、火山遺跡等眾多景觀，自然資源豐富，夏季可身處在「風吹草低見牛羊」的綠意盎然之中，冬季則可欣賞「千里冰封，萬里雪飄」的北國風光。

Inner Mongolia Autonomous Region is at the north of China. Neighboring outbound to Russia and Mongolia and inbound to eight different provinces, it stretches over three large areas, including the Northeast, North China and the Northwest. This provincial region spans over the most lines of longitudes in the country. Hohhot is its capital and Baotou its largest city.

As an inhabiting region for multiple nationalities, most of its population are Han people, taking up about 80 percent of the entire population. Among the ethnic minorities, Mongolian is naturally the largest minority group. The 17 percent of residents are Mongolian, more than 4 million people.

The region occupies 12 percent of the national area, and its altitude ranges from 600 to 1,400 meters. Abundant with natural resources, this piece of land is offering its visitors splendid sceneries of forests, grasslands, deserts, lakes, hot springs, volcanic relics, and so on... In summertime, you'll be able to immerse yourself in the vigorous green, and in the gentle breeze you can see the herds of animals hidden among the flouring prairie. When winter comes, you are able to admire a silver planet here with thousand miles of frozen ice and whirling snow.

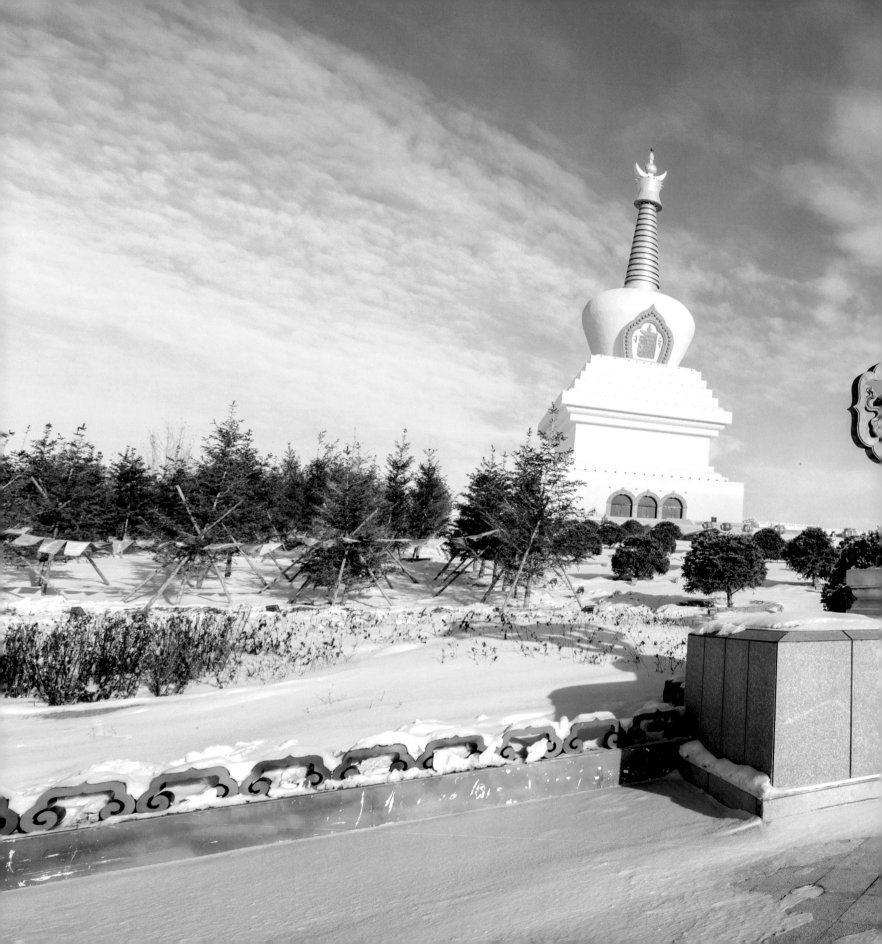

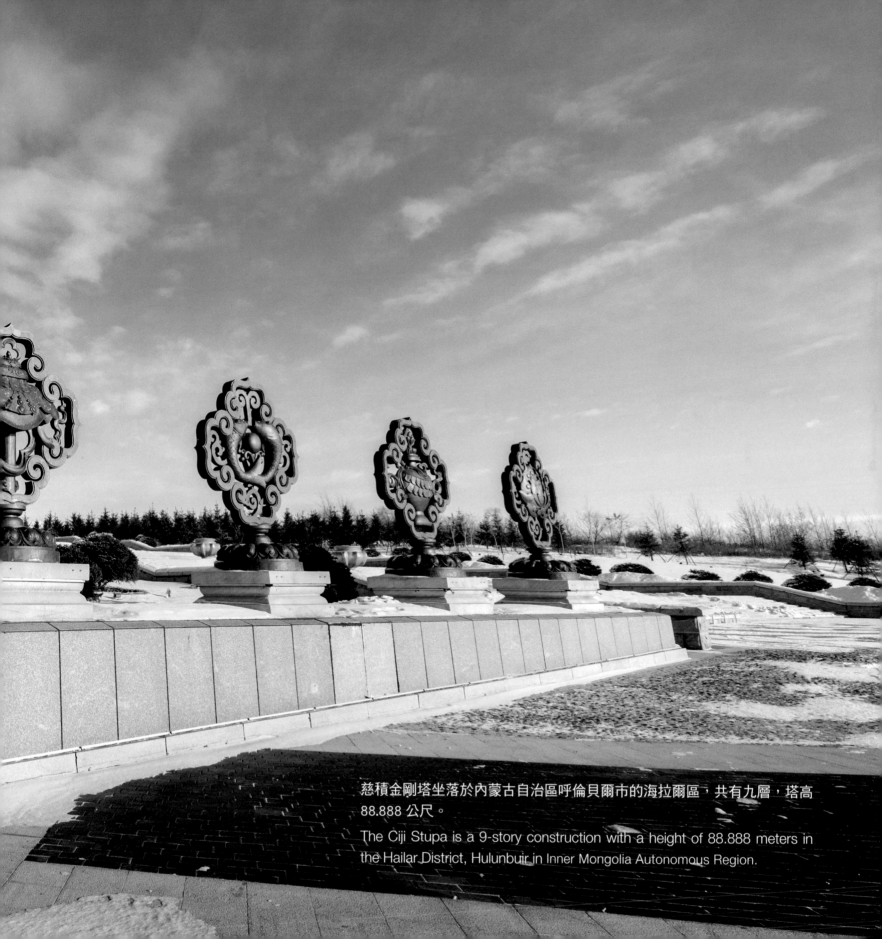

慈積金剛塔坐落於內蒙古自治區呼倫貝爾市的海拉爾區，共有九層，塔高88.888公尺。

The Ciji Stupa is a 9-story construction with a height of 88.888 meters in the Hailar District, Hulunbuir in Inner Mongolia Autonomous Region.

蒙古族

蒙古族是東北亞地區的主要民族之一，全球範圍內約有一千萬人口，主要生活在中國、蒙古國和俄羅斯。我國蒙古族的分佈以內蒙古自治區為主，部分居住在新疆以及東北三省。

在歷史上，蒙古族先民分散在蒙古高原之上、逐水草而居的眾多遊牧民族部落，都曾受到突厥的統治。部落之間並不把對方視為自己的同族之人，反而常因搶奪資源而發生衝突。直至 1206 年，鐵木真統一了各個部落，結束了草原上連年的戰爭，並把自己所在的部落名稱「蒙古」作為所有部落的統稱。由此，這個部落共同體才逐漸形成了一個新的民族共同體：蒙古族。

在中國的歷史上，蒙古族所統治的元朝（公元 1271 年 -1368 年）為中國與其他國家進行通商貿易創造了的條件，亦奠定了元代至清朝（公元 1271 年 -1912 年）國家長期統一的政治局面，也推動中國成為一個多民族統一的國家。

在 13 世紀初，處於統治階級的蒙古族根據回鶻、吐蕃等民族的文字確立了自己的文字系統。許多今時今日仍能看到的傳統藝術、生活習俗、節日慶典等，也在這個時期創立，當中就包括那達慕大會。

那達慕在蒙語中意為「遊戲」或「娛樂」，是蒙古族一年一度的傳統體能運動競技節日，一般在夏季舉行。但近年來，不少部族亦會在冬季舉行冰雪那達慕，讓蒙古男兒一展英勇及強悍。

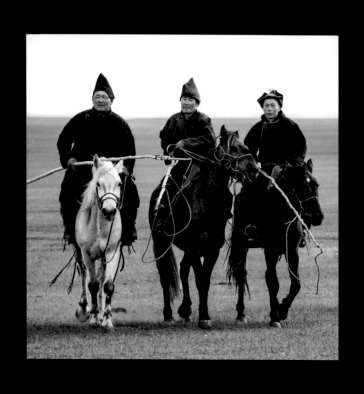

Mongols

The Mongols are a northeast Asian ethnic group. Globally, there are approximately 10 million Mongols, mainly in China, Mongolia and Russia. In our country, the group lives dominantly in Inner Mongolia in our country, while a small part of them also resides in Xinjiang and the three provinces in northeast China.

According to history, the ancestors of the Mongols are numerous groups of nomads scattering around the Mongolian Plateau who were once ruled by the Turkics. Instead of treating others as people from the same ethnicity, they often collide with each other for limited resources. It was not until 1206 when Genghis Khan unified all tribes on the Plateau did the continuing conflicts come to an end. He used the name of his tribe "Mongol" to designate the Mongolic tribal confederation. Since then, this community gradually turned into a new ethnicity: the Mongols.

In the history of China, the governance of Mongols in the Yuan Dynasty (1271-1368 AD) has created a favorable condition for business and trading between China and foreign countries, laid the foundation of long-term unification from Yuan to Qing (1271-1912 AD), and has also propelled our country to be a unified multinational state.

In the 13th century, the ruling class Mongols had created their writing system according to those of Hui and Tibetan. Many of the existing traditional arts, habits and customs, festivities originated during that period can still be seen today, including the Naadam.

Naadam in Mongolian has the meaning of "game" and "entertainment". It is an annual event for Mongols to hold traditional competitive sports meetings, which generally takes place in summer every year. In recent years, however, in order to demonstrate the bravery and sturdiness of Mongol men, winter Naadams are also held by different tribes.

從古至今，駱駝都被視為吉祥的象徵，蒙古族素來有養駝的習俗。

Since old times, as signs of luck, camels are kept as livestock by the Mongols.

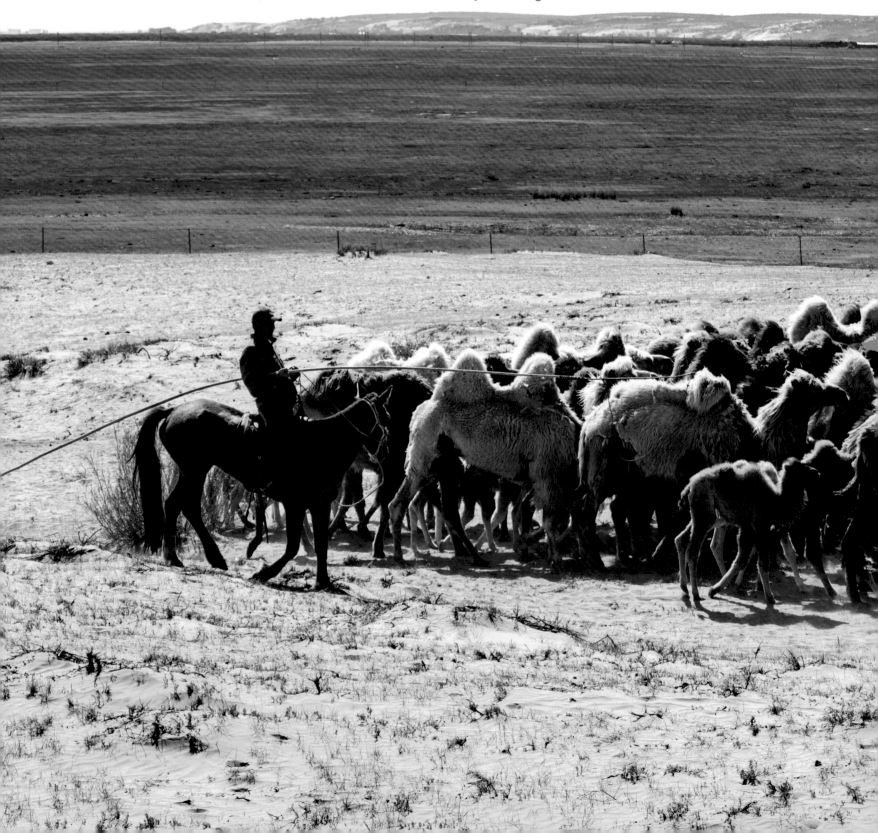

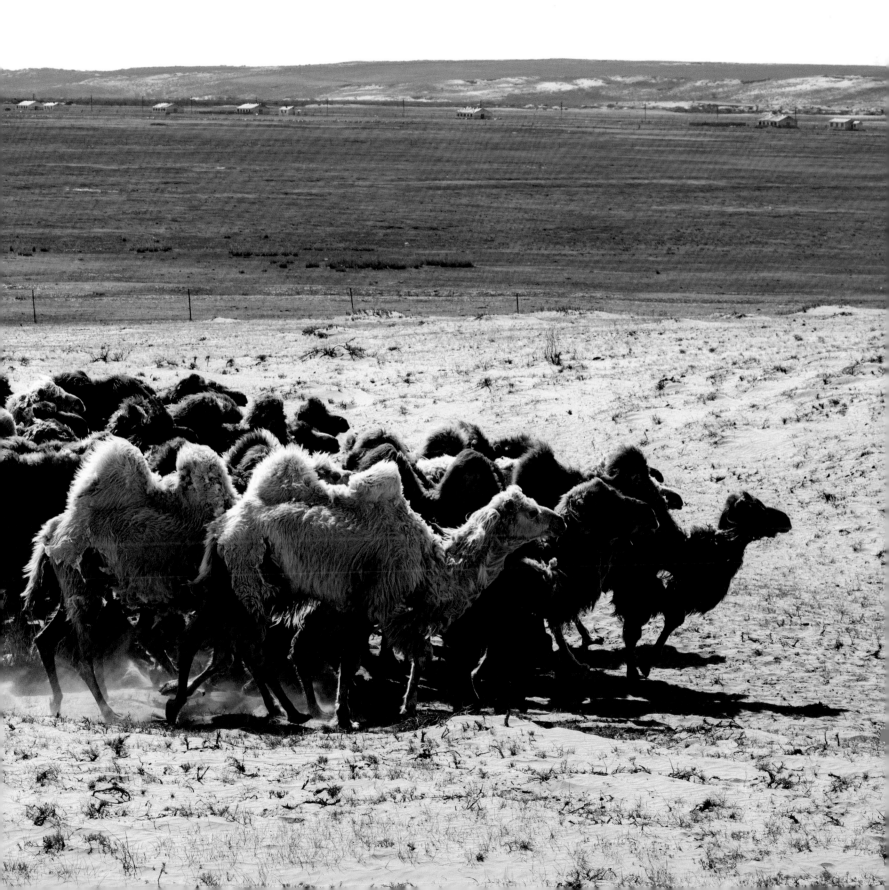

蒙古包的建造、拆除和搬遷都十分方便，不僅限於蒙古族，而在遊牧民族之間皆十分常見。

Mongolian yurts are easy to build, demolish and remove. It is a common residence for nomads, including but not limited to Mongols.

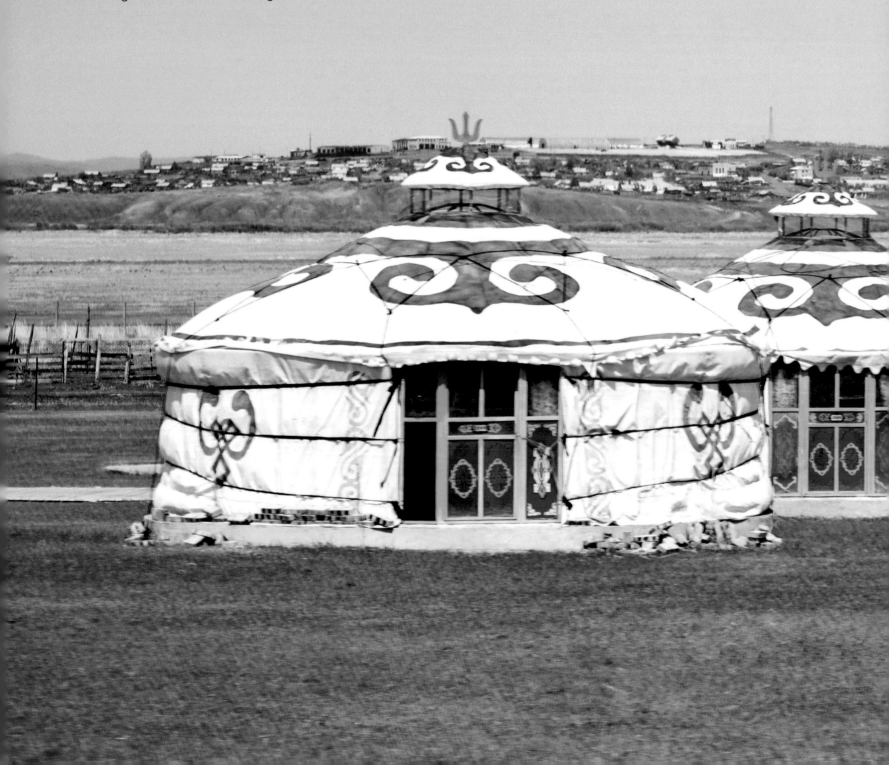

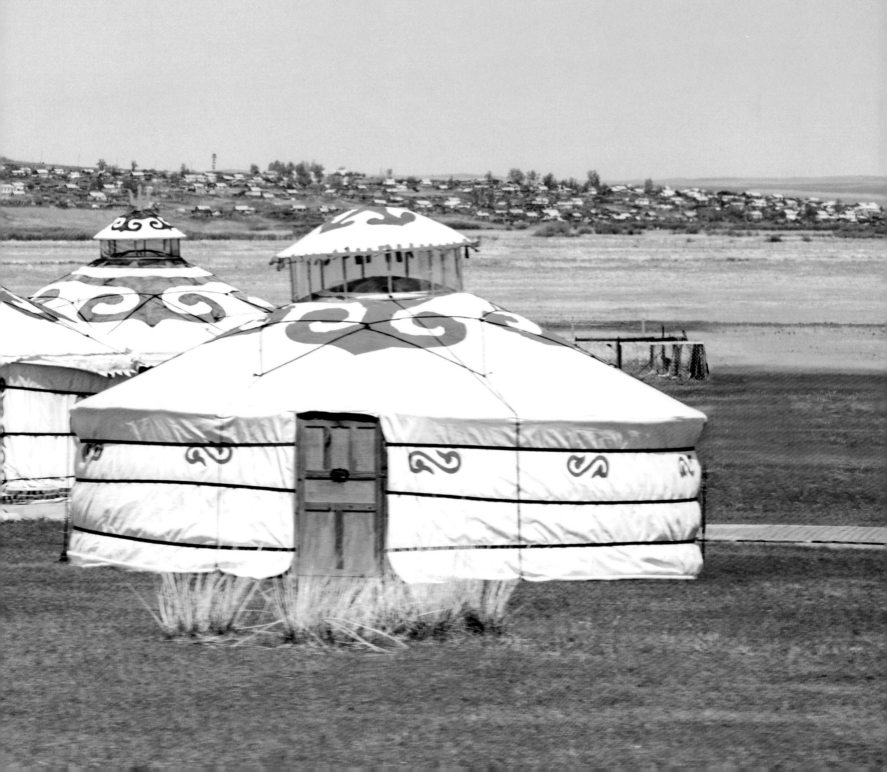

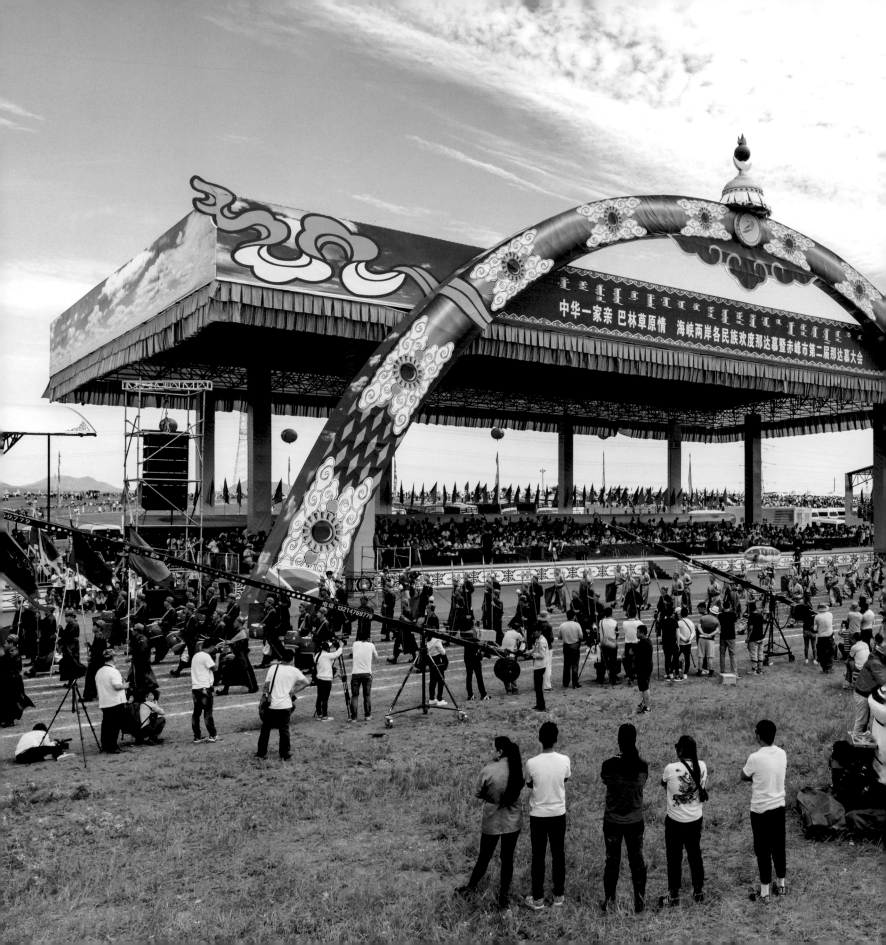

在內蒙古，不同部落都會舉辦自己的那達慕大會。為推動民族文化，位於內蒙古東部的赤峰市亦積極參與舉辦活動。赤峰是內蒙古人口最多的地級市，那達慕大會的規模尤為宏大，場面壯觀。那達慕歷史悠久，早在 11 世紀已有相關記錄，是蒙古族在長期游牧生活中，創造和流傳下來的、具有獨特民族色彩的競技項目和遊藝、體育項目。過去，在那達慕舉行期間，蒙古人還要進行大規模祭祀，焚香點燈、念經頌佛，祈求神靈保佑。而現代那達慕上會進行摔跤、賽馬、射箭、套馬、蒙古棋等項目，一些地方還會還有田徑、拔河、籃球等體育項目。

In Inner Mongolia, different tribes hold their individual Naadam. As the prefecture-level city with largest population in Inner Mongolia, Chifeng City hosts its own Naadam in order to promote folk culture, and it is especially magnificent in scale and has spectacular scenes. Naadam has a long history, which can be dated back to the 11th century. During their long-term nomadic life, Mongols have created and passed down Naadam as a unique ethnic sports and entertainment event. In the past, large-scale ritual activities are often seen in Naadams to pray for the blessing of the God. Modern Naadams included wrestling, horse racing, archery, Mongolian chess, and etc. At some occasions, general sports such as track and field, tug-of-war, and basketball competitions can also be found.

成吉思汗帶領著他的蒙古鐵騎征戰四方，使蒙古帝國擴張成為一個橫跨歐亞兩洲且在歷史上鄰接版圖最為遼闊的國家。那達慕大會的開幕式之上，有蒙古族人裝扮作成吉思汗及其軍隊，可見對民族英雄的崇敬。

Genghis Khan had led his Mongolian army to other countries, establishing the Mongol Empire, which later became the largest contiguous land empire in history that extends from Asia to Europe. At the opening ceremony of Naadam, Mongols dress themselves as Genghis Khan and his army to show respect to their hero.

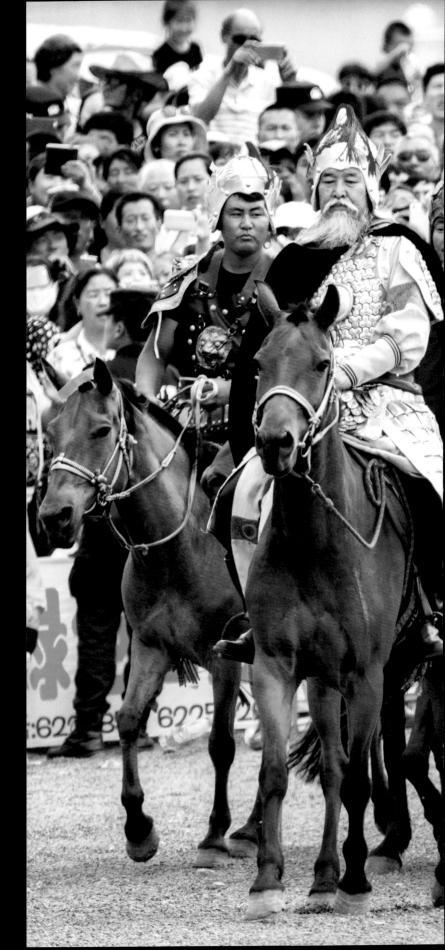

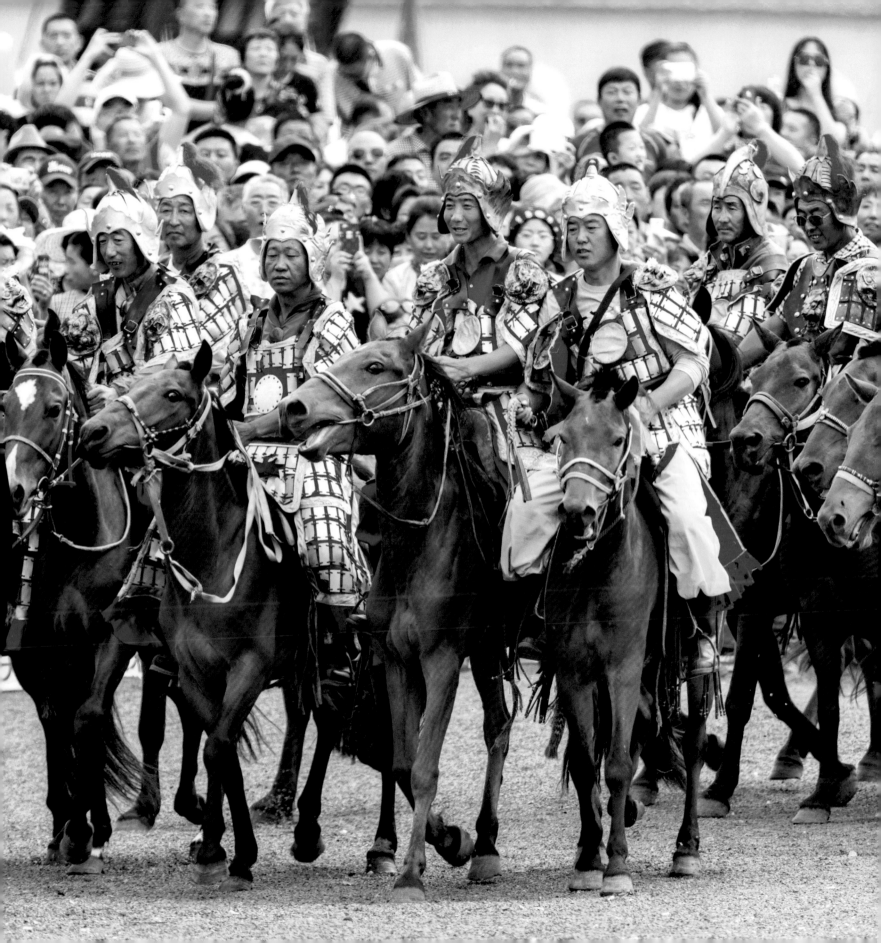

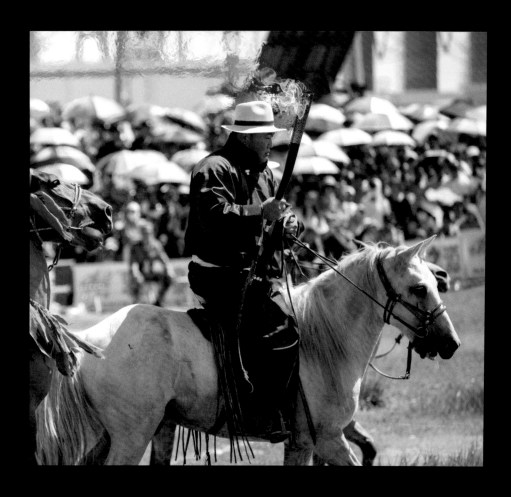

根據史書的記載，「蒙古」的意思為「永恆之火」，因此蒙古族對火也十分
崇拜。（左）那達慕開幕式之上，浩浩蕩蕩的蒙族男女騎著駿馬入場。（右）

"Mongol" has the meaning of "eternal flame" according to historic records,
so the Mongolian people also worship fire. (Left) At the opening ceremony
of Naadam, Mongolian men and women march in to the venue in great
procession. (Right)

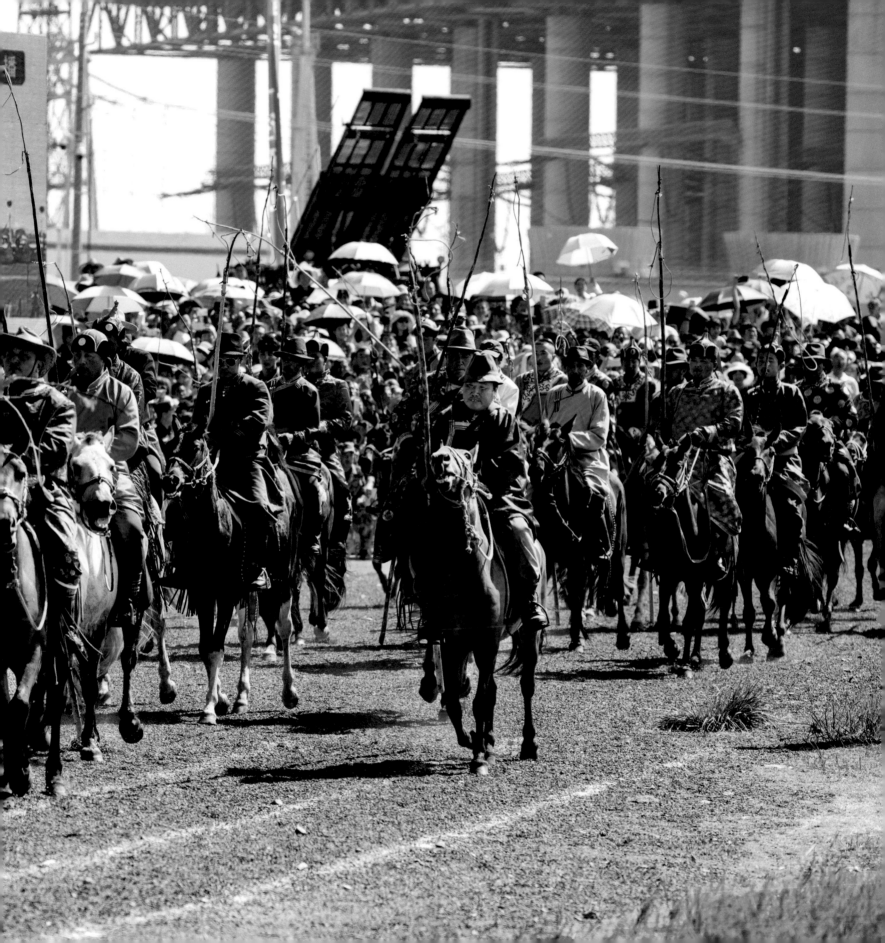

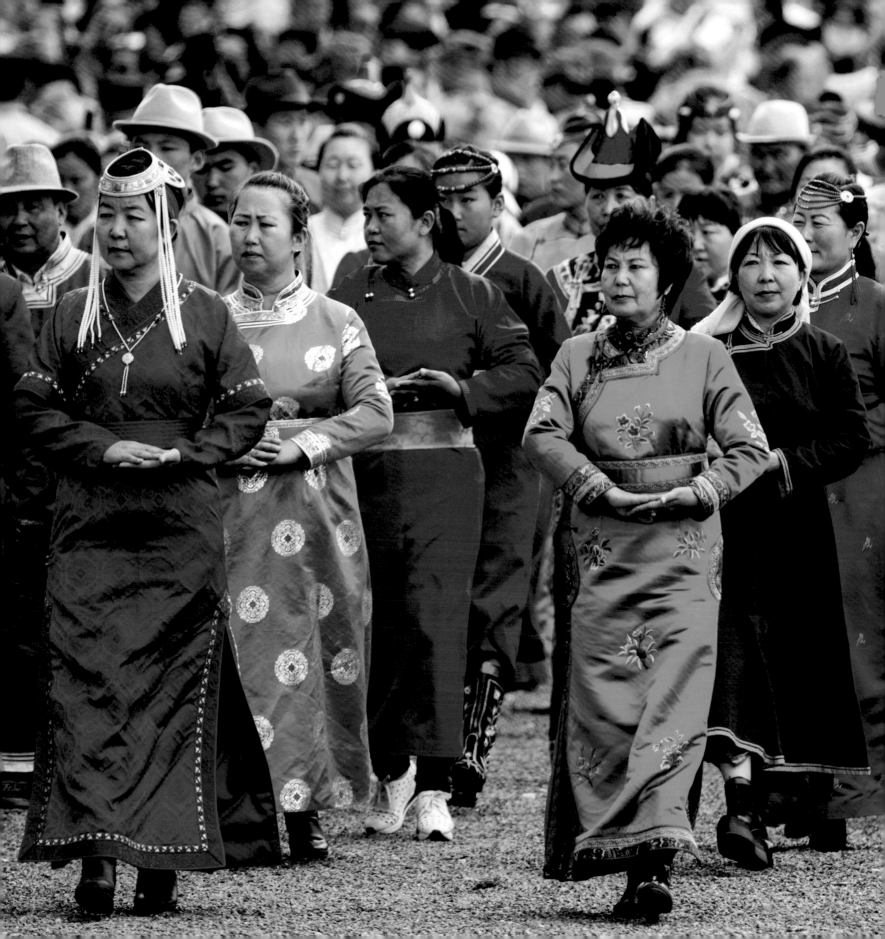

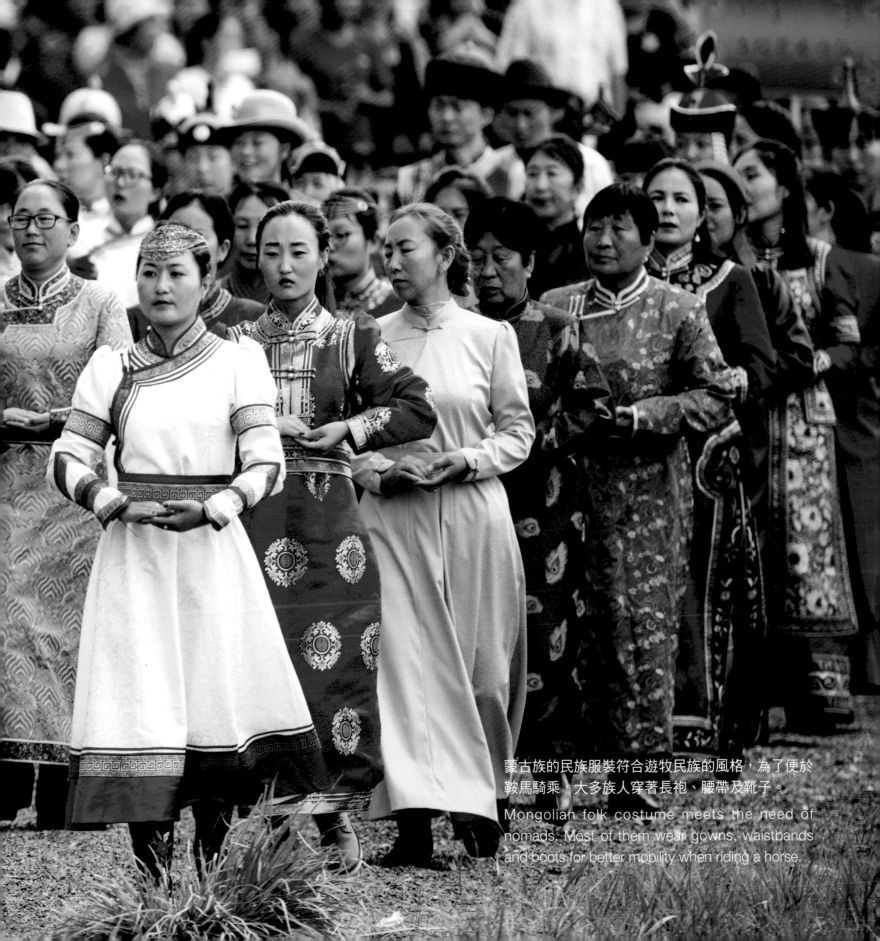

蒙古族的民族服裝符合遊牧民族的風格，為了便於鞍馬騎乘，大多族人穿著長袍、腰帶及靴子。

Mongolian folk costume meets the need of nomads. Most of them wear gowns, waistbands and boots for better mobility when riding a horse.

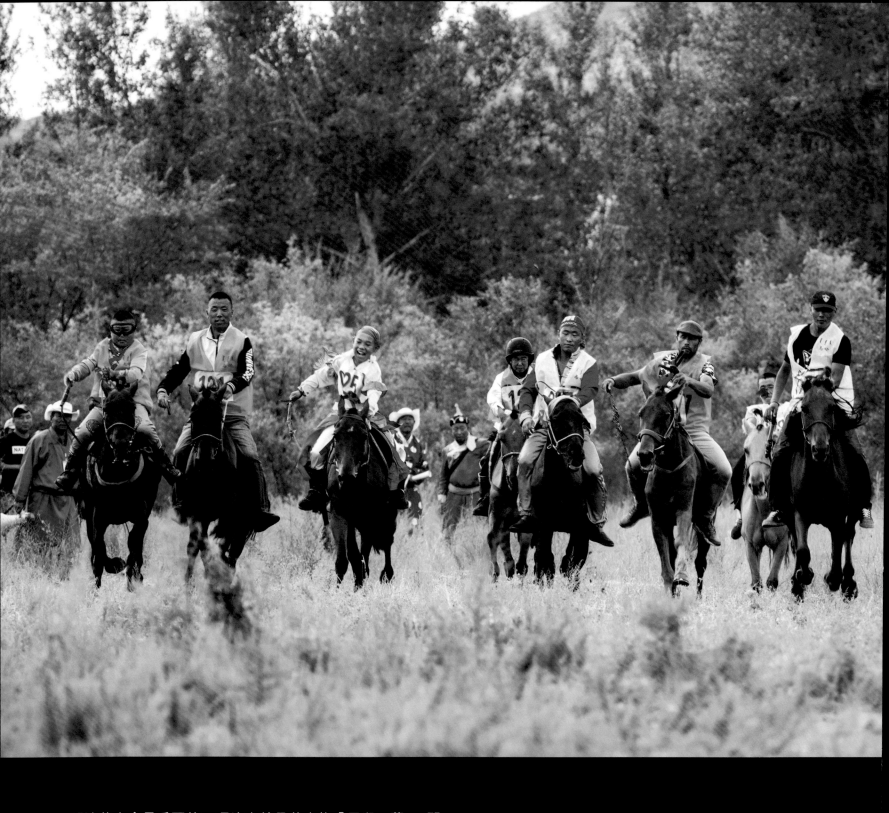

那達慕大會最重要的三項比賽就是蒙古族「男兒三藝」，即
摔跤、射箭及賽馬，蒙古族男子自幼便習馬術，因此在賽馬

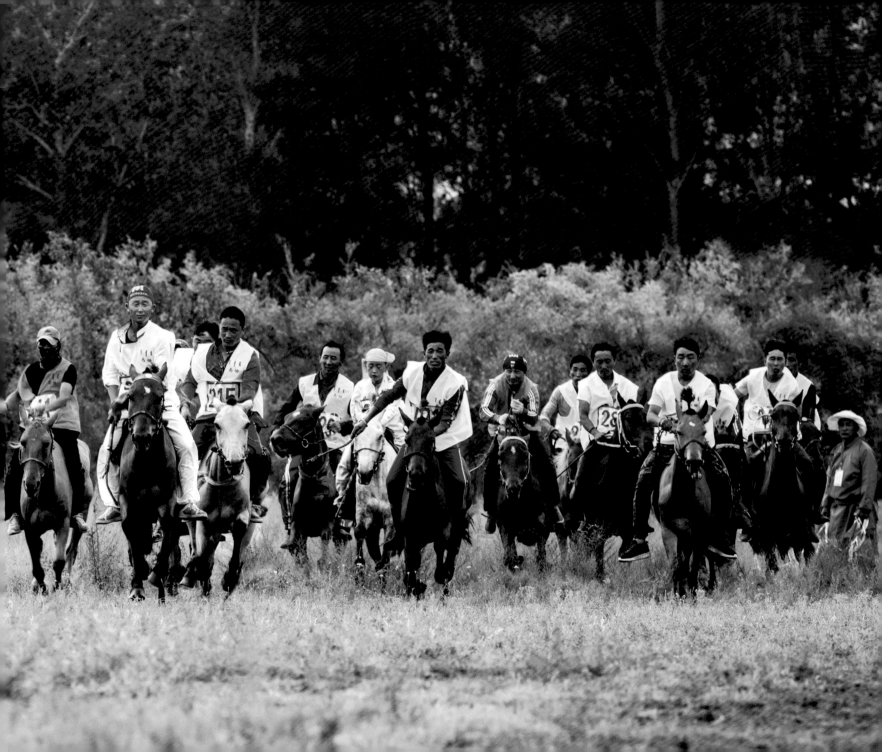

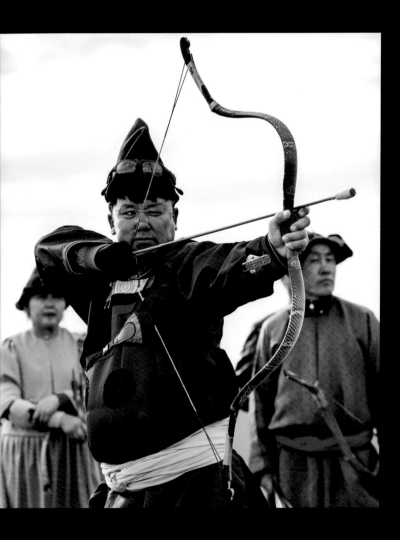

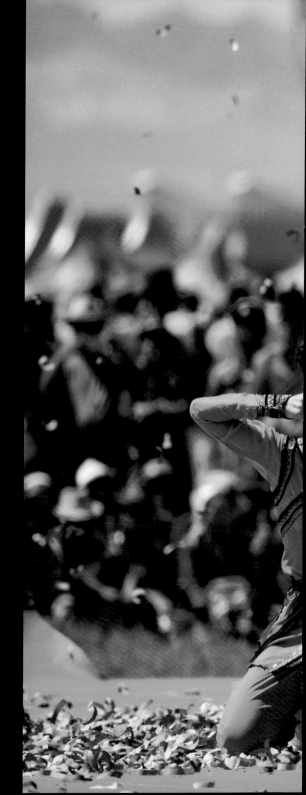

射箭也是那達慕大會最早的活動之一，皆因除了遊牧之外，狩獵也是古代蒙族的重要生存來源。（右）雖然地中海式射箭如今得到了國際賽事的廣泛應用，與之相對應的蒙古式射箭在東亞國家卻仍有一定的人氣。（左）

Archery is one of the major events in Naadam. In ancient times, Mongols earned their livings from pasture as well as hunting, making archery a significant technique. (Right) Although Mediterranean archery is generally adopted in international competitions today, the corresponding Mongolian archery is also favored in eastern Asian countries. (Left)

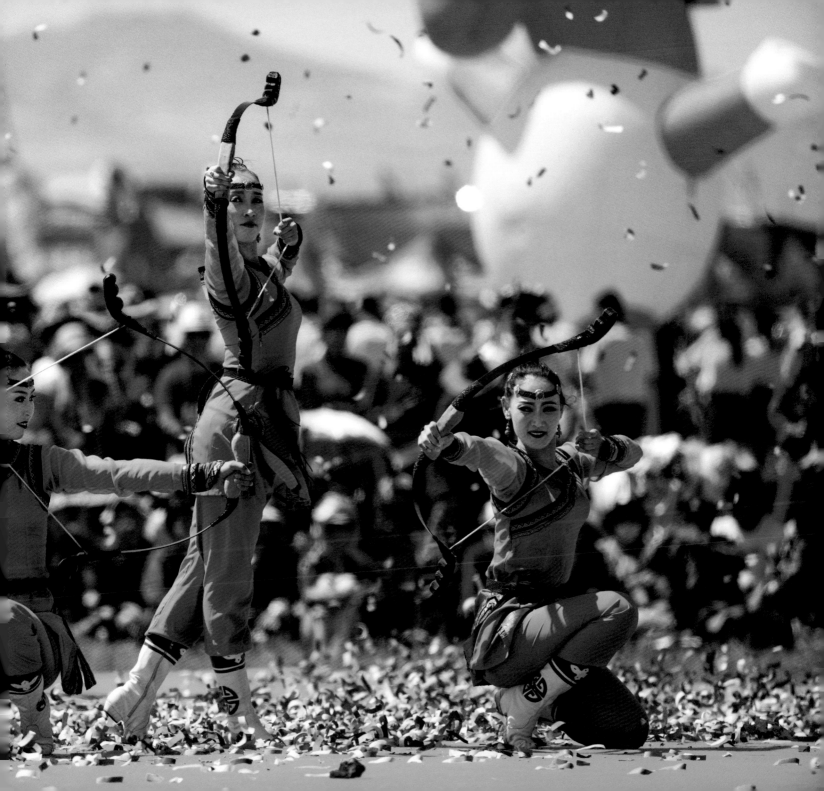

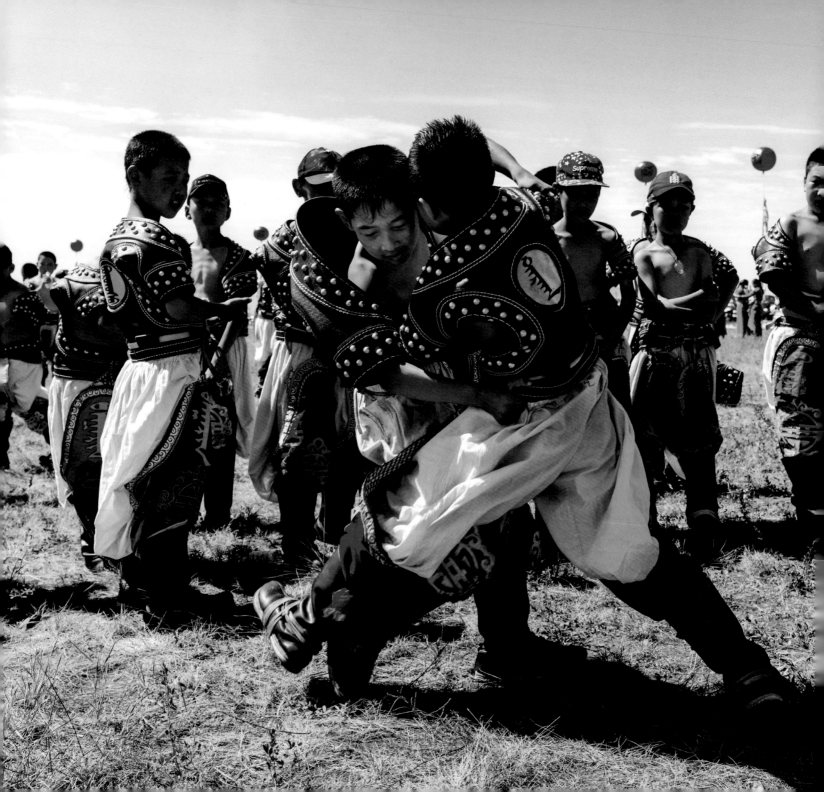

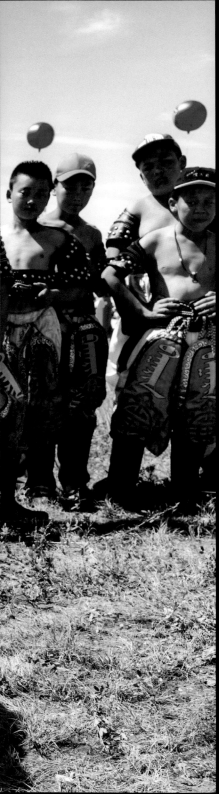

搏克即蒙古是摔跤，在蒙古語中的意思是「攻不破、持久永恆」。摔跤選手所穿的服裝被稱作「昭達格」，是一種皮製的緊身短袖夾克。

Bökh is Mongolian wrestling. The word means "indestructibility and durability" in Mongolian language. The outfit of wrestlers is called "Zodog", a type of tight leathered jacket with short sleeves.

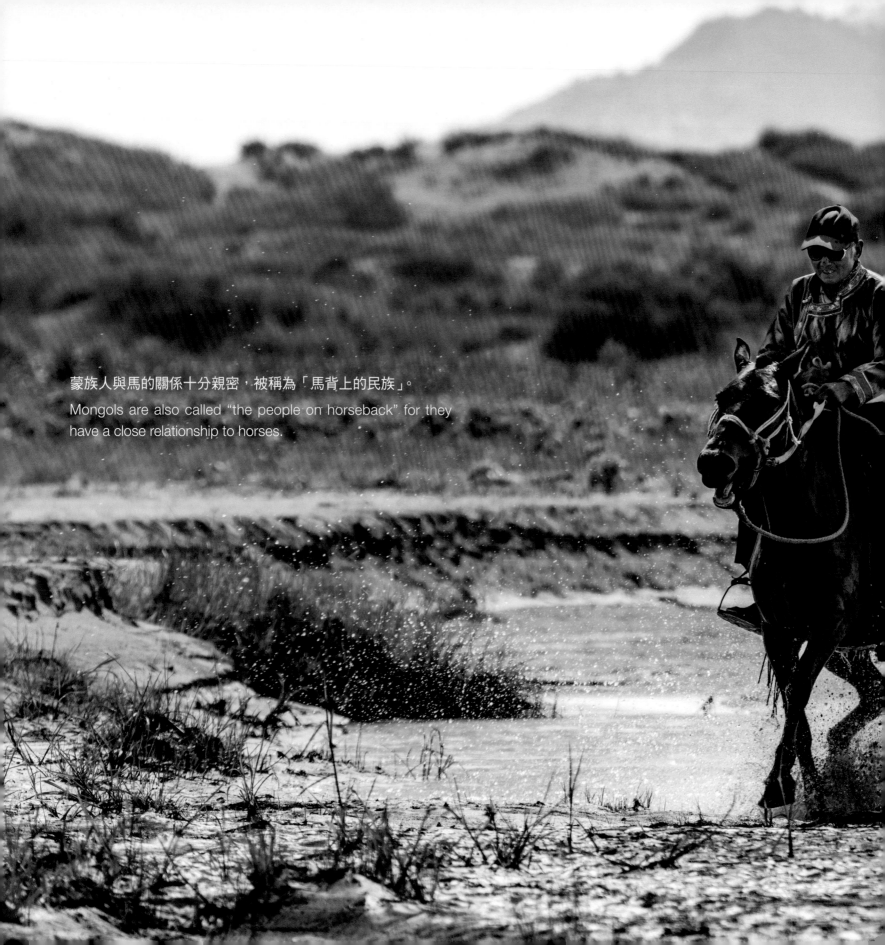

蒙族人與馬的關係十分親密，被稱為「馬背上的民族」。

Mongols are also called "the people on horseback" for they have a close relationship to horses.

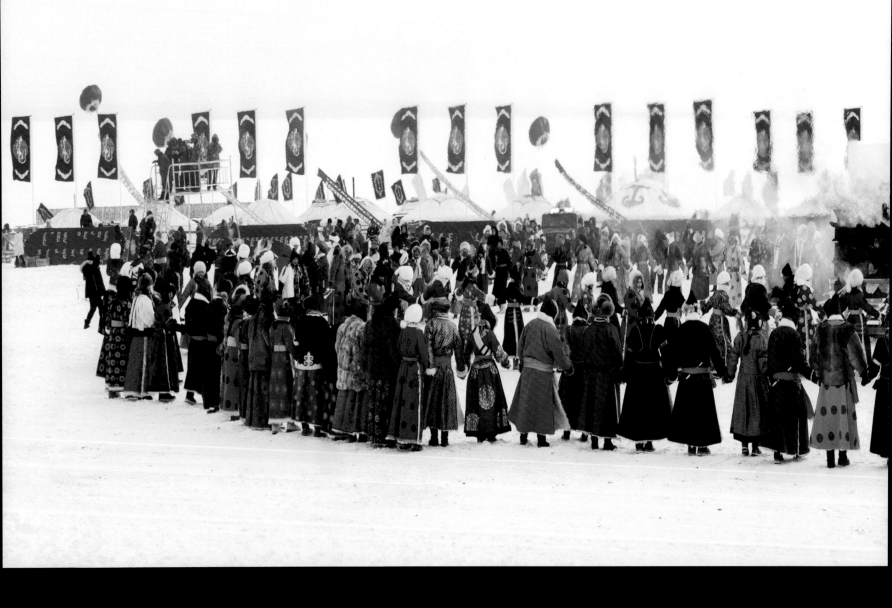

呼倫貝爾草原上水源豐富，是許多北方少數民族和游牧民族的發源地，蒙古族在此舉行冬季那達慕亦有祭祀祖先的意義。早在 1871 年，呼倫貝爾已有舉辦那達慕大會的記錄。1949 年後，呼倫貝爾幾乎每年都舉辦那達慕，它已成為當地群眾生活的重要組成部分。他們手持的五色哈達，白色代表著純潔與信任，藍色多用於兄弟之間，黃色象徵智慧和宗教，綠色為大地，紅色則是火焰。

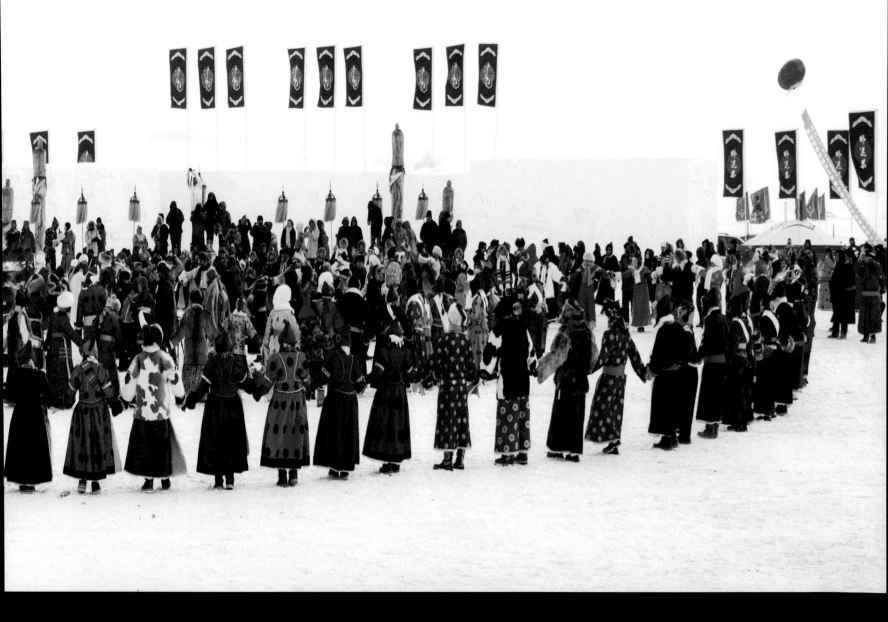

Being rich in water resource, Hulunbuir grassland is the birthplace of many northern minorities and nomadic peoples. Therefore, winter Naadams in Hulunbuir are particularly meaningful for they offer a chance to pay respect to ancestors. Records of Naadams in the city can be traced back to as early as 1871. Since 1949, Naadams are held in Hulunbuir every year, and has become an important part of the local people's social life. They are holding different colors of Khata, which, for Mongols, have different meanings: white means pure and trust, blue is used in brotherhood, yellow is the symbol of wisdom and religion, green represents the ground, and red is fire.

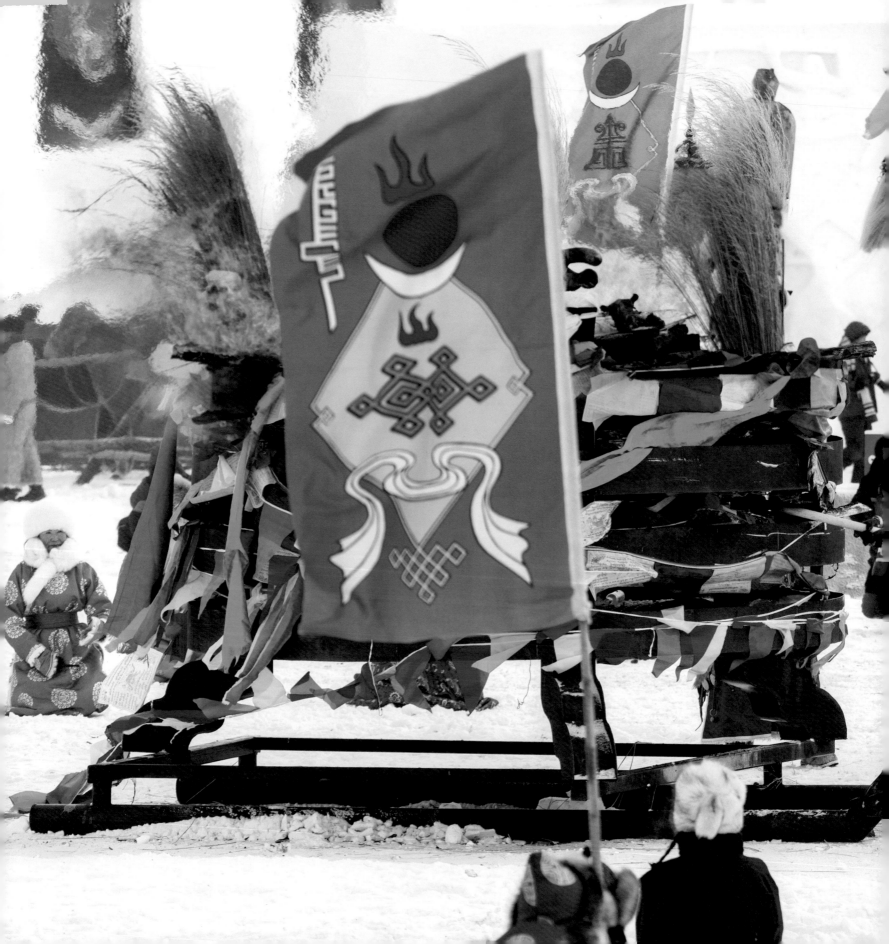

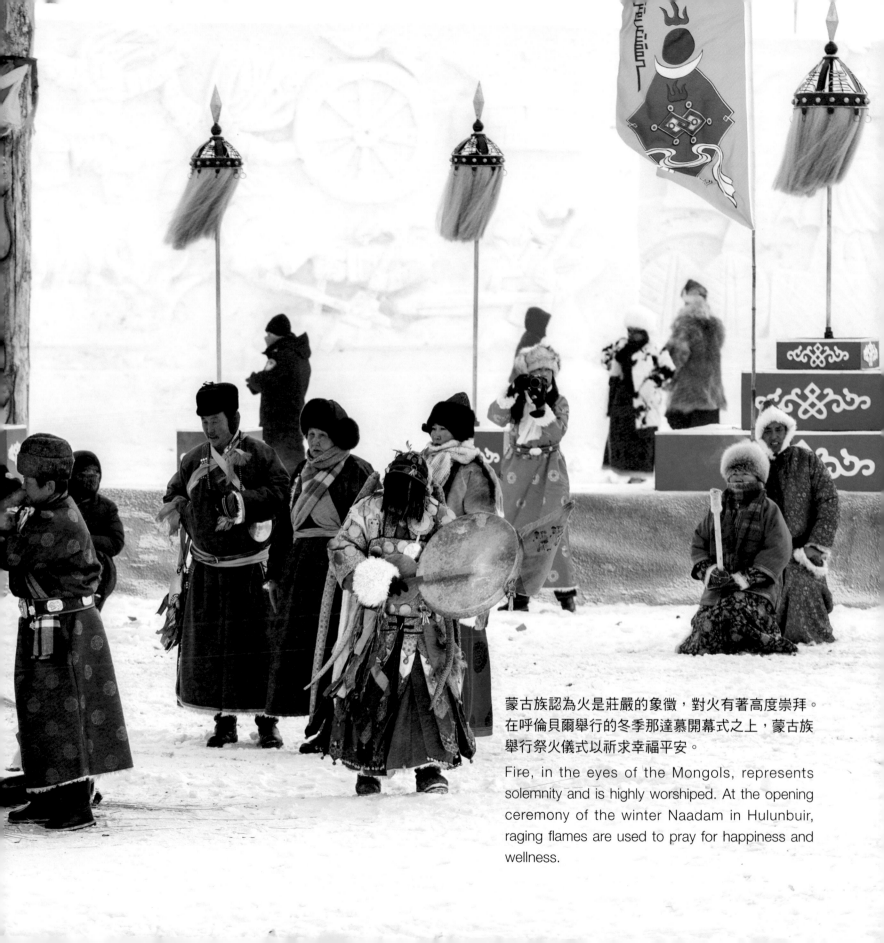

蒙古族認為火是莊嚴的象徵，對火有著高度崇拜。在呼倫貝爾舉行的冬季那達慕開幕式之上，蒙古族舉行祭火儀式以祈求幸福平安。

Fire, in the eyes of the Mongols, represents solemnity and is highly worshiped. At the opening ceremony of the winter Naadam in Hulunbuir, raging flames are used to pray for happiness and wellness.

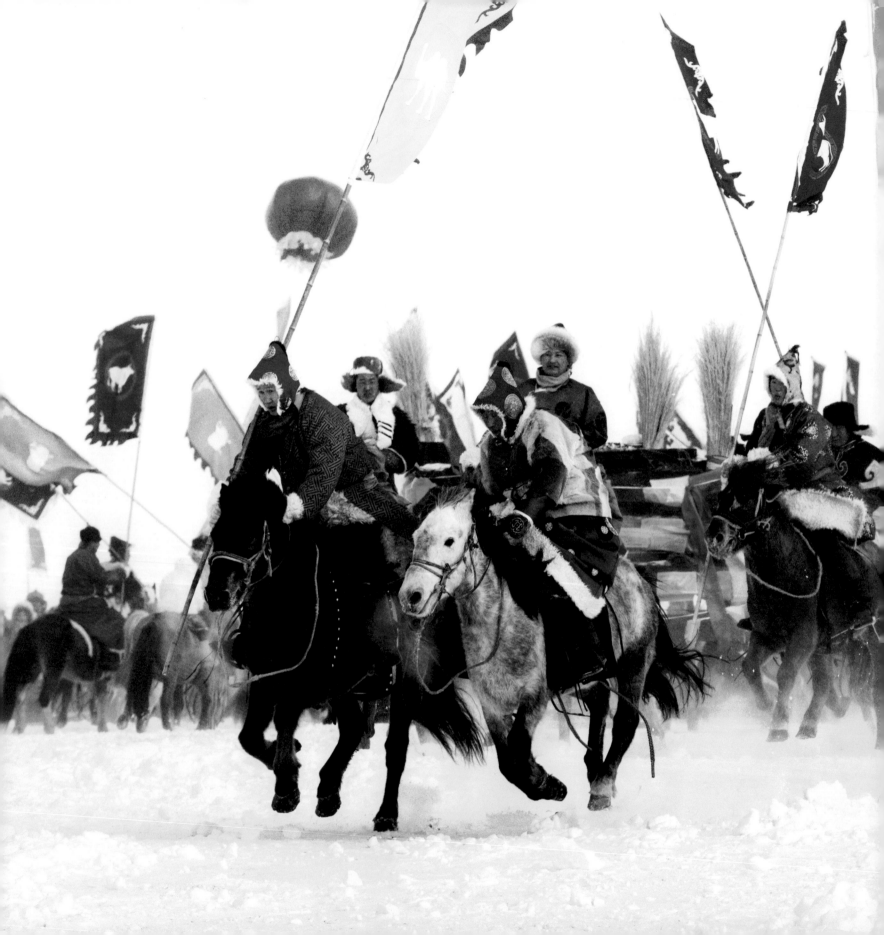

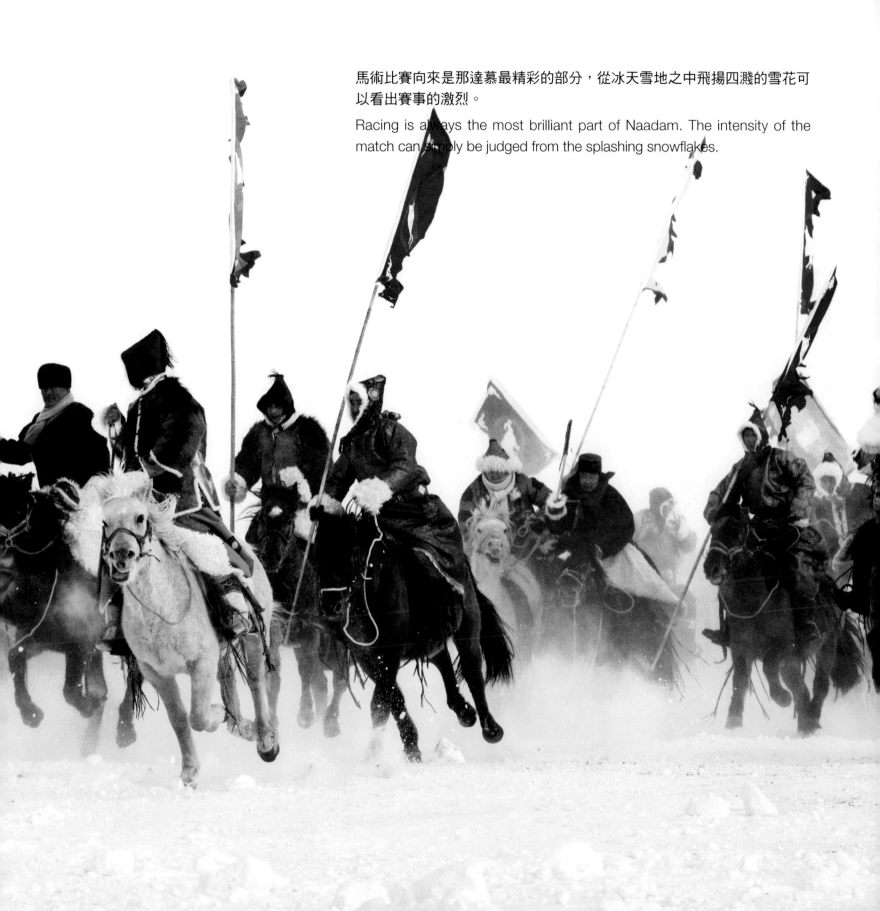

馬術比賽向來是那達慕最精彩的部分，從冰天雪地之中飛揚四濺的雪花可以看出賽事的激烈。

Racing is always the most brilliant part of Naadam. The intensity of the match can simply be judged from the splashing snowflakes.

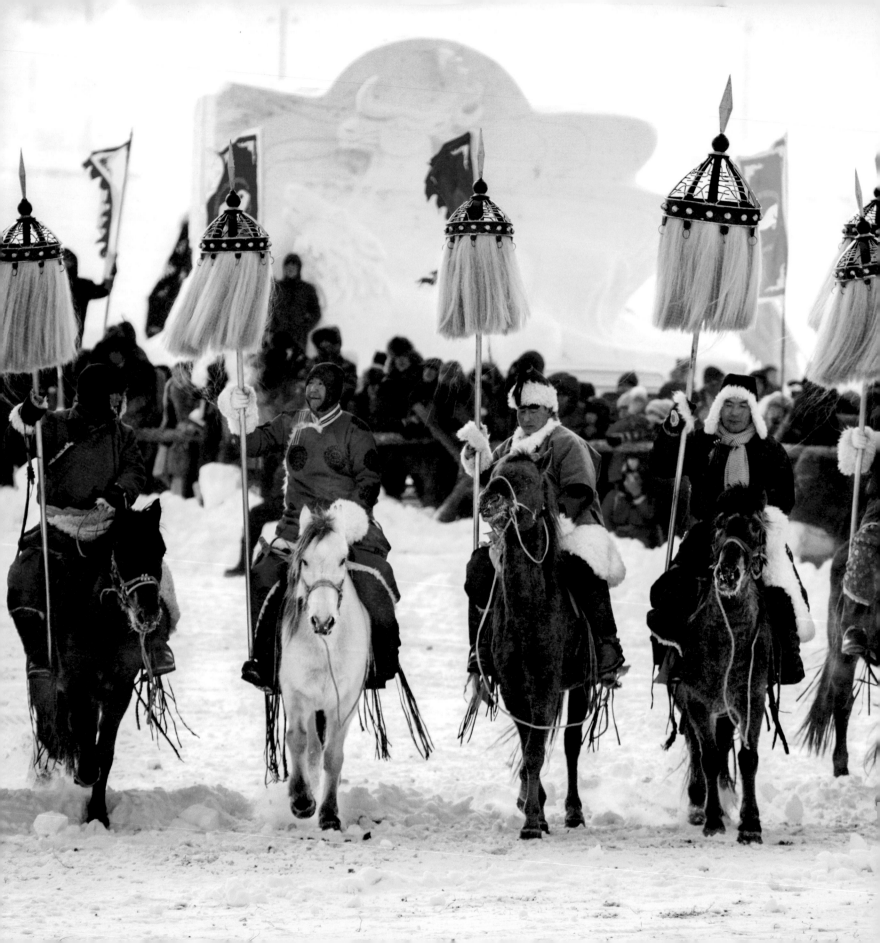

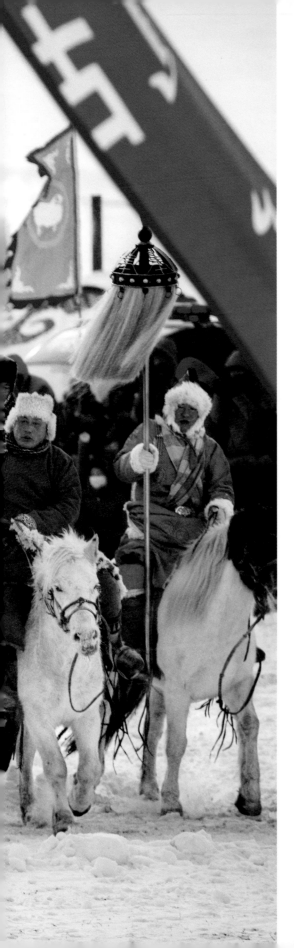

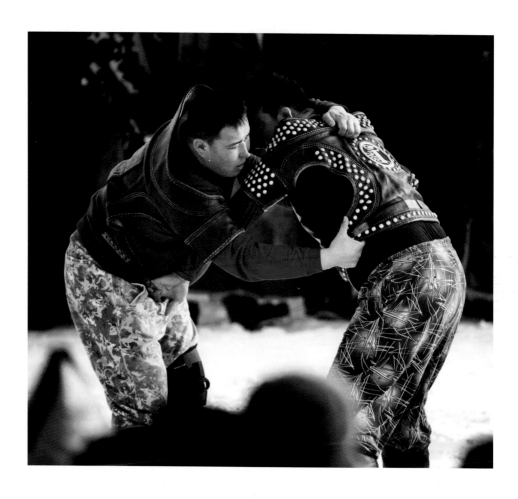

蒙古馬屬於矮種馬，能夠適應炎熱及嚴寒的極端環境。（左）摔跤是勇敢和力量的象徵，冬季那達慕之上，摔角手在昭達格內添加了禦寒衣物。（右）

Mongolian horse is a highland pony which is adaptive to extremely hot or cold weathers. (Left) Wrestling represents bravery and power. On Winter Naadam, wrestlers put on clothes under the Zodog to keep warm. (Right)

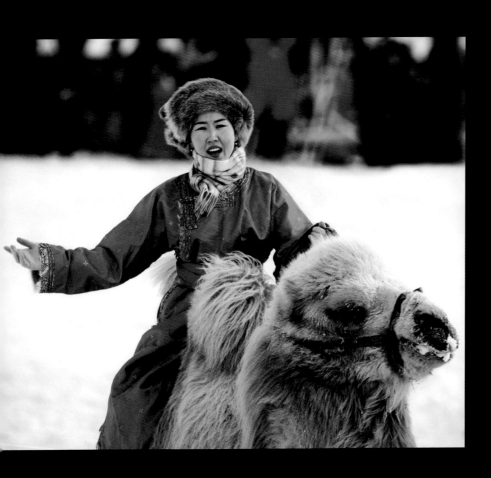

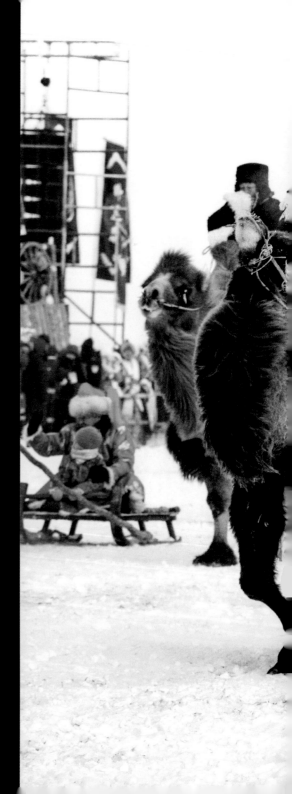

專統蒙古長調不僅歌曲時間較長，每個字的音節亦會延長。長調的特點是大量使用裝飾音和假聲，節奏變化豐富，音域極為寬廣，是冬季那達慕大會開幕式上的主要表演項目之一。演唱內容大多與牧民的生活習慣及民間風俗有關。（左）駱駝爬犁比賽是冬季那達慕中獨特的競技項目。（右）

Traditional Mongolian long drawn songs extend both the length of the songs and each syllable of lyrics. They are characterized by the use of decorative and artificial notes, rich rhythm changes, and an extremely wide range of tones. These songs are mostly themed with Mongolian lifestyle and folk customs. (Left) Racing of camel sledges is a unique competition exclusive to winter Naadam. (Right)

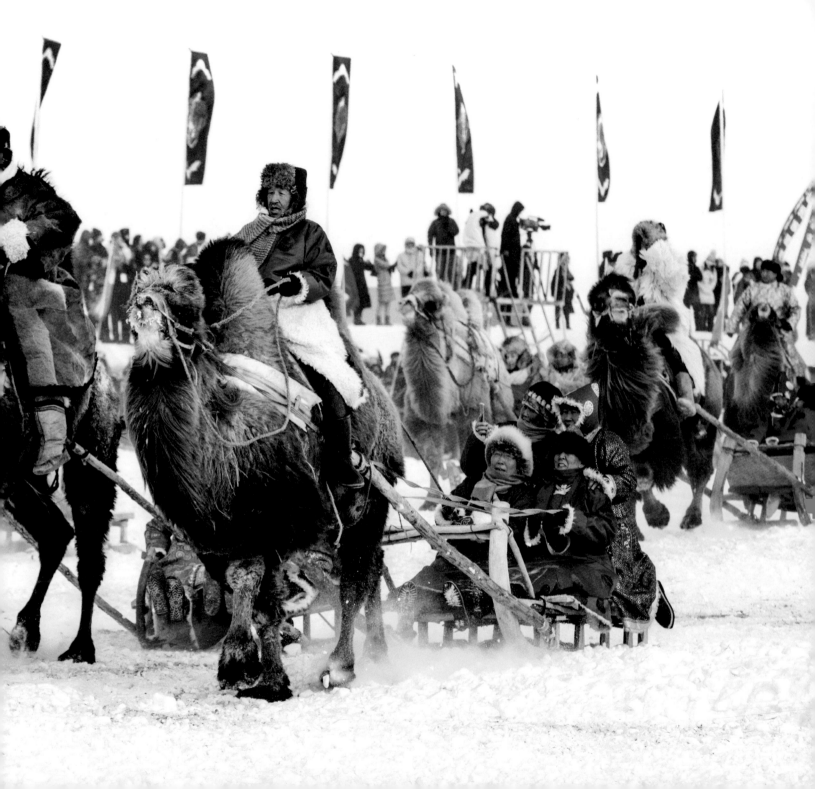

黑土之鄉

東北平原是中國面積最大的平原，擁有大片利於植物生長的黑土地，因此也有人直接以「黑土地」代指東北地區。土地肥沃、耕地廣闊的東北三省，包括黑龍江、吉林和遼寧，糧食總量約佔全國糧食總產量的 20%，是中國的最大「糧倉」。

也許是由於自然資源的優越，不少民族都起源於東北地區。根據統計，東北人在中國歷史上所建立的朝代是最多的，包括北魏（公元 386 年 -534 年）、遼國（公元 916 年 -1125 年）、金國（公元 1115 年 -1234 年）、元朝（公元 1271 年 -1368 年）、清朝（公元 1636 年 -1912 年）等。這些朝代的統治民族，包括鮮卑、契丹、女真、蒙古、滿族等，雖與西北的突厥、匈奴同為遊牧民族，但東北的民族既精於騎射打仗、又懂得輔以農耕，對中原地區的生活方式更能理解。

到了 19 世紀，由於黃河下游旱災嚴重，餓殍遍野，中原地區生活困難的漢族人口湧起了「闖關東」的浪潮。此處的「關東」指的就是山海關以東的東北地區。至此，直接使得當地的漢族人口超越了少數民族人口。

東北地區不只是一個地理區域或行政區域，而更接近一個文化大區。與中國其他省份地區有所不同，生活在東北地區的居民對「東北」的認可更大於對自身所在省份的認可。他們有著類似的生活習俗，說著相近的東北官話，甚至連日常所喜愛的娛樂文化也有所雷同。

吉林和遼寧兩省都是多民族聚居地，少數民族人口將近千萬，其中以滿族、蒙古族、回族、朝鮮族和錫伯族為主。兩省省會分別為長春及瀋陽。

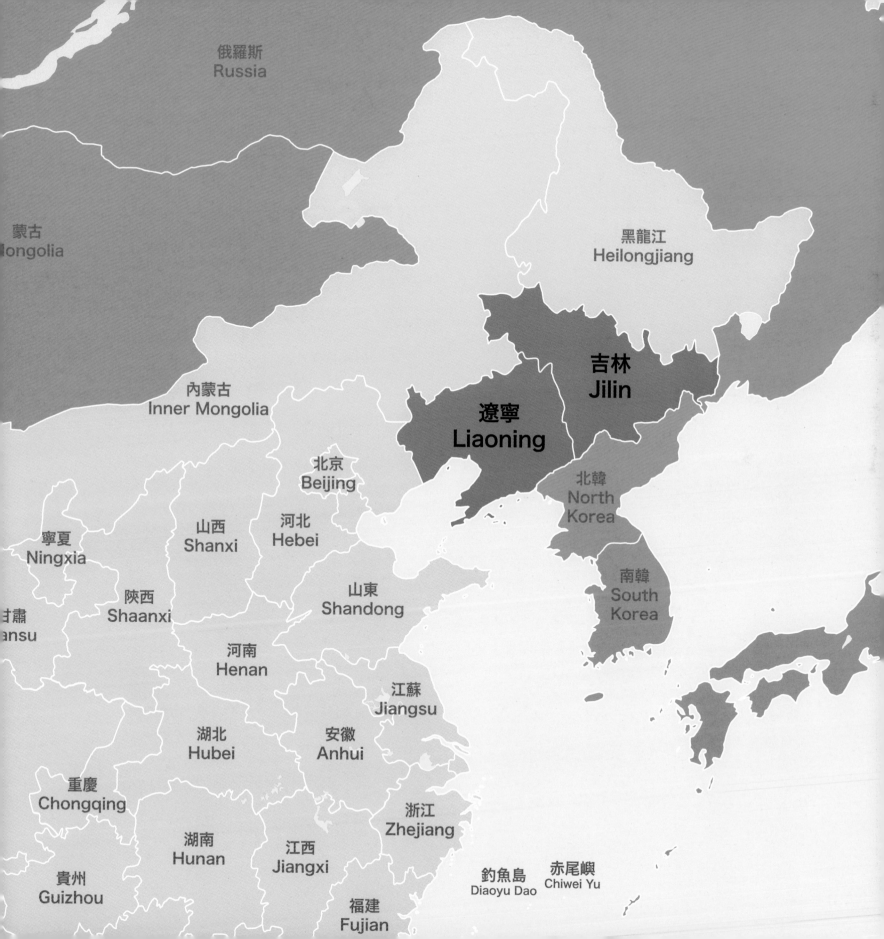

The Land of Black Soil

The Northeast China Plain is the largest plain in the country, with vast area of black-colored soil (chernozem) which is highly fertile. This is why some people refer this area as "the land of black soil". The Northeast China consists of Heilongjiang, Jilin and Liaoning. The cultivated lands, which are both fecund and extensive in these three provinces are producing 20 percent of the country's food production. It is the No.1 granary in China.

The abundance in natural resources is probably why the Northeast is the cradle for multiple ethnicities. Statistics show that ethnic groups from this area have established the most number of dynasties in history, including Northern Wei (386-534 AD), Liao (916-1125 AD), Great Jin (1115-1234 AD), Yuan (1271-1368 AD)

and Qing (1636-1912 AD) Dynasties. The ruling class of them are Xianbei, Khitan, Jurchen, Mongols and Manchu. Although being nomads just as the Turkic and Xiongnu from the northwest part, these peoples not only are skillful on the battlefields, but also know the importance of farming, which enabled them to understand the lifestyle of Zhongyuan area - the area on the lower reaches of the Yellow River, also known as the Central Plain.

In the 19th century, due to the severe draught along the downstream of the Yellow River, countless people were dying of starvation. The Han people who generally live in the China Proper started a trend of rushing to Guandong - the east to the Shanhai Pass, corresponding with the term Inner Manchuria. This

wave of migration has directly resulted in a quantum leap of Han population, surpassing that of ethnic minorities.

The term "Northeast" not only refers to geography or administration; it represents more of a cultural region. Unlike other provincial areas in China, people living in Guandong refer themselves as Northeast people, rather than people of a specific province. They share similar habits and customs, speak Northeastern Mandarin alike, and even prefer the same kind of daily entertainment.

Both Jilin and Liaoning are the inhabiting area for different ethnic groups, with the population of the minorities reaching almost 10 million. Manchu, Mongols, Hui, Korean and Sibe are the main minority groups. Changchun and Shenyang are their provincial capitals, respectively.

東北地區擁有適於農作物生長的黑鈣土，耕地面積廣闊。從吉林省東部龍井市的琵岩山上俯瞰，位於延邊朝鮮族自治州境內的海蘭江和農地彷彿沒有盡頭。

The Northeast possesses abundant Chernozem resources and large pieces of farm fields. Standing on top of the Piyan Mountain in Longjing in eastern Jilin, the enormous acreages of farmlands and Hailan River, located in Yanbian Korean Autonomous Prefecture, seem endless from a commanding view.

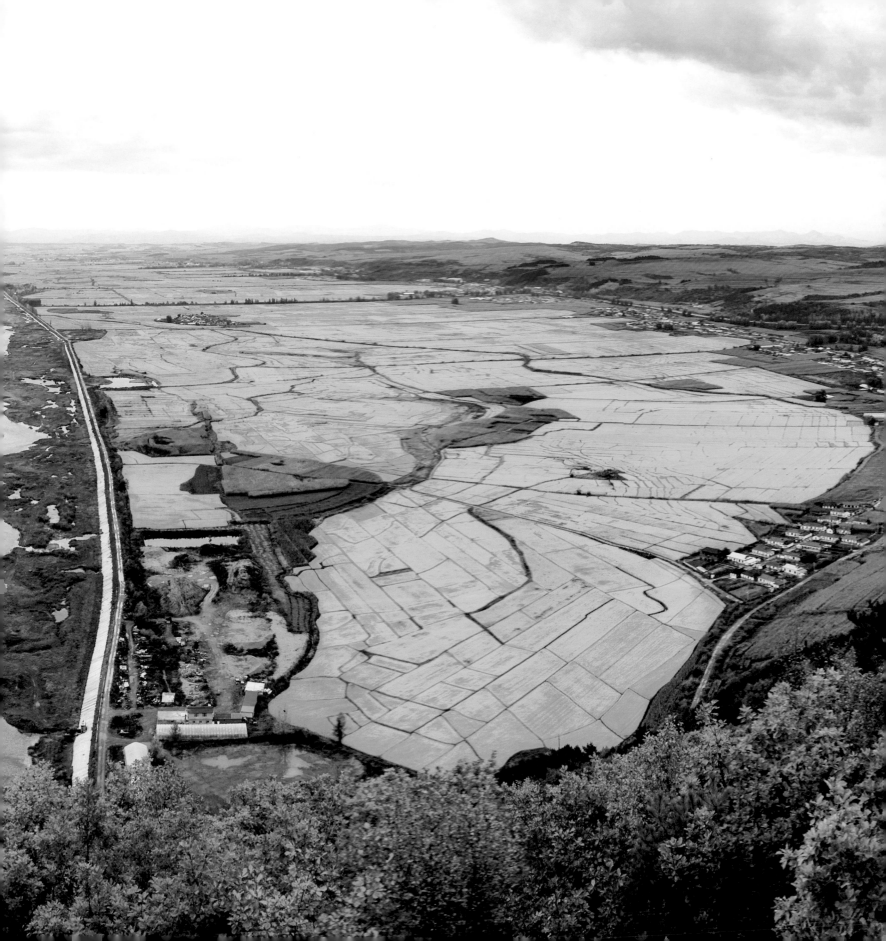

天池是長白山的火山口湖，為中國最深的湖泊。置身冰雪覆蓋下的天池，仿若來到了仙境。

Heaven Lake is a crater lake of the Paektu Mountain, and is also the deepest lake in China. The snow-covered scenery is heaven-like.

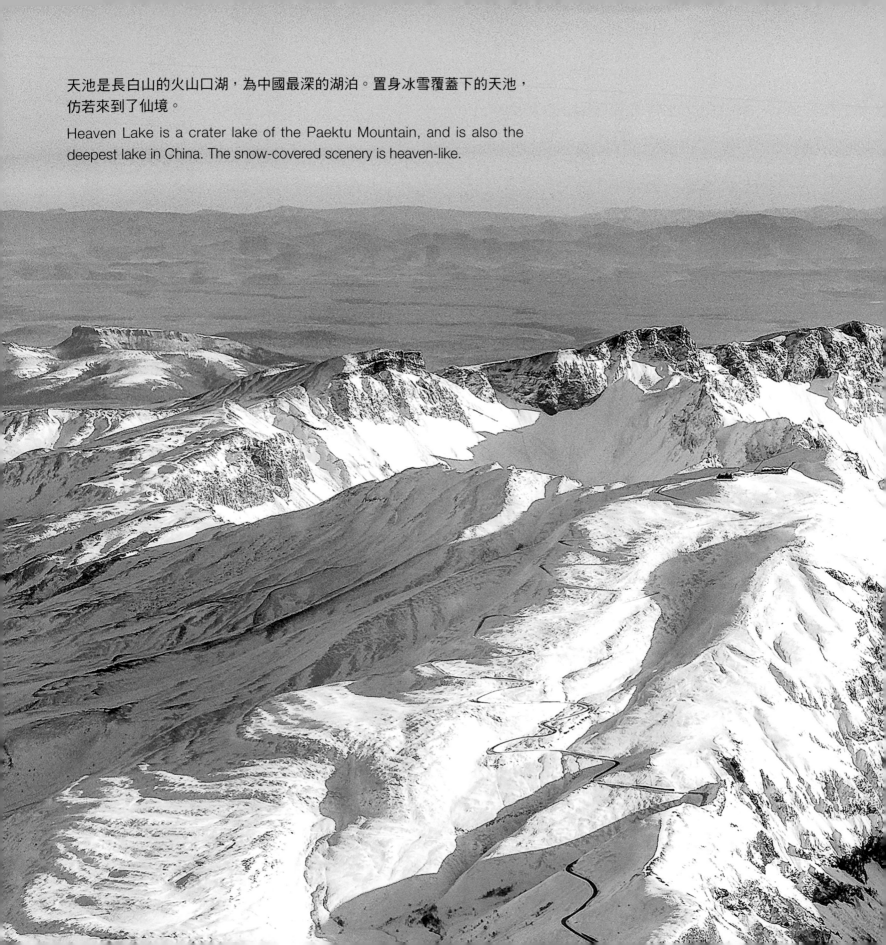

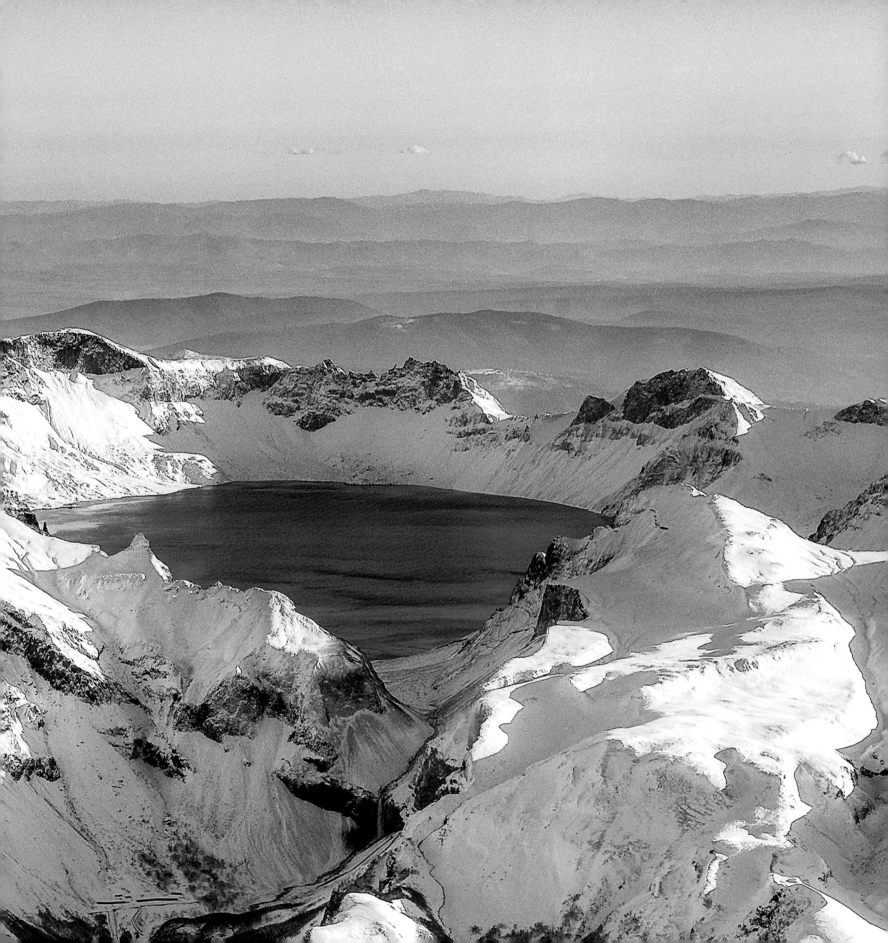

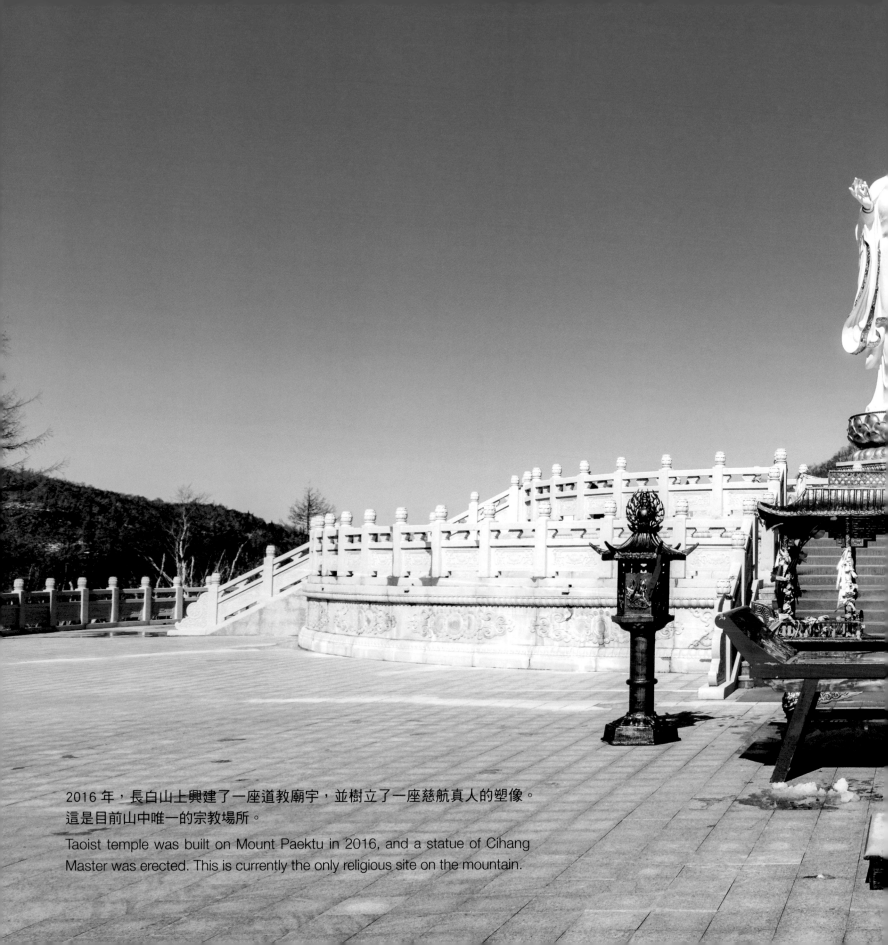

2016 年，長白山上興建了一座道教廟宇，並樹立了一座慈航真人的塑像。
這是目前山中唯一的宗教場所。

Taoist temple was built on Mount Paektu in 2016, and a statue of Cihang
Master was erected. This is currently the only religious site on the mountain.

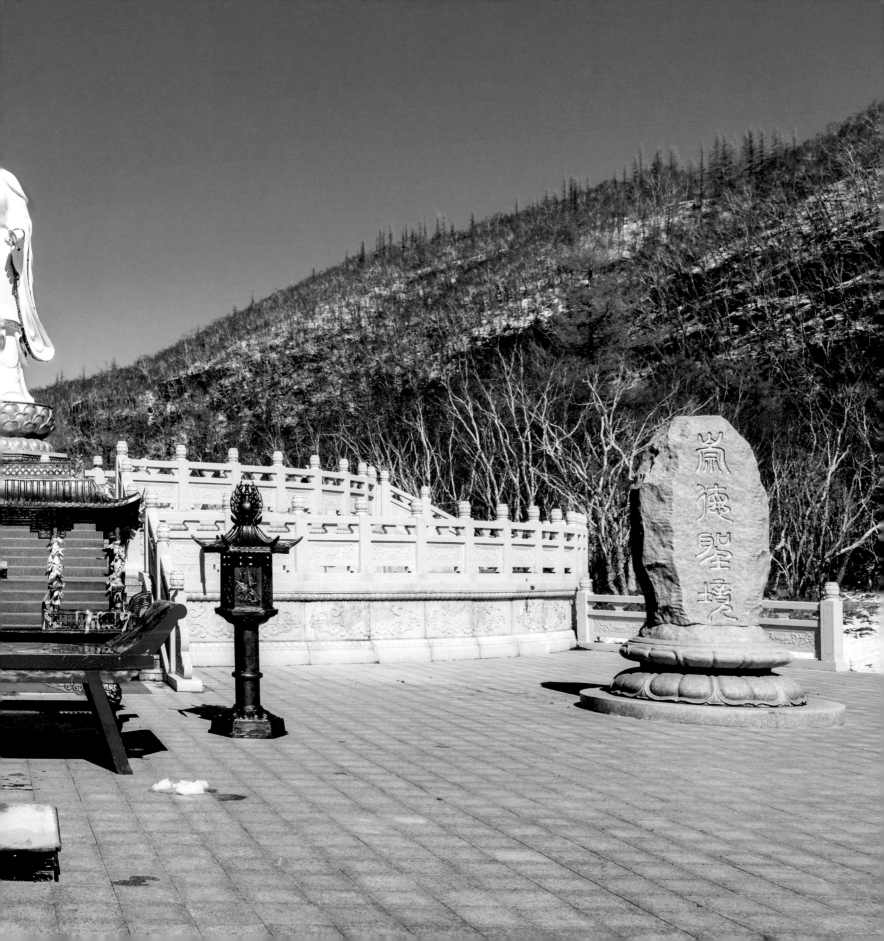

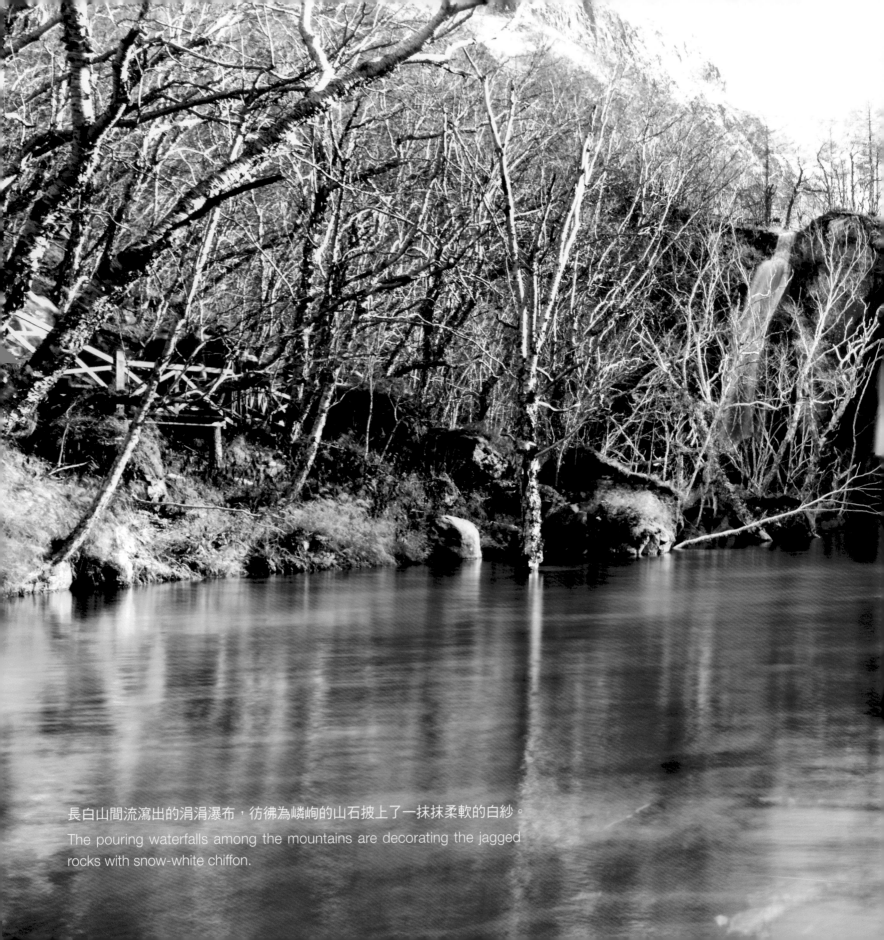

長白山間流瀉出的涓涓瀑布，彷彿為嶙峋的山石披上了一抹抹柔軟的白紗。

The pouring waterfalls among the mountains are decorating the jagged rocks with snow-white chiffon.

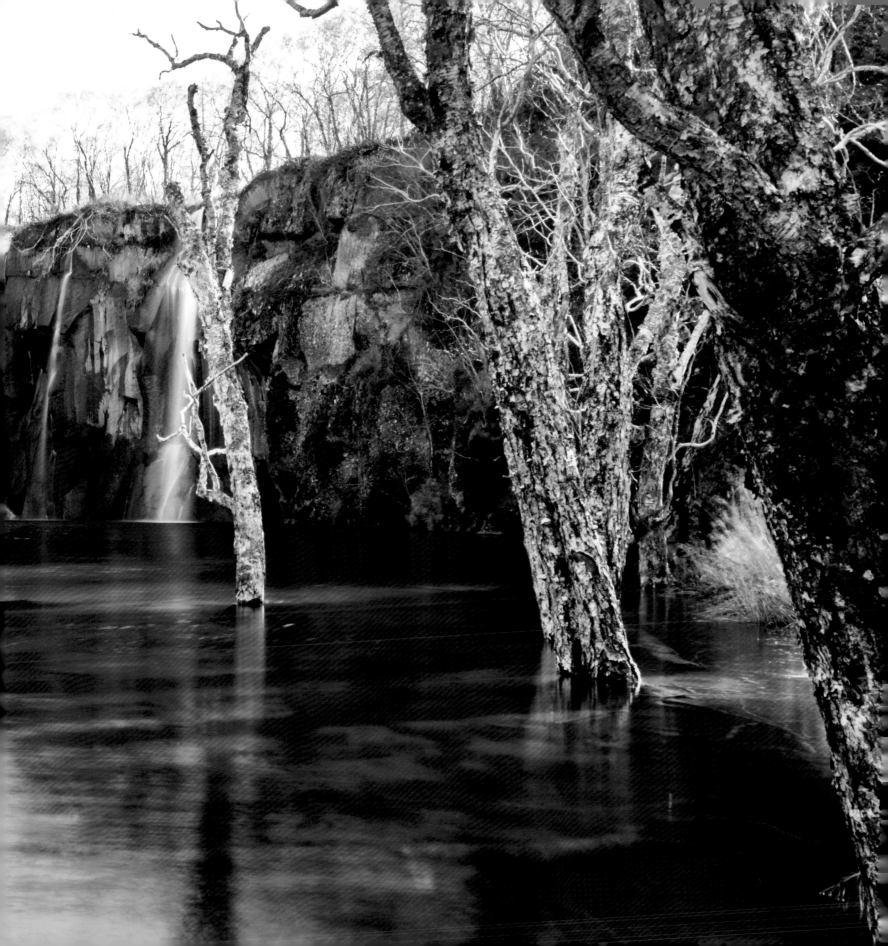

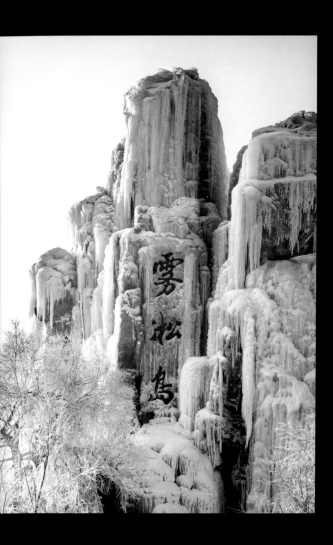

霧淞，被稱為中國四大自然景觀之一，吉林的霧淞島更是欣賞這幅絕境的好去處。（左）每年的 12 月至隔年 2 月，松花江面的霧氣蒸騰而上，凝結在樹枝之上形成了美麗的「樹掛」。（右）

Rime is regarded as one of the four natural attractions in China. The best place for rime admiration is on the Rime Island in Jilin. (Left) Every year from December to the following February, fog vaporized from the Songhua River gets frozen on the branches, becoming beautiful ornaments to the trees. (Right)

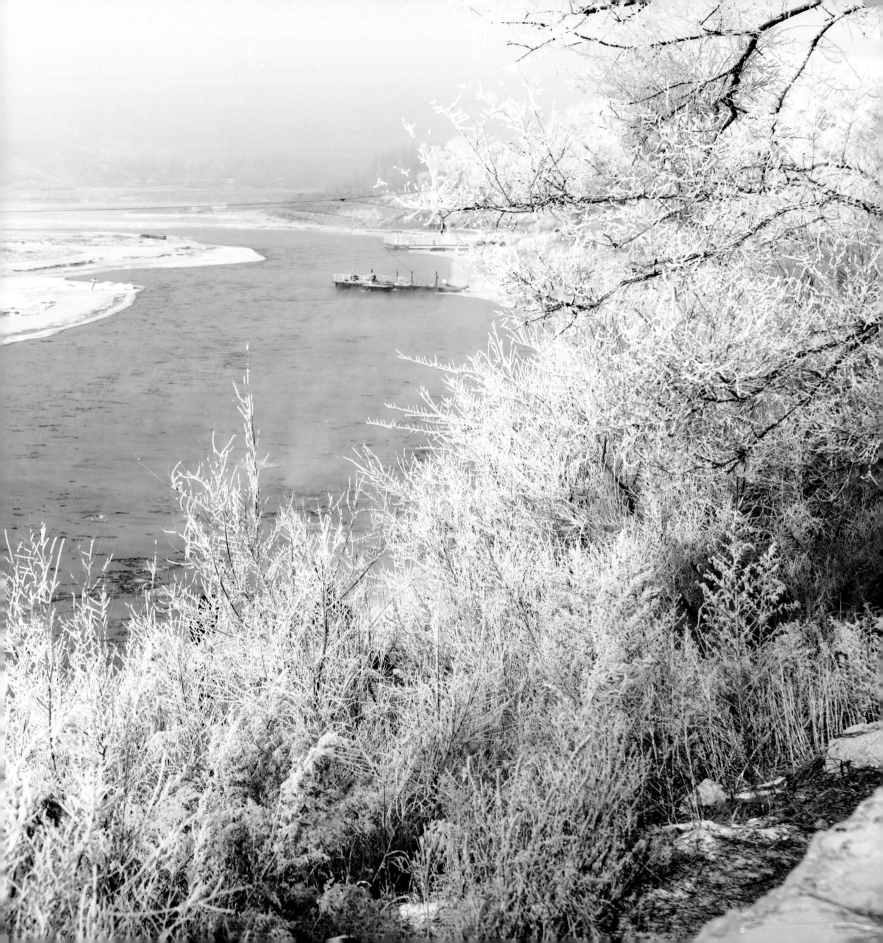

生活在東北的蒙古族
Mongols in the Northeast

東北地區在廣義上，包括了風土文化相近的內蒙古東四盟市，即呼倫貝爾市、興安盟、赤峰市和通遼市所構成的地區。因此，蒙古族在東北是最主要的少數民族之一。

除了東四盟市，其餘東三省的蒙古族聚居地有黑龍江的杜爾伯特蒙古族自治縣、吉林的前郭爾羅斯蒙古族自治縣、遼寧的喀喇沁左翼蒙古族自治縣，以及阜新蒙古族自治縣。

每年冬天，在吉林省的查干湖，更能一睹目前唯一仍然保留蒙古族最原始捕魚方式的活動——查干湖冬捕。查干湖冬捕也充分體現了古代蒙古人的智慧。

The generalized concept of the Northeast China covers Hulunbuir, Hinggan League, Chifeng and Tongliao, the four cities on the east side of Inner Mongolia, which is culturally similar to the three provinces in the Northeast. Therefore, the Mongols are also a major ethnic group in this area.

Apart from the above-mentioned four cities, other inhabiting areas of Mongols are: Dorbod Mongol Autonomous County in Heilongjiang, Qian Gorlos Mongol Autonomous County in Jilin, and in Liaoning, Harqin Zuoyi Mongol Autonomous County and Fuxin Mongol Autonomous County.

Every year in winter, at the Chagan Lake in Jilin, there is a special event which the prehistoric winter fishing technique exclusive to the Mongols can still be seen. This is the only remaining event for this tradition, which reflects the wisdom of ancient Mongolian people.

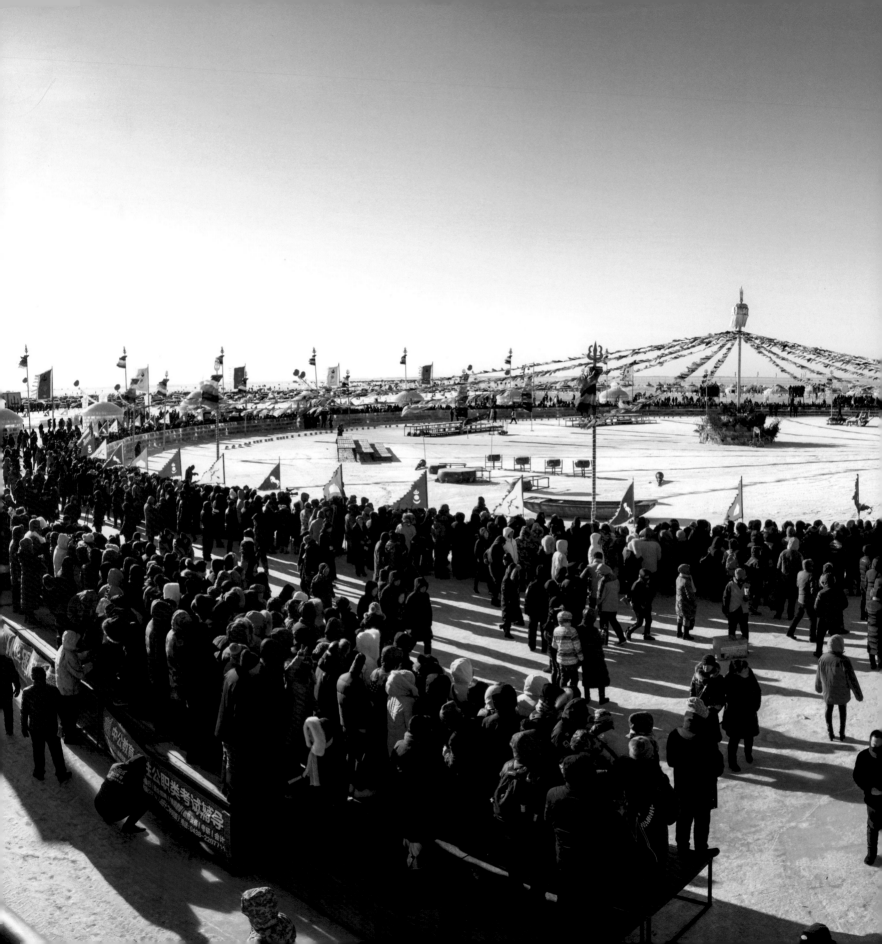

查干湖冬捕可追溯到遼金時代。在極低溫環境下，捕撈上來的魚會立即冰封，便於保鮮和運輸，因此，這個古老的蒙古族傳統一直流傳至今。2008 年，它被國務院批准確定為國家級非物質文化遺產。

The Winter Fishing at Chagan Lake can be dated back to the period from Liao to Jin dynasties. Under extremely cold weather, the fish would be frozen immediately after being caught, which is convenient for retaining freshness and transportation. This old tradition of Mongols, therefore, has been preserved and handed down to generations. In 2008, the Winter Fishing at Chagan Lake was approved by the Chinese government as a National Intangible Cultural Heritage.

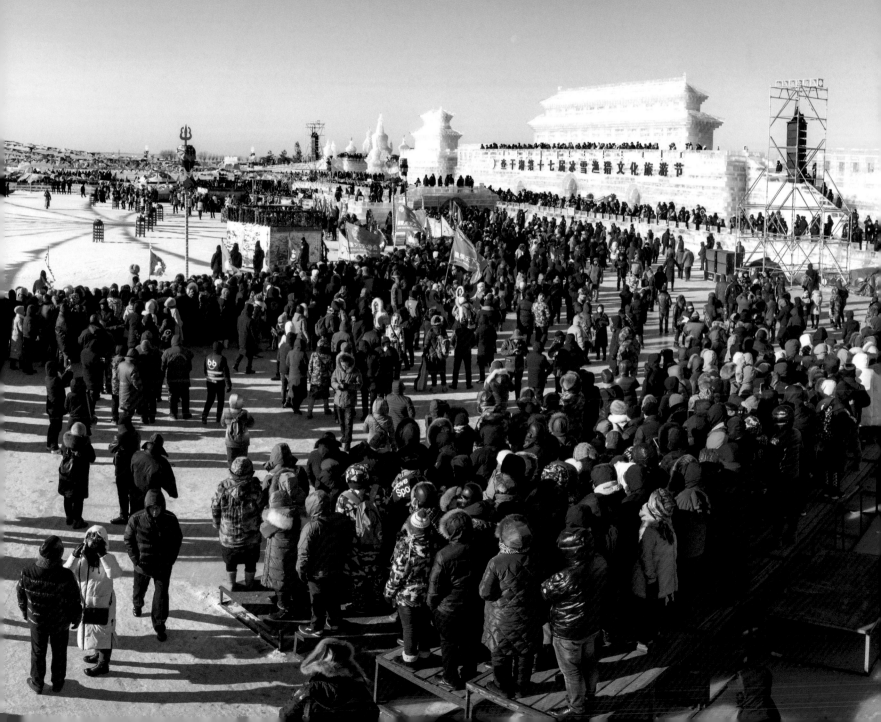

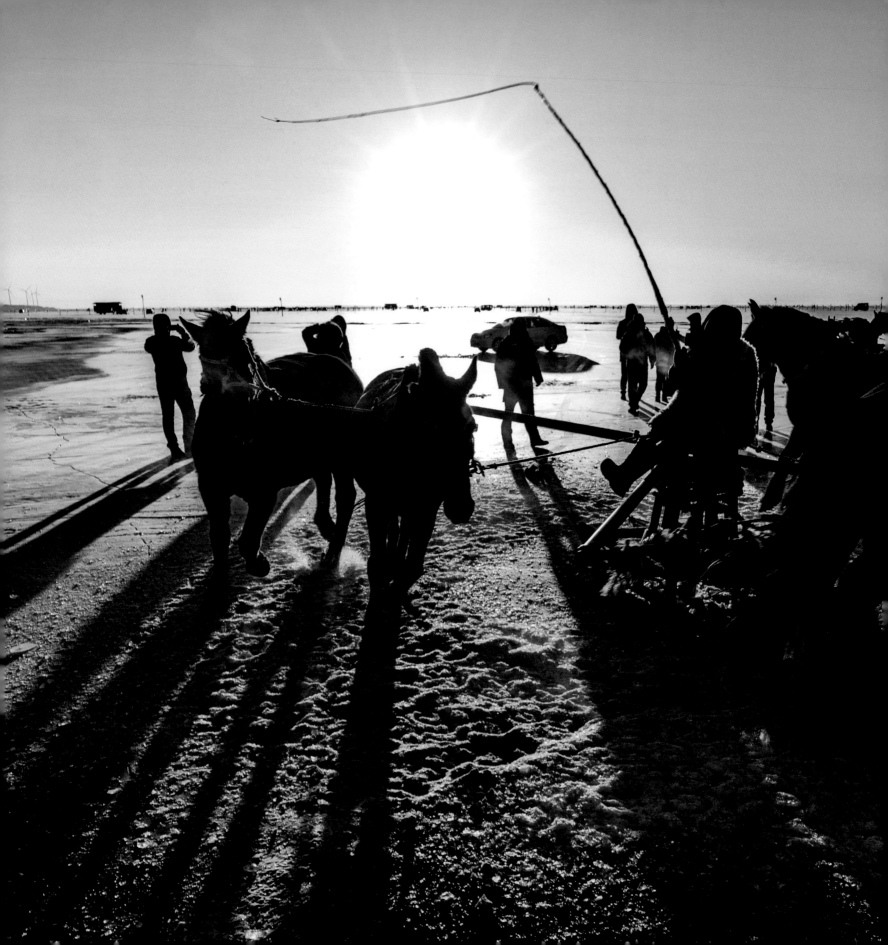

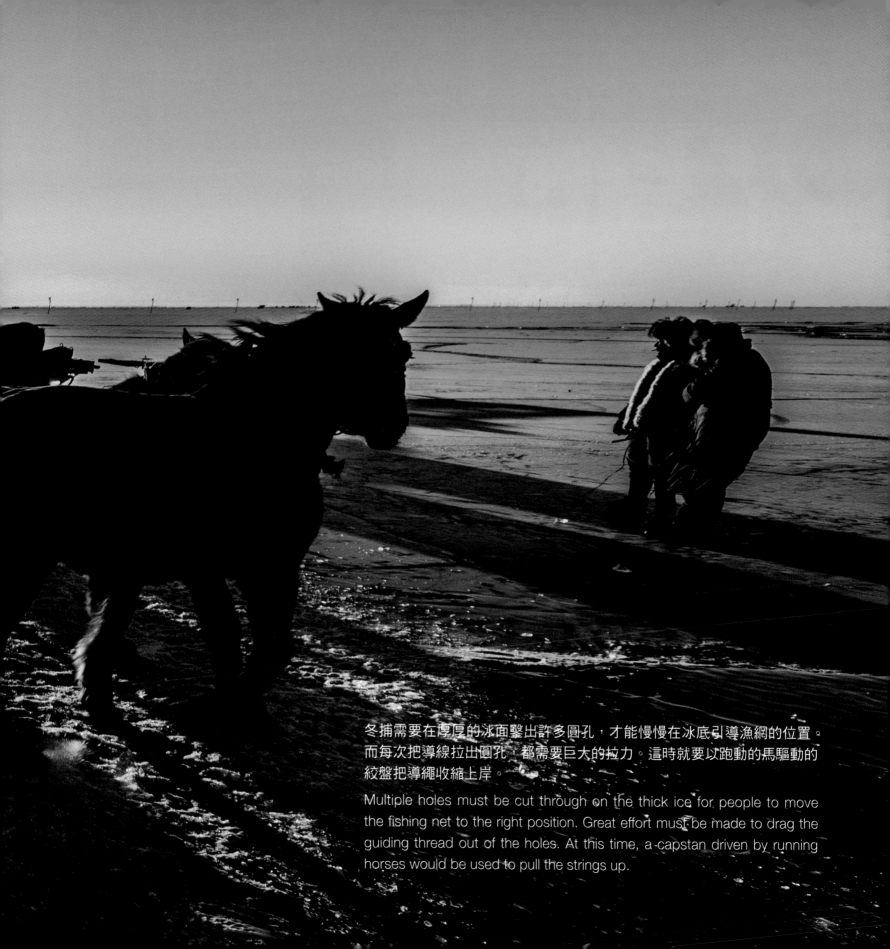

冬捕需要在厚厚的冰面鑿出許多圓孔，才能慢慢在冰底引導漁網的位置。
而每次把導線拉出圓孔，都需要巨大的拉力。這時就要以跑動的馬驅動的
絞盤把導繩收縮上岸。

Multiple holes must be cut through on the thick ice for people to move
the fishing net to the right position. Great effort must be made to drag the
guiding thread out of the holes. At this time, a capstan driven by running
horses would be used to pull the strings up.

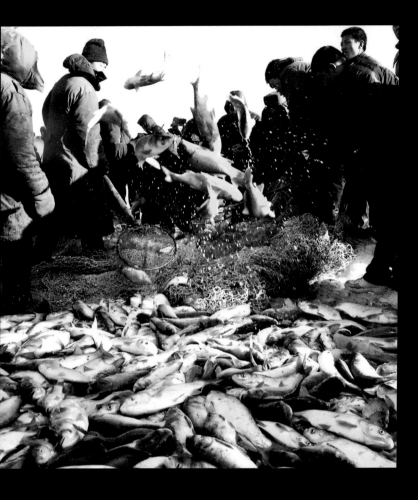

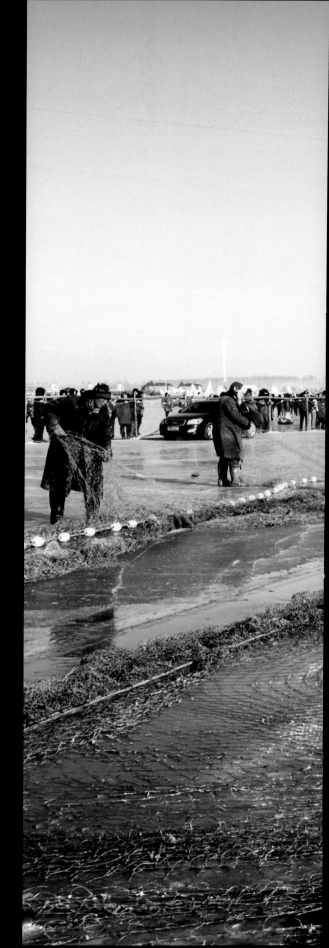

把漁網放置到厚厚的冰層下前，眾人需要把巨網展開，可見工程之浩大。（右）最後出網之時，網上密密麻麻的魚代表了又一次的豐收。2017 年，查干湖曾一次單網捕出 26 萬公斤的鮮魚，創下單網冬捕產量的健力士世界紀錄。（左）

Before placing the fishing net under the thick ice, people would have to unfold the vast net. The scale of the operation is astonishing. (Right) When the net is finally pulled out from the water, the swarm of fish is declaring another harvest. In 2017, at the Chagan Lake, the Mongols caught 260,000 kilograms of fish by one single net, setting a Guinness World Record in this category. (Left)

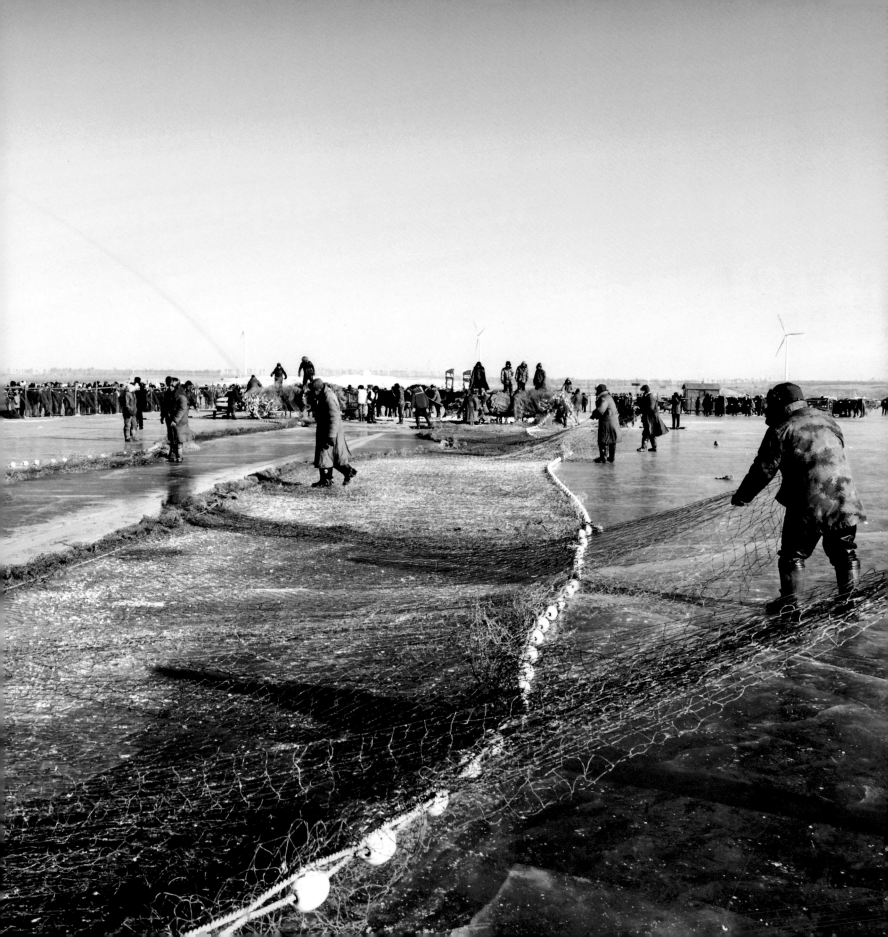

然而，早期移居中國的朝鮮人因應朝代的不同，大多已被漢化、蒙化、旗化。如今中國境內的朝鮮族，多為 19 世紀後遷入中國的朝鮮族人的後裔。

朝鮮族在中國有近 200 萬人口，列中國第 14 大民族，主要聚居在東北與朝鮮半島接鄰的地區。延邊朝鮮族自治州和長白朝鮮族自治縣是目前中國的兩個朝鮮族自治區。

朝鮮族的語言和文字與韓國、朝鮮、中亞地區的高麗人所使用的雖有些微的差別，但是彼此之間仍可以直接溝通、明白對方的意思。

農夫節是中國朝鮮族的傳統節日之一。

between the two places. However, the immigrants to China in the early phase have been integrated more or less by Han, Mongols or Manchu people. The existing Korean people in China are most likely the descendants of immigrants after the 19th century.

There are about 2 million Korean people in China, making it the 14th largest ethnic group in the country. Their inhabiting area is located closely to the Korean Peninsula in the Northeast. The Yanbian Korean Autonomous Prefecture and the Changbai Korean Autonomous County are currently the two major autonomous districts for Koreans in China.

Slight differences exist among the language and writing characters used by the Korean People, South Korea, North Korea and the Koryo-saram in Central Asia. Nonetheless, they are still able to communicate and understand each other directly.

Farmer's Day is a traditional festival of the Koreans in China.

中原地區的七月半中元節是慶祝豐收的日子，這個節日傳入朝鮮半島，被稱為「百種節」。2007 年，朝鮮族的百種節正式改稱農夫節。農夫節當日有傳統戲劇舞蹈、打糕製作、辣白菜製作等系列活動。

n Central Plain area, the Zhongyuan Festival held on the 15th night of the 7th lunar month is a celebration of harvest. When introduced into the Korean Peninsula, it was called the "Festival of a Hundred Seeds". In 2007, this tradition has been renamed among the Korean People to Farmer's Day. On the day of the Farmer's Day, there are series of activities, including traditional theatre and dancing, making of Korean tteok, making of Kimchi, and etc.

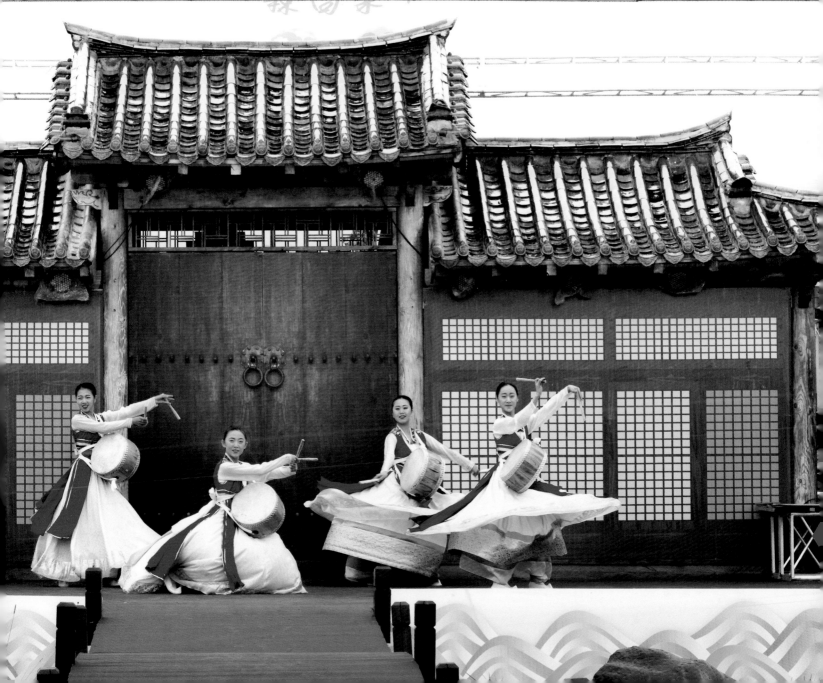

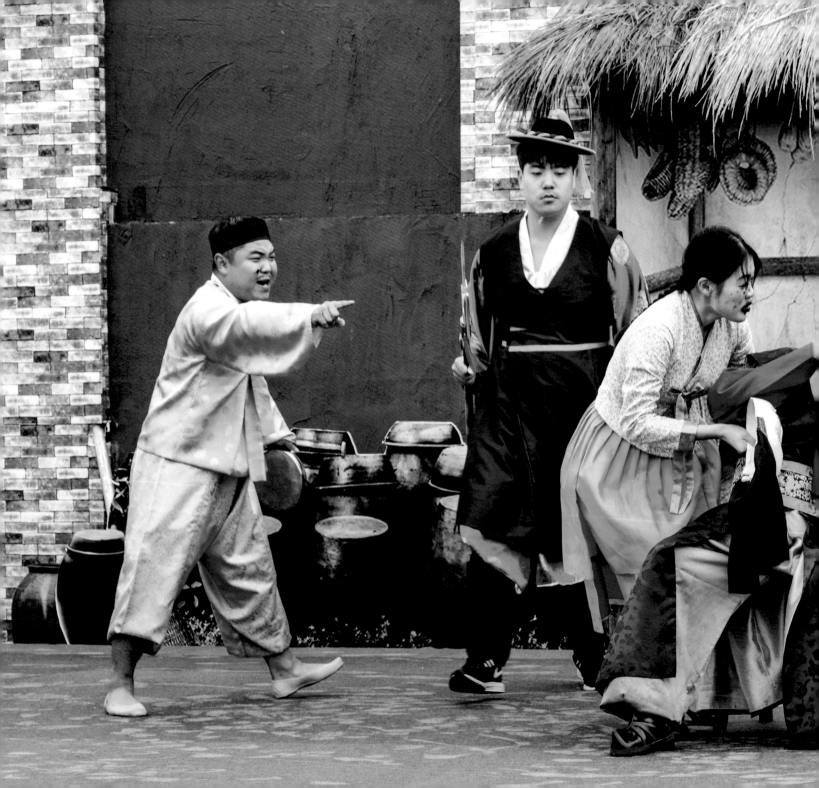

朝鮮傳統戲劇起源於史前宗教儀式。
在 20 世紀以前，相對於劇情，戲劇
更注重於表演本身。而隨著觀眾需求
的改變，這些戲劇加強了對故事情節
的關注，並把表演場地搬上了舞台。
朝鮮傳統戲劇亦是農夫節上的主要
表演節目之一。

Korean theatre originated from
prehistoric religious ceremonies.
Before the 20th century, relatively to
the storyline, theatric performance
was more important. Adjusting to
audience's demand, the storyline is
strengthened and the performing
venue has been moved onto stage.
Korean traditional drama is also
one of the main performances on
Farmer's Day.

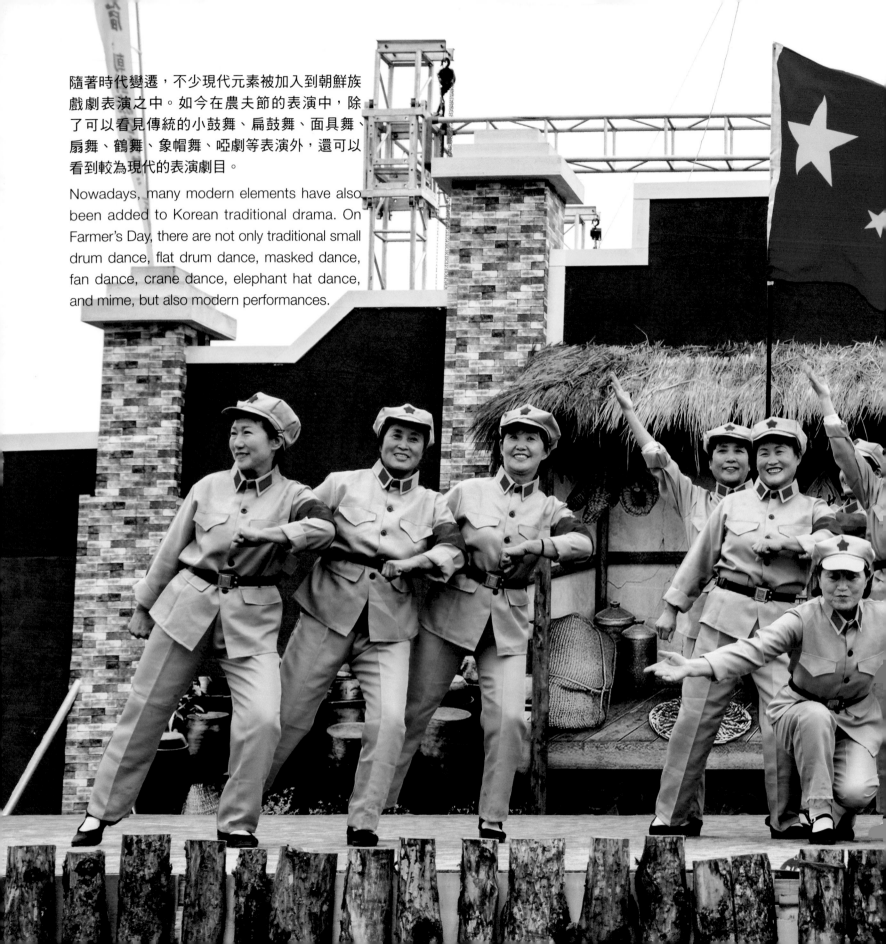

隨著時代變遷，不少現代元素被加入到朝鮮族戲劇表演之中。如今在農夫節的表演中，除了可以看見傳統的小鼓舞、扁鼓舞、面具舞、扇舞、鶴舞、象帽舞、啞劇等表演外，還可以看到較為現代的表演劇目。

Nowadays, many modern elements have also been added to Korean traditional drama. On Farmer's Day, there are not only traditional small drum dance, flat drum dance, masked dance, fan dance, crane dance, elephant hat dance, and mime, but also modern performances.

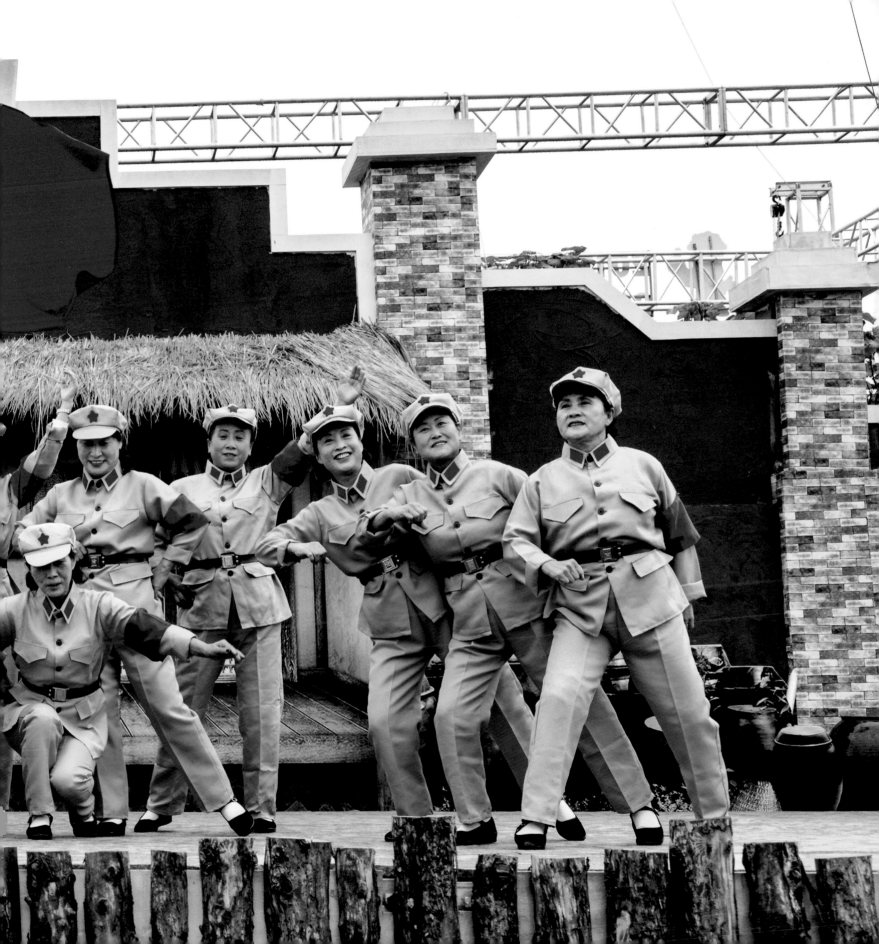

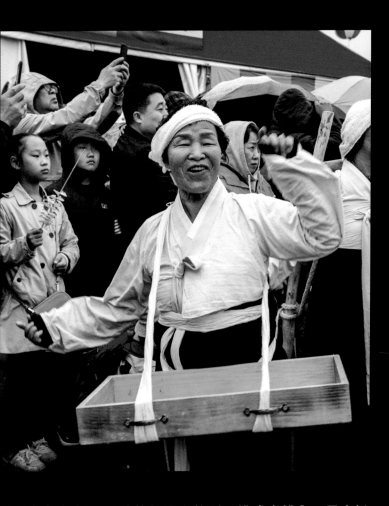

傳統朝鮮打糕，是蒸熟的糯米放到石槽或木槽內，用木槌反覆捶打而成。（右）一位朝鮮族婦女被節日的氣氛所感染，一邊手舞足蹈一邊派發打糕。（左）

Traditional Korean tteok is made of steamed sticky rice. Then it should be put into a stone or wooden trough, and to be smashed by wooden mallets. (Right) Being infected by the festive atmosphere, a Korean woman is distributing tteok while dancing. (Left)

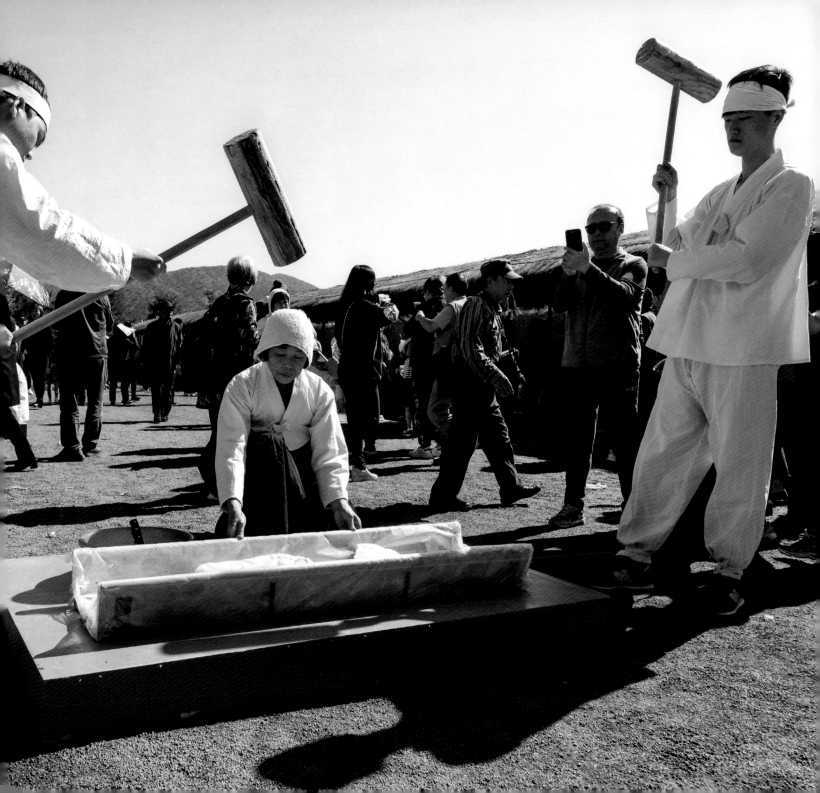

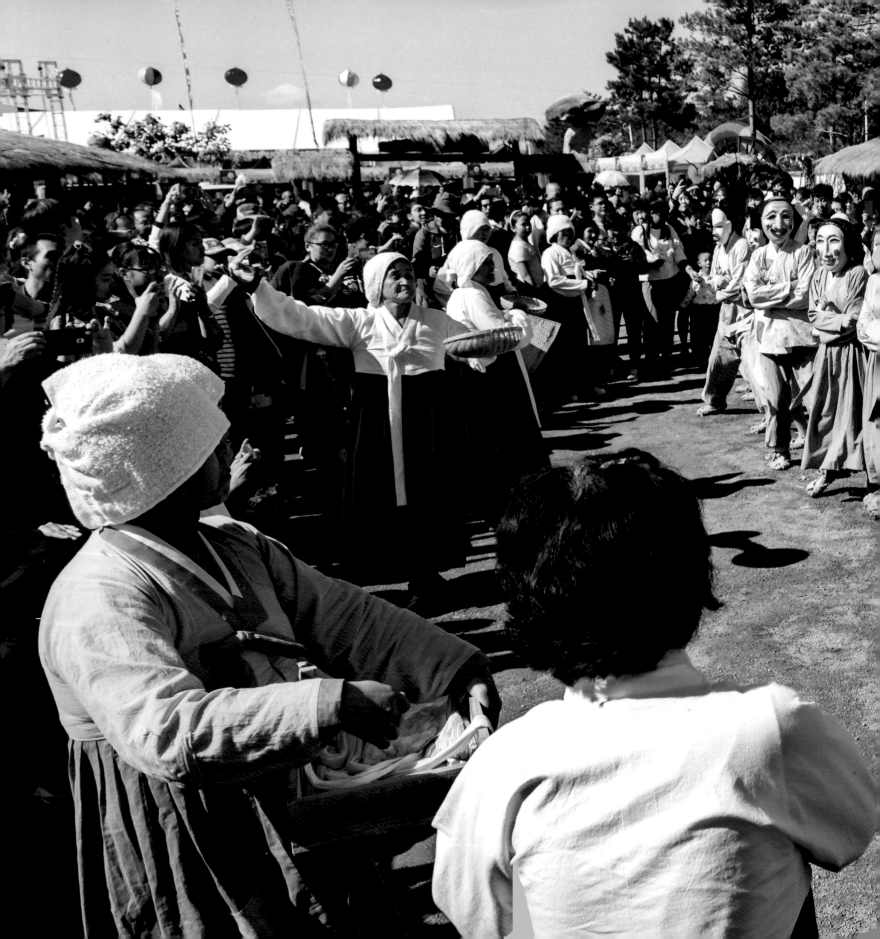

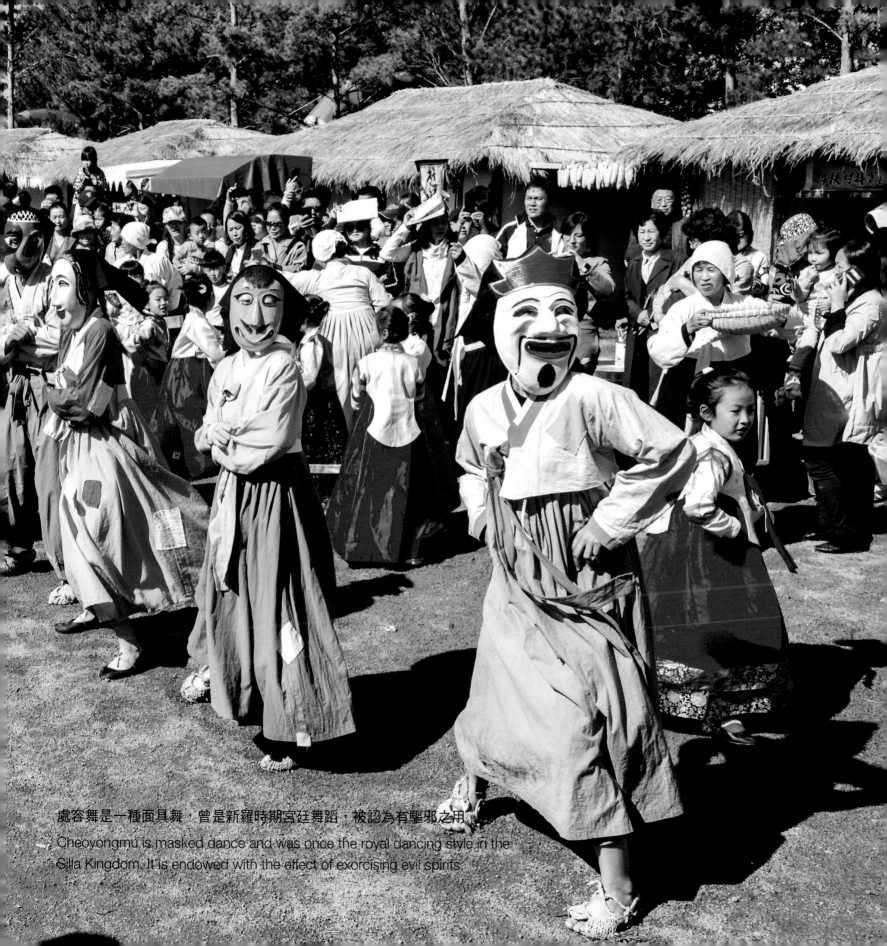

處容舞是一種面具舞，曾是新羅時期宮廷舞蹈，被認為有驅邪之用
Cheoyongmu is masked dance and was once the royal dancing style in the Silla Kingdom. It is endowed with the effect of exorcising evil spirits.

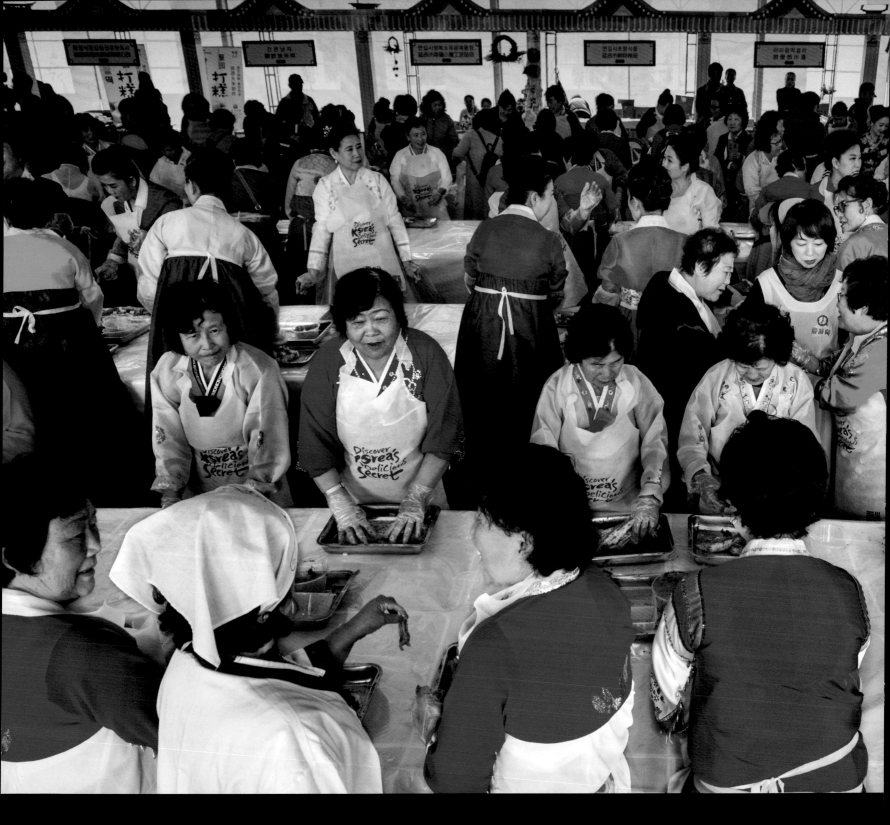

辣泡菜是朝鮮傳統食物，由於韓國文化的盛行，泡菜在非朝鮮人群體中也非常受歡迎。（右）數百名家庭主婦身著傳統服飾一同製作泡菜，一片歡聲笑語中，場面十分熱鬧。（左）

Kimchi is a traditional Korean food that is highly embraced even among non-Korean people due to the popularity of South Korean culture. (Right) Hundreds of housewives wearing folk costumes are making kimchi at the same time. The room is bustling with laughter. (Left)

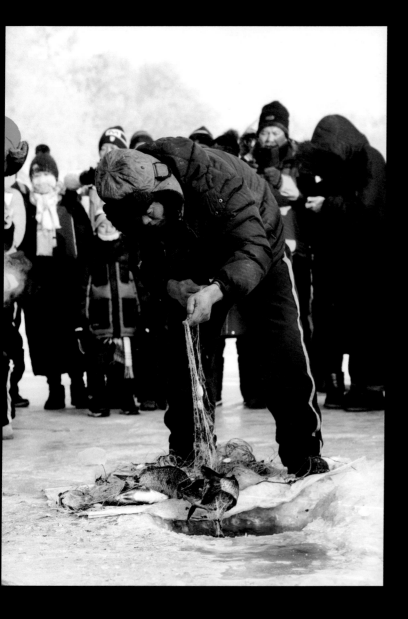

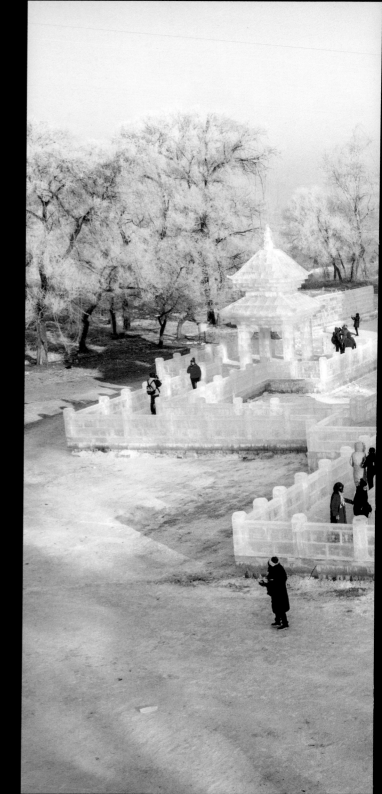

霧淞島的冰雪大世界，有著造型奇特的各類冰雕。（右）
冰下垂釣並非蒙古族的專利，生活在霧淞島附近的滿族人也有
此技能。（左）

The Ice and Snow World of Rime Island is abundant with various styles of icy sculptures. (Right) Fishing from under-ice water is not only exclusive to the Mongols. The Manchu people who live near the Rime Island are also capable of this technique. (Left)

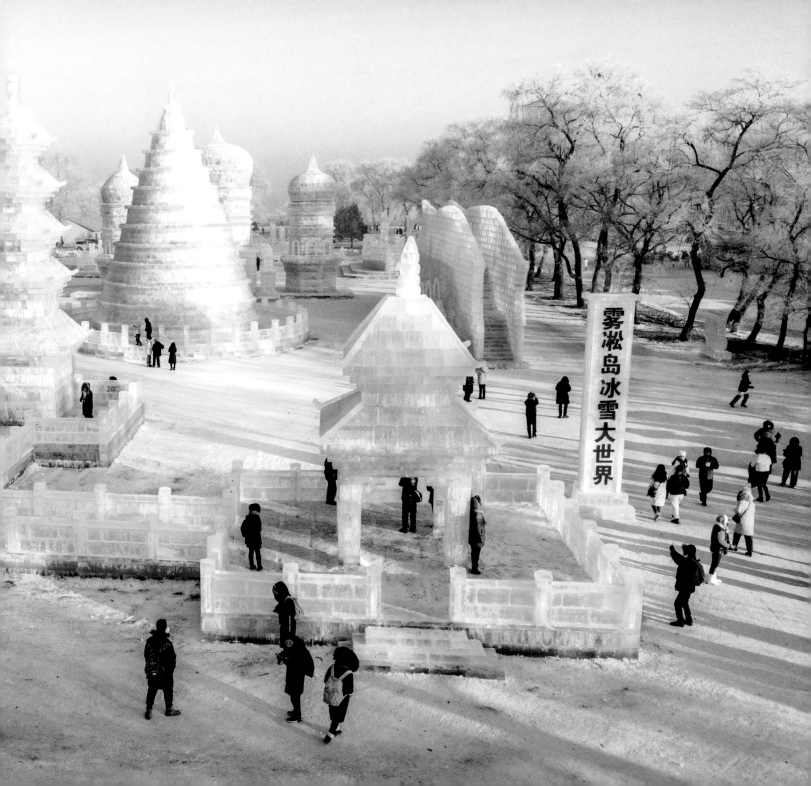

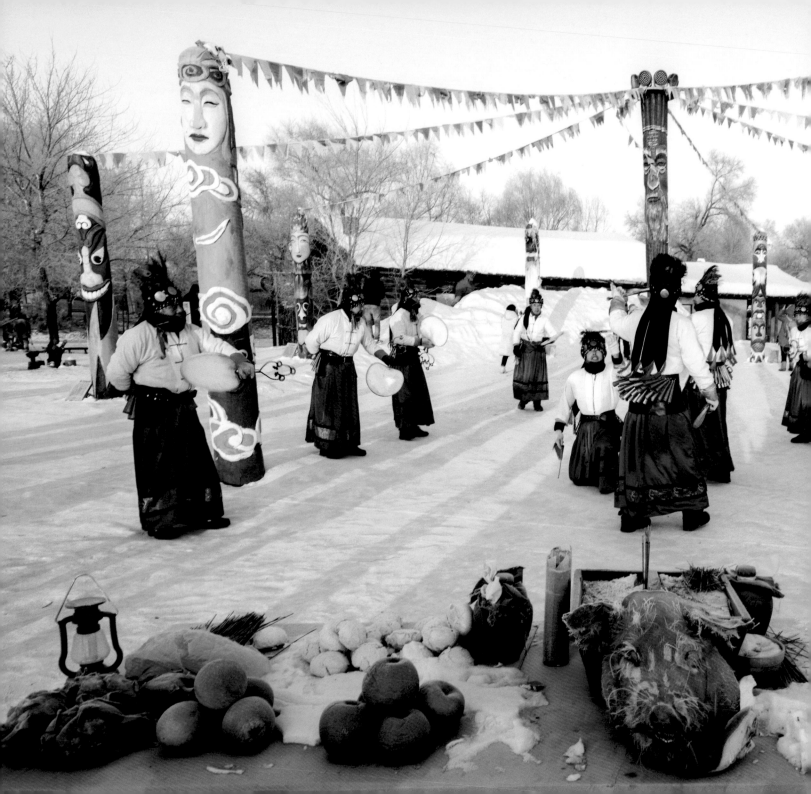

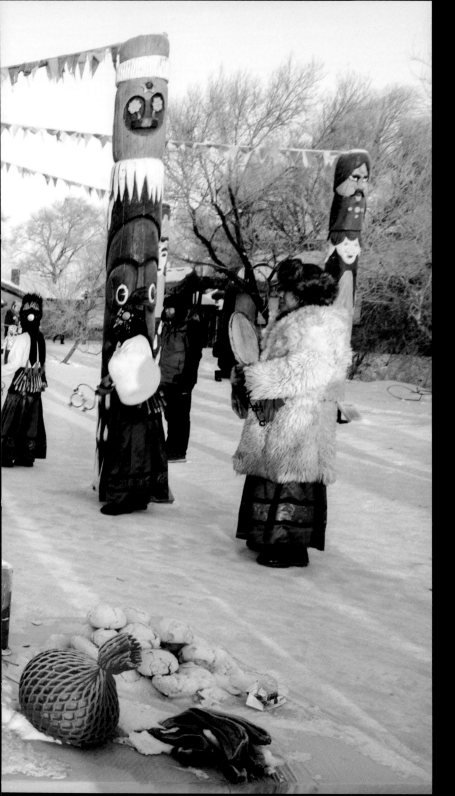

薩滿信仰在清代以前便在東北地區盛行，尤以滿族信眾為多，並與本族傳統進行結合。吉林市烏拉街滿族鎮上，一群滿族人正在舉行薩滿教祭祀。

Shamanism was once popular in the Northeast before the Qing Dynasty, especially among the Manchu, who had integrated the religion with their own traditions. In the Manchu Town on the Wula Street in Jilin City, a group of Manchu people are having a Shamanist ceremony.

瀋陽故宮位於遼寧省瀋陽市的中心區，為中國現存的兩大宮殿建築群之一，
又被稱為盛京皇宮，是清朝初期的皇宮。初建於努爾哈赤時期的 1625 年，
建成於皇太極時期的 1636 年。

The Shenyang Imperial Palace, also known as the Mukden Palace, is at
the center of Shenyang, Liaoning. It is one of the remaining two complexes
of palaces in China, and was once the royal palace in early Qing. The
construction was started in 1625 during the Nurhaci period, and finished in
1636 during reigning period of Hong Taiji.

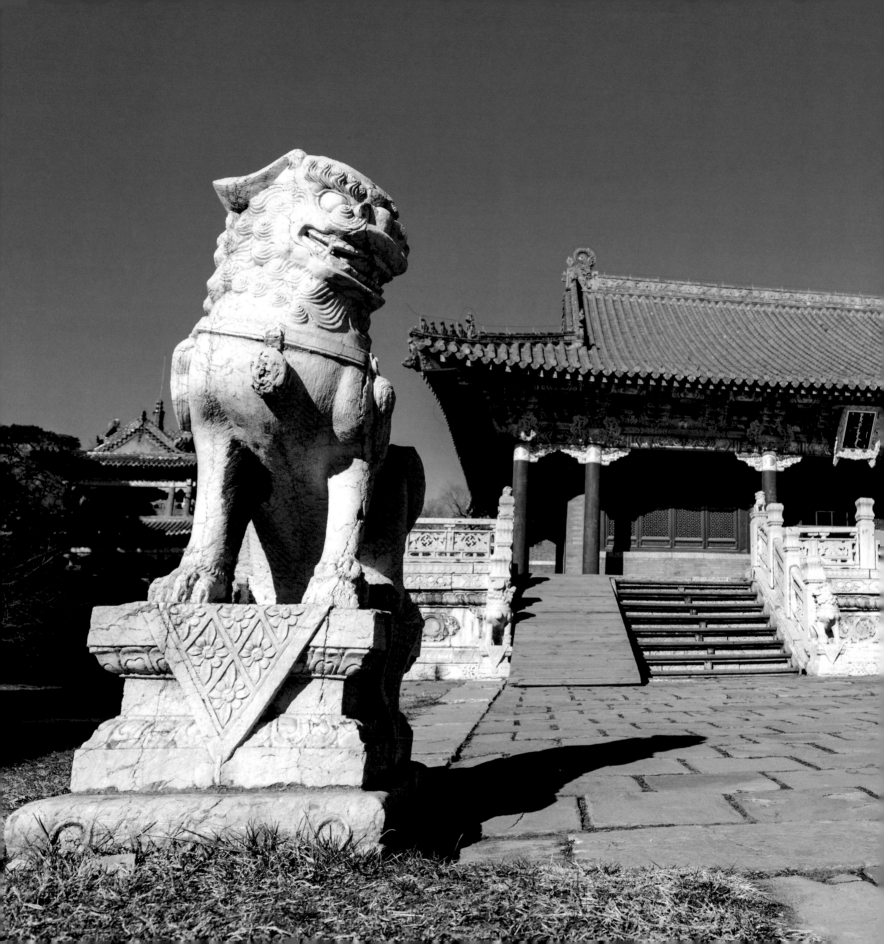

清朝遷都北京之後，瀋陽故宮成為了陪都行宮。

Since the Qing government moved its capital to Beijing, the Mukden Palace became a temporary palace in the auxiliary capital.

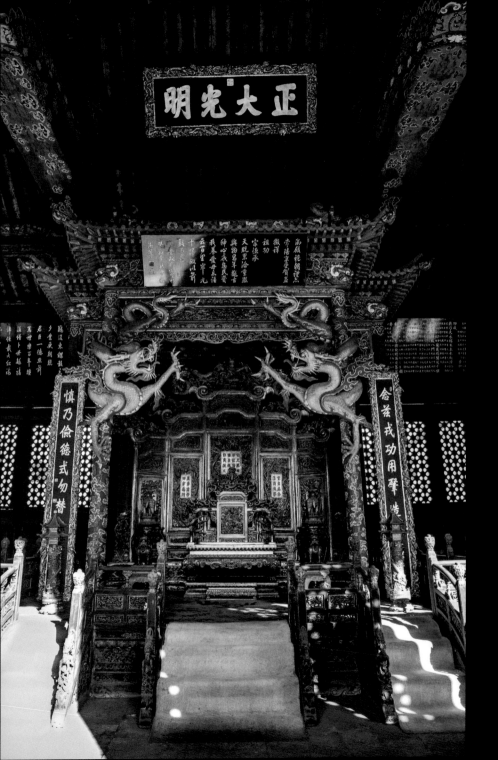

瀋陽故宮中的「正大光明」牌匾，位於崇政殿之中。崇政殿是皇太極處理政務、召見王公大臣的場所。

The "Zheng Da Guang Ming" plague is hung in the Chongzheng Hall in the Palace. The hall used to be the place where Hong Taiji dealt with government affairs and summoned his ministers.

皇太極是努爾哈赤之子、順治帝之父。1636年，他在瀋陽稱帝，正式建立了中國最後一個封建王朝——清朝，並把族名女真正式改為滿族。

Hong Taiji is son to Nurhaci and father to Shunzhi. In 1636, he claimed to be king and founded Qing, the last feudal dynasty in Chinese history. Jurchen was then renamed officially as Manchu.

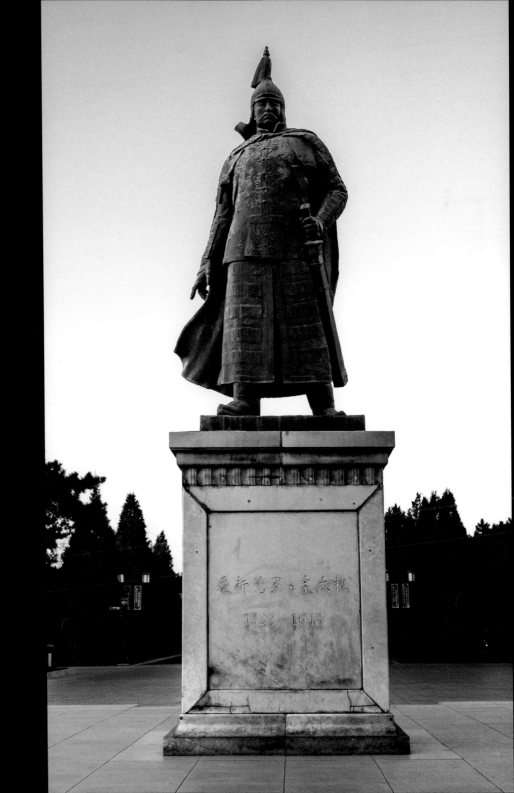

撫順市新賓滿族自治縣內有一條滿族老街，曾是后金時期周邊地區商賈與建州女真進行集市貿易的場所。

The Manchu Old Street in the Xinbin Manchu Autonomous County in Fushun city was once the market for Jianzhou Jurchens to trade with businessmen in the surrounding area during the Later Jin Dynasty.

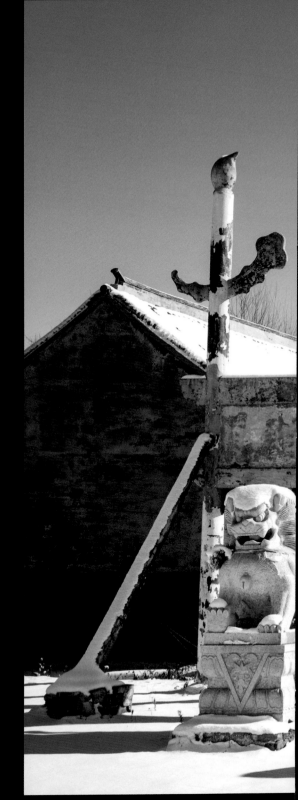

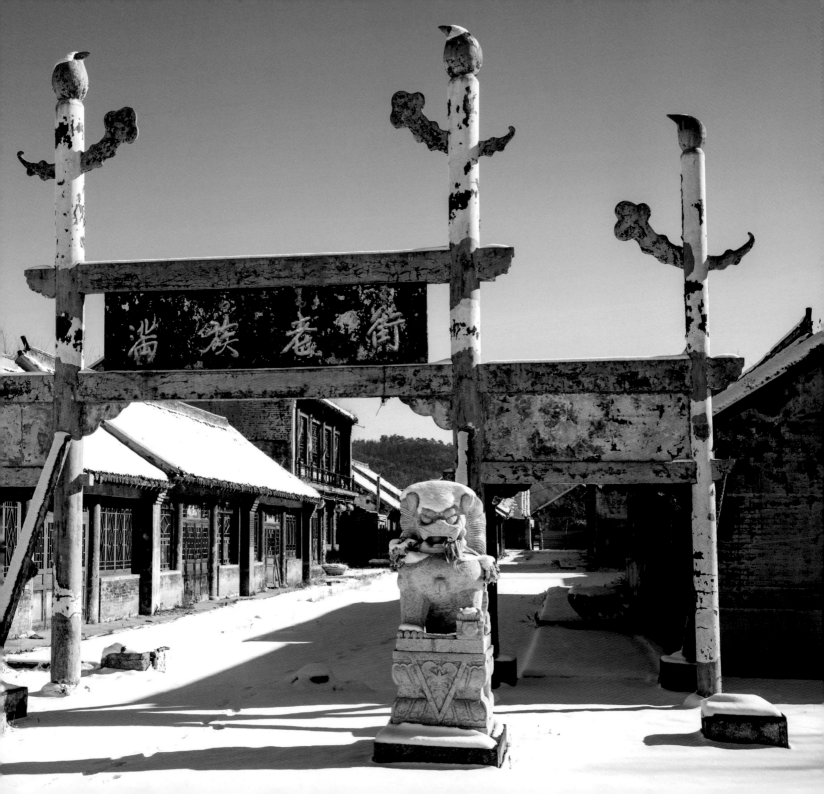

滿族

Manchu

滿族在中國的人口超過一千萬，僅次於壯族及回族，位列第三大少數民族。滿族人口主要分佈在東北地區，當中以遼寧為最。

滿族起源於長白山以北的黑龍江流域，其最早的歷史可追述到 3000 多年前的「肅慎」部族，漢至晉時期稱「挹婁」，南北朝時期為「勿吉」隋至唐時期稱「靺鞨」，遼至大金時期為「女真」。

在中國歷史上滿族及其先民靺鞨、女真曾先後建立起渤海國（公元 698 年 -926 年）、金朝（公元 1115 年 -1234 年）和清朝（公元 1636 年 -1912 年），更是唯一一個兩度入主中原的少數民族。

滿族的歲時風俗受到漢族文化的影響，同樣慶祝春節、端午節等日子，但慶祝活動中會加入自己的民族特色。滿族最為獨特的節日，則是形成於後金時期的滿族誕生日——「頒金節」。

With a population more than 10 million people, Manchu is the third largest ethnic minorities in China, after Zhuang and Hui. They mainly live in the Northeast, especially in Liaoning.

Manchu originated from the Amur River area. Its earliest history can be traced back to more than 3,000 years ago, when it was still called "Sushen". The name of the ethnic group was altered for several times in history, as "Yilou" from Han to Jin, as "Miut Kit" in the Northern and Southern dynasties, as "Mohe" from Sui to Tang, and as "Jurchen" from Liao to Great Jin.

In the Chinese history, the ancestors of Manchu Mohe and Jurchen, together with Manchu itself, had established three regimes, which are, respectively, the Balhae (698-926 AD), Great Jin (1115-1234 AD) and Qing Dynasty (1636-1912 AD). It is the only ethnic minority group that had set up dynasties in China's Central Plain twice.

The Manchurian festivities are greatly influenced by the Han culture, so they also celebrate Spring Festival and Dragon Boat Festival as Han people do, adding their own features into the celebrating activities. The most unique festival is the birthday of Manchu People, the Banjin Festival, which came into being in the Later Jin period.

頒金節為每年農曆十月十三日。在 1635 年，因「滿洲族」正式被皇太極定為族名，頒金節可說是滿族命名紀念日。滿語「頒金」表示「生機」、「生成」、「生氣勃勃」，因此也被稱為「生氣勃勃的節日」。當日，滿族人穿民族服裝、跳傳統舞蹈、唱起民歌，開展各種慶祝活動。同時，滿族重視祭祀活動，節日時會舉行祭天儀式，祈求風調雨順，家族平安。祭天時會在家中院子內立起「祭神桿」，並在桿上的容器內放入動物內臟、五穀雜糧等食物，餵養烏鴉、喜鵲等，希望牠們可將自己的願望帶到天上。

The Banjin Festival is on the 13th day of the 10th month in lunar calendar. On this day in 1635, the title of Manchu was officially endowed by Hong Taiji. It is, in fact, the naming anniversary for Manchu. "Banjin" in Manchu means vigorousness, productivity, vitality, and the festival is, therefore, also called "festival of vitality". During the festival, Manchus put on traditional costumes and carry out various celebrations, such as traditional folk dances and songs. Manchus attach great importance to ritual activities and ceremonies of worshiping the heaven are also held to pray for good weather and family peace. "Worship poles" are set up in their gardens, with internal organs of animals, grains and other food put into the baskets on the top of them. They believe birds who have eaten the food will bring their wishes to the heaven.

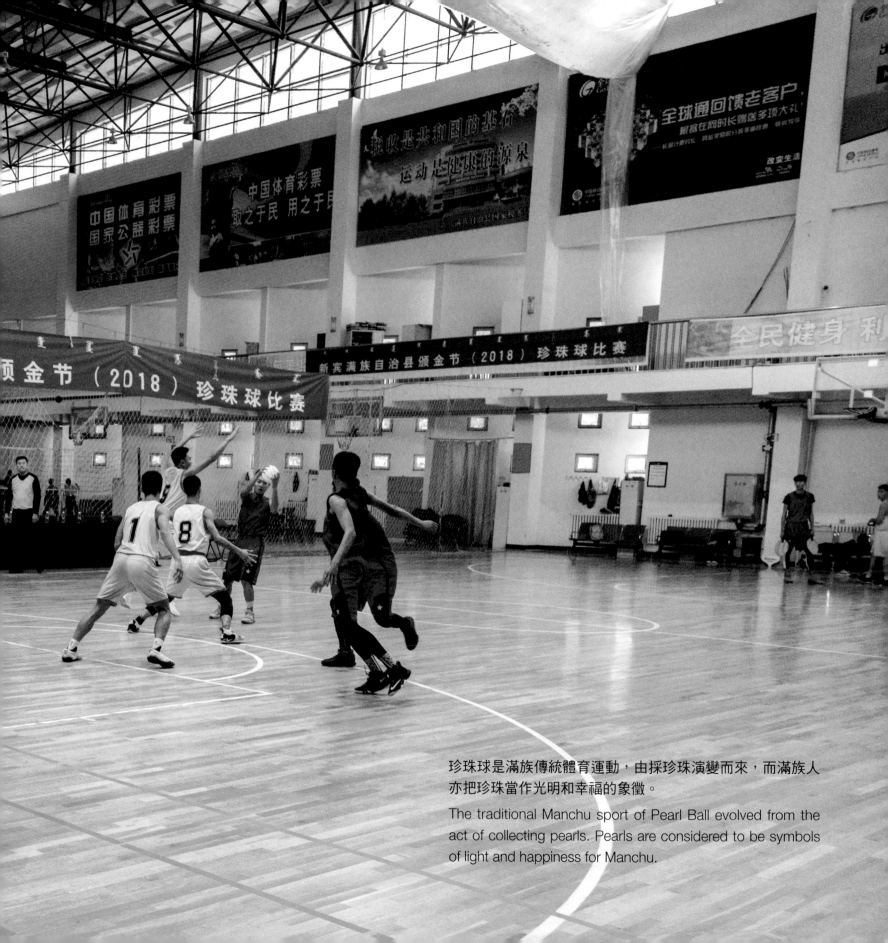

珍珠球是滿族傳統體育運動，由採珍珠演變而來，而滿族人亦把珍珠當作光明和幸福的象徵。

The traditional Manchu sport of Pearl Ball evolved from the act of collecting pearls. Pearls are considered to be symbols of light and happiness for Manchu.

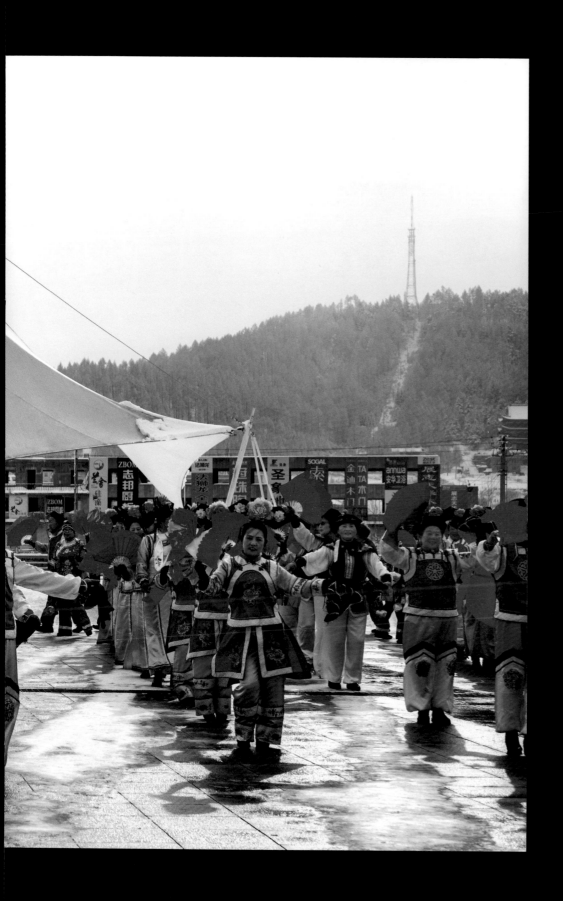

由於「清宮戲」的盛行，即使是
族外人，也對滿族的服裝、頭飾等甚
為熟悉。

Thanks to the popular dramas
based on royal families in Qing, the
Manchurian clothes and accessories
are familiar even to outsiders.

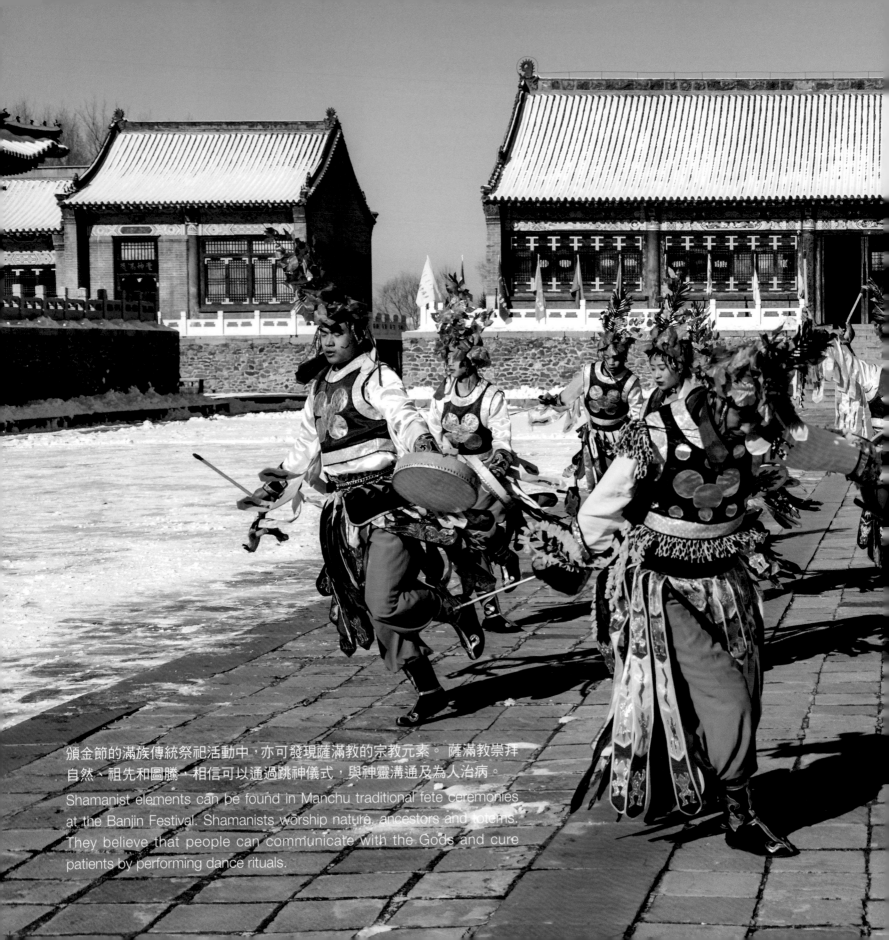

頒金節的滿族傳統祭祀活動中，亦可發現薩滿教的宗教元素。 薩滿教崇拜自然、祖先和圖騰，相信可以通過跳神儀式，與神靈溝通及為人治病。
Shamanist elements can be found in Manchu traditional fete ceremonies at the Banjin Festival. Shamanists worship nature, ancestors and totems. They believe that people can communicate with the Gods and cure patients by performing dance rituals.

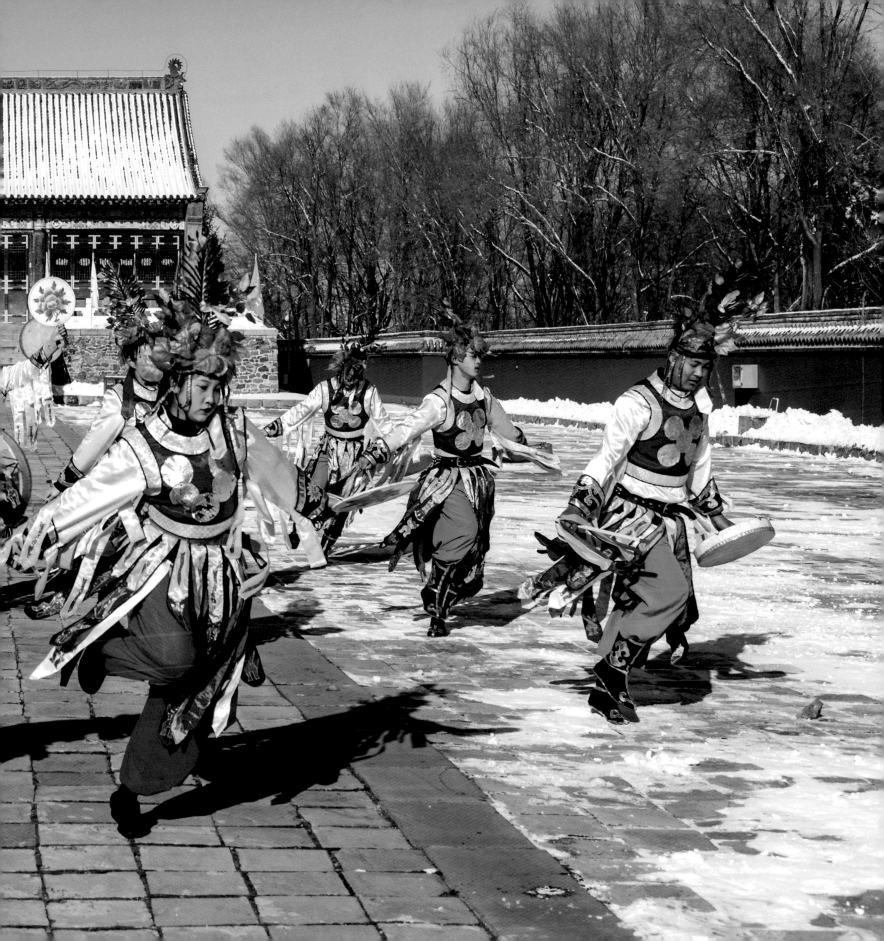

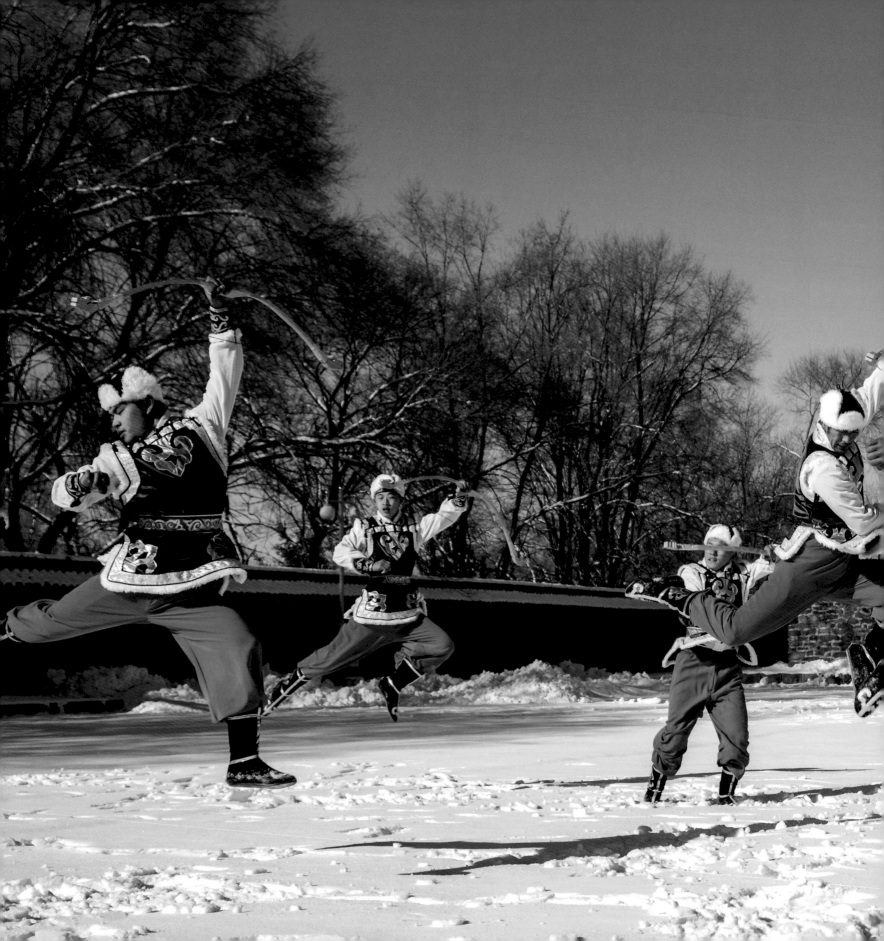

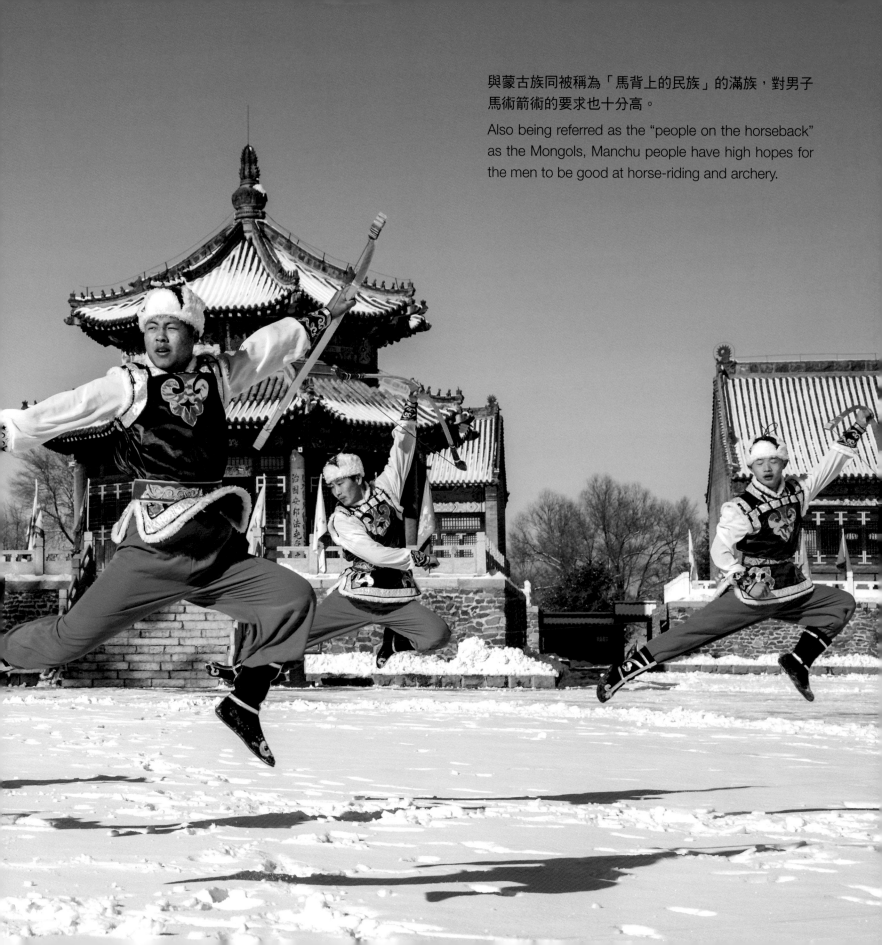

與蒙古族同被稱為「馬背上的民族」的滿族，對男子馬術箭術的要求也十分高。

Also being referred as the "people on the horseback" as the Mongols, Manchu people have high hopes for the men to be good at horse-riding and archery.

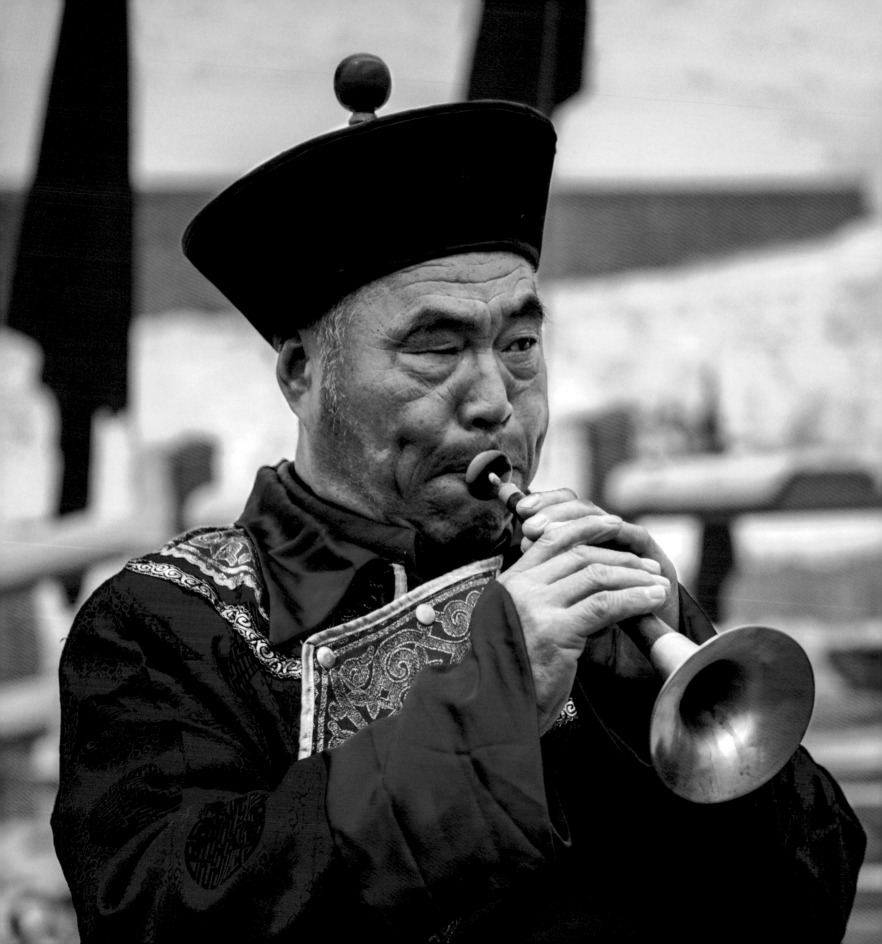

在清朝以前，中國習慣使用古箏、琵琶等清幽風雅的管弦樂器，而在滿族統治期間，音樂的風格逐漸向喜慶熱鬧轉變，嗩吶、鑼鼓等音色響亮的吹奏及打擊樂器在許多場合中使用。

Before the Qing Dynasty, instruments like Zheng or Pipa, which are relatively quieter and more peaceful, were often played in China. During the ruling period of Manchu, music style in the country had turned into a more joyful and lively one, with bright instruments like Suona, gong and drum are frequently used on many occasions.

「養活孩子吊起來」是亦是遊牧時期流傳下來的傳統，為了保護孩子在父母外出狩獵時受到野獸的侵害。

Keeping babies in suspended cradles is also a tradition from the nomad periods, which is to protect children from the beasts while the parents are out for hunting.

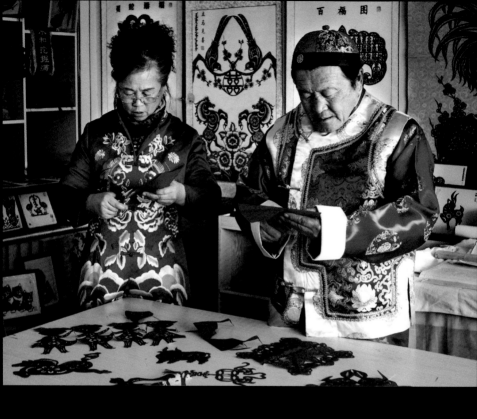

中國剪紙是人類非物質文化遺產之一，在早期多見於喪葬、祭祀等儀式中。滿族的剪紙，正是源於他們曾經信仰的薩滿教儀式。

The Chinese paper-cutting is one of the Intangible Cultural Heritage of Humanity, which first appeared in funerals or fete activities in early times. The Manchurian paper-cutting originates from their old religion Shamanism.

七彩民俗

若説北方少數民族給人以爽朗勇武的形象，南方的眾多民族就顯得多了一份婉約的氣質。由於氣候的差異，南方的民族服裝更多採用棉麻材質的短衣或裙類，顏色也更為鮮豔多彩，令人目眩神馳。

南方的民族和部落自古就眾多紛雜，在戰國時期（公元前 402 年—公元前 221 年），中原人把南方諸族統稱為「百越」，包括當今中國的東南沿海、中南部及西南地區。尤其是西南地區的雲南和貴州兩省，更是素有「十里不同風，百里不同俗」的説法。

雲南省是中國少數民族種類最多的省份，其中人口超過 5000 人的少數民族有 25 個，超過 1500 萬人口的少數民族佔全省總人口的三分之一，人數最多的為彝、哈尼、白、傣、壯等族群。雲南省省會昆明。

貴州省有超過 1200 萬少數民族人口，佔總人口的36%，多為苗、布依、土家、侗及彝。貴州省省會是貴陽市。

廣西壯族自治區 39% 人口為少數民族，是少數民族人口最多的自治區，其中絕大部分為壯族，總人口超過1500 萬。廣西首府為南寧市。

湖南省少數民族主要由土家、苗、侗、瑤、白族等組成，共佔全省人口的一成左右，多數在湘西、湘南一帶。省會長沙。

以廣州為省會的廣東省，自古民族成分複雜多樣，但是隨著世代的漢化，漢族人已經佔了廣東的絕大多數，省內少數民族人口僅約 2%。然而在粵北地區，仍可見世代居住的少數民族聚居，例如瑤族、壯族等。

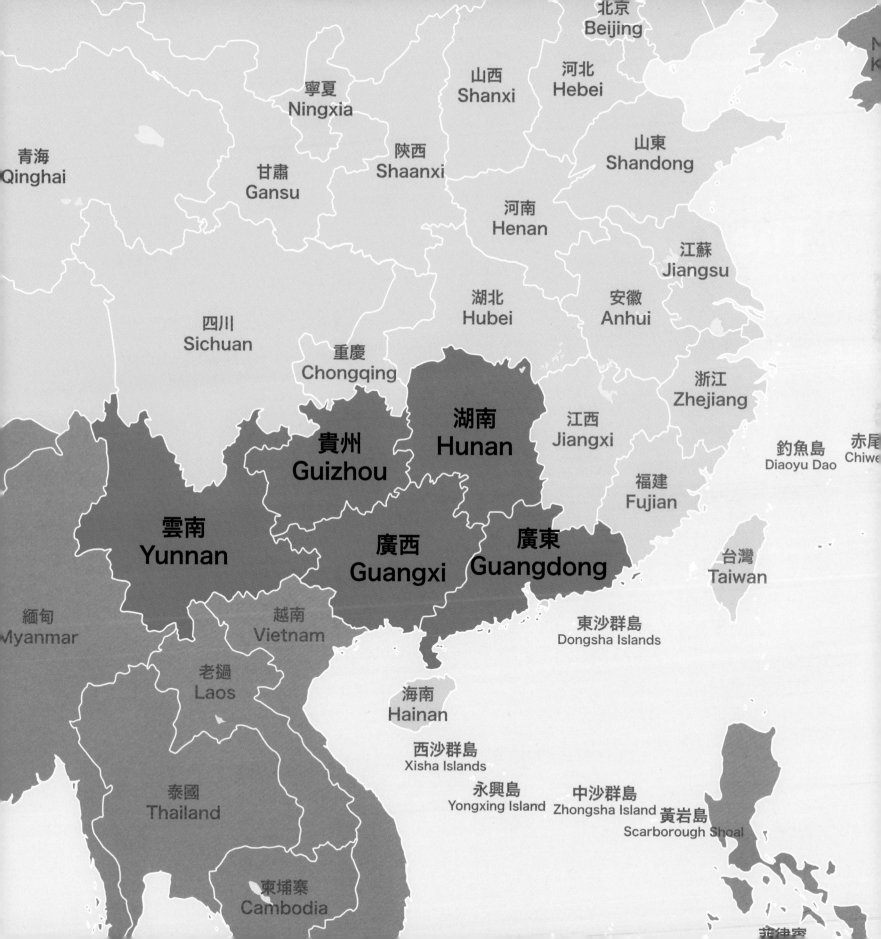

The Colorful Southern

While the northern ethnic groups impress us by their frankness and bravery, the southern ones possess a gentler temperament. Due to the difference in weather, nations in the southern area tend to wear cotton or linen short shirt and skirts. The colorful costumes are just dazzling.

Southern groups or tribes have always been numerous and jumbled since ancient times. In the Warring States period (402-221 BC), people in the Central Plain referred multiple tribes in the south jointly as Baiyue, which included ethnic groups in southeast coastal area, the South China and the Southwest China. In Yunnan and Guizhou in the Southwest, a common saying "different lifestyle in ten miles and different customs in a hundred" indicates the diversity of ethnicity in these two provinces.

Yunnan is the province with the most groups of minorities in the country, with 25 of them exceeding population of 5,000. Kunming is its capital. The 15 million and more ethnic minorities have taken up one third of the province's population, and Yi, Hani, Bai, Dai and Zhuang are the largest groups. Kunming is its capital.

In Guizhou, there are more than 12 million (36%) minority residents. Most of them are Miao, Bouyei, Tujia, Tong and Yi. The capital is Guiyang.

Guangxi Zhuang Autonomous Region is the provincial district with the highest population of ethnic minorities - 39 percent of its residents are non-Han people. Nanning is the capital of Guangxi. Zhuang, with more than 15 million people, is the largest minority group.

In Hunan, whose capital is Changsha, the major minorities are Tujia, Miao, Tong, Yao and Bai. Combined they have taken up about 10 percent of the provincial population, and most live in the west and the south of Hunan.

Guangdong, with Guangzhou being its capital, has been a multinational area for ages, but generations of integration into the Han nation has turned the province into an area with only 2 percent of minority population. In the northern part of Guangdong, however, there are still indigenous minority groups.

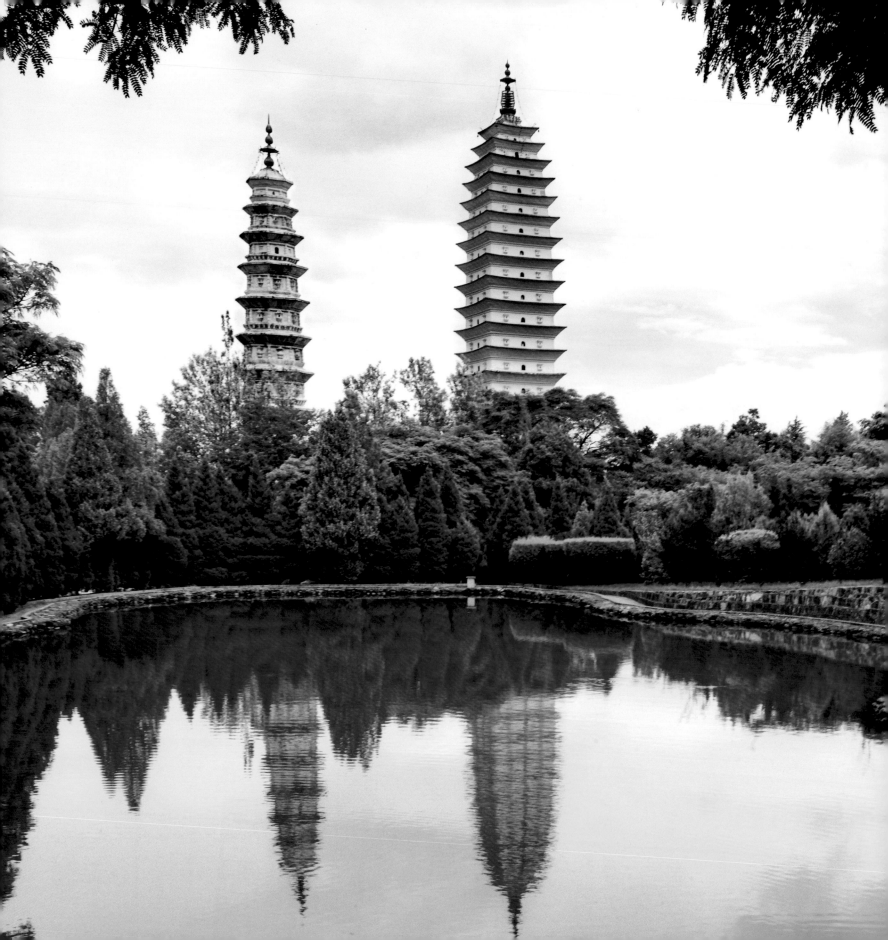

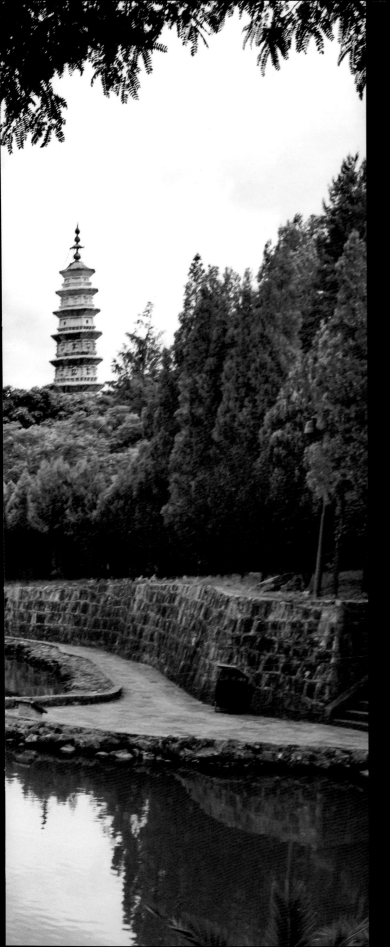

大理的崇聖寺三塔矗立於雲南大理古城的西北部，寺廟建於 9 世紀，曾是南詔、大理國皇家寺院。

The Three Pagodas of the Chongsheng Temple is located at the northwest of the Dali Old City in Yunnan Province. Constructed in the 9th century, Chongsheng was once the royal temple for Nanzhao and Dali Kingdom.

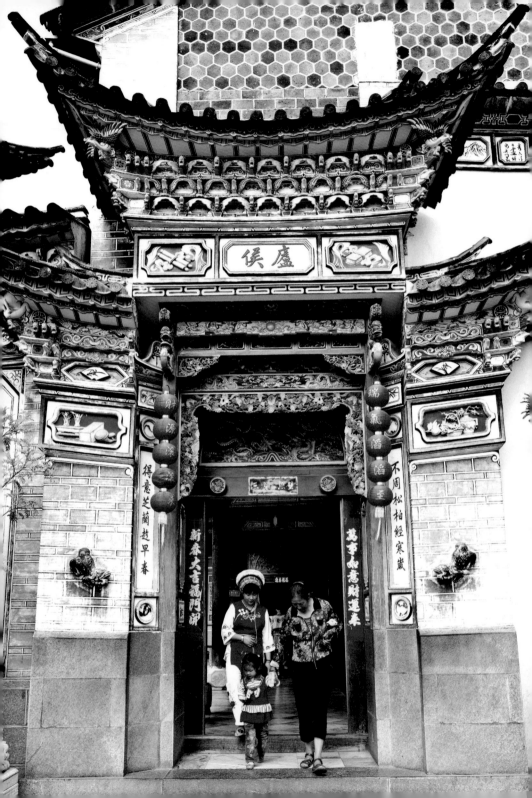

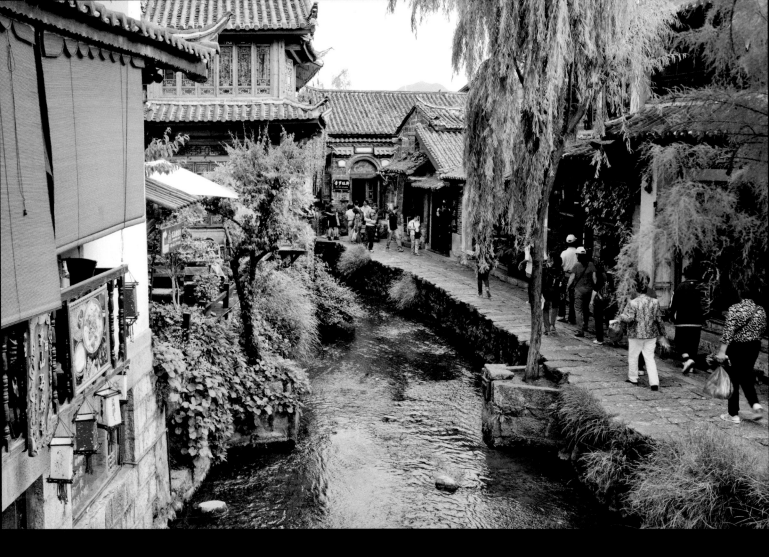

嚴家大院位於大理喜洲古鎮內，是一座典型的白族民居建築。（左）麗江古城建於宋代末年，至今已有 800 多年的歷史。
1997 年它被聯合國教科文組織列為世界文化遺產。（右）

The Yan's Compound in Xizhou Old Town in Dali city is a typical residential construction of Bai People. (Left) Old Town of Lijiang was constructed in late Song Dynasty, with a history of over 800 years. In 1997, it was listed as a UNESCO World Heritage Site. (Right)

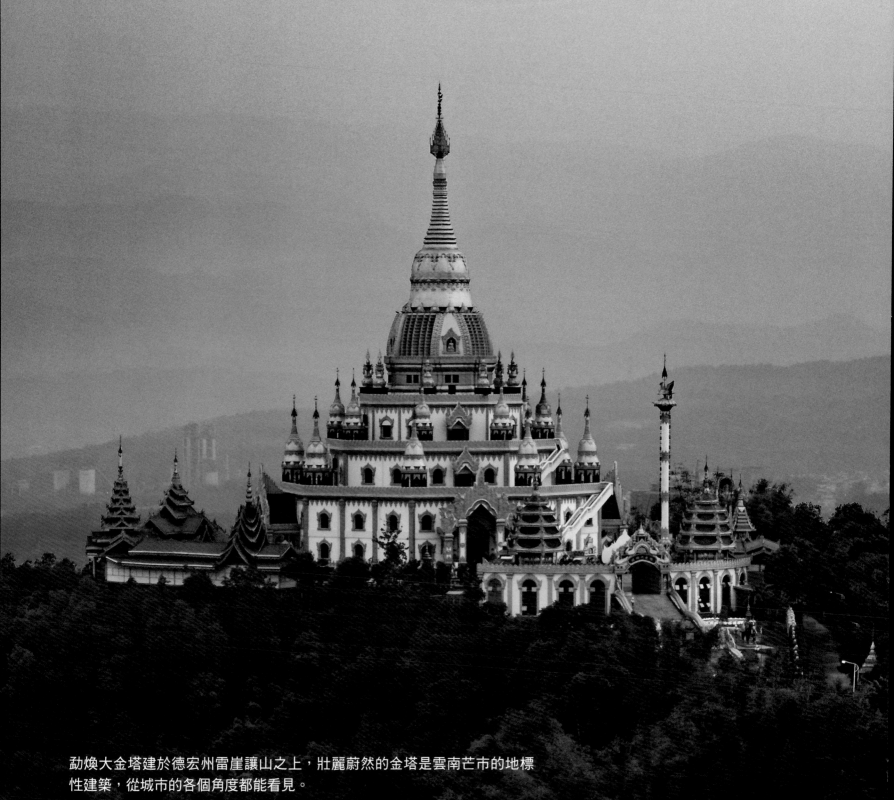

勐煥大金塔建於德宏州雷崖讓山之上，壯麗蔚然的金塔是雲南芒市的地標性建築，從城市的各個角度都能看見。

The Menghuan Grand Golden Pagoda is located at the Leiyarang Mountain in Dehong, Yunnan. This majestic construction is the landmark in the Mengshi Town, which can be seen from almost everywhere.

傣族

Dai People

傣族，在中國境內主要聚居於雲南省的西雙版納傣族自治州和德宏傣族景頗族自治州，根據 2010 年的人口普查，傣族人口超過 120 萬，為中國第 19 大民族。

傣族與緬甸的撣族和坎底傣、老撾的主體民族佬族、泰國的主體民族泰族以及印度阿薩姆阿豪姆人系出同源。他們同樣信奉上座部佛教，在文化、語言、文字、習俗等方面都有或多或少的共通點。傣族男子在一生之中，都要出家一段時間過僧侶的生活，然後才能結婚。

孔雀和大象被傣族視為吉祥的象徵，「孔雀舞」和「象腳鼓舞」更是在這個熱愛歌舞的民族內流行。從民族舞蹈對動物惟妙惟肖的模仿和美化，可以看出傣族對生活的熱情。

水，是傣族人心目中最純潔的事物，潑水節是族內最盛大的節日。

Dai people in China mainly live in the Xishuangbanna Dai Autonomous Prefecture and the Dehong Dai and Jingpo Autonomous Prefecture in Yunnan Province. According to the 2010 census, the Dai population exceeded 1.2 million. It is the 19th largest ethnic group in the country.

The Dai shares the similar origin with Shan and Khamti - nationalities in Myanmar, Lao - the main nation in Laos, Thai - the main nation in Thailand and Ahom - from the state of Assam in India. They all believe in Theravada of Buddhism, and there are more than a few similarities in their culture, language, characters, customs, and many other aspects. In Dai, every man has to live as a monk for a period of time before he gets married.

Peacocks and elephants are regarded as lucky symbols. Peacock Dance and Elephant Foot Drum Dance are popular among Dai. From the lifelike yet beautiful performance imitating animals, you can definitely feel the enthusiasm for life.

Water is the purest material in the eyes of Dai, and the Water-Sprinkling Festival is the most important event in the nation.

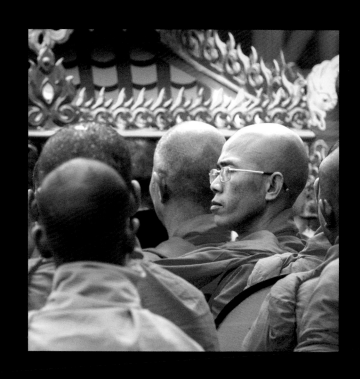

潑水節，亦稱「宋干節」，是泰國、老撾、斯里蘭卡、緬甸、柬埔寨等國的泛泰民族以及中國雲南傣族共同慶祝的傳統節日。傣族潑水節在傣曆六至七月舉行，即公曆的四至五月，又被視為傣族的新年，氣氛十分喜慶。傣族的文字從印度的婆羅米文字演變而來，與老撾文、泰文、緬甸文、高棉文屬于同一體系。

The water-sprinkling festival, also known as Songkran, is a traditional festival jointly celebrated by Tai People in Thailand, Laos, Sri Lanka, Myanmar and Cambodia as well as Dai People in Yunnan, China. Dai's water-sprinkling festival is usually held from June to July in the Dai calendar, which is April to May in Gregorian calendar. It is regarded as the New Year of Dai, and the holiday mood is jubilant. Dai characters revolved from the Indian Brahmi script, which is the same case for characters of Laos, Thailand, Myanmar and Cambodia.

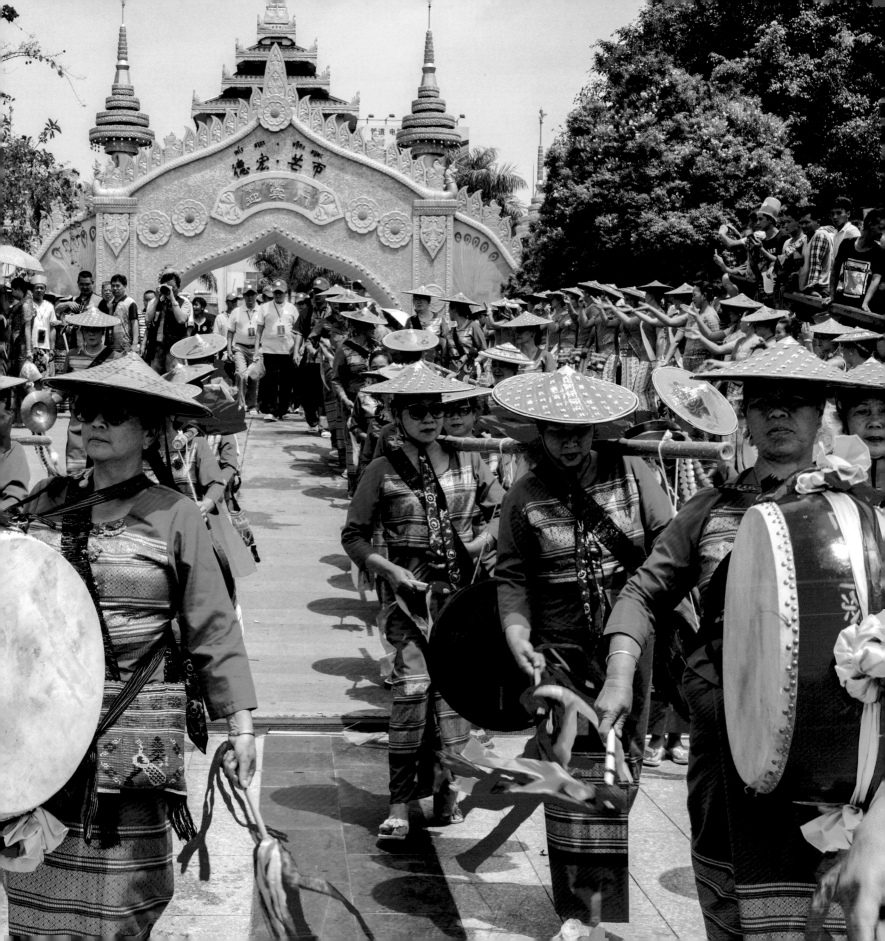

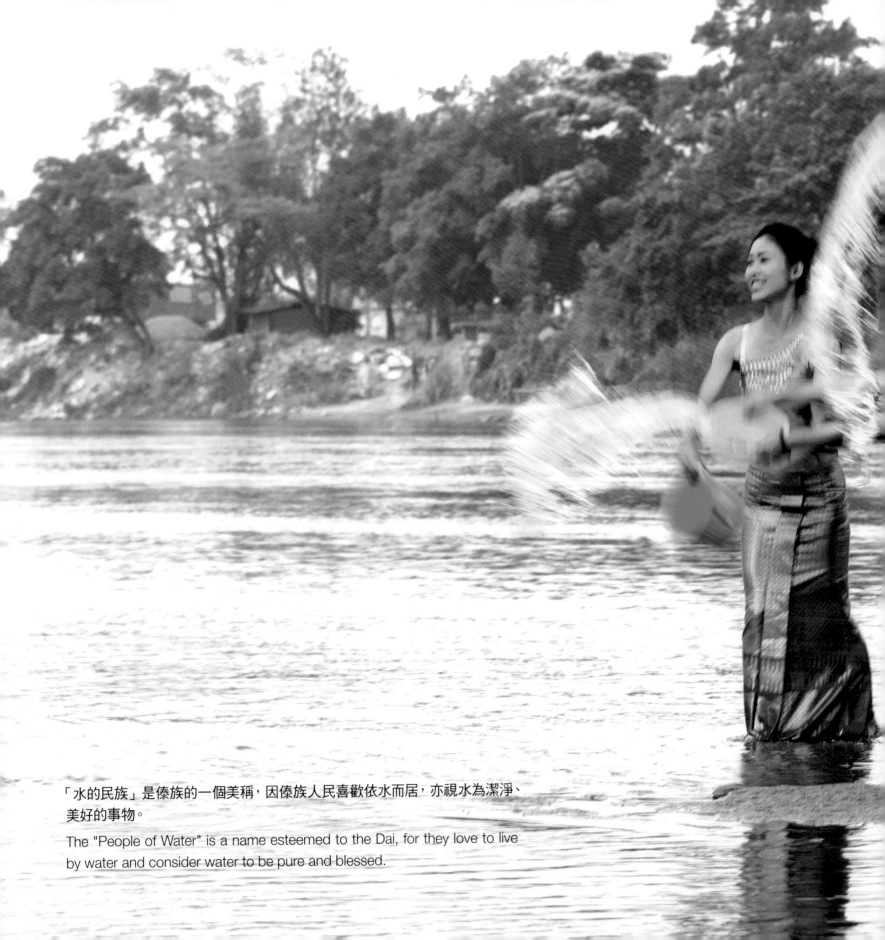

「水的民族」是傣族的一個美稱，因傣族人民喜歡依水而居，亦視水為潔淨、美好的事物。

The "People of Water" is a name esteemed to the Dai, for they love to live by water and consider water to be pure and blessed.

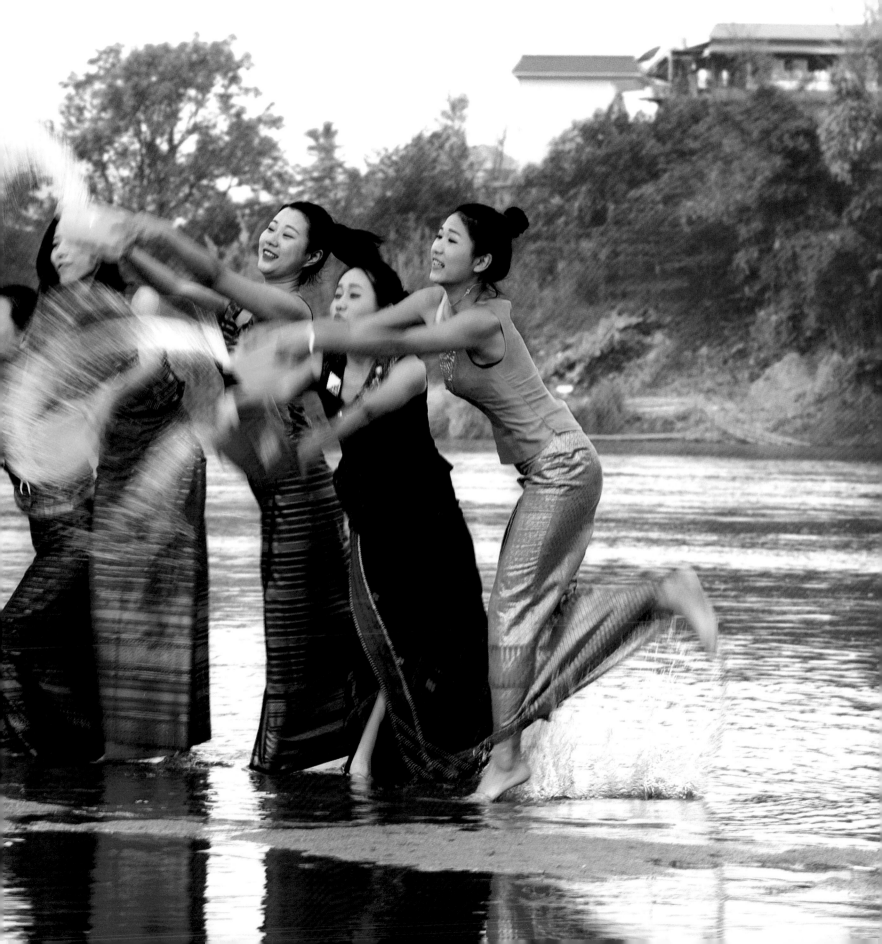

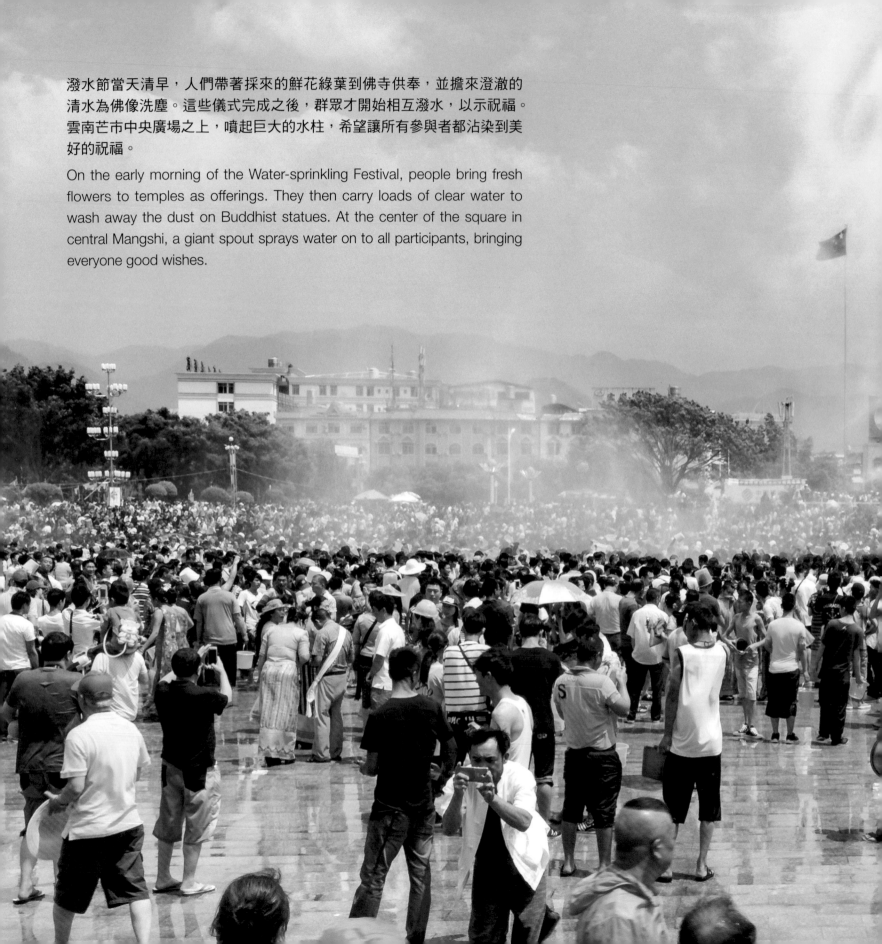

潑水節當天清早，人們帶著採來的鮮花綠葉到佛寺供奉，並擔來澄澈的清水為佛像洗塵。這些儀式完成之後，群眾才開始相互潑水，以示祝福。雲南芒市中央廣場之上，噴起巨大的水柱，希望讓所有參與者都沾染到美好的祝福。

On the early morning of the Water-sprinkling Festival, people bring fresh flowers to temples as offerings. They then carry loads of clear water to wash away the dust on Buddhist statues. At the center of the square in central Mangshi, a giant spout sprays water on to all participants, bringing everyone good wishes.

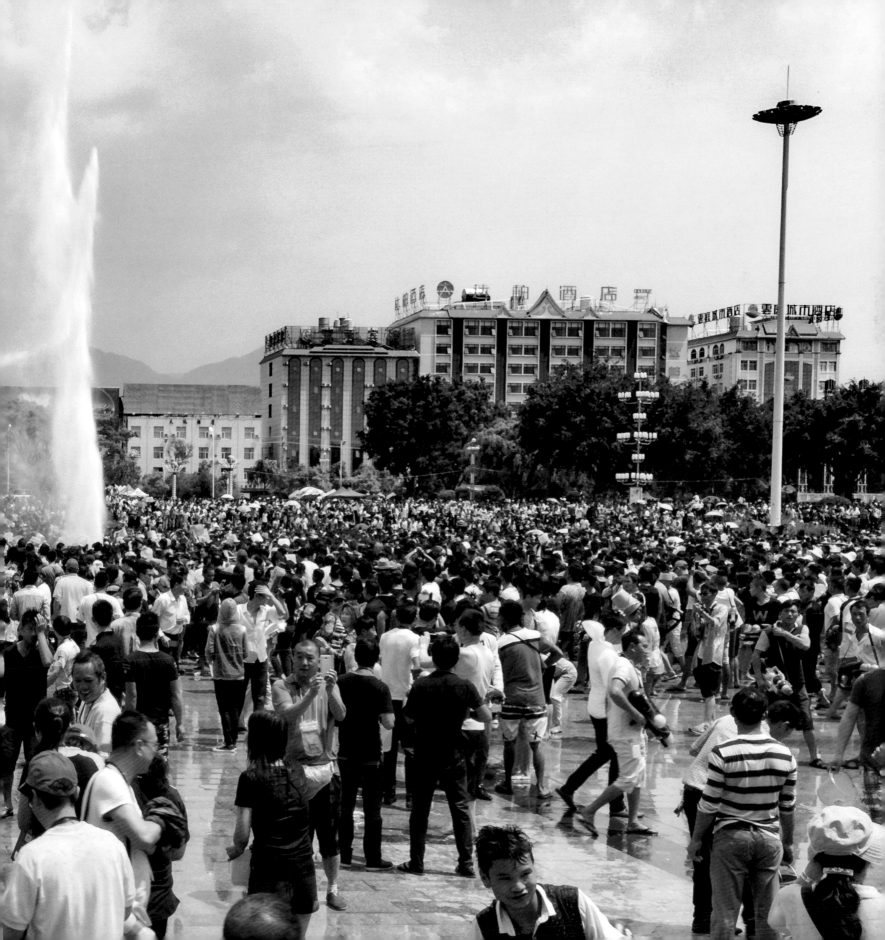

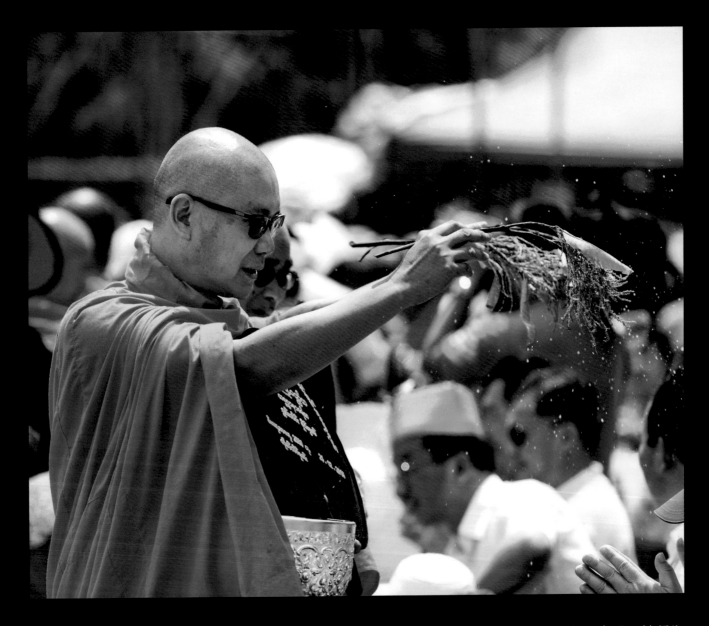

以枝葉取盆中的淨水，灑向信眾頭頂，代表最純潔的祝福。（左）傣族男子抬著佛像進入會場，被稱為「請佛」儀式。（右）

The water sprayed from the branches upon the heads of believer is bringing the purist blessing to them. (Left)

The Dai men are "inviting the Buddha" by lifting a statue of the Buddha into the venue. (Right)

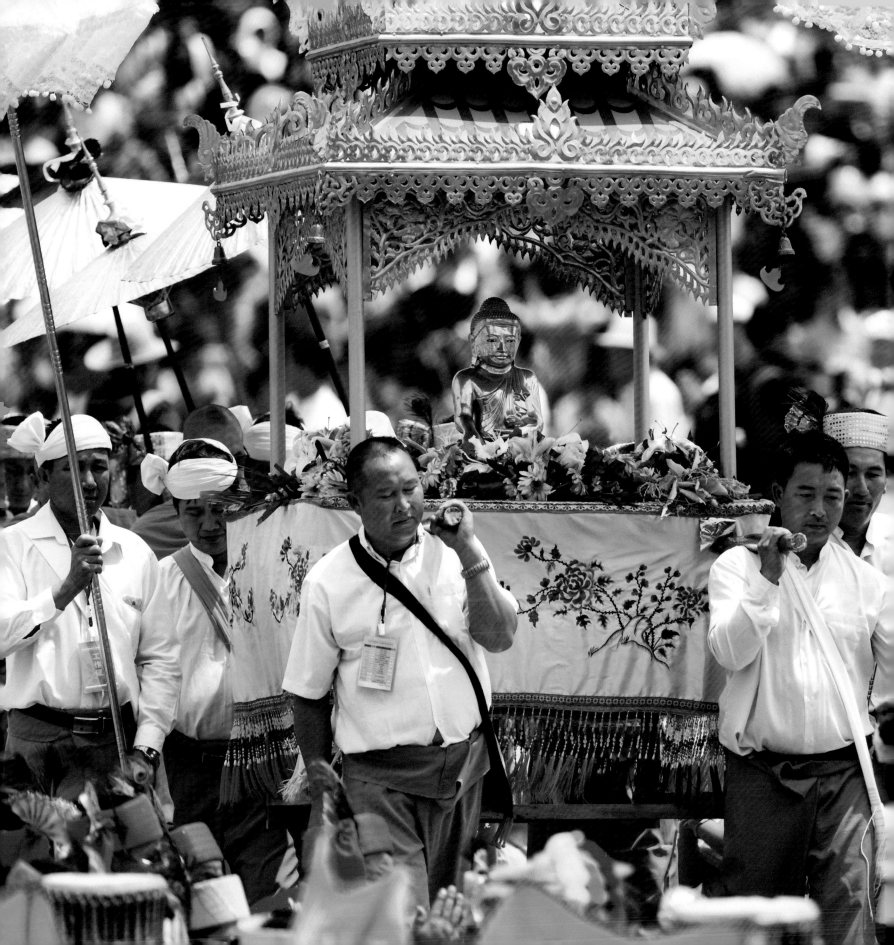

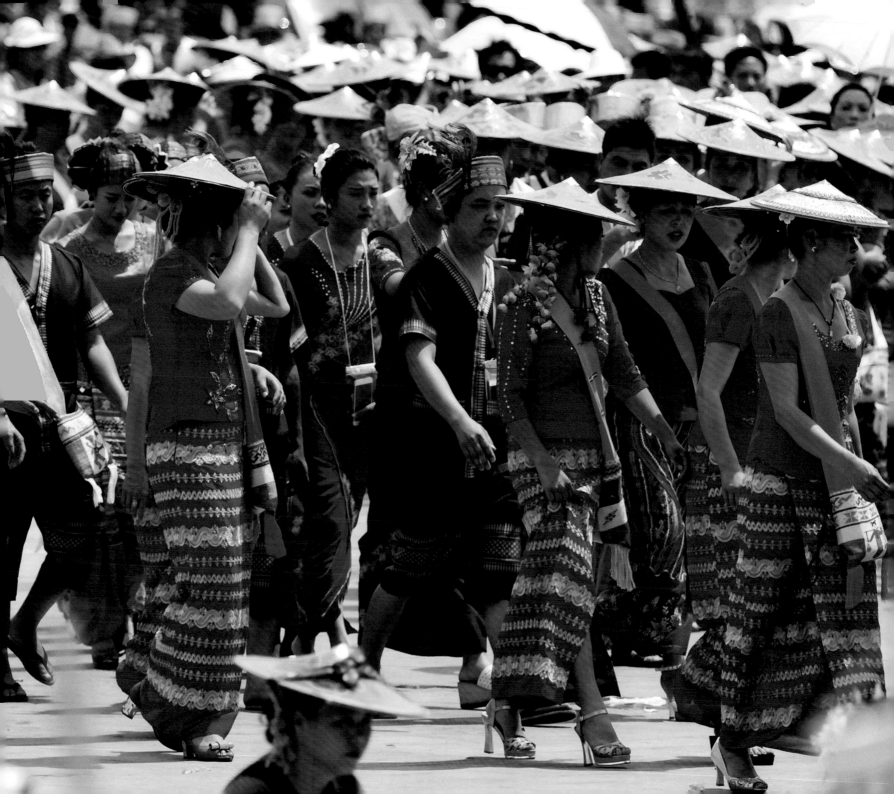

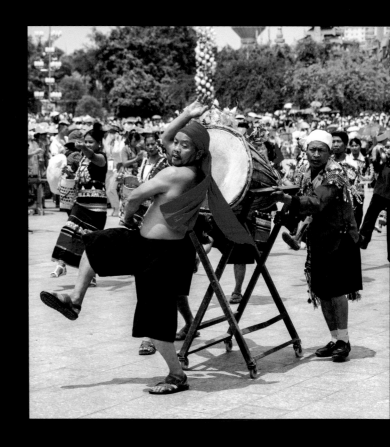

錐形斗笠帽是傣族女性喜愛的頭飾之一。（左）象腳鼓舞表演中，擂鼓者以奇特的姿勢吸引了觀眾的注意力。（右）

The cone-shape bamboo hat is one of the favorite headwear for Dai women. (Left) A drummer is drawing attraction from the audience by using strange gestures in the elephant-foot drum dance. (Right)

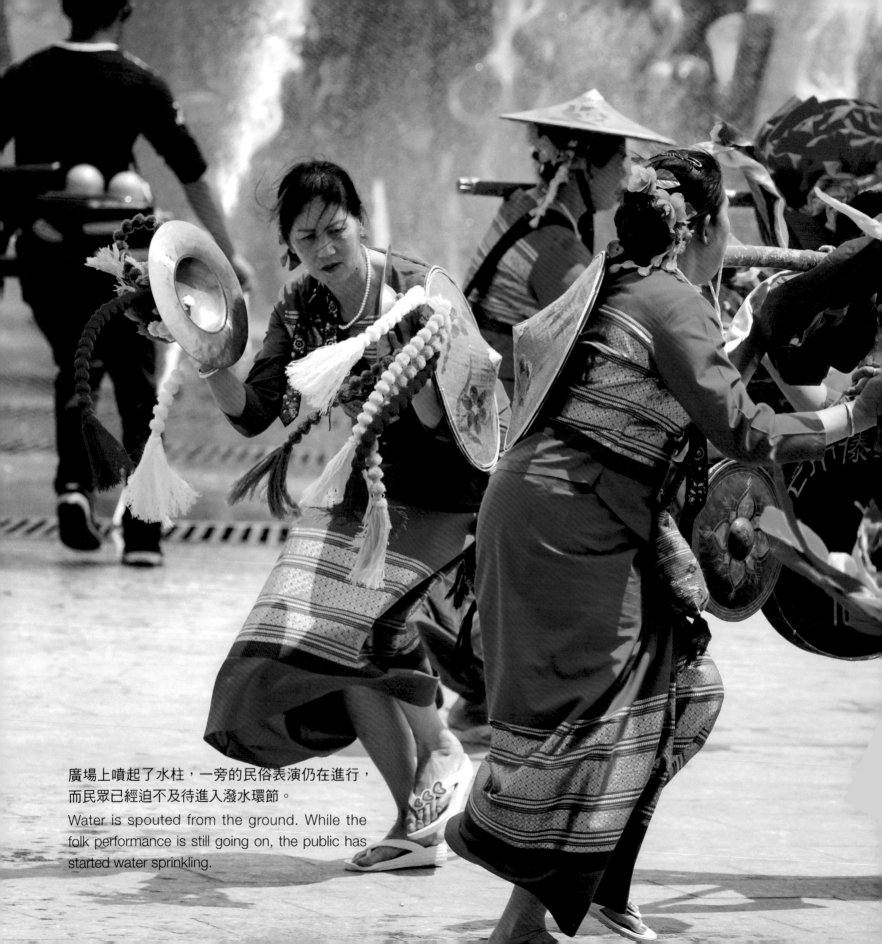

廣場上噴起了水柱，一旁的民俗表演仍在進行，
而民眾已經迫不及待進入潑水環節。

Water is spouted from the ground. While the
folk performance is still going on, the public has
started water sprinkling.

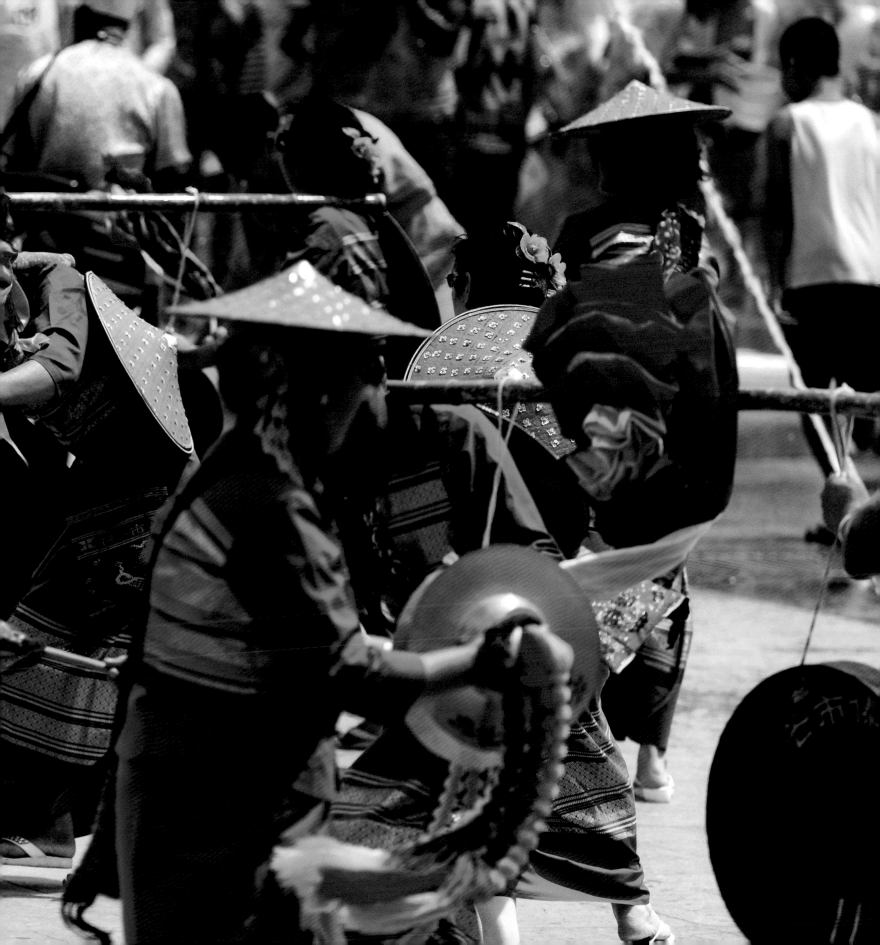

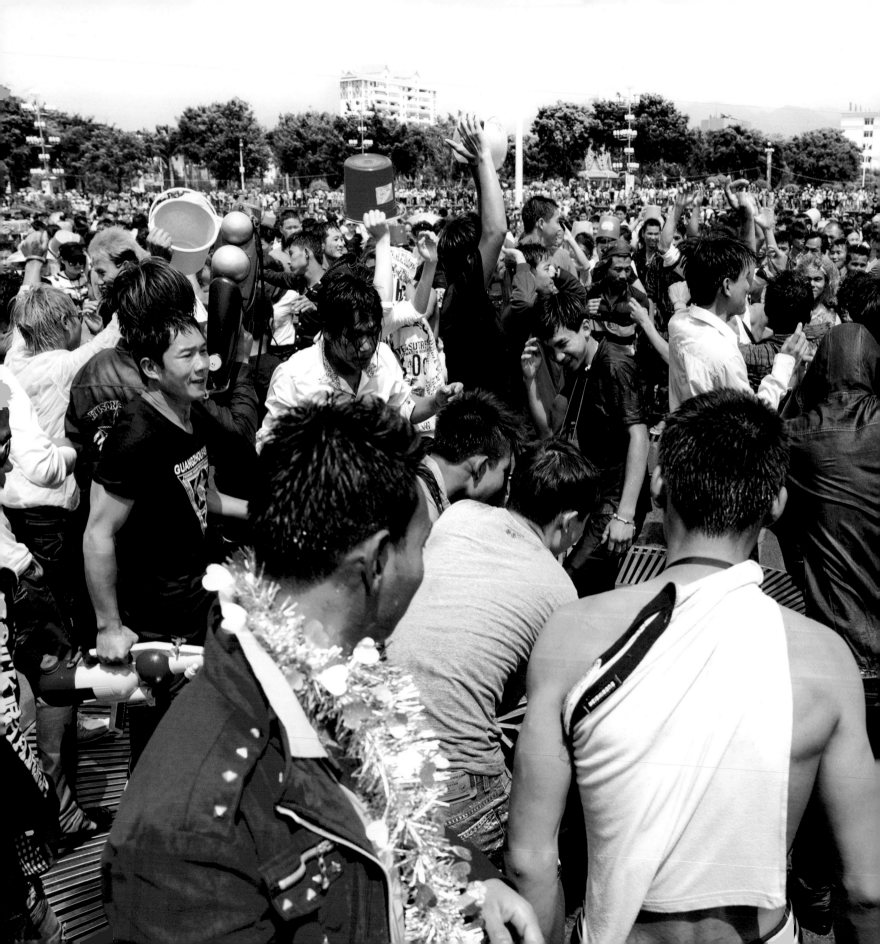

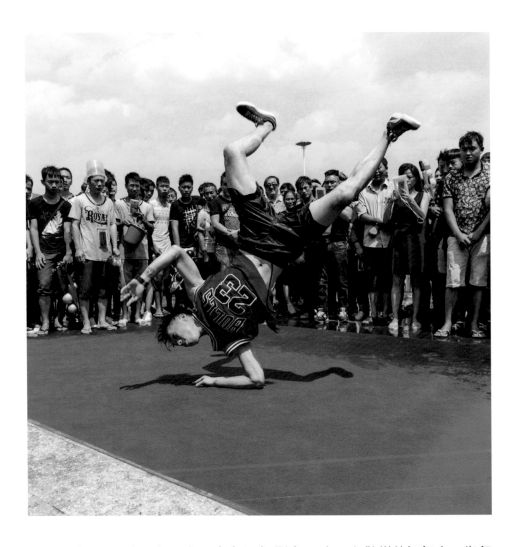

才剛開始潑水不久，便已有不少人全身濕透。（左）在歡樂的氣氛中，街舞愛好者不忘為眾人上演精彩的地板霹靂舞。（右）

Not long after the sprinkling, many are already wet all over. (Left) The joyful atmosphere has encouraged street dancers to put on a wonderful show of break dance. (Right)

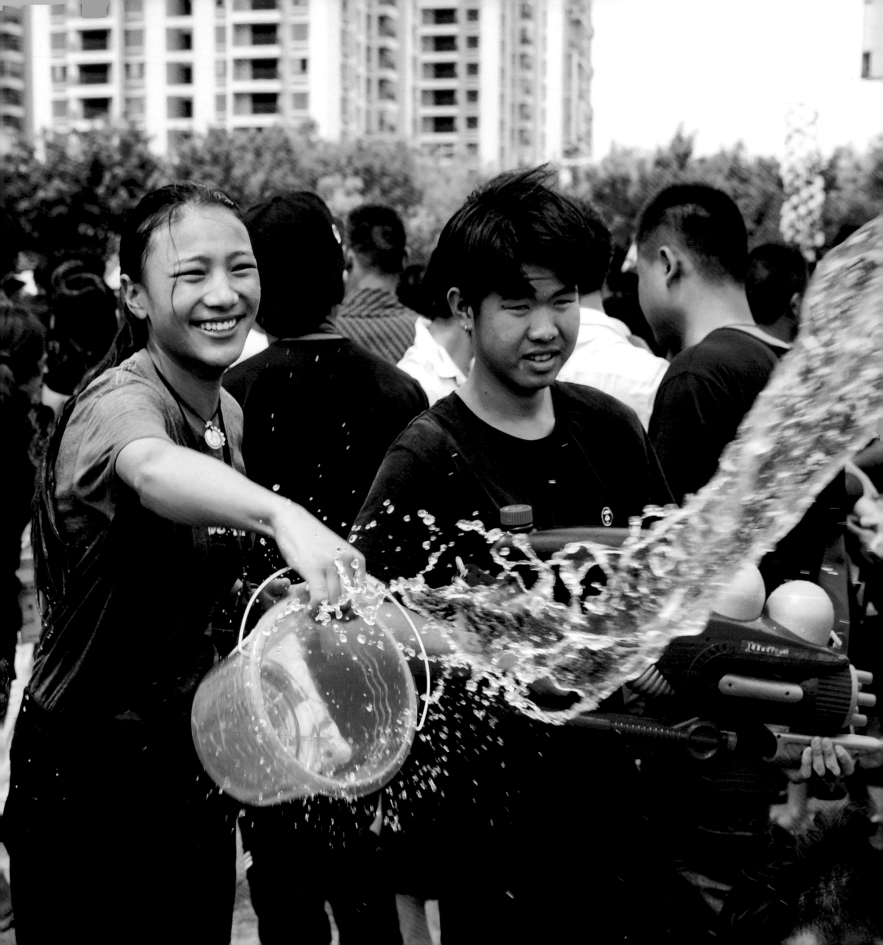

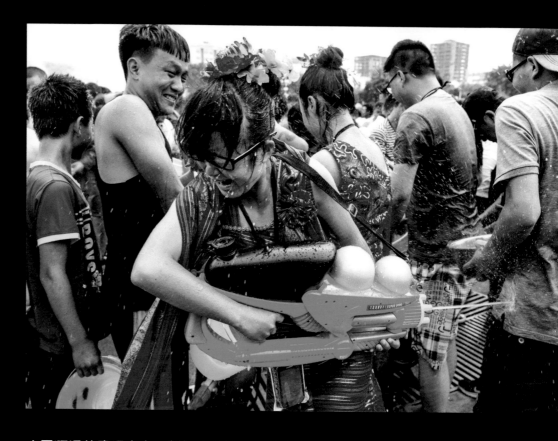

水霧瀰漫的廣場之上，每個人的臉上都帶著喜悅的笑容。（左）「全副武裝」的女孩在猛烈的水勢攻擊之下不忘還擊。（右）

On the square overlaid with water and mist, everyone is laughing happily. (Left) A "fully-armed" girl is fighting back under fierce attack. (Right)

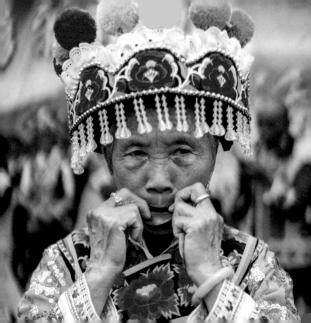

彝族

Yi People

彝族，曾稱倮倮，與哈尼、栗僳、拉祜等民族皆源於古羌族，是中國最古老的民族之一。彝族世代居住在中國西南地區，現主要分佈在雲南、四川和貴州三省，有少數在越南、老撾等東南亞地區。目前，全世界的彝族人口約為 900 多萬，其中 870 多萬居住在中國境內，是中國第六大少數民族。

彝族的內部分為不同的支系，以不同的稱謂區分，各個支系之間以方言和服飾作區分，乍看之下，這些支系彷彿本身就是獨立的不同民族。然而，他們其實皆屬彝族，都使用彝族文字，共同遵循彝族傳統。

彝族崇拜萬物有靈，也崇拜祖先，民間傳統節日繁多，主要節日有慶祝豐收的十月年和祈求豐年的火把節。

The Yi people was historically known as Lolo. Originated from the ancient Qiang like Hani, Lisu and Lahu peoples, Yi is one of the oldest ethnicities in China. Southwestern China has always been their inhabiting area. Yi people are now living mainly in Yunnan, Sichuan and Guizhou in China, while a small part is also in Vietnam and Laos in the Southeast Asia. At the moment, there are about 9 million Yi people in the world, with around 8.7 million in China.

Yi consists of many branch groups, all titled separately within the ethnicity. They speak their own dialects and wear various costumes, so it is easily misunderstood that they are from different ethnic groups. But, in fact, they are all Yi people, who use the language and characters of Yi and follow the traditions of the nation.

They believe in animism and worship their ancestors, so folk festivities are very common. The main festivities include the Double Tenth Festival which celebrates harvest and the Torch Festival which prays for a good year ahead.

彝人古鎮位於雲南省楚雄市內，古色古香的建築中來往的皆是穿戴著民族服飾的彝族人，讓遊客能夠充分欣賞彝族文化。不少民族都有舉行火把節的傳統，例如彝族、白族、納西族、基諾族、拉祜族，當中又以彝人古鎮的火把節最為豐富多彩。火把節一般在農曆六月廿五左右舉行，祈求豐年。

The Yi's Old Town is located in Chuxiong, Yunnan. Surrounded by classic constructions and passers-by in folk costumes, tourists are able to learn about the culture of Yi. Torch Festival is a tradition in many ethnicities, such as Yi, Bai, Nakhi, Jino and Lahu. The celebration at the Yi's Old Town is especially festive. The Festival is usually held on the 25th of the sixth lunar month, with a purpose of praying for harvest.

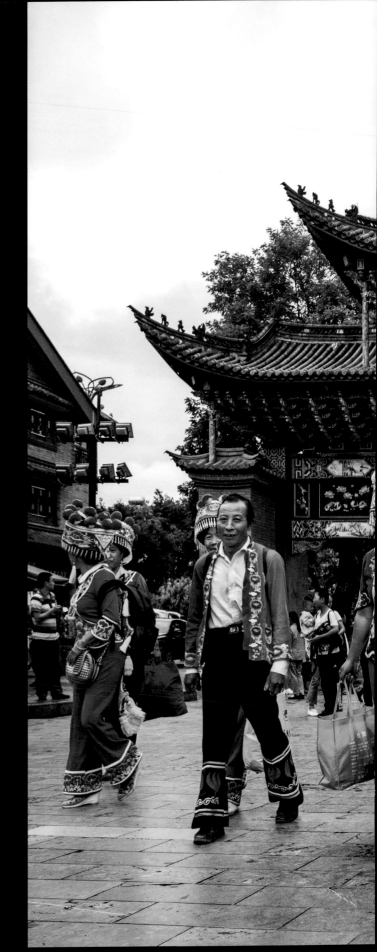

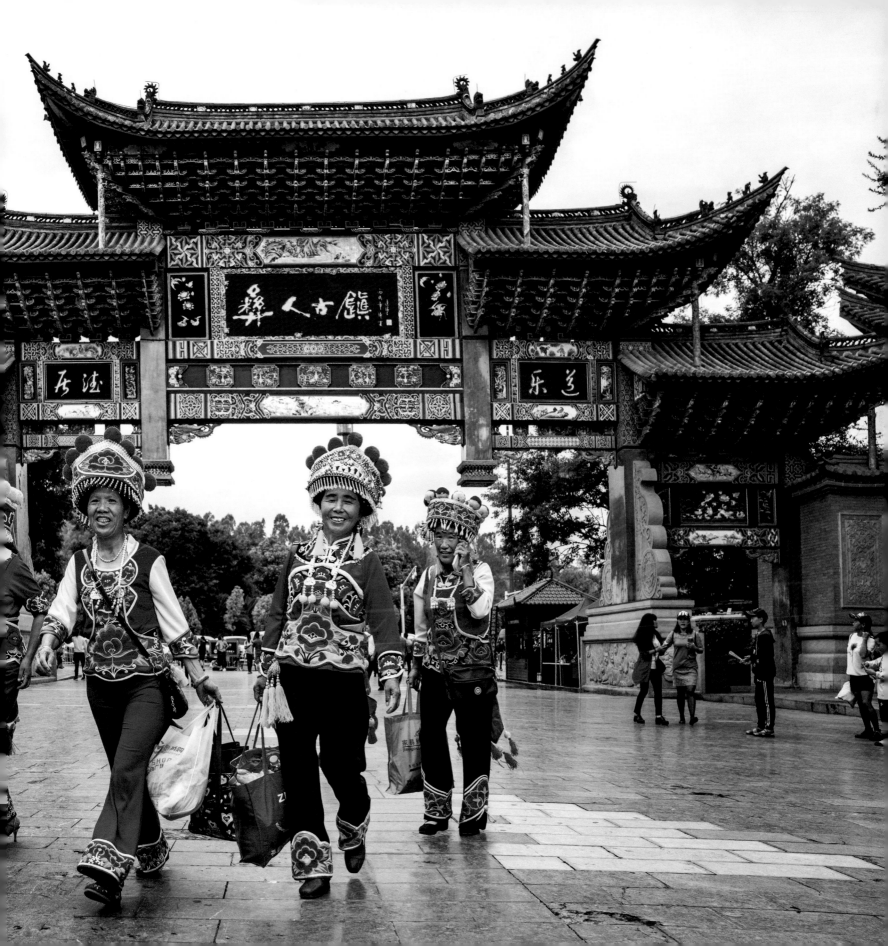

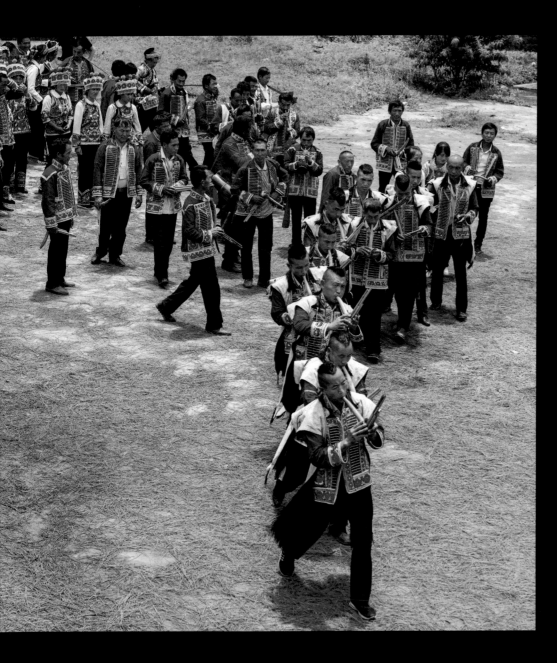
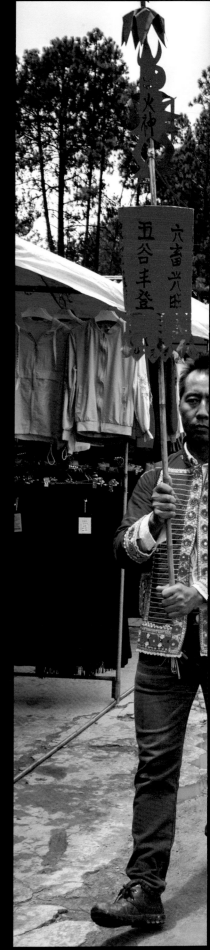

楚雄火把節首日清晨需要舉行迎接火神和祭祖儀式，祈求五穀豐登，六畜興旺。（右）
葫蘆笙流行於包括彝族在內的多個少數民族之間，樂聲輕快動聽。（左）

On the morning of the first day of Torch Festival in Chuxiong, ceremonies of inviting the
God of Fire and worshipping the ancestors are held in order to pray for a harvest and
thriving of domestic livestock. (Right) The Calabash Sheng, with lively and moving sound,
is a popular instrument among ethnic minorities in Southwest China, including Yi. (Left)

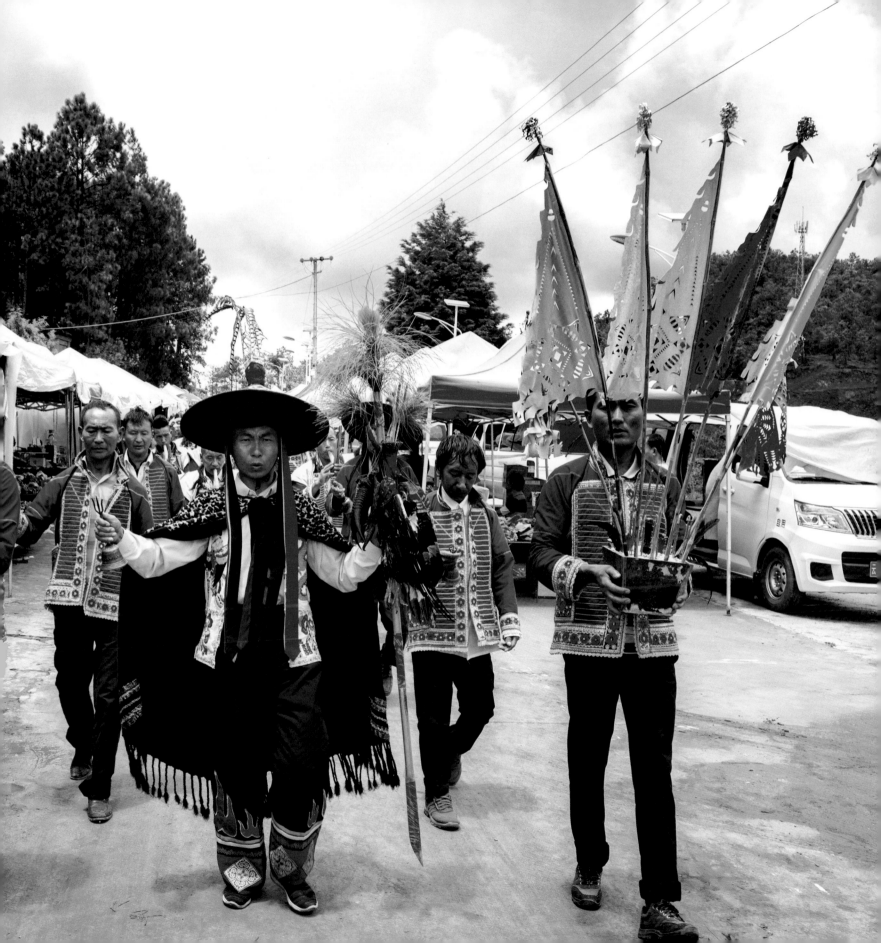

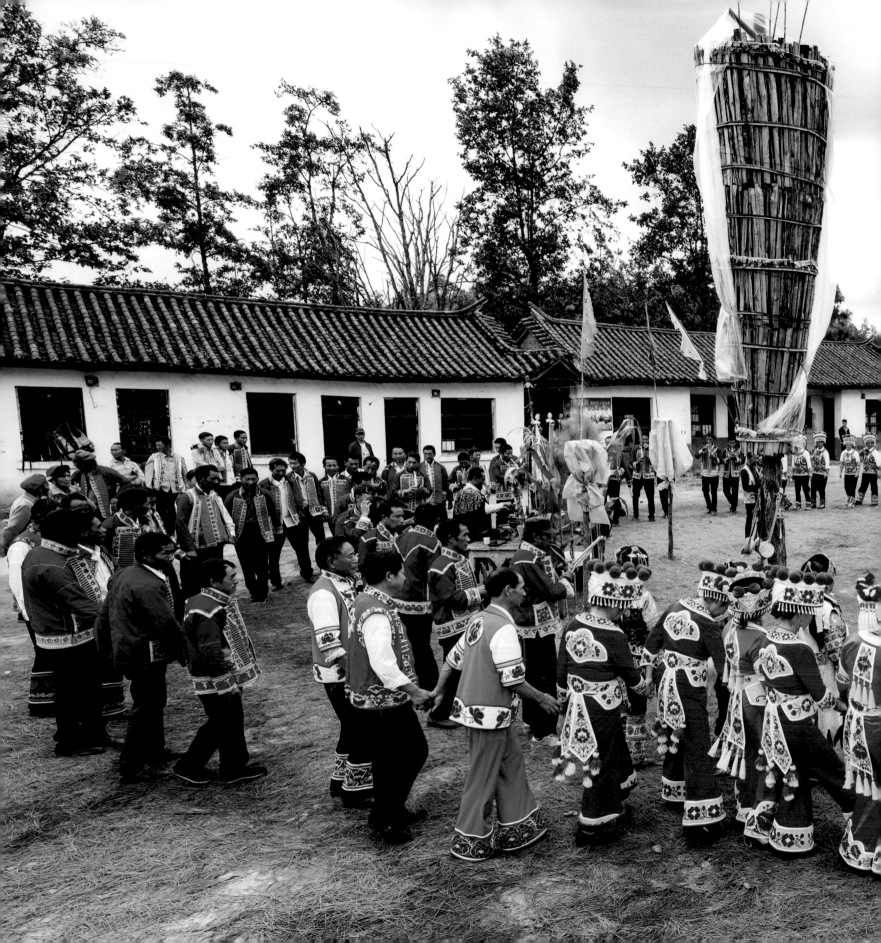

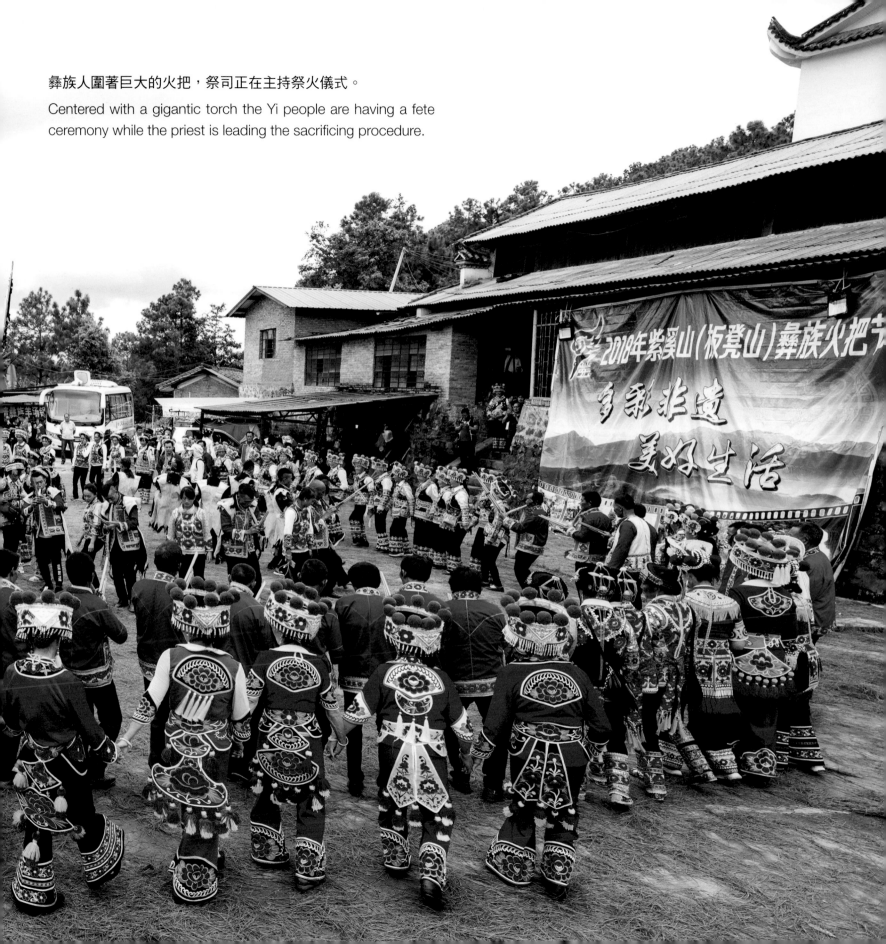

彝族人圍著巨大的火把，祭司正在主持祭火儀式。

Centered with a gigantic torch the Yi people are having a fete
ceremony while the priest is leading the sacrificing procedure.

2018年紫溪山（板凳山）彝族火把节

多彩非遗

美好生活

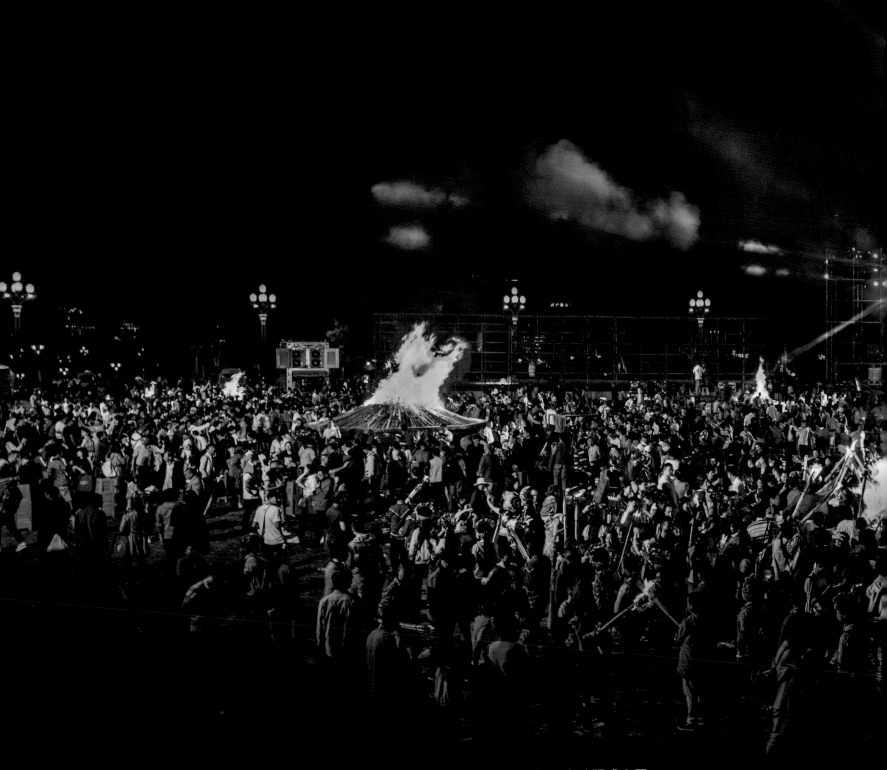

在太陽曆文化園太陽廣場舉行的祭火大典，無數的火把和篝火燒紅了天空，把黑夜映照成白天。

At the fire ceremony held at the Solar Square in the Solar Calendar Culture Park, countless torches and bonfires have dyed the sky red, turning night into day.

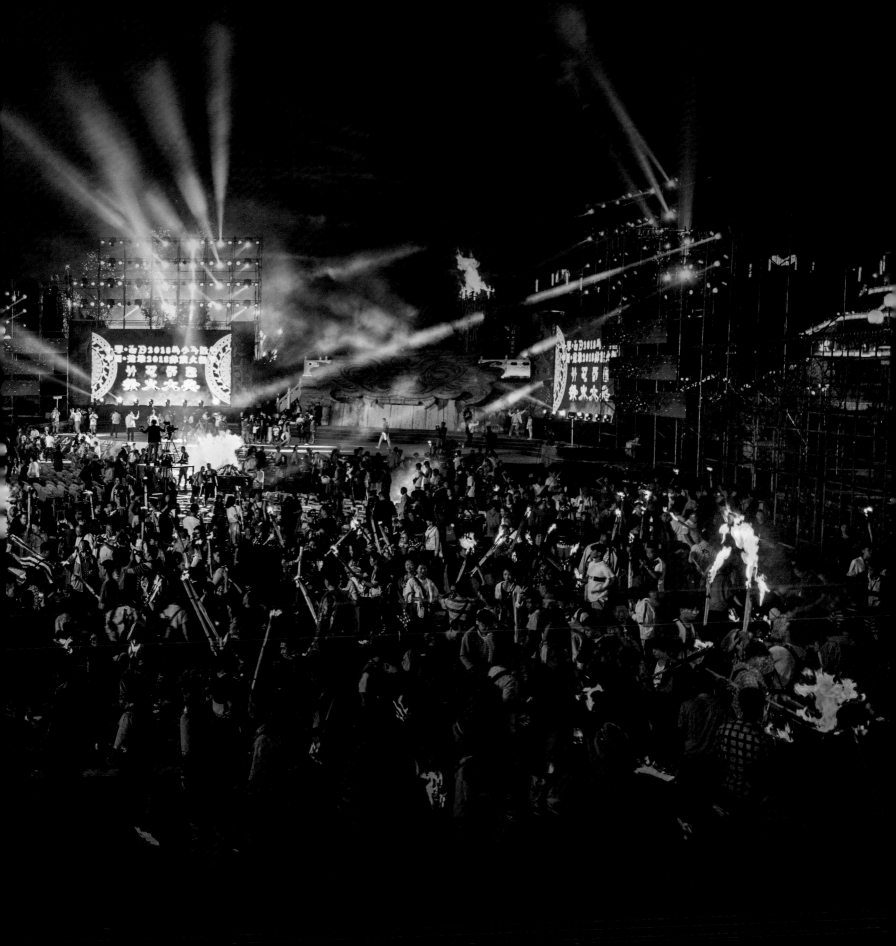

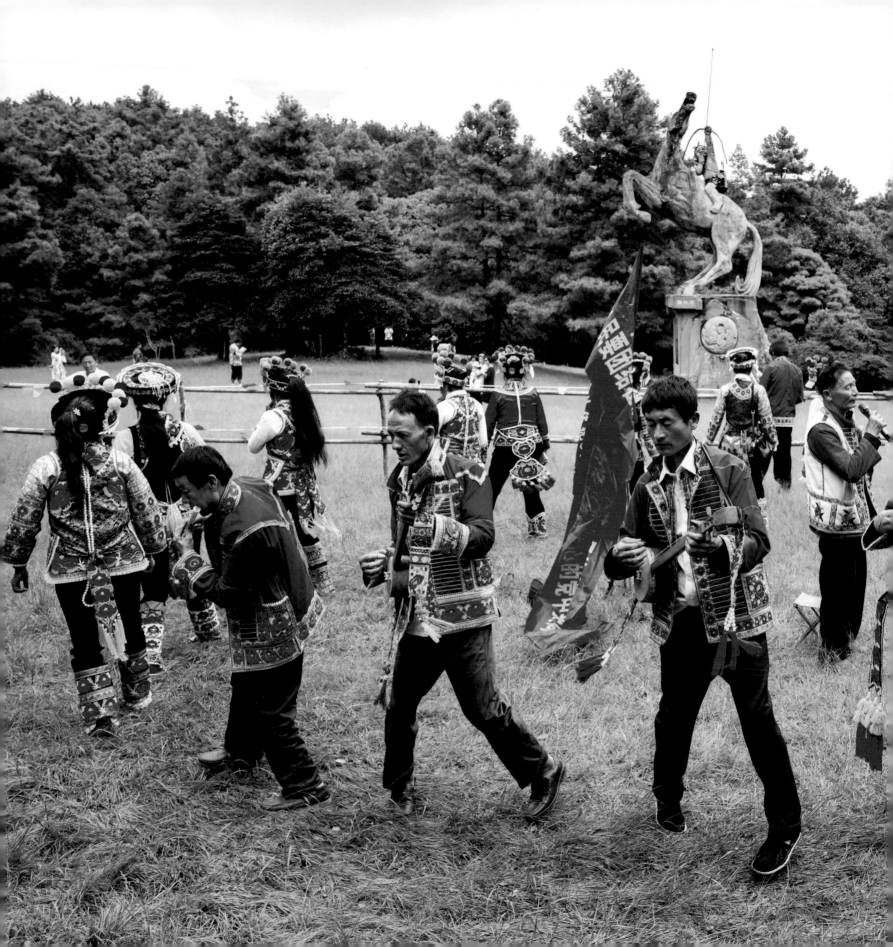

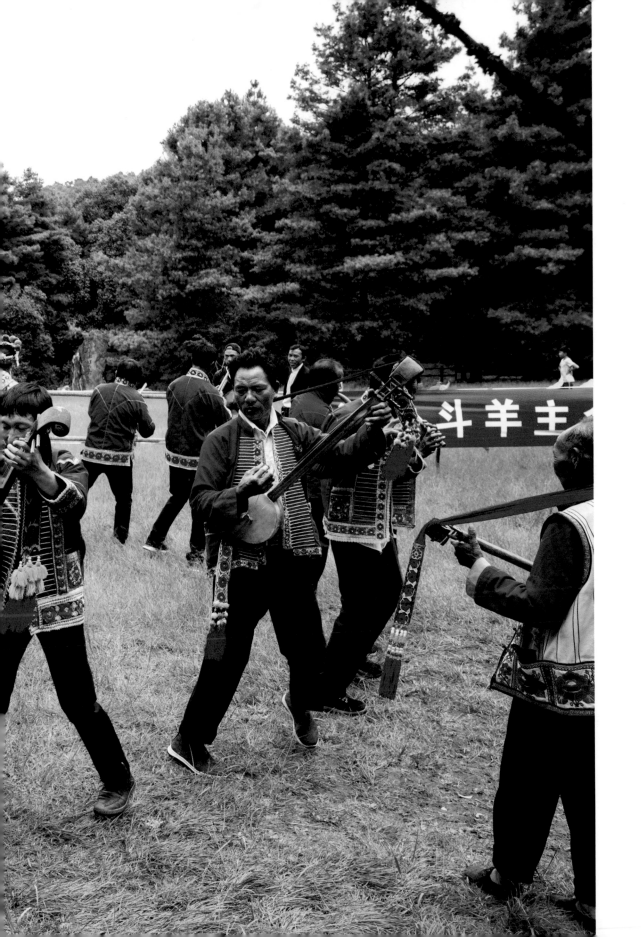

節日第二天，在鬥羊鬥牛
活動開始前，彝族人會先
演奏傳統樂曲助興。

Before the start of ram
fight and bull fight on the
second day of the festival,
the atmosphere will be
delighted by a traditional
music performance.

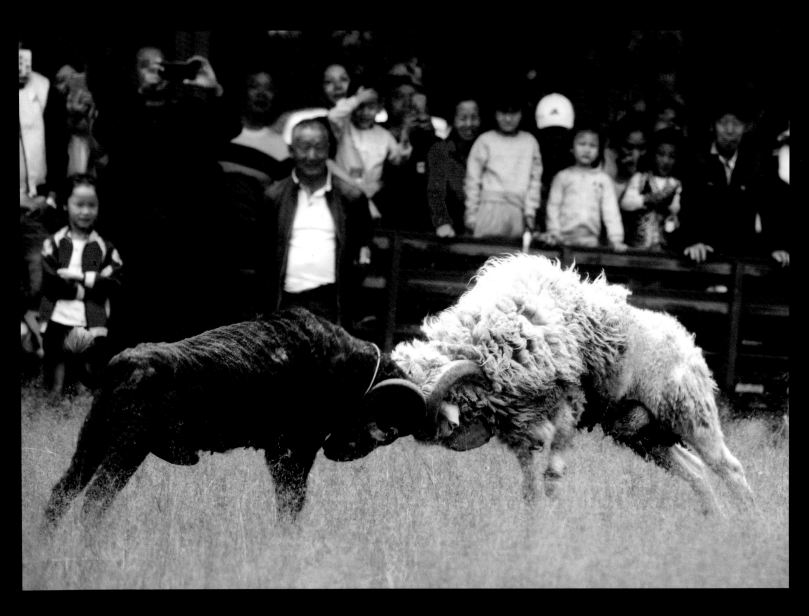

傳統的摔跤、鬥牛、賽馬等活動，來自民族英雄與惡魔摔跤、角力並最終戰勝的傳說。（右）為了紀念英雄，彝族人每到火把節就要重新呈現這個故事，漸漸這些活動就成了節日的重要內容之一。（左）

Traditional activities like wrestling, bull fight or horse racing came from the legend of the folk hero who wrestled and defeated the monster. (Right) In memory of this hero, Yi people would elaborate the story again and again on Torch Festivals. These activities have, gradually, become one of the main procedures of the festival. (Left)

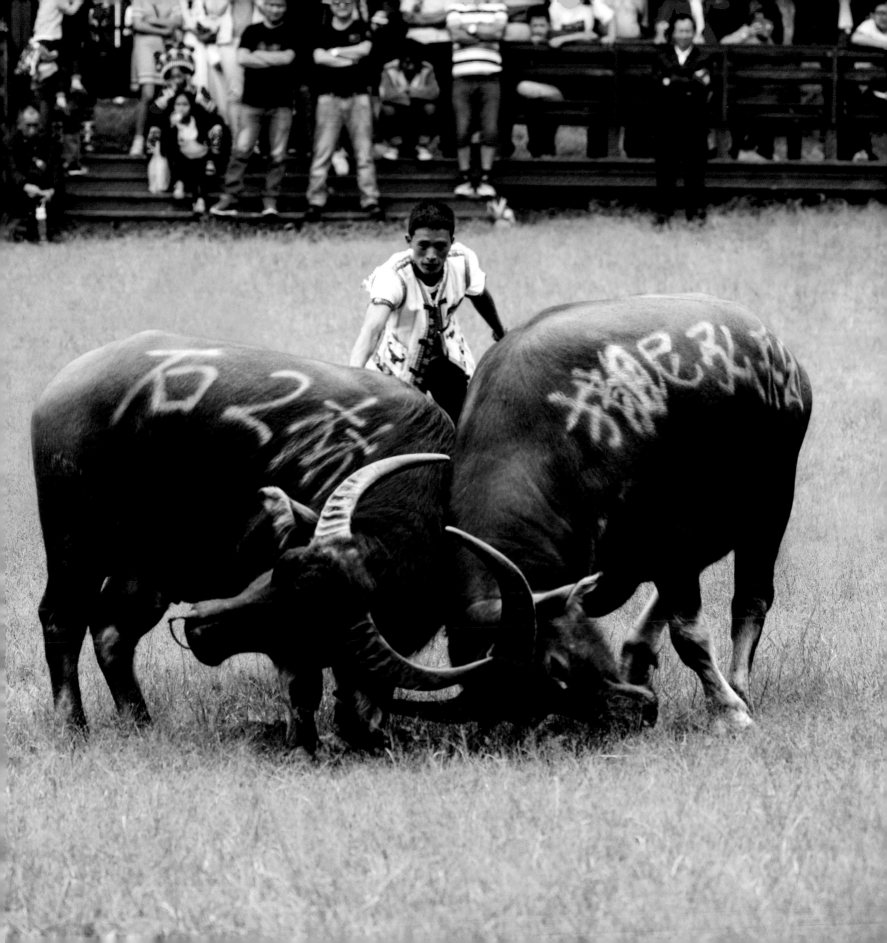

火把節一般從農曆六月二十四至二十七日持續三天三夜，期間火塘中的火不得熄滅。

Torch Festival is usually held from the 24th to 27th of the sixth lunar month for three successive days, during which the fire should be kept undying at the fire pits.

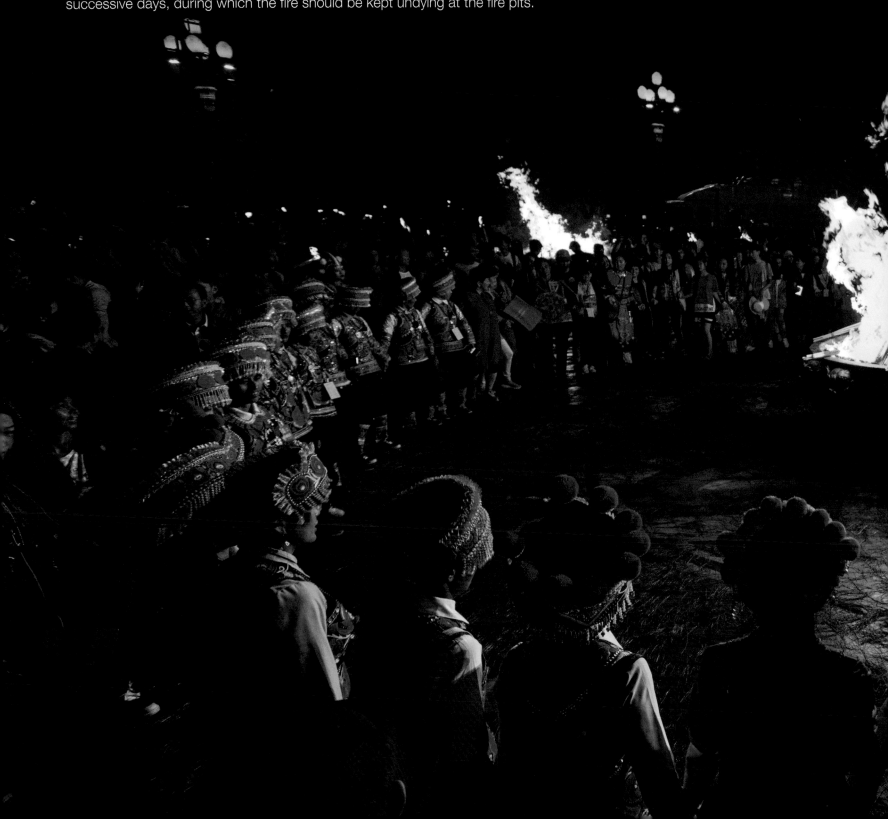

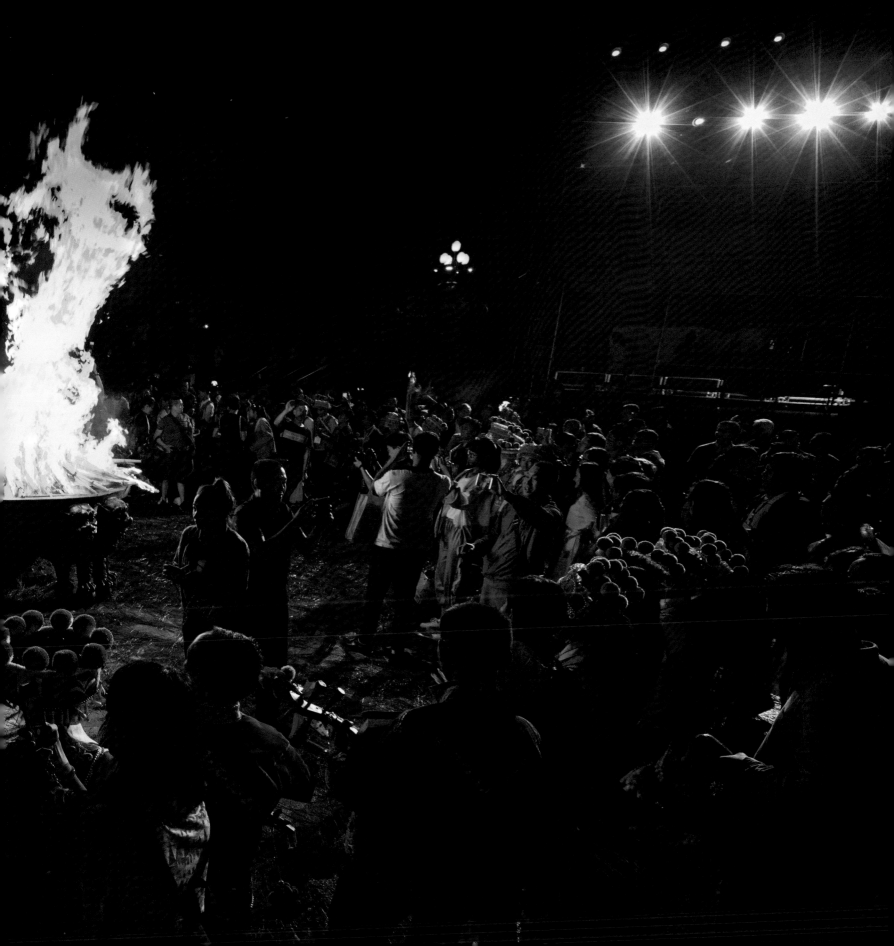

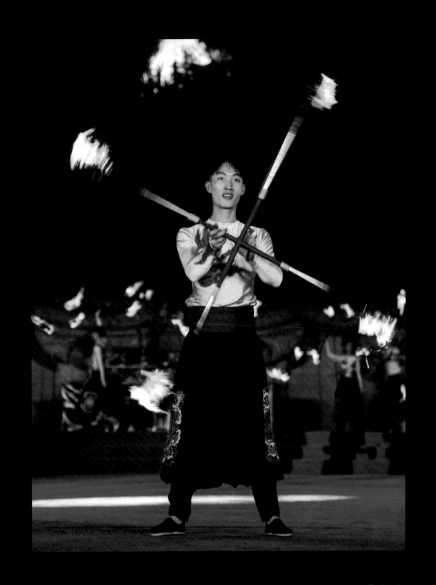

火把節是彝族最重大的傳統節日，表演繁多，被稱為「東方狂歡節」。（左）節日的第二天設有選美活動，挑選出族中的俊男美女。（右）

The Torch Festival is of utmost importance among all festivities of Yi. The many dazzling shows have won it the title of "Carnival of the Orient". (Left) On the second day, beauty contests are held to elect the most handsome man and prettiest woman in the nation. (Right)

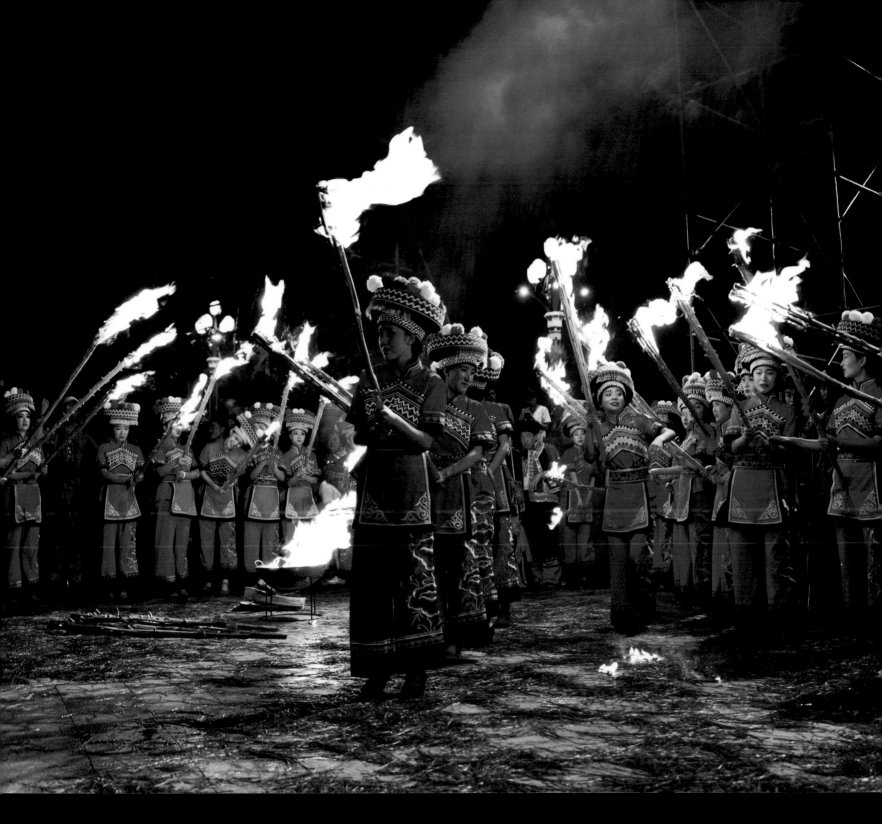

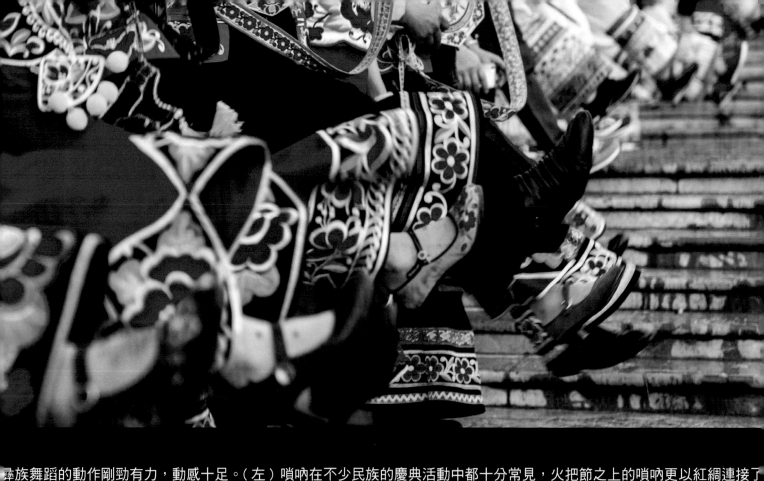

彝族舞蹈的動作剛勁有力，動感十足。（左）嗩吶在不少民族的慶典活動中都十分常見，火把節之上的嗩吶更以紅綢連接了一截圓筒金屬罩，把音量引至最大。（右）

The dancing style of Yi is powerful and dynamic. (Left) Suona is a commonplace in festive activities in different ethnic groups. At the Torch Festival, a section of cylindrical metalwork is connected to the instrument for augmentation. (Right)

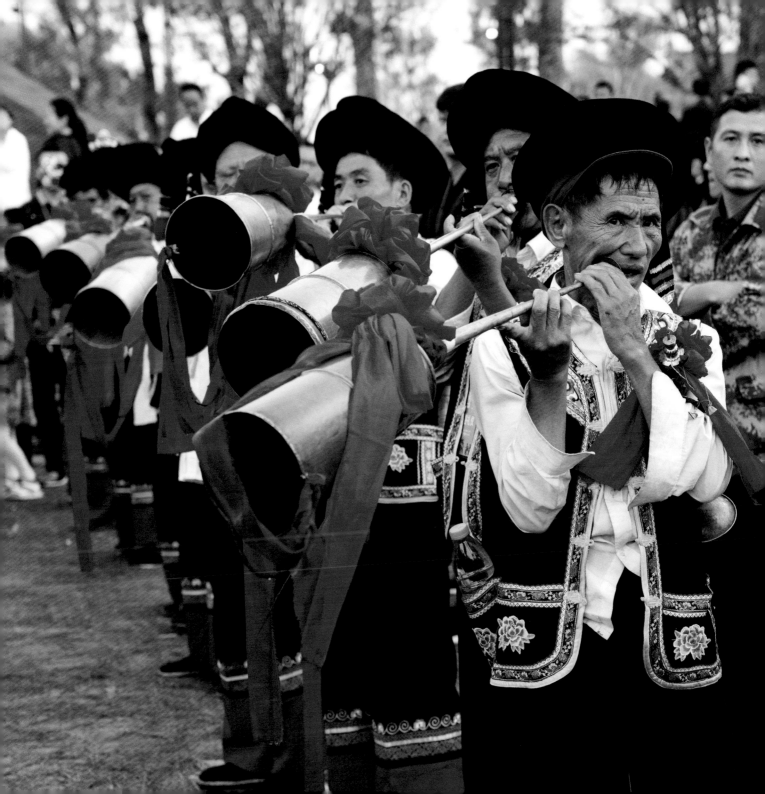

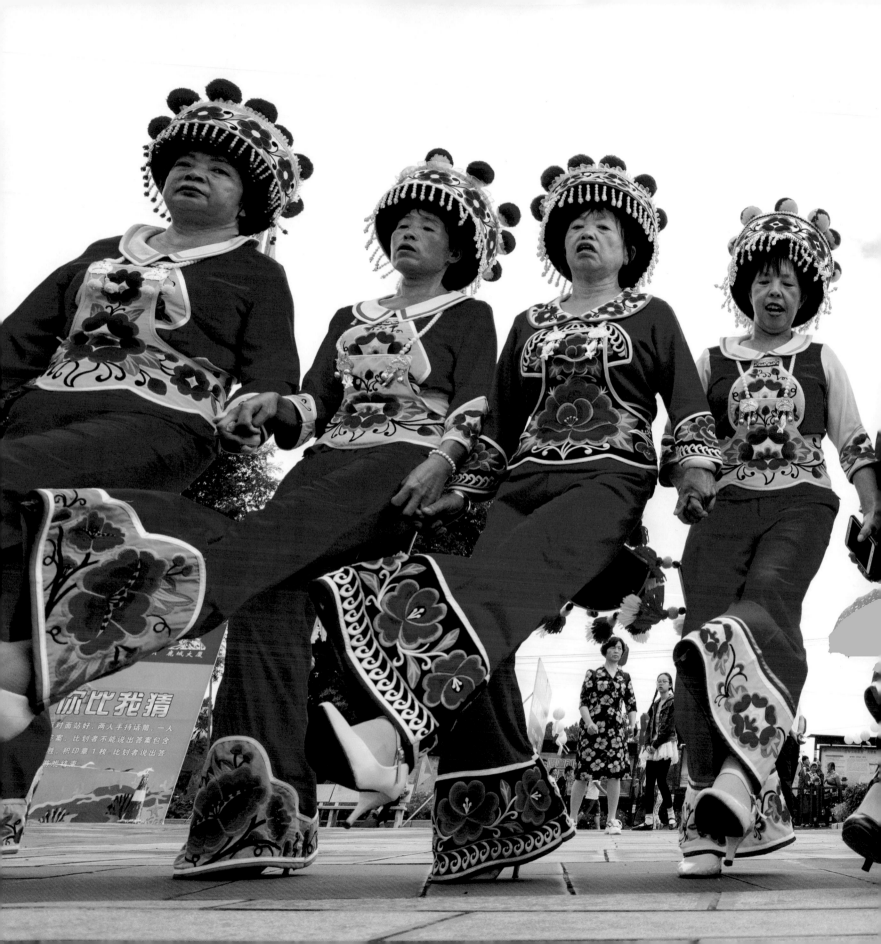

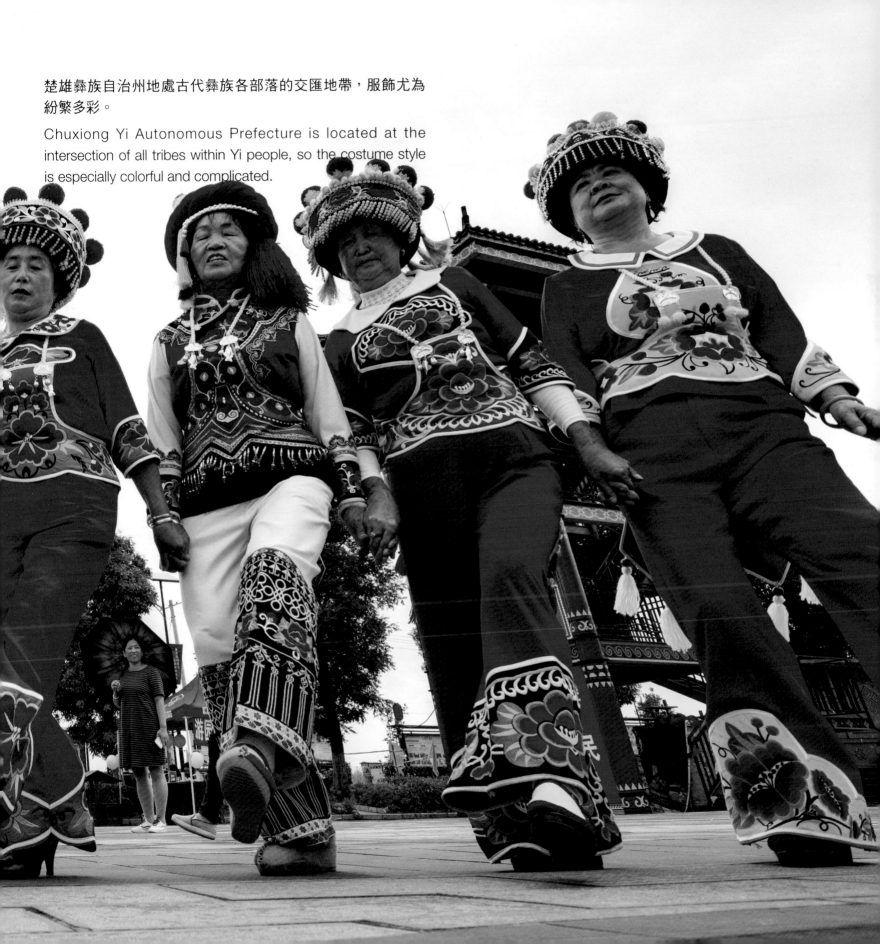

楚雄彝族自治州地處古代彝族各部落的交匯地帶，服飾尤為紛繁多彩。

Chuxiong Yi Autonomous Prefecture is located at the intersection of all tribes within Yi people, so the costume style is especially colorful and complicated.

彝族的支系繁多，且各地的服飾差異很大，服飾區別近百種，琳琅滿目，
各具特色。

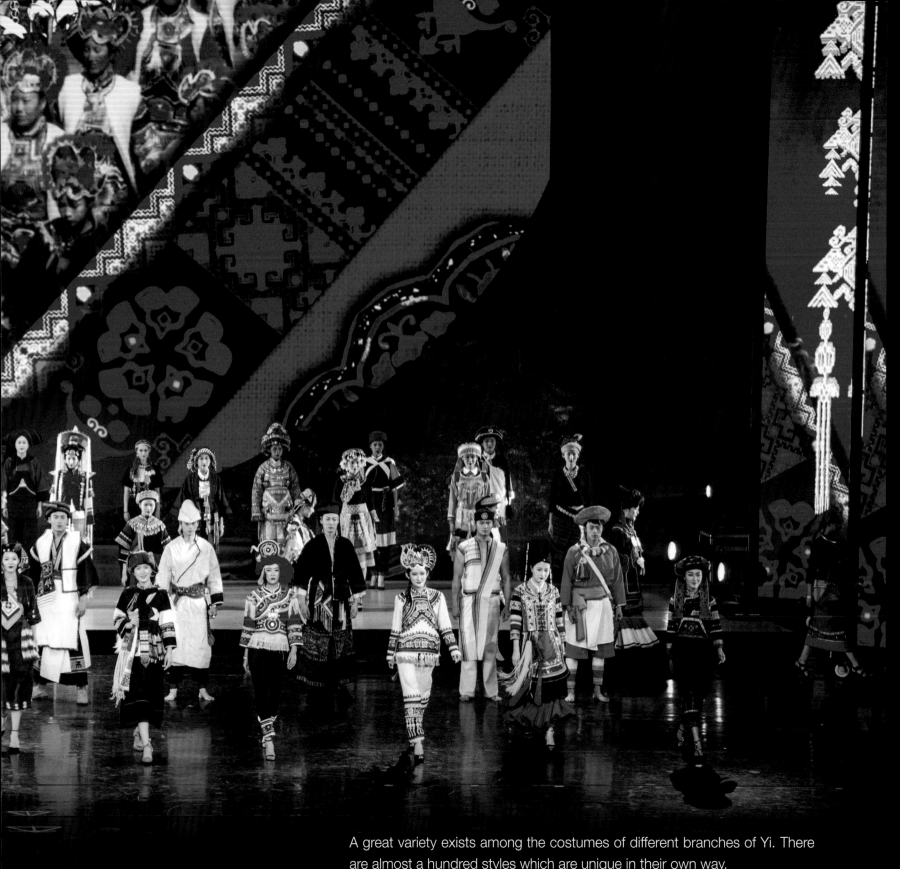

A great variety exists among the costumes of different branches of Yi. There are almost a hundred styles which are unique in their own way.

在煙火大會上，族中婦女圍著篝火盡情歡跳，到處洋溢著一片節日的喜氣。

With the firework display going on, Yi women are dancing around the bonfire. The atmosphere is festive and joyful everywhere.

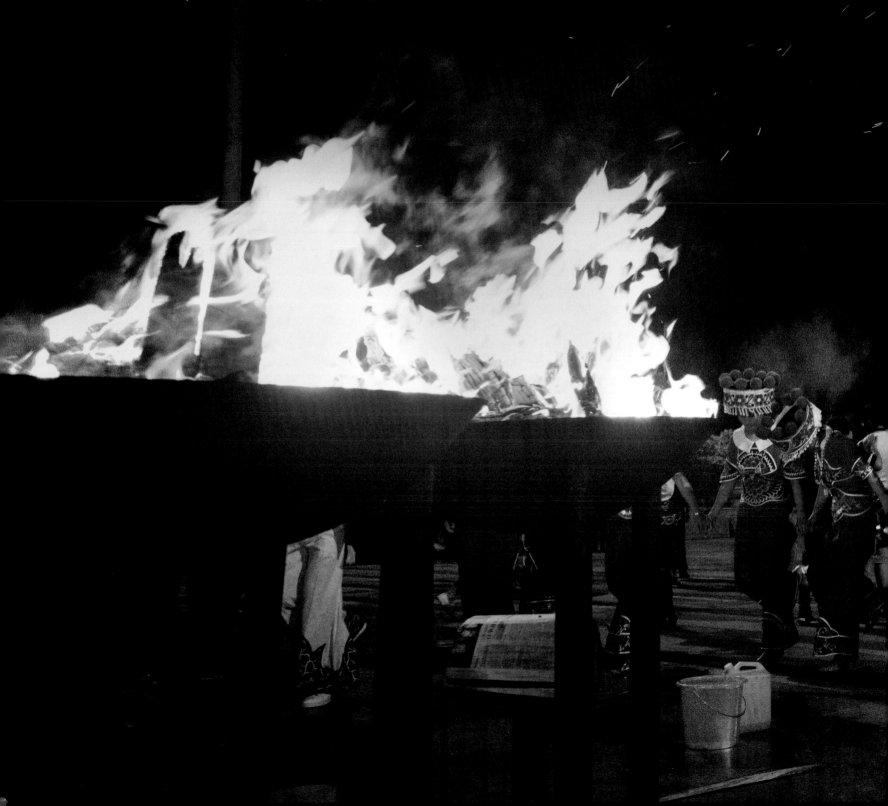

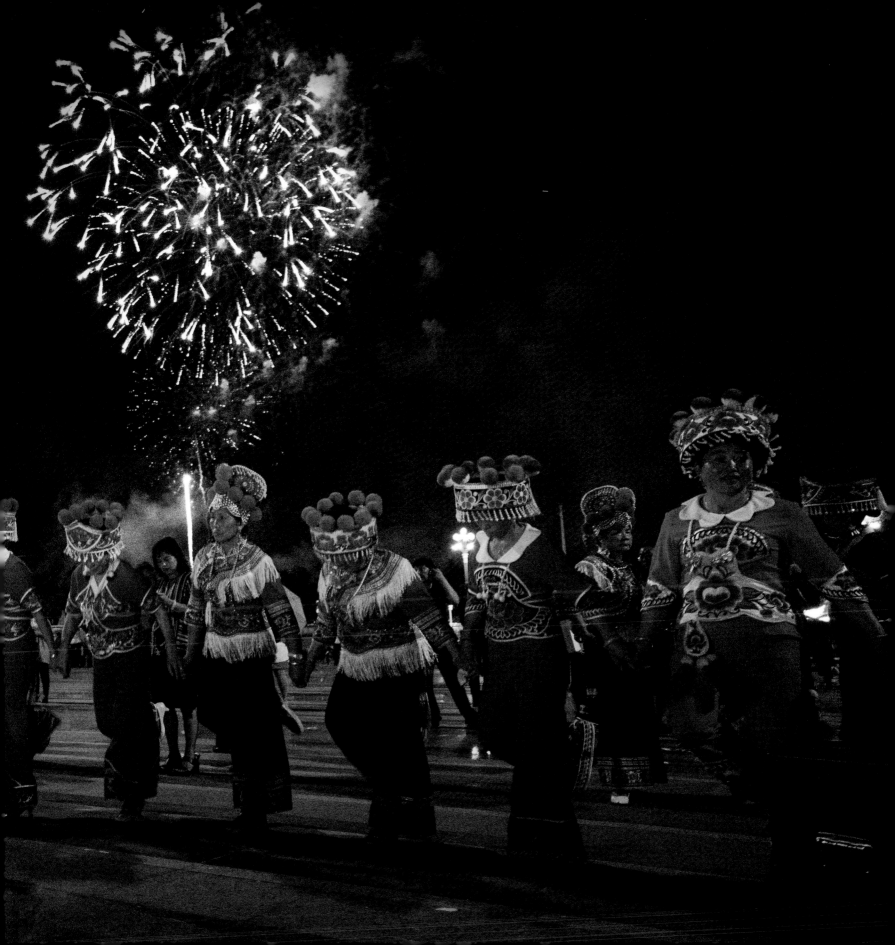

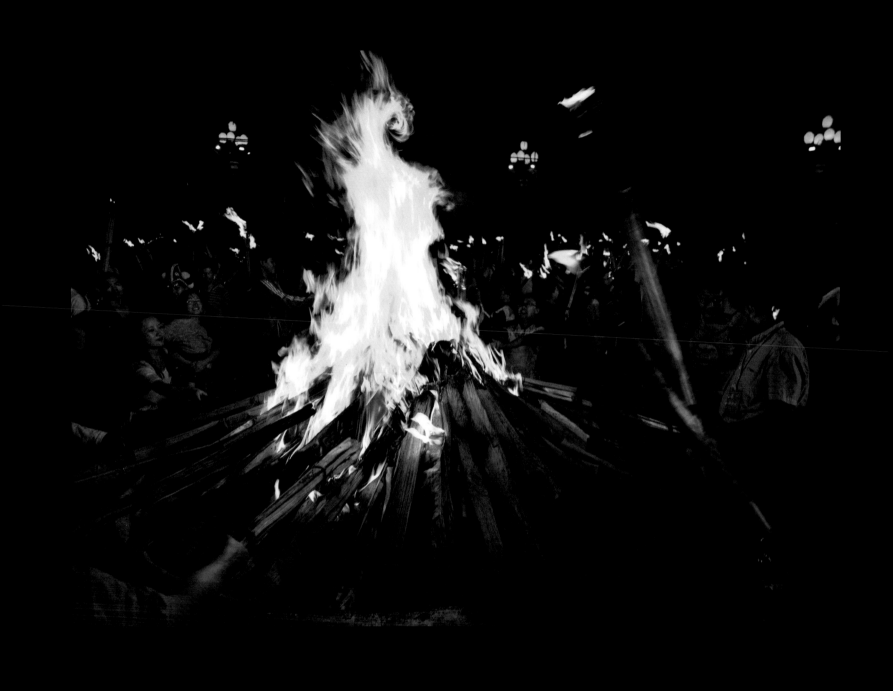

火把節期間，楚雄各處都會燃起熊熊火焰，當中規模最大的幾處位於太陽曆文化園的太陽廣場、彝人古鎮的火把廣場及紫溪鎮的廣場上。

During the Torch Festival, there are bonfires everywhere in Chuxiong. The largest scale ones are on the Solar Square in the Solar Calendar Cultural Park, the Torch Square in the Yi's Old Town and the square in Zixi Town.

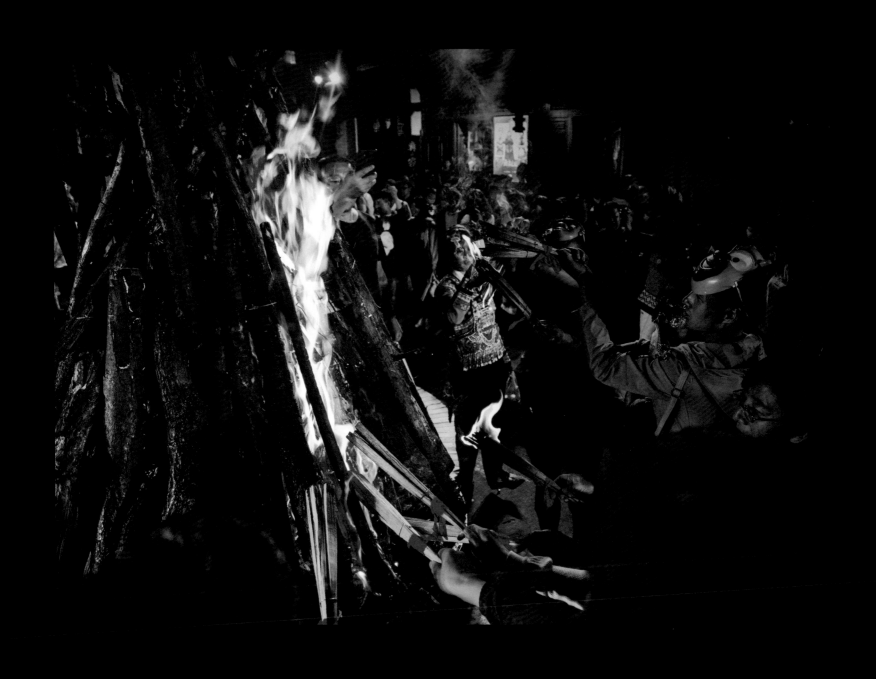

最後一天送火儀式中，眾人圍著火堆向火神祈禱，希望所有
噩運及不幸都能隨著火焰熄滅。

In the farewell to the God of Fire, people gather around the
bonfires and pray to the God, hoping that all bad lucks would
disappear as the flame dies out.

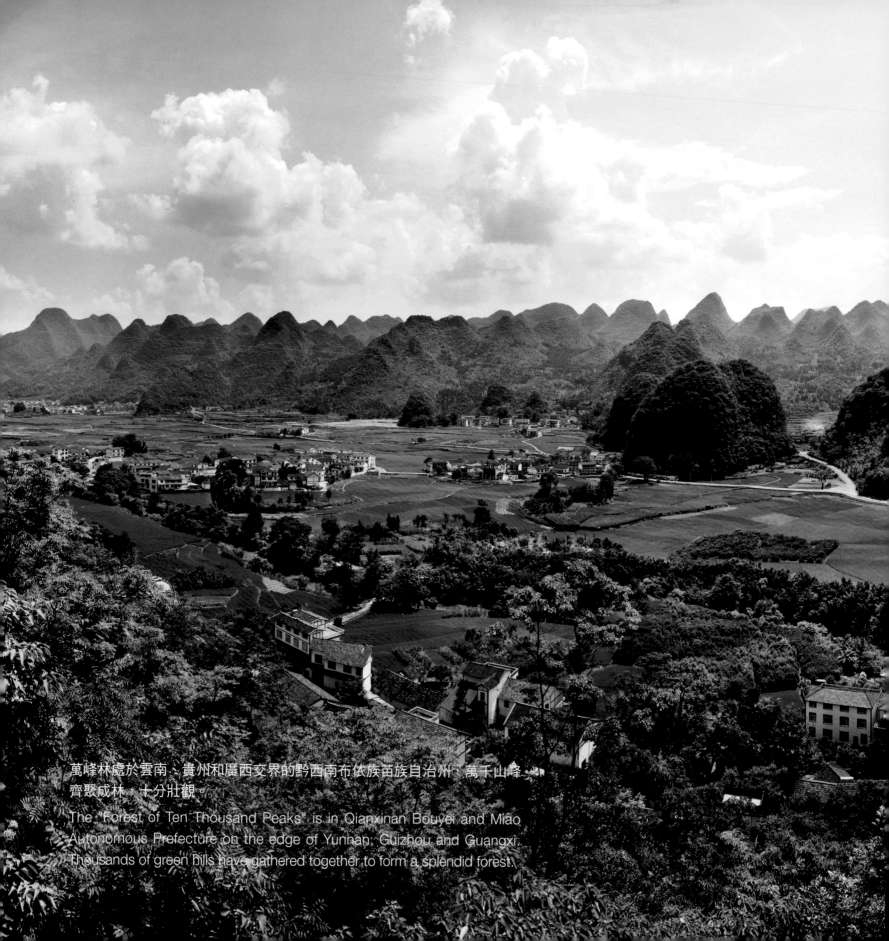

萬峰林處於雲南、貴州和廣西交界的黔西南布依族苗族自治州，萬千山峰
齊聚成林，十分壯觀。

The "Forest of Ten Thousand Peaks" is in Qianxinan Bouyei and Miao
Autonomous Prefecture on the edge of Yunnan, Guizhou and Guangxi.
Thousands of green hills have gathered together to form a splendid forest.

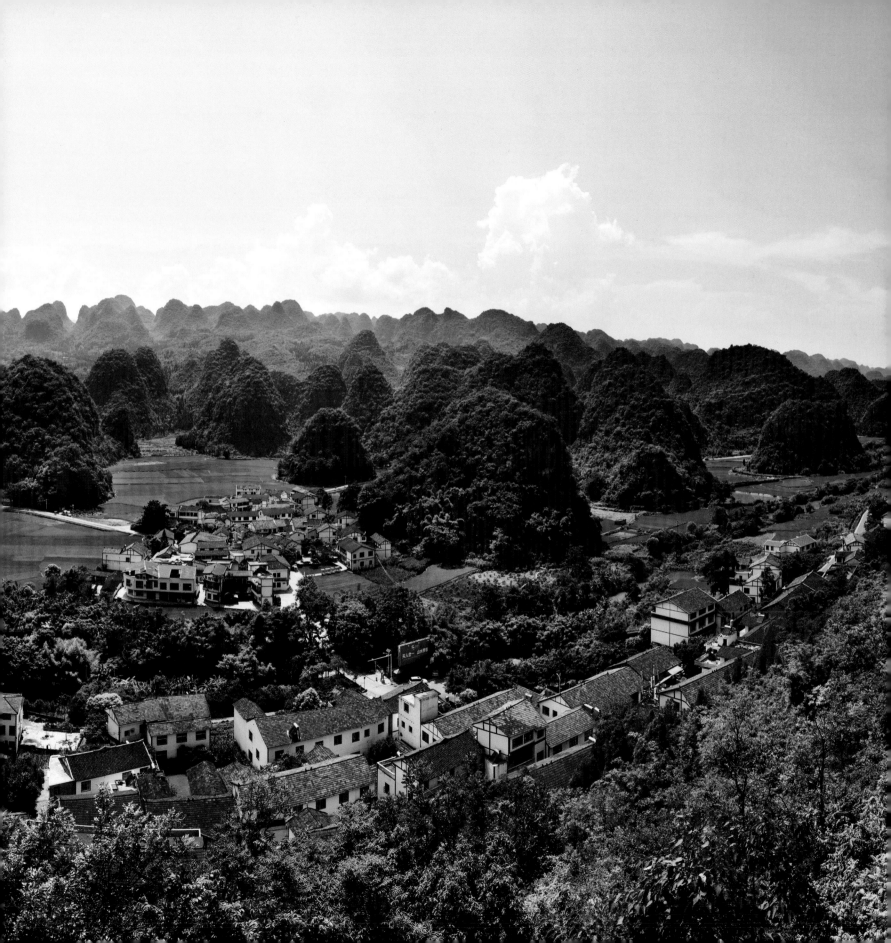

貴州省貞豐市內的雙乳峰因其外形而得名。隨著觀賞角度變化，兩座山峰呈現老中青三種年齡段的胸型。

The Double Breast Peaks in Zhenfeng, Guizhou Province, is named for its shape. When changing the perspective of viewing, the shape alters from breasts of young ladies to that of middle-age or elderly.

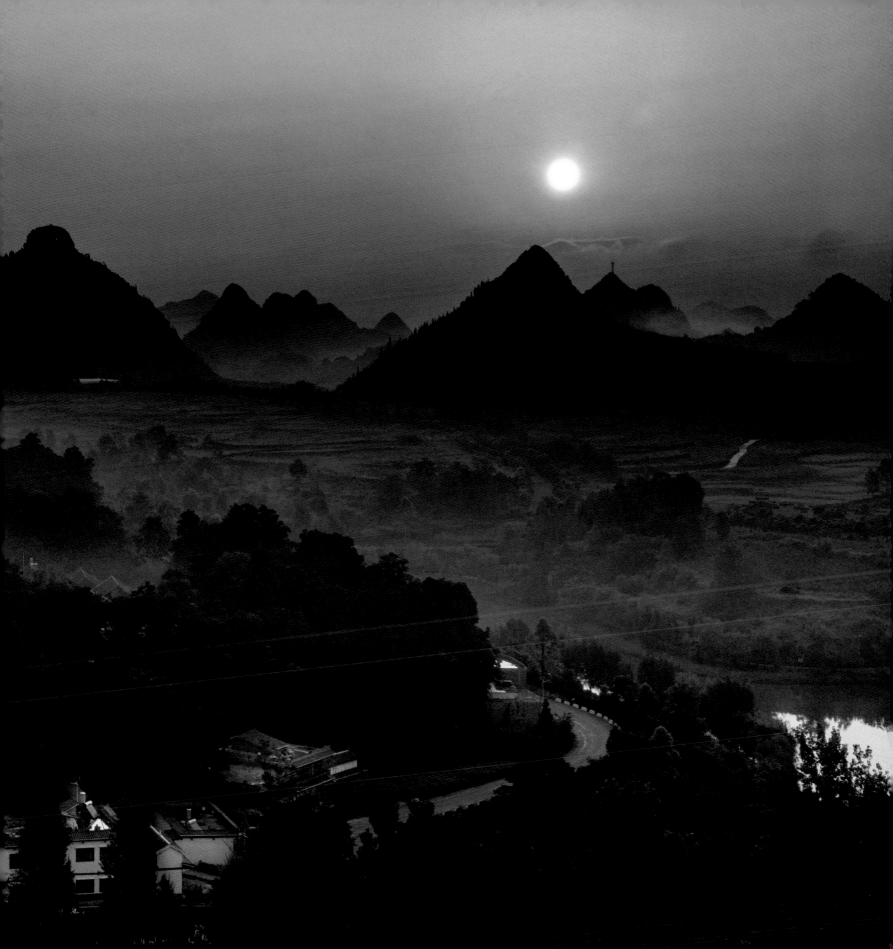

布依族

Bouyei People

布依族，在中國人口將近 300 萬，其中超過 95% 都集中居住在貴州省，除此之外，在雲南及四川兩省也有少數布依族聚居。

布依族自古以來就生活在中國這片土地上，曾是古代百越人的一支，有悠久的歷史，到今天仍保持百越的部分風俗習慣，形成了獨特的婚嫁、喪禮和節慶民俗。據傳，西漢時期（公元前 202 年 - 公元 8 年）的夜郎國與如今的布依族有著密切的關係。

過去，布依族曾經有許多不同的稱謂，但是皆非自詡之名，而是統治者對他們的稱呼。而「布依」一名，是 1953 年貴州省布依族內各個部落的族人，經過協商一致決定的結果。

布依族內有許多獨特的傳統節日，包括「三月三」、「六月六」等節日，其中又以農曆六月初六的慶典最為隆重。

There are nearly 3 million Bouyei people in China, and more than 95 percent of them are living in Guizhou Province. The rest of them also live in Yunnan and Sichuan.

Bouyei people have been living on the land of China since ancient times. It was once a part of the Baiyue people. With long historical standing, this ethnic group has kept many of the Baiyue traditions and formed a unique ceremonial style in weddings, funerals, festivities and folk customs. It is said that Yelang - an ancient political entity during the Western Han (202 BC-8 AD) in western Guizhou - is closely related to Bouyei.

In the past, people called Bouyei by different names, which, instead of claimed by themselves, were actually decided by rulers. And the current name was the consensus of discussion by multiple tribes of this ethnicity in Guizhou in 1953.

Several featured traditional festivals are celebrated every year by Bouyei people, including the Double Third Festival and the Double Sixth Festival. The latter is relatively more ceremonious.

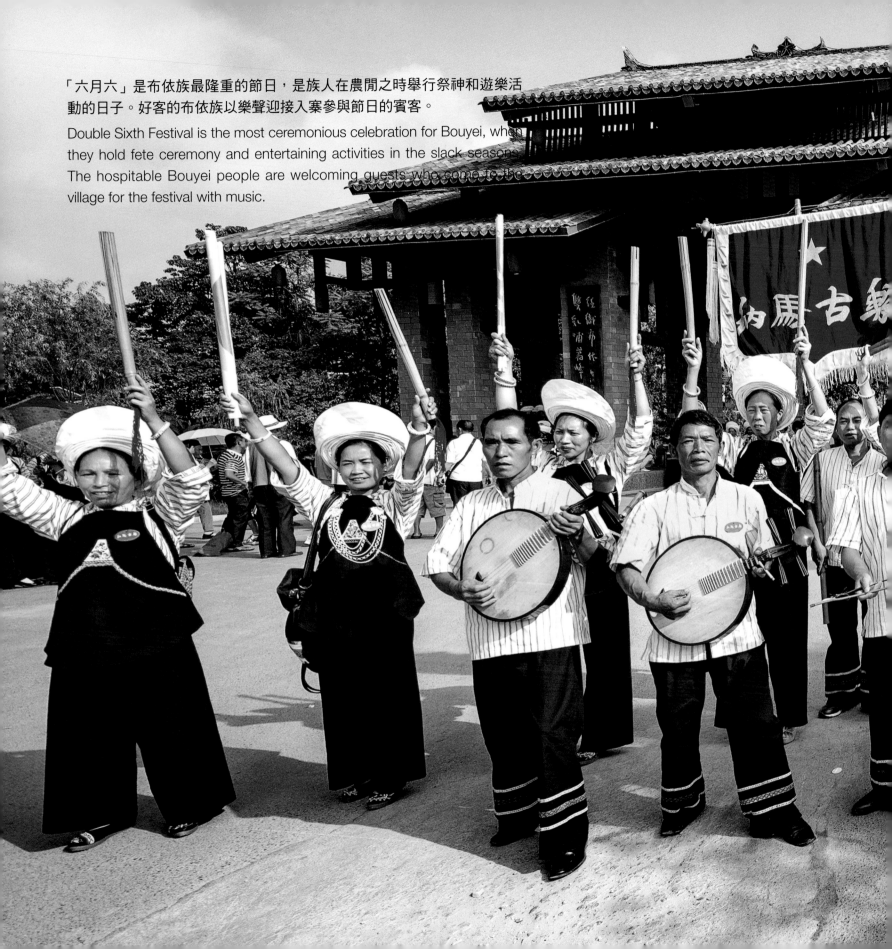

「六月六」是布依族最隆重的節日，是族人在農閒之時舉行祭神和遊樂活動的日子。好客的布依族以樂聲迎接入寨參與節日的賓客。

Double Sixth Festival is the most ceremonious celebration for Bouyei, when they hold fete ceremony and entertaining activities in the slack seasons. The hospitable Bouyei people are welcoming guests who come to the village for the festival with music.

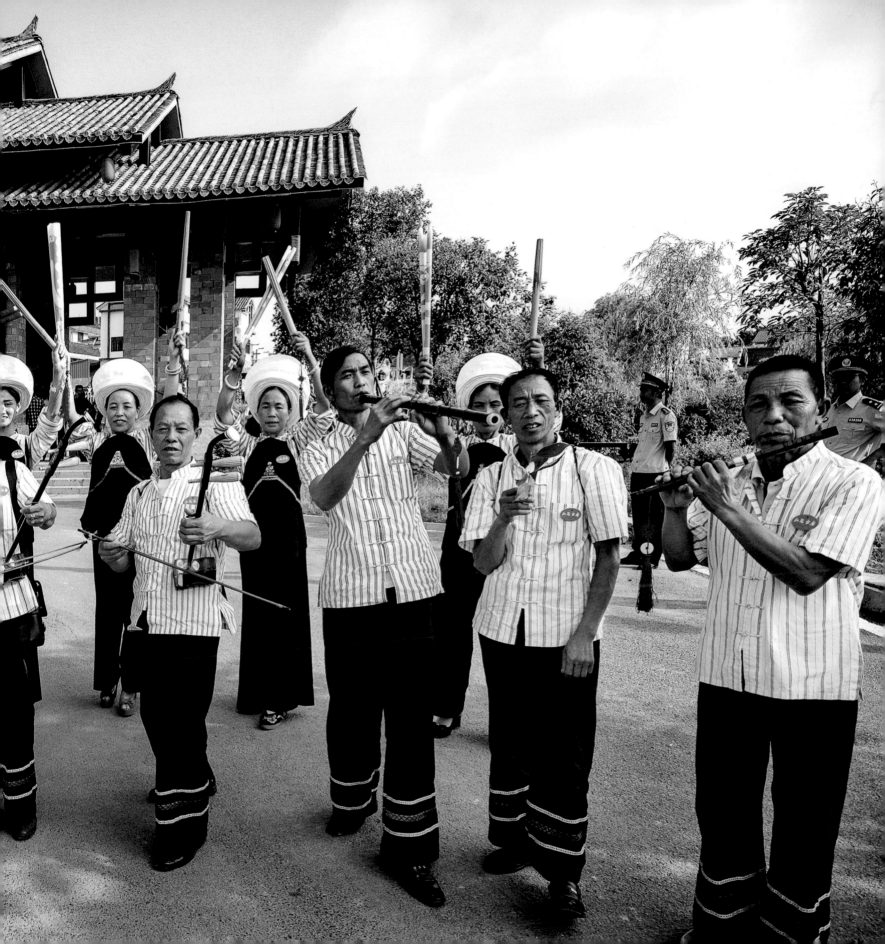

相傳盤古發明了水稻種植方法後，傳給兒子新橫。盤古於六月初六逝世後，新橫受到繼母虐待，欲毀掉親手栽培的水稻秧苗，絕其繼母生路。繼母向新橫乞求，表示只要他不毀壞莊稼，就不再迫害他，並於每年盤古忌日殺豬宰鴨。布依族人因此每年六月六日都舉行祭盤古、供祖先的活動，以求子孫延續、五穀豐收。「六月六」一早，在寨中德高望重老人的帶領之下，布依族舉行祭祀典禮。

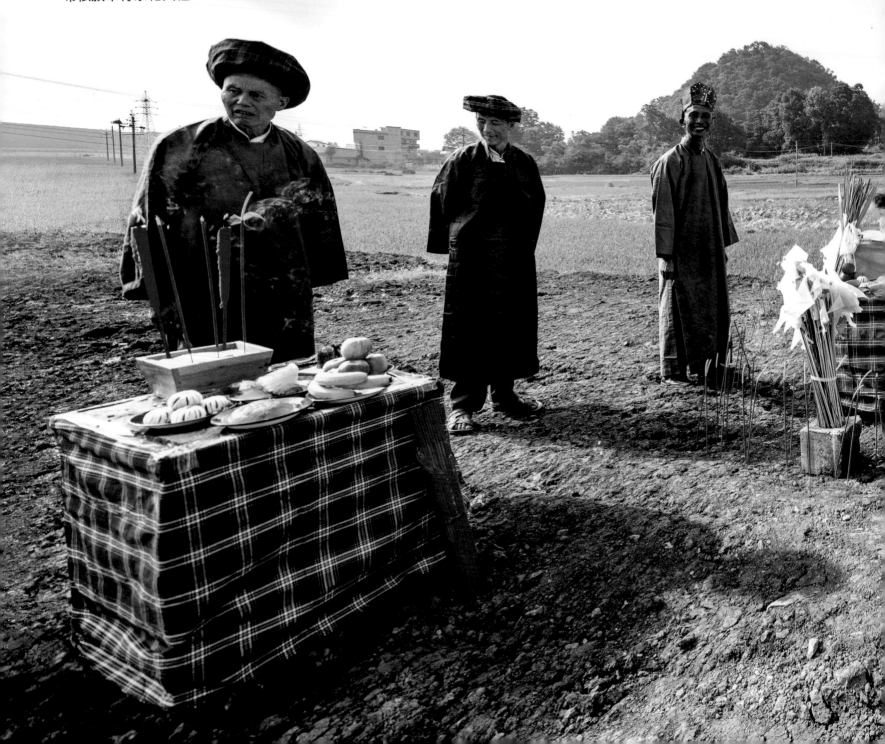

According to legends, after Pangu invented the rice planting method, he passed it down to his son Xinheng. After Pangu passed away on the 6th of the 6th lunar month, Xinheng was abused by his stepmother and decided to ruin all the rice he planted himself so as to starve his stepmother. She pleaded that she would stop abusing him and sacrifice animals on the anniversaries of Pangu's death, if only he would stop destroying the crops. Nowadays, the Bouyei sacrifice pigs and chickens during the Double Sixth Festival to worship Pangu and their ancestors. On the morning of the festival, venerable elder men of the village would lead the fete ceremony.

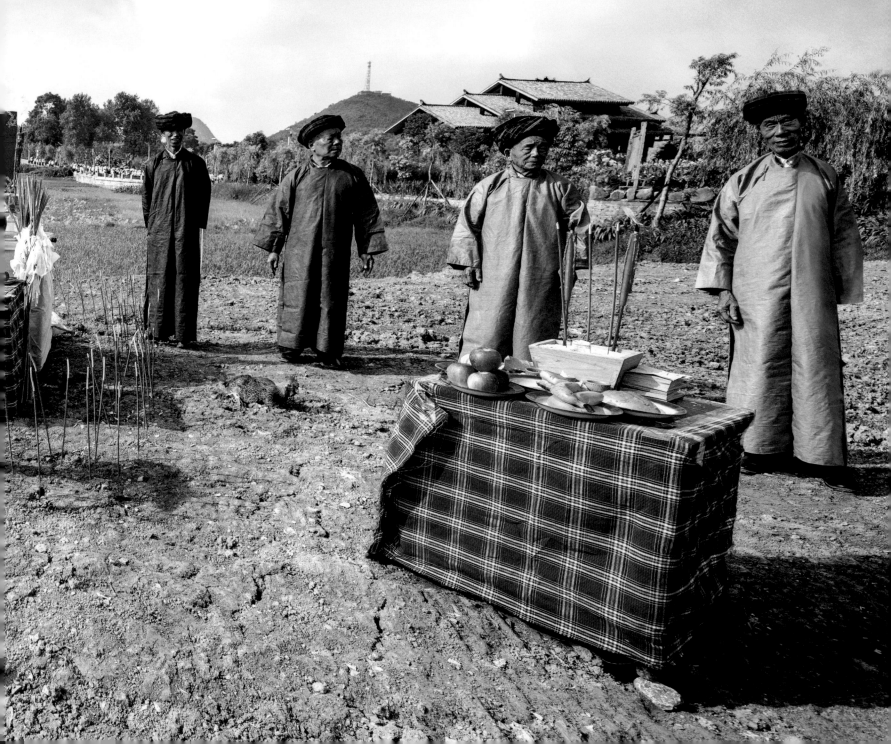

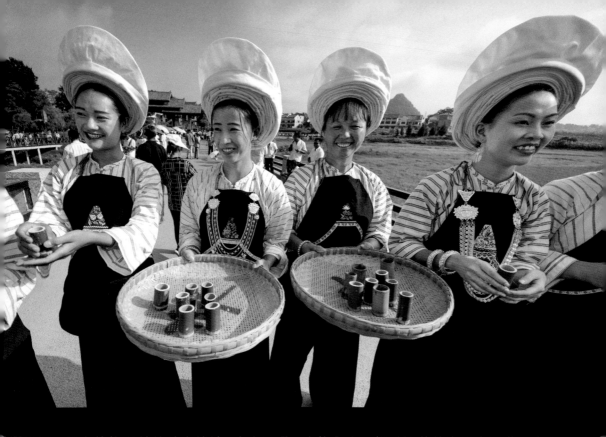

「攔門酒」是布依族獨特的待客傳統，賓客需喝下由族內女子親手捧著的米酒方可進入寨內。（左）

親手做年糕是農曆六月六的傳統活動之一。（右）

The "wine at the entrance" is a unique tradition - guests are not allowed to enter the village unti
hey have drunk the wine served in bamboo tubes, held by Bouyei women. (Left) Making rice
cakes is one of the traditions on the 6th day of the 6th lunar month. (Right)

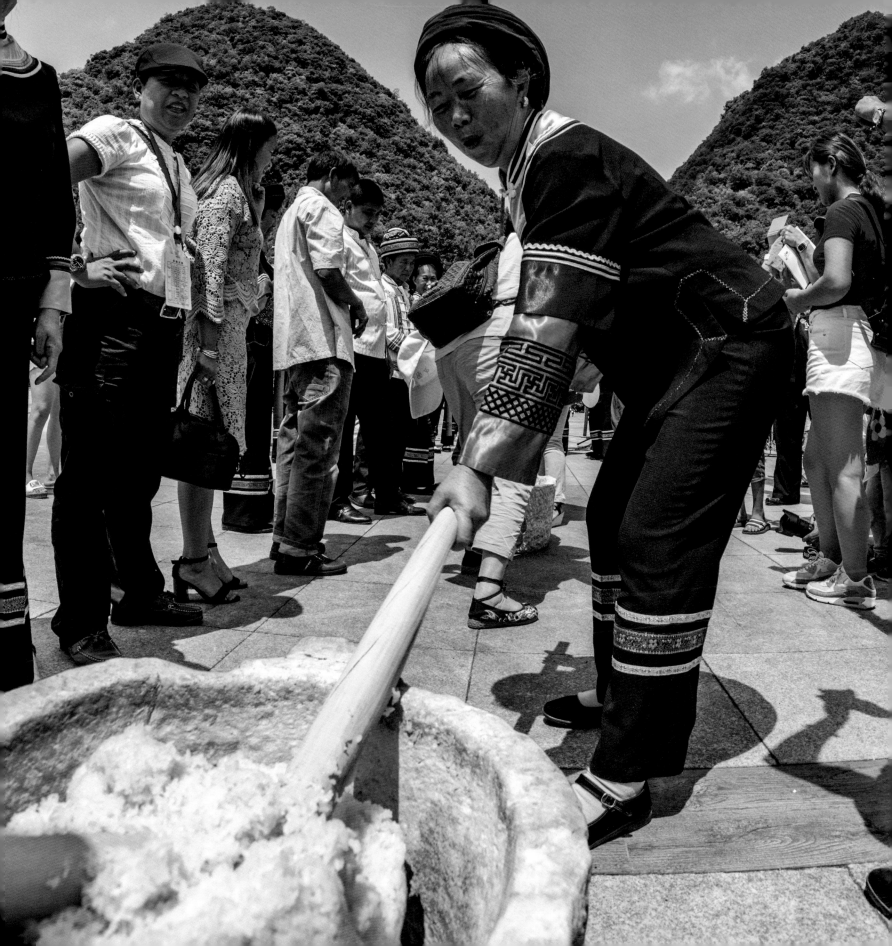

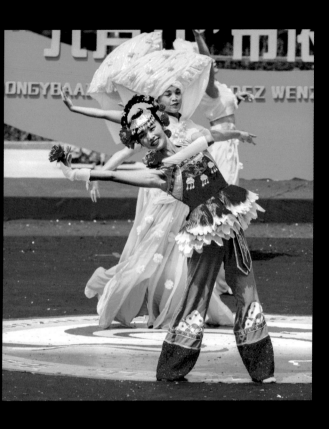

在納孔布依寨每年的「六月六」上，還會設舞台表演民族舞蹈。（左）布依族居住在氣候較熱的地區，服飾相對寬鬆。婦女的服飾集蠟染、扎染、挑花、刺繡等工藝於一身，繽紛多彩。（右）

On the Double Sixth at Nakong Bouyei Ancient Village, a dedicated stage is set to present folk dance. (Left) The Bouyei people like to wear loose clothes due to the relatively hot weather. Women folk costumes are very colorful for they have integrated techniques like wax-resist dyeing, tie-dye, cross-stitch and embroidery. (Right)

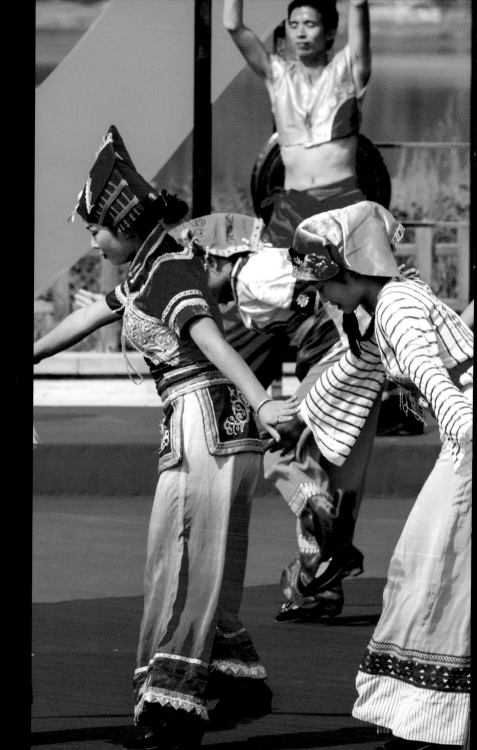

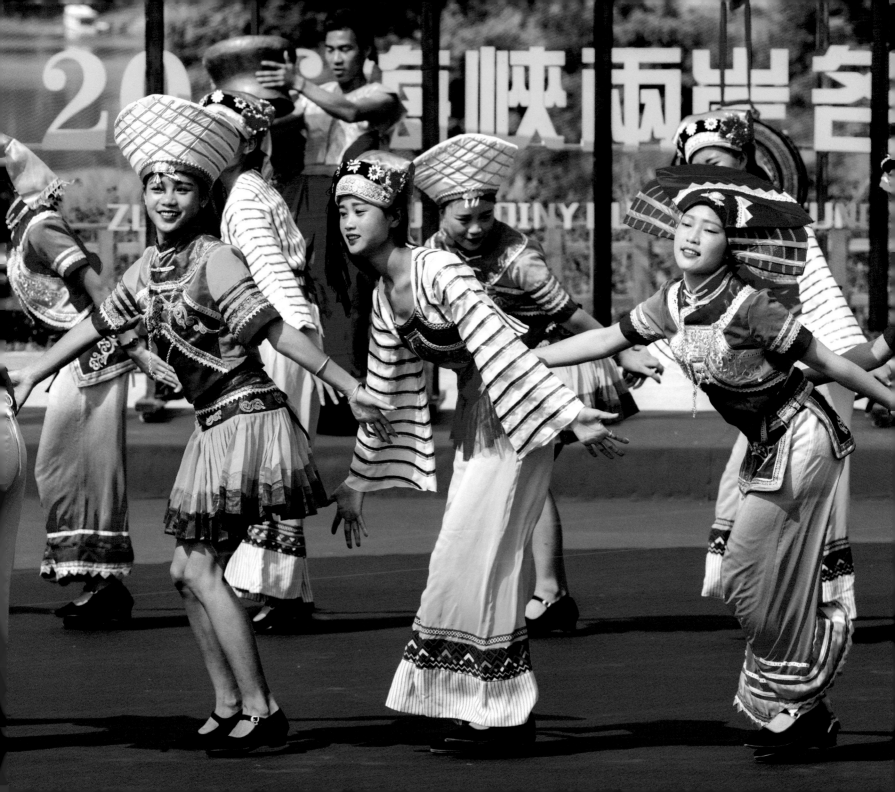

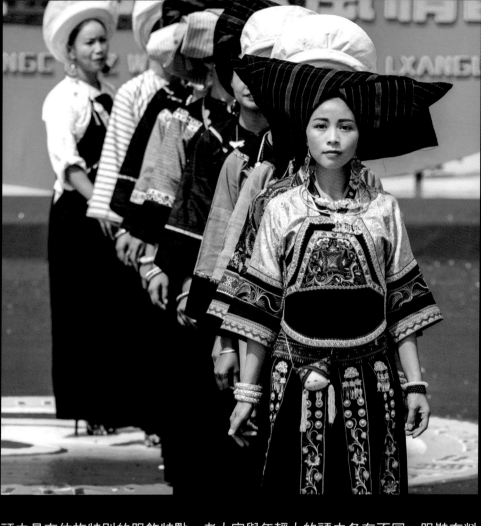

頭巾是布依族特別的服飾特點，老人家與年輕人的頭巾各有不同，服裝布料多使用獨特的傳統蠟染技術。（左）每逢重大節日或喜事，浩浩蕩蕩的樂隊會敲竹打鼓，把喜慶的樂聲傳遍寨中。（右）

Coverchief is a distinct feature of Bouyei costumes, and people of different age wear different styles. The cloth is generally dyed using the traditional wax-resist technique of batik. (Left) On occasions of festivals or joyous events, a large group of people would strike the bamboo tubes and drums, spreading happiness all around the village. (Right)

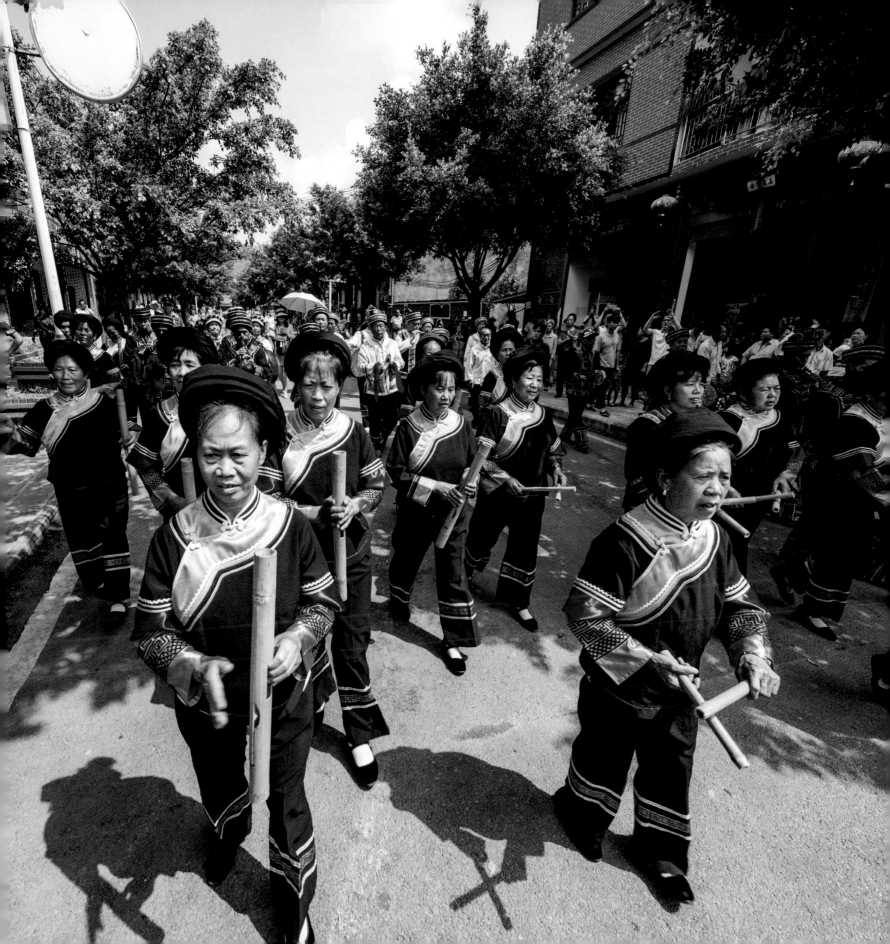

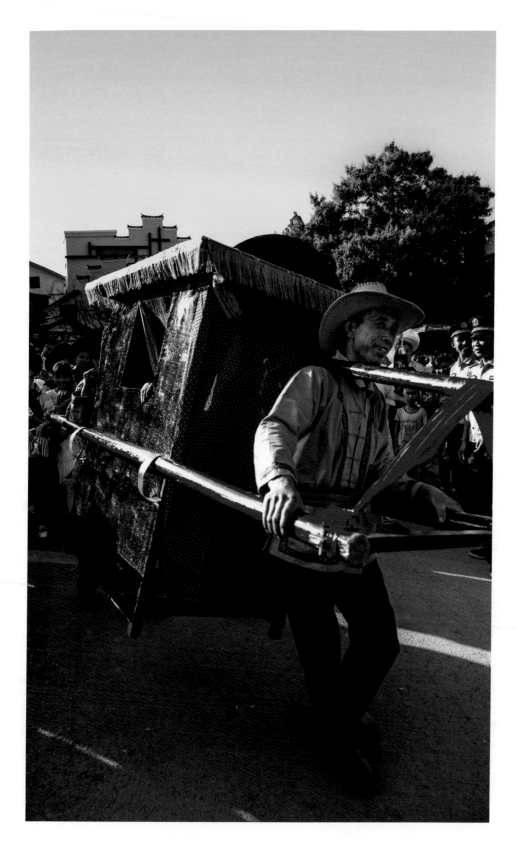

布依族的婚俗沿襲了古代的婚嫁儀式傳統，竟可見到在電視劇中才會出現的轎子。（左）新郎騎著高頭大馬，滿臉喜氣前往接親。（右）

Bouyei wedding ceremony has inherited the tradition of ancient China. The palanquin which appears now only on television can be seen here. (Left) The groom is riding a tall horse to pick up his soon-to-be wife with a jubilant look on his face. (Right)

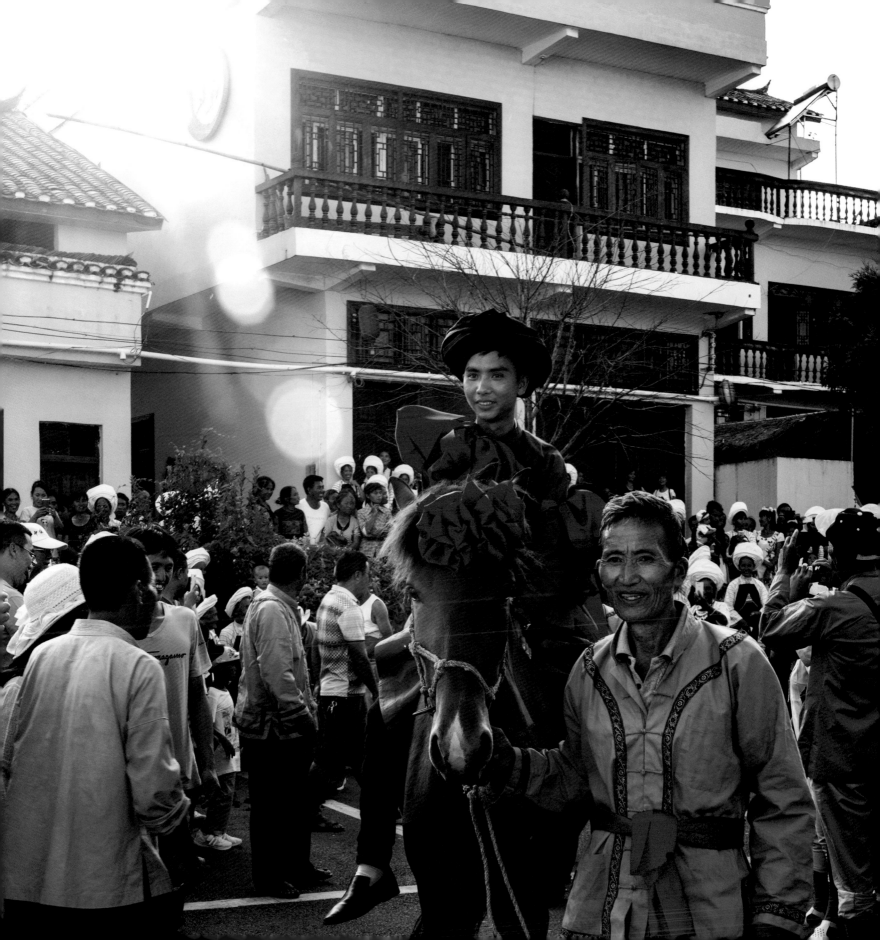

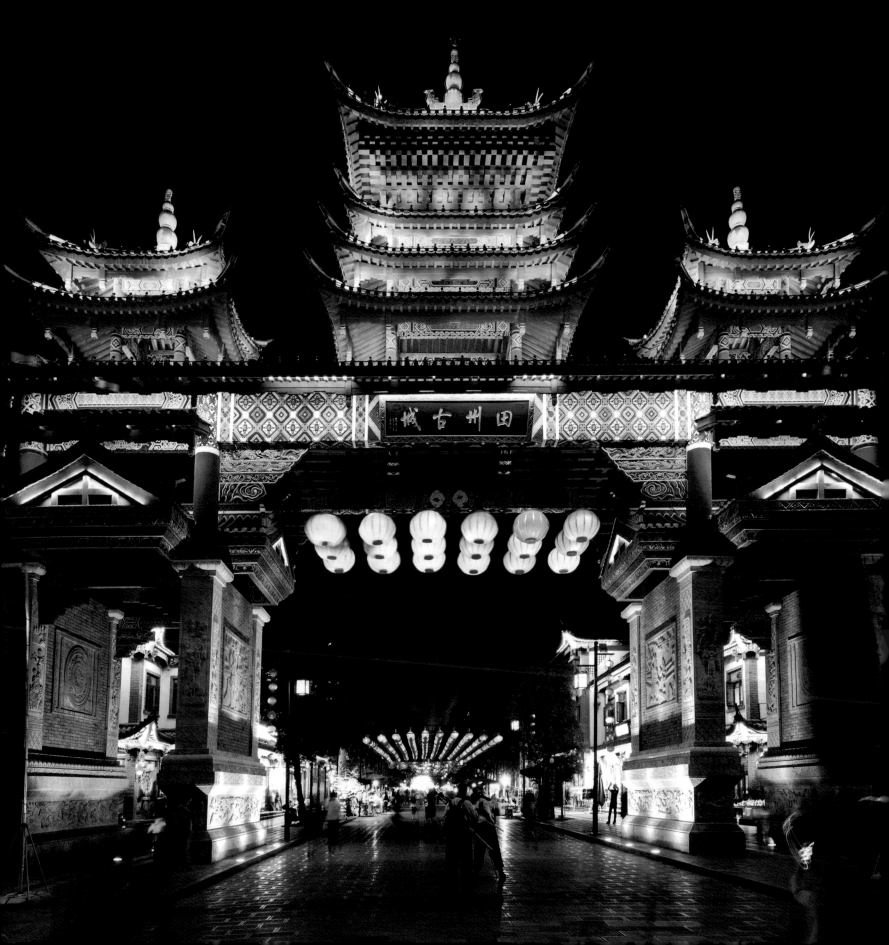

田州古城位於廣西壯族自治區百色市田陽縣。田陽亦是壯族的發祥地。（左）壯族人喜歡依水而居，村寨依山傍水，風光秀麗，仍保留古老的建築模式。（右）

The Tianzhou Old Town is located in the Tianyang County, Baise City, Guangxi. The county is a place of origin of the Zhuang People. (Left) Zhuang people love to live by the water, and their villages are generally beautiful places with mountains at the back and streams in the front. They have also kept the ancient architectural style. (Right)

壯族

Zhuang People

壯族，是中國人口最多的少數民族，全國共有 1800 萬。目前主要分佈在廣西壯族自治區、雲南、廣東和貴州等省區。

作為嶺南地區的土著民族，壯族擁有悠久的歷史，與歷史上百越中的西甌和駱越一脈相承，與貴州的布依、越南的岱依、儂、熱依等族群在語言文化方面非常相似，所以他們在歷史上也被統稱為「僚人」。

從秦始皇一統天下開始，不少漢人開始移居至嶺南地區，使得壯族的各個部落發生了不同程度的漢化。同時也有不少壯族先民被迫南遷，移居到了現東南亞地區的越南、老撾、泰國等地，並與當地的土著相通，形成了新的民族。

壯族人熱愛音樂，族內最為人所知的傳說人物便是唐代的「歌仙」劉三姐，更會定期舉行歌會。其中，最為隆重的歌曲節日，同時也是壯族祭拜祖先的大日子——「三月三」。

Zhuang is the largest ethnic minority in China, with a population of 18 million. Their main inhabiting areas are Guangxi Zhuang Autonomous Region, Yunnan, Guangdong and Guizhou.

As an indigenous nation in Lingnan (south of Nanling Mountains) area, Zhuang has a time-honored history. It is closely related to the West Ou and Luoyue tribes among the Baiyue people. In terms of language and culture, it also shares quite a few similarities with Bouyei in Guizhou, Tay, Nung and Giay people in Vietnam. So they collectively were referred as "Rau" peoples in ancient China.

Ever since Qin Shi Huang unified all of China, Han people started to migrate to Lingnan district, affecting the tribes of Zhuang on different levels. Meanwhile, many Zhuang ancestors were forced to move further down to the current Vietnam, Laos and Thailand areas. They later turned into new nationalities after centuries of miscegenation with local ethic groups.

Zhuang people ardently loves the art of music - even its most famous legend is the story of Liu Sanjie in Tang Dynasty, who is regarded as "the singing fairy". Singing parties are regularly held within the ethnic group. The most ceremonious party falls on the 3rd day of the 3rd lunar month, which is also the day of worshipping their ancestors.

「三月三」是南方多個少數民族的節日，而因這同時是壯族始祖「布洛陀」的誕辰，因此壯族「三月三」尤為隆重。此外，這亦是壯族歌節，古時壯族人會在這天以集體歌唱，祭祀神靈、祈求生育和豐收。歌節逐步演變成為青年男女「以歌擇偶」的節日活動。

Double Third Festival is celebrated by multiple ethnic groups in the South. The date is also the birthday of Zhuang's ancestor Bu Luo Tuo, so the celebration is extraordinarily grand among Zhuang people. It is also the Song Festival of Zhuang. In ancient times, Zhuang people performed group singing on this day to worship the God and pray for fertility and harvest. The Song Festival gradually evolved into a day for young men and women to "sing songs to one's beloved".

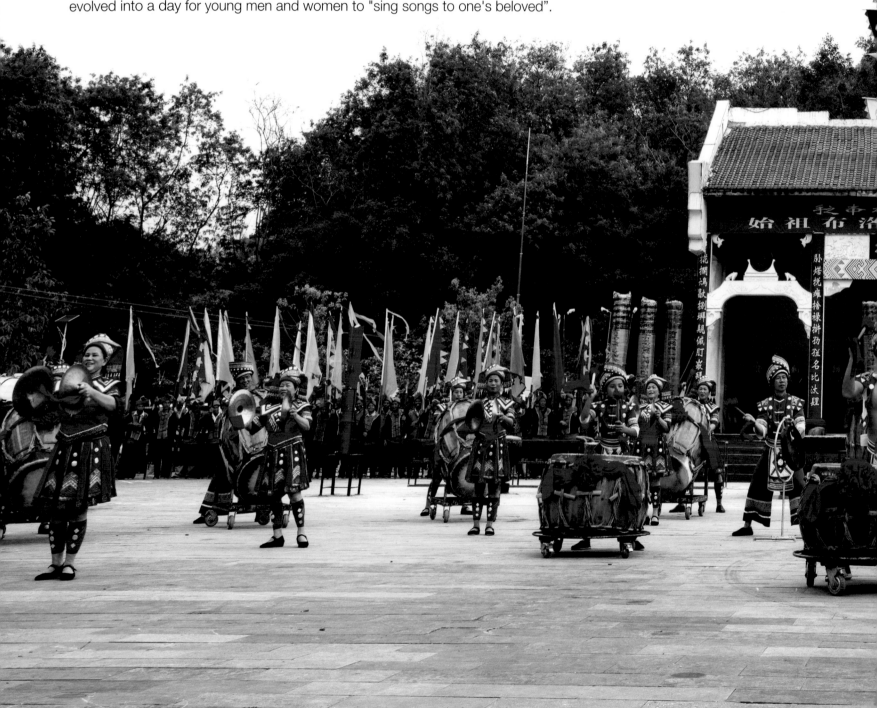

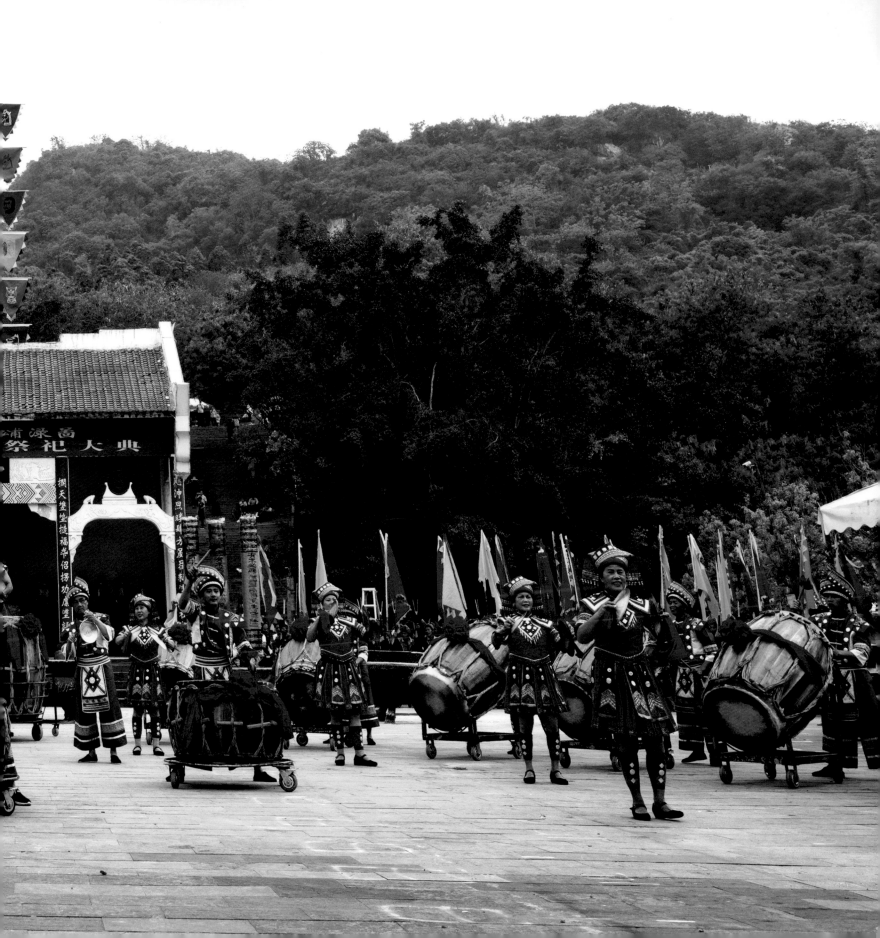

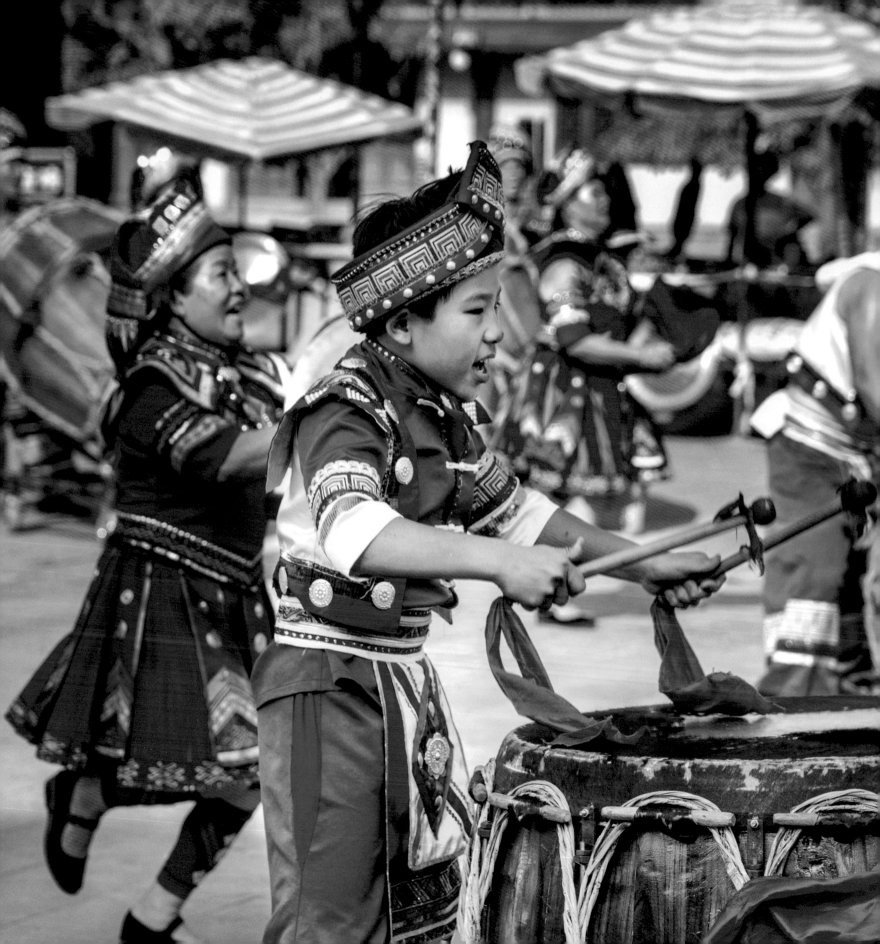

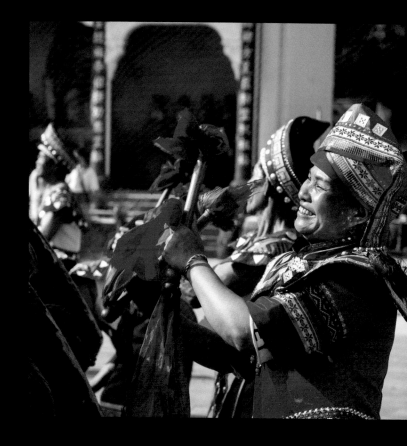

「三月三」是廣西的法定節日。在這一天，平日需要上班上學的壯族人都參與到節日慶典中。（左）祠堂前的廣場上，男女老少都歡快地敲著大鼓。（右）

The Double Third is a public holiday in Guangxi. On the day of the festival, those who usually go to work or school would also take part in the ceremonies. (Left) Zhuang people, regardless of age or gender, are striking the large drums happily on the square in front of the ancestral temple. (Right)

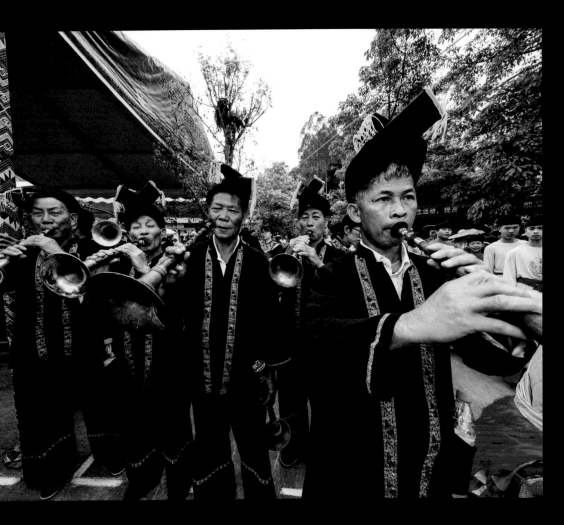

在樂聲之中，朝拜的隊伍浩浩蕩蕩地向山上進發。（左）「朝拜布洛陀」環節齊聚了來自各地的祭拜團隊。（右）

...he massive pilgrimage teams are heading uphill in the sound of festive melodies. (Left)
...he event of "Pilgrimage to Bu Luo Tuo" has gathered worshipping teams from various
...gions. (Right)

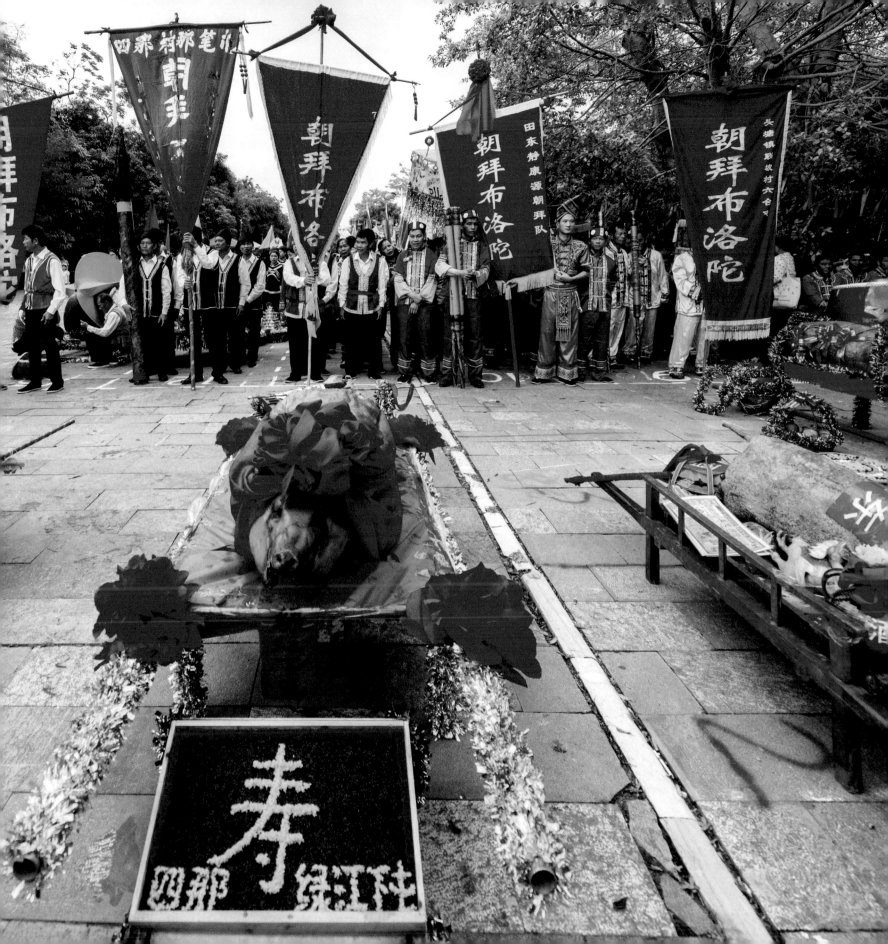

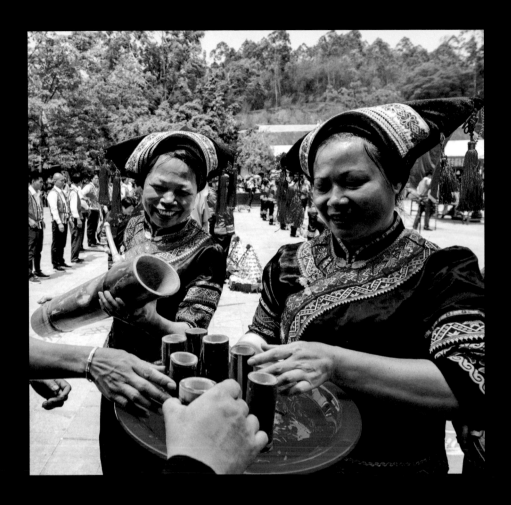

向客人奉上以竹筒盛載的香甜米酒，是熱情好客的壯族的待客禮節。（左）「布洛陀」是壯族先民口頭文學中的神話人物，是創世神。「布」在狀語中是「有威望的老人」，「洛」是「知道」，「陀」是「很多創造」的意思。（右）

Serving bamboo tubes of tasty rice wine to the guests is a welcoming courtesy of the hospitable Zhuang people. (Left) Bu Luo Tuo is the God of Creation in the declamatory literature passed down along generations from the ancestors of Zhuang. In Zhuang language, "Bu" means "an old man with great prestige", "Luo" is "to know", and "Tuo" stands for "many creations". (Right)

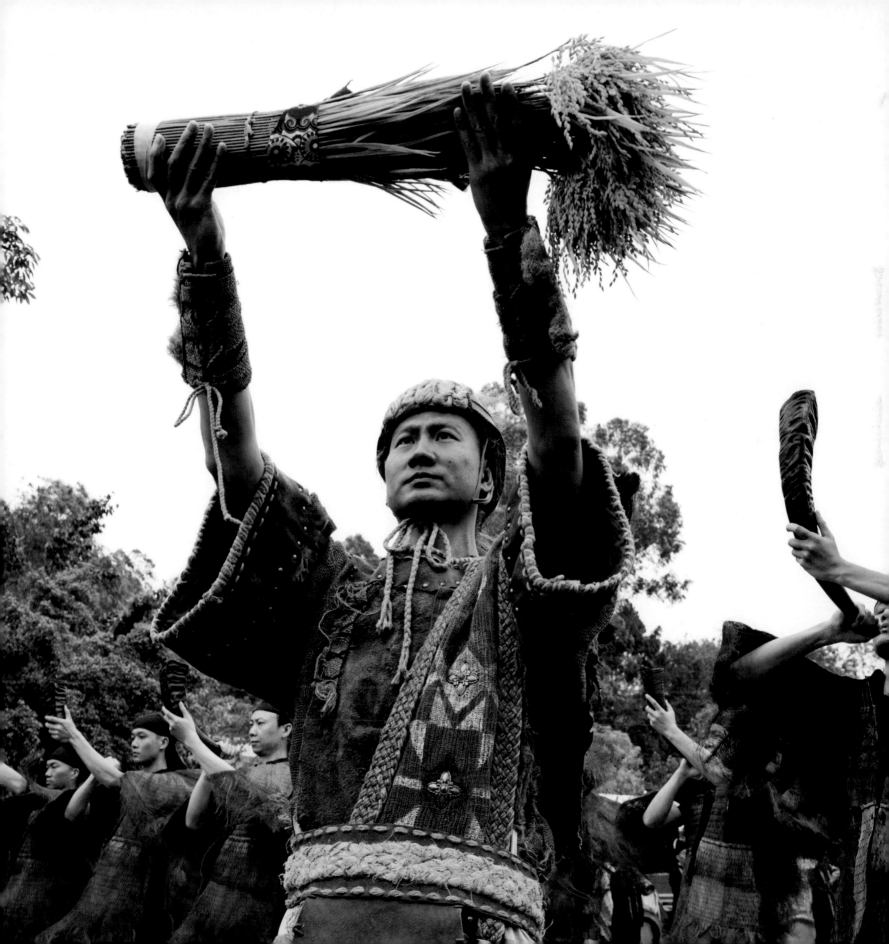

在明清時期，壯族婦女曾因善於織布而聞名。
她們所織出的色彩豔麗、極具民族特色的
樣式，被稱為「壯錦」。

In Ming and Qing Dynasties, Zhuang
women were famous for their weaving
technique. The colorful and folk-style cloth
is called "Zhuang brocade".

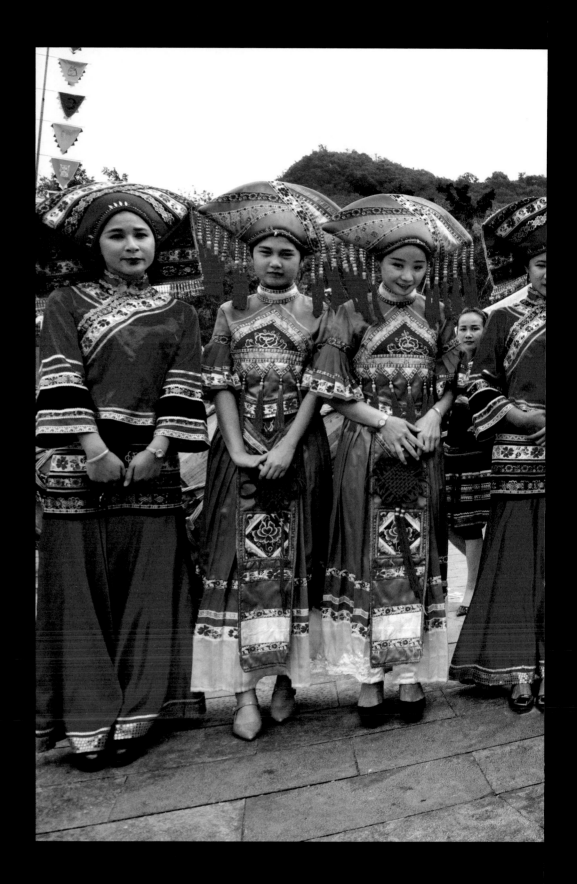

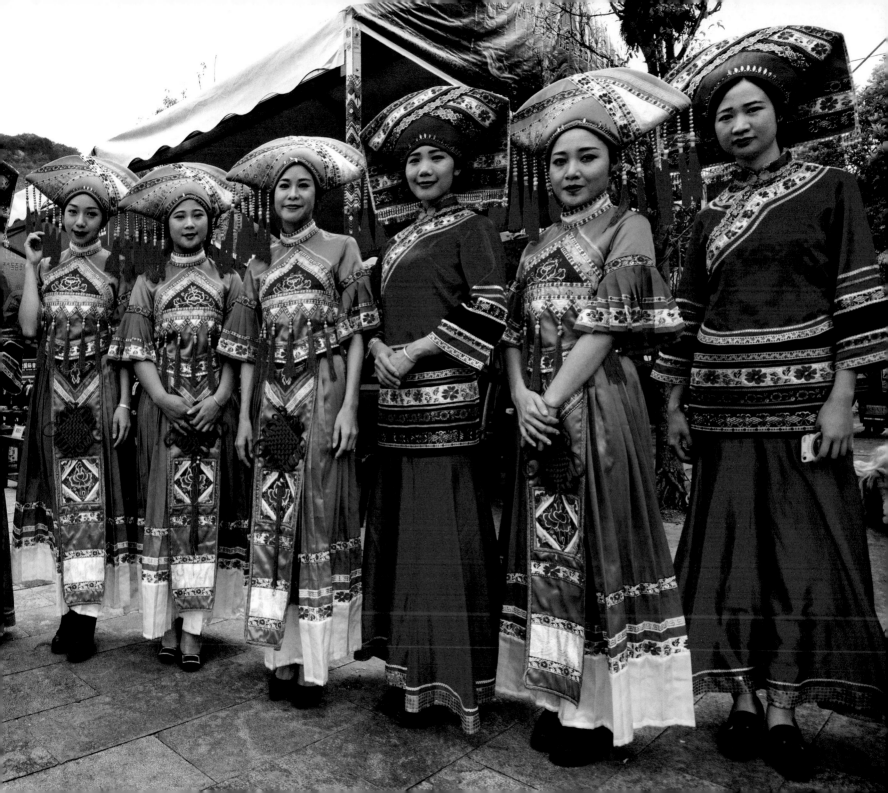

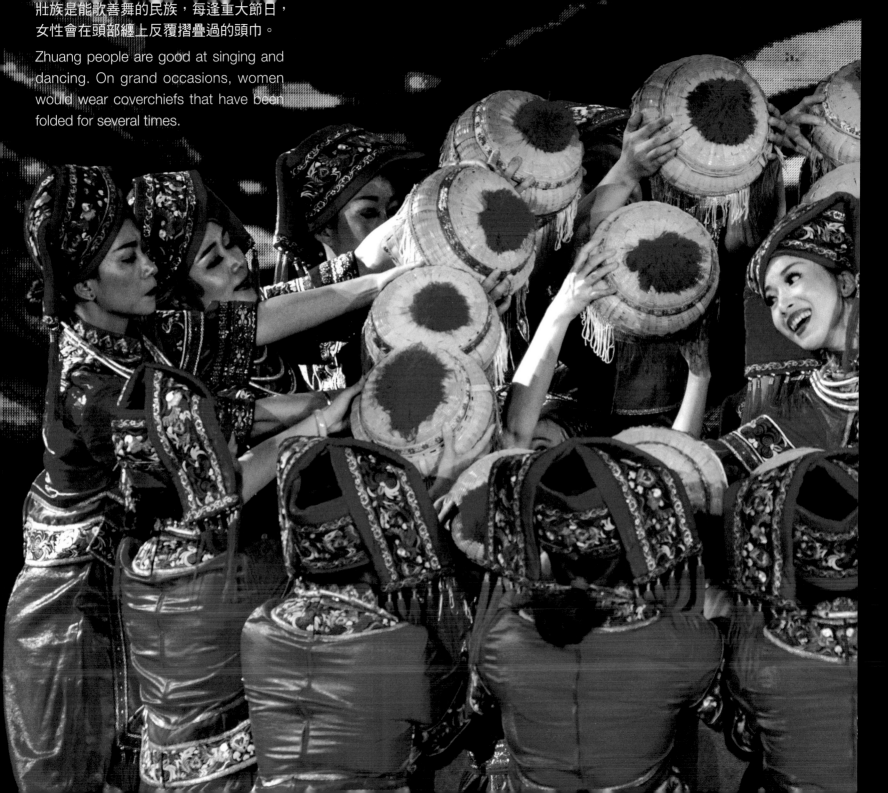

壯族是能歌善舞的民族，每逢重大節日，
女性會在頭部纏上反覆摺疊過的頭巾。

Zhuang people are good at singing and
dancing. On grand occasions, women
would wear coverchiefs that have been
folded for several times.

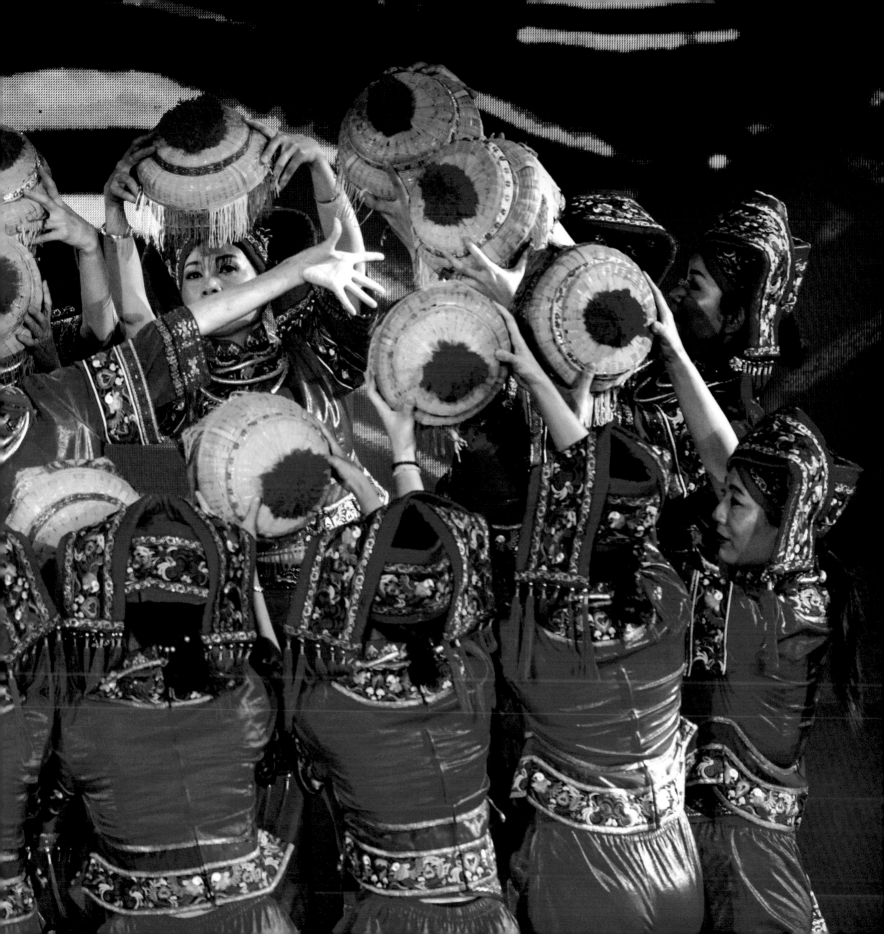

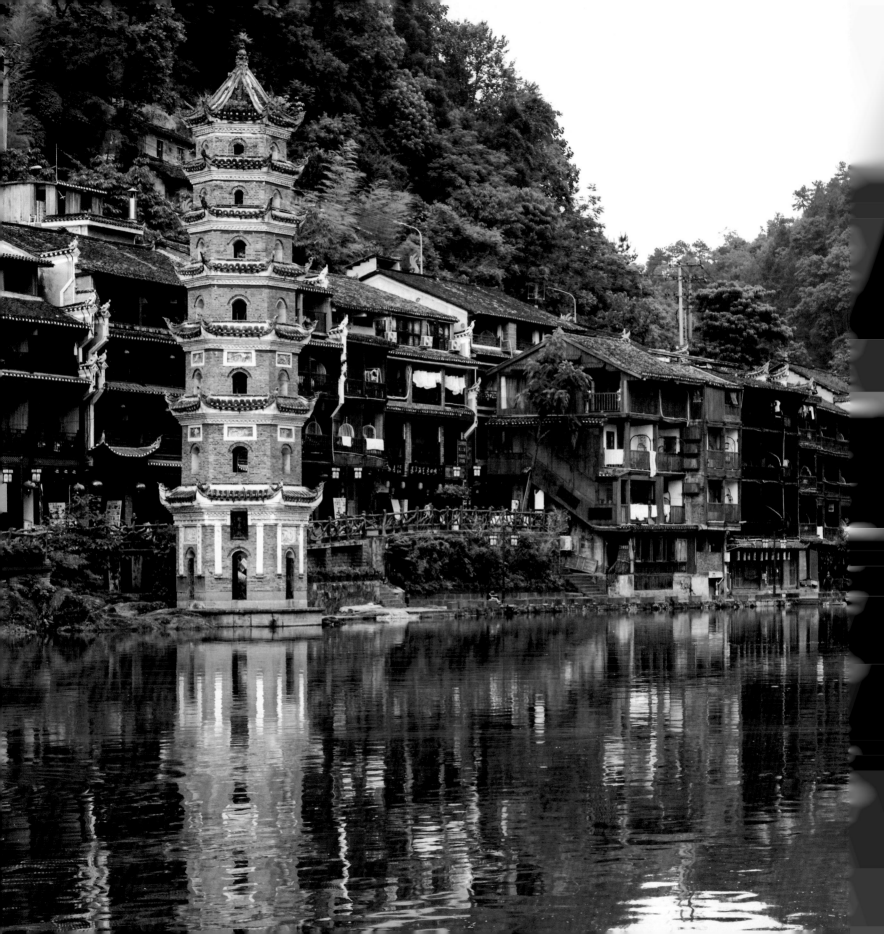

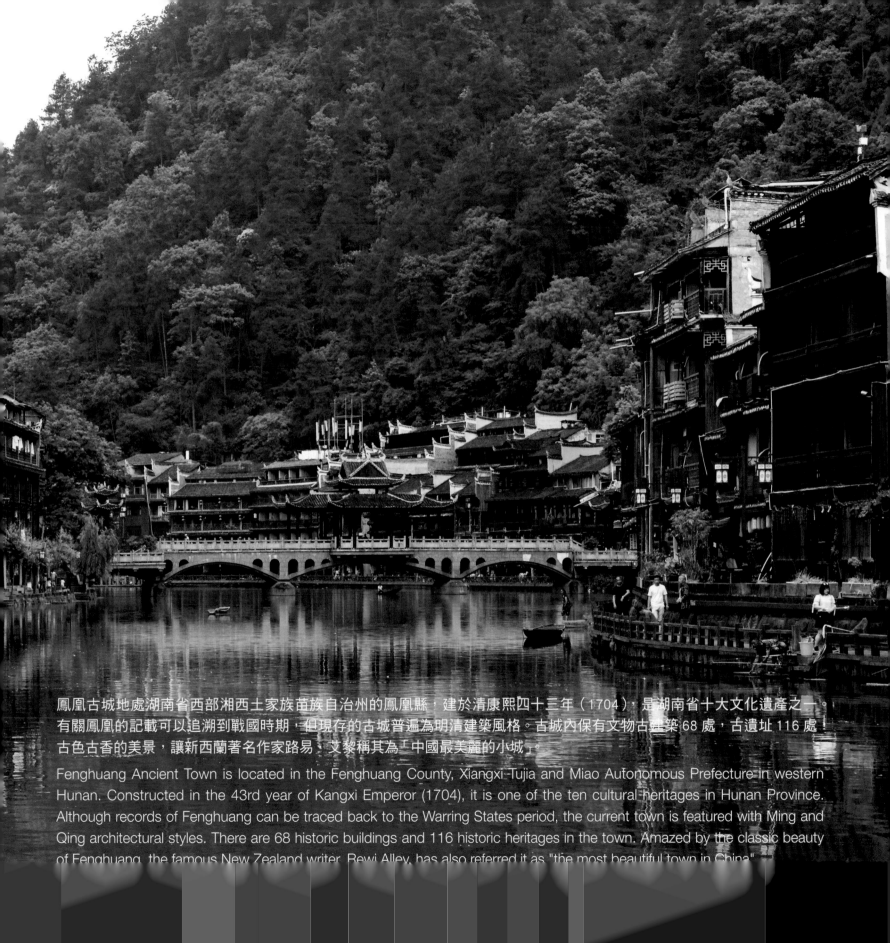

鳳凰古城地處湖南省西部湘西土家族苗族自治州的鳳凰縣，建於清康熙四十三年（1704），是湖南省十大文化遺產之一。有關鳳凰的記載可以追溯到戰國時期，但現存的古城普遍為明清建築風格。古城內保有文物古建築 68 處，古遺址 116 處。古色古香的美景，讓新西蘭著名作家路易‧艾黎稱其為「中國最美麗的小城」。

Fenghuang Ancient Town is located in the Fenghuang County, Xiangxi-Tujia and Miao Autonomous Prefecture in western Hunan. Constructed in the 43rd year of Kangxi Emperor (1704), it is one of the ten cultural heritages in Hunan Province. Although records of Fenghuang can be traced back to the Warring States period, the current town is featured with Ming and Qing architectural styles. There are 68 historic buildings and 116 historic heritages in the town. Amazed by the classic beauty of Fenghuang, the famous New Zealand writer, Rewi Alley, has also referred it as "the most beautiful town in China".

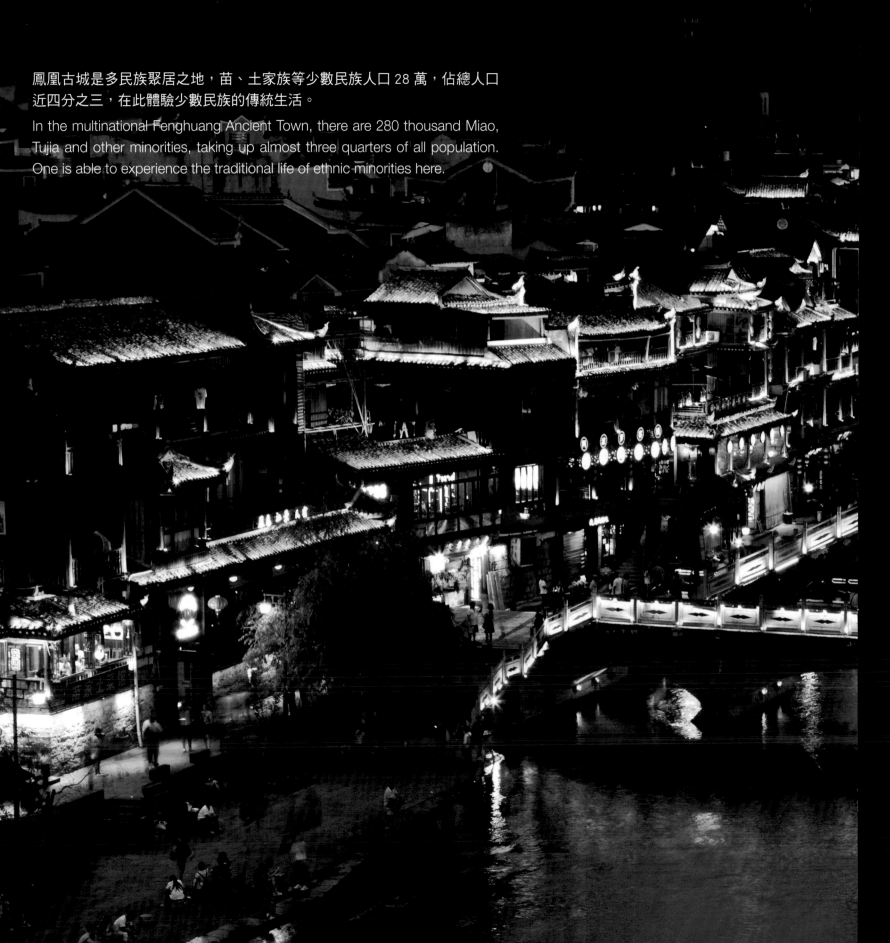

鳳凰古城是多民族聚居之地，苗、土家族等少數民族人口 28 萬，佔總人口近四分之三，在此體驗少數民族的傳統生活。

In the multinational Fenghuang Ancient Town, there are 280 thousand Miao, Tujia and other minorities, taking up almost three quarters of all population. One is able to experience the traditional life of ethnic minorities here.

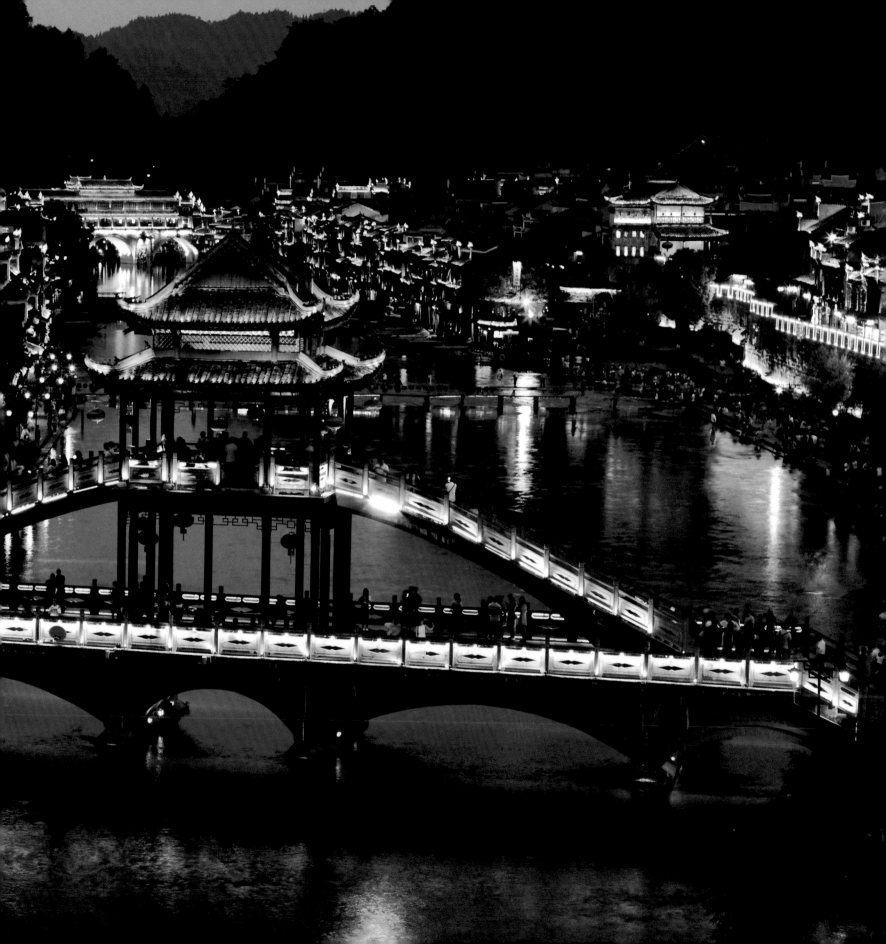

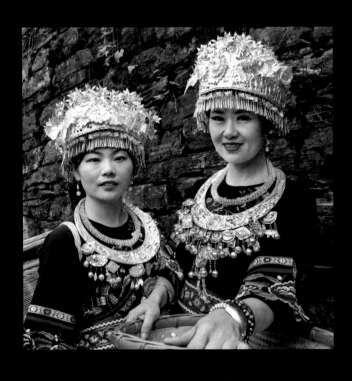

苗族

Miao People

苗族是中國第四大少數民族，人口超過 900 萬，主要分佈在貴州、湖南、湖北、四川、雲南等省，而東南亞地區也可見他們的身影。苗族人口過百萬的省份包括貴州、湖南及雲南。

苗族是一個古老的民族，發源於中國和東南亞地區。中國苗族早期主要集中在黃河中下游地區，據傳他們的祖先是蚩尤。歷史上曾因戰爭等因素遷移至江漢平原、西南山區和雲貴高原，因此形成了廣泛分佈的局面。

在外人的眼中，苗族總有著幾分高深莫測的神秘氣息，甚至有人相信苗人擁有遠古時期遺傳下來的巫蠱之術。其實，這些只是因為苗族的宗教儀式相對複雜。在古代，苗族信奉萬物有靈的原始宗教，咒語、草藥等只是苗族人在宗教儀式中用以敬神、驅鬼、祈福的工具。

Miao is the fourth largest ethnic minority group in China. There are over 9 million Miao people living in Guizhou, Hunan, Hubei, Sichuan, Yunnan and other provinces. Some of them are also living in the Southeast Asia. Guizhou, Hunan and Yunnan are the three provinces with more than a million Miao residents.

As an ancient nation, Miao originated in China and Southeast Asia. In ancient China, this ethnic group lived mainly in the downstream area of the Yellow River. It is said that they were descendants of the tribe of Chiyou. In history, they were forced to move to the Jianghan Plain, mountainous areas in the Southwest, and the Yunnan–Guizhou Plateau because of warfare or other adversities.

In the eyes of outsiders, Miao people are mysterious and unpredictable. Some even believe that people of this ethnicity are capable of using Gu - a legendary venomous and supernatural insect - to do harm. Actually, this is just a myth caused by their complicated religious ceremonies. Miao used to believe in the original animism, and all the curses or herbal medicines were just ceremonial tools for worshipping, exorcism and prayer.

苗族的「四月八」是為了紀念民族英雄「亞努」因領導苗民戰鬥，在農曆
四月初八犧牲的節日，又被稱為亞努節。從許多遠古流傳至今的部落圖騰，
可見苗族對儀式感的重視。四月八當日苗族會舉行跳花樹、舞草龍、鬥雞、
上刀梯、唱山歌等活動。

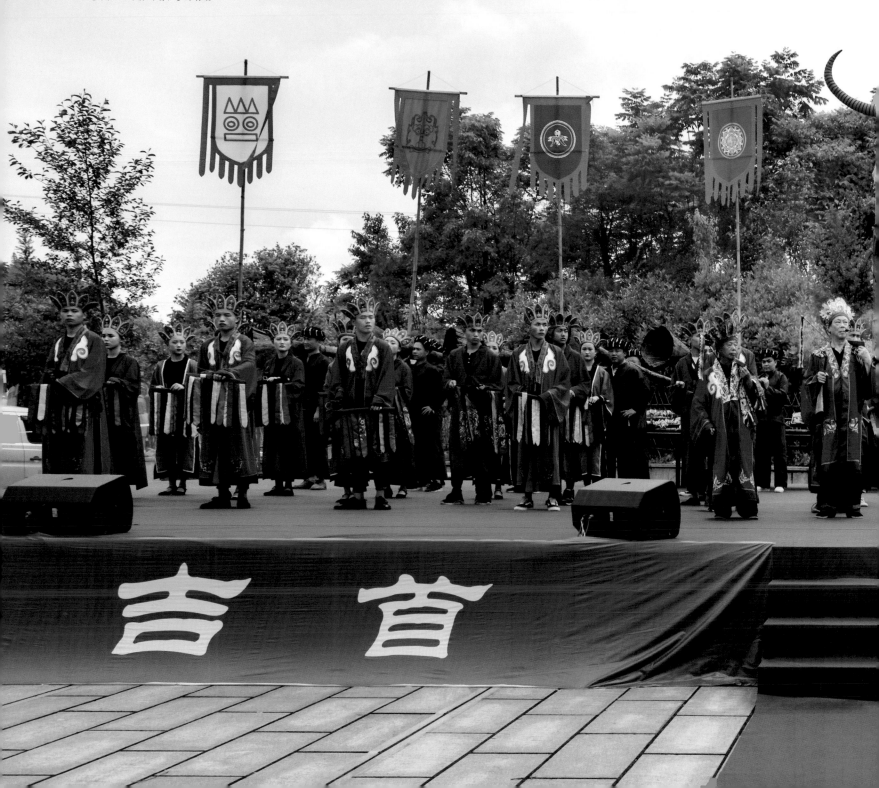

The Siyueba (literally April 8th) Festival is the day to commemorate the Miao folk hero Yanu, who died on the 8th day of the fourth lunar month. The festival, therefore, is also called Yanu Festival. From the tribal totems that got passed down from ancient times, we are able to see the importance of ritualization in the eyes of Miao people. "Dancing around the blossoming tree", "waving straw dragon", cock fight, "climbing the ladder of blades", singing Miao songs are the main activities of Siyueba.

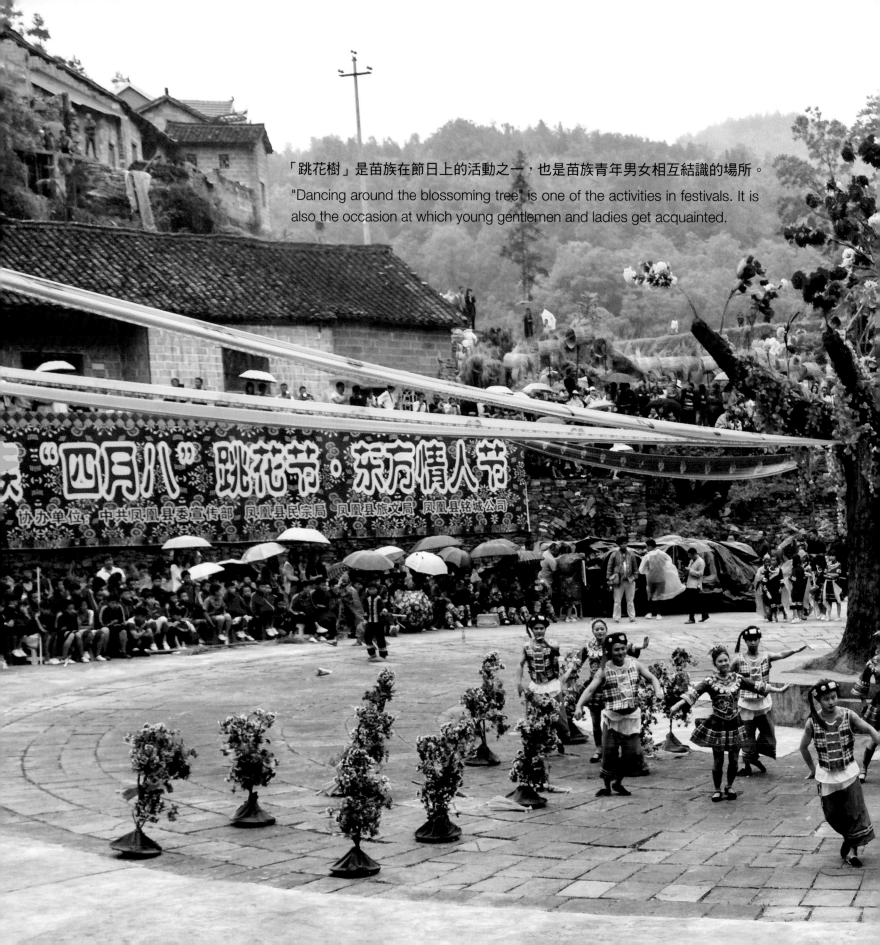

「跳花樹」是苗族在節日上的活動之一，也是苗族青年男女相互結識的場所。

"Dancing around the blossoming tree" is one of the activities in festivals. It is also the occasion at which young gentlemen and ladies get acquainted.

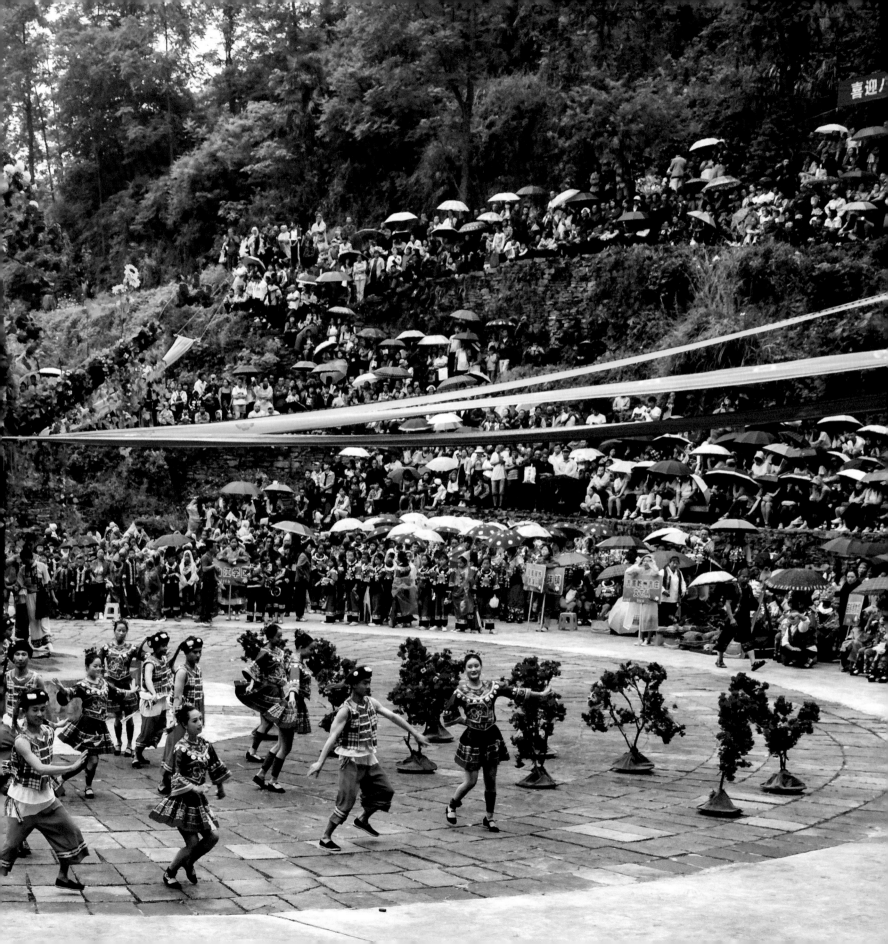

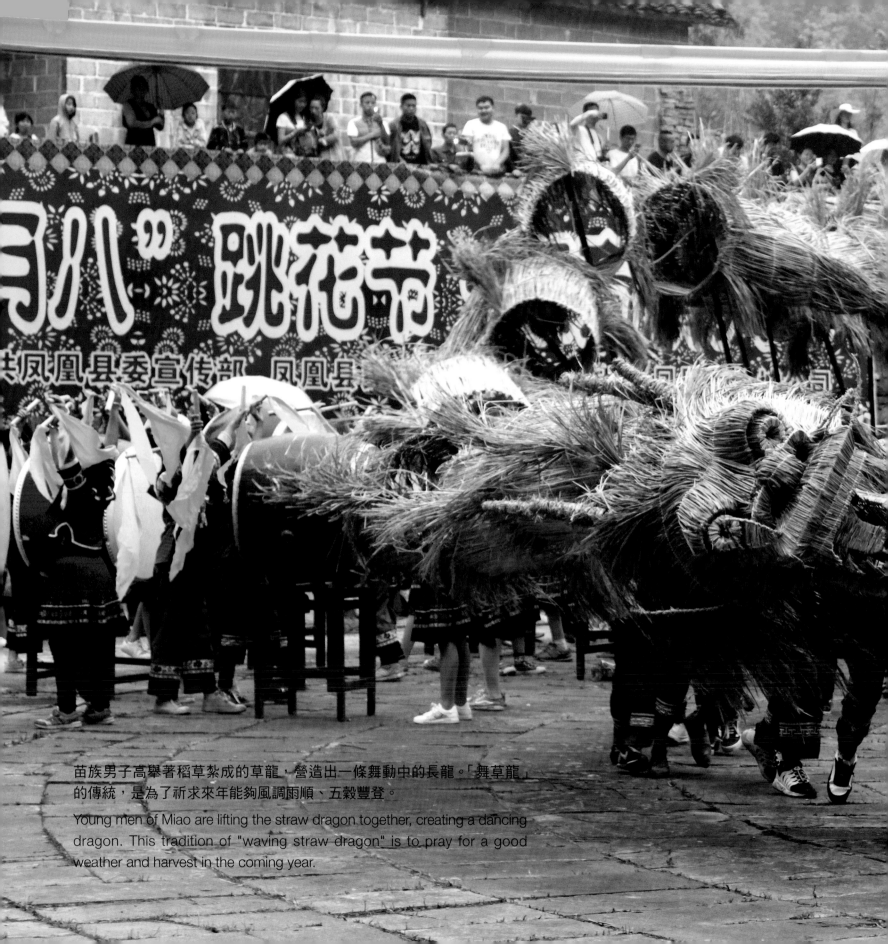

苗族男子高舉著稻草紮成的草龍，營造出一條舞動中的長龍。「舞草龍」的傳統，是為了祈求來年能夠風調雨順、五穀豐登。

Young men of Miao are lifting the straw dragon together, creating a dancing dragon. This tradition of "waving straw dragon" is to pray for a good weather and harvest in the coming year.

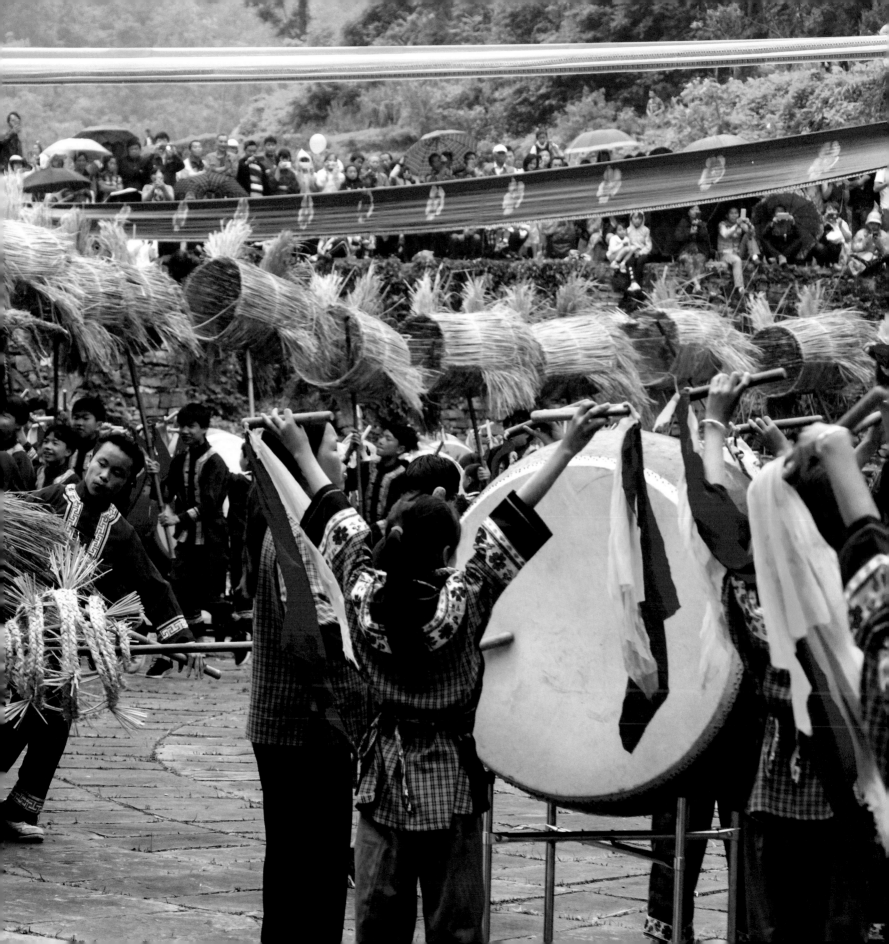

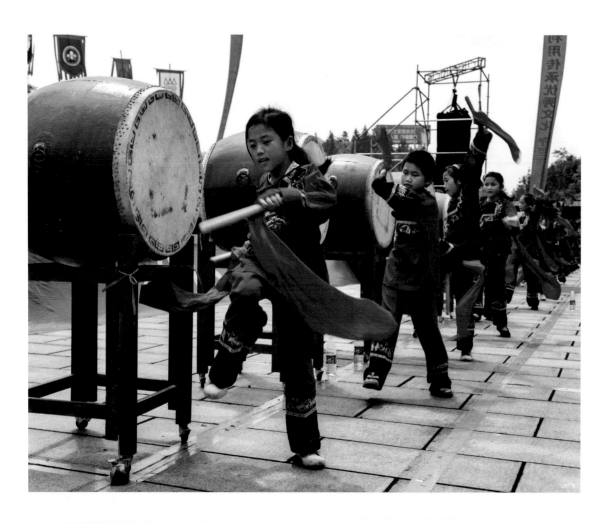

小朋友們穿著喜慶的紅衣為節日擊鼓助興。（左）祭祀環節中，苗族人會以他們最好的食物作為祭品。（右）

Children in festive red clothes are beating the drums to add some cheerful bustle to the festival. (Left) In fete ceremonies, Miao people take out their best food for sacrifice. (Right)

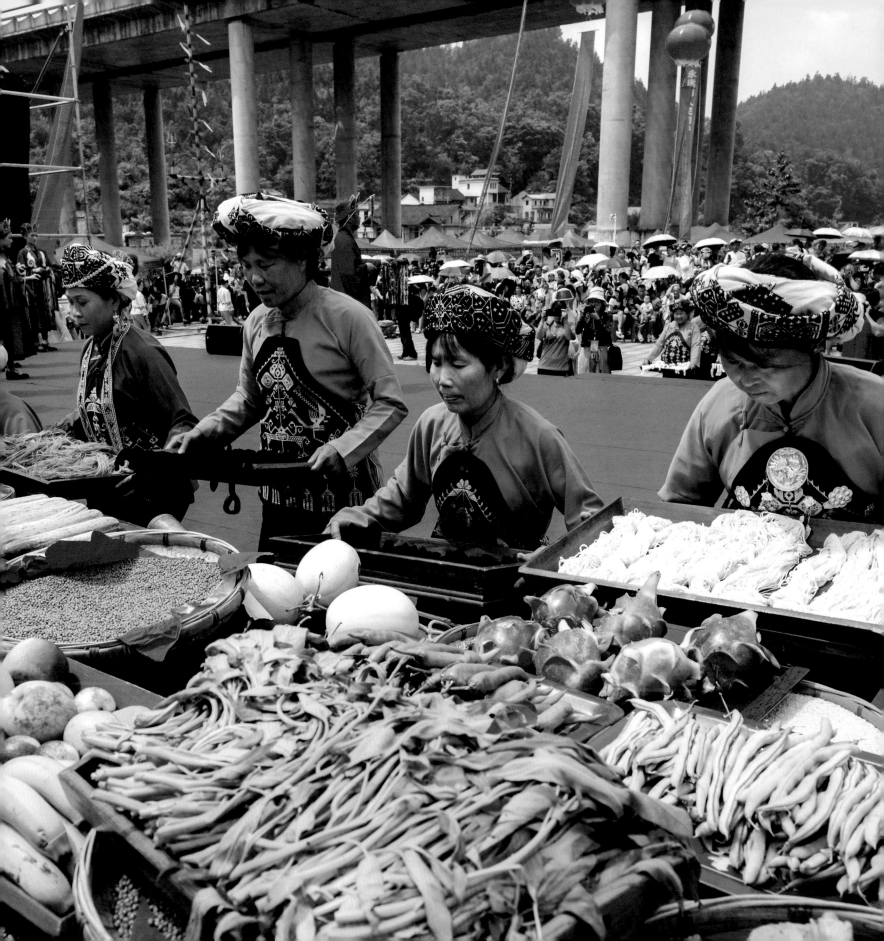

古代流行的鬥雞活動，在亞努節上仍可觀賞到。（左）「上刀梯」的絕技讓人嘆為觀止，苗族勇士在 72 把鋒利鋼刀所組成的刀梯上上下自如，卻能保持毫髮無傷。（右）

Cock fight was once popular in ancient China, which can still be found today in Yanu Festival. (Left) "Climbing the ladder of blades" is a jaw-dropping stunt of Miao people. The brave performer climbs up and down easily on the ladder made of 72 sharp blades easily, without even the slightest injury. (Right)

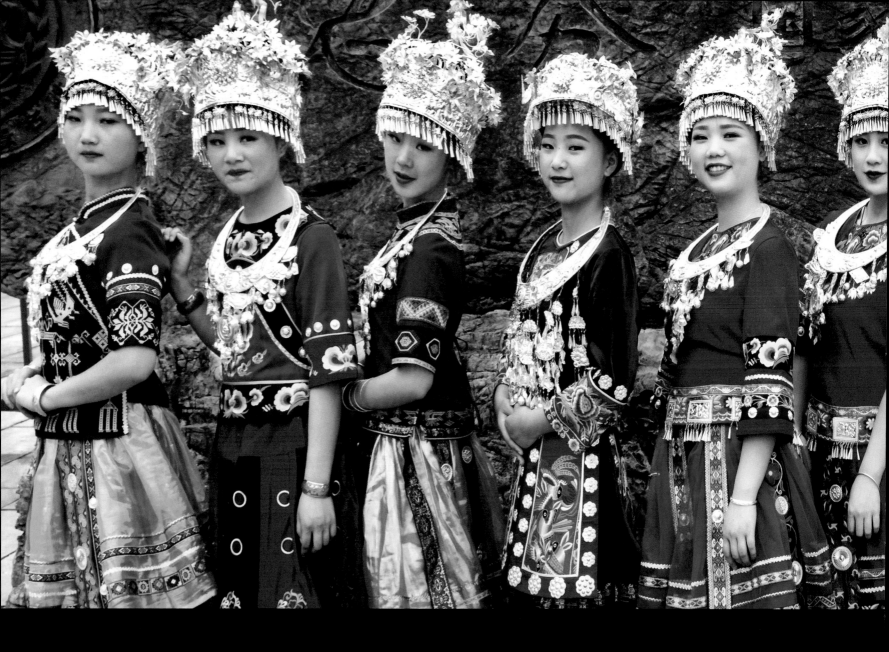

苗族的節日服飾十分繁複精緻，女孩尤其鍾愛銀飾，頭戴銀冠，
銀冠下沿垂掛一排小銀花墜，脖子上戴的銀項圈也款式繁多。

The Miao festive costumes are complicated and delicate. Girls
love silver - they would wear silver crowns with small silver
flowers hanging at the lower edges; the necklaces also come
in a wide variety of models.

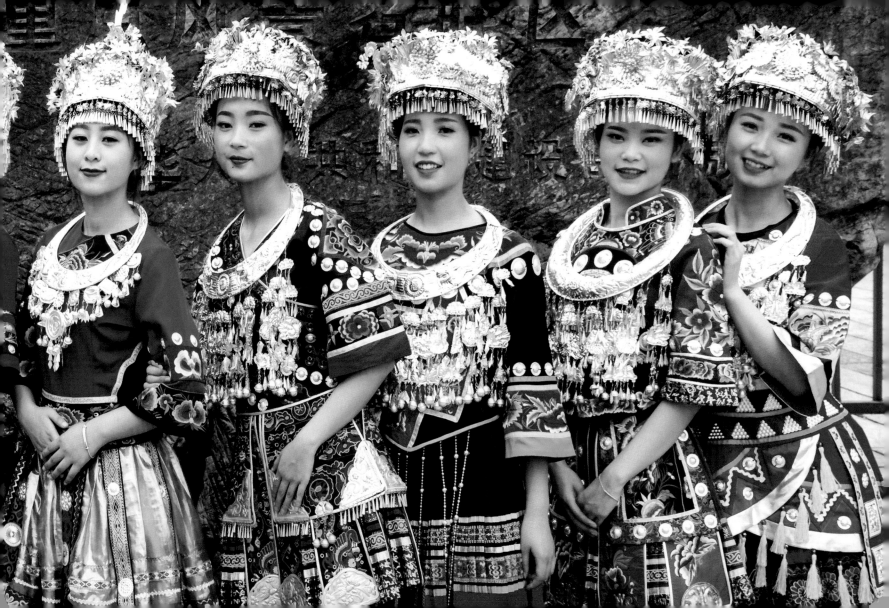

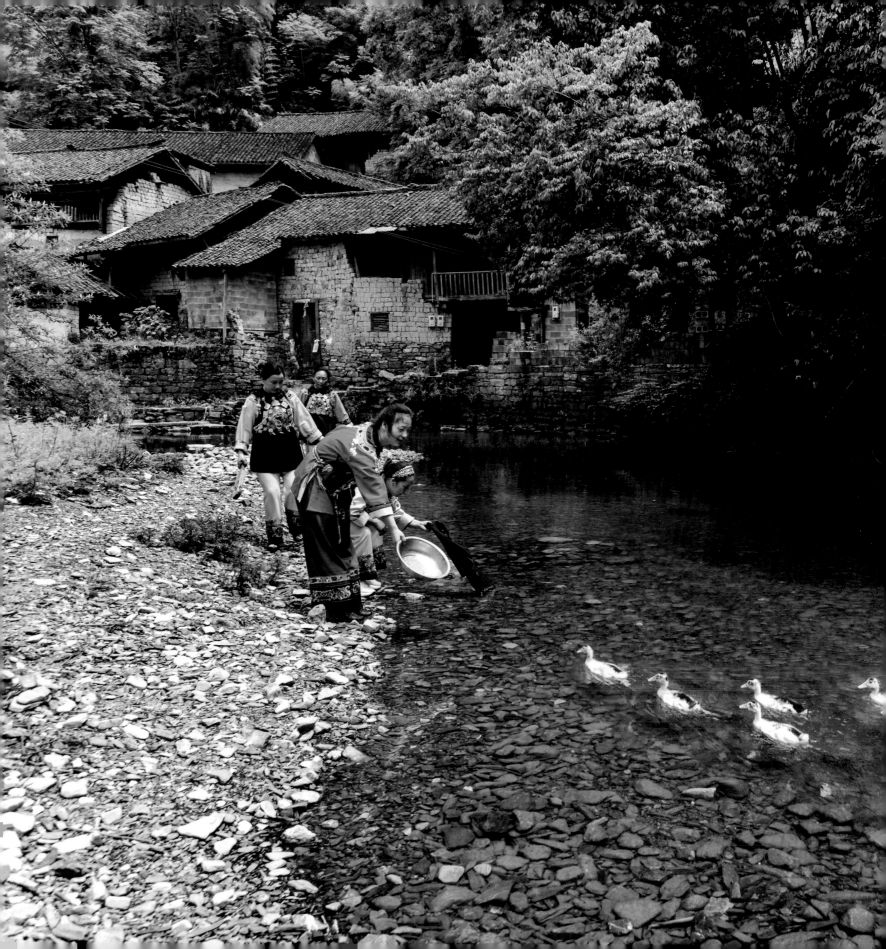

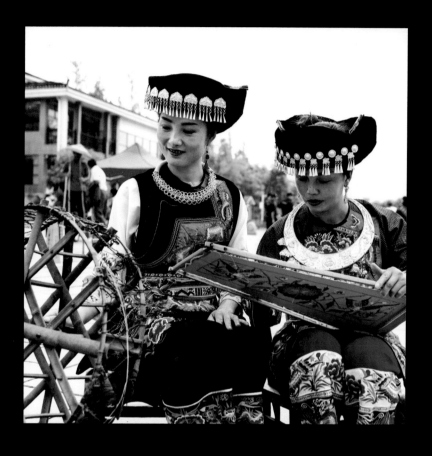

在原始的苗寨，生活十分靜謐安寧。（左）心靈手巧的苗族婦女擅於刺繡工藝，喜歡在衣服上繡上精美的圖案。（右）

The original lifestyle in the village is quiet and soothing. (Left) The ingenious Miao women are skillful in embroidery and like to add exquisite patterns onto the clothes. (Right)

苗歌是山歌的一種，在民族文化中十分重要，幾乎所有活動中都有苗歌。

Miao folk song belongs to the shan'ge genre, and is so important in its ethnic culture that it exists in almost every activity.

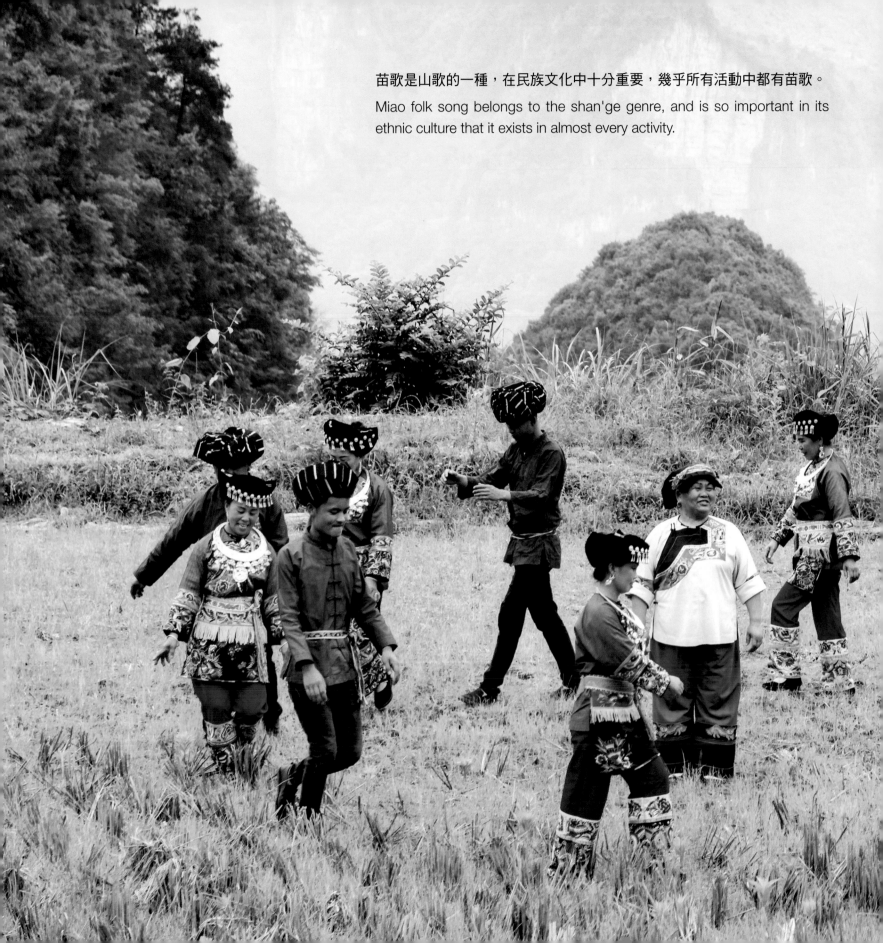

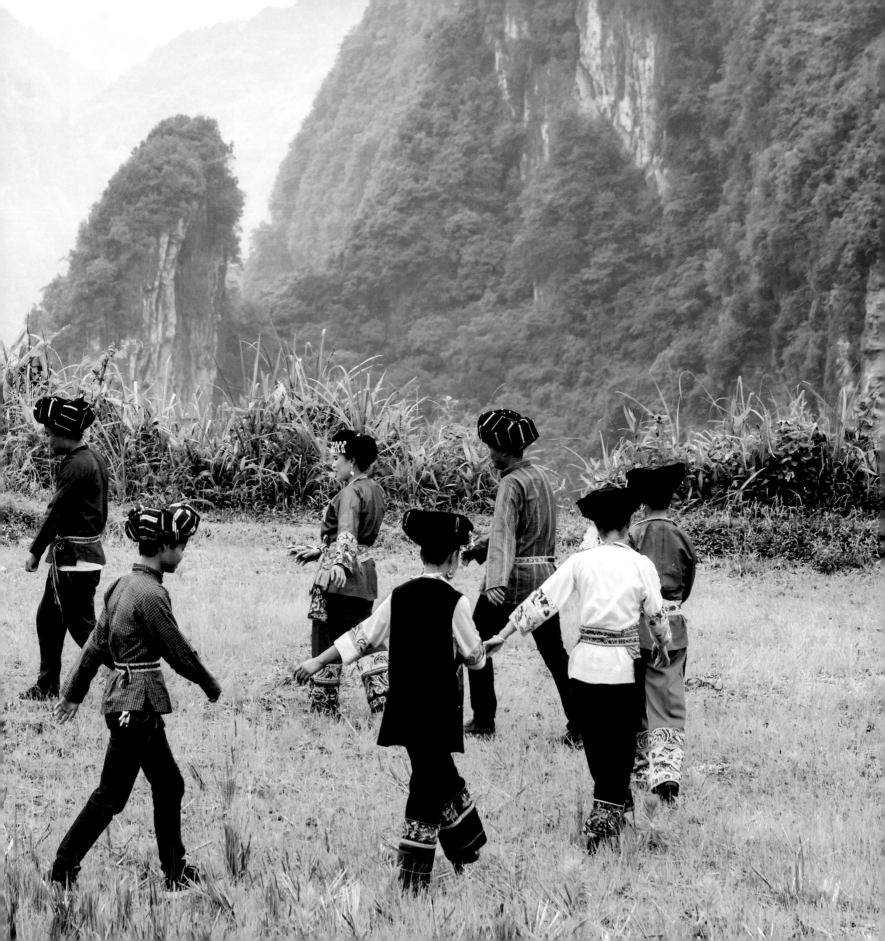

當晨曦微光初現，在廣東省清遠市連南瑤族自治縣的萬山朝王，綿延的山巒之間，透出炫目的日光，磅礴之勢讓人感受到王者的霸氣。

At the Liannan Yao Autonomous County in Qingyuan City, Guangdong Province, when the first rays of the morning sun shine through the long-stretching mountains of Wanshan Chaowang (literally means ten thousand mountains facing the king), the majestic scenery

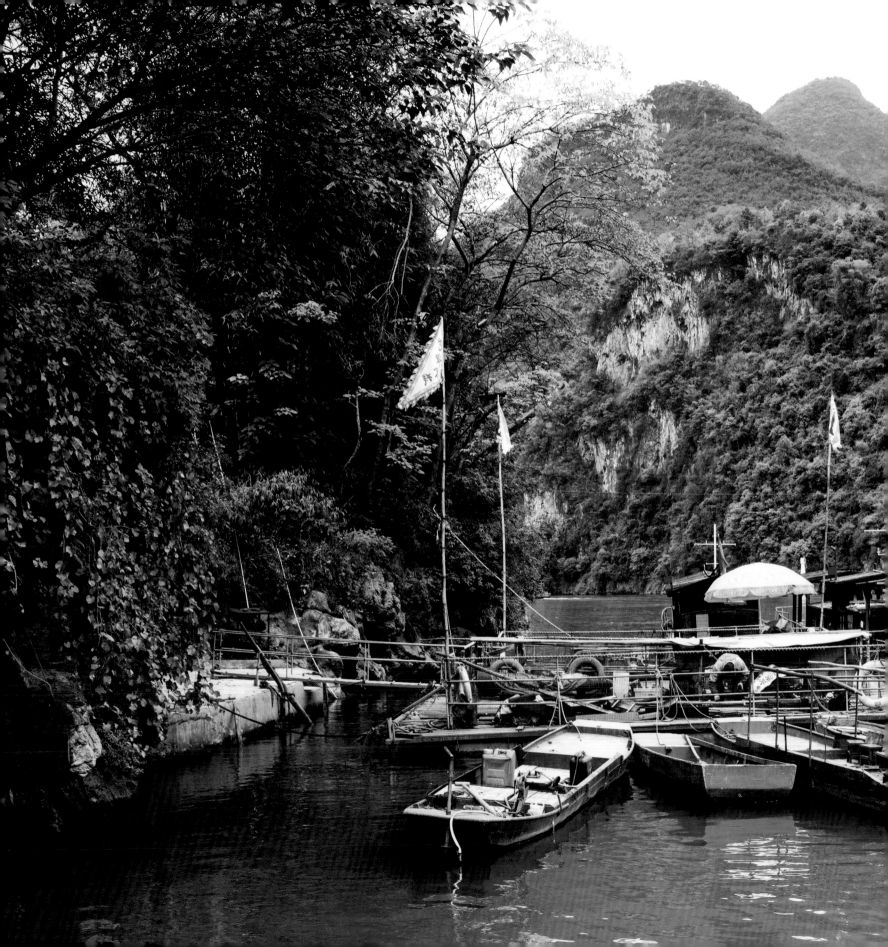

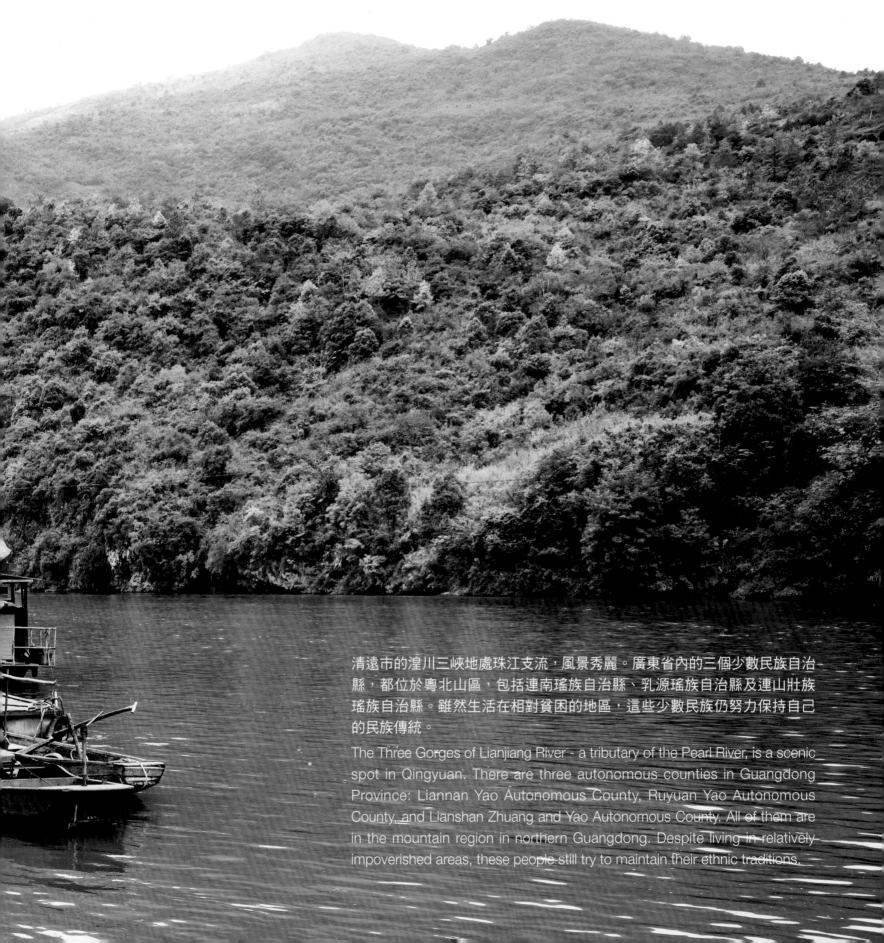

清遠市的湟川三峽地處珠江支流，風景秀麗。廣東省內的三個少數民族自治縣，都位於粵北山區，包括連南瑤族自治縣、乳源瑤族自治縣及連山壯族瑤族自治縣。雖然生活在相對貧困的地區，這些少數民族仍努力保持自己的民族傳統。

The Three Gorges of Lianjiang River - a tributary of the Pearl River, is a scenic spot in Qingyuan. There are three autonomous counties in Guangdong Province: Liannan Yao Autonomous County, Ruyuan Yao Autonomous County, and Lianshan Zhuang and Yao Autonomous County. All of them are in the mountain region in northern Guangdong. Despite living in relatively impoverished areas, these people still try to maintain their ethnic traditions.

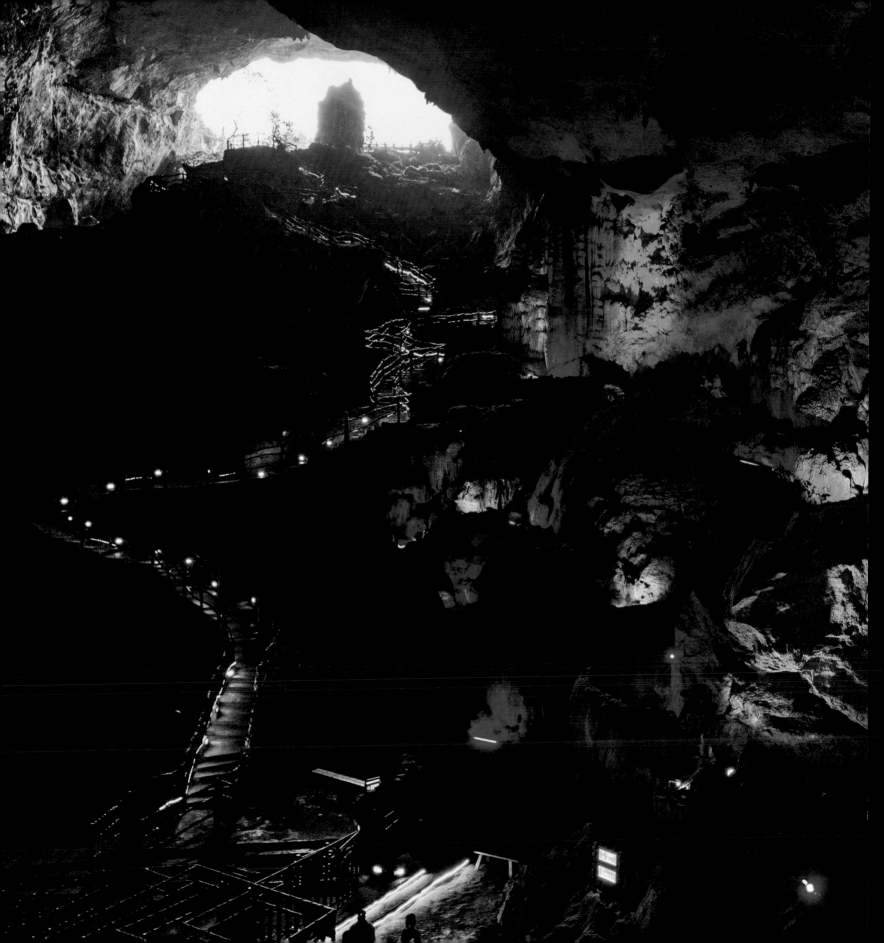

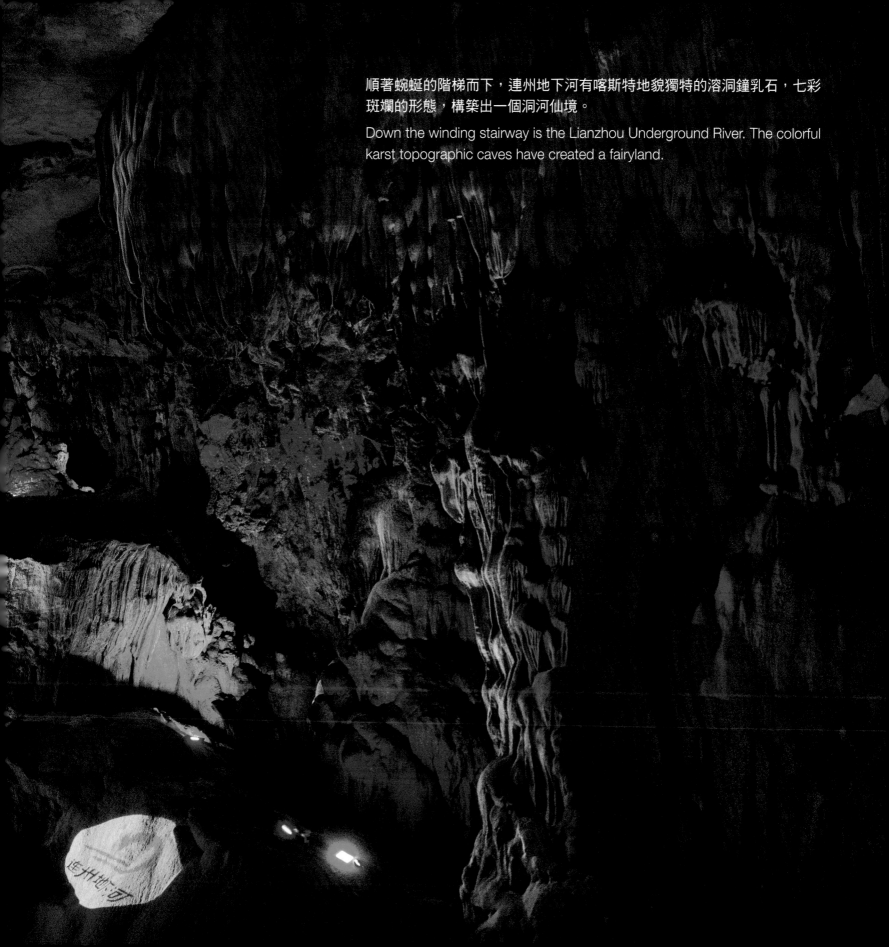

順著蜿蜒的階梯而下，連州地下河有喀斯特地貌獨特的溶洞鐘乳石，七彩斑斕的形態，構築出一個洞河仙境。

Down the winding stairway is the Lianzhou Underground River. The colorful karst topographic caves have created a fairyland.

千年瑤寨坐落於 800 多米的山上，鼎盛時曾住著 1,000 多戶人家，被稱作「中國瑤族第一寨」。（左）寨中有一個專門供奉先祖的小型廟宇。（右）

The Yao village with over a thousand years of history is situated on the 800-meter mountain. In its heyday, there lived more than 1,000 families. It is the oldest and largest Yao village in China. (Left) There is a small temple in the village dedicated to the ancestors of Yao. (Right)

連南設有民族歌舞劇團，以傳統排瑤族浪漫愛情故事，配合民族歌舞和音樂，宣傳排瑤文化。

There is a dedicated troupe in Liannan to promote the culture of Pai Yao by performing ethnic songs and dances based on traditional romantic love stories of Yao people.

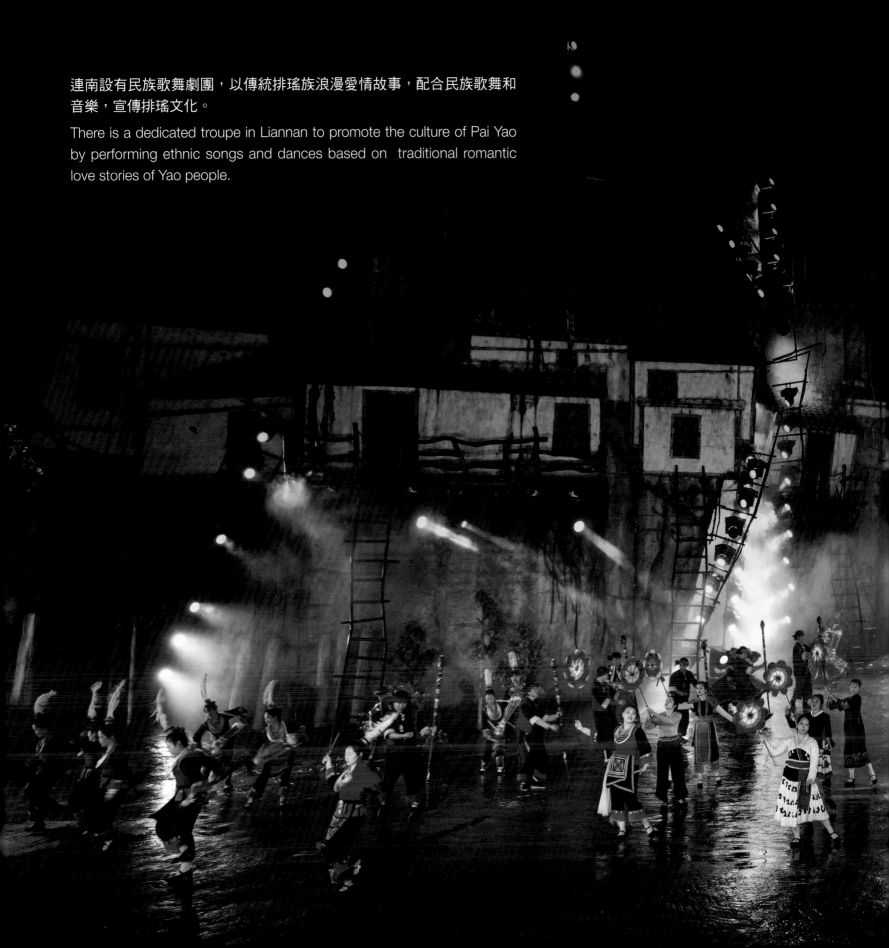

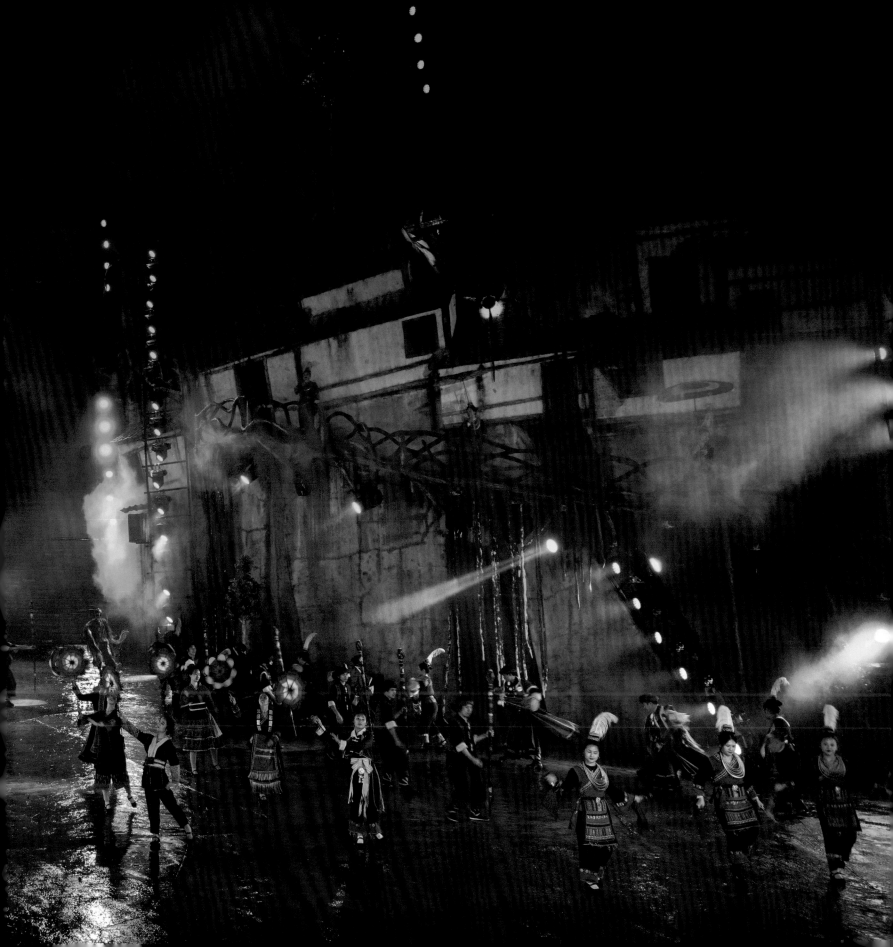

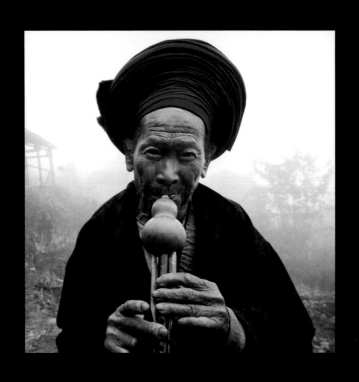

「南嶺無山不有瑤」，是對瑤族分佈地區的真實寫照。瑤族起源於古代東夷部落，擁有悠久歷史，他們往往依山而居，是典型的山地民族。

中國有將近 300 萬瑤族人口，其中超過六成聚居在廣西，在越南、老撾和泰國也可以找到他們的身影。

居住在廣東省清遠市連南瑤族自治縣的瑤族被稱為排瑤，信奉道教。這裏的男性多使用紅色頭巾。

盤王節是瑤族祭祀祖先的慶典活動，而連南的排瑤族在舉行盤王節之時，會一併舉行「耍歌堂」（瑤語音譯）活動，慶祝豐收。

"There are Yao people living on every Nanling Mountains" is a true description of Yao's population distribution. Originating from the prehistoric Dongyi tribe, Yao has a long historical standing. They are the typical mountain-living people.

Sixty percent of the nearly 3 million Yao people are now inhabiting in Guangxi. People of this ethnicity can also be found in Vietnam, Laos and Thailand.

Those who live in the Liannan Yao Autonomous County in Qingyuan, Guangdong Province, are called Pai Yao. Taoism is their general religion. Most of the men here would use headcloth in red color.

Panwang Festival is the day for Yao people to make sacrifice to worship their ancestor. On this date, Liannan people would also hold the "Ai Go Tong" (transliterating from Yao language) event, which is the celebration of harvest.

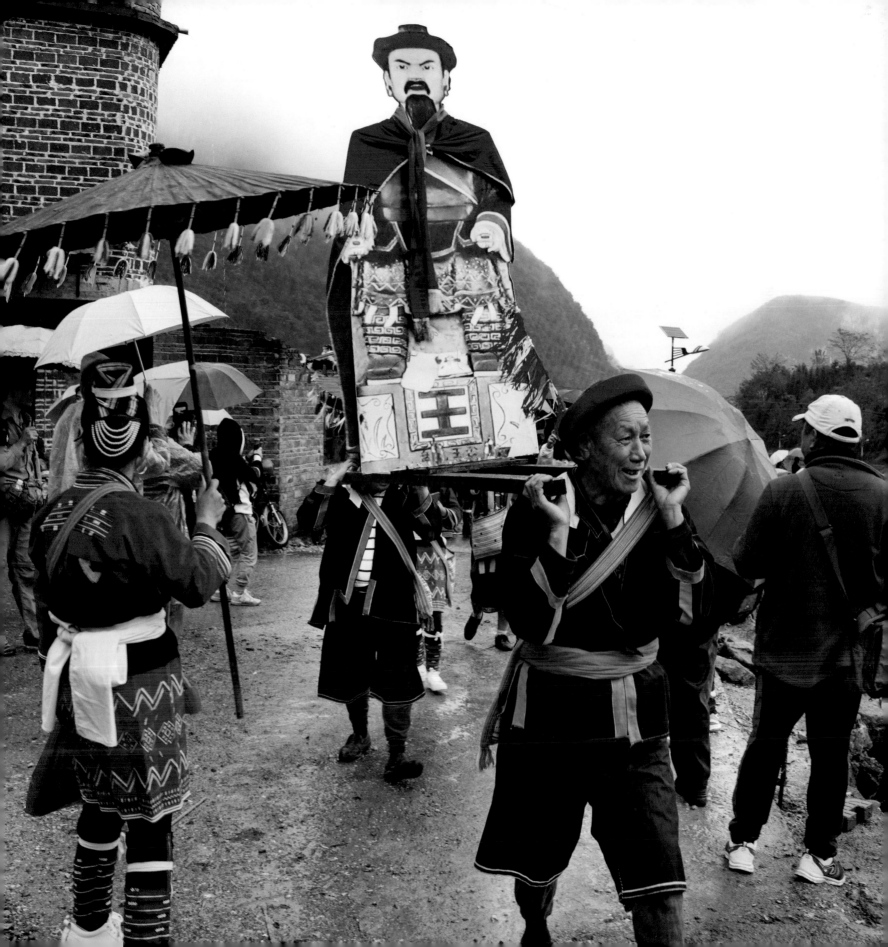

盤王節於每年的農曆十月十六日舉行，是瑤族人對他們的祖先盤王誕辰的慶典，至今已傳承了1,700多年。這一天，瑤族人會抬著盤王像進行「遊神」大典。相傳古時瑤胞乘船飄洋過海，遇上狂風大浪，船在海中漂泊多天不能靠岸。這時，有人祈求始祖盤王保佑家人平安。許過願後，風平浪靜，船很快靠岸，瑤人得救。這天是農曆十月十六日，恰好又是盤王的生日。因此，每年在盤王節當天，瑤族都會舉行隆重的祭祀儀式，答謝盤王。

Panwang Festival is held every year on the 16th day of the 10th lunar month, in memory of the birthday of the Yao's ancestor Panwang. This tradition has been passed along generations for over 1,700 years. On this day, Yao people would carry the figure of Panwang and parade around the village. Legends said that when travelling across the sea, Yao people encountered a devastating storm. The ship could not pull in to shore after many days of aimless drifting. At this time, some started to pray to Panwang for the safety of their families. Miraculously, the storm came to an end after that and they were rescued. That was the 16th day of the 10th lunar month - the birthday of Panwang. Therefore, every year on this day, Yao people hold grand fete ceremonies to express their appreciation to Panwang.

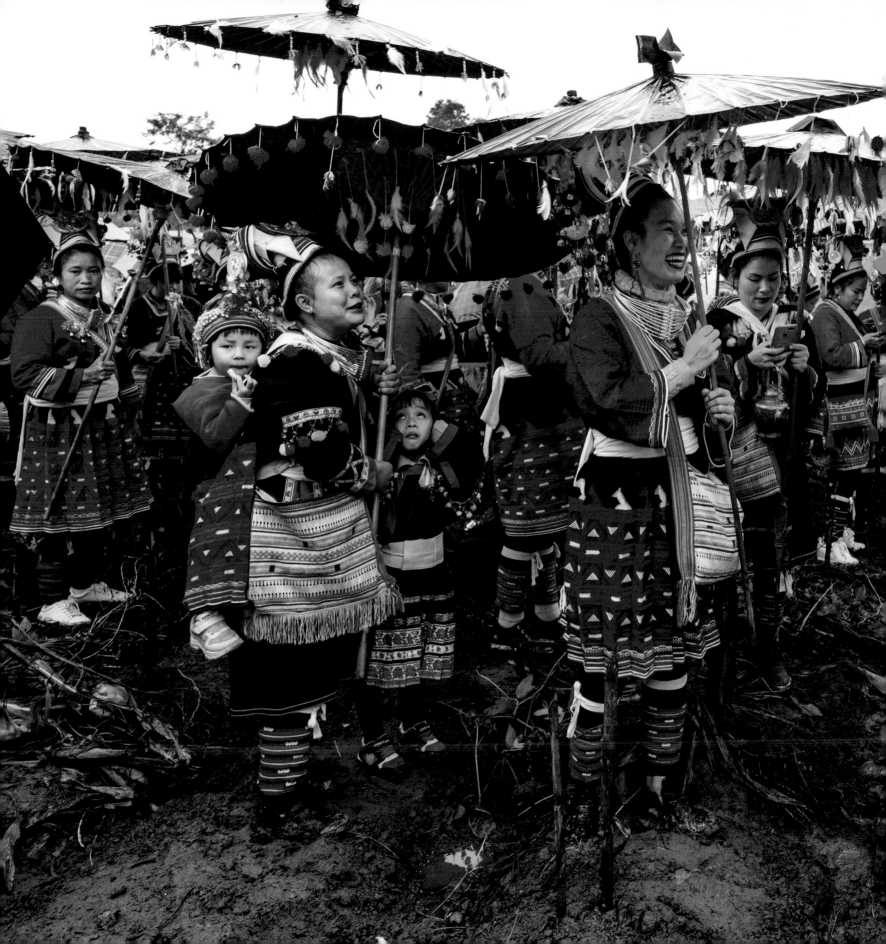

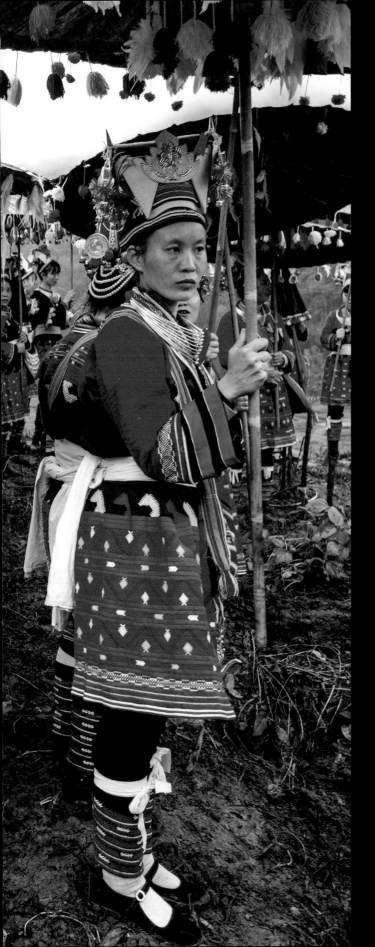

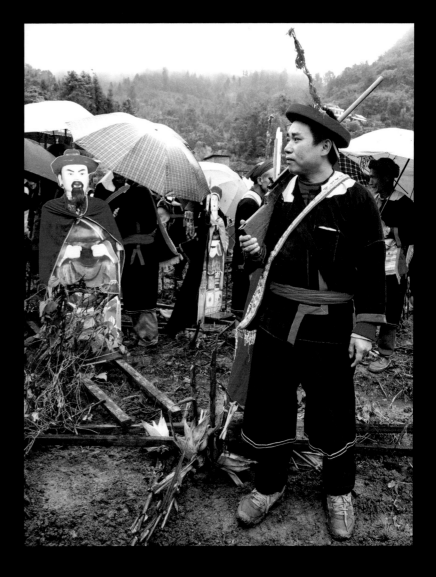

瑤族的民族服裝被稱為「斑斕布」，在鏡頭之下多姿多彩。（左）
狩獵自古以來就是生活在山中的瑤族重要的生活來源。（右）

Yao's folk costume is called "banlan (literally means multi-colored) cloth", which is especially eye-catching through the lenses. (Left)
Since old days, hunting has been an important source of living for the Yao people who live on the mountains. (Right)

當地最有威望的老人向空中撒紙以驅走鬼怪，其後
率領眾人進行「遊神」大典。

The most respected elderly in the village will throw
off shreds of paper for exorcism and then lead the
"parade of God" ceremony.

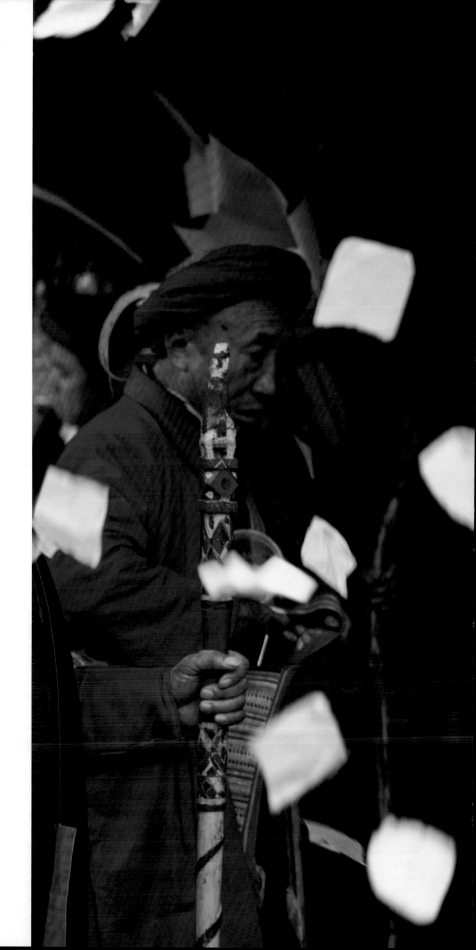

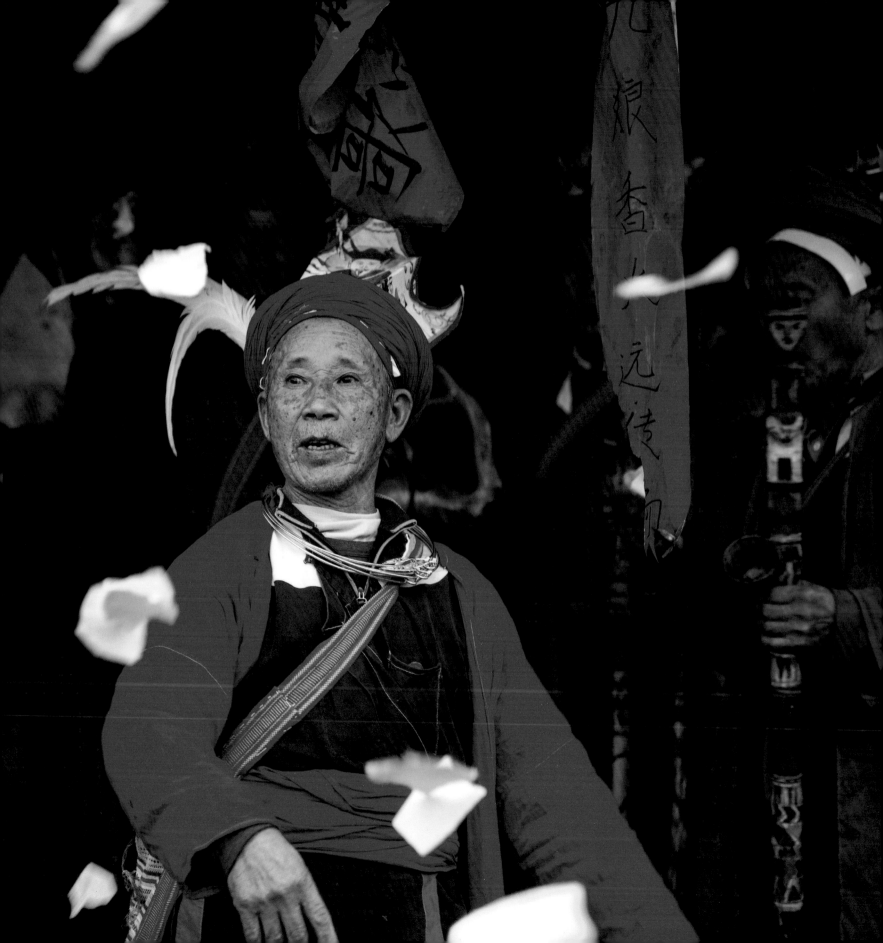

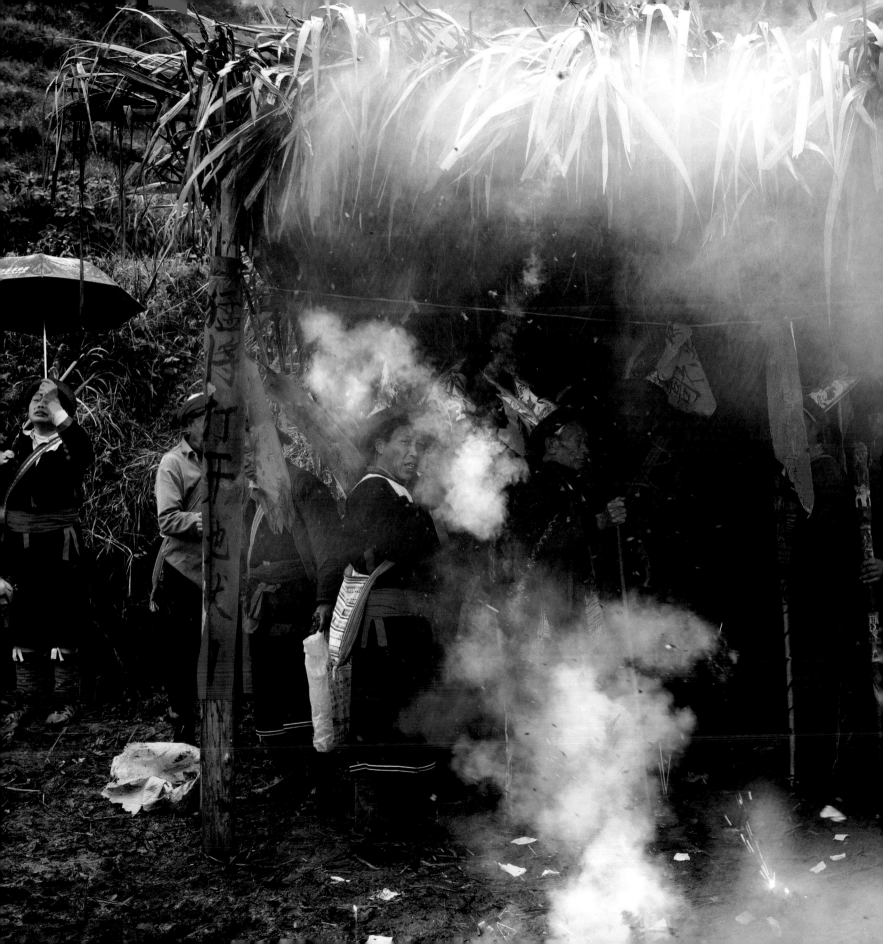

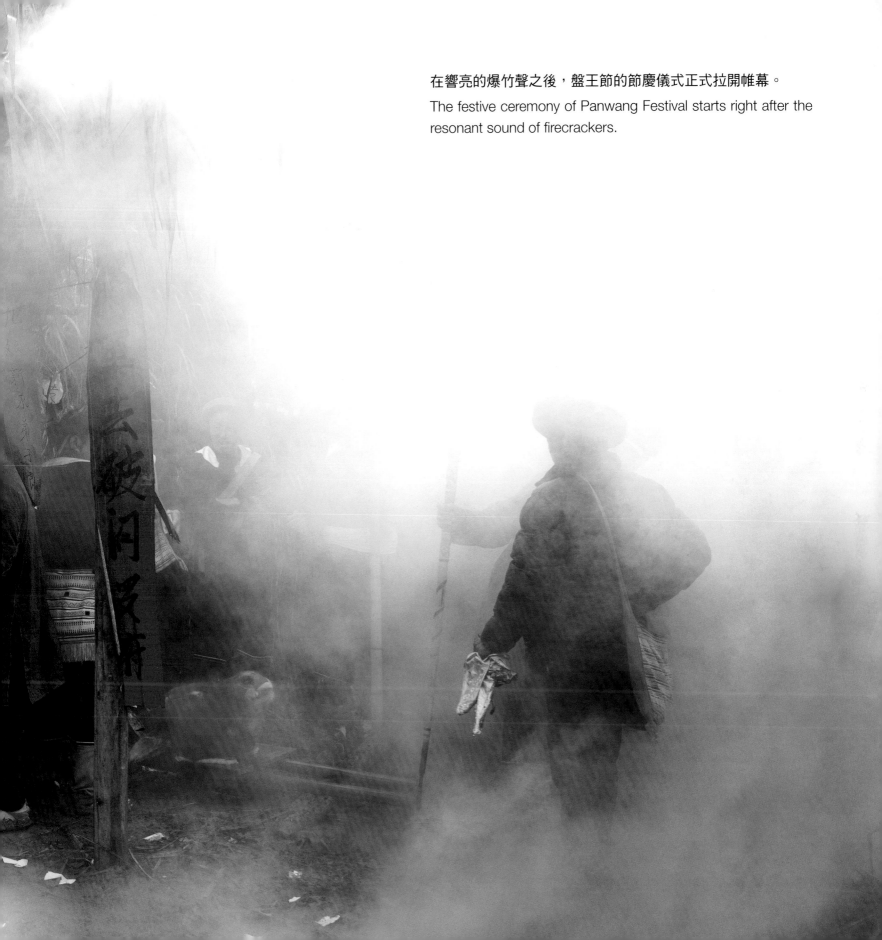

在響亮的爆竹聲之後，盤王節的節慶儀式正式拉開帷幕。

The festive ceremony of Panwang Festival starts right after the resonant sound of firecrackers.

在鳴鑼開道之下，浩浩蕩蕩的瑤族村民列成蜿蜒的長隊，跟隨著盤王像走遍村莊的每一個角落。

The gong sound is paving the way for the long and winding line of people, who is following the parade of the Panwang figure all around the village.

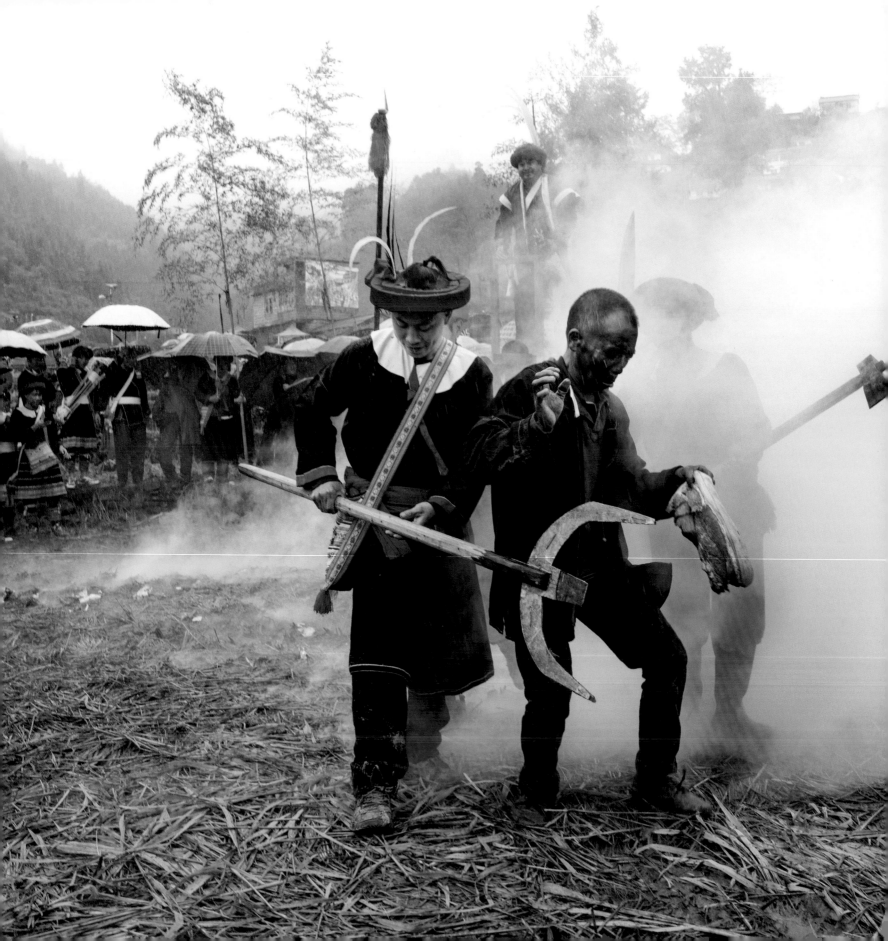

「黑臉公」角色代表著妖魔鬼怪的邪惡力量，眾人需要搶奪他們手中的豬肉，以表示戰勝邪惡。（左）盤王節上需要當眾殺雞祭祖。（右）

The "black face" is representing the power of monsters or ghosts. People have to snatch the pork in his hand to show the conquest over evilness. (Left) Sacrificing chickens in public is a procedure of the Panwang Festival. (Right)

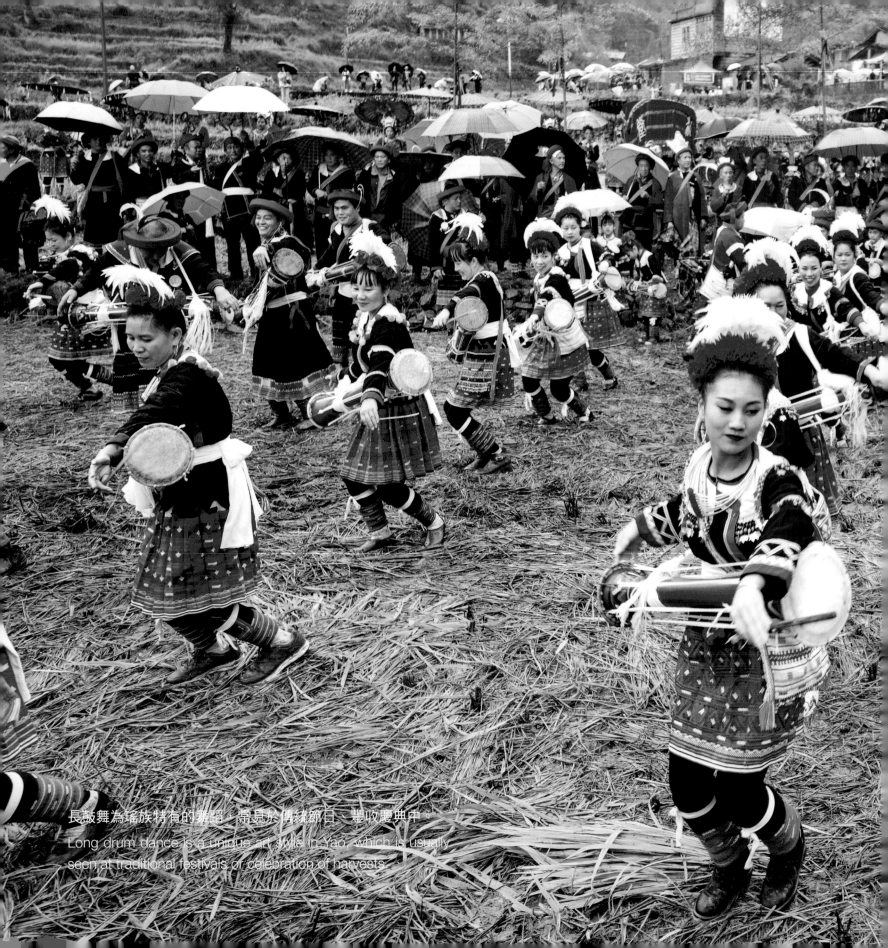

長鼓舞為瑤族特有的舞蹈，常見於傳統節日、豐收慶典中。

Long drum dance is a unique art style in Yao, which is usually seen at traditional festivals or celebration of harvests.

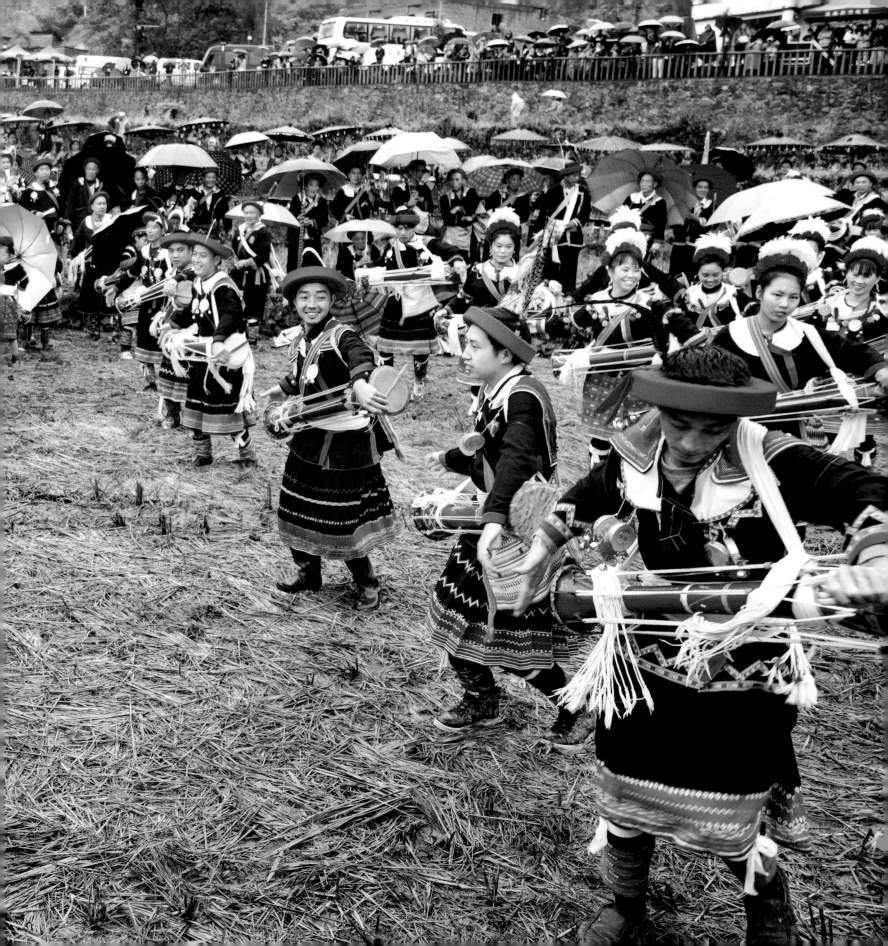

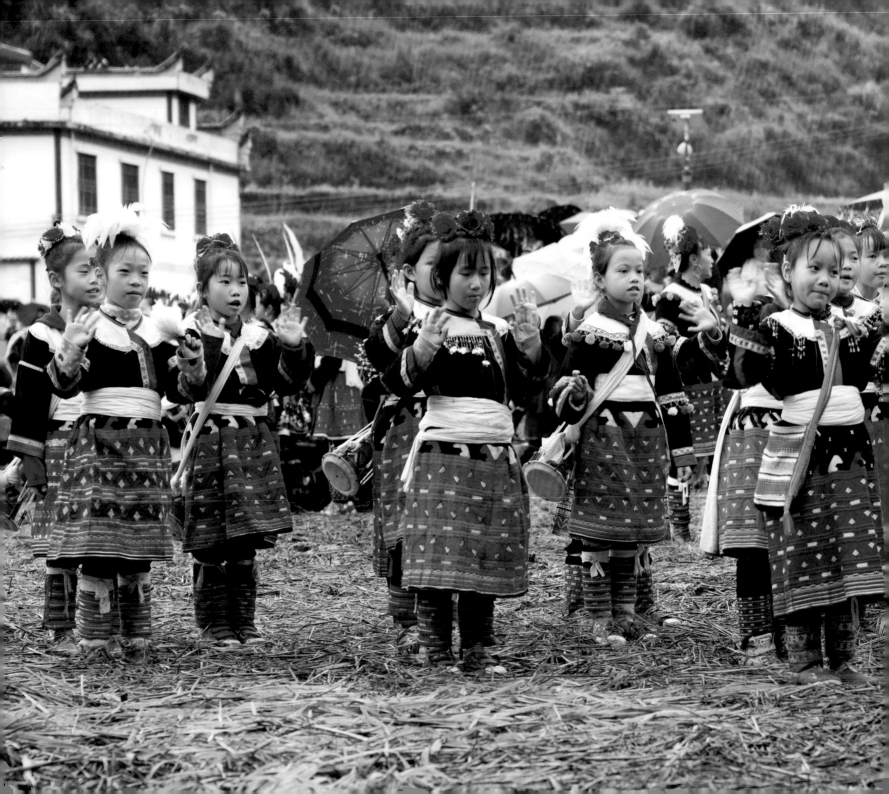

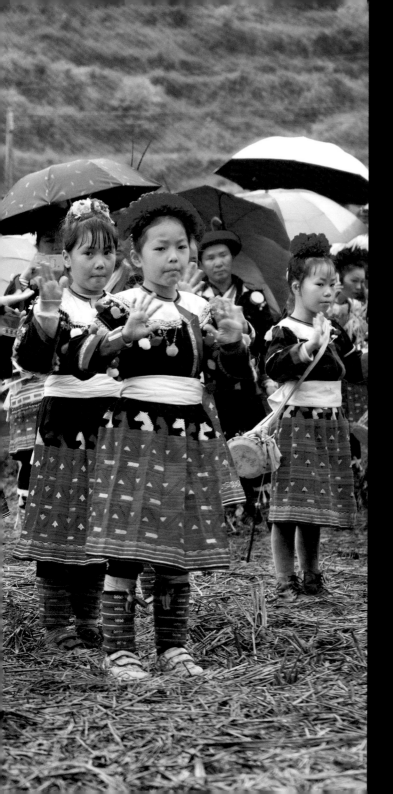

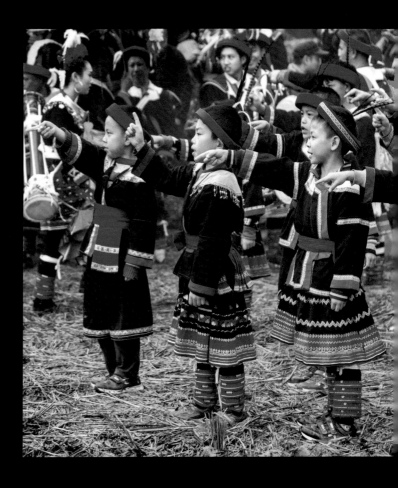

瑤族民俗活動習慣男女互相對應。女孩們正高舉雙手。（左）
而對面的男孩們則伸出了手指向對面。（右）

In Yao's ethnic activities, different genders are on different sides. The girls are lifting up their hands. (Left) The boys on the opposite are pointing their fingers out at the corresponding side. (Right)

在連南縣順德文化廣場舉行的盤王節文藝晚會，吸引了眾多的觀眾，整個縣城這一晚出現了萬人空巷的景象。

The evening party themed with Panwang Festival at the Shunde Cultural Square in Liannan has attracted numerous audience. The whole county turns out at the event.

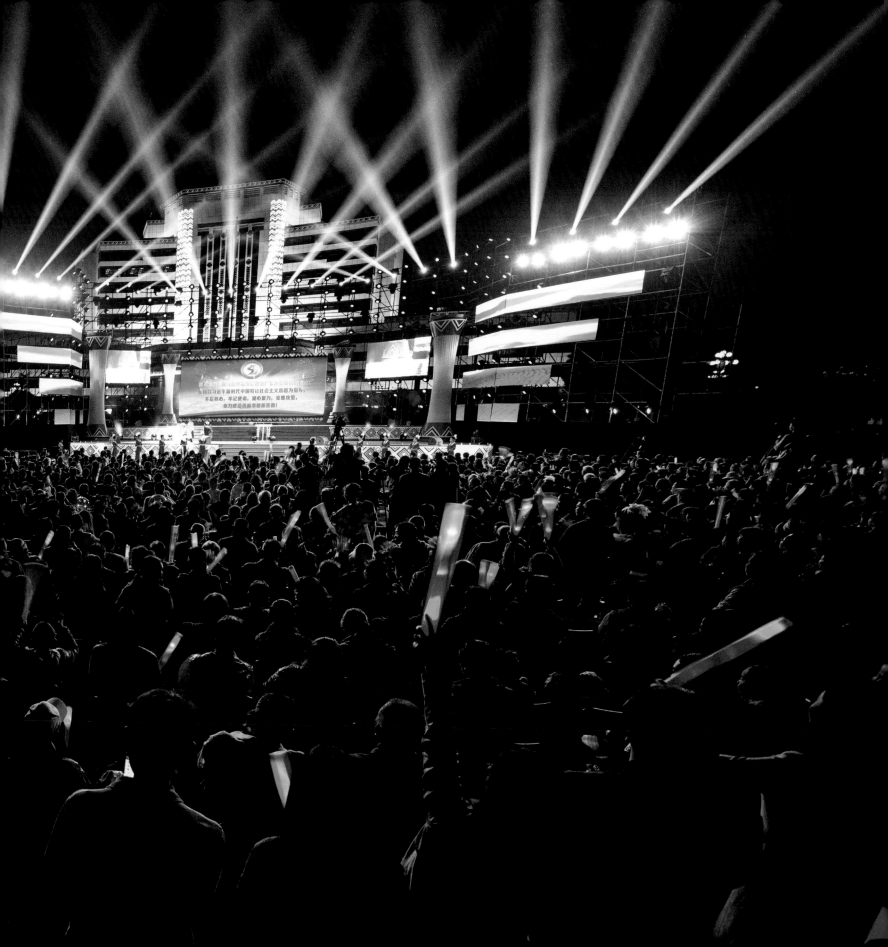

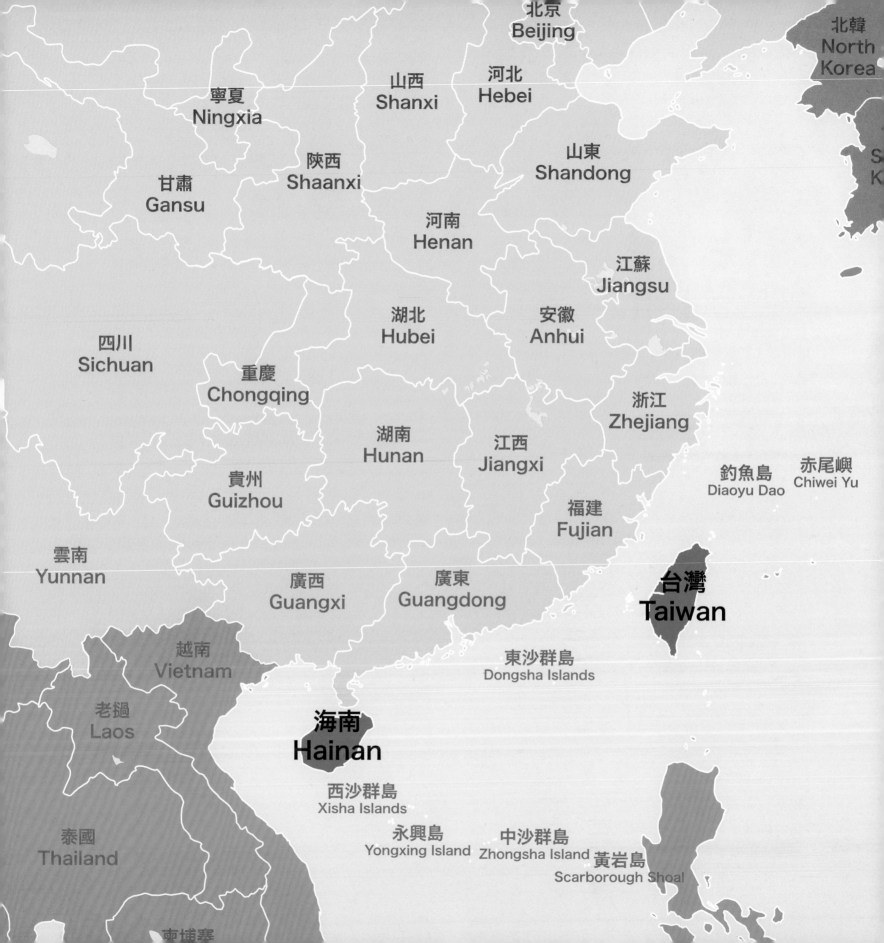

台瓊島著

在中國，面積在 500 平方米以上的島嶼超過 6,500 個，而面積超過 1,000 平方米的則是中國的三大島——台灣島、海南島及崇明島。

台灣島是中國的第一大島，總面積約 3.6 萬平方公里；海南島簡稱瓊，是中國的第二大島，總面積 3.5 萬平方公里。兩大島嶼與中國大陸隔海相望，對古代統治者來說，兩島屬於邊陲之地，因此世居於此的少數民族得以繁衍。

台灣舊稱「福爾摩沙」，位於中國的東南部，首府為台北。全省人口約 2300 萬，其中大部分為漢族，原住民高山族僅佔人口的 2% 左右。而在高山族群內，又可以細分為 16 個不同的部族，例如阿美族、排灣族、阿魯閣族、卑南族、噶瑪蘭族等。1998 年，台灣成立了原住民族委員會，負責審核及認定原住民中的各個部族。

海南省位於中國最南端，省會為海口市。海南全境包括海南島、中沙、西沙、南沙群島及其周圍的海域，雖然陸地面積只有 3.5 萬平方公里，海域面積卻有約 200 萬平方公里，是中國海洋面積最大、陸地面積最小的省，也是中國最年輕的省份和最大的經濟特區。海南常住人口超過 860 萬，其中近兩成為少數民族，而世居於此的黎族則是海南最主要的少數民族。

The Indigenous on Islands

There are over 6,500 islands with an area larger than 500 square kilometers. As for those larger than 1,000, three islands are on the list - Taiwan Island, Hainan Island and Chongming Island.

Taiwan and Hainan are the largest and second largest islands in China, taking up an area of 36 and 35 thousand square kilometers, respectively. For rulers in ancient China, the separated islands from the mainland were regarded as frontier areas. The indigenous people have been living on the islands for hundreds of generations.

Taiwan, formerly known as Formosa, is in the southeast corner of China. Taipei is its capital city. Of the 23 million residents, most of them are Han people, and only about 2 percent of them are the indigenous Gaoshan people. Within the ethnicity, there are currently 16 subdivided groups, including Amis, Paiwan, Truku,

Puyuma, Kavalan, and etc. The Council of Indigenous People founded in 1998 is responsible of approving and recognizing these groups.

Hainan Province is at the most southern part of China, with Haikou being its capital. Its full territory covers Hainan Island, Zhongsha, Xisha and Nansha Islands, as well as the surrounding maritime space. Although the land area of Hainan is only 35 thousand square kilometers, its sea area covers 2 million square kilometers. It is the province with the most maritime area and least land area. Besides, Hainan is the youngest provincial district and the largest special economic zone in the country. Resident population is over 8.6 million, with almost 20 percent of them being ethnic minorities, among which Li is the dominant group.

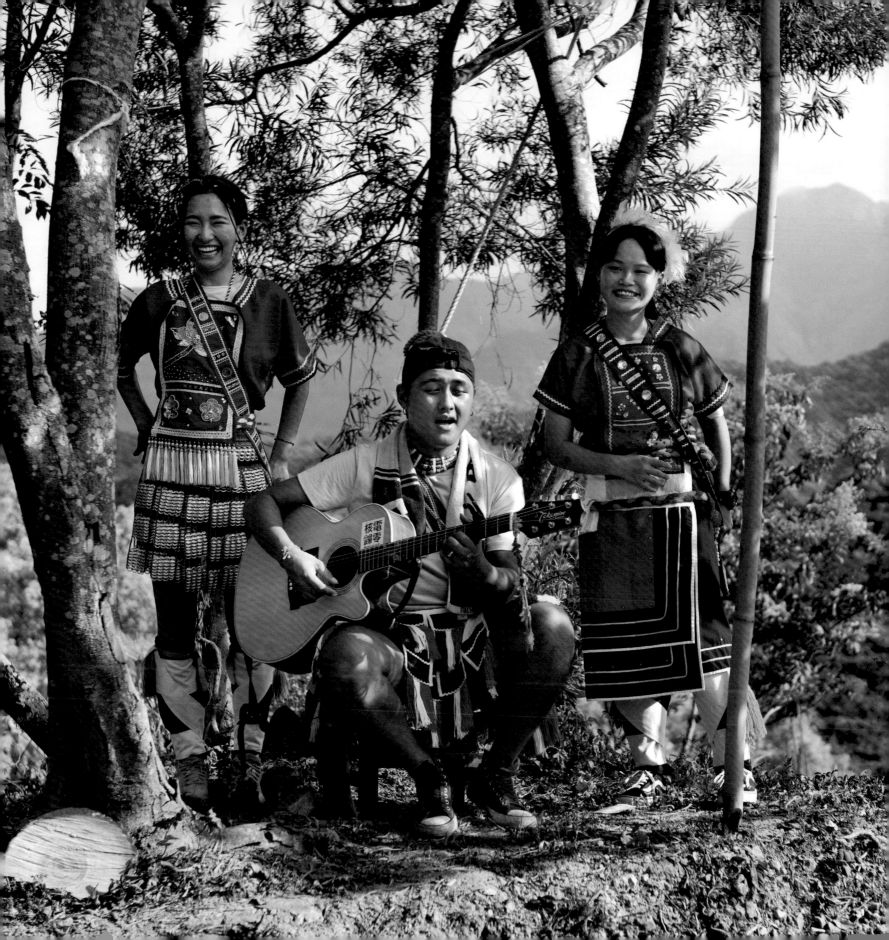

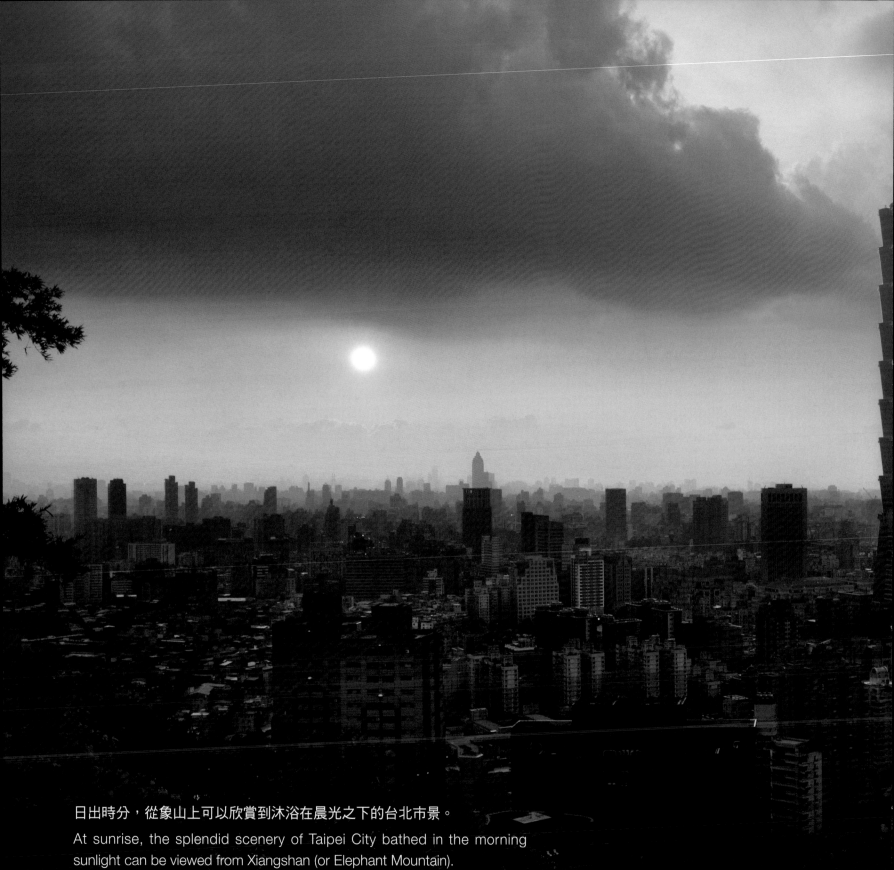

日出時分，從象山上可以欣賞到沐浴在晨光之下的台北市景。

At sunrise, the splendid scenery of Taipei City bathed in the morning sunlight can be viewed from Xiangshan (or Elephant Mountain).

自由廣場位於中正紀念堂前方，經常舉行大型活動。（右）
廣場上每天都會舉行升旗儀式。（左）

The Liberty Square in front of the Chiang Kai-shek
Memorial Hall is a venue for massive assemblies. (Right)
Flag-raising ceremony is held every day on the square. (Left)

台北市凱達格蘭大道因曾是原住民凱達格蘭族領地得名，正面是「總統府」，大道與自由廣場同是集合活動的主要地點。凱達格蘭族曾與噶瑪蘭族有著密切聯繫，但由於已幾乎完全漢化，現已難以區分。

Named after the aboriginal Ketagalan tribe's traditional territory, the Ketagalan Avenue in Taipei which faces the "Presidential Office" is an important venue for gathering activities, along with the Liberty Sqaure. Ketagalan was closely related to Kavalan people. However, it is hard to distinguish them nowadays since they had almost assimilated into Han.

西門町每天都有眾多的街頭表演。人體大環表演吸引了不少觀眾駐足觀賞。

Street performances are not uncommon in Ximending. The cyr wheel show has kept the audience unwilling to leave.

台灣的夜市有著過百年歷史，不少小食馳名中外。（右）
夜市中不時可見街頭表演。（左）

Night markets in Taiwan have a history over a century. Many
snacks are globally renowned. (Right) Street performances
are often seen at night markets. (Left)

台東縣成功鎮東北方的三仙台小島，以一條八拱步橋與本島連接。清晨，
可在此迎接台灣本島的第一道曙光。

A small island named Sanxiantai in northeast Chenggong Township,
Taitung County is connected to the main island by an eight-arch bridge. In
the morning, the first glimmer of the sun shines on the horizon.

台灣原住民普遍在音樂上非常有天賦，當地不少知名歌手都是原住民。（左）貓公部落內豎立著大港口事件紀念碑，以銘記在戰爭中犧牲的勇士。（右）

A majority of indigenous people in Taiwan are gifted in music. Many of the local singers are indigenous. (Left) Within the Fakong Tribe, there is a monument of the "Cepo Incident" (Cepo means a major port in Amis language) to memorize the warriors who sacrificed in warfare. (Right)

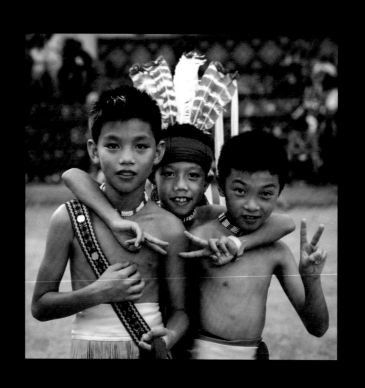

阿美族

Amis

阿美族總人口約 20 餘萬，是台灣原住民中人數最多的族群，與紐西蘭的毛利人有相近的語言、文化。

阿美族在傳統上被歸類為母系社會，家中主要以女性繼承財產和家業，男孩長大以後離開自己的家，入贅到妻子的家庭。

雖然很多部落可見男性頭目的身影，但他們普遍只處理家庭之間的家族關係，被視為協助女性處理宗族事務。

豐年祭是阿美族重要的祭祀儀式，是族人慶祝豐收、並與祖先和神靈溝通的慶典，重要性相當於漢族的農曆年。除了阿美族之外，台灣其他原住民民族亦會舉辦自己的豐年祭。

With more than 200,000 people, Amis is the largest ethnic group in the indigenous people in Taiwan. They share similar language and culture with Māori people in New Zealand.

Traditionally, Amis society is classified as practicing matrilineality, in which females inherit all of the property and family business, while male adults have to move into their wives' family after marriage.

Although many leaders in Amis tribes are male, they are mainly responsible for maintaining relationship among different families, thus they are regarded as assistants to the women.

The Harvest Festival is an important fete ceremony for Amis, where they celebrate harvest and communicate with their ancestors and the God. It is as significant as to what Chinese New Year is to Han people. Apart from Amis, other indigenous people would also hold their own festivities to celebrate harvest.

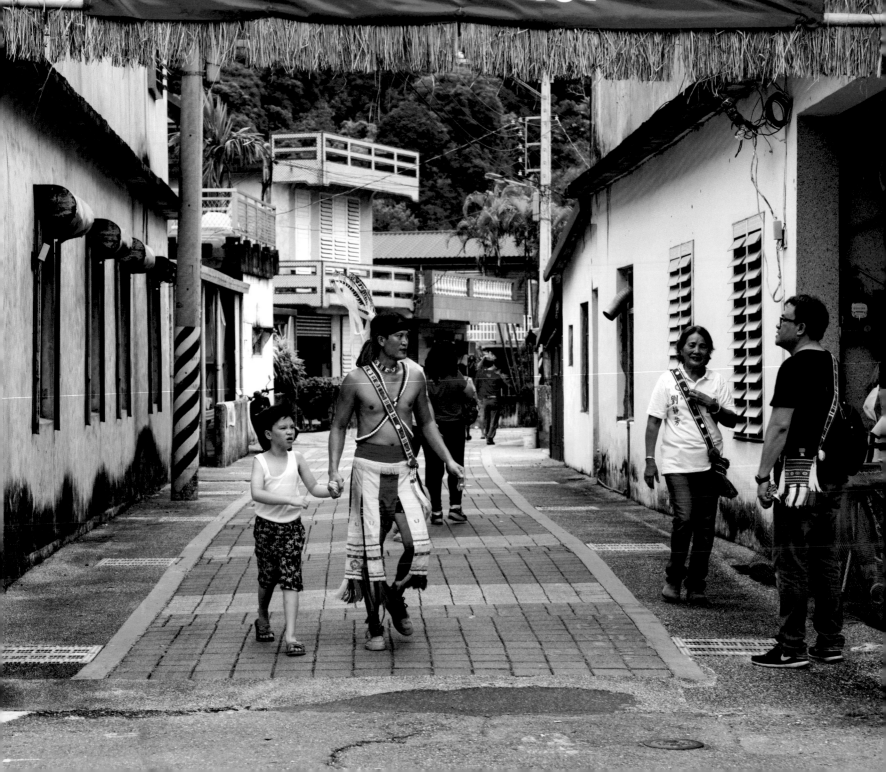

花蓮縣豐濱貓公部落107年豐年祭

花蓮豐濱的阿美族屬於「貓公部落」，據傳早期阿美族移居於此時，看見河階滿佈「貓公草」（即文殊蘭），因此就以其阿美族語「貓公」作為地名。豐年祭是台灣原住民古老的傳統祭祀活動，根據不同部落的稱呼，可以分為「伊利幸」、「馬拉里基」和「齊魯馬安」三種，而中文則統稱為豐年祭，以每年的農耕收成時分作為慶典的日期。族人在這天喝酒、設宴、跳舞、狂歡，祈求豐收。（左）當地政客喜歡與民眾打成一片，同時也不忘為自己的政黨增加宣傳。（右）

The Amis tribe in Fengbin, Hualien is called the "Fakong Tribe". It is said that when Amis migrated to this area in early times, they saw countless "Fakong grasses" (namely, poison bulbs) at the river terrace. They therefore used "Fakong" in the Amis language as the name of the location. The Harvest Festival have three different names in various tribes: "Ilisin", "Malalikid" and "Kilumaaan". They are generally referred as the "Harvest Festival" in Chinese. It takes place during the harvest seasons every year. People drink, give banquets, dance and have fun on this day, while praying for a golden harvest. (Left) Politicians like to integrate themselves into local events, while taking the chance to propagate for their parties. (Right)

不同區域的阿美族在服飾上有所差異，北部以紅、黑、白三色為主，而南部則融合了卑南族服飾特點。每到豐年祭之時，無論是在海外生活或在城市工作的阿美族人，都會不遠千里回到自己的家鄉參與慶典。

Folk costumes for Amis in different parts of Taiwan are slightly different from each other. The northern Amis wear clothes mainly in red, black and white colors, while the southern ones have added to their costume some features of Puyuma clothing. At the time of the Harvest Festival, Amis will go back to their hometown for celebration no matter where they are.

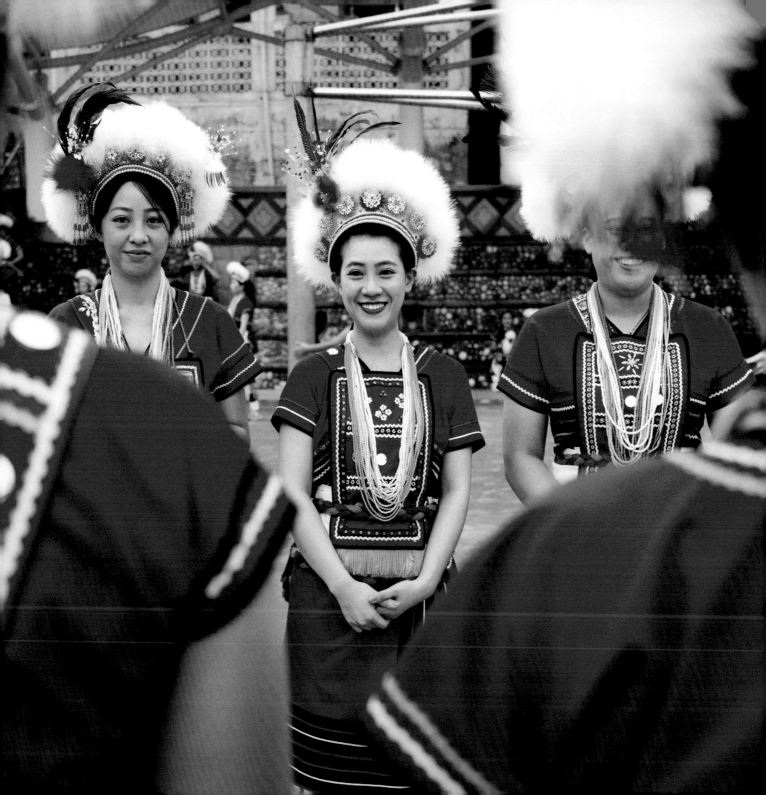

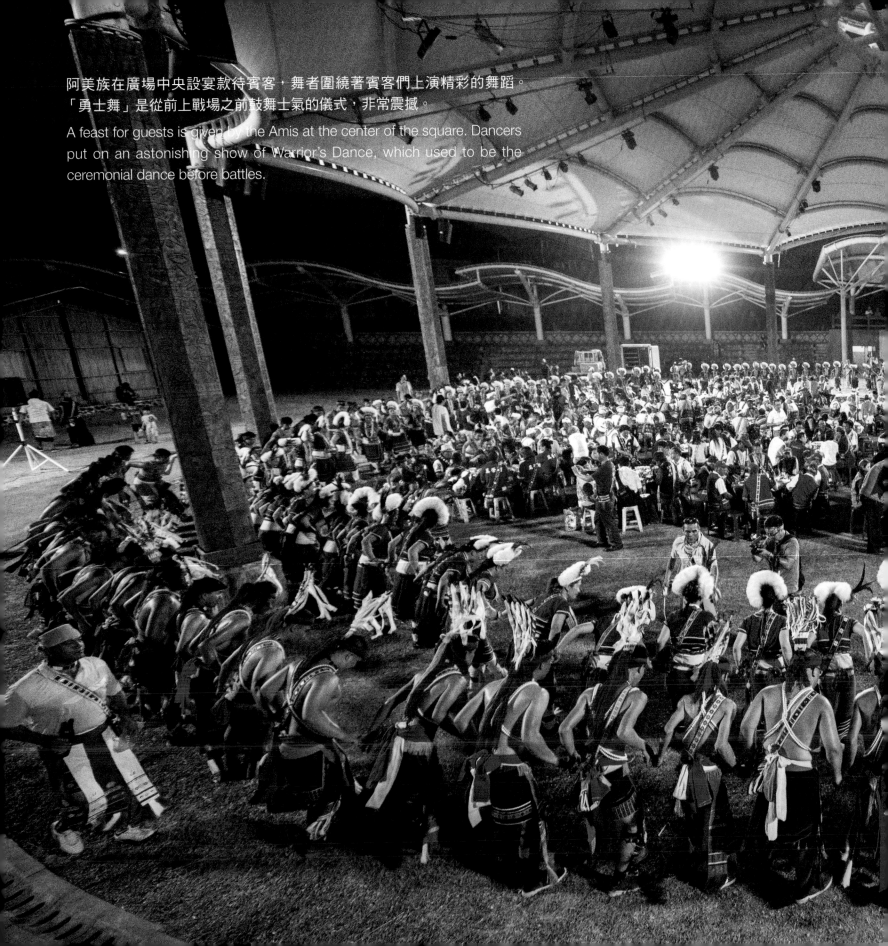

阿美族在廣場中央設宴款待賓客，舞者圍繞著賓客們上演精彩的舞蹈。
「勇士舞」是從前上戰場之前鼓舞士氣的儀式，非常震撼。

A feast for guests is given by the Amis at the center of the square. Dancers put on an astonishing show of Warrior's Dance, which used to be the ceremonial dance before battles.

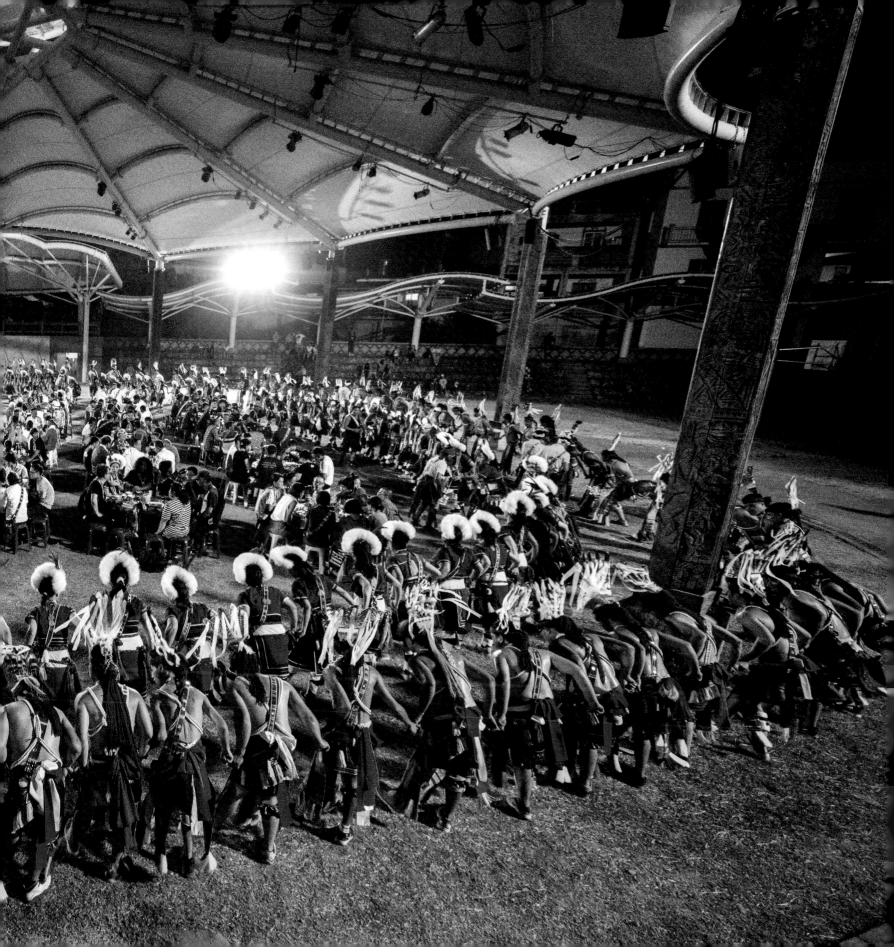

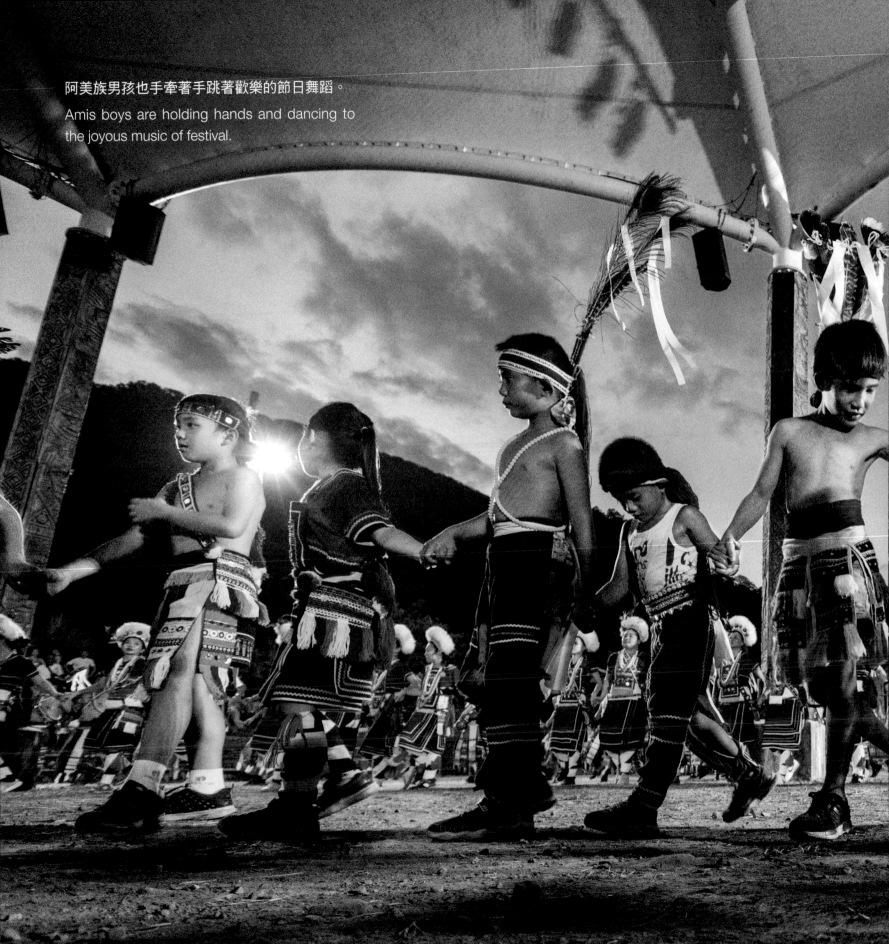

阿美族男孩也手牽著手跳著歡樂的節日舞蹈。
Amis boys are holding hands and dancing to the joyous music of festival.

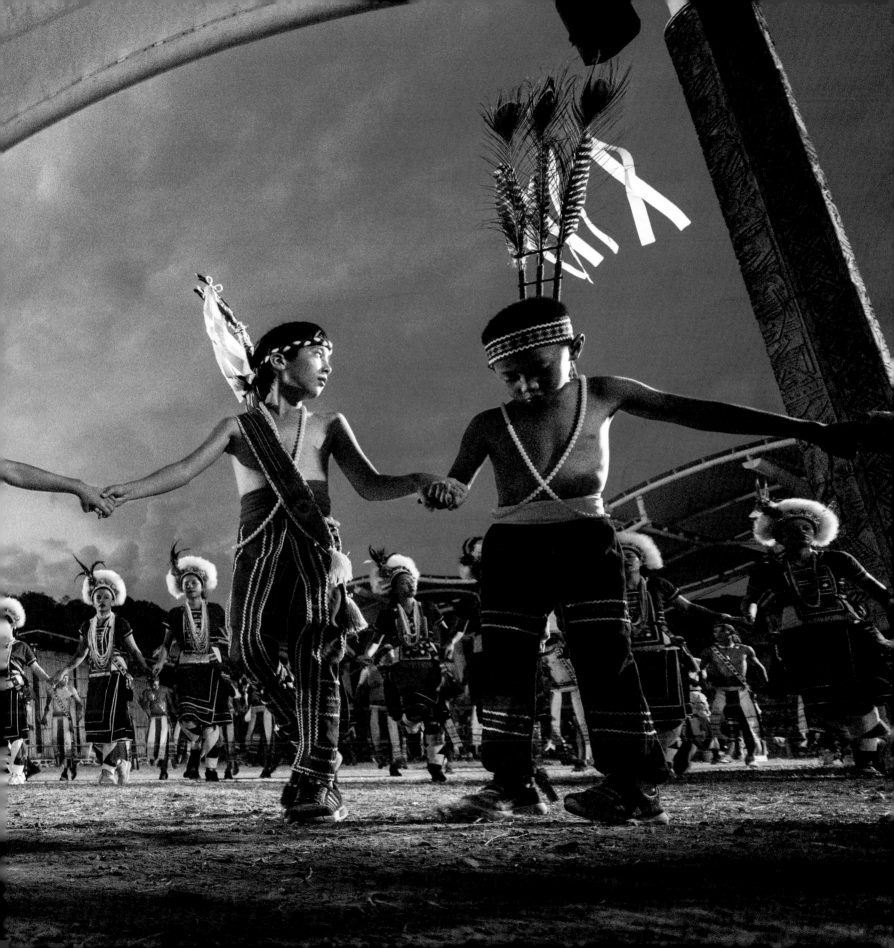

噶瑪蘭族
Kavalan people

在噶瑪蘭語裡面，族名「噶瑪蘭」是「平原之人類」的意思。根據 1650 年荷蘭人佔領台灣時期的文字紀錄，當時的噶瑪蘭人有 40 多個部落，人口有 9000 多人左右。

歷史上，噶瑪蘭族多次受到外族侵害，迫使他們離開自己世代生存的居住地區，散居在各地。從此，有些族人就與別族通婚，成為別族一員，有些則集體居住在別的部族聚居地，仍然保有自己的民俗特性。然而，離開習慣的居住地，還是直接導致了噶瑪蘭族人數的銳減，在 2005 年的統計中，噶瑪蘭族人只剩下 900 多人。

一直被半強迫附屬在阿美族當中的噶瑪蘭族，其實不論是祭典或語言文化，都與阿美族完全不同。因此從 1980 年開始，噶瑪蘭族的原住民就展開尋根正名運動，經過長期的努力，2002 年 12 月 25 日，原住民族委員會正式認定噶瑪蘭族為台灣原住民的第十一族。

In Kavalan language, the word "Kavalan" means "people living on the plain". According to historic records during the Dutch Formosa period, in 1650, there were over 40 tribes of more than 9,000 Kavalan people living in Taiwan at the time.

Yet being constantly persecuted by other ethnic groups, the Kavalan people were forced to leave the inhabiting area which they had lived for many generations. Some of them then chose to marry into other ethnic groups, while some lived with other ethnic groups but still kept their folk customs. However, leaving their homeland has directly led to the decrease of their population. In a census conducted in 2005, there were only around 900 Kavalan people remaining.

Although Kavalan group integrated into Amis group involuntarily throughout history, but their folk customs and language were quite different to the Amis Group. Therefore, starting from 1980, Kavalan started their campaign to seek the recognition of their ethnic group. After long period of hard work, on the 25th of December 2002, the Council of Indigenous Peoples has officially recognized Kavalan as the 11th indigenous group in Taiwan.

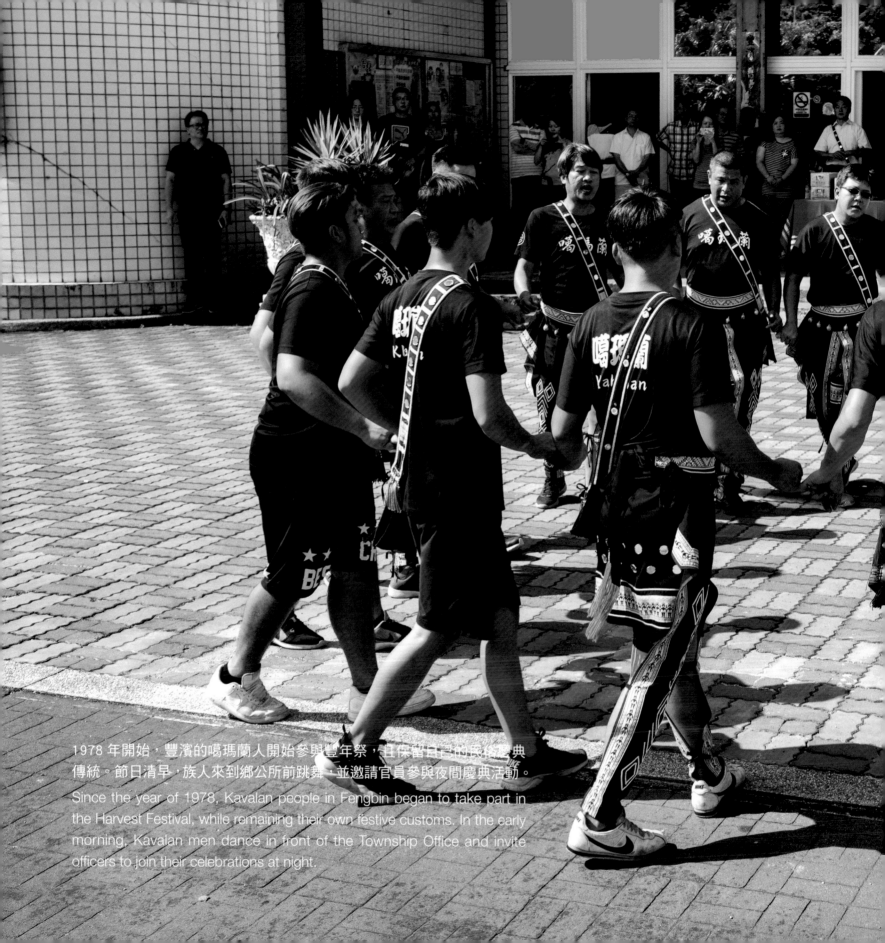

1978 年開始，豐濱的噶瑪蘭人開始參與豐年祭，且保留自己的民俗慶典傳統。節日清早，族人來到鄉公所前跳舞，並邀請官員參與夜間慶典活動。

Since the year of 1978, Kavalan people in Fengbin began to take part in the Harvest Festival, while remaining their own festive customs. In the early morning, Kavalan men dance in front of the Township Office and invite officers to join their celebrations at night.

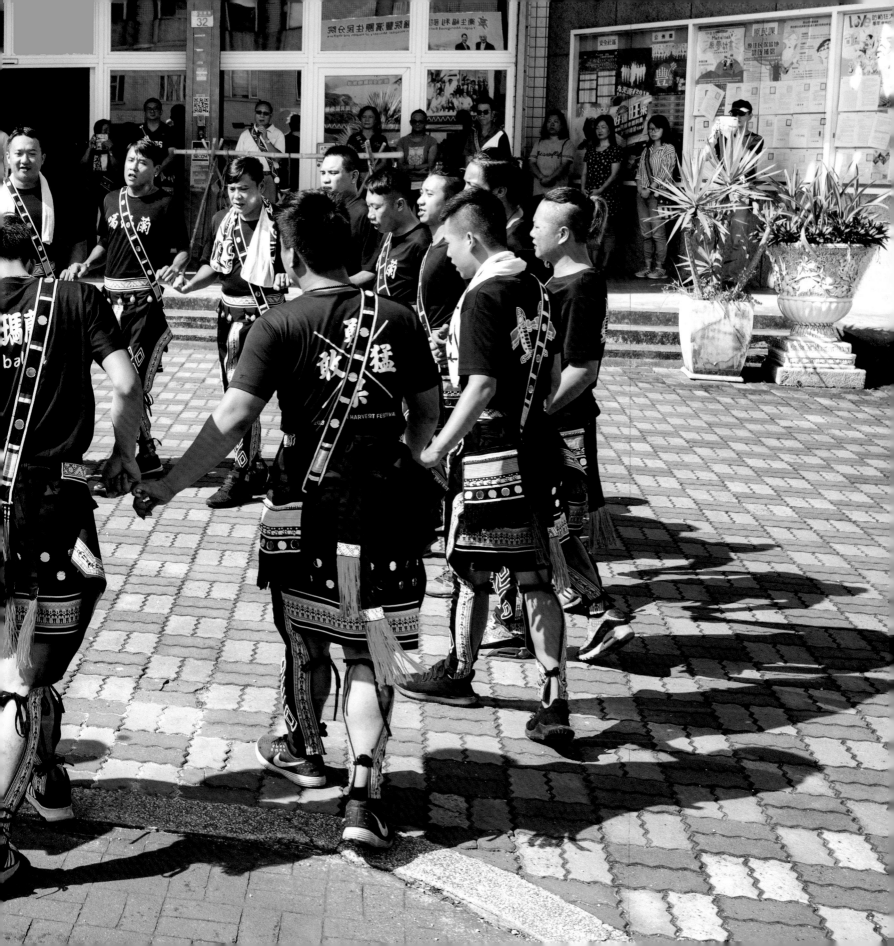

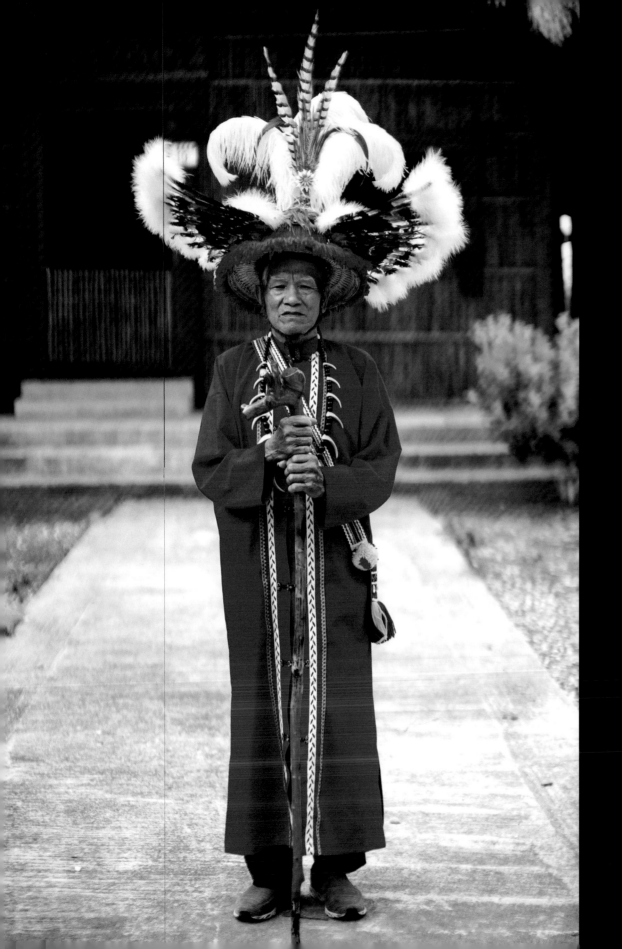

阿美族貓公部落的頭目服飾隆重，
盡現威嚴之態。

The leader of the Fakong tribe of
Amis appears to be commanding
in the complicated ceremonious
costume.

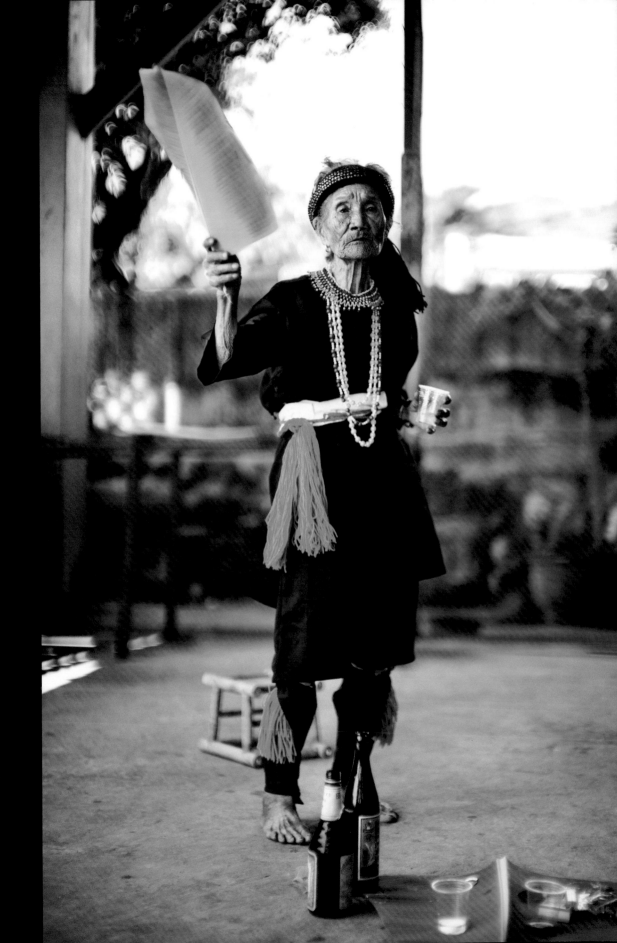

噶瑪蘭族祭司皆為女性。圖中 94 歲
高齡、曾受多家國際媒體採訪的潘
烏吉祭司，已於 2019 年 1 月逝世。

l Kavalan priests are female. The
4-year-old lady Ibay in this picture,
ho was interviewed by several
ternational publications, passed
way in January, 2019.

熱氣球嘉年華
Balloon Festival

為推動台東旅遊業的發展，從 2011 年開始，鹿野高台都會舉辦一年一度的熱氣球嘉年華。身處鹿野高台，可把整個高台地區與卑南溪谷的景色盡收眼底。絕佳的地理條件，讓它成為優良的空域活動場地。

活動通常在六月至八月間舉行，期間眾多色彩繽紛的熱氣球漂浮在鹿野高台地區，十分壯觀。熱氣球已經逐漸成為了台東的標誌之一。

一顆顆造型奇特的熱氣球從茵茵綠草之上起飛，在山谷中隨風浮動。在藍天的映襯之下，這幅動人的風景，便是比起馳名國際的土耳其熱氣球景色，也毫不遜色。夜間，動感十足的光雕音樂會亦為人們呈現視覺和聽覺的雙重盛宴。

With an aim to promote tourism in Taitung, the Balloon Festival has been held every year since 2011 in Luye Highland. After mounting onto the highland, one can overlook the beautiful sceneries of highland area and Beinan River valley. This superb location has granted it the advantage of being a perfect place for aerial activities.

The festival is usually held between June and August, during which numerous colorful hot air balloons float in the sky of Luye Highland, creating a majestic view. The hot air balloon has become one of the symbols of Taitung.

A number of hot air balloons in uniquely different shapes take off from the green grassland and are drifted by the wind among the hills. Under the blue sky, the picturesque scenery is not any less beautiful than the internationally famous balloon scene in Turkey. During nighttime, the dynamic "Night Glow" concerts have presented a visual-audio feast.

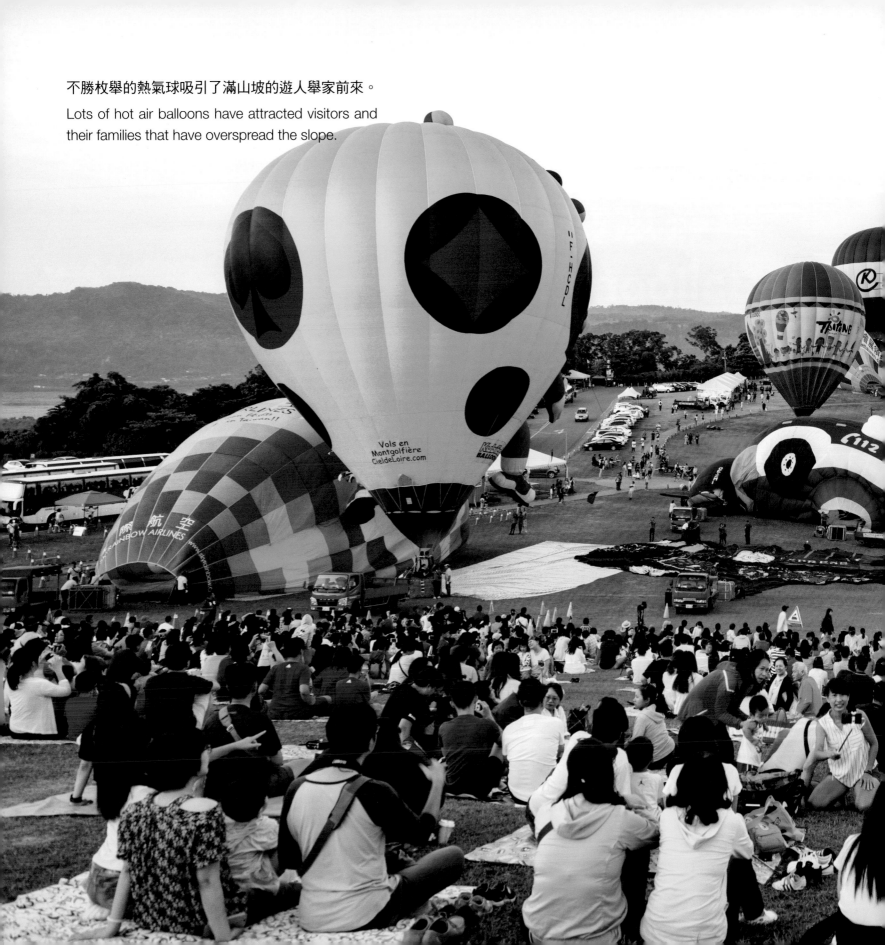

不勝枚舉的熱氣球吸引了滿山坡的遊人舉家前來。

Lots of hot air balloons have attracted visitors and their families that have overspread the slope.

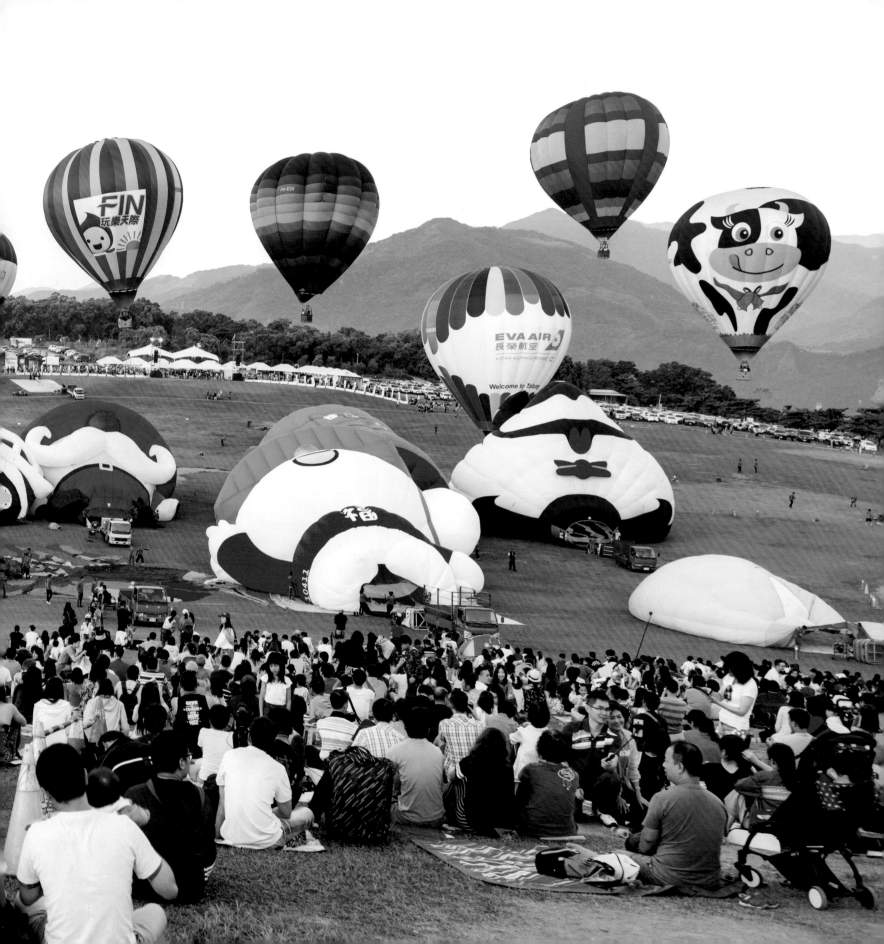

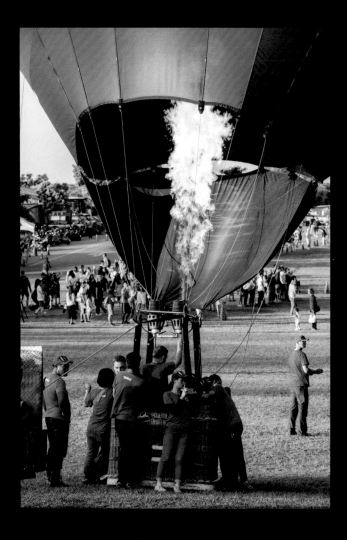

一個載人熱氣球正準備升空。（左）現場熱情的舞蹈為節日增加了更多歡樂的氣氛。（右）

A manned hot air balloon is about to take off. (Left)
The enthusiastic on-scene dancing has added to
the jubilant atmosphere. (Right)

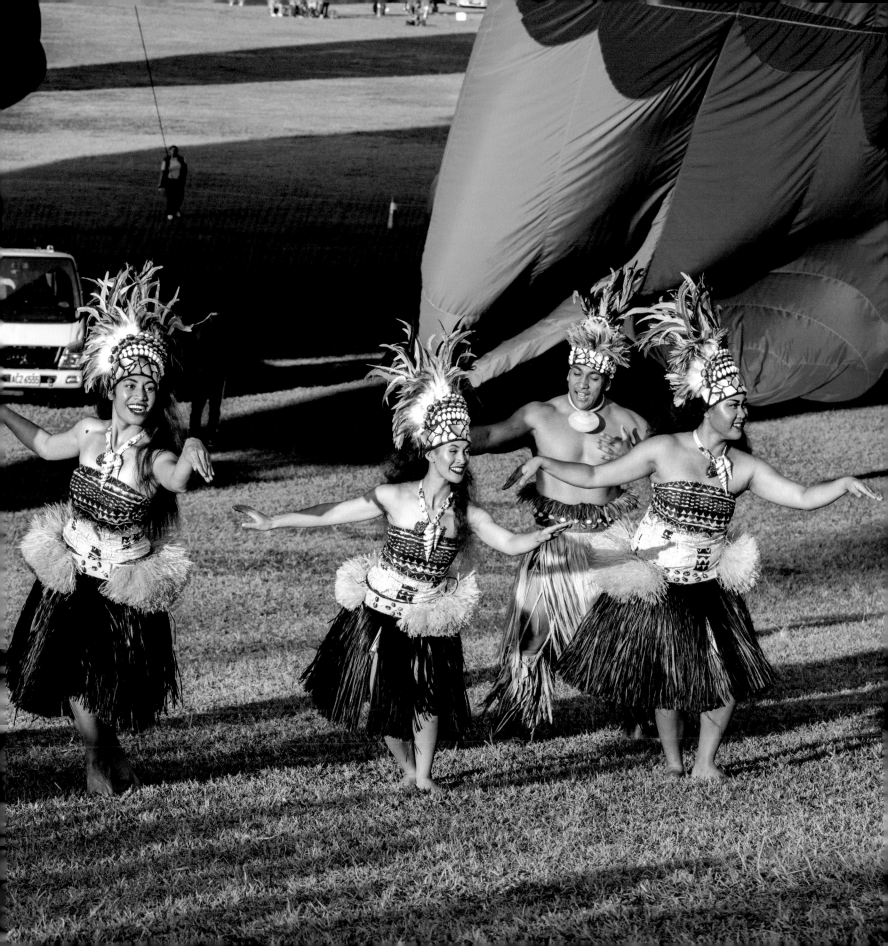

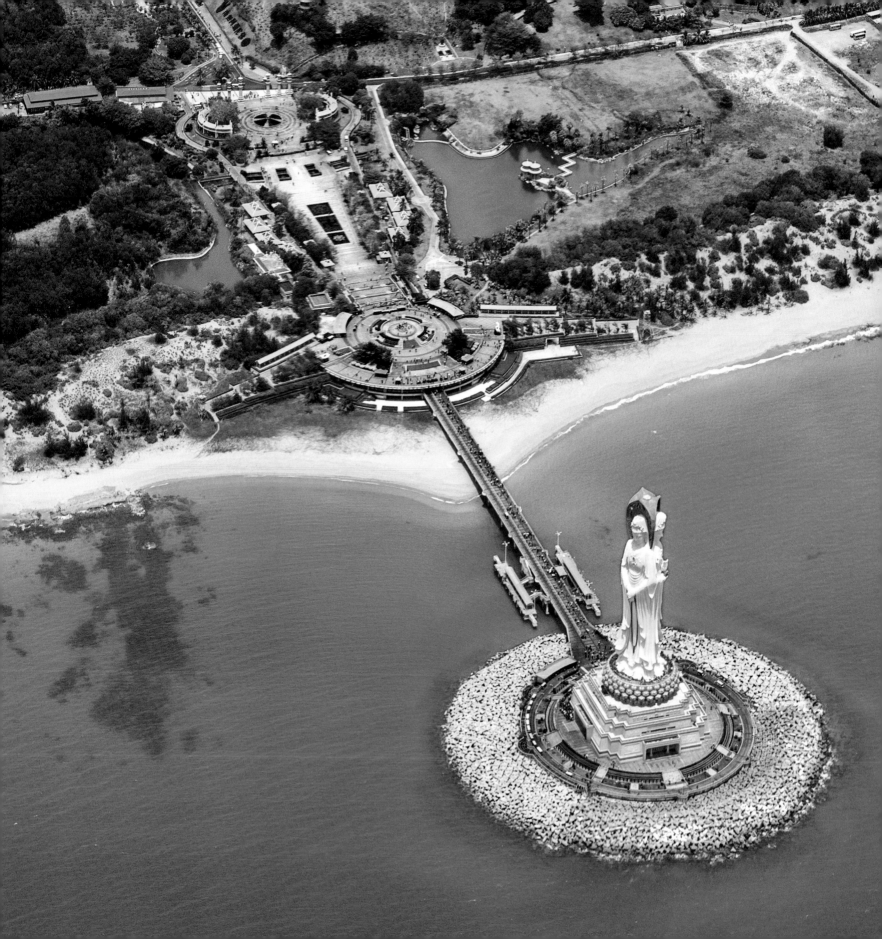

自從中國政府於 2018 年宣佈，計劃在海南建設自由貿易試驗區及自由貿易港之後，海南全島發展加速，預計未來海南將會成為中國經濟急速增長的省份。有著「東方夏威夷」之稱的三亞，是極具熱帶風情的著名旅遊城市，中國北方許多居民在冬季時為避嚴寒，都會選擇到三亞旅行避冬。南山海上觀音聖像，位於三亞南山寺內，是世界上最大的白衣觀音佛像。

Since the Chinese government announced Hainan's free trade port and free trade pilot zone projects in 2018, the development of the island started to accelerate. Going forward, Hainan Province is very likely to become one of the areas with highest economic growth in the country. Sanya City, famous for its tropical weather, is often regarded as "Hawaii in the Orient". It is a popular destination of travel for residents in the northern China to stay away from the coldness in winter times. The Guan Yin of the South Sea of Sanya, sited in the Nanshan Temple, is the world's largest statue of the bodhisattva Guanyin in white clothes.

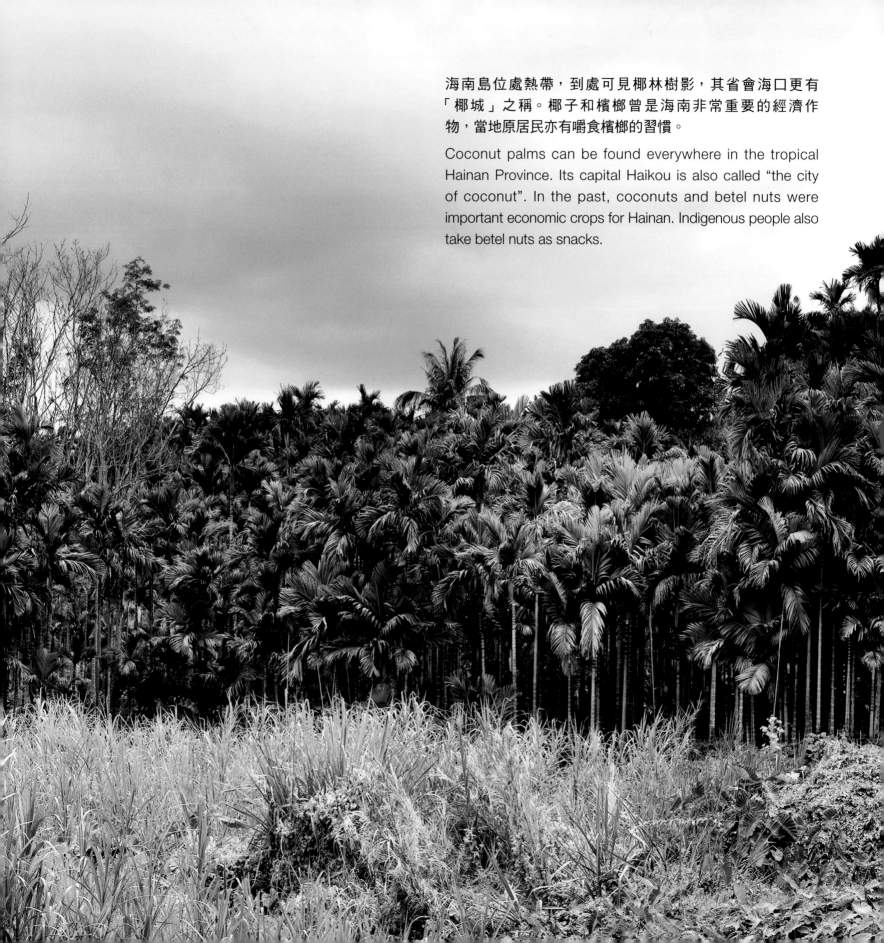

海南島位處熱帶，到處可見椰林樹影，其省會海口更有「椰城」之稱。椰子和檳榔曾是海南非常重要的經濟作物，當地原居民亦有嚼食檳榔的習慣。

Coconut palms can be found everywhere in the tropical Hainan Province. Its capital Haikou is also called "the city of coconut". In the past, coconuts and betel nuts were important economic crops for Hainan. Indigenous people also take betel nuts as snacks.

黎族

Li People

黎族是中國南方少數民族，列中國第18大民族。黎族也是海南島最早的居民，世居於島上，直到現代。貴州、廣東、廣西和江西等省區亦可以找到黎族人的身影。黎族總人口數約146萬人，其中近94%聚居在海南省。

現在普遍認為，黎族是從古代越族發展而來，與駱越分支的關係較為密切。「黎」是漢民族對黎族的稱呼，黎族則稱漢族為「美」，意即「客」，他們以漢人為客人，自己則以土著自居。

黎族傳統信奉萬物有靈，盛行圖騰崇拜、自然崇拜和祖先崇拜。除道教在黎族社會中影響較大外，佛教、基督教等外來宗教影響有限。

黎族的傳統節日大多數與漢族相同，但節期和節日風俗有差異，除春節、端午節外，黎族還保留具有自己民族特色的傳統節日以及婚俗慶典。

Li is an ethnic group in southern China, and is the 18th largest ethnicity in the country. As the oldest indigenous inhabitants on Hainan Island, it was not until recent decades did Li people appear in other provinces, such as Guizhou, Guangdong, Guangxi and Jiangxi. The total population of Li is about 1.46 million, 94 percent of which are living in Hainan.

It is generally believed that Li originated from the ancient Yue People, and was closely related to Luoyue, an embranchment of Yue. "Li" is the form of address by Han people, while the Li addresses Han as "Mei", meaning visitors or guests. They regard Han as guests and themselves as indigenous people.

The tradition of Li upholds animism, totemism, naturism and worship for ancestors. Taoism has greatly impacted on the society of Li, whereas foreign religions like Buddhism and Christianity are only slightly influential.

Most festivities of Li are similar to that of Han, such as the Chinese New Year and Tuen Ng Festival, despite the minor differences in specific dates and customs. Li also celebrates their own festivals and wedding featured with their own folk customs.

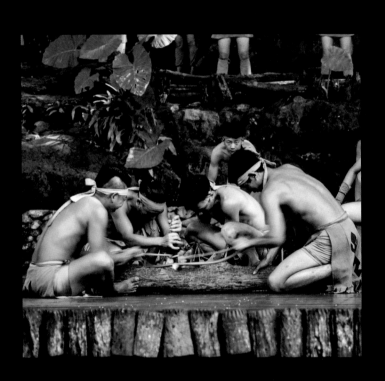

年青族人仿效古時鑽木取火。（左）海南黎族著名的火
把舞，眾多族人一同手持火把起舞，甚為壯觀。（右）

Young men are imitating prehistoric people to make
fire by drilling wood. (Left) The famous torch dancing
of Li creates a spectacular sight when lots of Li people
dance with torches in their hands. (Right)

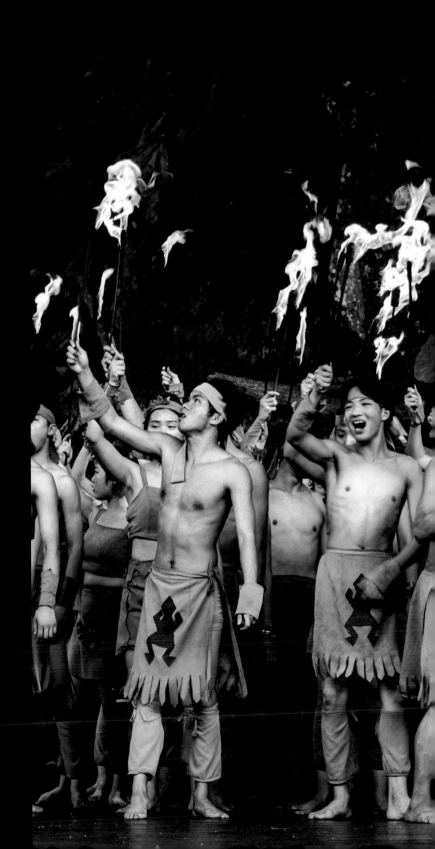

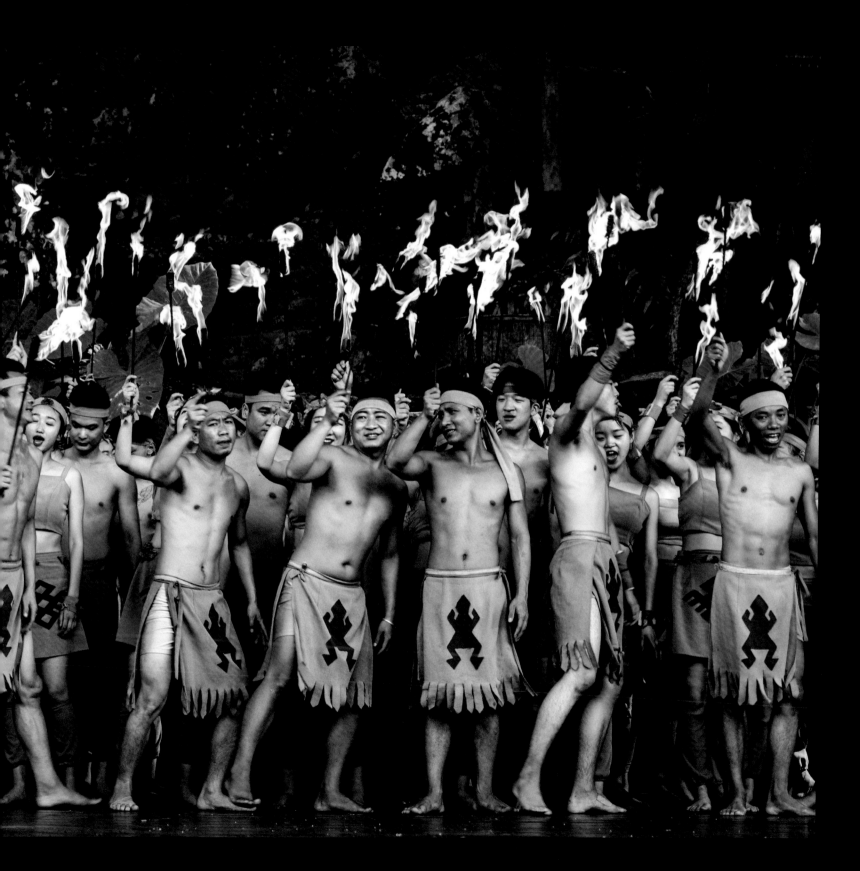

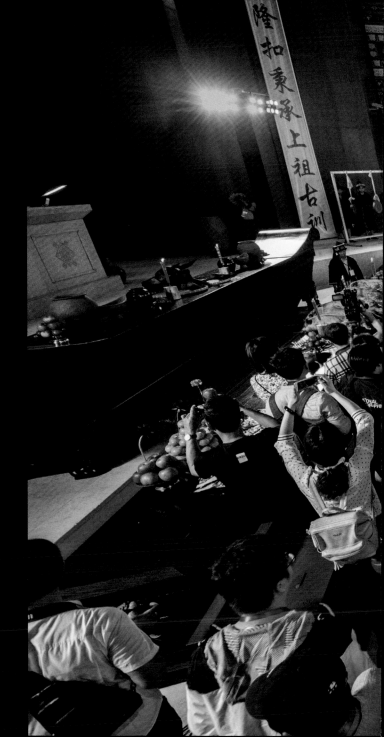

黎祖大殿位於五指山市水滿鄉的黎峒文化園，需登上 600 多級
台階方可到達。（左）黎族「三月三」在農曆三月初三舉行，
又稱「祭祀袍隆扣大典」，族人齊聚一堂祭拜始祖袍隆扣。（右）

The grand hall of Li's ancestors is located in the Lidong Cultural
Park in Shuiman Village, Wuzhishan City, accessible only after
mounting more than 600 stone steps. (Left) Double Third, also
called "Paolongkou Fete Ceremony" in Li, is on the third day of
the third lunar month, at which people worship their ancestor
Paolongkou. (Right)

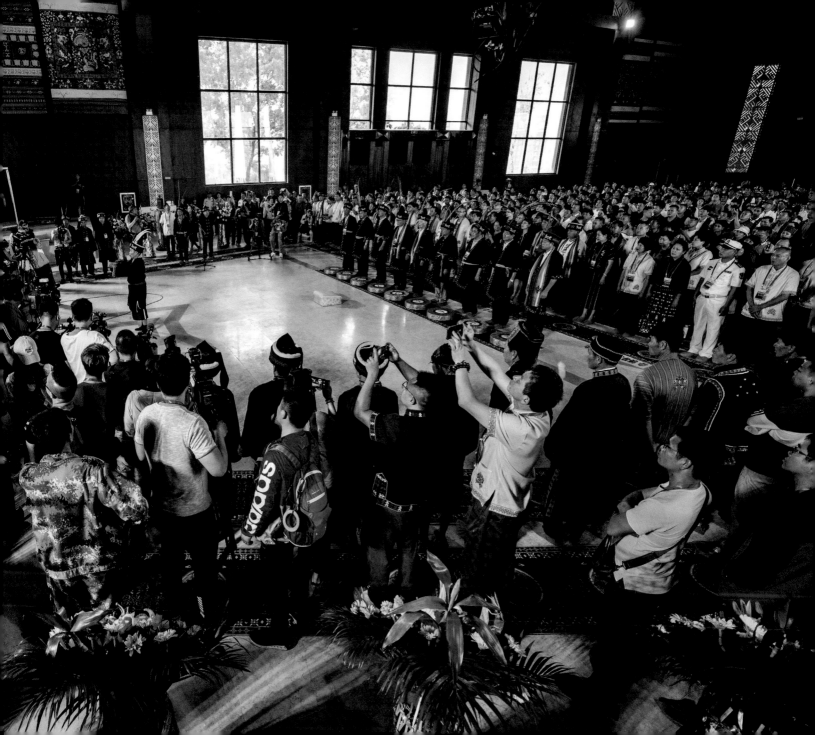

族人敲響巨大的鼓，標誌慶典正式開始。（左）相傳古時黎族遭旱災，一名黎族青年偶遇一隻百靈鳥，其後鳥兒幻化成姑娘，並答應幫助青年，解救旱災。不料百靈鳥之舉惹怒惡神，黎族青年與百靈鳥擊敗惡神後，化鳥飛翔。從此黎族在三月初三舉行慶典，祝福兩人，「三月三」也成了黎族談愛日。（右）

A beat on the giant drum signifies the official commencement of the festival. (Left) Legend said that a long time ago, when Li people suffered from drought, a young man came across a lark, which later became a girl who was willing to save Li people from drought, but the lark's action infuriated a devil. The young man and the lark fought against and defeated the devil. They then transformed into birds and flew away. Since then, Li people hold celebrations on the Double Third to bless the young man and lark. This day has also become the day of love in Li. (Right)

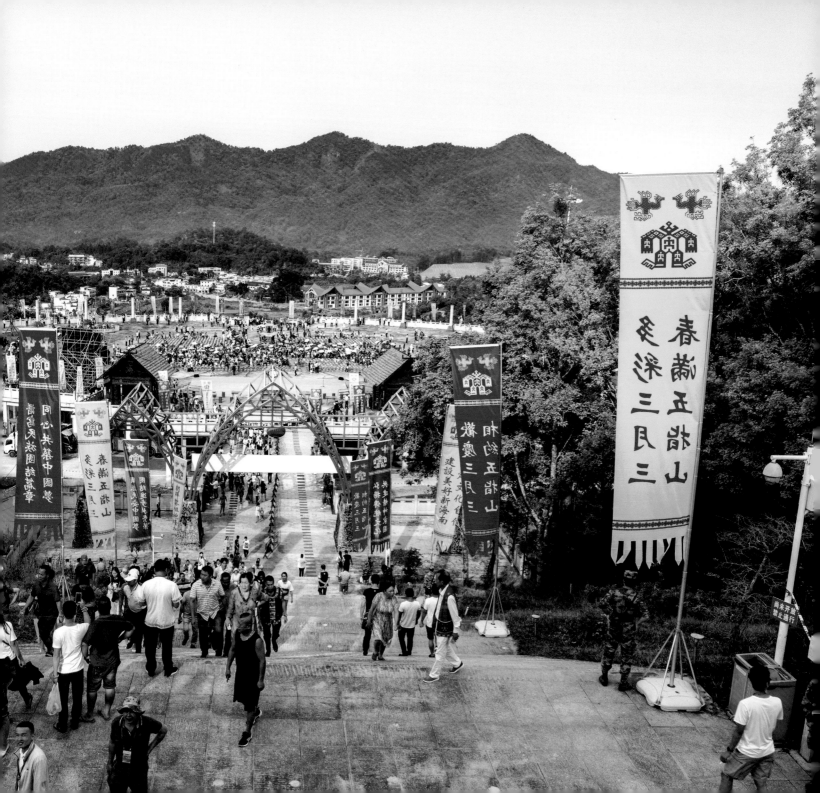

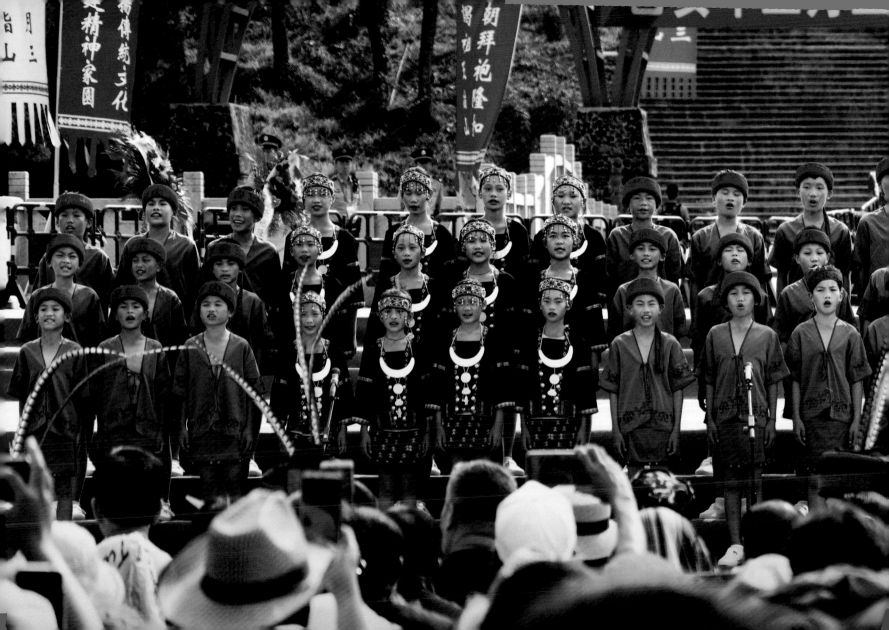

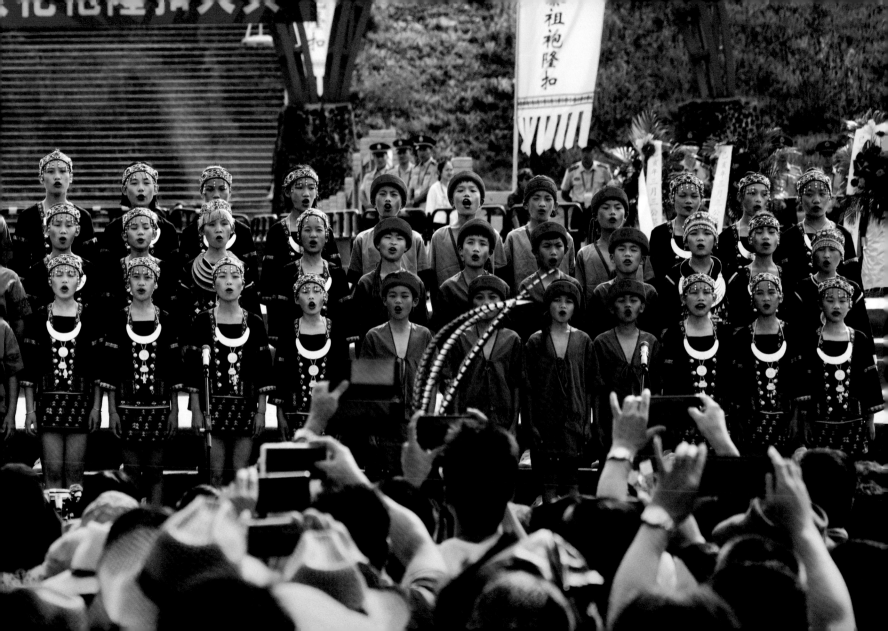

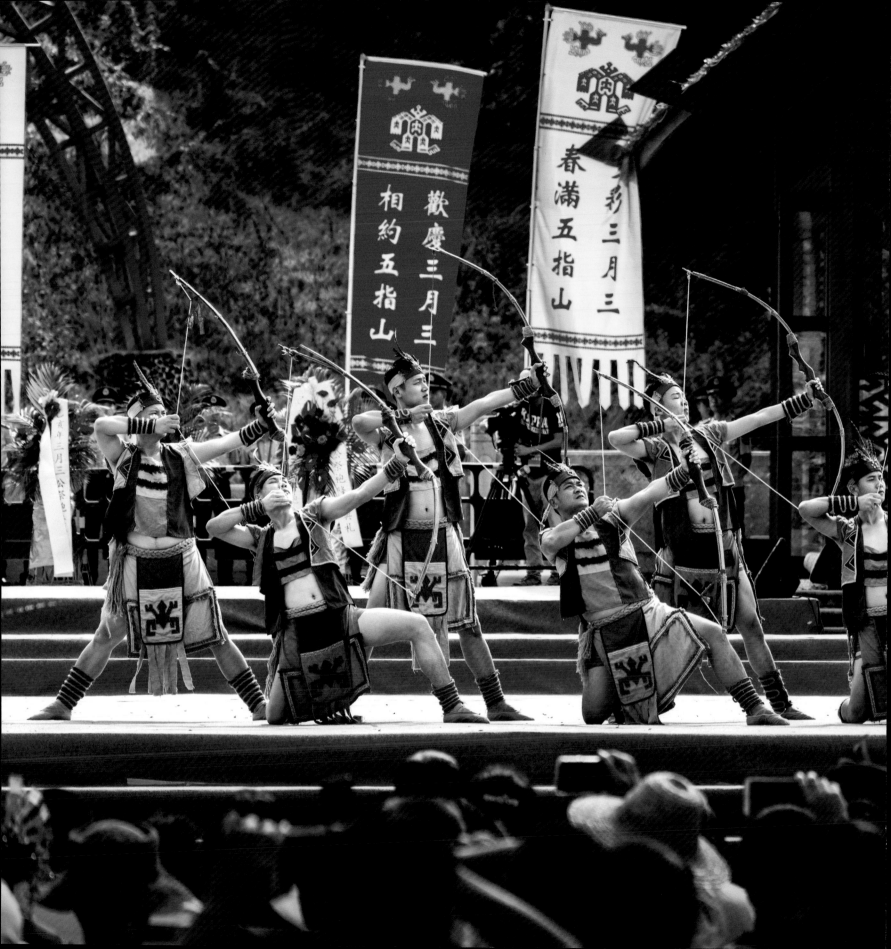

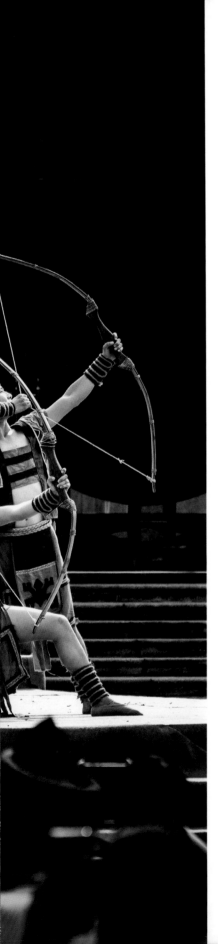

族人引弓朝向山上大殿的方向以示敬意。(左)典禮上有展示
黎族傳統生活習慣的表演。(右)

Ritual archery positions are made towards the grand hall on the
mountain as a sign of respect. (Left) There are demonstrations
of Li's traditional lifestyle at the ceremony. (Right)

黎族婦女普遍喜愛穿著黑衣。（左）每逢節日，更
會配以諸多飾物，尤以銀飾為主。（右）

Li women love wearing black clothes. (Left) On
festive occasions, they'd also put on accessories,
in which silverwares are quite popular. (Right)

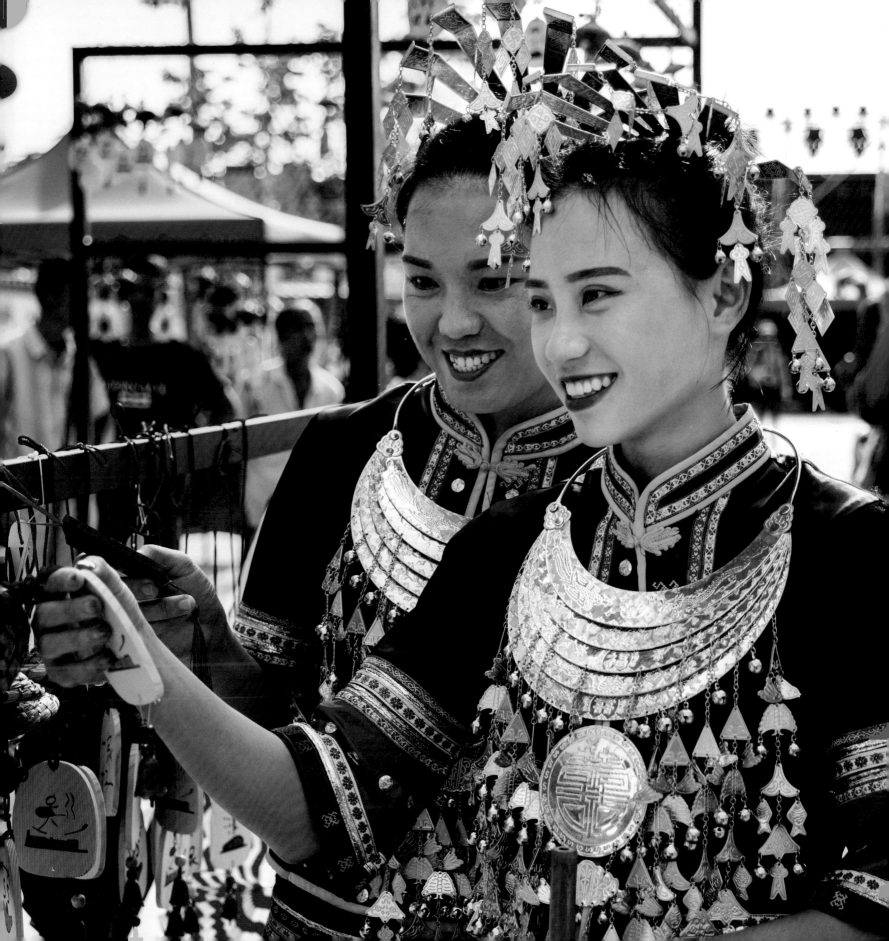

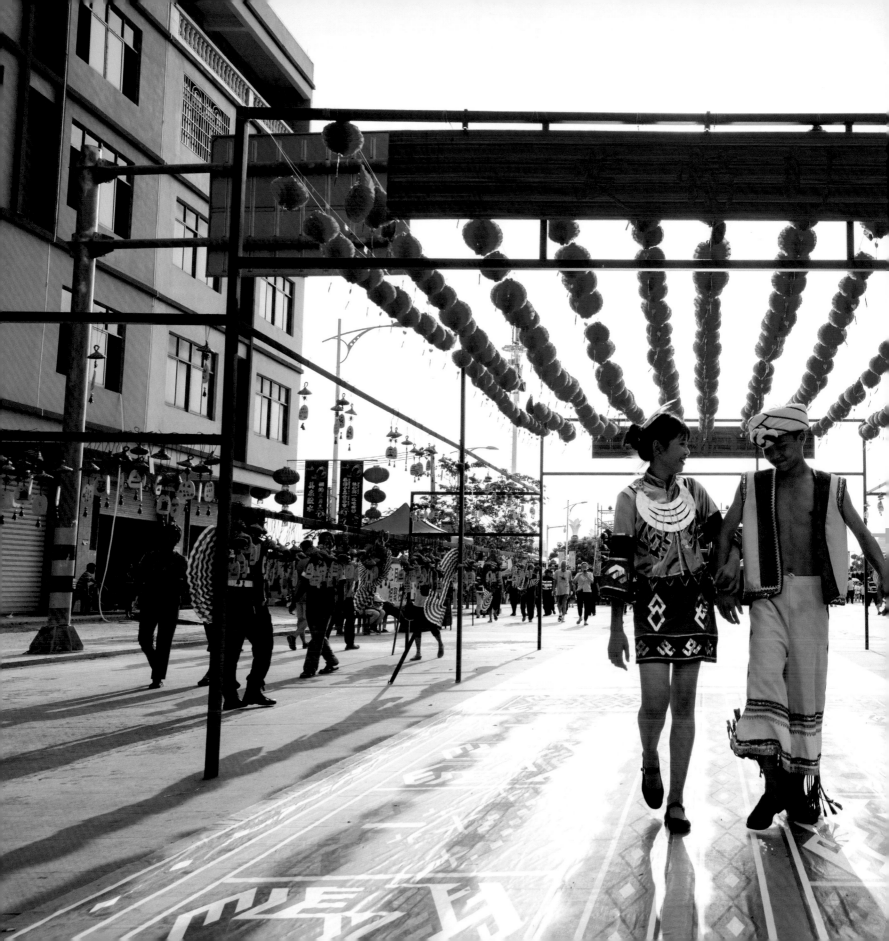

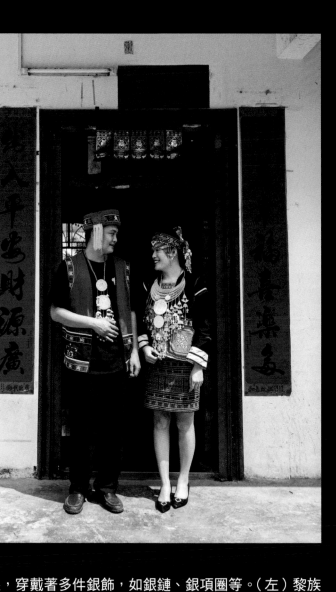

，穿戴著多件銀飾，如銀鏈、銀項圈等。（左）黎族
物器皿，以小竹筒作酒杯，對酒當歌。（右）

s folk costume and many silver accessories, including
klaces. (Left) At Li weddings, people use bamboo
oo tubes to drink while singing to each other. (Right)

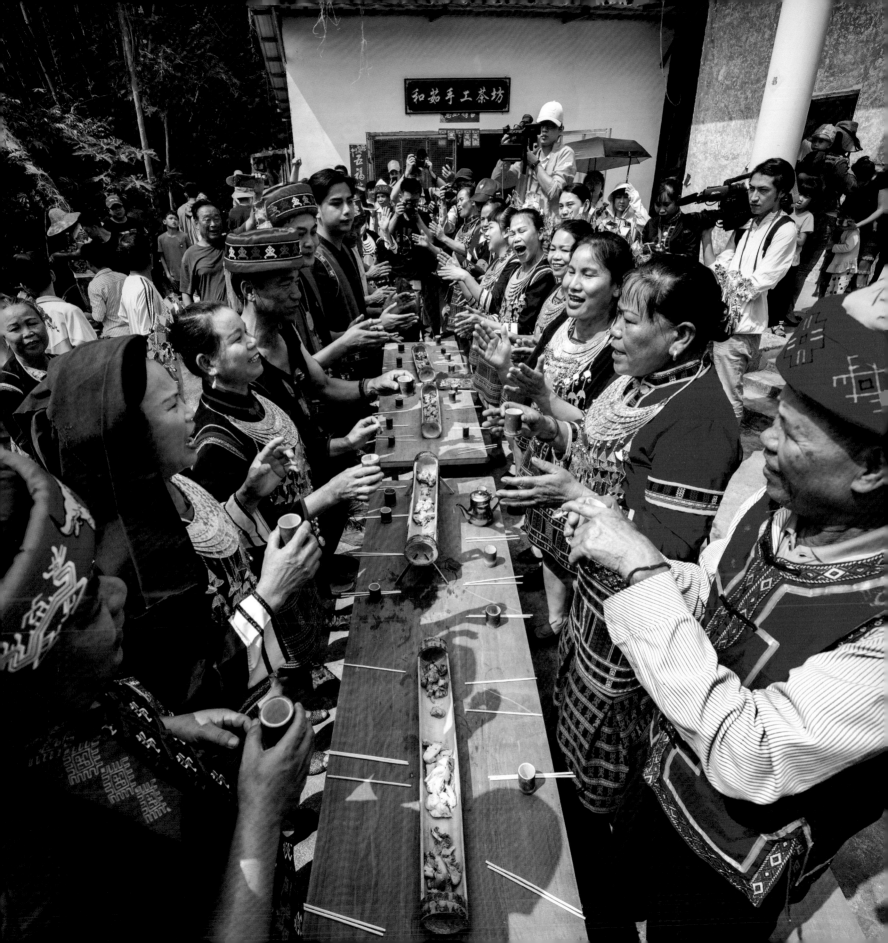

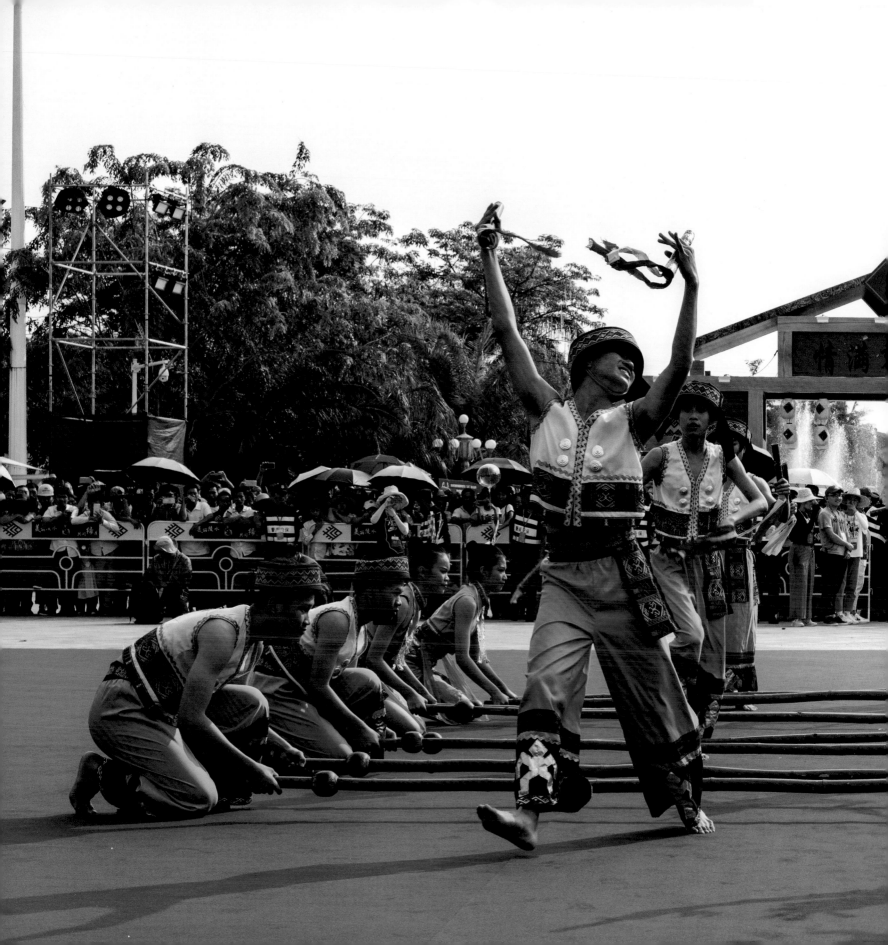

黎族傳統舞蹈可以分為五大類型：宗教祭祀舞蹈、生活習俗舞蹈、娛樂喜慶舞蹈、生產勞動舞蹈和英勇鬥爭舞蹈。

Folk dances in Li can be classified into five types: religious, conventional, entertaining, production-related and battle dancing.

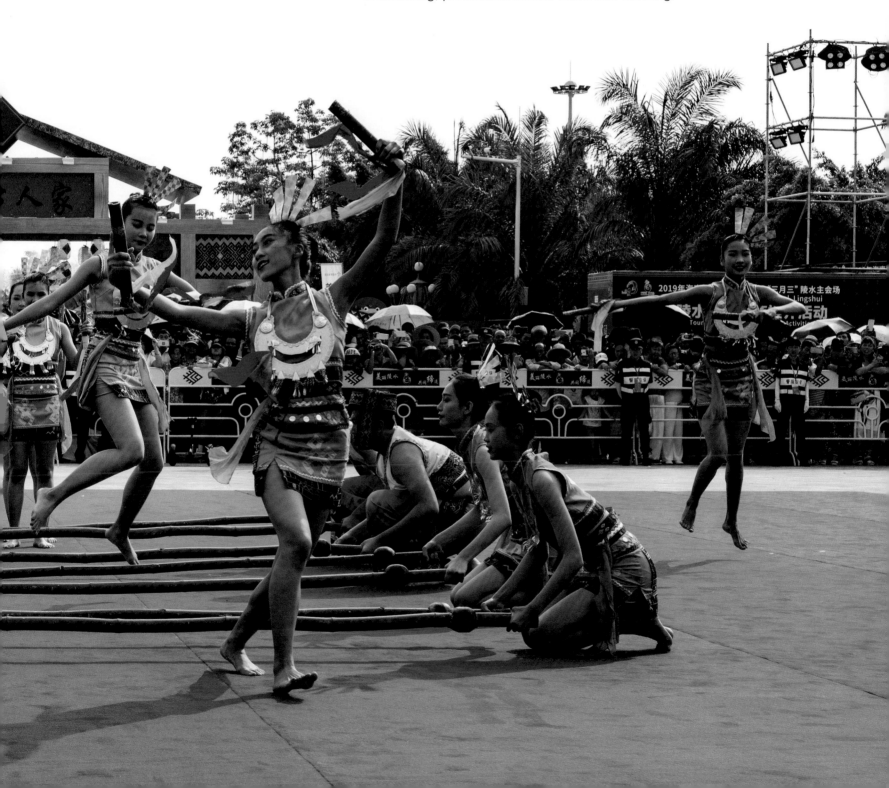

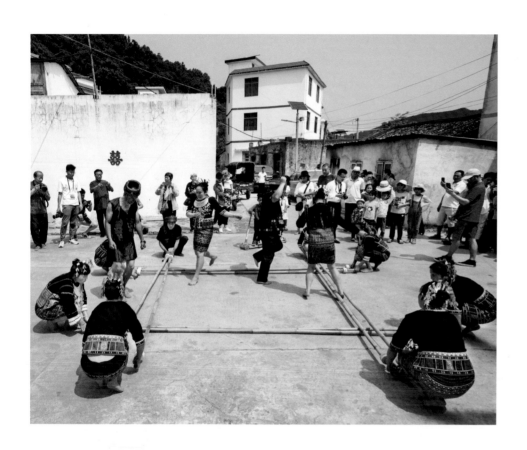

「竹竿舞」是黎族最具民族代表性的舞種。（左）舞蹈極具感染力，男女老少都適合。（右）

Bamboo Dance is the most representative dance in Li. (Left) This enchanting style is suitable for all genders and age groups. (Right)

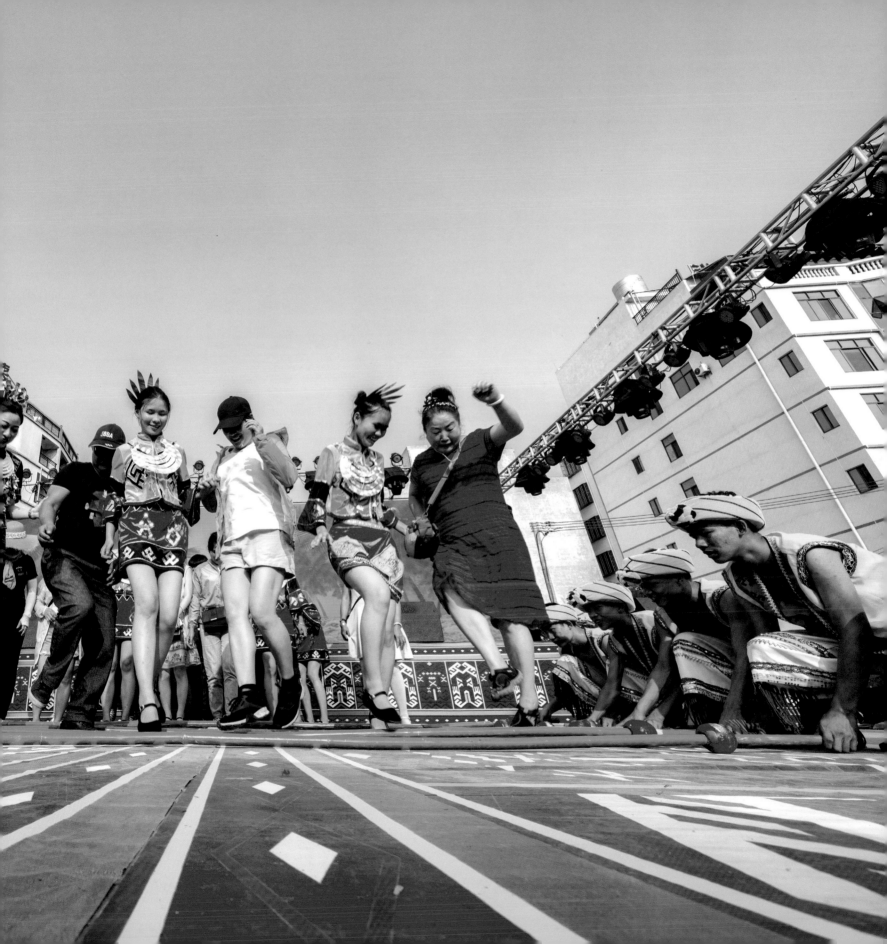

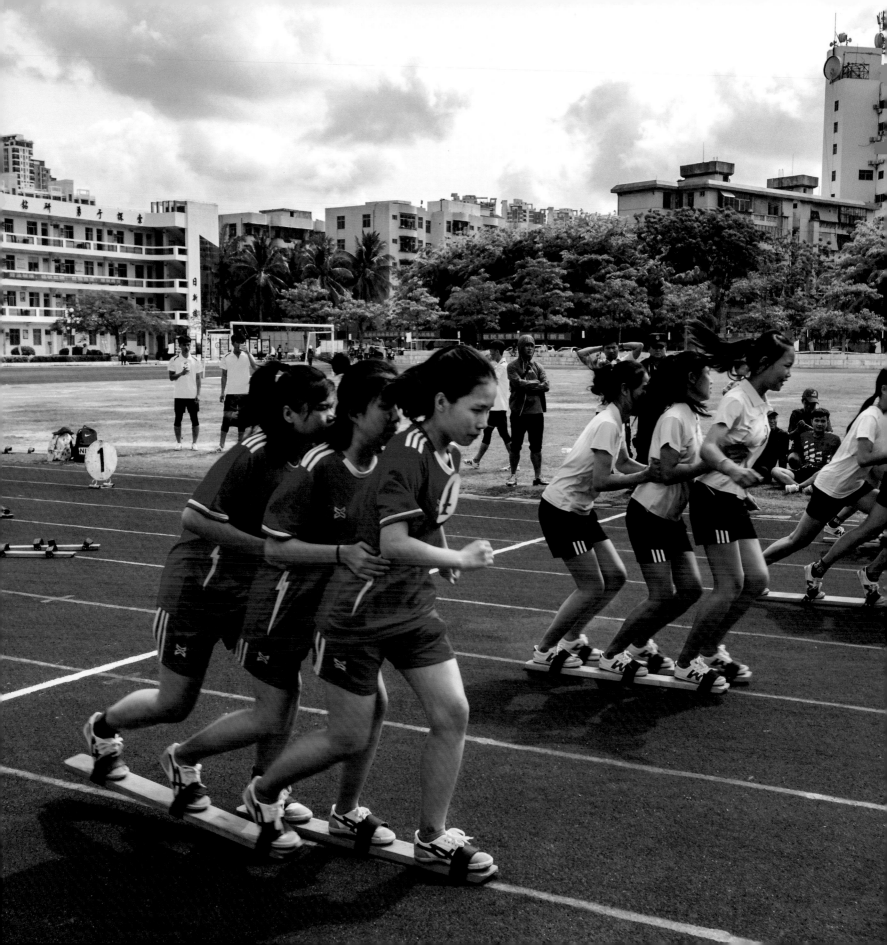

作為海南的主要少數民族，黎族和苗族在「三月三」會共同舉行民歌對唱比賽。（右）孩童之間設有考驗協作力的運動會。（左）

As the dominant ethnic minorities in Hainan, Li and Miao would jointly hold singing competitions at the Double Third Festival. (Right) There are also sports meetings for children to test their capability of coordination. (Left)

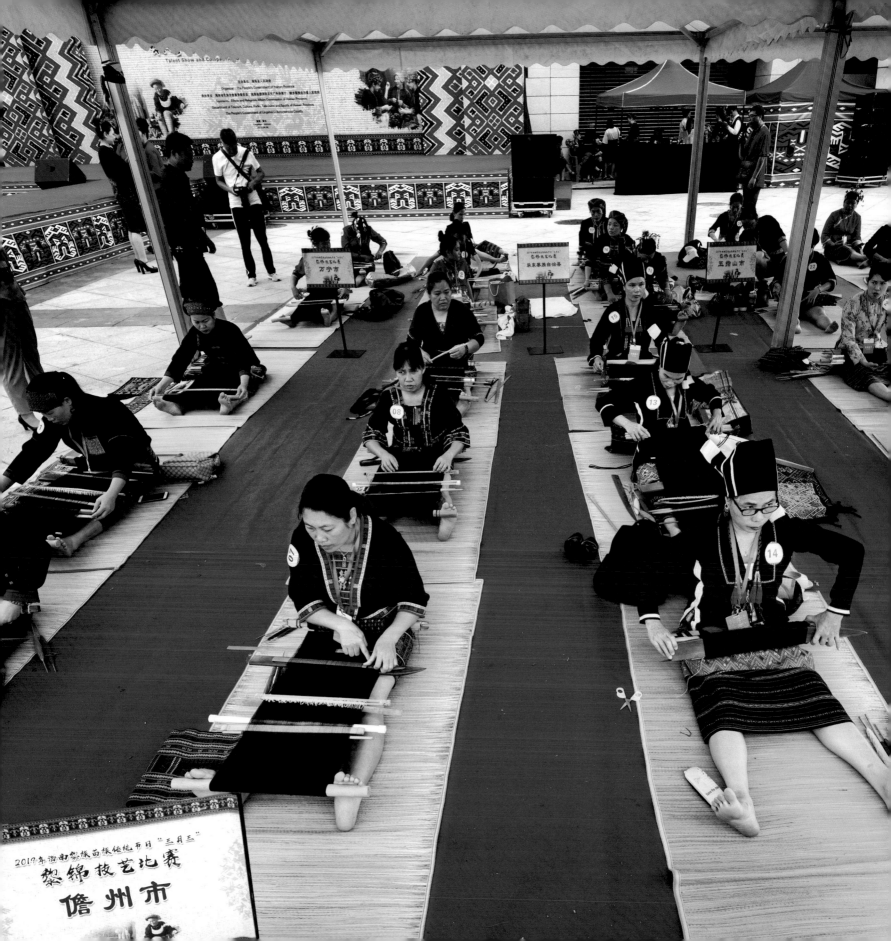

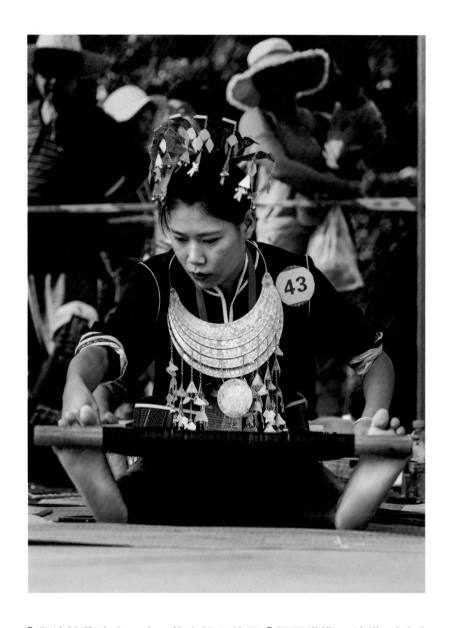

「黎錦技藝比賽」中，族中婦女使用「踞腰織機」紡織。（左）黎族傳統布藝包括紡、染、織、繡四大工序，過程複雜。黎錦被列為世界非物質文化遺產之一。（右）

At the "Li Brocade Competition", women are using the "waist-side loom". (Left) Li's traditional cloth-making skills include the four intricate steps of spinning, dyeing, weaving and embroidering. Li Brocade is a world intangible cultural heritage. (Right)

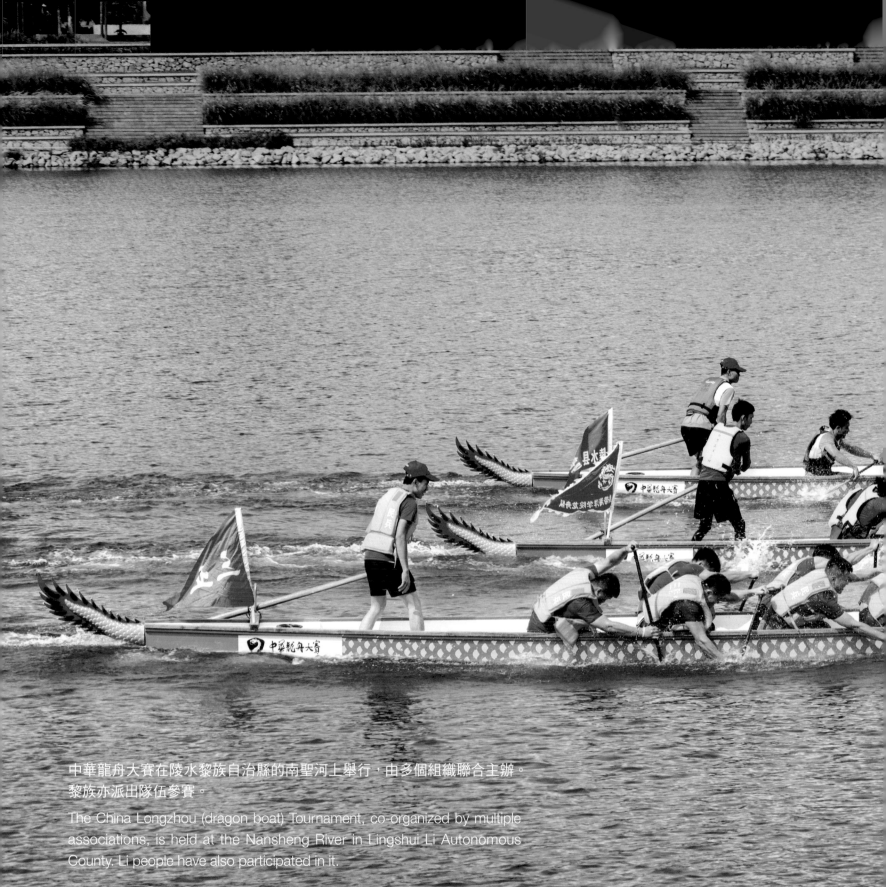

中華龍舟大賽在陵水黎族自治縣的南聖河上舉行，由多個組織聯合主辦。
黎族亦派出隊伍參賽。

The China Longzhou (dragon boat) Tournament, co-organized by multiple associations, is held at the Nansheng River in Lingshui Li Autonomous County. Li people have also participated in it.

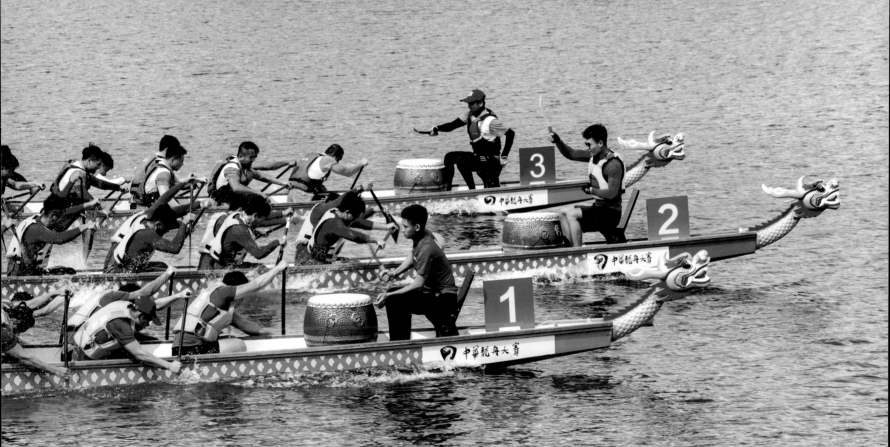

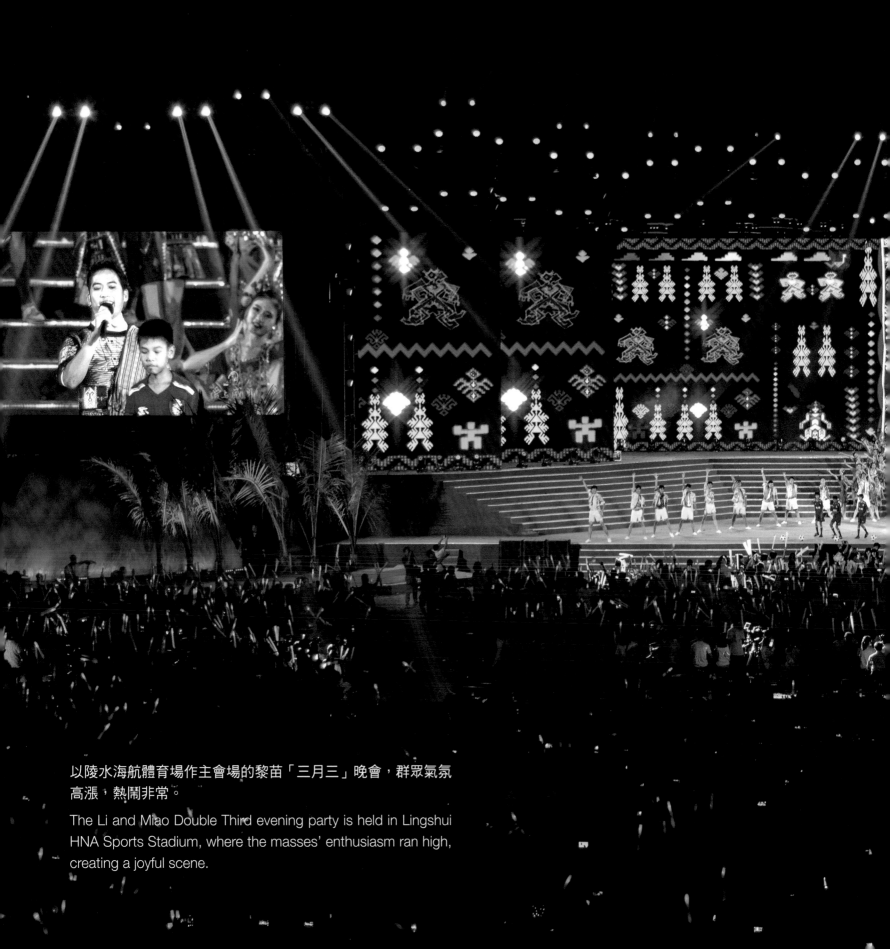

以陵水海航體育場作主會場的黎苗「三月三」晚會，群眾氣氛高漲，熱鬧非常。

The Li and Miao Double Third evening party is held in Lingshui HNA Sports Stadium, where the masses' enthusiasm ran high, creating a joyful scene.

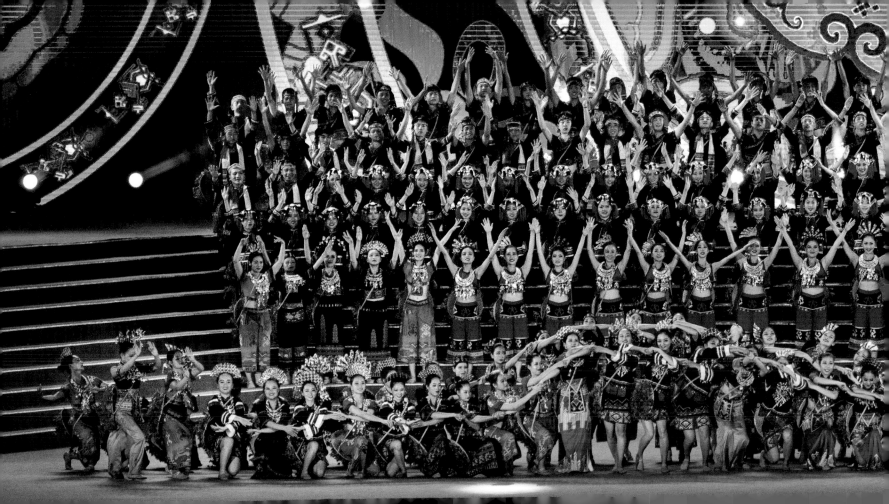

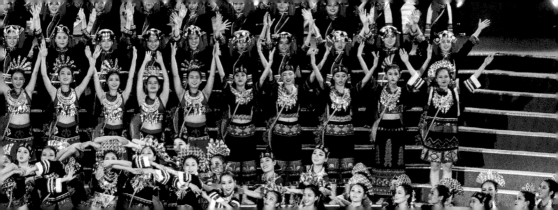

鳴謝 Acknowledgements

Zimman Shunji, Natalie Li, Pang Siu Leung, Chan Hiu, Kristie Leung, Victor Ma, Ryan Mok, Kola Ng